PASOLD STUDIES IN TEXTILE, DRESS
AND FASHION HISTORY

Volume 1

Threads of Global Desire

PASOLD STUDIES IN TEXTILE, DRESS AND FASHION HISTORY

ISSN: 2515-9038

This series, published in association with the Pasold Research Fund and comprising monographs and edited collections, is concerned with textile, fashion, and clothing history from academic and museological perspectives. The range incorporates social, cultural, and economic history and material culture history, along with distinctive approaches drawn from anthropology, art history, fashion theory, and critical studies. Recent trends in fashion and dress history seen in popular museum exhibitions and in an increasingly global understanding of the manufacture and trade in textiles are reflected in this series.

The Pasold Research Fund was established in 1964 to promote the pursuit of high quality research in all aspects of the history of textiles, dress, and fashion. Since then, it has supported hundreds of research projects in Britain and beyond ranging from archaeological excavations to twentieth-century fashion and fabric design, including the history of textile manufacturing and technologies, the textile labour force, the cultural and social contexts in which textiles and dress are produced and consumed, and textile conservation.

Threads of Global Desire

Silk in the Pre-Modern World

Edited by

Dagmar Schäfer, Giorgio Riello and Luca Molà

THE BOYDELL PRESS
PASOLD RESEARCH FUND

First published 2018

A Pasold Research Fund publication
Published by The Boydell Press
PO Box 9, Woodbridge, Suffolk IP12 3DF, UK
and of Boydell & Brewer Inc.
668 Mt Hope Avenue, Rochester, NY 14620–2731, USA
website: www.boydellandbrewer.com

ISBN 978-1-78327-293-8

ISSN 2515-9038

A catalogue record for this book is available
from the British Library

The publisher has no responsibility for the continued existence or accuracy of URLs for
external or third-party internet websites referred to in this book, and does not guarantee that any
content on such websites is, or will remain, accurate or appropriate

This publication is printed on acid-free paper

Typeset by BBR Design, Sheffield

Contents

List of Illustrations vii
List of Maps xiii
List of Tables xiv
List of Figures xv
Preface xvi

Introduction: Silk in the Pre-Modern World 1
Dagmar Schäfer, Giorgio Riello, and Luca Molà

PART I
ASIAN ORIGINS

1. Power and Silk: The Central State and Localities in State-owned
 Manufacture during the Ming Reign (1368–1644) 21
 Dagmar Schäfer

2. Why Velvet? Localised Textile Innovation in Ming China 49
 Angela Sheng

3. The Dutch East India Company and Asian Raw Silk:
 From Iran to Bengal via China and Vietnam 75
 Rudolph Matthee

4. The Localisation of the Global: Ottoman Silk Textiles and
 Markets, 1500–1790 103
 Amanda Phillips

PART II
EUROPEAN DEVELOPMENTS

5. Ottoman Silks and Their Markets at the Borders of the Empire,
 c. 1500–1800 127
 Suraiya Faroqhi

6. A Study in Contrasts: Silk Consumption in Italy and England
 during the Fifteenth and Sixteenth Centuries 149
 Lisa Monnas

7. 'What d'ye lack Ladies? Hoods, Ribbands, very fine silk stockings':
 The Silk Trades in Restoration London 187
 David Mitchell

PART III
GLOBAL EXCHANGE

8. From Design Studio to Marketplace: Products, Agents, and
 Methods of Distribution in the Lyons Silk Manufactures,
 1660–1789 225
 Lesley Ellis Miller

9. The Manila Galleon and the Reception of Chinese Silk in New
 Spain, c. 1550–1650 251
 José L. Gasch-Tomás

10. 'The Honour of the Thing': Silk Culture in Eighteenth-Century
 Pennsylvania 265
 Ben Marsh

11. A Global Transfer of Silk Reeling Technologies: The English
 East India Company and the Bengal Silk Industry 281
 Karolina Hutková

12. Changing Silk Culture in Early Modern Japan: On Foreign Trade
 and the Development of 'National' Fashion from the Sixteenth to
 the Nineteenth Century 295
 Fujita Kayoko

13. Textile Spheres: Silk in a Global and Comparative Context 323
 Giorgio Riello

Glossary 343
Bibliography 351
List of Contributors 396
Index 398

Illustrations

1.1 Drawloom with pattern tower from Wang Zhen, *Book on Agriculture* (*Nong shu* 農書, preface 1313). 28

1.2 Representation of court attire from *Pictures of Court Costumes and Manners in the Ming Dynasty* (*Minggong guanfu yizhang tu* 明宮冠服儀仗圖), Beijing, Palace Museum. 32

2.1 Diagram of inserted wires as a false weft for weaving velvet: Fanny Podreider, *Storia dei Tessuti d'Arte in Italia, secoli XII– XVIII* (Bergamo, Instituto Italiano d'Arti Grafiche, 1928), p. 10, Fig. 13. 51

2.2 Diagram of a voided ciselé velvet: Dorothy K. Burnham, *Warp and Weft: A Textile Terminology* (Toronto, Royal Ontario Museum, 1980), p. 165. Reproduced by permission of the Royal Ontario Museum © ROM. 53

2.3 Mantle made of Chinese velvet at the Uesugi Shinto shrine, Yonezawa, Yamagata Prefecture, Japan, dated 1574 (L: 114.5 cm): Ogasawara Sae (ed.), *Nihon no senshoku* (Japanese Weaving and Dyeing), Vol. 4 *Yokan hakusai no senshoku* (Weaving and Dyeing Imported from Abroad). 65

2.4 Ming dragon robe, solid ciselé, embroidered, early seventeenth century: Harold Burnham, *Chinese Velvet*, Acc. No. 956.67.2 (Toronto, Royal Ontario Museum, 1959), Pl. IV. Reproduced by permission of the Royal Ontario Museum © ROM. 68

3.1 Fort Zeelandia, Taiwan: *Gedenkwürdige Verrichtung Der Niederländischen Ost-Indischen Gesellschaft in dem Kaiserreich Taising oder Sina … verrichtet durch Pieter van Hoorn / hrsg. von Olfert Dapper* (Amsterdam: Jacob von Meurs, 1675). 85

3.2 View of Deshima, Japan, 1669: The Hague, Koninklijke
Bibliotheek, inv. no. KW 388A6. 87

3.3 View of Bandar 'Abbas, c. 1704: The Hague, Nationaal Archief,
1ste afdeling, 4. Aanwinsten 1891, no. 29. 92

3.4 VOC silk factory, Cossimbazar, Bengal, c. 1665, by Hendrik
van Schuylenburgh: Amsterdam, Scheepvaartmuseum, Inv. No.
RB.0568. 93

4.1 Ottoman voided and brocaded silk velvet (*çatma*) length,
c. 1550–70. Victoria & Albert Museum, inv. 145-1891. © Victoria
and Albert Museum, London. 112

4.2 Ottoman voided and brocaded silk velvet (*çatma*) length,
c. 1570–1600. Washington, DC, Textile Museum, inv. 1.52. 114

4.3 Ottoman voided and brocaded silk velvet (*çatma*) cushion cover,
c. 1625–75. Victoria & Albert Museum, inv. 4061-1856. © Victoria
and Albert Museum, London. 118

4.4 Two Ottoman voided and brocaded silk velvet (*çatma*) cushion
covers, sewn together, c. 1720–1750, MAK – Austrian Museum of
Applied Arts / Contemporary Art, Vienna, inv. T–5995. 121

5.1 Gold-woven silk fabric, Istanbul, 1550–1575. Athens, Benaki
Museum/Museum of Islamic Art. 131

5.2 *Prince Sigismund Kasimir of Poland (1640–1647)*, 134 x 98 cm,
Vienna, KHM-Museumsverband. 134

6.1 Detail of a fragment of crimson silk damask. Italy, second half of
the fifteenth century, 71 x 31.3 cm. London, School of Historical
Dress, no. THSD-Tex1-2015. 154

6.2 Fragment of lampas silk, brocaded with gilt membrane wrapped
thread, with birds, dogs, and rabbits. Italy, first quarter of
the fifteenth century, 66 x 43 cm. Riggisberg: Abegg-Stiftung
inv. no. 457. 155

6.3 Dalmatic of green voided satin velvet, with apparels of crimson
velvet cloth of gold of tissue, and part of an applied embroidered
monogram IHR. Italy, second half of the fifteenth century,
118 x 140 cm. Riggisberg: Abegg-Stiftung inv. no. 268. 156

6.4 Detail of a composite fragment of crimson *alto e basso* velvet.
 Possibly Milan, late fifteenth or early sixteenth century.
 Victoria and Albert Museum, no. 593-1884. © Victoria and
 Albert Museum, London. 157

6.5 Alonso Sánchez Coello (1531–1588), *Portrait of Isabella Clara
 Eugenia with Magdalena Ruiz*, 1585–1588. Oil on canvas,
 207 x 129 cm. Madrid, Museo del Prado, no. P00861. 161

6.6 Albrecht Dürer, *Venetian woman*, 1495. Pen-and-ink and brush
 drawing in grey and black with light wash, on paper. 29 x 17.3 cm.
 Vienna, Grafische Sammlung Albertina, no. 30634r. 171

6.7 Agnolo Bronzino, *Eleonora di Toledo with her son Giovanni
 de' Medici*, c. 1545. Oil on panel, 115 x 96 cm. Florence,
 Uffizi Gallery, no. 748. 174

6.8 Unknown artist, *Portrait of Henry VII*, dated 1505. Oil on panel,
 42.5 x 30.5 cm. National Portrait Gallery, NPG 416. © National
 Portrait Gallery, London. 180

7.1 Two looms, including a small table-top loom, on the frontispiece
 to the pattern: Nicolò Zoppino, *Esemplario di lavori dove le tenere
 fanciulle et altre donne nobile potranno facilmente imparare il modo
 et ordine di lavorare, cusire, raccamare et finalmente far tutte quelle
 gentilezze et lodevoli opere, lequali può fare una donna virtuosa
 con laco in mano, con li suoi compassi et misure* ... (Venice, 1529).
 New York, The Metropolitan Museum of Art, Rogers Fund, 1921. 194

7.2 Ivory self-patterned silk sixpenny ribbon (4 cm wide) at the waist
 of an English doublet, 1635–1640. Victoria and Albert Museum,
 no. 347-1905. © Victoria and Albert Museum, London. 199

7.3 Portrait of Margaret, daughter of William Hallyday, Lord Mayor
 of London, and wife of Sir Edward Hungerford, MP, by Cornelius
 Johnson, 1631, oil on panel. © Historic England Archive. 201

7.4 Detail of Charles II dancing at The Hague, by Hieronymous
 Janssens, 1660, oil on panel, London, Royal Collection Trust,
 RCIN 400525. © Her Majesty Queen Elizabeth II, 2017. 202

7.5 Gold gimp lace applied to gold satin bed hangings, late
 seventeenth century, probably English, private collection. 204

7.6 An English calendar showing the horse post to the right: *Planche CXXXII, signéer. Soierie, Calandre Royale ou Calandre Angloise.* In: *Encyclopédie, ou dictionnaire raisonné des sciences, des arts et des métiers, Nouvelle impression en facsimile de la première édition de 1751–1780*, Denis Diderot and Jean le Rond d'Alembert (eds) (Friedrich Frommann Verlag: Stuttgart, 1967), vol. 32, p. 38. Courtesy of the Max Planck Institute for the History of Science, Berlin. 208

8.1 Page from French merchant's sample book showing some simple patterns for *florences brochés*, nos. 172–175. Lyon, c. 1763–1764. Victoria and Albert Museum, no. T.373-1972, f. 9v. Acquired with the help of Marks and Spencer Ltd and the Worshipful Company of Weavers, © Victoria and Albert Museum, London. 229

8.2 Page from French merchant's sample book showing some complex brocaded patterns for *cannellés broché*, Lyon, c. 1763–1764. Victoria and Albert Museum, no. T.373-1972, f. 25v. Acquired with the help of Marks and Spencer Ltd and the Worshipful Company of Weavers, © Victoria and Albert Museum, London. 230

8.3 and 8.4 Frontispieces to 'Inventaire des archives de la Grande fabrique de soie, 1536–1785': vol. 2, 'The alliance of their art surpasses nature', and vol. 3, 'As long as extravagance reigns, the manufactures will survive'. Drawings, ink on paper. Courtesy of the Archives Municipales de Lyon. 234

8.5 and 8.6 Jean Paulet, *L'art du fabricant d'étoffes de soie. Description des arts et métiers* (Paris: Académie Royale des Sciences, 1789), second part of 7th section, Plates 194 (freehand sketches) and 196 (point paper designs/*mises-en-carte*), details. Courtesy of the Abegg-Stiftung, Riggisberg. 238

8.7 and 8.8 *Mise-en-carte* (recto and verso) for a *gros de tours en dorures et nuences*, probably by Daniel Symiand, for L. Galy, Gallien et cie., No. 850, dated 8 July 1763. Gouache and ink on engraving. 48 x 51.8 cm. © Victoria and Albert Museum, London, no. T.413-1972. 241

8.9 Trade card for silk manufacturer Jean Cabrier of Lyon, 1668. Waddesdon Rothschild Collection, 3686.1.24.38. 245

8.10 Trade card for the retail outlet set up by the manufacturers
of Lyon in Paris under royal patronage, c. 1780. Waddesdon
Rothschild Collection, 3686.2.20.49. 246

9.1 Red satin tunic embroidered with gold and Chinese dragons,
Qing Dynasty, between 1726 and 1800. Museo Nacional de Artes
Decorativas. Photo credit: Masú del Amo Rodríguez, Museo
Nacional de Artes Decorativas, Madrid. 259

9.2 Francisco de Zurbarán, *Santa Isabel de Portugal*, 1635. Museo del
Palacio Real, Madrid. 262

10.1 Detail from page 3 of the *Pennsylvania Gazette* (17 March 1773,
No. 2308) containing a listing of the prize-winning cocoon
harvesters in Pennsylvania that year. 274

10.2 Swatches of fabric appended to a manuscript of John Fanning
Watson, 'Extra-Illustrated Autograph Manuscript of "Annals
of Philadelphia," Germantown, 1823' Library Company
of Philadelphia. LCP Print Room: *Annals of Philadelphia*,
John F. Watson, Yi 2 / 1069.F., Box 1. 279

11.1 Piedmontese reeling machine as depicted in Lardner's *Treatise*
(1832). Source: Dionysius Lardner, *A Treatise on the Origin,
Progressive Improvement, and Present State of the Silk Manufacture*
(Philadelphia: Carey & Lea Chestnut Street, 1832), p. 155. 286

12.1 Weaving a brocade on a *sorahiki-bata* handloom and weaving a
velvet. Illustrations from Akisato Ritō and Takehara Shunchōsai,
Miyako Meisho Zue [A Pictorial Guidebook to Kyoto], volume 1
(1780). Waseda University Library, Bunko30 E0214. 313

13.1 Emperor Justinian receiving the first imported silkworm eggs
from two Nestorian monks, Plate 2 from *The Introduction of the
Silkworm [Vermis Sericus]*. Print by Karel van Mallery (Antwerp,
1571–1645), after Jan van der Straet, called Stradanus, published
by Philipp Galle. c. 1595. The Metropolitan Museum of Art, The
Elisha Whittelsey Collection, The Elisha Whittelsey Fund, 1950. 329

13.2 The reeling of silk, Plate 6 from *The Introduction of the Silkworm
[Vermis Sericus]*. Print by Karel van Mallery (Antwerp,
1571–1645), after Jan van der Straet, called Stradanus, published

by Philipp Galle. c. 1595. The Metropolitan Museum of Art,
Gift of Georgiana W. Sargent, in memory of John Osborne
Sargent, 1924. 330

13.3 Detail of a nightgown. Silk satin, interlined with wool, and lined
with silk. Produced in Spitalfields, London. Woven in 1707–1708
and made into a garment in 1707–1720. © Victoria and Albert
Museum, London, no. T.281-1983. 338

13.4 Cotton, resist- and mordant-dyed dress or furnishing fabric.
Produced on the Coromandel Coast, India, c. 1715–1725.
© Victoria and Albert Museum, London, 342 to B-1898. 339

Maps

0.1 How the production of silk thread, sericulture, silk weaving, and
 the textile trade spread across the world. 5

1.1 Ming China showing the locations of former Yuan Weaving
 and Dyeing Bureaus and those established in the Ming period,
 highlighting overlaps. 35

2.1 Ming China showing centres of velvet production in Zhangzhou,
 Quanzhou, Hangzhou, Suzhou and Nanjing. 50

3.1 The expanded silk trade routes connecting Asia, particularly Iran,
 and European states, after the sixteenth century. 77

3.2 Asian shipping lanes of the VOC in the seventeenth century,
 connecting VOC ports in Southeast Asia, China, and Japan with
 India and the Middle East. 88

13.1 The three areas of textiles and their trade in the medieval and
 early modern world. 326

Tables

6.1 Types and prices of raw silk purchased by the firm of Andrea Banchi in Florence, and their usage by the Banchi firm. 151

6.2 Prices extracted from the accounts of Henry VII, 1498–1499. 158

6.3 Narrow wares and other small finished silk items imported into England listed in the Book of Rates, 1558. 163

6.4 Purchases by Hugh Dyke, mercer, embroiderer, and vestment-maker, 1440–1441. 177

7.1 Specialty identified at end of apprenticeship in the Dyers' Company, 1660–1684. 190

7.2 Selected inventories of weavers and framework knitters, 1660–1710. 196

7.3 Bed hangings in London 1660–1704: rooms valued at more than £30. 209

9.1 Value of raw silk and silk thread in New Spain per origin (in per cent), c. 1590–1630 257

9.2 Value of silk fabrics per type and origin in New Spain (in per cent), c. 1591–1630 260

12.1 The amount of silk yarns in *piculs* produced in diverse places in Asia and imported into Japan through the two gateways of Nagasaki and Tsushima by Portuguese, Chinese, and Dutch traders and Tsushima-*han*. 304

Figures

12.1 The amount of silk yarns produced in diverse places in Asia and
 imported into Japan through the two gateways of Nagasaki and
 Tsushima by the Portuguese, Chinese and Dutch traders, and
 Tsushima-*han*. 303

13.1 Creating design on cloth in early modern Eurasia. 340

Preface

Silk textile is the product of many trades. First-quality silks were produced only when actors cooperated efficiently throughout the entire process, from production to consumption and use. Farmers had to plant mulberry trees in advance and they had to yield in due time. Entire households were seasonally engaged in the breeding of the caterpillar, and then the reeling of the thread that weavers, in private or state-owned workshops, used to produce varied types of cloth. Equally the history of silk is the product of many trades. Collaboration is necessary to bring together the varied research fields and many different literatures that, over the course of the last decade, have contributed to and expanded our growing understanding of silk as the product and commodity of a globalising pre-modern world.

In December 2010, a number of experts gathered at a conference organised at the Max Planck Institute for the History of Science in Berlin. Fields of expertise ranged from the fabric and its production methods, through silk's varied sources and histories of its consumption and use. On this occasion, first discussions were held on how to narrate a global history of silk: what are its main chapters and who are its main actors? How can one combine in-depth research with wider interpretations that span across time and space? We realised quickly that we had a shared agenda, but also that knowledge of terminology, of processes of technological diffusion and on the typology of products available to consumers was fragmented across fields of regional studies and divided among those who study the fabric, its production methods, or its varied sources and histories of consumption and use.

Since then, the original group of scholars has continued a sustained conversation aimed at providing a connected and interdisciplinary view on silk. The present volume includes new contributors as well as scholars who have closely worked with the editors since the start of this project. It does not attempt to be comprehensive in either its geographic or chronological coverage. Silk history is extremely dispersed and its long history and many aspects deserve an encyclopedic approach that is far beyond the scope of a single book or project. The thirteen chapters in this volume are meant to provide a starting point for anyone who might be interested in understanding the process of development of a global

industry, of a material and a product in the pre-modern age. This book should be read in conjunction with *Seri-Technics: Historical Silk Technologies*, an Edition Open Access special issue published by the Max Planck Institute for the History of Science, that comprises a further selection of papers resulting from these conversations.

Like any lasting effort, this project relied not only on a sturdy ground weft, but even more so on helping hands that guided the shuttle through the right patterns and sheds: Maxine Berg, Chen BuYun, Zhao Feng, Anne Gerritsen, Donald Clay Johnson, Dorothy Ko, Lisa Onaga, and Prasannan Parthasarathi provided excellent comments and advice along the way. We are particularly grateful for the support of the various institutions that helped us to develop this project: the University of Manchester, the University of Warwick, and the Max Planck Institute for the History of Science, Department III, 'Artefacts, Action and Knowledge'. On an even more basic level, this book would have not come to fruition without the invisible hands that helped give the right twist to each single thread: Gina Partridge-Grzimek and her team at the Max Planck Institute for the History of Science, our copy-editors and the team at Boydell & Brewer. Finally, our thanks go to the anonymous reviewers for their incisive comments, and the Pasold Research Fund and especially its Director Stana Nenadic and former Chair Pat Hudson for accepting this work as the first volume of the Fund's new series in the 'History of Textiles, Dress and Fashion' published by Boydell & Brewer.

The Editors
January 2018

Introduction: Silk in the Pre-Modern World

Dagmar Schäfer, Giorgio Riello, and Luca Molà

Silk begins as a liquid extruded by a caterpillar through a small opening on its back. Upon contact with air, the liquid solidifies into a filament. This filament constitutes the raw material for a highly coveted textile. Ever since Antiquity, the love and longing for silk textiles has fostered connections across Asia, Europe, and the Atlantic. By the late sixteenth century the trade of silk yarn and cloth was truly global, spanning all known continents. Many strove to discover the principles of silkworm breeding and unveil the secrets of producing high-quality silk yarn. Sericulture and silk manufacturing thus propelled both peaceful interchange and cross-cultural competition, generating wealth and power, and transforming economies and societies.[1]

Studies in this volume scrutinise local conditions and disentangle cross-regional ties, illustrating how the material that people dealt with in their everyday lives (sericulture) and the stuff that they dreamt of (silk textiles) exalted human imagination and fostered technical and economic change. The global dimension of silk becomes apparent only through a multi-layered perspective of cultivation, production, trade, consumption, and use. Calling on knowledge from textile, economic and social history, art and design studies, archaeology and the history of science and technology, in this book thirteen scholars consider processes of technological diffusion and change, and the social and cultural dynamics shaped by silk before the nineteenth century.

Organised in three parts, *Threads of Global Desire* follows the spread of sericulture and the trade of silk products from East Asia through its southern and western parts to Europe and the Americas, and back to the Asian coasts. The first part discusses the origins and evolution of silk production in Asia, with a

[1] For the purposes of this volume, we understand 'sericulture' to include not only the worm but also moriculture, i.e., the cultivation of mulberry plants.

particular emphasis on the regions under Ming (1368–1644) and Qing dynastic (1645–1911) rule as well as the Ottoman empire, South Asia, and the Near East. The second part narrows the focus to the role of sericulture and silk textile production in Europe, in particular Italy, France, and Britain. The third and final part addresses the local and global connections generated around silk production and consumption in the pre-modern globalising world in areas as diverse as Latin and North America, Europe, India, and Japan.

SILK IN GLOBAL HISTORY

Silk has long been seen as a global commodity, an item that, because of its remarkable qualities, high value, and relative portability came to be traded over very long distances.[2] In the nineteenth century, when Ferdinand von Richthofen (1833–1905) 'invoked Marinus and Ptolemy's description of silk trade routes to develop a competitive German blueprint for a commercial railroad linking China with Europe',[3] the term 'silk roads' became popular, highlighting the key role that silk and silken textiles had played in Eurasia since Antiquity. Generations of art historians as well as economic and textile historians have followed the movements of silk as an item of trade over the *longue durée*, focusing on silk as a luxury item.[4] Today, this position is challenged in at least three ways.

First, in line with a historiographical shift over the past two decades, many of the contributions in this volume demonstrate that the importance of silk lay not just in its ability to cater for and connect elites across continents and seas, but also in its wider social and economic function. In all the regions discussed, sericulture and silk processing profoundly affected people's lives. The manufacture of silk textiles was a profitable occupation for thousands of men and women, supporting entire agrarian and urban economies; its consumption affected common people who wished to possess silken textiles, if only in the form of narrow ribbons and cheap trimmings. The story of silk is therefore entwined

[2] For more on world trade in silk see Debin Ma (ed.), *Textiles in the Pacific, 1500–1900* (Aldershot, 2005), especially ch. 1.

[3] Tamara T. Chin, 'The Invention of the Silk Road, 1877', *Critical Inquiry*, 40/1 (2013), 194–219. For a re-evaluation of the economic role of Western trade for the early Han see Tamara T. Chin, *Savage Exchange: Han Imperialism, Chinese Literary Style and the Economic Imagination* (Cambridge MA, 2014). See also Debin Ma, 'The Modern Silk Road: The Global Raw Silk Market 1850–1930', *Journal of Economic History*, 56/2 (1996), 330–55; and Feng Zhao, *The Silk Road: A Road of Silk* (Hangzhou, 2016).

[4] Studies of world or global history as well as those specialising on silk regularly invoke the early expansive character of silk. See, for instance, Mary Schoeser, *Silk* (New Haven, 2007), 13; and Shelagh J. Vainker, *Chinese Silk: A Cultural History* (London, 2004).

with that of consumption and manufacturing and the rise of design and fashion as a new concept and practice over several centuries and across the globe.[5]

Second, the study of silk allows us to map forms of global connection that are not necessarily linked to either trade or consumption. Drawing from material culture studies, several chapters in this volume consider silk through a series of material practices. Such practices include how the material is used and handed down from generation to generation, the re-cycling and repair of silk textiles, as well as the design and making of the cloth. This volume moves beyond the concept of consumption to a wider notion of 'use' to appreciate the connection between labour, forms of production, and the distribution and consumption patterns that silk created.[6] This wider view includes how silk inspired debates about technical and aesthetic standards, as well as moral and legal values and ideas.

A final and important contribution of the history of silk to recent global history is its challenge to established narratives of economic development and social and cultural modernity. Changes in production modes, labour segmentation, and consumer-driven innovation – all central elements in late eighteenth- and nineteenth-century global shifts in power and wealth between 'East' and 'West' – are apparent much earlier in the silk sector (and led to a circulation of practices and skills from East to West). From the viewpoint of silk, the 'great divergence' that Kenneth Pomeranz identified in his global analysis of Europe's trajectory towards industrialisation is difficult to support.[7] Asian empires, from the Song (960–1279 CE) to the Qing dynasty in China, the Ottoman empire (1299–1923) in West and Central Asia, or the Tokugawa (1603–1867) and Meiji (1868–1912) shogunates in Japan, were as innovative as European producers in the manufacture and trade of silk well into the nineteenth century.[8] In the

[5] Beverly Lemire and Giorgio Riello, 'East & West: Textiles and Fashion in Early Modern Europe', *Journal of Social History*, 41/4 (2008), 887–916; John Styles, 'Fashion and Innovation in Early Modern Europe', in Evelyn Welch (ed.), *Fashioning the Early Modern: Dress, Textiles, and Innovation in Europe, 1500–1800* (Oxford, 2017), 33–53.

[6] This approach, in its emphasis on production, borrows from Marx. Yet new approaches equally emphasise the long life of artefacts in use. In contrast, historian Frank Trentmann, 'Beyond Consumerism: New Historical Perspectives on Consumption', *Journal of Contemporary History*, 39/3 (2004), 373–401, prefers to retain the label 'consumption' but re-defines it in wider terms to include any practice related to material things. On material culture approaches see Anne Gerritsen and Giorgio Riello (eds.), *Writing Material Culture History* (London, 2015).

[7] Kenneth Pomeranz, *The Great Divergence: China, Europe, and the Making of the Modern World Economy* (Princeton, 2000).

[8] Similar to the case of cotton, the story of Europe's bid to become a major silk manufacturing centre is intertwined with wider global shifts in power and wealth. See Giorgio Riello, *Cotton: The Fabric that Made the Modern World* (Cambridge, 2013).

case of silk, France, Italy, England, Germany, and Spain were latecomers and their dominant position in the sector had already waned by the twentieth century. Instead of opposing the 'West' to the 'Rest' or 'industrial' to 'traditional' societies, the history of silk tells a story that is both chronologically and regionally articulated and conceptually nuanced.

WHY SILK? THREADS AND CONNECTIONS

The silk industry – from sericulture to the weaving of cloth – was one of the most important sectors in medieval and early modern economies. Silk production and consumption spread from the banks of the Yellow River eastward to the empires of what is now modern Korea and Japan, and westward via the Indian subcontinent, Persia, and the Byzantine empire, across Europe, to North Africa and the Americas. Although not all of these regions have been equally well studied (as sources are not evenly distributed), we can see that in this process of diffusion the desire for silk often fostered technological innovation and created opportunities for new forms of labour organisation to emerge. Concurrently, silk consumption constantly reshaped social hierarchies, gender roles, aesthetic and visual cultures, as well as rituals and representations of power.[9]

The globally expanding desire for silk created a unique pattern of connectivity because of the different pace at which the production of silk thread, sericulture, silk weaving, and the textile trade spread across the world (Map 0.1). Silk production is regionally diversified because for a long period the silk worm, a food and climate specialist, resisted human attempts to modify it. Raw silk production thus remained localised and confined to small variations in moth varieties. Sericulture with domesticated worms was limited to the distance that would ensure the worm could be fed fresh mulberry leaves – its food of choice – and thus survive the process of transfer. Even within the bounds of the climate belt in which the worm could be raised, the pace of the spread of sericulture was haphazard, moving in hops, skips, and jumps from the East Asian plains to locations such as Dai-Vietnam, Thailand, the Indian subcontinent, and the European Mediterranean.[10]

[9] For a similar methodology see: Marie-Louise Nosch, Zhao Feng, and Lotika Varadarajan (eds.), *Global Textile Encounters* (Philadelphia, 2015).

[10] Francesca Bray and Joseph Needham, *Science and Civilisation in China, Vol. VI. Biology and Biological Technology Part 2. Agriculture* (Cambridge, 1984), 57–63. For the early history of reeling and weaving in China see: Dieter Kuhn and Joseph Needham, *Science and Civilisation in China. Vol. V, Chemistry and Chemical Technology. Part 9. Textile Technology: Spinning and Reeling* (Cambridge, 1988). The worm could prosper only in the humid to sub-humid tropical climates to be found mainly between '30 and 35 degrees latitude north. Jiang Youlong, 'Shu qian nian lai woguo sang can

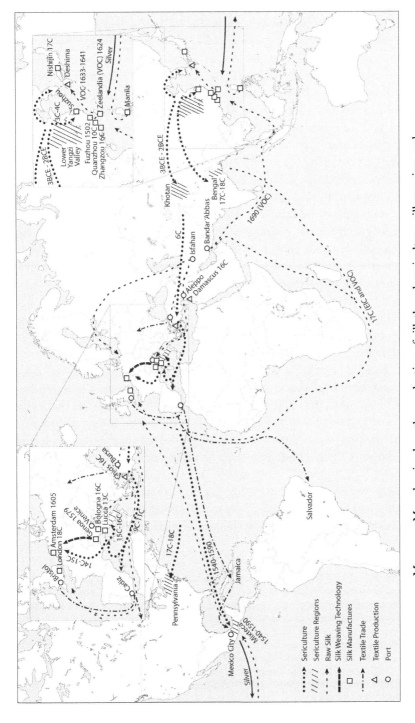

Map 0.1 Map showing how the production of silk thread, sericulture, silk weaving, and the textile trade spread across the world. Design: Julian Wickert.

Despite regional fragmentation, the desire for silk generated some shared characteristics, such as high regard for extremely light and evenly woven silks or lavishly coloured textiles or accessories with complicated wefts produced from long and even threads with soft, smooth surfaces. Clusters of techno- logical expertise emerged that relied on complex market networks to access and distribute raw material. Reeling the silk and breeding the worm seem to have remained connected whereas elite and merchant investment spurred local processing industries.[11] Artefacts suggest that by the seventh century weavers were already performing on a variety of looms and pursuing local techniques of dyeing threads and textiles in Japan, Persia, and Byzantium.[12]

Technological and social intricacies, as well as the tension between diversi- fying markets, explain the historical nature of the trans-regional networks that the desire for silk generated. Although China long remained the centre of raw silk production, silk manufacturing achieved high standards of quality in different parts of the world. By 1600 several areas, ranging from China to Japan as well as Iran and western Europe, excelled in the production of different types of silk. At this time, there was no single preeminent silk producer of silk yarn and cloth at the world level, unlike the cotton industry, whose core region of production – the Indian subcontinent – retained its leadership well into the period of European industrialisation.[13]

As studies of surviving silk textiles have emphasised, the regional spread of silk products and technology meant that designs, fashion, and consumption patterns, in all their local variations, impacted, and were impacted by, cultures across the world. Equally, the regional pattern of textile production and sericulture left important marks on local customs and habits. While states attempted to interfere in and profit from the silk trade – with officials enacting sumptuary laws, and the elites writing learned tracts – wherever and whenever sericulture and silk textile weaving was successfully implemented, its material requirements and technical logic encroached on social patterns, labour relations (for instance, in the case of gender), aesthetics, and notions of technological change. Silk therefore was not

zai jiayang xia de yanbian' [Thousands of Years of Evolution in Raising Domesticated Silkworms in China]', *Acta Entomologica Sinica*, 20/2 (1977), however, identifies three different kinds (for terri- torial distribution see his map at p. 349) suggesting that breeding and selection enabled an expansion on the mainland of East Asia to approximately 45 degrees latitude.

[11] For example, in Japan, as Kayoko Fujita in this volume illustrates.

[12] Sasanian weavers, for instance, were building on Syrian drawloom technology. Heleanor B. Feltham, 'Lions, Silks and Silver: The Influence of Sasanian Persia', *Sino-Platonic Papers*, 206 (2010), 16; Lisa Monnas, 'Loom Widths and Selvedges Prescribed by Italian Silk Weaving Statutes 1265–1512: A Preliminary Investigation', *CIETA Bulletin*, 66 (1988), 35.

[13] Riello, *Cotton*, esp. ch. 1.

just subject to globalisation, but was itself an active agent, forming aesthetics, creating values, and shaping lives.

The beautiful silk textiles that are now displayed in museums around the world also underline the universal appeal of silk as a symbol of status and wealth. As a rarity, with a high cost but unique material properties, silk triggered powerful reactions, enticing devotees and repelling critics. Silk as a debauched and dissolute form of luxury is not an early modern conceptualisation. King Shang Tang 商湯 (1617–1588 BCE) is said to have conquered the kingdom of Xia – the state which Chinese scholars would later invoke as the quintessential model of governance – only because the king's concubines had been fascinated by the sound made by the tearing of high-quality silks.[14] On the other side of the Eurasian landmass, in Roman Italy, Emperor Diocletian in 301 CE specifically controlled the prices of raw silk, possibly from China. By this time silk had become an item worn by both men and women, notwithstanding the fact in 16 CE the Senate had forbidden men from wearing this imported fabric. Silk, was considered – in the words of a historian of ancient times – 'an unambiguous marker of vice'.[15] The opposition between public virtue and private luxury remained a matter of moral concern in Europe, the Near East, and Far East alike throughout early modernity, and the wearing of silk continued to be a frequently employed trope of moral decay. Eighteenth-century Chinese literati called to mind the fall of the ideal kingdom of Zhou, and European writers evoked the supreme Roman Emperor Tiberius who, fighting prodigality, ordered 'that no silk dress should henceforth degrade a Roman citizen'.[16]

Spurred by the prospect of high profits, kings and merchants across cultures invested in the reception and adaptation of sericulture and the development of processing techniques and designs.[17] Heavily patterned satins or damasks woven in Florence and Genoese workshops in the mid sixteenth century, for instance, produced large profits as they suited the desire and taste of the French who wanted

[14] Dieter Kuhn, 'The Silk Workshops of the Shang Dynasty, 16th–11th century BC', in Hu Daoding (ed.), *Explorations in the History of Science and Technology in China* (Shanghai, 1982), 383–6.

[15] Grant Parker, 'Ex Oriente Luxuria: Indian Commodities and Roman Experience', *Journal of the Economic and Social History of the Orient*, 45/1 (2002), 60–1.

[16] Joseph Hazzi (Ritter von), *Letter from James Mease: Transmitting a Treatise on the Rearing of Silkworms* (Washington, 1828).

[17] For patenting, see Luca Molà, *The Silk Industry of Renaissance Venice* (Baltimore and London, 2000). See also Jean-François Fava-Verde, *Silk and Innovation: The Jacquard Loom in the Age of the Industrial Revolution* (Histancia, 2011); Angela Sheng, 'Innovations in Textile Techniques on China's Northwest Frontier, 500–700 AD', *Asia Major* (3rd Series), 11/2 (1998), 117–60. For an analysis of different impulses given during and beyond the Mongol period see: Angela Sheng, 'Why Ancient Silk Is Still Gold: Issues in Chinese Textile History', *Ars Orientalis*, 29 (1999), 147–68.

'cloths that cost little and last even less'.[18] Even if style remained stable, fashion did not. As markets became increasingly global and silk with innovative or traditional designs found new outlets, how did customers know about new textiles and their uses? Who could tell them what excellent quality was? By the pre-modern age influential and wealthy elites across the world served as role models for local consumption, yet brokers and retailers increasingly influenced the dissemination of consumer and producer know-how, pre-selecting from a growing range of products, sizing up quality, and communicating what was fashionable elsewhere.

The papers in this volume show how market diversification was a common denominator for the spread of silk technology in general. Investigations of product flows and their impact support Debin Ma's suggestion that 'the historical diffusion of the technologies of silk-making, transportation and communication, over time, not only brought down considerably the costs of both making and moving silk around the world. It also inadvertently set off a dynamic process which saw the gradual erosion of the status of silk cloth as a luxury good. New research indicates that this progressive democratization of silk products started earlier than expected',[19] spreading out from Asia, where silk products had long been ubiquitous in elite life and for everyday uses.

ASIAN ORIGINS

The success of silk rests on the shoulders of many trades; only long, high-quality threads that are carefully degummed, thrown, reeled, dyed, and woven produce good cloth. Behind the product stand technical processes and forms of social organisation that were already highly sophisticated in Antiquity. In 2013, the excavation of a Han dynasty (206 BCE–220 CE) tomb in Laoguanshan (Sichuan province in modern China), revealed a wealth of devices for the manufacture of silk: warping, rewinding, and weft winding tools. Four different wooden loom models, preserved in hidden boxes, manifest the mechanical knowledge of this era. Wooden figurines clothed in long-sleeved Han robes reveal in their postures some of the key steps of production, reeling, and weaving techniques. Once coloured in bright yellows, greens and reds, these statues – with names written on the left side of their chests – give a body and face to the weavers of fine polychrome Sichuan *jin* silks.[20]

[18] Molà, *Silk Industry of Renaissance Venice*, 96.

[19] Ma (ed.), *Textiles in the Pacific*, 31.

[20] Although studies are still in progress, the buried person was most likely a state official. 成都老官山汉墓. Zhao Feng, *Antiquity*. For an example of Sichuan silks see James C. Y. Watt et al., *China: Dawn of a Golden Age, 200–750 AD* (New York, 2004), 76.

Archaeological evidence provides the opportunity to review our understanding of the technological, social, and aesthetic choices and changes that punctuate the history of silk production since the Han dynasty. The Han tomb underlines the close attention elites gave to silk production and use. Those in power not only strove to consume the cloth, they laid claim to its production.[21] Across cultures, a general rule seems to have been that rulers wanted to get down to the fundamentals of the trade and localise sericulture to achieve direct access to the raw material. Mulberry trees and silk worms thus populated imperial gardens for experimental reasons. In some regions, such as Russia or the Prussian State, but also in the imperial palace of the Manchu–Qing emperor in Beijing, such idealised garden cultures were also all that was achieved. Production itself was almost always a rural task, constituting a highly risky source of revenue for adventurous farmers that the state soon exploited by way of taxation. Most often elite actors – states, religious networks, and large corporations such as the East India Company – used financial steering to promote raw material production or to balance need and market demand. They provided the funds, adjusted taxation rules, and encouraged or regulated consumption through legal and ritual codification. The elements of production that were most amenable to direct political take-over seem to have been the processing trades: dyeing and weaving in China and under Ottoman rule, and carpentry in Persian Ilkanats.[22]

Like the Tang Dynasty, the Byzantine and Ottoman empires established state-owned workshops and created 'strictly circumscribed hierarchies: state-owned workshops both in China and the Byzantine Empire produced silk products for diplomatic gift-giving, imperial use or ritual purposes'.[23] Throughout the modern period we can see such workshops increasing in scale and scope. Of 268 looms noted in Constantinople, 88 were 'attached to the palace', producing gold cloth.[24] The status of silk as a luxury good was partly maintained by the state and elite practice of regulating textile consumption and use through legal and ritual codification.

Threads of Global Desire opens by contextualising the ascent of silk in China and especially the role of state and innovation. Analysing the logistics behind

[21] For an early anthropological survey into silk see Helen Diner, *Seide. Eine kleine Kulturgeschichte* (Leipzig, 1949). Sericulture is used to illustrate the passing of time as well as mortality in *The Book of Poetry (Shijing)*, where female beauty is likened to the life of a silk moth. *The Book of Poetry*, trans. James Legge (New York, 1967), p. 65. The comprehensive literature on the role of silk as a marker of status and wealth cannot, for reasons of space, be discussed here.

[22] M. A. Hann, 'Origins of Central Asian Silk Ikats', *Research Journal of the Costume Culture*, 21/5 (2013), 784.

[23] Heleanor B. Feltham, 'Justinian and the International Silk Trade', *Sino Platonic Papers*, 194 (2009), 1–40.

[24] Philip Mansel, *Constantinople: City of the World's Desire, 1453–1924* (London, 1995).

princely robes in the early Ming period, Dagmar Schäfer tackles two central historiographic issues of the history of silk: first, the tension between material culture and the literary account and second, how an analytical view is impacted by both the politics of history and temporal framing, that is, the start and end point of a historical narrative. Silk in China is a particularly appropriate subject for this analysis because of its long history and because historical narratives often stress continuities and shifts in silk technologies and their management within the framework of political ideals of rulership and social development. Contemporary and modern historians tend to concur with these historical narratives that align technological change along a politically defined dynastic timeline, often ignoring strong evidence to the contrary.

As a luxury good, silk was constantly being innovated. Angela Sheng's essay unfolds the manifold traits of innovation through the analysis of Zhang velvet (*Zhang rong* 漳絨). Named after the city of Zhangzhou, this special kind of patterned velvet enjoyed great prestige in the late Ming, but the term came to be used for the same type of velvet produced elsewhere. Contemporaneous texts emphasise *Zhang-rong*'s foreign origin. Indeed, an ancient prototype was even discovered at Mawangdui near Changsha in Hunan province. Analysing Zhangzhou's association with the production of velvet and the notion of its foreign origin, the chapter reveals the impact of maritime trade and the Ming government's changing organisation of textile labour as two of the many factors that led to unexpected innovations in both the public and private sectors.

Throughout the Ancient Roman period, consumers outside China asserted that silk, especially the best silk, was Chinese. By the pre-modern age this notion had spread from China and Rome throughout Europe and Asia. While sericulture and silk production in the homeland of the domesticated caterpillar was sophisticated, other medieval and early modern societies built up reliable market structures to access raw materials and finished products. We must imagine merchants loading camels or ships with silk fabric, or more often silk thread, that travelled across the world. The most mobile elements were intermediate products (such as silk thread), expertise (embodied in people), and designs (the decorative pattern of a cloth). Centres of silk trade developed (among others) in South India, Iran, the Ottoman empire, and further into the Mediterranean. Unlike the state-driven initiatives of Chinese or Byzantine rulers, such centres of silk trade were marked by a vibrant mix of manufacture and marketing and multiple political actors from the Medici family in Florence and the pope in Rome to the elites living in Avignon or Paris.[25]

[25] Eliyahu Ashtor, *Levant Trade in the Later Middle Ages* (Princeton, 1983), 56–61.

New centres of silk manufacturing were well connected within Asia and participated in a long-distance trade that, particularly in the Mediterranean, still relied heavily on trade routes established during the Crusades.[26] Migration of expert labour was often not voluntary. Especially the highly skilled weavers of complex wefts moved only when forced to by economic or environmental pressure or because states and elites sponsored or ordered their transfer. The most prominent example is the enslavement and relocation of Muslim weavers by the Mongolian Yuan in Northern China.[27] In Ming China officials used tax laws and corvée labour to encourage artisan mobility. By the sixteenth century, Japanese daimyos forced weavers to relocate whenever the number of weaving workshops exceeded the permitted limit within an administrative unit.[28]

Persia became a major silk producing region for the world, delivering yarn and finished cloth to places such as Italy and France, Japan and Holland.[29] The Verenigde Oostindische Compagnie (Dutch East India Company, hereafter VOC) was central to the spread of Asian raw silk, a story that, as Rudolf Matthee brings to the fore, connects the VOC and the English East India Company (EIC) not only to Iranian silk but also to a growing network of silk trade in Japan, China, Taiwan, and Vietnam. Matthee shows that political and economic forces in the seventeenth century made Iranian silk a mere interlude in Europe's silk imports. Difficulties in securing a steady supply of Chinese raw silk inadvertently turned China into a regional supplier, and ultimately made silk from Bengal the more attractive option for both the VOC and the EIC. Matthee stresses that, in such global trade, the impact of local politics on regional market structures became an important concern. Silk was the major export of Savafid Iran, financing the court and state. Between the reign of Shah 'Abbas I (1587–1629) and the demise of Safavid power in the 1720s, Persian sources yield virtually no data on the silk trade, which leaves us to speculate that the Safavids were successful and encountered few problems, were unconcerned, or left such issues to private entrepreneurs. Neither the Dutch nor the English were willing 'to take great logistical

[26] David Jacoby, *Byzantium, Latin Romania and the Mediterranean* (Aldershot, 2001), 48.

[27] Thomas Allsen, *Commodity and Exchange in the Mongol Empire: A Cultural History of Islamic Textiles* (Cambridge, 1997).

[28] For China see Peng Zeyi, 'Cong Mingdai guanying zhizao de jingying fangshi kan Jiangnan sizhiye shengchan de xingzhi [A view of the nature of Jiangnan silk production from the Ming official weaving workshops]', *Lishi yanjiu* (1963), 2 reprinted, in Cuncui xueshe (ed.), *Zhongguo jin sanbai nian shehui jingji lunji*, vol. 3 (Hong Kong, 1979), 49–69. For Japan see: Masayuki Tanimoto, 'Introduction and Diffusion: How Did Useful and Reliable Knowledge Feature in the Industrial Development of Early Modern Japan?', *Technology and Culture* (forthcoming).

[29] Irfan Habib, 'Mughal India', in Tapan Raychaudhuri and Irfan Habib (eds.), *The Cambridge Economic History of India; Vol. I. c. 1200–c. 1750* (Cambridge, 1982), 217.

and financial risks' and travel inland for silk floss as long as they could easily obtain it at the coastal ports.[30]

The rise of the Middle East as a key centre of production and consumption of silk yarn and silken textiles is further considered in the chapter by Amanda Phillips. Using court cases, price lists, probate inventories, travellers' accounts, and contemporary social critiques, Phillips's chapter illuminates the sumptuous consumption of a unique and easily identifiable type of voided and gold-brocaded figured silk velvet (*çatma*) upholstery that wealthy Ottoman subjects in Edirne and Istanbul desired. In the city, silk was consumed and consumer knowledge was produced. Ideas of fashion emerged that, as Phillips suggests, reveal how little effect sumptuary laws generally had on consumption in this period. By using a micro-perspective that focuses on specific product typologies, Phillips unearths evidence of the relationship between product innovation, social hierarchy, and the development of long-distance trade.

A EUROPEAN TRADE: SILK AROUND THE MEDITERRANEAN SEA

The development of a large-scale silk industry in Anatolia and the prestige that Ottoman silks acquired across Asia and in Europe should not just be read as the final chapter in a story of translation of silk manufacturing and consumption from East to West Asia. The appreciation of silk textiles, their making, and eventually the uptake of sericulture in Europe – first in the Mediterranean basin and later in Continental Europe – owes a great deal to developments in the Middle East and in the Ottoman empire in particular. As Suraiya Faroqhi shows in this volume, the trade of Ottoman silk textiles and yarn to eastern and southern Europe provided the impetus for the development of a new industry and for substantial sartorial changes across the continent and eventually in the New World.

Before and during the expansion of European silk manufacturing and consumption, Ottoman silk cloth was exported to surprising markets both in eastern and central Europe. Elucidating this little-known history of commerce, Faroqhi's chapter introduces the Ottoman empire's regular exchange of goods with polities on its northern and central European borders. Provincial silk manufacturers of Damascus and Cairo exported silk cloth to Christians and even for use in Christian churches in Polish territories. The diplomatic gifts sent to the tsars were the high end of a production and consumption chain that served

[30] Rudolph Mathee, *The Politics of Trade in Safavid Iran: Silk for Silver 1600–1730* (Cambridge, 2006), 9. Sericulture spread to the region from Yargan and Farghana, *ibid.*, 15, 197.

both global and local needs.[31] Sixteenth- and seventeenth-century travellers and commentators were even more impressed by the diversity of silk in urban Ottoman silk textile markets where much more than robes or shifts were to be found. Even the most frugal scholars and misers were tempted by luxurious items for daily use: upholstered chairs, cushions, bedding, or lavishly embroidered belts.

The late medieval migration of patterns and technological know-how and their appropriation in Europe by consumers and producers alike resulted in a veritable explosion in the use of silk throughout the continent starting in the fifteenth century. Lisa Monnas' contribution asserts that European aristocracy and the thriving merchant and professional classes replaced high-quality woollens with silks, dressing their walls and arraying their horses in it, and waged war wearing plate armour or defensive doublets lined or covered in silk. Local differences in the appetite for silk according to social structure, customs, and the availability of the material can be discerned. Renaissance Italy – as a result of the development of its international trading and banking networks – was the main European producer at that time, and the leader in large textiles. As the Italian peninsula was composed of independent states boasting several important weaving centres, Italian production and consumption of silk remained varied and diffused.

Research on Italy, in particular Venice, has revealed the alliance between manufacturers and government to promote the industry in a changing international economic environment.[32] England, by contrast, manufactured smaller silk items and relied entirely upon importation of raw materials. Thanks to the presence of a monarchy with a centralised administration, London was the main focus of both trade and consumption. As David Mitchell illustrates, the English capital turned into a leading urban hotbed for new trends with its port and industrial sites, especially from the sixteenth century onwards.[33] The most expensive and luxurious woven silk textiles, damasks, brocades, and velvet, were imported into England through the port of London, initially from Italy and Spain, and subsequently from France. By the early modern age, London was receiving an unprecedented amount of raw and thrown silk. Before the Civil War in the mid seventeenth century, silk had been imported by the Levant Company, but by the time of the Restoration this source had been ousted by suppliers from

[31] Linda Komaroff, *Gifts of the Sultan: The Arts of Giving at the Islamic Court* (New Haven, 2011).

[32] Molà, *Silk Industry of Renaissance Venice*.

[33] The water network became a substantial limiting factor in this expansion: Leslie Tomory, 'Water Technology in Eighteenth-Century London: The London Bridge Waterworks', *Urban History*, 42/3 (2015), 381–404.

the Middle East. The increased supply was mostly used in embroidery or to weave narrow wares; particular plain silks and mixed fabrics were produced in London, Canterbury, and Norwich. Inventories of citizens concerned with the silk trade filed in the Court of Orphans, together with the commercial records of the Levant merchants, substantiate the growing impact of retailers in the creation of a global web of knowledge and know-how about silk supplies.

Traders cooperated across national boundaries, especially when it came to the development of new designs and, as their remit grew, their activities contributed to the emergence of a new class of specialist designers that Lesley Miller identifies in the Lyon silk manufacturers of the late seventeenth and eighteenth centuries. Designers of this era are distinguishable from earlier periods in which weavers and expert craftsmen were in charge of setting up the looms, developing and transposing patterns into heddles or strings to raise the warps and create complicated wefts.[34] Miller brings to light that within the manufacturing process, designers became crucial for the success of Lyon silks in domestic and international markets. They negotiated consumer interests and, through direct contact with wealthy consumers, managed to gain social status and wealth. Guild records, commercial, parish, and notarial archives, as well as surviving artefacts ranging from designs and woven textiles to the sample books used to sell silks, show that designers also increasingly participated in production and triggered product innovations.

GLOBAL EXCHANGE

The emergence of varied centres of production of silk textiles that could rival those of China was not solely based on the local gathering of knowledge, technological adoption, and product innovation. It relied on a complex web of global connections both for the sale of finished product and the restructuring of the chain of production. Sericulture was once again at the forefront of a process of diffusion, this time in the New World. When silkworms reached the Americas and more specifically New Spain in the sixteenth century, silk and sericulture in China and Europe were at their height. Products from various origins were traded across the world, readily available in urban centres in Hangzhou and Bengal as well as in European cities such Venice, Amsterdam, or Paris. Knowledge about the intricacies of the various trades was equally at one's

[34] For the heddle see Han tomb in Zhao Feng, *Antiquity*. Drawlooms with pattern towers are depicted in various Chinese contemporary sources and were also regularly commissioned for painting catalogues by the emperor. See Roslyn L. Hammers, *Pictures of Tilling and Weaving: Art, Labor and Technology in Song and Yuan China* (Hong Kong, 2011).

fingertips: horticulturalists of the royal society in Britain published academic tracts; Italian merchants elaborated commercial classifications and practices; and French designers shared their motifs though sample and pattern books. The rise and fall of sericulture, silk and dye industries all around the world, in New Spain and the North American colonies as delineated by José L. Gasch-Tomás and Ben Marsh respectively, and in Bengal as considered by Karolina Hutková, reflects the intricacies of a global market economy, in which the price of silk in Bursa or working conditions in Bengal had repercussions on the tastes of the elites in New Spain or the product availability in London and Paris.

In such a global market both the circulation of knowledge and products were paramount. As detailed by Gasch-Tomás, by 1550 New Spain had emerged as a key centre of silk cultivation and production. Drawing on Spanish and Italian sericultural knowledge and silk technologies, and thanks to its favourable climatic conditions, Mexico fast became a new world silk area. Yet the apogee of the silk trade in New Spain was short-lived; silk became an established production in the 1550s but by the early seventeenth century it already showed signs of decline. Global taste and trade explain the unfulfilled potential of the New Spain silk industry: the opening in the 1750s of the galleon route between Manilla and Acapulco allowed for the importation into New Spain of large quantities of Chinese silk in exchange for silver.[35] Gasch-Tomás argues that some segments of the New Spain silk industry survived competition but that the market was characterised by plurality: the presence of Chinese, European, and local silk products can be seen in Mexican notarial records that show a mixture of silk cloaks from Toledo, Granada, and Seville, alongside Chinese damasks, New Spanish taffeta, and Italian silk stockings.

As in the case of consumer taste, knowledge exchange had long been key to the global spread of sericulture and silk manufacture. However, during the early modern period knowledge exchange as the subject and object of science and technology became more significant than the spread of modes of production or the adoption of specific tools. Furthermore, knowledge exchange came to rely on knowledge accumulation; when settlers from England and the Mediterranean built up sericulture in the early modern Atlantic world, they could rely on

[35] Richard von Glahn, 'Myth and Reality of China's Seventeenth-Century Monetary Crisis', *Journal of Economic History*, 56/2 (1996), 429–54 has argued against the commonly held view that a fall in silver imports lead to the fall of the Ming, suggesting that changing approaches to money in China were much more relevant than global flows. Dennis O. Flynn, 'Comparing the Tokugawa Shogunate with Hapsburg Spain: Two Silver-based Empires in a Global Setting', in James D. Tracey (ed.), *The Political Economy of Merchant Empires: State Power and World Trade 1350–1750* (Cambridge, 1991), 335 by contrast shows the significance of global flows of silver in the economies of Asia, Europe and the Americas.

previous experience. This transmission – unlike sericulture's move towards the Eurasian plain – was soon thriving thanks to the expansive literature produced over centuries that dealt with the challenges and opportunities of cultivating caterpillars in new climates and territories. Success was not guaranteed, however, as Spaniards, Italians, Englishmen, Germans, Persians, and Chinese flocked to a new continent that promised better lives and immeasurable wealth.

Marsh's study of sericulture in South Carolina vividly makes the point that the knowledge gathering in the North American colonies, while following British and French practices, was substantially different. State and industry hired scientists and created 'scientific' manuals. Science also sustained credibility and provided social capital which included situating sericulture within a quest for botanical and scientific advancement. In this period we can see famous men, natural philosophers, and mathematicians in the industrial and scholarly 'think-tanks' of Philadelphia, and their colleagues in the silk factories in East London, discussing silk in monthly journals in one and the same breath as a commodity, a natural product, and a production technology.[36] A large thin silk handkerchief with a metal tip was in Benjamin Franklin's tool-kit for an experiment to verify lightning with an electrical discharge.[37] As telescopes increased in power in the eighteenth century, David Rittenhouse (1732–96) noted that even the finest wire or silk filaments that had been used thus far were much too thick for astronomical observations as they obstructed the image.[38]

Hutková details the effort and substantial investment of the English East India Company in the second half of the eighteenth century aimed at developing raw silk production in Bengal. As Britain totally relied on the import of raw silk and silk yarn, the procurement of raw silk from the newly conquered area of Bengal was deemed to be both advisable and potentially profitable. Hutková traces the company's large investment in the technological transfer of Piedmontese silk-throwing technology to Bengal. This amounted to over £1 million sterling and included the careful transfer of both technology and experts from northern Italy; yet it was ultimately a failure. Hutková shows the tension between the ambitions

[36] Joseph Dandridge (1660–1744), for example, was a naturalist and silk designer. Natalie Rothstein, *Spitalfields Silks* (London, 1975), 8; Natalie Rothstein, 'Joseph Dandridge, Naturalist and Silk Designer', *East London Papers*, 9/2 (1966), 13. William Allen (1770–1843) quit the family business of silk weaving and pursued a career in chemistry as a member of the Geological Society. John Dollond (1706–61), a trained silk weaver, solved the problem of chromatic aberration in lens production.

[37] Benjamin Franklin, 'From Benjamin Franklin esq. Philadelphia to P. Collinson, 21 Dec. 1752', *Philosophical Transactions of the Royal Society*, 47 (1752), 553–8.

[38] David Rittenhouse, 'Transactions of the American Philosophical Society at Philadelphia', *The Monthly Review*, 2 (1787), 143–4, continued 217.

of an emerging silk industry in the British Isles wishing to upgrade its products and the complexity of implementing the attempted technological transfer. Italian technologies, the political economy of the British state, colonial policies in India, the organisation of labour in Bengal, and demand for finished products on domestic and international markets became entwined at a global level via silk production and manufacturing.

Similar to New Spain, North America, and Bengal, the case of Japan also illustrates the new role of silk as an enriching object and subject of science and national wealth at a global level. Kayoko Fujita's study illustrates that the transition of Meiji Japan (1868–1912) towards industrial production substantially relied on an earlier engagement with silk. Tokugawa Japan (1603–1867) had turned to sericulture in the period after 1630, when overseas navigation by Japanese ships as well as the entrance of foreigners into its territory was either prohibited or put under strict control. By the eighteenth century the position of Japan had shifted from being an importer of Chinese raw silk for the production of silk cloth, to an exporter of raw silk. Unlike colonial America, where settlers brought books and practical expertise, Japanese sericulturalists and weavers had to rely on artefacts and hearsay as direct contact with China or other regions was restricted. Daimyos and elites promoted re-engineering and experimenting processes by circulating capable talents across regions and enforcing laws that restricted the number of weaving workshops and masters in urban and rural spaces.[39]

Fujita identifies three steps in Japan's gradual shift from reliance on raw material import sources such as China, Tonkin, Persia, and India via diverse agents (Chinese, Portuguese, and Dutch traders) to domestic production. First an excessive supply of Chinese silk triggered change in consumption patterns and new local styles emerged. Second, elites systematically invested in the import of products not made in China, followed by an engagement with thread and colouring. Only in the third and final phase was there a larger engagement with the actual silkworm eggs, and the ultimate expansion into sericulture was achieved.

In each of these instances we can see that entrepreneurs and scholars focused on different kinds of knowledge and expertise.[40] Together with textiles, knowledge about different consumer tastes and ideals also travelled; techniques of dyeing, twisting, and weaving were exchanged; tools were mobilised and exchanged

[39] See Tanimoto, 'Introduction and Diffusion'.

[40] Here it is also clear that the biggest challenge was transmission rather than keeping secrets about the trade. Pamela O. Long, *Openness, Secrecy, Authorship: Technical Arts and the Culture of Knowledge from Antiquity to the Renaissance* (Baltimore, 2001).

and eventually sericulture and silk manufacture also invoked the need to learn more about what one thought one already knew. Local climatic conditions were analysed which also stirred a heightened sense for local plants and environments. Social relations were considered and rethought. Political systems and beliefs were established and challenged, and as people still wished to wear and tear silk, old spaces of global interaction were revitalised, and new networks were spun.

CONCLUSION

Among the many fibres used for clothing, furnishing, and other purposes, silk offers a particularly complex geographic narrative of production, use, and change. Sericulture and technologies for further processing developed continuously over long timespans from the Neolithic to the modern age. As Giorgio Riello observes, in comparison to the seed fibre of cotton which is closely tied to the narrative of British industrial growth and industrialisation, silk shows a continuous (though wavering) trajectory of cross-regional production schemes, especially in Chinese, Near Eastern, and Ottoman empires.[41] Its qualitative properties made silk threads also conducive to a broad range of uses long before technologies allowed this for plant fibres such as flax-linen or hemp. And while woollens and linens clothed the commoner and often remained linked to local trade, silk products, as a luxury commodity, occupied early cross-regional trade.

The threads of global desire that silk produced were thus viral and real, forging connections between distant areas of the world and spurring social, environmental, and political change. The movement of finished and semi-finished cloth, primary commodities, and silk threads is central to the story narrated in this book. Silk industries developed locally distinct features, but when commodities moved they also mobilised and transmitted ideas, knowledge, and practices. Producers and consumers responded to changing uses of silk across Eurasia and eventually worldwide. China remained for several centuries key to the international success of silk and its products were desired across the globe. In this sense the history of silk is a story of riches and knowledge flowing from Asia to slake a global desire.

[41] David Jacoby, 'Cypriot Gold Thread in Late Medieval Silk Weaving and Embroidery', in Susan B. Edgington and Helen J. Nicholson (eds.), *Deeds Done Beyond the Sea: Essays on William of Tyre, Cyprus and the Military Orders presented to Peter Edbury* (Farnham, 2014), 101–14; David Jacoby, 'Silk Economics and Cross-Cultural Artistic Interaction: Byzantium, the Muslim World and the Christian West', *Dumbarton Oaks Papers*, 58 (2004), 197–240.

PART I

Asian Origins

Power and Silk: The Central State and Localities in State-owned Manufacture during the Ming Reign (1368–1644)

Dagmar Schäfer

Silk, the fibre and the textile, has been a constant companion to Chinese history from the Neolithic to the modern age. In its many roles as a tax payment, a luxury, and an everyday commodity, silk was tightly woven into the social and political fabric of the dynastic age (221 BCE–1911 CE). Within this *longue durée* view, the Ming period (1368–1644) is conspicuous for its elaborate bureaucracy surrounding silk manufacture and trade. The Ming state installed an expansive network of production and administrative sites, reaching across its territory from the capitals of Nanjing and Beijing (after 1403) to provide textiles for imperial (*yu* 御), imperial-ritual (*gong* 供), public (*gong* 公), and official (*guan* 官) use. Hence the state engaged in all silk matters and interfered with all that mattered to silk, from resource management right up to its use by the public or at the court.

Since the Qing dynasty (1644–1912), scholars and historians have judged Ming silk manufacture on the basis of its performance in the final years of the dynasty. Qing historiographers framed the decay of a once successful state system of production as collateral damage in the skirmish between public state rights and imperial will, a tussle for power in which the Ming court eunuchs increasingly wrested control from local officials.[1] Modern historiography sees the withdrawal

[1] Peng Zeyi, 'Cong Mingdai guanying zhizao de jingying fangshi kan Jiangnan sizhiye shengchan de xingzhi [The Nature of Jiangnan's Silk Trade Viewed in the Light of Managerial Patterns in Ming Dynasty State-owned Weaving Production]', in Nanjing daxue lishi xi (ed.), *Ming Qing zibenzhuyi mengya yanjiu lunwenji* [Essays Investigating the Sprouts of Capitalism During the Ming and Qing Era] (Shanghai, 1981), 307–44. Fan Jinmin, *Ming Qing Jiangnan shangye de fazhan* [The Development of Jiangnan's Economy during the Ming and Qing Reign] (Nanjing, 1998). See also Dagmar Schäfer,

of the late Ming emperor Wanli (1572–1620) as a turning point after which society commodified, local diversity thrived, and labour markets were liberated.[2] Dynastic and modern historiography concur that the initial design of the Ming state system was made up of three essential components: one, a decisive emperor who, by relentlessly innovating state-owned silk manufacture, enforced Ming 'Han Chinese' ritual and styles of dress; two, effective central state control; and three, scholar-officials who kept greedy eunuchs, local concerns, and corruption in check.

Over the last decade, a shift in research on early Ming sources and newly excavated material evidence has shaken these three assumptions to varying degrees. Rather than portraying an autocratic ruler introducing new, recognisably non-Mongolian (Yuan, 1271–1368) social and political norms, David Robinson's analysis of bureaucratic and private accounts highlighted the continued presence of Mongolian structures and staff in the early phase of the Ming state.[3] Inspired by the excavated riches of princely tombs, Craig Clunas has encouraged us to consider the early Ming dynasty as a state with many centres.[4] And only recently, Hu Dan has dented the late Ming Neo-Confucian image of Zhu Yuanzhang 朱元璋 (1328–98, Hongwu reign 1368–98), the founder and first emperor of the Ming dynasty, as an adversary of the court eunuchs by revealing the central role that the emperor gave to this group in pre-Ming and Hongwu politics.[5]

Des Kaisers Seidene Kleider: Staatliche Seidenmanufakturen in der Ming Zeit (1368–1645) (Heidelberg, 1998). On the changes in dynastic systems, see Dieter Kuhn, 'Fashionable Weaves and Ingenious Craftsmanship', in Dieter Kuhn (ed.), *Chinese Silks* (New Haven, 2012), 1–65; Chen Juanjuan, 'Mingdai de sichou yishu [Silk Art of the Ming Era]', *Gugong bowuyuan yuankan*, 55/1 (1992), 59.

[2] Timothy Brook, *The Confusions of Pleasure: Commerce and Culture in Ming China* (Berkeley, 1998). At the heart of this shift stood the 'Single Whip' tax reforms which, as Du Yongtao, *The Order of Places: Translocal Practices of the Huizhou Merchants in Late Imperial China* (Leiden, 2015), 174 remarks, 'would only see its completion in the abolition of labor conscription' in the 1650s during the Qing regime.

[3] David Robinson, 'Images of Subject Mongols under the Ming Dynasty', *Late Imperial China*, 25/1 (2004), 61. I use the term 'non-Mongolian' to emphasise that the first Ming emperor may have been more concerned with advertising a change in rulership than with ethnic identities. Edward L. Farmer, *Zhu Yuanzhang and Early Ming Legislation: The Reordering of Chinese Society Following the Era of Mongol Rule* (Leiden, 1995), 30 also sees Zhu's attempts as a shift towards being 'Chinese', in the sense of Confucian norms.

[4] Craig Clunas, *Screen of Kings: Royal Art and Power in Ming China* (London, 2013), 21–3 suggests adopting the Chinese literal translation of 'king' (*fanwang* 藩王) or 'clan king' (*qinwang* 親王) instead of 'prince'. I here use 'prince', following David Robinson, 'Princely Courts of the Ming Dynasty', *Ming Studies*, 65 (2012), 3, as my examples mainly relate to the first generation, following Zhu Yuanzhang.

[5] Hu Dan, 'Hongwu chao neifu guanzhi zhi bian yu Ming chu de huanquan [Changes in the Management of the Palace Treasury and the Power of Eunuchs in the Hongwu Period]', *Shixue yuekan*, 5 (2008). For a list of contemporary sources, see also Hu Dan (ed.), *Mingdai huanguan shiliao changbian* [Compilation of Historical Sources on Ming Eunuchs] (Nanjing, 2014). For Zhu Yuanzhang as the ideal ruler, see Jiang Yonglin, 'In the Name of "Taizu": the Construction of Zhu

These findings challenge current historiography that, in line with the Chinese historiographic notion of dynastic cycles and change, regularly aligns the rise and fall of state-owned silk manufacture with the life spans of the dynasties of which it was a part. It also evaluates the original infrastructure of the system against what it eventually became. The slow nature and pace of change in silk manufacture and design during the early Ming, however, raises serious questions about the validity of assessing political power, systemic choices, and technical change on notions developed from an *a posteriori* historical view. The obvious disjunct between artefactual and textual evidence invites a closer look at narratives that explain the continuities in technological infrastructures (and correspondingly also those in production methods and design) far into the mid Ming period as the 'delayed' effect of political activities and will, caused by phlegmatic large-scale bureaucratic structures or technological choices.[6]

Artefacts, materials, and texts are major informants of historical accounts on developments, even though different disciplines (art, archaeology, and literary study) assign them different values. In this chapter, I promote a cross-disciplinary view. I ask what role texts played in the production of silk and what can be read from excavated textiles. My cases in point are the prince of Lu, Zhu Tan 朱檀 (1370–89), and the prince of Shu, Zhu Chun 朱椿 (1371–1423), who were awarded fiefdoms in regions where the Ming subsequently established state-owned manufacture. Zhu Tan's tomb in Shandong contained robes that were in no way inferior to imperial robes. Excavation reports do not mention textile finds in the tomb of Prince Zhu Chun.[7] If we put together what we learn from the artefacts of this period with what we know about the logistics of producing princely robes, we discover that, in the case of the early Ming dynasty, artefacts

Yuanzhang's Legal Philosophy and Chinese Cultural Identity in the Veritable Records of Taizu', *T'oung Pao*, second series, 96/4–5 (2010), 465.

[6] For more on the 'delayed' effect, see Jiang Yonglin, *The Mandate of Heaven and 'The Great Ming Code'* (Seattle, 2011). Chinese clothing and fashion history regularly works with 'dynastic' styles. See also Chen Juanjuan and Huang Nengfu, *Zhongguo fuzhuang shi* [A History of Chinese Clothing] (Beijing, 2001); Antonia Finnanne, *Changing Clothes in China: Fashion, History, Nation* (New York, 2008); Shih-shan Henry Tsai, *The Eunuchs in the Ming Dynasty* (Albany, 1996). James C. Scott, *Seeing Like a State: How Certain Schemes to Improve the Human Condition Have Failed* (New Haven, 1998), 243 explains such delays also with 'bureaucratic pathologies'.

[7] Until the twenty-first century, archaeologists regularly either ignored or did not mention textiles which were of a minor quality or in poor condition. The absence of any textiles from burials would be astonishing as at least the corpse was dressed. For a photograph of Zhu Tan's robe, see Craig Clunas and Jessica Harrison-Hall (eds.), *Ming: 50 Years that Changed China* (London, 2014), 73. Huo Wei, 'Lun Jiangxi Mingdai houqi fanwang muzang de xingzhi yanbian [On the Evolution of the Structure of Late Ming Princes' Tombs in Jiangxi]', *Dongnan wenhua*, 1 (1991). For an overview of Zhu Chun's tomb, see Zhang Qin, 'Sichuan Mingdai muzang shitan [Probing Ming Tombs in Sichuan]', *Xue lilun*, 14 (2012), 183–4.

underline continuity whereas texts invoke change. Dress codes and production styles were much less susceptible to change than later generations of the Ming may have wished to acknowledge. Indeed, in times of political change, fashions and structures of production were perpetuated, and local circumstances defined central politics. Autocracy was defined from the bottom up.

HISTORIES OF TEXTILES, HISTORIES OF TEXTS

Four gowns, among them two polychrome yellow dragon robes with gold threads (*zhijin longpao* 織錦龍袍), accompanied Zhu Tan, tenth son of Zhu Yuanzhang, into his grave as burial goods (*mingqi* 冥器). One was made of *duan*-satin (*duan* 緞) with round dragon-and-cloud patterns around the contrasting collar and narrow sleeves and another featured dragons around the shoulder pads. Placed into the tomb alongside the corpse, these burial goods lent status and prestige to the deceased.[8] In line with Ming state historiography, historians of the early Ming such as Yuan Zujie depict Zhu Yuanzhang as an almighty ruler who, at his Nanjing court, purposefully exploited clothing to advocate political change.[9] New ideals and standards are often implied to have taken immediate effect. As textual records and archaeological excavations are mutual informants in Chinese history, unsurprisingly, the Chinese archaeological report of Zhu Tan's tomb concurs with this interpretation, emphasising that the pattern on Zhu Tan's robe, produced in the early days of Zhu Yuanzhang's rule, complies with a dress code ruling that the third Ming emperor, Yongle (1402–24) did not sanction until 1404 – fifteen years after Zhu Tan's death; an anachronism to say the least.

Excavated textiles are ambiguous informants in the analysis of change. The robe's colour, for instance, is now a shiny yellow (*huang* 黃) bringing to mind the Ming imperial colour of choice. The original vegetal dye has long faded, however,

[8] By contrast, the published report does not mention anything about the burial dress covering the corpse. Shandong sheng bowuguan, 'Fajue Ming Zhu Tan mu jishi [Excavation Report of Zhu Tan's Tomb]', *Wenwu*, 5 (1972), 27; Liu Lin et al., 'Jiangxi Nancheng Ming Yixuan wang Zhu Yiyin fufu hezangmu [The Tomb of the Yixuan Prince Zhu Yiyin and His Wife in Nancheng County, Jiangxi]', *Wenwu*, 8 (1982); Liu Lin et al., 'Jiangxi Nancheng Ming Yiding wang Zhu Youmu mu fa jue jianbao [Brief of the Excavation of the Tomb of Yiding Prince Zhu Youmu in Nancheng County, Jiangxi]', *Wenwu*, 2 (1983). For the English translations of Chinese textile terminology, I follow the index in Kuhn (ed.), *Chinese Silks*, 522–9.

[9] Yuan Zujie, 'Huangquan yu lizhi: yi Mingdai fuzhi de xingshuai wei zhongxin [Imperial Power and Ceremonial System: The Rise and Fall of Costume System in the Ming Dynasty]', *Qiushi xuekan*, 5 (2008), 127, emphasises in this context also Zhu Yuanzhang's invocation of a restored Chinese rule against Tartarians (*dalu* 韃虜). For a shorter English version, see Yuan Zujie, 'Dressing for Power: Rite, Costume, and State Authority in Ming Dynasty China', *Frontiers of History in China*, 2/2 (2007).

and the original colour cannot be determined.[10] Based on literary evidence, the excavation report suggests that the robe was woven with a gold weft in rice-yellow (*mihuang* 米黄).[11] Official Ming historiography reinstates the Tang dynasty code which would have seen clan princes dressed in purple (*zi* 紫)[12] and thus neither the yellow of the excavated robe today nor the red that historians consider the standard of the Ming.[13] The coherent fading might indicate a limited or even monochromatic colour scheme (that is, one made of of varying shades of the same hue) that is also characteristic of Mongolian-style robes (*zhisun fu* 質孫服).

Pattern and fibre are equally ambiguous historical informants to say the least. In the 2014 British exhibition 'Ming: 50 Years that Changed China', the robe was displayed as an imperial emblem, the pattern of a four-clawed dragon signifying the wearer's status as well as his dynastic identity, powers, and rights.[14] Such patterns were, however, widely used, even before the emergence of the Ming. A blue and white *duan*-satin datable to the 1340s at the Hermitage Museum, St Petersburg, shows a similar design along the shoulders, as does a lady's skirt of a similar date on which the pattern is seen in red on a white background.[15] Diffusion of colours and patterns hence discredits the textual narrative that assigns early Ming rulers the power to change dynastic style in one fell swoop.

Among the excavated tombs of the first generation of Ming princes, Zhu Tan's is the only one thus far that is said to have contained lavish textiles in

[10] Most clothing excavated in recent years has this yellow tone. White silk also takes a yellow tint with age.

[11] Shandong sheng bowuguan, 'Fajue Ming Zhu Tan mu jishi', 27.

[12] Wang Pu, *Tang huiyao* [Institutional History of the Tang] (Beijing, [961] 1955), vol. 1 (*juan* 31, 573). Chen Juanjuan and Huang Nengfu, *Zhongguo fuzhuang shi* [History of Chinese Costume] (Beijing, 2001), 149. For the role of colour schemes, see Chen BuYun, 'Material Girls: Silk and Self-Fashioning in Tang China (618–907)', *Fashion Theory*, 21/1 (2017).

[13] Li Yi, 'Tangdai dui Mingdai guanyuan changfu yingxiang kaoban [On the Influence of the Tang Dynasty on the Ming Dynasty Official Daily Dress]', *Zhejiang fangzhi fuzhuang zhiye jishu xueyuan xuebao*, 1 (2013). This standard is set in Li Dongyang et al., *Da Ming huidian* [Collected Statutes of the Ming] (Yangzhou, [1587] 2007), 1039 (*juan* 60, *libu* 18, 46a–b). Princely courts and elites across the Ilkhanates of the Mongolian Yuan era favoured red for certain occasions. Thomas T. Allsen, *Commodity and Exchange in the Mongol Empire: A Cultural History of Islamic Textiles* (Cambridge, 1997), 49; Peng Daya, *Hei-Ta shih-lüeh, kurzer Bericht über die Schwarzen Tatan*, Peter Olbricht and Elisabeth Pinks (trans.), in Peter Olbricht and Elisabeth Pinks (eds.), *Meng-Ta pei-lu und Hei-Ta shih-lüeh. Chinesische Gesandtenberichte über die frühen Mongolen, 1221 und 1237* (Wiesbaden, 1980), 121–2.

[14] Clunas and Harrison-Hall (eds.), *Ming*, 73.

[15] I would like to express my thanks to Maria Menshikova, curator of the East Asia collection of the Hermitage Museum, for bringing these pieces to my attention in a personal communication. According to Menshikova, the tomb's other artefacts do not connect the deceased lady to the Yuan imperial clan. This would suggest that by the Yuan and Ming transition period this pattern was also available and used beyond the court.

different fibres of cotton and silks. There is a fair chance that the buried textiles already belonged to Zhu Tan in his lifetime and that he was an afficinado of fashion and the textile arts, in the same way that other princes collected porcelain or published books.[16] As such the textiles could also have been looted goods that originated from Yuan elites or even their imperial tombs.[17]

According to the official canon, a state-owned bureau, the Hall for Ritual Silks (*shenbo tang* 神帛堂), was in charge of textiles for special imperial occasions (such as weddings or funerals) it produced on demand. For the early period, however, very few orders are documented.[18] With all circumstances taken into account, the textiles in Zhu Tan's tomb are no indication that the Ming silk weaving trade was in full working force. Even if we assume for a moment that the robe was produced specifically for Zhu Tan, its style, colour, and applied technologies follow Yuan textile practices. By 1405 (Yongle 3), the regular court gowns of the princes were supposed to be identical to those 'used in the Eastern Palace' (*donggong* 東宮), the residence of the crown prince.[19] Zhu Tan's dragon robe indeed complies with the description of a crown prince's regular gown (*changfu* 常服) which would have had a 'round collar and narrow sleeves. The shoulders are covered with gold-brocade circular dragon patterns.'[20] In terms of colour schemes and pattern, it seems we should assume that the rules Yongle laid down in 1403 followed current practice and did not implement change. Textual records show that Zhu Yuanzhang directed his attention to clothing only after the borders of his realm were secure in 1384 (Hongwu 17, month 4).[21] This increased interest in central state infrastructures followed Zhu Yuanzhang's investment in

[16] For the princes' publishing efforts see Jérome Kerlouégan, 'Printing for Prestige? Publishing and Publications by Ming Princes (Part 1–4)', *East Asian Publishing and Society*, Part 1: 1/1 (2011), Part 2: 1/2 (2011), Part 3: 2/1 (2012), Part 3: 2/2 (2012).

[17] The combination of cotton and silk textiles with gold threads is more characteristic for the Mongolian period (personal conversation with Zhao Feng and James Watt, 20 October 2015 in Hangzhou).

[18] An early order, addressed to the Ministry of Works (*gongbu* 工部) in 1398, asks that the goods be in full accordance with those used in daily life. Li et al., *Da Ming huidian*, vol. 3, 1489 (*juan* 96, *libu* 54: *sangli* 1, 2b); Liu Yi, 'Tangji yilai diwang shisuhua zangyi yongpin tanwei [The Exploration of Imperial Secularised Funeral Supplies since the Late Tang Dynasty]', *Nanfang wenwu*, 1 (2012), 67. Official terms are, if not otherwise noted, according to Charles Hucker, *A Dictionary of Official Titles in Imperial China* (Taipei, 1985).

[19] Li et al., *Da Ming huidian*, 873 (chap. 47, *libu* 5, 17b–18b). Yu Ruji, *Libu zhigao* [Draft Monograph of the Ministry of Rites] (Beijing, 2003, *Siku quanshu* version), 289 (juan 18, 23a). Zhang Tingyu et al., *Ming shi* [History of the Ming] (Beijing, [1736] 1974), vol. 6, 1619 (*juan* 66, *yufu* 2, *zhi* 42), which shaped Qing views, reiterates this notion.

[20] Zhang et al., *Ming shi*, vol. 6, 1626–7 (*juan* 66, *yufu* 2).

[21] Xia Yuanji et al., *Ming Taizu shilu* [Veritable Records of the Emperor Taizu (1368–1398)], in *Ming shilu* [Veritable Records of the Ming Dynasty] (Taipei, [1418] 1962–6, 1972), 2503 (*juan* 161, 8a) staffed with supervisor and assistants ranked nine. Only the plans for the staffing and set-up of

the creation of a village self-monitoring system (*lijia* 里甲) motivated by what Sarah Schneewind has described as the emperor's nagging mistrust of the local administration.[22]

Paintings and tomb murals of the early Ming equally underline the continuity of fashion in the fourteenth century, aligning them with dress styles found across Central Asian territory among (elite) inhabitants across regions and periods of the Khitan Liao (907–1125), Jurchen Jin (1115–1234) and Mongol Yuan.[23] The excavated princely gown is commonly referred to as a *zhisun* robe which, although it came to mean different things in different times, denotes a 'Yuan-Mongolian'-style monochrome, patterned robe, tailored with an emphasis on the waistline.[24] The tailoring and silhouette is quite distinctive from both the Tang dynasty version, which featured long sleeves, high waist and multiple layers of cloth, and the later, post-1550s Ming era, no-waisted robes.

The two buried robes of Zhu Tan also substantiate continuity between the two dynasties in terms of the technology used. Each was tailored from two (or more) bolts of silk. The patterned part was 'tailor-made' (*zhicheng* 織成), that is, the design across the shoulders was woven to suit the final cut, much like other official and elite robes excavated from this era.[25] For this tailor-made design, a drawloom (Illustration 1.1) was required, like that depicted by the Yuan dynasty

the Caps and Kerchiefs Service (*jinmao ju* 巾帽局) and the Sewing Service (*zhengong ju* 針工局) for the Inner Court were laid out.

[22] Sarah Schneewind, 'Visions and Revisions: Village Policies of the Ming Founder in Seven Phases', *T'oung Pao*, second series, 87/4–5 (2001), 334–6 points out that Zhu Yuanzhang developed different political foci over the period of his thirty-year reign.

[23] Zhao Feng, 'Meng Yuan longpao de leixing ji diwei [Role and Styles of the Mongolian Yuan Dynasty Dragon Robes]', *Wenwu*, 8 (2006), 87. See also Zhao Feng, *Styles from the Steppes: Silk Costumes and Textiles from the Liao and Yuan Periods, 10th to 13th Century* (London, 2004), 16–19. The Yuan styles followed those of the Liao and Jin dynasties.

[24] Yuan sources indicate that people at a banquet wore the same colour robe as a statement of political status, corporate identity, and relation to the ruler. Late Ming and contemporary Chinese scholarship uses *zhisun* as a generic reference for a 'Mongolian-looking' gown, referring to many different aspects such as golden silk robes and nested folds or plait-lines that emphasise the waistline. Dang Baohai, 'The Plait-line Robe: A Costume of Ancient Mongolia', *Central Asiatic Journal*, 47/2 (2003), 12 also observes that the tailoring style of Zhu Tan's robe imitates the plait-line style, arguing that 'although the Ming government forbade the Mongolian costumes and the Mongolian language, the influence of the Mongols could not disappear within one hundred years'. Identifying fashions alongside dynastic periods (by historical actors and analysts) thus substantially contributes to the confusion of dress styles. I would like to thank David Robinson for asking me to clarify this point.

[25] Zhao Feng and Jin Lin, *Fangzhi kaogu* [Textile Archaeology] (Beijing, 2007), 182. Similar robes were excavated from tombs in key silk areas along the coast, see Wang Xuan, 'Zouxian Yuan dai Li Yu'an mu qingli jianbao [Preliminary Excavation Report of the Yuan Dynasty Li Yu'an from Zou County]', *Wenwu*, 4 (1978), 16. The tomb revealed fifty-five pieces of cloth made of silk, cotton and hemp (*ma* 麻).

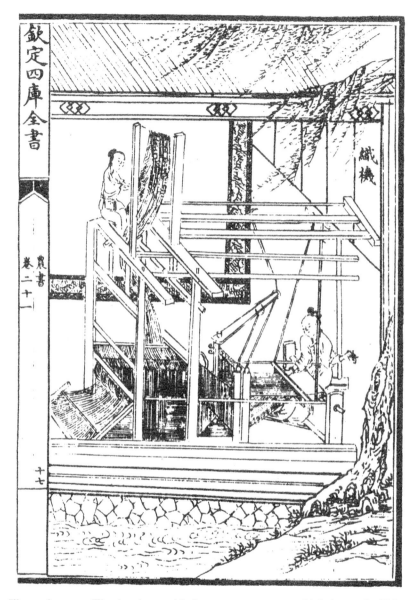

Illustration 1.1 The drawloom with the pattern tower was widely known in China. Wang Zhen depicted one using a new approach to illustrate technical matter. Wang Zhen 王禎 *Book on Agriculture* (*Nong shu* 農書, juan 卷 21, Nongqi tupu 18 農器圖譜十八, Zhiren men 職紝們, p. 17a (Siku quanshu 四庫全書). Facsimilie in: *Wenyuan ge Siku quanshu*, Zibu: Nongjia lei 子部: 農家類文淵閣四庫全書, Vol. 730, pp. 315–607, p. 584.

official Wang Zhen 王禎 (1290–1333) a century earlier in his *Agricultural Treatise* (*Nongshu* 農書, preface 1313).[26] A survey of other textile artefacts excavated from late Yuan and early Ming tombs equally demonstrates continuities rather than ruptures in practices and fashion.

SYSTEMIC CHOICES: YUAN PRECEDENTS AND MING DESIGN

Like its predecessors, the Ming state was confronted with patterns of settlement, social relationships, infrastructural and technological choices that it wanted, in the words of James Scott, to 'domesticate' for its own purposes.[27] Although our knowledge of the Yuan dynasty set-up of workshops, their tasks and forms of cooperation can by no means be considered complete, it is clear that the Ming adopted major institutional premises such as the household registration system.[28] Also Yuan and Ming rulers followed a two-fold approach of both centrally and locally organised units. How much then did or could the new dynasty change?

The historical account regularly highlights that the intentions, ideals, and values of Yuan and Ming rulers varied. The Yuan appreciated the North. Climate change was only one of the reasons that Ming sericulture and economy settled in Jiangnan. The Yuan valued materials and colour, taxing textiles, for instance, based on colour identification. By the late Ming period, the emphasis had moved to patterns and wefts. A comparison of institutional narratives reveals striking differences in Yuan and Ming ideas of labour, skill, and notions of political control. This becomes probably most evident in the divergent attention and authority that both dynasties assigned to design in their structural approach to state-owned production. The Yuan structure exploited local specialities, skimming the cream of what was designed and produced locally. The Ming

[26] Wang Zhen, *Nongshu* [Agricultural Treatise] (Beijing, [1300] 1956), 495. The image, however, is from the *Siku quanshu* edition. For the 1530 edition, see Roslyn Hammers, *Pictures of Tilling and Weaving: Art, Labor, and Technology in Song and Yuan China* (Hong Kong, 2011), 102. Reports are lacking, for the early Ming period, about multi-coloured warp- and weft-based patterns covering almost the entire surface, such as those seen in the finds from the Dingling tomb of the late Ming emperor, Wanli. Zhongguo shehui kexue yuan kaogu suo (ed.), *Dingling* [Dingling, the Imperial Tomb of the Ming Dynasty] (Beijing, 1990), 46, 49.

[27] Scott, *Seeing Like a State*, 184.

[28] Ming historians created the Yuan dynasty's official history in considerable haste, mainly drawing on central state records, with local gazetteers and private historiography providing important contributions, although usually retrospectively. Bai Gang, 'Yuan shi shiliao yaoji gaishu [Overview of Historical Sources on the Yuan Dynasty]', *Lishi jiaoxue*, 2 (1981). Local officials decided quite deliberately which information to include in their records. Joseph Dennis, *Writing, Publishing, and Reading Local Gazetteers in Imperial China, 1100–1700* (Cambridge, MA, 2015), 22.

concocted a use-based structure of manufacture. Public ministries at the capital organised production in a network of workshops defined by the final purpose of the silk (for tribute, ritual, or imperial use). Unlike the Yuan, the Ming divided production and design responsibilities institutionally and geographically. At the point when such structure became effective, uniform styles – a subject important to the emperor, according to sources – would have required some working procedures such as the systematic exchange of staff, templates, patterns, and techniques. The first emperor indeed implemented rotational *corvée* labour. Early Ming contemporaries, however, rarely mention bureaucratic uses of templates or pattern exchange in relation to silk weaving or state-owned structures.

During the Yuan era when pairs of Mongolian and Chinese officials supervised silk institutions at the central capital and its various court seats, Embroidery Bureaus (*xiuju* 繡局) were in charge of *jin*-polychromes (*jin* 錦) with gold threads and their embroidery for use by princes and the hundred officials (*baiguan* 百官). The General Courtyard for Brocading Patterns (*wenjin zongyuan* 文錦總院) and the Bureau for *Luo*-Gauzes (*luo* 羅) of Zhuozhou District (*Zhuozhou luoju* 涿州羅局) concentrated on bolts of light gauze (*shaluo* 紗羅).[29] In his private historiography, Tao Zongyi 陶宗儀 (1329–1410) also lists a Weaving and Dyeing Bureau (*zhiran ju* 織染局) under the Ministry of Works (*gongbu* 工部) and furthermore notes that the Imperial Literature Office (*yuwen tai* 御文臺) had a Bureau for *Ling*-Twill Damasks and *Jin*-Polychromes (*lingjin ju* 綾錦局), producing silk accessories for paintings and calligraphy.[30]

The Yuan spun a locally administered web across their territory to control silk textile production, allocating responsibilities to the provincial governments around the capital region (of Dadu, near modern Beijing). Another set of bureaus across the territory cherry-picked local craftsmen who could produce yarns in fibres such as cotton, wool, or hemp.[31] Provincial and local administration kept registries for tax and *corvée* labour but did not engage directly in

[29] Song Lian et al., *Yuan shi* [History of the Yuan] (Taipei, [1369] 1981), 2147 (*juan* 85, *zhi* 35: *baiguan* 1).

[30] Tao Zongyi, *Nancun chuogeng lu* [Records Taken at the Southern Village after Ploughing] (Beijing, [1366] 1959, Wujin Yuan keben), 258 (*juan* 21), for the weaving and dyeing bureau under the Ministry of Works. Tao, *Nancun chuogeng lu*, 259–61 (*juan* 21) lists another weaving and dyeing bureau subordinate to the Household Administration of the Empress Dowager (*huizheng yuan* 徽政院) which existed on and off 1294–1324 and again 1334–1368 and also produced *jin*-polychromes. Additionally, the Imperial Manufactories Commission (*jiangzuo yuan* 將作院) and the Felt Bureau (*zhongshang jian* 中尚監) also maintained special weaving and dyeing facilities for court demands. Both operated with provincial farmer-craftsmen (*lu zhongtian renjiang* 路種田人匠).

[31] Allsen, *Culture and Conquest*, 40. Mixed fibres and their use are a neglected topic open to debate in Asian/Chinese history.

production. All silks produced outside the capital were officially designated for military and tributary use. Yuan rulers kept control in the hands of the court or, more concretely, in the hands of the imperial clan.

When Zhu Yuanzhang announced a four-fold infrastructure of manufacturing sites at his capital Nanjing in 1370, he also relied on the spatial proximity to the local industry of sericulture in Jiangnan to facilitate knowledge flows.[32] But state manufacture lost this connection/advantage when Zhu's successor and son, Yongle, moved the capital to Beijing, a region with no such background. The Outer Weaving and Dyeing Bureau (*wai zhiranju* 外織染局) in Beijing thus took charge of raw materials and dyeing, while the Inner Weaving and Dyeing Bureau (*nei zhiranju* 內織染局) was the only institution with actual looms suitable for weaving all kinds of labour-intensive fabrics such as the fine, lightweight *sha*-gauzes (*sha* 紗) and *luo*-gauzes, satin (which had become fashionable by the Yuan period), and *jin*-polychrome compound weaves or any combination thereof. Dragon robes are explicitly addressed in these records and hence we can surmise that the record keepers had, at least, the intention of rigorously supervising designs that were, however, then executed in Nanjing, the southern capital, or in the local bureaus with the best weavers in Suzhou and Hangzhou. We know this because the Beijing bureaus had no output and continuously ran short of capable weavers.[33]

When the first emperor hence put ministries and officials, localities, and central institutions in charge of silk manufacture, officials had to find a way to communicate not only across fields of expertise, but also across temporal and geographic distances.[34] The *Collected Statutes of the Ming* invokes classics of statecraft such as the *Rites of Zhou* (*Zhouli* 周禮) to put the Ministry of Rites (*libu* 禮部), located in Nanjing, in charge of clothing design and the supervision of ritual regulations.[35] Officials of this ministry developed regulatory measures

[32] Both the *Collected Statutes of the Ming* and the *History of the Ming* describe this set-up: see Li et al., *Da Ming huidian*, vol. 5, 2771 (*juan* 208, *gongbu* 28, 10b) and Zhang et al., *Ming shi*, vol. 7, 1997 (*juan* 82, *shihuo* 6).

[33] Li et al., *Da Ming huidian*, vol. 5, 2772 (*juan* 208: *gongbu* 28, 12a). He Shijin, *Gongbu changku xuzhi* [Noteworthy Information about the Factories and Storehouses of the Ministry of Works] (Taipei [1615] 1985), 2258–9 (*juan* 1, 22b–23a), meticulously records materials by the early seventeenth century. I assume that even if the storage system existed during the early Ming period in the evolving capital Nanjing, its actual contents may have differed.

[34] Schäfer, *Des Kaisers Seidene Kleider*.

[35] In the early days, the Ming followed the *Tang liudian* (Compendium of Administrative Law of the Six Divisions of the Tang Bureaucracy), which does not specify any such institutions. Only in 1497 did Xu Pu 徐溥 (1429–99) direct the compilation of the *Collected Statutes of the Ming*. A first version was finalised in 1502, but revised and printed only in 1509 (Zhengde 4) under the directorship of Li Dongyang 李東陽 (1447–1516). Only 75 of the 180 *juan* of this compilation are

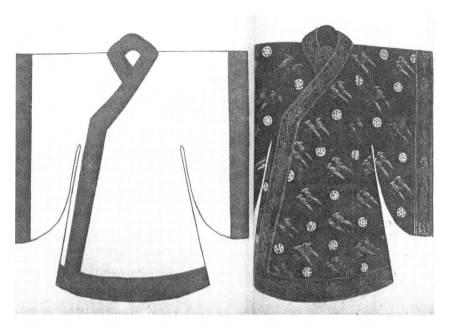

Illustration 1.2 Example of court attire *Pictures of Court Costumes and Manners in the Ming Dynasty* (*Minggong guanfu yizhang tu* 明宮冠服儀仗圖). The illustrations in this text represent the most important and complete set of images on Ming Dynastic court clothing. Apart from court robes it includes accessories and insignia as well as flags. It contains complete sets of the court robes of the empress, the crown princes and the feudal kings as well as colored sets of the ritual and regular gowns of concubines and several examples of ritual dress and items for commoners. It also provides insights into the development of standards of representation for aesthetic and technical information in visual formats that were mainly used as reference for the production and assessment of clothing rules.

and provided models, sketches, and templates (*shiyang* 式樣) of proper attire (Illustration 1.2).[36] It is quite likely that the draft compilation (*gaoben* 稿本) of the *Pictures of Court Costumes and Manners in the Ming Dynasty* (*Minggong guanfu*

still extant. I here used the widely available revised version by Shen Shixing 申時行 (1535–1614), published in 1587 (Wanli 15) in 228 *juan* which must be considered an *a posteriori* vision of early Ming state ideals. Yuan Ruiqin, 'Da Ming huidian banben kaoshu [Inquiry on the Editions of the *Da Ming huidian*]', *Shixue xinlun*, 181/1 (2011).

[36] Such production was classified as 'in accordance with the standards' (*rushi* 如式) or 'following templates' (*shiyang* 式樣). See the edict (*gaochi* 誥敕) issued 1393 (Hongwu 26), in Chen Menglei and Jiang Tingxi (eds.), *Gujin tushu jicheng* [Complete collection of texts and illustrations, past and present] (Shanghai, [1726] 1934), vol. 781, 51 (*jingji hui bian, kaogong dian, zhigong bu, huikao*).

yizhang tu 明宮冠服儀仗圖)[37] was compiled from a collection of singular design sheets originally produced by the officials of the Ministry of Rites for communication between the court and the workshops in the south. This book, however, seems not to have circulated beyond the court. It achieved no broader function in Ming bureaucracy (as it is not referenced elsewhere), although within the court context it was preserved and its existence seems to have been known in court circles until the Qing period.

How then did information on textile designs circulate, if not through books? Structurally, the Ming ancestor banked on the Yuan dynasty's systemic focus on artisanal expertise and, by 1386, had invigorated the Yuan system of household registration of the mainly urban professional artisans. This system was, as Liu Yonghua has exemplified in the case of Sichuan, still in full effect during the reign of Jiajing (1521–1567).[38] Mobilising people, not things, seem to have been Zhu Yuanzhang's key to unify styles and transport techniques, an approach not unlike that of the Yuan. How different or similar were then the two dynastic systems? As mentioned above, the Ming state adopted the Yuan division between centrally supervised tasks and local bureaus, and shifted the regional focus from the North to bureaus based in Jiangnan and Zhili. A closer look at local sources reveals that the spatial redesign of the Ming did not take immediate effect.

LOCALLY AND CENTRALLY RUN MANUFACTURE SITES

Late Ming dynasty historiography evidently envisioned its approach to silk manufacture as different to that of the Yuan dynasty. As mentioned above, the underlying values and methods that informed Yuan institutionalising practices were not those of the 'Ming'; an appreciation of colour, for instance, undergirded the Yuan tax system, whereas at least by the late Ming, taxation emphasised weft and patterns as well. The extent to which the Ming regime was able to adjust or generate silk manufacture in the fourteenth century to its needs, and what impact lofty ethics and political machinations would eventually have, depended not only

[37] I consulted the *Pictures of Court Costumes and Manners in the Ming Dynasty* in the form of unpublished photocopies of the original manuscript now stored at the Forbidden City Museum, Beijing, which contains an entire *ce* 冊 on princely dress. For a description, see Li Zhitan, Chen Xiaosu, and Kong Fanyun, 'Zhengui de Ming dai fushi ziliao: Ming gong guanfu yizhang tu zhengli yanjiu zhaji [Notes of *Ming Gong Guanfu Yizhang Tu*: Pictures of Court Costumes and Manners in the Ming Dynasty of China]', *Yishu sheji yanjiu*, 1 (2014).

[38] Liu Yonghua exemplifies by way of the case of Ping Shixiu, who was asked to provide service in the Weaving and Dyeing Bureau of Sichuan in 1549 (Jiajing 28). By that time, the clan originally charged with *corvée* had grown and thus the various tasks from actual weaving to the delivery of the end product to the capital was divided among various branches of the clan.

on how powerful the emperor was but also on local conditions and technological choices on the ground.

Just as in other fields across the former Yuan territory, by 1369 sericulture and textile production had suffered from the destruction of war, though nothing is noted on the situation of weaving and dyeing workshops specifically. Local gazetteers of the mid Ming period document that Ming officials expanded spaces, moving facilities previously operated by the Yuan dynasty to new addresses, and also established bureaus in new locations (Map 1.1). Relocations and shifts in administrative staffing structures are one indication that the Ming state made efforts to alter Yuan institutions, transforming what later historians (pejoratively) liked to condemn as a 'Mongolian' system of tax-exploitation into their network of manufacturing a Ming textile style.

The 'Yuan' state approach to managing textile production was marked by preventive caution towards the numerically preponderant Chinese officials. Every known Yuan bureau, right down to the local level, was staffed by a local 'Chinese' supervisor and a Mongolian (loyal non-local) deputy who were mostly concerned with the registration, recruitment, and trafficking of weavers.[39] For instance, the bureau in Zhenjiang, one of the few bureaus that continued to operate from the Song (960–1279) into the Ming period, was supervised by the Han Chinese Zhang Guoxiang 張國祥 (n.d.) and the Mongolian deputy (*jufu* 局副) Esen Buqa (n.d.) (*Yexian buhua* 也先不花). District bureaus mainly held a stamp master (*yinshe dashi* 印設大使) who supervised thousands and tens of thousands of households, but did not interfere with production directly.[40]

In Zhenjiang, the Yuan state had turned the former residence of the military campaign garrison headquarters (*dutong si* 都統司) 'south of the old district bridge' into a weaving and dyeing facility. With 115 rooms (*ying* 楹), the building offered enough space to set up looms.[41] Zhenjiang was located about eighty-five kilometres up the Yangtze River east of the later Ming capital, Nanjing. In Nanjing's Yanyang district, the Yuan state had operated a weaving and dyeing

[39] Song et al., *Yuan shi*, 1060 (*juan* 88, *zhi* 38: *baiguan* 4) indicates mainly how the offices were staffed.

[40] The *History of the Yuan* does not contain Zhang Guoxiang's biography, but he is mentioned briefly. Song et al., *Yuan shi*, 4440 (*juan* 197, *liezhuan* 84: *xiaoyou* 1). He is not to be confused with his later name twin, the celestial master Zhang Guoxiang. Yu Xilu, *Zhishun Zhenjiang zhi* [Zhenjiang Gazetteer of the Zhishun Era (1332–33)] (Taipei, 1981), 647 (*juan* 17, 6a), lists Yima Duding 亦馬都丁 as supervisor (*dashi* 大使) and Liangba lasi 梁八剌思 as assistant supervisor (*fushi* 副史). *Yexian buhua* is a common Mongolian alias. Stamp masters registered tax payments and controlled quality. Dagmar Schäfer, 'Peripheral Matters: Selvage/Chef-de-piece Inscriptions on Chinese Silk Textiles', *UC Davis Law Review*, 47/2 (2015).

[41] *Ying* means 'column' and in this case 'room', as the space between four pillars makes up one room.

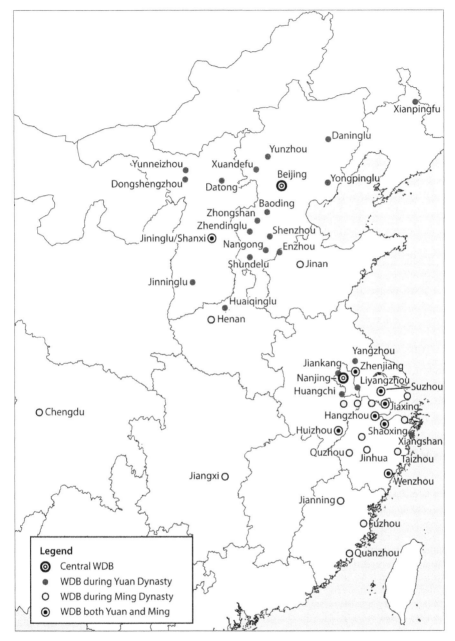

Map 1.1 Ming China showing the locations of former Yuan Weaving and
Dyeing Bureaus, WDB established in the Ming and highlighting overlaps.
Design: Julian Wickert.

bureau in a former school, exemplifying once again that the Yuan practice was to re-allocate buildings rather than build new ones.[42]

A closer look at the local gazetteer of Zhenjiang reveals that the Supervisorate of Brocade Weaving and Dyeing (*lingjin zhiran tichu si* 綾錦織染提舉司) locally distinguished two bureaus, the Weaving and Dyeing Bureau, and a Bureau for Raw Silk Tabby (*shengbo ju* 生帛局). The gazetteer's editor Yu Xilu 俞希魯 (1279–?) notes furthermore that the bureau started with the registration of 300 households in the Dantu district, where married women and their daughters were renowned for their skill at weaving *sha*-gauzes.[43] Households that had gained a reputation (*deming* 得名) for their work were then registered for craft service.[44]

It is not clear if the same can be said of Nanjing, where the local Weaving and Dyeing Bureau during the Yuan era had also branched into two production sites, one for weaving and another one to dye threads:

> [T]he Eastern Weaving and Dyeing Bureau was established in the 17th year of Zhiyuan (1281) in the Eastern city. A supervisor and assistant supervised 3,006 households with 154 looms that produced an annual production quota of 4,527 bolts of (otherwise unspecified) silk fabrics and 11,502 *jin* 斤, 8 *liang* 兩 of coloured silk thread.[45]

What is clear, however, is that when installing weaving institutions, early Ming state officials could draw on a pre-existing local infrastructure of weaving and, in some places, its management. While some localities offered expertise and raw materials, most bureaus received new tasks and many were moved to new sites. Nanjing, for instance, had previously had a local bureau, but had since become a state capital. As such, Nanjing had to undergo a transformation from a rural area with tax obligations named 'Golden Hills' (Jinling 金陵) into an imperial walled

[42] For example, in Liyang, one district of Nanjing. Zhang Xuan et al., *Zhida Jinling xinzhi* [Record of Jinling (Nanjing), Newly Compiled in the Zhida Era (1308–1311)] (Shanghai, [1344] 2003, *Siku quanshu* edition), vol. 492, 30 (*juan* 1, 35a). Also, the tax office was re-designated. Ming gazetteer compilers may have been inclined to report this change in function to pinpoint (name and shame?) (and blame) the Yuan dynasty's preference for crafts over the scholarly arts. We must imagine these registries as locally specific. In urbanised spaces such as Yuan dynasty Nanjing, each district had such an office. The provincial weaving and dyeing bureau of the circuit Jiqing Lu 集慶路 had an eastern and western branch. The eastern branch was located in the former Song tributary courtyard, the western in the Metropolitan Cavalry Command (of the Three Capital Guards) (*weima junsi* 衞馬軍司). Zhang et al., *Zhida Jinling xinzhi*, vol. 492, 21, 22 (*juan* 1, 16b, 19a).

[43] For the editor, see 'Preface' of the Zhang et al., *Zhida Jinling xinzhi*. For Yu Xilu's authorship and background, see Yang Jiqing, 'Yu Xilu qiren [On Yu Xilu]', *Zhenjiang shizhuan xuebao*, 4 (1987), 98–100.

[44] Yu, *Zhishun Zhenjiang zhi*, vol. 1, 209 (*juan* 6, 13a).

[45] Zhang et al., *Zhida Jinling xinzhi*, vol. 492, 316 (*juan* 6 *shang*, 22b).

capital responsible for protecting the imperial bureaucracy, the state's presence as well as its commercial activities.[46]

In spite of large investment from the state, all local sources imply that change was a slow process, contradicting the late Ming historiography that sees Zhu Yuanzhang's officials jump-starting four fully functional central state institutions in Nanjing and fifteen official local weaving and dyeing units at the time of Prince Zhu Tan's death in Shandong in 1385. Only six of the fifteen Ming bureaus were in the same locations as the Yuan centrally recognised bureaus (Map 1.1). This includes Nanjing, where the Ming had to invest heavily to turn local bureaus with distinct tasks into three purpose-oriented high-profile central state institutions. Whereas Yuan bureaus had been located around the northern capital Dadu, the Ming assigned 60 per cent of the final total to the regions of Zheli and Jiangnan.[47] In traditional sericulture regions such as Jiangnan, Zheli, Sichuan, and Shandong, Yuan officials' main responsibility had been the organisation of expertise and raw materials for the manufacture of silk in private workshops. Ming officials, however, took over the manufactures and ran them under state control.

According to the idealised Ming historiography, the Nanjing central state workshops produced princely gowns – and thus also Prince Zhu Tan's buried robes – as part of their annual quota. If we assume that the robes were originally produced as attire, then the Inner Weaving and Dyeing Bureau would have been responsible for their manufacture. The Hall for Ritual Silks, also located in Nanjing, would have produced any garment for exclusive use as a burial robe. We can assume that both institutions had the necessary materials and expertise at their disposal, or could have recruited skilled labour locally at short notice. Nanjing already housed several communities of weavers and dyers and it is therefore quite possible that twenty years after Zhu Yuanzhang's ascendance was long enough for Nanjing's sericulture and weaving trade to have recovered from the negative effects of war.

Textual accounts, however, document rash changes in the rules of production in the short life span of Zhu Tan, particularly between his appointment to Shandong and his early death, that taken together raise doubts that the princely robe could have been manufactured in Nanjing. While the *Collected Statutes of the Ming* meticulously defines the silk textile provisions for princes, it also notes that

[46] Fei Si-yen, *Negotiating Urban Space: Urbanization and Late Ming Nanjing* (Cambridge, MA, 2009), 76–7. Late Ming scholars and Qing sources, such as Zhang Tingyu in his *History of the Ming*, imply that Zhu Yuanzhang took a direct personal interest in institutions, reforms and practices, whereas in other cases we have no such information.

[47] Moving the capital, the Yongle emperor installed counterparts of the Inner and Outer Bureaus in Beijing only in 1422. In the first decades the court mainly relied on its institutions in Nanjing. Schäfer, *Des Kaisers Seidene Kleider*, 39–41.

the princely households had not received their annual quota of *jin*-polychromes or any other silk bolts directly from the court since at least 1376.[48] Instead, 'an annual provision for labour is granted. The princely court is to pay for the manufacture of the robes.'[49] Furthermore, I could find only one occasion when Zhu Yuanzhang explicitly bestowed dragon robes upon the princes, namely in 1379 (Hongwu 12), when Zhu Tan was nine years old.[50] When Zhu Tan moved to his fiefdom in the year 1385, he was in his teens. He died in 1389 from elixir poisoning at the age of nineteen, and it is quite likely that, by that time, he had outgrown his fifteen-year-old size.[51] The original robe would have had to be replaced as the prince grew. In a later case, when the prince of Tang, Zhu Qiongda 朱瓊炟 (1412–75), outgrew his dragon robe in 1453 and requested a replacement, he was ordered to have one manufactured himself (*zizhi* 自製).[52] Shandong had a very long tradition in the production of *jin*-polychromes, making it very likely that the later adjustment paid respect to an actual practice, rather than announcing the discontinuation of a former rule. It is not clear if local expertise extended to the making of dragon robes. The literary account clearly holds that Shandong's sericulture and weaving legacy reached further back than the reputation achieved by Nanjing by the early Ming era.

FIEFDOMS AND SILK: SERICULTURE AND TEXTILES MADE IN SHANDONG

One of the oldest classics of Chinese scholarship, the *Book of Documents* (*Shangshu* 尚書) identifies Yanzhou, Shandong as the origin of fine raw silk, woven baskets, and woven textiles for the supply of the imperial court.[53] We can see how, over the course of the centuries, politicians and scholars used this source to legitimise imperial and state claims to sericulture and silk weaving. A closer look, however, also reveals that the local conditions – in terms of climate, social conditions, and

[48] Princes with blood ties received 40 bolts, half-blood princes (*ban qinwang* 半親王) 20 bolts and commandery princes (*junwang* 郡王) 10 bolts. Zhu Qinmei et al., *Wangguo dianli* [Rites Statutes of Kingdoms] (Beijing, [1615] 2002 in *Xu xiu Siku quanshu*), 346 (*juan* 3, 46a), lists all kinds of silks as tributes to the kings. A relative king, for instance, received furthermore 300 bolts of *zhusi* 紵絲 (a kind of satin with gold threads), 100 bolts of each *sha*- and *luo*-gauze and 500 bolts of tabby silk.

[49] Zhang et al., *Ming shi*, vol. 7, 1999 (*juan* 82, *shihuo* 6).

[50] Xia et al., 'Ming Taizu shilu', vol. 5, 2017 (*juan* 126, 5a–b). He bestowed gold-woven dragon robes and well-bred horses on all feudal princes.

[51] Zhang et al., *Ming shi*, vol. 12, 3575 (*juan* 116, *liezhuan* 4). He was bestowed with the fiefdom in the second month after his birth in 1370 (Hongwu 3).

[52] Li Xian et al., *Ming Yingzong shilu* [Veritable Records of Emperor Yingzong (1436–49)], in *Ming shilu*, vol. 33, 5003–4 (*juan* 229, 3a–b).

[53] *Shujing* [Book of Documents] (Beijing, 2009), 54 (*xiashu*, *yugong*).

workforce – speak against the idea that the local state-owned workshop was involved in the production of Zhu Tan's robe or that private weavers produced it locally.

Song dynasty scholars emphasised the migration of silk expert labour to Shandong's south within a larger political agenda that aimed at undermining the importance of the North which, at that time, was under Jurchen rule. Ma Duanlin 馬端臨 (1245–1322) of the Yuan dynasty postulates Yanzhou's expertise in 'weaving and embroidered silks with patterns' within a larger agenda of authorising Mongolian rulership as legitimate successor of Jurchen rule and his era's tax assignments as righteous.[54] Historians recently pinpointed the importance Liao and Jin rulers assigned to silk. But, contextual records also clearly imply that by the end of the Yuan era Shandong weavers were no longer up to the task. Yuan officials record the negative impact of changes in climate such as frost, locust plagues, or drought on Shandong's sericulture output.[55] The fact that Kublai Khan (1215–94) and his followers commissioned the publication of scholarly works such as the *Fundamentals of Agriculture and Sericulture* (*Nongsang jiyao* 農桑輯要, edited ca. 1273) underlines the imperial determination behind attempts to promote silk (along with cotton and corn) in the northern provinces of Hebei, Shandong, and Henan, but it does not prove its success.[56]

As a matter of fact, sericulture indeed increasingly moved southwards.

The Jin and Yuan dynasties had both run a weaving and dyeing bureau in Enzhou.[57] The Ming now assigned local weaving and dyeing bureaus to the seat

[54] Ma Duanlin, *Wenxian tongkao* [Comprehensive Examination of Literature] (Beijing, [1324] 1986) (*juan* 22: *tugong kao*, 1a). The effects of the revocation of material traditions in classics on the general development and shifts in Chinese history are still far from understood. Clearly though, even centuries later, officials were still authorising tax demands based on classic literature. Lu Yi et al., *Shandong tongzhi* [Comprehensive Gazetteer of Shandong Province], in Zhu Dingling et al. (eds.), *Tianyige cang Mingdai fangzhi xuankan xubian* (Shanghai, [1533] 1990), vol. 51, 497 (*juan* 8, *wuchan*, 1a).

[55] Lu et al., *Shandong tongzhi*, vol. 51, 501 (*juan* 8, *wuchan*, 3a). Song et al. (eds.), *Yuan shi*, 730 (*juan* 50, *zhi* 3 *shang*: *wuxing* 1) notes, for instance, a complete loss of harvest by 1269 for all regions north of Jinan and subordinate to Enzhou district. See also Song et al., *Yuan shi*, 1639 (*juan* 96, 45 *shang*) and Wang Qi, *Xu Wenxian tongkao* [Extended Comprehensive Examination of Literature] (Taipei, [1603] 1979), 13192 (*juan* 222, *wuyi kao*, 29b). Wang Xiang, 'Zhongguo sichou shengchan quyu de tuiyi [Regional Shifts in Sericulture in China]', *Caijing luncong*, 117/4 (2005), 94, dedicates, like many other authors, only a few sentences to the development of the silk textile trade during the Yuan.

[56] The book was most likely produced under the supervision of Chang Shiwen 暢師文 (1246–1317), Meng Qi 孟祺 (n.d) or Miao Haoqian 苗好謙 (n.d.) who mostly originated from Shandong, Henan and Hebei. Mau Chuan-hui, 'Les progrès de la sériciculture sous les Yuan (XIIIe–XIVe siècles) d'après le Nongsang jiyao', *Revue de Synthèse*, 2 (2010).

[57] Song et al., *Yuan shi*, 2151 (*juan* 85, *zhi* 35: *baiguan* 1). Chen Gaohua et al., *Yuan dianzhang* [Collection of Statutes and Substatutes of the Yuan] (Tianjin, [1297–1307] 2011), 220–2 (*libu juan* 1, *dianzhang* 7), which was compiled by unknown officials of the Yuan and covers the period between 1257 and 1322, also mentions Enzhou. Tu Shufang et al., *Jianwen chaoye huibian* [Account of Jianwen Vacating His Throne] (Beijing, [1598] 1988), 25 (*juan* 1, 18a).

of the provincial government in Ji'nan which was in the south of the province. Zhu Tan's fiefdom seat and final burial site in Yanzhou was located only fifty miles away from Ji'nan, near enough for Prince Zhu Tan to communicate his wishes. But did the bureau actually produce anything?

According to contemporary provincial and local gazetteers the Weaving and Dyeing Bureau in Shandong had no buildings – an indication that weavers did not weave in the Ji'nan bureau.[58] Conversely there is no record that Shandong ever fell short of its annual quota (*suizao* 歲造) – as other places regularly did – which Zhu Yuanzhang had fixed at the modest number of 720 bolts of high-quality *zhu*-satin (*zhu* 紵), *sha*-gauze, *luo*-gauze, and *jin*-polychromes.[59] One indication that Ji'nan's bureau might have purchased goods from other regions and commissioned private weavers for its modest production quota is that local sources remain attuned to a gendered division of labour with 'men tilling and women weaving'. In other places with state-owned manufacture and commercialised textile trade, silk weaving developed from an 'exclusively female domain' into a craft 'under male control',[60] such as in Dengzhou district, He'nan province, where the agricultural tasks of breeding, the work of spreading the hibernating worms and carrying them around was considered fieldwork done by women, whereas the labour of [weaving] white silk was the public work of men and their sons.[61] The late Qing gazetteer explicitly identifies Ji'nan as a backwater because 'in its small villages females reel and weave, whereas males are without work during the winter months'.[62] In Yanzhou also 'sericulture was a female task. They weave silk into tax-silk or it could also be *ling*-twill damask silk (*ling* 綾).'[63]

By the Ming era, private weavers in Ji'nan were best known for common household production of the simple weave (tabby and variation) and not for anything requiring an expensive drawloom with a pattern tower. Yanzhou's

<hr>

[58] Lu et al., *Shandong tongzhi*, 899 (*juan* 15, 11a) just specifies that it was located 'northwest of the government'.

[59] Wei Wenjing, Xia Weizhong and Wang Liang, 'Cong suizao renwu kan Mingdai difang zhizao de xingshuai bianqian [Discussions on the Development and Decline of Local Weaving in the Ming Dynasty from Annual Manufacturing Tasks]', *Sichou*, 51/3 (2014).

[60] Francesca Bray, *Technology and Gender: Fabrics of Power in Late Imperial China* (Berkeley and Los Angeles, 1997), 183.

[61] Fang Ruyi, *Zengxiu Dengzhou fuzhi* [Expanded Gazetteer of Dengzhou (Guangxu era)], in *Zhongguo fangzhi jicheng: Shandong fuxian zhi ji* (Nanjing, [1881] 2004), vol. 48, 73 (*juan* 6: *fengsu*, 9a).

[62] Interestingly Wang Zengfang et al., *Ji'nan fuzhi* [Gazetteer of Ji'nan (Daoguang era)] (Taiwan, [1840] 1968), 1111 (*juan* 13, *fengsu*, 2a), identifies labour structures as an indicator of a region's economic development and civilisation.

[63] *Yanzhou fu wuchan kao* [Examination of the Local Products of Yanzhou], in Chen Menglei et al., *Gujin tushu jicheng*, vol. 11, 1024 (*juan* 238, *zhifang dian*, 48).

ling-twill damask silk was recognised for its 'dense weft, in which it was impossible to weave further patterns'.[64] It was also the market place for local specialities such as the Ji'nan branded 'tabby from the River Ji',[65] which suggests that traders regularly commuted between these two places. The local gazetteer of nearby Zhangqiu boasted about the local production of *sha*-tabby (*sha juan* 紗絹).[66] Both River Ji tabby and *sha*-tabby could in principle be woven on a simple loom. Zhu Tan, allocated a fiefdom with a history of sericulture, hence had local access to raw materials and expert labour, as well as the creative innovative energy required to produce silk textiles, but not dragon robes. A state-owned manufacturing site may have not existed by the early Ming.

What does not easily fit into this picture is that the central state records note the successful collection of 10,000 bolts of *jin*-polychromes from Shandong as an annual tax payment in 1372 (Hongwu 5, month 7 to 8), a decade after the fall of the Yuan dynasty.[67] These *jin*-polychromes were exactly the textile which the Ming imperial court would later regularly bestow as annual tribute upon ranked princes. Shandong's reputation in literature as a silk centre in fact caused the Ming state to demand annual taxes of 23,900 bolts of plain tabby silk (*juan* 絹), raised to 32,800 bolts during the Hongzhi era (1487–1505). Shandong seems to have been able to meet the increasing demand partly because it brought in higher yields. The fact that there are no recorded complaints about the limitations of existing structures of production could mean that provincial officials were used to acquiring textiles from weavers in other regions. This is even more likely when we consider that, although seventy miles south of the provincial seat (which may have put Zhu Tan at a distance from provincial politics), Yanzhou was conveniently linked to the Grand Canal.

All facts considered, if the dragon robe was produced locally, it was either made in a private workshop, or, even more likely, it was, like other high-quality silks, purchased from other regions. Was Shandong an exception within the Ming state-owned silk manufacture network? To answer this, let us look at the situation in Sichuan, another region under princely rule that was long renowned for its weaving expertise within the territory of the Ming.

[64] *Yanzhou fu wuchan kao.*

[65] Dong Fuheng, *Wanli Zhangqiu xianzhi* [Gazetteer of Zhangqiu County of the Wanli era] (Beijing, [1596] 2013) (*juan* 14, *fengtu zhi*, 97a).

[66] Dong, *Wanli Zhangqiu xianzhi* (*juan* 14, *fengtu zhi*, 97a).

[67] The expression *jin* is not exclusive to silk, it can also refer to a mixed fibre textile.

SILK PRODUCTION IN CHENGDU, SICHUAN

Two Ming dynasty *jin*-polychrome compound wefts with double lion patterns and round snow-flower patterns are showcased in Sichuan's Provincial Capital Museum. A yellow ground with triple weft threads displays compositions of blue, light green, yellow and black flowers twining in small circles around furling phoenixes and in larger circles around a pair of lions. A substructure shows a grass and cloud motif. Splendidly decorated, these two pieces of Sichuan *jin*-polychrome (*Shujin* 蜀錦) exemplify this region's proficiency in silk manufacture, outranking places like Shandong in terms of tradition, quantity and quality. Sichuan brocades were expensive, as the late Ming dynasty Assistant Administration Commissioner (*canyi* 參議) Wang Shixing 王士性 (1546–98) explained in his *Further Elucidations on My Extensive Record on Travels (Guang zhi yi* 廣志繹).[68] Few could afford them at all: '*jin*-polychromes cost fifty pieces of gold. Each is several *fen* 分 thick and the weaving is delicate, hence it cannot be used for clothing. It might fulfil the purpose of a coverlet that only royal palaces can afford. It is not suitable for commoners.'[69]

Despite Sichuan's rich and long tradition in sericulture and its high proficiency in silk textile production, no dragon robe is reported to have been found in Prince Zhu Chun's tomb. By contrast, local contemporary sources leave no doubt that, when Prince Zhu Chun finally arrived in Sichuan in 1389, he held court in a manner that was in no way inferior to that of the capital court. With all due pomp and circumstance, he moved into a spacious newly built residence in his fiefdom, the city of Chengdu.[70]

Unlike Zhu Tan who died young, the adult Zhu Chun achieved influence as a military leader and local figure, fulfilling roles similar to those of his three brothers, the princes of Qin, Jin, and Yan. He was granted comprehensive privileges, including administrative and economic responsibilities, in return for pacifying the constant uprisings of minority groups in this region.[71] As Zhu Yuanzhang made use of the princes to keep localities under control, he used eunuchs (*taijian* 太監) early on to keep localities (and the princes) in check. While literature silences eunuch activities, excavations – obituaries, institutional and

[68] Wang Shixing held the position of Assistant Administration Commissioner in several provinces: Sichuan, Guangxi, Yunnan and Shandong.

[69] Wang Shixing, *Guang zhi yi* [Geography of China] (Beijing, [1662] 1981), 107. For an example of such works, see Clunas and Harrison-Hall (eds.), *Ming*, 83.

[70] Zhang Tianju, '*Mingdai Shuwangfu goucheng* (The Structure of Prince Shu's Palace during the Ming Dynasty)', *Wenwu jian ding yu jian shang* 60/2 (2015).

[71] In 1390 (Hongwu 23), Prince Zhu Chun was also granted additional troops. Yongle dismissed most of these military rights upon his accession to the throne.

temple inscriptions – give a prominent place to praising the generous patronage of individual eunuchs in Sichuan in silk manufacturing, allocating their place within the administration of the princely court.

Since the Song era, Sichuan's proficiency in sericulture and textile production had been within the purview of dynastic rule. General studies suggest that Yuan sericulture in this region declined considerably in favour of cotton cultivation, but very little research specifically examines silk production in Sichuan during the Yuan era.[72] Yuan contemporaries such as Fei Zhu 費著 (*jinshi* 1324) praise Sichuan's *jin*-polychromes, but when specifying styles and patterns they mainly speak of Song traditions.[73] Centuries later the late Qing local gazetteers also wax nostalgic about Song silk and claim that Sichuan's famous *Shujin*-polychromes became sought after and rare during the Ming dynasty. No clear date or reign period is given though.

Within the dynastic narrative, the establishment of Sichuan's Weaving and Dyeing Bureau is aligned with the opening of other bureaus. Thus the installation of all state-owned silk manufacture is portrayed as one event directly after Zhu Yuanzhang's ascendance to the throne in 1368. The local gazetteer of Sichuan complicates this view, however, by dating the founding of the bureau to the year 1373.[74] In the *Veritable Records of the Ming Dynasty* (*Ming shilu* 明實錄), a report on the establishment of Sichuan's Weaving and Dyeing Bureau follows one on the construction of the princely palace (*wangfu* 王府) which suggests that the central government approached institutional building in Sichuan in a comprehensive manner.[75]

Ordered to produce an annual provision of *jin*-polychrome, Sichuan 'established a special workshop for the weaving of *jin*-polychromes for imperial use'.[76] Two obituaries excavated from the tombs of princely household servants of the

[72] Guo Shengbo, 'Lishi shiqi Sichuan cansang shiye de xingshuai [Historical Periodisation of the Rise and Fall of Sichuan's Sericulture]', *Zhongguo nongshi*, 3/21 (2002), 13, suggests the Yuan as a low point. He also notes, however, that during the Yuan dynasty, Sichuan was one of three locations that hosted a stately embroidery courtyard (*zhijin yuan* 織錦院), which I could not verify. Sichuan's embroidery was particularly famous during the Song era. Suzhou's Song *jin*-polychrome was traced back to Sichuan brocade, a branded product of the Tang era.

[73] Fei Zhu, *Shujin pu* [Treatise on Sichuan Brocades], in Huang Binhong and Deng Shi (eds.), *Zhonghua meishu congshu* [Collection of China's Art Books] (Beijing, 1998), vol. 13, 247–54. The short essay is an addendum to Fei's treatise on paper, *Jianzhi pu* 箋紙譜.

[74] 'Shujin-polychrome' (*Shujin* 蜀錦) is simply mentioned as a local product in Luo Tingquan, *Tongzhi Chengdu xian zhi* [Gazetteer of Chengdu County in the Tongzhi Era] (Taipei, [1873] 1971), 2898 (*juan* 16, *zalei zhi: jiyu*, 33b).

[75] Xia et al., *Ming Taizu shilu*, 1455 (*juan* 80, 5a). The Veritable Records are organised by date based on court records.

[76] Zeng Jian et al., *Huayang xianzhi* [Local Gazetteer of Huayang County (of the Jiajing era)], in *Sichuan fangzhi zhiyi* (Taipei, 1967), 2346 (*juan* 34, 35b).

Zhengde period (1505–21) give the most insight into the inner workings of the princely residence in Sichuan. According to the inscriptions, the doorkeeper Su Rong 蘇荣 (born 1456) and his assistant the eunuch Teng Ying 騰英 (1458–1518?) who served in the Apparel Service (*dianfu suo* 典服所) were 'obtained from the Inner Bureau for Weaving and Dyeing'. Both entered the prince's household at an early age, and according to the stele were in their fifties when, in the autumn of 1516 (Zhengde 11), they received the 'Emperor's order to supervise and manage the Weaving and Dyeing Bureau in Sichuan'.

Teng Ying's tomb, like the tombs of many eunuchs, is sumptuous.[77] The obituary is the equal of any official's in style and rhetoric. Allusions to early signs of his brilliance, similar to those found in scholarly genealogies ('since childhood he was extraordinary: everyone found this rare'), are followed by a chronological account of his career: 'As he grew up he entered Sichuan as an ordinary service man (*zhongshi* 中士)'.[78] From the Chenghua era (1455–68) onwards, Teng held the reins of government, and achieved executive responsibilities. Teng's place in the princely palace was hence stable over a long period of time and his influence grew over the years.[79]

Ming sources also suggest that, while silk was widely available in Sichuan, by the early Ming era the city's proficiency no longer lay in weaving high-quality textiles. Tax assignments were shifted to raw silk, that is, silk threads instead of woven textiles. Furthermore the principal government was required to deliver a high quota of a rather simple weave: 4,516 bolts of wide raw silk tabby (*kuosheng juan* 闊生絹), with an additional 377 bolts in leap years.[80] In unison local sources emphasise a long tradition of mulberry plantations, silkworm breeding and reeling, claiming that 'even the less adept' were able to reel 'threads so thin, smooth, and glossy' that they came to be known as 'fluid silk' (*shuisi* 水絲).[81] Weaving was no longer the main concern. Local textile production occasionally

[77] Jiang Dianchao and Yu Dezhang, 'Chengdu Baimasi di liu hao Ming mu qingli jianbao [Excavation Report of Ming Tomb No. 6 of the Baimai Temple of Chengdu]', *Wenwu*, 10 (1956). Several other eunuchs' tombs were found during the construction of the railway throughout the 1950s.

[78] Tang Shuqiong and Ren Xiguang, 'Sichuan Huayang Ming taijian mu qingli jianbao [Excavation Report of Ming Eunuch Tomb from Huayang, Sichuan]', *Kaogu tongxun*, 3 (1957), 43–9.

[79] Teng Ying's case indicates that the increasing complaints by local officials of eunuchs meddling in local silk manufacture were indeed justified. Similar complaints also arose in other sectors. Officials blamed eunuchs' venality and corruption for sparking local resentment and violence even for the early sixteenth-century rebellions in various parts of the empire. David Robinson, *Bandits, Eunuchs and the Son of Heaven: Rebellion and the Economy of Violence in Mid-Ming China* (Honolulu, 2001), 87.

[80] Li et al., *Da Ming huidian*, vol. 5, 2706 (*juan* 201: *gongbu* 21, 8b).

[81] Yang Sizhen, *Baoning Fuzhi* [Local Gazetteer of Baoning] (Ming Jiajing jian keben, 1543), 231 (*juan* 5).

wavered, for example, during the early Ming dynasty's military campaigns. In 1380, Xuzhou and Chongqing were allowed to replace their tax duty of *juan*-tabby with raw silk yarn (*si* 絲) and 'those who deliver rough silk yarn [silk that cannot be reeled] that cannot be woven into *juan*-tabby can substitute [their duty in] textiles with [providing] transportation'.[82]

While at the moment no conclusive evidence can be drawn on the place of production for Zhu Shun's gowns, it is clear that the princely court in the long run functioned as the fulcrum for the extension of imperial control over silk manufacturing in Sichuan. The sum of historical sources, though partly from a later date, suggests that eunuchs were sent to the region to help reinstall weaving manufacture following its decline after the war between the Yuan armies and those led by the later Ming ancestor Zhu Yuanzhang. The prince thus might have had direct access to the bureau. Over time, weaving in Sichuan's state-owned bureau went into decline while at the same time, as Liu Yonghua's study of legal cases has revealed, the state also regularly recruited weavers in the form of *corvée* labour from this region,[83] and thus private weavers of a high quality continued the trade.

CONCLUSION

Dress was an important signifier of social and political status in the Chinese world, long before and long after the Ming dynasty. This made the control of designs and styles a central indicator of a ruler's ability to exert his authority. Yet while late Ming historians emphasised the first Ming emperor's attention to dress codes and infrastructural changes of silk manufacture, excavated artefacts and a closer look at contemporary sources reveal that the Ming ruling class developed, rather than ad hoc determined and implemented, their concept of state-owned silk manufacturing. The first emperor of the Ming, Zhu Yuanzhang, might not have been interested in interfering with manufacture and dress codes in the way that later sources would have us believe. Clearly he was not able to change everything at one fell swoop. The most marked characteristic of silk manufacturing and textile styles from the mid fourteenth to the mid fifteenth century, during the Yuan-Ming transition, is continuity, rather than transformation. With regard to textile and clothing styles, preservation seems to have been the key.

[82] Xia et al., *Ming Taizu shilu*, 2093 (*juan* 132, 1a).

[83] Liu Yonghua, 'Mingdai jiangji zhidu xia jianghu de huji yu yingyi shitai: jian lun wangchao zhidu yu minzhong shenghuo de guanxi [Internal Structure and Labour Services of Artisan Households during the Ming Period: Toward an Interpretation of the Relationship between Imperial Institutions and Social Life]', *Xiamen daxu xuebao*, 2 (2014).

We may argue that the first generation was either too busy or oblivious to such issues. It is quite likely, though, that despite later historiographic imagination, Zhu Yuanzhang, like many other usurpers might have chosen to show superiority over the defeated power by continuing long-established codes of social distinctions. Historically, elites, in attire and attitudes, regularly sought to celebrate their elite status by adopting and adapting emblems of power while attempting to consolidate their rule.[84] Artefactual evidence suggests that novel attire and attitudes came into play later. Research on local conditions and technical change shows furthermore some indications that silk manufacture continued alongside Yuan patterns. Within the expanding web of state-owned silk manufacture, local issues often informed and formed the nature of central control far into the reign of Yongle and later rulers.

Thus far it seems that chance and personal interest defined princely access to silk manufacture, although a final answer to the question of whether or not princely access to dragon robes at this early stage was ruled by other principles will have to await the excavation of all twenty-four tombs. The single example of the presence of dragon robes in Zhu Tan's tomb is not enough to create a general argument about princely rights or dress codes. According to the records, following generations of princes increased their demands to the central government. In 1502 (Hongzhi 15) sustenance for each feudal prince was quoted at 17,280 *liang*. The ministry also noted annual costs for weaving amounting to more than 60,000 *yin* of salt.[85] Increasingly princes could afford and therefore *chose* to be dressed in splendid dragon robes. For the early part of the period, no such case can be made.

Zhu Chun's case exemplifies that while princely courts, especially in this early phase, served and fostered their own individual aims, the ruling elite cooperated pragmatically to make ends meet. In summary, the excavations suggest that central structures of production and control remained a distant dream and that the very idea of what 'state-owned' actually meant differed greatly in different localities.

In the current narrative on technical development and historical change, historians give strong emphasis to socio-political power. When studying

[84] Jean-Pascal Daloz, *The Sociology of Elite Distinction: From Theoetical to Comparative Perspectives* (London, 2010), 131, points out that it is 'advisable to contrast the varying degrees of social prestige accorded to the old and the new depending upon the actual perceptions of the elites under consideration. [...] Where greatest distinction comes from antiquity (Rolls-Royces), the elite will seek the older, more distinguished model, while the nouveau riche will buy the newer models.'

[85] Li Dongyang et al., *Xiaozong shilu* [Veritable Records of the Xiaozong Emperor (1487–1505)], in *Ming shilu*, 3552 (*juan* 192, 8b). During this year, weaving matters were discussed in abundance. See also Li et al., *Xiaozong shilu*, 3546 (*juan* 192, 5b).

state-owned manufacture, political history undoubtedly offers an important and relevant but not necessarily unambiguous framework. A close look behind the scenes reveals that political rhetoric, institutional shifts, and actual technological choices did not simply coincide. Decades after the start of Ming rule, structures and methods of silk manufacture installed by the Yuan state were still central to the functioning of silk textile production for state usage. An argument could be made that politics as often as not lagged behind, authorising changing practices long after the fact. In core regions of silk production – Sichuan and Jiangnan – the state equally conceded to reality when initiating the 'Single Whip' tax reform (*yitiao bianfa* 一條鞭法) and substituting tax provisions and *corvée* labour with silver payments in the early sixteenth century.

Finally, I suggest that the early Ming case is not an exception, but rather a typical example of Chinese dynastic historiography's tendency to emphasise structural ruptures in fields such as sericulture or other crafts correspondent to political change when in fact continuity was the order of the day. Similarly, during the seventeenth century, silk manufacture in Jiangnan halted only briefly despite the transition from Ming to Qing rule, displaying evidence once again of continuity below the surface of the political power change. I have shown elsewhere that the quantity of silk textiles recorded to have entered state and court use during the Ming dynasty remained consistently high despite considerable changes to the forms of organising and appropriating production.[86] Changes in the production, consumption and use of material goods are more often than not continuous and slow even when humans wish it to be swift and clear cut.

[86] Schäfer, *Des Kaisers Seidene Kleider.*

2.

Why Velvet? Localised Textile Innovation in Ming China

Angela Sheng[1]

Zhang-velvet (*Zhang rong* 漳絨) enjoyed great prestige in the late Ming period (1368–1644). The *Zhang* in the name refers to its place of manufacture, Zhangzhou, located on the Jiulongjiang (Nine Dragon River) in southern Fujian province, even though nearby Quanzhou also produced velvet, as did weaving centres in the Lower Yangzi valley: Hangzhou, Suzhou, and Nanjing (Map 2.1). The Chinese term for velvet, *rong* (絨), means soft as feather down and suggests the 'pile loops' raised in the warp of the fabric.

In order to weave the warp-faced compound tabby (*jin* 錦) into pile loops (*qirong jin* 起絨錦), or velvet, early Chinese artisans inserted a false weft through the warp as part of the weaving process. Weavers used ramie yarn, multi-ply silk, or even thin bamboo reeds as false weft which they pulled through the loops after weaving.[2] Examples of such velvet were unearthed in 1972 from the tomb of Lady Dai 軑 (d. 168 BCE), wife of Li Cang (利倉), Marquis Dai (d. 185 BCE), at Mawangdui, now a suburb of Changsha in Hunan province.[3] These velvet fragments feature small, repeated geometric motifs. Experimentation in the 1980s

[1] I am most grateful to all the reviewers for their helpful comments and to Dagmar Schäfer for her close reading, especially her judicious remarks on the organisation of textile labour during the Ming dynasty. Also, I would like to thank Perry Hall, librarian at the University of Toronto Robarts Library for facilitating my consultation of many requested sources, textile curators Sarah Fee and Anu Liivandi for providing access to examples of seventeenth-century Chinese velvet in the Royal Ontario Museum, and to textile historian Masako Yoshida for sending me her articles on this topic from Kyoto City University of Arts. Of course, I am solely responsible for any remaining errors.

[2] Shanghai shi Fangzhi Kexue Yanjiuyuan and Shanghai shi Sichou Gongyegongsi Wenwu Yanjiuzu, *Changsha Mawangdui yihao Hanmu chutu fangzhipin de yanjiu* [Research on Textiles Excavated from Number One Han Tomb of Mawandui] (Beijing, 1980), 44, 50–1.

[3] These include a perfume bag, a mirror case, and twelve robes with collars and sleeve cuffs trimmed with such velvet. Hunan sheng bowuguan and Zhongguo kexue yuan kaogu yanjiusuo

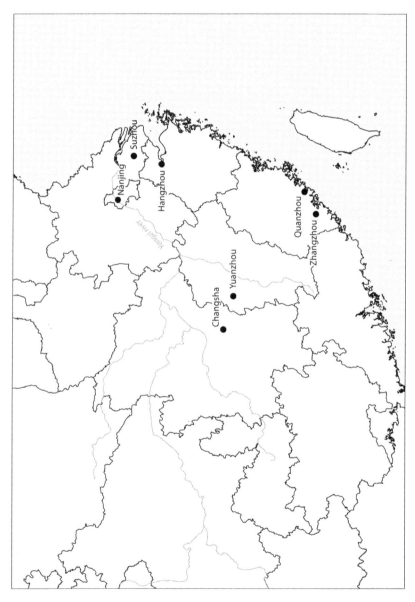

Map 2.1 Ming China showing centres of velvet production in Zhangzhou, Quanzhou, Hangzhou, Suzhou and Nanjing. Design: Julian Wickert.

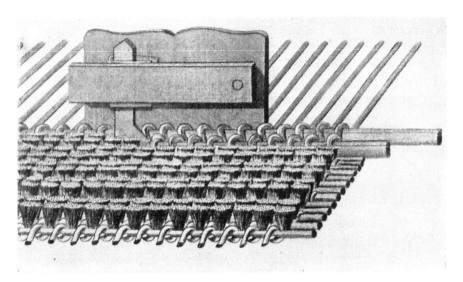

Illustration 2.1 Diagram of inserted wires as a false weft for weaving velvet.
From Fanny Podreider, *Storia dei Tessuti d'Arte in Italia, secoli XII–XVIII*
(Bergamo, Instituto Italiano d'Arti Grafiche, 1928), p. 10, Fig. 13.

by the late John Becker (1915–86) led him to hypothesise that it was possible for a weaver with an assistant to weave this kind of piled loops on a horizontal loom by using pattern heddle rods to make the repeat patterns and using a false weft to raise the loops in the warp.[4] Medieval Italian weavers also produced velvet by inserting metal wires through the warp as a false weft (Illustration 2.1).[5]

Did knowledge of this early technology survive to be implemented centuries later? On the one hand, the Mawangdui examples clearly attest to an early Chinese mastery of weaving velvet. On the other hand, in 1613 the editor of the local gazetteer of Zhangzhou, Yuan Yesi 袁業泗 (*jinshi* degree in 1598), identified the weaving of 'swan-down velvet' (*tian-e-rong* 天鵝絨) in Zhangzhou as a foreign transmission and reported that the weavers inserted metal wires but then cut them out from the woven fabric.[6] At issue is whether the knowledge

(eds.), *Changsha Mawangdui Yihao Han Mu* [No. 1 Han Tomb at Mawangdui, Changsha] (Beijing, 1973), i, 51, 71–2 (perfume bag no. 442, mirror case nos. 441–3).

 [4] John Becker and Donald Wagner, *Pattern and Loom: A Practical Study of the Development of Weaving Techniques in China, Western Asia and Europe* (Copenhagen, 1987), 71–8.

 [5] Fanny Podreider, *Storia dei tessuti d'arte in Italia, secoli XII–XVIII* (Bergamo, 1928), 10, Fig. 13.

 [6] "天鵝絨, 本出外國, 今漳人以絨織之. 置鐵線其中, 織成割出, 機制雲蒸, 殆奪天巧", in Yuan Yesi et al. (eds.), *Zhangzhou fuzhi* [Gazetteer of Zhangzhou], Wanli period (1573–1620), 1613

of weaving velvet was transmitted from 168 BCE to the seventeenth century or (re)introduced from other regions, and if the earlier velvet-weaving techniques impacted on the later development of new velvet weaves. More pertinent still, how and why did Zhangzhou become famous for its velvet in the late Ming?

This chapter analyses Zhangzhou's association with the production of velvet and varying notions of its origin and thus historiographic arguments about linear versus cross-regional or cross-cultural forms of transmission. I argue that economic gain motivated the people in Zhangzhou to specialise in weaving velvet in the sixteenth century, particularly for the export market and, furthermore, that their contact with foreigners was critical to technological innovation in this sector.

The chapter first defines velvet and explores its historiographic and linguistic ambiguities, followed by a concise survey of extant sources on velvet prior to Ming times. Then a review of how silk manufacture began in Fujian is followed with a description of how Zhangzhou became a weaving centre during the Ming era and the fortuitous historical circumstances that led to Zhangzhou developing into a port for direct overseas trade. Finally, *Zhang*-velvet is situated in the context of the domestic versus export market, in order to appreciate the discourse on its name.

WHAT WAS VELVET BEFORE MING TIMES?

Aligning terminology with artefacts is a difficult task in textile history. Indeed, Chinese nomenclature for fabrics is as ambiguous as in any other language. The French word 'velours' can be traced back to its Latin source, 'villosus', which describes the soft texture of velvet fabric but not its technical structure. The modern definition of 'velvet' corresponds to archaeological evidence: 'a warp-pile weave in which the pile is produced by a pile warp that is raised in loops above a ground weave through the introduction of rods during the weaving. The loops may be left as loops or cut to form tufts.'[7] Further terminological distinctions are based on the way in which the patterns are achieved: by covering the entire ground with loops or leaving parts of the weave free from pile, forming patterns by using cut or uncut loops, and so on (Illustration 2.2).

The first reliable textual references to any velvet or velvet-like textured textile appear more than one millennium after the Mawangdui finds, during the Song

edition, *juan* 27, local customs B (*fengtu*), products (*wuchan*), 2 cited in Xu Xiaowang et al. (eds.), *Fujian tongshi* [A General History of Fujian Province] (Fuzhou, 2006), iv, 256–7.

[7] For more details on these technical terms, see Dorothy K. Burnham, *Warp and Weft: A Textile Terminology* (Toronto, 1980), 163–70. Regarding the equivalent Chinese nomenclature, see Zhao Feng, *Zhongguo sichou yishu shi* [A History of Chinese Silk Art] (Beijing, 2005), 75–8.

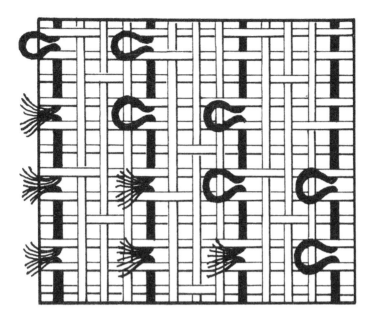

Illustration 2.2 Diagram of a voided ciselé velvet. Source: Dorothy K. Burnham,
Warp and Weft: A Textile Terminology (Toronto, Royal Ontario Museum, 1980),
p. 165. Reproduced by permission of the Royal Ontario Museum © ROM.

dynasty (960–1279). A Song emissary, Xu Jing 徐兢 (1091–1153?), claimed to
have seen *rong* (絨) during his trip to Korea around 1120–5. With a silk radical,
rong might have referred to silk floss or some kind of silk that had a soft velvet-
like surface. Xu noted that: '[T]hanks to merchants from Shandong, Fujian,
and Zhejiang, various silks, *rong*, and sewn goods came [to Korea]'.[8] As *rong* was
written similarly to the term *rong* for a surface in a compound weave (*rongbei jin*
絨背錦), the former might have been an abbreviation of the latter, possibly with
raised warp, a speciality of Hangzhou during the Southern Song (1127–1279).[9]
Since the illustrations to Xu's text are now lost, we lack any images of the silks he
was referring to.

[8] Xu Jing, *Xuanhe fengshi Gaoli tujing* [Illustrated journey to Korea commissioned during the
Xuanhe reign period 1120–1125] (Taipei, [facsimile rpt. of 1167 ed.] 1974) cited in Lin Jinshui and
Xie Bizhen (eds.), *Fujian duiwai wenhua jiaoliushi* [The History of External Relations in Fujian]
(Fuzhou, 1997), 37, fn. 3.
[9] Chen Weiji (ed.), *Zhongguo fangzhi kexue jishu shi – gudai bufen* [The History of Chinese
Textile Science and Technology, Ancient Part] (Beijing, 1984), 376. Zhao Feng argues that the loops
were made in the weft, see his *Sichou yishushi* [A History of Silk Art] (Hangzhou, 1992), 58.

In 1965 archaeologists excavated a tomb in Suzhou belonging to the parents of Zhang Shicheng 張士誠 (1321–67), who had occupied the local area as a self-proclaimed king of the Wu 吳 in late Yuan times. Zhang Shicheng's parents were buried together in 1365 and the tightly-sealed coffin of his mother (née Cao 曹) contained a thinly-padded silk jacket with silk lining and an exterior silk which Chinese scholars also identify as *rong*.[10] However, this is a compound weft weave, not velvet.[11] In 2010, an excavation in Inner Mongolia uncovered a man's crumpled hat woven in plain dark brown velvet, which archaeologists dated to the Yuan dynasty (1279–1368).[12] Texts confirm that Mongol elites were very interested in luxury silks. Yet, even though the thickness of velvet made it ideal for the cold northern climate, it is rarely mentioned in the sources.[13] The *Yuan shi* 元史 [History of the Yuan Dynasty] lists textiles according to season and occasion in its detailed sartorial regulations for the emperor and his court officials, but does not identify velvet. Worth noting are two kinds of silks made for monochrome banquet robes called *zhisun* (質孫), transliterated from the Mongolian *jîsün*.[14] One was called *nasîj* (*nashishi* 納石失) in Mongolian and 'gold brocade' (*jin jin* 金錦) in Chinese. The other was 'cut tuft' (*jian rong* 翦茸) of the *qiemianli* (怯綿里). Extant examples of *nasîj* can be distinguished from the complex patterned weave of contemporary lampas by its use of a secondary binding warp to bind the weft into its design which was made continuously in a gold-covered weft.[15]

Nasîj was highly prized and much in demand. Khubilai Khan (r. 1260–94) even moved craftsmen from Besh Baliq (just north of Turfan in today's Uyghur Autonomous Region of Xinjiang) to his capital Dadu (today's Beijing) as early as 1275 to weave *nasîj* for use in collars and cuffs.[16] In 1278 he ordered

[10] Suzhou shi wenguan hui, Suzhou shi bowu guan, 'Suzhou Wu Zhang Shicheng mu Caoshi mu qingli jianbao' [A Brief Report on the Tomb of a Woman with the Surname Cao, Mother of Zhang Shicheng of Wu of Suzhou], *Kaogu*, 6 (1965), reprinted in Suzhou diqu wenhua ju, Suzhou shi wenwu guanli weiyuan hui, Suzhou bowu guan, *Suzhou wenwu ziliao xuanbian* [Selected Information about Suzhou's Cultural Relics] (Suzhou, 1980), 129–34.

[11] Masako Yoshida, 'The Formation of Velvets in China: A Study of Velvet-Related Terminology in Chinese Documents', *Hata*, 5 (1998), 35–47 (in Japanese with a summary in English).

[12] China National Silk Museum, Acc. no. 3461. I am grateful to Zhao Feng for showing me this specimen on 5 July 2011 at the China National Silk Museum in Hangzhou.

[13] Due to the controversy surrounding Marco Polo's trip, his account is excluded from consideration. See Frances Wood, *Did Marco Polo Go to China?* (London, 1995).

[14] Song Lian (1310–81) et al., *Yuan shi* [History of the Yuan Dynasty] (Beijing, 1983), *juan* 78, vii, 1938. Thomas T. Allsen, *Commodity and Exchange in the Mongol Empire* (Cambridge, 1997), 19. Allsen provides sources that he has consulted in Chinese, Mongolian and Arabic.

[15] Dieter Kuhn (ed.), *Chinese Silks* (Yale, 2012), 334–6.

[16] *Yongle Dadian*, vol. 92, *juan* 19781, leaf 17, as cited in James C. Y. Watt and Anne Wardwell, 'Luxury-Silk Weaving under the Mongols', in James C. Y. Watt and Anne Wardwell (eds.), *When Silk Was Gold: Central Asian and Chinese Textiles* (New York, 1997), 130–1, fn. 17.

the administrator of the Longxing Circuit, Bie-du lu-ding (Baidu-al-din)[17] to recruit skilled West Asian weavers to teach Han Chinese displaced persons, freed slaves and other householders in Hongzhou and Xunmalin (both in modern Hebei province) how to weave *nasîj*.[18] Local artisans who knotted wool tufts for weft-faced carpets and silk weavers evidently mingled and might have learned techniques from each other. Could the 'cut tuft' have simply been a knotted and cut yarn of some sort?[19] *Rong* could refer here to 'fine animal hair, new shoots of grass, and silk floss for embroidery', so might be interpreted as a type of velvet.[20] Also, the word *rong* 茸 in *jian rong* 翦茸 of the *qiemianli* differs from *rong* 絨 in the Song emissary Xu Jing's text of 1120–25 and the 1964 report on the find in Suzhou.

If the 'cut tufts' were knotted in a weft-faced weave, this means that they were not woven in a velvet weave structure where the raised pile is formed in the warp. *Qiemianli* is clearly a phonetically-based loan word like *nasîj* but, unlike *nasîj*, its material evidence remains elusive. Moreover, even if *qiemianli* was velvet, thus far it is unclear if it was imported into China or produced in China.

The Flemish Franciscan monk William Rubruck (1220–1293) reported to King Louis IX (r. 1226–1270) that Mongolian women used different materials to decorate their *boghtas* hats, such as velvet, buckram, gold embroidery, pearls, and feathers.[21] What Rubruck identified as 'velvet', though, might well have been some wool fabric with a velvety surface, rather than true woven velvet or even the *qiemianli* with 'cut tufts' recorded in the *Yuan shi*. The relationship between the velvet of the Mongol Yuan dynasty and the *Zhang*-velvet of the Ming dynasty remains an enigma.[22]

[17] Baidu-al-din later rebelled from Daqûqâ, c. 1294–5. See John Andrew Boyle, *The Cambridge History of Iran* (Cambridge, 1968), v, 375–76.

[18] Allsen, *Commodity and Exchange*, 96, citing and interpreting Song Lian et al., *Yuan shi, juan* 39, viii, 2263. For more details, see Watt and Wardwell, 'Luxury-Silk Weaving', 131, fn. 19–21.

[19] Song Lian et al., *Yuan shi*, vii, 1938.

[20] Watt and Wardwell, 'Luxury-Silk Weaving', 138. Zhao Feng deduces as much in *Zhongguo sichou yishu shi*, 75.

[21] As cited and cross-referenced in Allsen, *Commodity and Exchange*, 18.

[22] Angela Sheng, 'Circulating the Roundel: Knowledge Mobilization in Textile Design and Technology between China and the Mediterranean Shores, 500–1500', presented at the peer-reviewed panel on China and Cross-Cultural Exchange, 500–1500 chaired by Susan Shih-Shan Huang and Diane Wolfthall, Rice University, at the annual meeting of the College Art Association, Chicago, 15 February 2014; Angela Sheng, 'Materiality and Knowledge Transmission: Weaving Velvet in the Global Early Modern Cultures', presented to the Spring Colloquium, 'Material Splendor and Global Early Modern Art', Department of Art History, University of Southern California, Los Angeles, 24 April 2015.

THE BEGINNING OF SILK WEAVING IN FUJIAN

As Fujian's topography was not suitable for rice agriculture, the inhabitants planted tea and produced salt, honey, sweets made of sugar cane, and dried fruit such as white plums. Since the Song dynasty, Fujian had been part of a lively trade in other commodities, such as dyes made of indigo and madder, woven fans, baskets, mats, and even wooden boats.[23] Fujian was also home to textiles of all kinds, cloths made of ramie, creeper vine, and banana leaves, cotton, and even silk.

Sericulture had been well established in Fujian province since the Tang dynasty (618–907 CE).[24] People in the Zhangzhou area could harvest silk from silkworms five times a year, exceeding even the frequency of harvests in the most renowned silk production centres of the Lower Yangzi valley. The best quality silk came from Longxi county in Zhangzhou prefecture.[25] Zhangzhou was sparsely populated and its land was owned by a wealthy few. Mulberry bushes were widely cultivated, as their leaves were fed to the silkworms. Monasteries followed the example of landowners and practised sericulture on donated land.[26]

Over time, the gradual population growth in Fujian spurred craft manufacture; the limited arable land meant farming could not provide a livelihood for everyone, some had to find other means of making a living. There were an estimated 12,420 households (*hu* 戶) in Fujian province during the Sui dynasty (581–618 CE), averaging one household per ten square kilometres. By the tenth century in the early Song dynasty, the number had increased nearly fourfold, to an estimated 46,000.[27] Zhangzhou's population nearly quadrupled,

[23] For more on Fujian, see Hugh R. Clark, *Community, Trade, and Networks: Southern Fujian Province from the Third to the Thirteenth Century* (Cambridge and New York, 1991) and Xu Xiaowang et al. (eds.), *Fujian tongshi*, iii, 309.

[24] Although Fujian produced silk, it was better known for its specialised cloth production using bast fibres, such as those made from banana leaves (*jiaobu* 蕉布) or creeper vines (*gebu* 葛布) which met the aristocratic and elite need to look elegant even in the extreme summer heat. See the local tribute dated to the years 26–29 of the Kaiyuan era (738–41) in Li Jifu, *Yuanhe juxian tuzhi* [Maps and Gazetteers of the Provinces and Counties in the Yuanhe Reign Period, 806–20 CE] (Beijing, 1983), ii, 715–23.

[25] Luo Qingxiao (Ming), *Zhangzhou fuzhi* [Gazetteer of Zhangzhou], 1573, facsimile reprint contained in *Mingdai fangzhi xuan* [Selected Gazetteers of the Ming Dynasty] (Taipei, 1965), iii, 24 and 28 (*juan* 1, p. 8b and 16b).

[26] Liang Kejia, *Sanshan zhi* [Gazetteer of the Three Mountains], *juan* 33, 7973–4 as cited in Xu Xiaowang et al. (eds.), *Fujian tongshi*, ii, 206.

[27] Xu Xiaowang et al. (eds.), *Fujian tongshi*, ii, 11. Monasteries owned large territories throughout the middle period. For a discussion about monastic enterprises and the need for land as social capital in the thirteenth century, see Michael John Walsh's study of Mingzhou (today's Ningbo), also on the southeast coast, *Sacred Economies: Buddhist Monasticism and Territoriality in Medieval China* (New York, 2010).

reaching 21,695 households in the Yuan era, and by the time of the reign of Ming Longqing (1567–72), Zhangzhou was home to an estimated 48,863 households.[28] Those who were unable to make a living from their allotted land turned to crafts such as paper, porcelain, and textile production, mining and ship-building, or worked aboard ships, even sailing overseas.[29]

The increase in population also meant that the limited arable land was farmed for food, where possible, and not for growing mulberry trees, the leaves of which sustained the silk worms. As a result, Zhangzhou weavers imported more and more raw silk from the Lower Yangzi valley.[30] After the eighth century, Zhangzhou offered more complex weaves as tribute to the court: *qi* 綺 (warp-faced silk with a pattern in 3/1 twill), silk gauze (*luo* 羅), brocaded silks (*jin* 錦), and even a silk banner woven in the polychrome *jin* with an image of a bodhisattva (*jinwen zhicheng pusa fan* 錦紋織成菩薩).[31]

Silk gauzes with large floral designs became Fujian's weaving speciality, as attested by the important finds in 1975 from the tomb of Lady Huang Sheng 黃昇 (1225–42), who died near Fuzhou at the age of seventeen.[32] These luxury silks were woven mostly in the state workshops of the Tribute Bureau (*gongjü* 貢局) and the Hundred Crafts Academy (*baigong yuan* 百工院), where skilled weavers could experiment and innovate with no thought of the cost. The silk gauzes from Huang Sheng's trousseau for her marriage to an imperial clansman the year before her death were woven, however, not in Fuzhou, but in Quanzhou where her father, Huang Bu 黃補 (*jinshi* degree in 1229), was the appointed prefect in 1230. As Quanzhou was the seat of the Administrative Office of Maritime Tributary Trade (Shibosi 市舶司) during both Song and Yuan times, her father was also in charge of maritime trade until 1235 and could well afford expensively patterned silk gauze for his daughter's trousseau.[33]

Quanzhou first rose to prominence for its silk weaving in the tenth century, its reputation even reaching foreigners arriving from the Indian Ocean. By 1131 the first mosque was built in the southeastern part of the city.[34] Arab traders, who

[28] Luo, *Zhangzhou fuzhi*, iii, 88–9 (*juan* 5, 2a–3a).

[29] Clark, *Community, Trade, and Networks*.

[30] Luo, *Zhangzhou fuzhi*, iii, 233 (*juan* 13, 19b–20a).

[31] See the tribute dated to the year 25 of the Kaiyuan era (737), preserved in the *Compendium of Administrative Law of the Six Divisions of the Tang Bureaucracy* (*Tang Liudian* 唐六典), finished in 738, submitted to the Emperor Xuanzong (r. 712–55) by the Counsellor-in-chief, Li Linfu 李林甫 (683–753), as cited in Xu Xiaowang et al. (eds.), *Fujian tongshi*, ii, 211.

[32] Fuzhou sheng bowu guan (ed.), *Fuzhou Nan Song Huang Sheng mu* [The Southern Song Tomb of Huang Sheng in Fuzhou] (Beijing, 1982), 81–4; English summary on pp. 1–3, 145ff.

[33] Fuzhou sheng bowu guan (ed.), *Fuzhou Nan Song Huang Sheng mu*, 83–4.

[34] Based on epigraphy, see Bai Shouyi (ed.), *Zhongguo Huihui minzushi* (A History of Chinese Muslims) (Beijing: Zhonghua Shuju, 2003), 469–73.

occasionally took up permanent residence in the port, referred to Quanzhou as Zaitun or Zayton (*citong* 刺桐 Lat. *Erythrina indica Lam*), a phonetic transliteration of the name of a tree with flaming red flowers which grew indigenously along China's southeastern coast and surrounded the city walls of Quanzhou. Chinese praised 'Quanzhou silk' for being 'smooth like a mirror', referring to the distinct feature of 'satin' due to its long warp floats (satin being a phonetic adaptation of *citong* or Zaitun).[35]

From 1293, when the Franciscan missionary, Giovanni da Montecorvino (1246–1328), sent by Pope Nicholas IV (1227–92, papal r. 1288–92), landed in Quanzhou, the city also supported a Christian community. A bishopric was established there in 1313, active until the death of Bishop Andrea da Perugia Firenze in 1326.[36] Although Archbishop Montecorvino (promoted in 1307) and later bishops in Quanzhou favoured vestments made of costly silk like the pope's garments in Europe, the Chinese elite in the humid southern coast preferred lighter silk gauze and damask. Such silks also reached Europe. An example of red Chinese silk twill damask, dating to the late thirteenth century, was even discovered in a reliquary in Åbo, Finland.[37] A similar Chinese silk of c. 1300 was used for the imperial dalmatic also known as the 'eagle dalmatic', with embroidered roundels of eagles and ospreys depicting rulers, now in the Kunsthistorisches Museum in Vienna.[38] According to the inventory of the Holy See taken in 1295, for example, weavers in Lucca were already weaving Pope Boniface VIII's (1294–1303) coat of arms into patterned silks; these were lampas, though, not velvet.[39]

A special Patterning and Embroidery Bureau (*Wenxiu jü* 紋繡局) was set up in Fuzhou by the Yuan government. More than five thousand weavers and embroiderers, both male and female, were forced into service to make and embellish fancy silks. The Han Chinese, imbued with a Confucian morality, criticised the

[35] Wang Shengshi, *Manyou jilue* [A Brief Record of Travels], *juan* 2, 5 cited in Xu Xiaowang et al. (eds.), *Fujian tongshi*, iv, 256. See also Luc-Normand Tellier, *Urban World History: An Economic and Geographical Perspective* (Quebec, 2009), 221.

[36] Yan Kejia, *Zhongguo tianzhujiao jianshi* (A Brief History of the Roman Catholic Church in China) (Beijing: Zongjiao wenhua chubanshe, 2001), 18–21.

[37] Agnes Geijer, *A History of Textile Art* (London, 1979), 115: VII, fig. 5 and 147.

[38] Weltliche Schatzkammer, inv. no. XIII 15. Lisa Monnas, *Merchants, Princes and Painters: Silk Fabrics in Italian and Northern Paintings, 1300–1550* (New Haven and London, 2008), 13, fig. 12. See also Franz Kirchweger, 'The Coronation Robes of the Holy Roman Empire in the Middle Ages: Some Remarks on Their Form, Function and Use', in Evelin Wetter (ed.), *Iconography of Liturgical Textiles in the Middle Ages* (Riggisberg, 2010), 113. In addition to this article, this volume contains detailed discussions of many other important vestments, many of which were woven in velvet, some dating from the early fifteenth century.

[39] See Monnas' chapter in this volume, See also Monnas, *Merchants, Princes and Painters*, 5.

mixing of gender in labour and the Bureau was soon abandoned. Instead, a top official purchased special weaves such as silk twills (*ling* 綾, *jin* 錦, *qi* 綺) and thin crepe silks (*chou* 綢) from local producers known as 'loom households'. Velvet, however, was never mentioned.[40]

In the subsequent centuries, political incidents connected to the rise and fall of the Yuan impacted on Quanzhou's economy and craft trade. While its maritime trade contributed to wealth in the port, its hinterlands grew impoverished. The decline of Quanzhou's leading role in Fujian's silk trade was heralded by Pu Shougeng's 蒲壽庚 (1245–84) massacre of three thousand imperial clansmen in 1279, which not only destroyed craft manufacturing networks but also greatly reduced the local elite's capacity to consume extravagant silks. By the fourteenth century, the region's continuous political and social insecurities had also impacted negatively on the environment. Quanzhou's port had not been adequately maintained so it silted up until, eventually, seafaring vessels could no longer enter. Traders soon diverted to neighbouring ports such as Fuzhou to the northeast and Zhangzhou to the southwest. In 1502 the Ming government finally moved the Administrative Office of Maritime Tributary Trade permanently to Fuzhou, thus ending Quanzhou's official role in foreign trade. To evade the officials now based in Fuzhou, smugglers landed at Moon Harbour in Zhangzhou.[41] With its own Jiulongjiang (Nine Dragon River) drainage system, Zhangzhou had always functioned as a port but had previously been bypassed by Arab traders who were already familiar with Quanzhou.[42] This was no longer the case. Thus, relocating the government office to Fuzhou indirectly contributed to textile innovation in Zhangzhou and, indeed, external influences on the social and economic conditions encouraged weavers in Zhangzhou towards innovation.

THE RISE OF SILK WEAVING IN ZHANGZHOU DURING THE MING DYNASTY

The Ming dynasty continued to run state-owned silk manufacturing, initially with success. The founding Emperor Hongwu (r. 1368–98) actively promoted sericulture even before ascending to the throne. In 1356, while paying respects

[40] Gong Shitai, *Wanzhai ji* [Records of the Collecting Studio], *juan* 6, 47, as cited in Xu Xiaowang et al. (eds.), *Fujian tongshi*, iii, 304–5.

[41] Li Donghua, *Quanzhou yu woguo zhonggu de haishang jiaotong* [Quanzhou and the Maritime Traffic during China's Middle Period] (Taipei, 1986), 233–4.

[42] Clark, *Community, Trade, and Networks*, 7. See also Li Renchuan, 'Fukien's Private Sea Trade in the 16th and 17th Centuries', in Eduard B. Vermeer (ed.), *Development and Decline of Fukien Province in the 17th and 18th Centuries* (Leiden, 1990), 163–73.

at the Confucian temple in Zhenjiang (about eighty kilometres northeast of Nanjing), he ordered all the attending scholars to supervise agriculture and sericulture.[43] After his ascension in 1368, Hongwu ordered any farmer in his empire with 5 to 10 *mu* of land to plant at least one half a *mu* each of mulberry, hemp, and cotton.[44] The penalty for contravention was one bolt of plain silk, hemp, or cotton, respectively. More regulations on widespread planting followed. By 1394 every household was to plant 200 mulberry (and jujube) trees; this number doubled in 1395 and increased to 600 in 1396. By then, anyone in violation was conscripted into the army and sent to Yunnan.[45] By 1512 the ever more extensive planting had extended even to fallow wastelands.[46] Such policies really only increased the supply of raw silk in the Lake Tai area of the Lower Yangzi valley, due to the particularly favourable conditions for sericulture there. For example, after increased numbers of mulberry bushes were planted, Huzhou prefecture's yield in silk as measured by tax payment increased from 661,072 *liang* in 1391 to 826,262 *liang* by 1522.[47]

The state-run silk manufactures in Nanjing and, after 1403, in Beijing were supervised by the Board of Works (*gong bu* 工部) and Finances (*hubu* 戶部) for tributary and court use. Workshops catering to the imperial household were designated Imperial Bureaus (*neiju* 內局 lit. internal). The Ministry of Rites (*libu* 禮部) took charge of the production of silk for ritual purposes in the Hall for Ritual Silks (*shenbo tang* 神帛堂). Twenty-three prefectures, most of them in the Lower Yangzi valley, with some in Fuzhou and Quanzhou, supervised their local prefectural Weaving and Dyeing Bureaus (*zhizao jü* 織染局)[48] and contributed to the tribute. Quality control was strict. For example, when the Board of Works

[43] *Ming Tongjian* [The Comprehensive Mirror of the Ming], ed. by Xia Xie (1799–1875), *qianbian, juan* 1, *qianji* 1, *Yuan Zhizheng* 16 *nian* (Beijing, Zhonghua shuju, 1980 printing), vol. 1, 23.

[44] One *mu* of land is about 580 square metres. Regarding measurements conversion, see Ogawa Tamaki et al., *Shi ji en* [A New Source of Characters] (Tokyo, 1987), 1224.

[45] This policy encouraged textile production in general, as it also promoted the planting of hemp and cotton. *Da Ming Huidian* [Collected Statutes of the Ming] [compiled by Xu Pu and Liu Jian in 1502, revised by Li Dongyang in 1509] *juan* 17 *nongsang* (Taibei, Zhongwen shuju, 1963 reprint of 1587 edition), vol. 1, 321–23.

[46] The official regulations prescribed that about forty trees should be planted per *mu* of land in Zhangzhou. Luo, *Zhangzhou fuzhi*, iii, 97 (*juan* 5, 19a–b). For details on the potential yield of silk per *mu* of land according to density of plantation, see Angela Sheng, 'Textile Use, Technology, and Change in Rural Textile Production in Song China 960–1279' (unpublished Ph.D. thesis, University of Pennsylvania, 1990), 213, Table 3.

[47] One *liang* in the Ming period equalled about 37.3 grams. Fan Jinmin and Jin Wen, *Jiangnan sichoushi yanjiu* [Research on the History of Silk in Jiangnan] (Beijing, 1993), 80–1. Regarding conversion of measurements, see Ogawa et al., *Shi ji en*, 1224.

[48] *Ming Huidian, juan* 201 *zhizao*, cited in Li Renfu, *Zhongguo gudai fangzhishi gao* [Draft History of Ancient Chinese Textiles] (Changsha, 1983), 167.

(*gong bu* 工部) found the quality of tribute silk satins from Fujian deficient in 1462, Emperor Yingzong (r. 1436–49 and 1457–64) demoted two provincial officials (more senior than local officials) named Liu 劉 and Zhang 张.[49] This incident suggests it was common practice to include sub-standard products in order to meet the quota.

Labour was recruited through a complicated levy system that went through several revisions over the years. Some of the officially recruited craftsmen (*guanjiang* 官匠) were on 'set-term service' (*lunban jian* 輪班匠), meaning that they had to labour in shifts in a government unit. This could be at the capital, in their home town, or at the provincial Weaving and Dyeing Bureau where they would work at their own expense; supposedly 23,208 such households were sent to the capital in 1393. Some civilians, reporting to the Imperial Bureau (*neiju* 內局 lit. internal), were assigned to 'sit and work' (*zhuzuo jiang* 住坐匠), meaning they stayed in the capital to work there. Around 27,000 such 'sit and work' households were moved from Nanjing to Beijing during the reign of Yongle (1403–24). By the reign of Jiajing (1522–66), these numbered around 12,255, with eighty-seven officials supervising 1,340 craftsmen in the 'internal' Imperial Bureau, though it was primarily a storage facility and did not actively produce silks.[50] Military personnel had to report to the Capital Defence Unit (*dusi weisuo* 都司衛所) where they presumably worked in a silk workshop. Other craftsmen were retained in local prefectures as 'resident artisans' (*cunliu jiang* 存留匠), that is, they worked ten days per month and then went home; and there were around one thousand of these in important prefectural manufactures in Suzhou, Songjiang, Jiaxing, and Huzhou.[51] Dagmar Schäfer shows how the complexity of this recruitment system led to the artisanal labour force becoming much more mobile.[52] In turn, this mobility resulted in increased transmission of technical knowledge, thereby facilitating innovation.

[49] *Ming Yingzong shilu* [True Records of Ming Emperor Yingzong, r. 1457–64], *juan* 342, 3, as cited in Xu Xiaowang et al. (eds.), *Fujian tongshi*, iii, 231. Dagmar Schäfer, *Des Kaisers Seidene Kleider: Staatliche Seidenmanufakturen in der Ming-Zeit (1368–1644)* (Heidelberg, 1997).

[50] Note that the 'internal' imperial workshops produced silks for the use of the court as opposed to those producing tribute silks and similar in 'external' workshops outside the capitals. Personal communication with Dagmar Schäfer.

[51] I am following Qing historian Jonathan Spence in his use of the word 'manufacture', in describing state-owned workshops in the Lower Yangzi valley. See Jonathan Spence, *Ts'ao Yin and the K'ang-hsi Emperor: Bondservant and Master* (Yale, 1966).

[52] Regarding the numbers see Li Renfu, *Zhongguo gudai fangzhishi gao*, 166–68. However, these numbers might have been inflated, see Dagmar Schäfer, *The Crafting of 10,000 Things: Knowledge and Technology in Seventeenth-Century China* (Chicago and London, 2011), 98–105, especially Fig. 3.3 which charts the changes in recruitment over time. See also Tong Shuye, *Zhongguo shougongye*

By the mid Ming period, silk production in the Lower Yangzi valley was flour-ishing to such an extent that, except for a few rarities, the court in Beijing lost interest in Fujian silks. The efficiency of sericulture in the Lower Yangzi also attracted prefectural officials in charge of silk production elsewhere, including Fujian, to purchase their quota goods there, sometimes even taking silver to the capital to buy the silks needed to fulfil quota then and there. As a result, the local Weaving and Dyeing Bureaus outside Zhili and Jiangnan no longer served any real purpose and, soon after 1531, the Weaving and Dyeing Bureau of Fuzhou disappeared altogether.[53] Similarly, only one Bureau of Miscellaneous Manufacture (*zazao jü* 雜造局) remained in Zhangzhou, which produced 'bows and arrows and bolts [of cloth]'.[54] By the end of the Ming, whereas the state-owned silk manufactures in Suzhou and Hangzhou continued to supply the court with elaborate silks, silk production at various locales including those in Fujian province had become a more private affair.

The rise in private enterprise resulted in part from the state's commutation of tax payment in labour to compensation in silver, which was initially intended to resolve labour disputes. However, craftsmen who were unwilling to bear the burden of conscripted labour resorted to desertion – around 5,000 people absconded in 1426 and this increased to 34,800 by 1450. Thus, in 1485, the state permitted artisans of 'set-term service' to commute their service by paying their dues with silver. Southern artisans could free themselves from corvée labour in the northern capital for 6 *qian* 錢 of silver (6/10 of a *tael*) per month and northern artisans could do the same, though they did not have to pay as much for their travel to the capital as their southern confreres in the first place.[55] The system of 'set-term service' was finally abolished in 1529, even though it had inadvertently allowed artisans from the private sector to transmit knowledge to those weaving in the state-owned manufactures. By calculating levied labour as a quantifiable wage, the state effectively opened the market for artisanal labour, both in the north and the south. Moreover, working in the Imperial Bureau of Beijing and Nanjing and, later, in the Weaving and Dyeing Bureau of Suzhou

shangye fazhan shi [History of the Development of Chinese Handicrafts and Industries] (Jinan, 1981), 216–17.

[53] Xu Xiaowang et al. (eds.), *Fujian tongshi*, iii, 232.

[54] Luo, *Zhangzhou fuzhi*, iii, 39–40 (*juan* 3, 3b–5b).

[55] *Ming huidian, juan* 189, cited in Tong Shuye, *Zhongguo shougongye shangye fazhan shi* [History of the Development of Chinese Handicrafts and Industries] (Jinan, 1981), 217. The phenomenon of wage labour as a commodity has generated much heated debate among economic historians regarding the emergence of capitalism in China. Tong Shuye argues that, since the ostensible wage labour at this time was still restricted by guild-like associations and the craftsmen were not fully free to work as they wished, labour was not yet a true commodity (218–19).

and Hangzhou – both designated to supply the court – had allowed artisans to acquire specialised skills in weaving highly-crafted silks, such as satins with brocaded patterns (*zhuanghua jin* 妝花錦).[56] Those artisans could now transmit this knowledge into the private sector, stimulating the innovation of new products. This late Ming phenomenon brought the situation full circle back to an earlier time when set-term-service artisans working partially in the private sector, especially in Suzhou and Hangzhou, had brought innovation to state-owned manufacturers.

The change in artisanal availability was timely. As the Ming dynasty grew stable and prosperous, a burgeoning middle-class emerged with a desire to consume ever more luxurious goods for their daily life: clothing, furniture, furnishings, porcelain, lacquer, and so forth. Visual and material cultures thrived, including textiles.[57] In Suzhou and Hangzhou, but also in prefectures with an earlier weaving tradition beyond the Lower Yangzi valley, such as Fuzhou and Quanzhou, new weaves met this new market demand, which was partially driven by the illicit maritime trade along the coast. Fuzhou was known for '*jin* woven on improved looms' (*gaiji jin* 改機錦) which was, in fact, a compound silk weave using four layers of warp instead of five.[58] Quanzhou produced 'patterned silks' (*huazhi* 花織), 'cloud-patterned silks' (*yunzhi* 雲織) as well as 'silks woven with gold threads' (*jinxianzhi* 金線織, that continued the *nasîj* trend fashionable in earlier Yuan times), plain and patterned thin *sha* 紗, '*sha* woven with gold threads' (*sha jin* 紗金), 'silk gauzes' (*luo* 羅) and, especially, the 'mirror-surface-like' silk satin. Weavers in Zhangzhou also improved traditional silk weaves such as silk tabby patterned in twill (*qi* 綺), silk gauzes and *guang su duan juan* (光素緞絹). In addition, they were credited with weaving the most unusual and unique 'swan-down' or silk velvet, the technology of which purportedly came from abroad – as noted in 1613 by the editor of the local gazetteer of Zhangzhou, Yuan Yesi 袁業泗 – but which, as archaeological finds attest, had previously already existed in the Chinese world.[59]

[56] Yuan Xuanping and Zhao Feng, *Zhongguo sichou wenhua shi* [The History of Chinese Silk Culture] (Jinan, 2009), 194, 199–201.

[57] Regarding this emphasis on consumption, see Craig Clunas, *Superfluous Things: Material Culture and Social Status in Early Modern China* (Urbana, IL, 1991). He discusses different visual forms in Craig Clunas, *Empire of Great Brightness: Visual and Material Cultures of Ming China, 1368–1644* (Honolulu, 2007).

[58] *Fuzhou fuzhi* [Gazetteer of Fuzhou], Wanli (1573–1620) edition, *juan* 37, *shihuo* 12, *wuchan*, contained in Xie Guozhen (ed.), *Mingdai shehui jingji shiliao xuanbian* [Selected Extant Texts on the Social and Economic History of the Ming Dynasty] (Fuzhou, 1980), i, 134.

[59] Xu Xiaowang et al. (eds.), *Fujian tongshi*, iv, 256–57.

THE OPPORTUNITY

The red Chinese velvet used to make a mantle which was given in 1574 to *daimyo* Uesugi Kenshi 上杉謙信 (1530–78) of the Echigo province in north-central Japan provides evidence that Portuguese traders acted as middlemen between Chinese weavers and their Japanese clientele (Illustration 2.3). This red velvet mantle has a blue collar and is trimmed with golden braids along the front opening and hem.[60] The red velvet features a stylised golden peony, reminiscent of similar designs in contemporaneous Ming silks.[61] The mantle apparently first belonged to another powerful *daimyo*, Oda Nobunaga 織田信長 (1534–82), who was seen placing this garment in a storage box, as noted in the *History of Japan* by Luís Fróis (1532–97), a Portuguese missionary.[62]

The Portuguese first secured Malacca on the Malaysian coast by force in 1511 as a base for expansion of trade into Asia. In 1517, the captain and pharmacist Jorge Mascarenhas Fernão de Andarade (d. 1552?) landed in Guangzhou but was immediately dispatched to Ryukyu for further explorations. However, inclement weather and the silted-up port of Quanzhou forced him to dock at Zhangzhou. The Portuguese then flocked to Moon Harbour there, after being banished from Guangzhou in 1523 and even more so after their expulsion from Mingzhou (today's Ningbo) in 1548.[63]

The Portuguese traders' serendipitous arrival in Zhangzhou enabled the locals to export their wares directly for profit, thanks to the loosely enforced state policy of Maritime Prohibition (revoked in 1568). However, in 1549 locals clashed with the Portuguese, who were withholding all the goods of two local merchants who had yet to settle their debts. In support of the Chinese merchants' complaints, local official Zhu Wan 朱紈 (1494–1549) cut off supplies to the Portuguese who, in turn, raided nearby villages for food. The local Chinese burned all thirteen docked Portuguese carracks in revenge, killing almost 500 Portuguese. Zhu Wan was impeached for this incident and, unable to make good his 'error', he committed suicide. The reports of this incident provide insights into the range of merchandise being traded. As trade goods the Portuguese brought pepper, corn,

[60] Weighing 1.7 kilogrammes and measuring 114.5 cm in length, the mantle is now kept at the Uesugi Shinto shrine in Yonezawa city in the Yamagata Prefecture. Ogasawara Sae (ed.), *Nihon no senshoku* [Japanese Weaving and Dyeing], vol. iv: *Yokan hakusai no senshoku* [Weaving and Dyeing Imported from Abroad] (Tokyo, 1983), 64–5, Figs. 39 and 40.

[61] Kuhn (ed.), *Chinese Silks*, velvet is discussed on 399–402, shot satin on 378, Fig. 8.6.

[62] http://www.nobunaga-lab.com/labo/07_ibutu/07-02_ihin/23_hata/hata.html (accessed 26 July 2013). Many thanks to Takako Okada for referring me to this source and for helping with Japanese phonetics.

[63] Lin Zisheng, *Shiliu zhi shiba shiji Aomen yu Zhongguo zhi guanxi* [The Relationship between Macau and China from the Sixteenth to the Eighteenth Century] (Macau, 1998), 14–17.

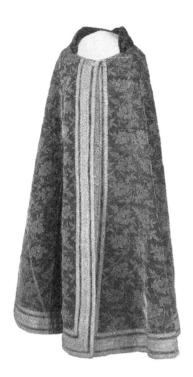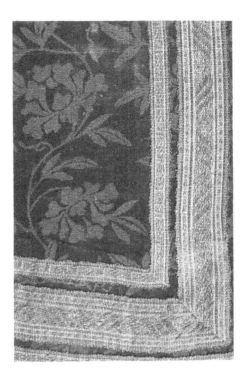

Illustration 2.3 Mantle made of Chinese velvet at the Uesugi Shinto
shrine, Yonezawa, Yamagata Prefecture, Japan, dated 1574 (L: 114.5 cm).
Source: Ogasawara Sae (ed.), *Nihon no senshoku* (Japanese Weaving and Dyeing),
Vol. 4 *Yokan hakusai no senshoku* (Weaving and Dyeing Imported From
Abroad) (Tokyo, Chuo koron sha, 1983), 64–65, Illustration 39 and 40,
http://www.nobunaga-lab.com/labo/07_ibutu/07-02_ihin/23_hata/hata.html.

and ivory, and different kinds of spices and incense such as cloves, cinnamon, and
sandalwood; the Chinese sold plain and patterned silks, porcelain, and musk.[64]
Velvet was not yet included.

A recently discovered text written by a Korean envoy to the Ming court reveals
that the Portuguese mercantile leader Tomaso Pirès (1465?–1524 or 1540?) wore

[64] *Lin Ciya xiansheng wenji* [Collected Writings of Mr. Ciya Lin], *juan* 5 and Fernão Mendes,
Peregrinação, cited in Lin, *Shiliu zhi shiba shiji Aomen yu Zhongguo zhi guanxi*, 14 and 17. This was
a famous incident, reported verbatim in a Chinese translation from Portuguese in Fernão Mendes'
Peregrinação in Jin Guoping, *Xili dongjian: Zhong Pu zaoqi jiechu zhuixi* [Western Forces Press
Close: A Recall of the Early Relations between the Chinese and the Portuguese] (Macau, 2000),
68–70.

velvet on his first mission to China in 1521.[65] While the Chinese hosts mistook Pirès' Chinese interpreter Yasan 亞三 for the head of the Portuguese mission,[66] the Korean envoy recognised Pirès as the true Portuguese ambassador because his attire was made of 'swan-down' fabric – that is, velvet.

At some point, some Chinese weavers must have seen velvet and worked out how to raise the pile in the warp. After some experimentation, weavers would have first produced the simplest uncut, plain velvet, such as the black velvet used to make a male official's formal hat of 'loyalty and tranquillity' (*zhongjing guan* 忠靖(靜)冠 height 22 cm, diameter 17 cm) that was unearthed in 1966 in Suzhou from the tomb of Wang Xijue 王錫爵 (1534–1614) and his wife.[67] Made during the owner's lifetime, this hat was further embellished with five ridges and *ruyi* cloud outlined in gold. Evidence supporting the theory that velvet technology was transmitted from China to Japan appears one century later, when the Portuguese inadvertently took some Chinese uncut velvet with the wires still in place to Nagasaki in 1639.[68]

Even in the late sixteenth century, patterned velvet was a rarity on the global market, to judge by a carefully constructed list of items that Alessandro Valignano (1539–1606), the Plenipotentiary Visitor in Macau, gave to his subordinate, the Jesuit Michele Ruggieri (1543–1607), to bring back as gifts from Italy. Among scientific and luxury objects such as clocks and globes, Valignano also requested 'twenty-five pieces of brocade of the highest quality' from Rome. Prominent among these were five pieces of the finest velvet, in crimson, rose, white, green, and yellow.[69] Appointed in 1573 by the Superior General of the Society of Jesus, Valignano was in charge of the Society's expansion of overseas missions, and sought Pope Gregory XIII's (r. 1572–85) approval for Jesuit engagement in

[65] Nigel Cameron, *Barbarians and Mandarins: Thirteen Centuries of Western Travelers in China* (Chicago and London, 1970), 131–48.

[66] Jin Guoping and Wu Zhilang, *Zaoqi Aomen shi lun* [The History of Early Macau] (Guanzhou, 2007). Regarding the Korean document, see 293–7, regarding the Chinese translator mistaken for the ambassador by the Chinese, see 280.

[67] Suzhou shi bowuguan, 'Suzhou Huqiu Wang Xijue mu qingli jilue' [A brief record of sorting the [finds] from Wang Xijue's tomb at Huqiu in Suzhou], *Wenwu*, 3 (1975), 51–6. See also Steve Shipp, *Macau, China: A Political History of the Portuguese Colony's Transition to Chinese Rule* (Jefferson, NC, 1997), 12–32.

[68] Yosûburo Takekoshi mentions this without giving any precise reference, so it can be disputed, see Yosûburo Takekoshi, *The Economic Aspects of the History of the Civilization of Japan* (New York, 1930), i, 315, as cited in Harold Burnham, 'Chinese Velvets, a Technical Study', *Art and Archaeology Division of the Royal Ontario Museum – Occasional Paper 2* (Toronto, 1959), 12 (fn. 20).

[69] On the Jesuits' involvement in the silk trade, see Jonathan D. Spence, *The Memory Palace of Matteo Ricci* (New York, 1984), 174–8. Regarding the list, see Mary Laven, *Missions to China: Matteo Ricci and the Jesuit Encounter with the East* (London, 2011), 71. For examples of fancy Italian silk, see Lisa Monnas, *Renaissance Velvets* (London, 2012).

the Portuguese traders' highly-profitable silk trade, arguing that the overseas members of the Society lacked revenue-generating land in Macau. In 1588, Valignano understood that ornate Italian velvet would appeal to the Chinese emperor.

DOMESTIC VERSUS EXPORT MARKET

Although there is scant material evidence that velvet was available on the Chinese domestic market in the Ming period, what evidence there is points to elite consumption. Wang Xijue's plain black velvet official hat from 1620 is one example. Others were found among garments belonging to the concubine who became Empress Xiaojing 孝靖 (1565–1611) unearthed from Ding Ling, The Tomb of Certainty, of the Ming Emperor Shenzong (Wanli r. 1573–1620). These included three examples of velvet in yellow, red and blue. All were embroidered with motifs related to imperial rule, such as the *sihe ruyi* 四合如意 (Four Harmonies sceptre motif).[70] While the blue velvet was single-sided, the red, yellow and black were all double-sided velvet; all could be dated to 1620 or earlier, and all were woven with a foundation of some sort of twill.[71]

The Royal Ontario Museum in Toronto houses a rare piece of Ming dynasty velvet in yellow with patterns of auspicious clouds and eight Buddhist-inspired treasures, made from four widths sewn together, the total size being 2.72 metres wide and 3.09 metres long (Illustration 2.4). Additional embroidery in polychrome silk thread and gold filé forms two coiled, front-facing, five-clawed dragons surrounded by colourful clouds in a central medallion as a cloud-collar (*yunjian* 雲肩). Mountains emerging from waves further confirm that this piece was designed to be a Ming dynasty dragon robe or for imperial use.[72] The styles of the dragons and clouds date the fabric to the early seventeenth century.

Technical analysis by the late Harold Burnham's shows that the ground weave of Ming dynasty velvet was derived from a 3/1 twill foundation and repeats

[70] Kuhn (ed.), *Chinese Silks*, 401. See also Beijing shi Changping qu Shisanling tequ banshichu, *Dingling chutu wenwu tujian* [Catalogue of Cultural Relics Unearthed from Ding Ling] (Beijing, 2006).

[71] Masako Yoshida, 'A Structural Analysis of Ming and Qing Dynasty Velvet', *Tama Art College Bulletin*, 14 (1999), 49–59 (with a summary in English). Yoshida also found four examples of velvet which had an irregularity in their weave structure that might reflect a developmental process within China.

[72] On dragon robes, see the seminal work by Schuyler R. V. Cammann, *China's Dragon Robes* (Chicago, [1952] 2001). For this particular piece, see K. B. Brett, 'A Ming Dragon Robe', *Bulletin of the Division of Art and Archaeology of the Royal Ontario Museum*, 27 (1958), 9–14.

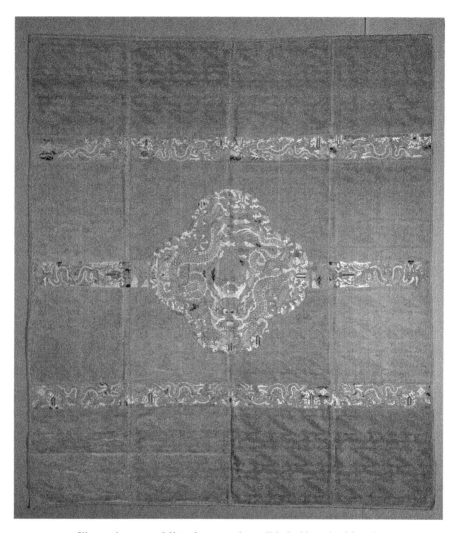

Illustration 2.4 Ming dragon robe, solid ciselé, embroidered,
early seventeenth century. From Harold Burnham, *Chinese Velvet*,
Acc. No. 956.67.2 (Toronto, Royal Ontario Museum, 1959), Pl. IV.
Reproduced by permission of the Royal Ontario Museum © ROM.

on six ends and six picks, just like that in Spanish velvet.[73] It is likely that the Portuguese traders had taken Spanish velvet to a weaving centre on China's coast, perhaps Zhangzhou, from the late sixteenth century onwards so that the Chinese weavers could copy it.

These examples of imperial use of velvet within China date from around 1620 (viz. Empress Xiaojing's robes), that is, after some Chinese velvet had been shipped to Japan, such as the mantle made of Chinese velvet given to *daimyo* Uesugi Kenshin in 1574 (see Illustration 2.3 above). Chinese velvet was also cut and sewn into jackets or vests for high-ranking samurai (*jinbaori* 陣羽織). One such jacket, made of brown Chinese velvet patterned with peonies and further embellished with embroidery, was in the possession of Toyotomi Hideyoshi 豊臣秀吉 (1536–98), the *daimyo* who succeeded Oda Nobunaga 織田信長 (1534–82). It is kept at the Hideyoshi and Kiyomasa Memorial Museum in Nagoya city.[74]

The textile historian Yoshida Masako's detailed analysis of this jacket reveals that the velvet was woven in China sometime between the late sixteenth and early seventeenth centuries, possibly on a private loom used for the general domestic market, and that it was *probably* produced in Zhangzhou or Quanzhou in Fujian, Guangzhou or Shaozhou in Guangdong, or Suzhou and Nanjing in the Lower Yangzi valley – then the three key centres of textile innovation. Although the embroidered motifs, techniques, and materials suggest China as the production site, Yoshida identifies certain design elements as deriving from the Iberian peninsula, Italy, and Iberian colonies from the latter half of the sixteenth century to the early seventeenth century, as well as some from Ming China. She further adds that a Bengalese influence on the embroidery design is especially striking on the front panels of the jacket.[75]

Other examples of Ming dynasty velvet include a *jinbaori* vest kept at the Tokugawa Art Museum, Nagoya, whose design resembles a larger panel of red velvet kept at the Victoria and Albert Museum, London.[76] Both are dated to the first quarter of the seventeenth century and both feature similar designs of a bird encircled by stylised flora with tendrils, all embroidered in gold filé. A similar samurai's vest, tailored in the late seventeenth century, is made of earlier Chinese

[73] Harold Burnham, *Chinese Velvet* (Toronto, 1959), 18 and 30–34, Pls. IV and V.

[74] Morihiro Ogawa (ed.), *Art of the Samurai: Japanese Arms and Armor, 1156–1968* (New York, 2009), 175.

[75] Masako Yoshida, 'The Embroidered Velvet Jinbaori Jacket Purportedly Owned by Toyotomi Hideyoshi: Its Place of Production, Date, and Background', *Bijutsuhi* (Journal of the Japan Art History Society), 59/1 [no. 167] (2009), 1–16 (in Japanese with English summary).

[76] Victoria and Albert Museum, London, Acc. No. T.36-1911.

velvet with designs copied from those usually woven into Spanish velvet. This example is stored at the Metropolitan Museum of Art in New York.[77]

At least ten contemporaneous examples of Chinese velvet survive in Japan.[78] Their novel 'Southern Barbarian' (*namban* 南蠻) style appealed to the ruling Japanese military elite from the late sixteenth century onwards. When the Portuguese traders recognised the lucrative potential of the fabric, they commissioned the weaving of velvet and even embroidery in China and then shipped the goods to Nagasaki. There, Japanese tailors specialising in western garments reformatted the embroidered velvet fabric into suitable clothing, for example, the *jinbaori* in Hideyoshi's possession.[79] The Portuguese traders arrived at Nagasaki with abundant Chinese goods, benefitting from the Ming state's ban on maritime trade until 1568. However, this ended when the Japanese Tokugawa Shogunate instituted the isolationist policy (*sakoku* 鎖国) from 1663 until 1853. Under this policy, contact with foreigners was forbidden, and so the import of Chinese velvet ceased until the late nineteenth century.

If the Japanese knew that Portuguese traders brought them Chinese velvet, however, the source of the velvet remained obscure in China. Song Yingxing 宋應星 (1587–1666), a minor civil official in the seventeenth century best known for his *Tiangong kaiwu* 天工開物 (*The Works of Heaven and the Inception of Things*, 1637), considered velvet weave ('Japanese satin' or '*woduan*' 倭緞) sufficiently important to give it a specific entry in his chapter on clothing:

> The manufacture of all Japanese satins originated by the eastern tribes (that is Japanese), [people] of Zhangzhou and Quanzhou on the seashores imitated and effectuated this method. The [raw] silk comes from Sichuan; merchants [travel] for ten thousand *li* (miles) to sell it [here] in exchange for pepper [and spices] to return home with. The weaving methods have also been transmitted from tribal countries. The raw silk comes previously dyed. Sometimes [weavers] use silk floss hidden in the warp surface [to weave it]. [After] very few *cun* (inches), the woven part would be scraped to reflect black gleam. [People] of the north who plunder and exchange at [frontier] markets, when they see this kind of silk, they like it. However, this kind of silk can most easily disintegrate and get dirty. If used for [men's] headdresses, it gathers dust in

[77] Metropolitan Museum of Art, New York, Acc. No. 1998.190. Regarding the two vests, see Craig Clunas, *Empire of Great Brightness: Visual and Material Cultures of Ming China, 1368–1644* (Honolulu, 2007), 15, Fig. 2 (the piece with a Spanish influence) and 227, Fig. 194. On the larger panel kept at the Victoria and Albert Museum, see Burnham, *Chinese Velvet*, 22, Pl. II.

[78] For a complete inventory of the ten examples, see Masako Yoshida, '16–17 seiki o chūshin to suru Chūgoku kōeki to hakurai some ōhin no juyō' [Chinese Trade in the Sixteenth and Seventeenth Centuries and the Acceptance of Imported Textiles in Japan], Kyōto shiritsu Geijutsu Daigaku Bijutsugakubu kenkyū kiyō (*Bulletin of Kyoto City University of Arts*), 51 (2007), 27–38.

[79] Yoshida, 'The Embroidered Velvet Jinbaori Jacket'.

no time at all. If used as collar [of a long gown], it could be damaged the very next day. Now, both the Han and tribal peoples despise it. In time it will be discarded. There is no need to transmit its technology.[80]

Song Yingxing's description of *woduan* makes it clear that the people in Zhangzhou and Quanzhou were weaving a kind of velvet. This entry was fourth in a list of nine types of clothing, which he wrote in this order: clothes made of silk gauze, degummed silk tabby, dragon robes, *woduan*, cotton, hemp, ramie for summer, fur and wool, including some with knotted tufts. His comments about the *woduan* or velvet from Zhangzhou and Quanzhou seem puzzling when read in the context of his preface and his comments on silk gauze and dragon robes. In the former, he clearly states that the Heavens determined the rules of clothing for the elite and for commoners (thus absolving himself of any moral responsibility). In the latter, he specifies that lowly officials wore plain silks, but high-ranking officials wore summer robes made of silk gauzes and thin silks (*huaisu* 懷素), and that the emperor wore dragon robes requiring intensive labour and expensive material, out of respect for his standing.[81]

On the one hand, Song Yingxing's reference to velvet used for headdresses was borne out by the find of Wang Xijue's hat in Suzhou (dated 1614). On the other hand, his remark about the Han and tribal people despising velvet would suggest that it did not have a high status. However, the unearthed velvet robes of Empress Xiaoduan (dated 1620) testify to the contrary. Moreover, the Grand Secretary Yan Song 嚴嵩 (1481–1567) also collected velvet. When the Ming state confiscated his family property in 1565 for crimes of corruption, the itemised list in *Tianshui bingshan lu* 天水冰山錄 (Record of Heavenly Dew and Ice-Capped Mountain),[82] included 585 bolts of velvet and 113 velvet garments, among which 65 per cent were decorated in colour.[83]

[80] '凡倭緞製起東夷，漳泉海濱效法為之. 絲質來自川蜀，商人萬里販來，以易胡椒歸里. 其織法亦自夷國傳來. 蓋質已先染，而斷綿夾藏經面，織過數寸，刮成黑光. 北虜互市者見而悅之. 但其帛最易朽污，冠弁之上，頃刻集灰；衣領之間，移日損壞. 今華夷皆賤之，將來為棄物，織法可不傳云.', Song Yingxing's entry on Japanese satin (*woduan* 倭緞) in Song Yingxing, *Tiangong kaiwu* [The Works of Heaven and the Inception of Things, 1637], annotated by Zhong Guangyan, *Tiangong kaiwu* [The Works of Heaven and the Inception of Things] (Beijing, 1978), 94. For a contextual analysis of this primary source, see Schäfer, *The Crafting of the 10,000 Things*.

[81] '分名 凡羅 熟練 龍袍 倭緞 布衣 枲著 夏服 裘 褐 氈', Song Yingxing, *Tiangong kaiwu*, 90–109. On the order of clothing, see p. 54: '蓋人物相麗，貴賤有章，天實為之也'.

[82] Wu Yunjia (of Qing) (ed.), *Tianshui bingshanlu* [Record of Heavenly Dew and Ice-Capped Mountain], in *Congshu jicheng* (Shanghai, 1937). See Appendix 2 in Gau Fu-lin, 'Mingdai Baiguan Fushi Zhidu Jiqi Jianyue Yu Lanshang Yanjiu' [Official Dress Code and Violations in the Ming Dynasty (A.D.1368-1644)] (unpublished MA thesis: Fujen Catholic University, Taipei, 1995), 172–94.

[83] Kuhn (ed.), *Chinese Silks*, 401; Yoshida, 'The Formation of Velvets in China', 38.

Coincidentally, the corrupt Yan Song was a native of Fenyi, next to Fengxin. Both places were part of Yuanzhou prefecture, the homeland of Song Yingxing's great-grandfather, Song Jing 宋景 (1477–1547), who served Emperor Shizong's court as Chief Censor to the Imperial Censorate (*duchayuan zuodu yushi* 督察院左都御史) at the same time as Yan Song had accrued power at the court.[84] As Song Jing's great-grandson, Song Yingxing must have been acutely aware of Yan Song's moral depravity, which was well-known in the empire, in contrast to his own great-grandfather's upright virtuous behaviour, which had hardly been acknowledged anywhere.

Song Yingxing unsuccessfully took the metropolitan examination five times, failing his last attempt in 1631 at the age of forty-four, his efforts to restore family glory to the heights achieved by his great-grandfather coming to naught.[85] With his family background in mind, might his derisive remarks about velvet – alongside neutral, if not more positive, comments on dragon robes and silk gauzes – embody a hidden satire? Perhaps he saw velvet as signifying corruption? If his negative judgment of velvet and condemnation of its uselessness actually resulted in the conspicuous absence of velvet in contemporaneous texts, this hypothesis requires further research. It could, for instance, explain why the list of Yan Song's wealth captured in the *Record of Heavenly Dew and Ice-Capped Mountain* provided collectors and the nouveau riche with a model for a collection as,[86] after a change of dynasty to the Manchu Qing (1644–1911), Yan Song's corruption had long been forgotten.

By coincidence, the editor of the local gazetteer of Zhangzhou, Prefect Yuan Yesi (*jinshi* degree in 1598), also hailed from Yuanzhou. Song Yingxing, who only passed the local examination in 1615, would have considered Yuan Yesi his elder colleague. Is it therefore possible that Song Yingxing obtained his information on '*woduan*' or Zhangzhou and Quanzhou velvet from Yuan Yesi? Song Yingxing probably never actually saw any velvet himself, as he described the 'swan-down' literally as real swan feathers used to make a furry garment.[87] An earlier reference made by Yuan Yesi on *Zhang*-velvet in 1613 was published in the local gazetteer of Quanzhou, dated 1602. This states that silk gauzes woven in Quanzhou compared poorly with those woven in Suzhou and Hangzhou, and that velvet woven in Quanzhou could not compete in beauty with that woven in Zhangzhou.[88]

[84] Today Yichun in Jiangxi province.

[85] Schäfer, *The Crafting of 10,000 Things*, 26.

[86] For a discussion on collecting and connoisseurship, see Craig Clunas, *Superfluous Things: Material Culture and Social Status in Early Modern China* (Urbana, IL, 1991).

[87] Song Yingxing, *Tiangong*, 104.

[88] Yoshida, 'The Formation of Velvets in China', 37.

Textual evidence thus narrows the date when velvet was first produced in Zhangzhou to some time between 1549, when the Portuguese clash with locals revealed that no velvet was yet being traded, and 1602 when velvet was being woven in both Quanzhou and Zhangzhou. Certainly, the 1574 Uesugi red velvet mantle with a pattern of carved gold peony would suggest that the technical complexity of export velvet made in the private sector surpassed the simpler, monochrome velvet made by the state manufacture to supply the court, viz. Xiaojing Empress' three velvet garments and the dragon robe velvet fabric at the Royal Ontario Museum.

CONCLUSION

Historically, Zhangzhou remained inconspicuous while, in the mid twelfth century, Fuzhou enjoyed a high administrative status and Quanzhou attracted seafaring merchants from far and wide. Muslim Arabs even came to control Quanzhou, calling it Zayton, which was already famous for high-quality silks such as satin, its namesake. By the fourteenth century, however, Quanzhou's port had silted up and was unusable. The relocation of the maritime trade office to Fuzhou forced the smugglers to dock at Moon Harbour in Zhangzhou, thus bringing the latter into use as a viable port. Meanwhile, both changes in the state system on how craftsmen's labour was levied and the burgeoning consumption of luxury goods led to advances in weaving in the private sector from the late fifteenth century onwards.

In 1517, when inclement weather fortuitously led Portuguese traders to Zhangzhou's Moon Harbour, it brought them into direct contact with the local inhabitants of Zhangzhou. Responding to the new Japanese market demand, mediated by the Portuguese, local weavers started to produce new weaves, including velvet. Possibly, the arrival of the Portuguese in Zhangzhou led the Chinese to associate velvet with foreigners? At a time when the place of manufacture was not yet woven into the textile itself, a local speciality was known by the name of its place of origin.[89] The misconception that velvet originated in Japan arose from this misunderstanding, inverting Japan's actual position as the destination for the export. Velvet, being a heavy fabric, was not suitable for local use, and was probably rarely seen in the south, thus adding to its mystery. At the same time, the imperial and bureaucratic elite living in Beijing and facing its cold winters welcomed the new velvet product that was produced for them

[89] For a discussion on inscribed textiles, see Dagmar Schäfer, 'Peripheral Matters: Selvage/Chef de piece Inscriptions on Chinese Silk Textiles', *UC Davis Law Review*, 47/2 (2013), 705–33.

by state manufactures in Nanjing, Suzhou, or Hangzhou. However, these same manufactures were also busy producing far more colourful brocaded satins with complex patterns, to which textual references abound. In comparison, the simpler monochrome velvet met with benign negligence.

In any case, the twill used as a foundation weave in the velvet samples from 1620 differs fundamentally from that of the 168 BCE prototype, the warp-faced, compound tabby unearthed from Mawangdui. Even if the Chinese did develop a new way of weaving velvet in the early Ming period, this method did not descend directly from ancient times. Further research on this point must wait until archae-ologists discover more velvet from the Yuan and early Ming dynasties. Thanks to the cross-cultural trade between southeast China and Japan via the Portuguese in the sixteenth and seventeenth centuries, Zhangzhou became famous for its local specialty: *Zhang*-velvet. As a Chinese abbreviation for patterned velvet, this appellation spread beyond its original place of manufacture, as it was then woven elsewhere, in nearby Quanzhou and major weaving centres in the Lower Yangzi valley.

3·

The Dutch East India
Company and Asian Raw Silk:
From Iran to Bengal via China and Vietnam

Rudolph Matthee

After money and sex but long before petrochemicals and information technology, textiles made the world go round – and no textiles were more prized than those made of silk. Raw silk has been known since Antiquity, and sericulture is now known to go back to the Harrapa Indus civilisation in the mid third millennium BCE, two thousand years prior to the introduction of domesticated silk in China.[1] Yet until the late Middle Ages most silk originated in East Asia, and to a lesser extent, the Middle East. In Europe silk textiles were mainly used for ecclesiastical purposes, as material for vestments and church decorations. Starting in the fifteenth century, Europe developed a growing demand for silk as material for luxury clothing fuelled by the desires of a rising urban elite concerned with status and fashion and using ostentatious display as outward markers of wealth. This transformed the demand for silk in Europe, giving rise to a tremendous expansion of existing markets and a search for new sources that spanned the period from the sixteenth to the early eighteenth century.[2]

Traditionally, silk came from three production areas in Asia: China, India, and Iran. China was the oldest of these suppliers but given the distance to European markets and the centralised nature of its government it was, until the seventeenth century, also the least accessible source of raw silk. India, or rather Bengal and the surrounding region, too, only came within the purview of customers in the

[1] I. L. Good, J. W. Kenoyer and R. H. Meadow, 'New Evidence for Early Silk in the Indus Civilization', *Archaeometry*, 51 (2009), 50.
[2] Beverly Lemire and Giorgio Riello, 'East and West: Textiles and Fashion in Early Modern Europe', *Journal of Social History*, 41/4 (2008), 887–916.

West after the establishment of the European maritime companies at the turn of the seventeenth century.

Iran, known for its fine silk weaving from the early part of the first millennium, the period of the Parthians (247 BCE–224 CE) and the Sasanians (224–651 CE), and a supplier of raw silk since the age of the Crusades (1096–1487) and the country's Mongol domination (1219–1370), was in some ways the more accessible of the three supply regions. In the words of historian Philippa Scott, 'The passage of silk from East to West was historically controlled by the dynasties that flourished and fell in the lands of Persia'.[3] The supply of raw silk had always followed the land-based channels across Anatolia and Syria, connecting the production areas in northwestern Iran to Bursa, whose silk bazaar still bears witness to its past role as a major terminus of Iranian silk, and the ports of the Levant.

This route underwent a great expansion in the late sixteenth century, following a decade or more of decline as a result of prolonged warfare between the Ottoman Turks and the Iranian Safavids between 1578 and 1590. The main catalyst for this surge was the arrival of the French and English so-called Levant Companies in the ports of the eastern Mediterranean in the 1580s and 1590s. The Europeans were at first primarily interested in Asian spices, but turned to Iranian silk as they became confronted with a growing direct supply of condiments via the oceanic route. Soon thereafter a new line of supply from Asia was opened up by way of the newly established European East India Companies. The English East India Company (EIC), and its Dutch counterpart and rival, the Verenigde Oostindische Compagnie (VOC), made their entry into the Persian Gulf in the early seventeenth century, seeking to cash in on trade in Iranian raw silk by transporting it via the Cape of Good Hope (see Map 3.1). Allowed to operate in Iran by the Safavid ruler Shah 'Abbas I (r. 1587–1629), by the 1620s both companies were busy carrying relatively large consignments of silk from the Caspian region to European markets via the Cape.[4] They also sought to activate the trade from China and Bengal. For the time being they failed in this latter attempt. Yet by the century's end conditions had changed dramatically: Iran's silk had lost its lustre, the Dutch especially had given up on China altogether, and Western importers were in the process of shifting to cheaper and better-quality silk from Bengal.

This essay traces the reasons for these shifts. It examines the interplay of political and economic forces that in the seventeenth century directed the attention of the Dutch and English East India Companies to Iran, inadvertently turning China into a regional supplier. This ultimately made silk from Bengal

[3] Philippa Scott, *The Book of Silk* (London and New York, 1993), 134.

[4] Rudolph P. Matthee, *The Politics of Trade in Safavid Iran: Silk for Silver, 1600–1730* (Cambridge, 1999).

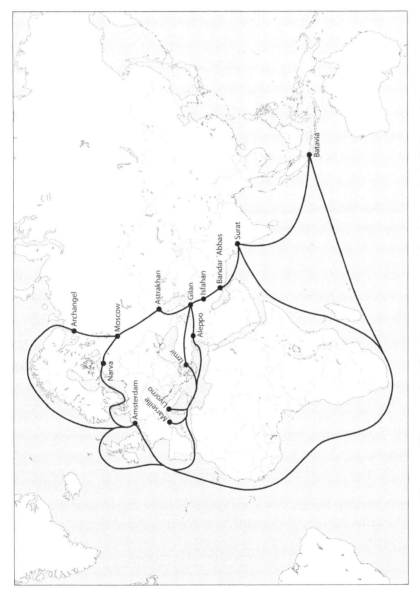

Map 3.1 The expanded silk trade routes connecting Asia, particularly Iran, with European states, after the sixteenth century. Design: Julian Wickert.

the more attractive option for both the VOC and the EIC, rendering Iranian silk a passing phase or a mere interlude in Europe's silk imports. Mainly relying on the records left by the chartered companies, I argue that a complex set of conditions and circumstances accounts for the difficulty in securing a steady supply of Chinese raw silk, the loss of European interest in Iranian silk, and the growing allure of silk from Bengal. These include questions of quality and consistency in relation to price and preferences in the domestic market, but also logistical considerations involving distance and accessibility to the sources of sericulture. In addition to this there were political concerns ranging from Iran's domestic conditions and the difficulty of dealing with the Safavid government to the geopolitical context in the wider Asian arena beyond the Indian Ocean.

SILK FROM IRAN

Long known as a land of silk weaving, Iran first became a source of raw silk destined for the European market in the thirteenth century – the period of Mongol or Il-Khanid domination (1256–1353). The new overland trade was mostly conducted by Italian merchants plying the routes that linked north-western Iran, Gilan on the Caspian littoral and Shirvan in the Caucasus, to the ports of the eastern Mediterranean. Chinese silk, at that time deemed inferior yet cheap, as well as silk from Iran and Central Asia, reached Italy and France via this route from the 1250s.[5] This connection was interrupted by the fall of the Il-Khanid state in Iran and the onset of the Black Death in the mid fourteenth century. It would not resume until more than a century later, mainly by Armenian merchants operating out of Iran's northwestern borderlands with the Ottoman empire. Intermittent warfare between the Ottomans and the Safavids, the rulers of the state that emerged in Iran at the turn of the sixteenth century, periodically hampered, but never totally halted trade until the last round of hostilities from 1578 to 1590.[6]

The latter year may be considered the beginning of a sustained export flow of raw silk between Iran and Europe via the Levant. Aleppo initially functioned as the main entrepôt for this flow and Venice was the principal European destination of Iranian silk carried westward. This was soon followed by attempts to redirect Iranian silk via the Cape route as part of a sustained project to open up the oceanic channel for the commodity flow between Asia and Europe.

[5] Luciano Petech, 'Les marchands italiens dans l'empire mongol', *Journal Asiatique*, 250 (1962), 550–51.
[6] Fernand Braudel, *The Mediterranean and the Mediterranean World in the Age of Philip II*, trans. Siân Reynolds (Berkeley, 1995), i, 565; Matthee, *Politics of Trade*, 21–2.

A fortuitous confluence of circumstances triggered Europeans' eagerness to acquire silk from Iran – first via the Ottoman and, to a lesser extent, the Russian overland route, and later, by ship around Africa. One such circumstance was an explosive increase in the European demand for silk and other luxury goods that accompanied rapidly rising prosperity in the northwestern part of the continent. Originating in the Middle Ages in Italy and France, the European silk industry underwent tremendous growth in the fifteenth century, spreading across the Alps to Germany and Flanders. Silk manufacturing further expanded in the sixteenth century as the secular elite in those countries developed a liking for silk clothing. In England a domestic silk manufacturing industry emerged in the late sixteenth century. The Spanish sack of Antwerp in 1585 catalysed the development of silk weaving in the northern Netherlands, where Amsterdam became a major centre of import and Haarlem a thriving centre of manufacture.[7] As the incipient Italian and French sericulture could not keep up with the rising demand in the north, European merchants ventured out to explore new sources of the commodity.[8]

A second impulse came in the form of new trading opportunities offered by Iran itself following the coming to power of Shah 'Abbas I in 1588. After this most energetic and visionary of Safavid rulers had established a power base, subdued his main domestic rivals and, temporarily and strategically, made peace with the Ottomans in 1590, he embarked on a multifaceted project designed to accumulate the revenue needed to consolidate his power by way of military, administrative, and commercial reforms. He thus facilitated domestic trade via secure routes lined with a multitude of newly constructed caravanserais; opened up new international trade channels; awarded members of Iran's domestic Armenian merchant community a privileged role in plying them, and allowed foreign competitors a share in the alternative trade routes. In all this the shah was careful to balance forces, controlling rivals and competitors by keeping them divided.[9]

[7] For the transfer of the silk trade from East to West, see David Jacoby, 'Oriental Silks Go West: A Declining Trade in the Late Middle Ages', in C. Schmidt Arcangeli and G. Wolf (eds.), *Islamic Artifacts in the Mediterranean World: Trade, Gift Exchange and Artistic Transfer* (Venice, 2010), 71–88. For the silk industry of Venice, see Luca Molà, *The Silk Industry of Renaissance Venice* (Baltimore and London, 2000). For the rise of Holland as a silk-manufacturing centre, see Sjoukje Colenbrander, *When Weaving Flourished: The Silk Industry in Amsterdam and Haarlem, 1585–1750* (Amsterdam, 2013).

[8] Fernand Braudel, *The Wheels of Commerce, i: Civilization and Capitalism 15th–18th Century*, trans. Siân Reynolds (New York, 1982), 178, 312–13; L. van Nierop, 'De zijdenijverheid van Amsterdam historisch geschetst', *Tijdschrift voor Geschiedenis*, 45 (1930), 18–40, 151–72; and Molà, *Silk Industry of Renaissance Venice*, 3ff.

[9] Rudi Matthee, 'The Politics of Protection: European Missionaries in Iran during the Reign of Shah 'Abbas I (1587–1629)', in Sabine Schmidtke and Camille Adang (eds.), *Contacts and*

Shah 'Abbas next launched a series of foreign policy initiatives in order to advance his wider geopolitical agenda, which was primarily driven by a desire to weaken the Ottoman empire by way of exploring the formation of an anti-Turkish alliance with various European powers. To that end, the shah engaged in a series of diplomatic exchanges, sending a number of envoys to various European courts and receiving just as many emissaries from countries as varied as Portugal, the Vatican, England, and Russia. Here too, the Safavid ruler proved to be a master in the art of balancing competing forces, and silk played a crucial role in his balancing act. Shah 'Abbas's strategy included a partial rerouting of Iran's silk trade from the land-based routes through Anatolia, Mesopotamia, and Syria, located in Ottoman territory, and allowing European maritime companies a share in the emerging oceanic trade. The shah thus dispatched consignments of silk with some of the embassies he sent to Europe. The most notable of these was the mission led by an official called Jangiz Beg (d. 1613) that arrived in Lisbon in 1610 with 19,200 pounds of silk, whetting the appetite of European rulers with a proposal to help divert Iran's silk trade via the maritime route.[10]

This diplomatic exchange came to involve the Dutch following an encounter between a private merchant from the southern Netherlands named Gilles de la Faille (n.d.) and the English adventurer-cum-diplomat Robert Sherley (1581–1628), brother of the even more well-known traveller Anthony Sherley (1565–1635), in Spain in 1610. Sherley and de la Faille discussed the formation of a commercial company that was to deal mainly in Iranian silk. De la Faille took the idea to Holland, where it met with some approval but ultimately foundered on resistance by the newly established VOC, whose directors, unsurprisingly, opposed the formation of a rival commercial venture.[11]

The final impulse came with the establishment of a series of chartered European trading companies specialising in long-distance commerce. The first of these were the previously-mentioned Levant Companies. Their arrival in the eastern Mediterranean in the late sixteenth century, coinciding as it did with the conclusion of a protracted round of Ottoman–Safavid warfare, gave a fillip to the overland route from Iran, which had long served Venice and the burgeoning silk manufacturing industry of Italy.[12] Since the mid sixteenth century the favoured route had been the southern 'Syrian' branch, terminating in Aleppo and that

Controversies between Muslims, Jews and Christians in the Ottoman Empire and Pre-Modern Iran (Würzburg, 2010), 245–71.

[10] Matthee, *Politics of Trade*, 80–2.

[11] H. Dunlop (ed.), *Bronnen tot de geschiedenis der Oost-Indische Compagnie in Perzië* (The Hague, 1930), 1–4.

[12] Molà, *Silk Industry of Renaissance Venice*, 56–64.

city's maritime outlet, the port of Alexandretta (modern Iskenderun) in the (now Turkish) Hatay region. Such was the frenzy among silk buying merchants in Aleppo at the turn of the seventeenth century that they reportedly pulled the silk bales off the camels' backs as soon as caravans arrived, willing to make purchases without even opening the bales.[13] Between 1590 and 1604 the Venetians imported an average annual quantity of almost 1,450 bales or some 362,500 pounds via this route.[14]

In the next few decades, however, the activities of the Levant Companies were to be overshadowed by the much more ambitious VOC and the EIC, sophisticated maritime companies that sought to capture the Asian trade by circumventing the Ottoman empire and following the Portuguese around the Cape of Good Hope. The EIC entered the Persian Gulf in 1615 and managed to conclude an agreement with Shah 'Abbas a year later, and the VOC followed in 1623.

The apparent enthusiasm for Iranian silk notwithstanding, it is important to note that the directors of the EIC and VOC were not particularly interested in silk when they entered the Persian Gulf in search of profitable commodities. In earlier years, Chinese silk had caught the attention of the Dutch. In 1604, 1,200 bales of Chinese silk, part of the cargo of a Portuguese vessel that the Dutch had seized off Johor near Singapore, was sold by public auction in Amsterdam, yielding tremendous profits. Coinciding as it did with a crop failure in Italian sericulture, the sale did much to boost Dutch interest in (Chinese) silk.[15] The VOC saw importing silk from East Asia to Europe as a potential alternative to pepper, which was a virtual Portuguese monopoly at the time.[16] Conversely, when the Dutch entered the Iranian market in 1623 their first objective was not the purchase of silk, but rather to set up a trade in Asian spices for Iranian cash. Iranian silk was cheaper, to be sure, but it was also known to be of inferior quality relative to Chinese silk – which is why it was deemed mainly good for sewing.[17] Chinese silk was much more highly prized, even at the higher price. A comparison from 1624 makes this clear. Iranian *ardas* and *legia* silk, the main grades produced for export purposes, fetched Dutch florins (Dfl.) 9.60 per

[13] P. R. Harris, 'An Aleppo Merchant's Letterbook', *British Museum Quarterly*, 22 (1960), 67.

[14] Molà, *Silk Industry of Renaissance Venice*, 58.

[15] Willem Floor, 'The Dutch and the Persian Silk Trade', in Charles Melville (ed.), *Safavid Persia: The History and Politics of an Islamic Society* (London, 1996), 326.

[16] Kristof Glamann, *Dutch–Asiatic Trade, 1620–1740* (Copenhagen and The Hague, 1958), 112.

[17] Otto Heinz Matthiesen, 'Die Versuche zur Erschliessung eines Handelsweges Danzig-Kurland-Moskau-Asien besonders für Seide, 1640–55', *Jahrbücher der Geschichte Osteuropas*, 3 (1938), 560–61.

pound in Amsterdam.[18] Raw white silk from China by contrast, was sold for Dfl. 16.20 per pound. Though it was more expensive, Chinese silk was thus far more profitable. A consignment sold in Holland in the summer of 1621 yielded an impressive 320 per cent in gross profit.[19] The Dutch had two reasons for opting to be paid in silk for the wares they sold in Iran. The first was that the Safavid court simply gave them no choice. The second was competition from the English and the desire to 'frustrate' their hated 'hypocritical friends', as they called their rivals from across the North Sea.[20]

Nor was Iranian silk a prime objective for the English who, having received permission from Shah 'Abbas to engage in trade in 1617, started operating in his realm a year later. The EIC agents saw the Iranian silk trade as a derivative of their Indian operation, a function of the fact that they found no customers for the heavy woollen cloth they had for sale in the Indian regions of Gujarat and Coromandel. Iran, with its colder climate, was different, and just as English woollens were routinely exchanged for silk in Aleppo, so they found a ready market on the Iranian plateau. But it was not yet clear that silk would be the main exchange commodity. Thomas Roe (1581–1644), who in 1615 was sent on a pioneering EIC trade mission to the Mughal court at Agra, initially wished to concentrate on the Red Sea trade. Sceptical about Iran's ability to supply silk in sufficient quantity, and viewing commerce in the context of the Ottoman–Safavid enmity, he providentially surmised that, once the shah had made peace with the Ottomans, he would give up his interest in the diversion of the overland trade. He also foresaw a need to provide cash in payment for Iranian silk and, having been informed about the small volume of Iran's trade, worried about long-term profitability.[21] Yet the agents in Surat, the western headquarters of the EIC, ignored his advice and decided to go through with the venture, authorising a first mission in 1616. Lured by the promise of an expected annual volume of up to 3,000 bales of silk for the EIC and by the prospect of gaining a monopoly on maritime exports, the English were buoyant in their prognosis for the future.[22]

[18] For the various types of Iranian silk and their characteristics, see Matthee, *The Politics of Trade*, 36–8.

[19] Glamann, *Dutch–Asiatic Trade*, 112.

[20] M. A. P. Meilink-Roelofsz, 'The Structures of Trade in the Sixteenth and Seventeenth Centuries: Niels Steensgaard's *Carracks, Caravans and Companies*. A Critical Appraisal', *Mare Luso-Indicum*, 4 (1980), 32.

[21] Thomas Roe, *The Embassy of Sir Thomas Roe to the Court of the Great Mogul, 1615–1619*, ed. William Foster (London, 1899), 132–3, Thomas Roe to the King of Persia, 14 February 1615, and 407–11, Roe to the 'expected general which shall arrive this year', 30 August 1617.

[22] Matthee, *Politics of Trade*, 97–8.

As a result of these various factors, both companies quickly found themselves exporting large quantities of Iranian silk. They did so under the auspices of the Safavid government, which meant that the purchase of silk in Iran from the very outset was a political proposition as much as a commercial one. This proved to be a recipe for disagreement and conflict. The agreement that the EIC concluded with Shah 'Abbas in 1617 included neither a monopoly nor the anticipated silk for credit, nor even the desired toll exemption. The first consignment that was delivered consisted of a measly seventy-one bales, which the English bought at nearly 50 tumans per load – more than 20 per cent above the going market rate.[23] Short on cash, the English tried to renegotiate the deal, promising to buy up to 8,000 bales in exchange for fixed custom rates and the establishment of a protected Persian Gulf port. They received neither, and instead in September 1619 were asked to participate in a silk auction set up by the Safavid crown to award purchase and export rights to the highest bidder. The background to this event was the termination of the latest round in Safavid–Ottoman hostilities in the form of the Peace of Sarab, which had been concluded a year earlier. The trade routes through Anatolia had been reopened as a result, giving Iran's Armenian merchants an incentive to emerge as the winners from the auction. The Julfans, as they were called, referring to (New) Julfa, the suburb of Isfahan that was their hub, indeed outbid the English, leaving the latter with no silk.[24] Frustrated and powerless, the following year, the EIC agents turned to the Dutch with a proposal to cooperate with them by pooling their resources and dividing the export of Iranian silk to Europe. However, the VOC directors, keen to gather more information about the market in the hope of outperforming their rivals, declined the offer. In spite of the decisive naval assistance the English would lend to the Iranians in ousting the Portuguese from the strategically located island of Hormuz in 1622, they fared little better in the next few years. They managed to export 820 bales of silk in the 1622–23 trading season. In subsequent years, hampered by a lack of ready money and faced with growing scepticism at EIC headquarters in London, they only took between sixty and seventy bales each year, a far cry from the thousands they had counted on as their annual share a few short years earlier.

The Dutch waited until after the completion of the events around Hormuz and the attendant opening of maritime channels to Iran before entering the Safavid market. They fared little better than their rivals though. Shah 'Abbas, balancing foreign powers with as much care as he did his domestic rivals, clearly saw the

[23] Dunlop, *Bronnen tot de geschiedenis*, 197, Visnich, Isfahan to Heeren XVII, 17 August 1626.
[24] Matthee, *Politics of Trade*, 101–5.

Dutch as welcome competitors for his silk, one more party that might be played off against the others, in particular the English. The contract the VOC concluded with the Safavid ruler in 1623 was ambiguous on the issue of tolls and taxes, and bound the Company to the purchase of silk at a fixed price of 50 tumans per *carga* – two loads or around 180 kilograms – in return for an exemption of customs duties. Although the price was high, the Dutch directors initially approved the deal, in the expectation that they would be able to pay for the silk with commodities, predominantly spices, from other parts of Asia. For the first five years that was indeed the case, as VOC annual purchases averaged some 350 bales, with a peak of 761 in 1628. As a result, in the period 1626–31 silk was not just Iran's only viable export commodity – a status it would long retain – but competed with pepper for first place in European maritime imports from Asia.[25]

In this period, dynastic China was still out of reach as a supplier of raw silk for the European market, for reasons having as much to do with the difficulty of gaining direct access to China as with the peculiarities of the Tokugawa Japanese (1603–1867) market economy.

CHINESE AND VIETNAMESE SILK FOR JAPANESE SILVER

Initially the VOC, intent on setting up a self-sufficient Asian trade that would obviate the shipment of any precious metal from Holland, sought to generate a maximum amount of bullion with its trade in the South China Sea in order to purchase Chinese and especially Indian cotton textiles, thought to be the most profitable of all Asian commodities after spices. Japan, the focus of the company's East Asian operations, was to supply much of the gold and silver needed to purchase Indian manufactured cotton textiles. In 1609 the Dutch gained access to the Japanese market by establishing a factory at Hirado (near Nagasaki), on the southern island of Kyūshū. From the outset, however, they were forced to adapt to a market based on the exchange of raw silk imports from China for the export of Japanese silver. There was no question that Chinese silk was the only commodity with which the VOC would be able to purchase the bullion it needed to buy Indian cotton cloth. Silk was highly prized in Japan, where it was manufactured into ceremonial clothes worn by the feudal lords and the urban upper classes, with much of it ordered through the intervention of the shogun. But Chinese silk was hard to come by, and the Dutch, like the English before them, found it difficult to penetrate the Chinese market and gain access to the Japanese silver they required.

[25] Niels Steensgaard, *The Asian Trade Revolution of the Seventeenth Century: The East India Companies and the Decline of the Caravan Trade* (Chicago, 1973), 396.

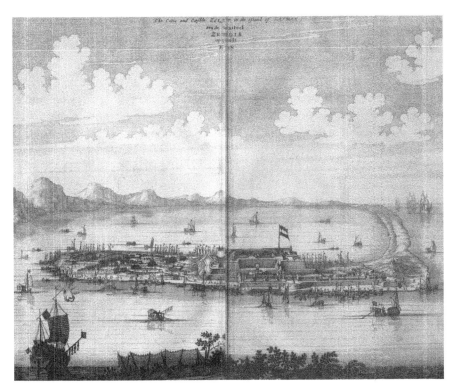

Illustration 3.1 Fort Zeelandia, Taiwan, from *Gedenkwürdige Verrichtung Der Niederländischen Ost-Indischen Gesellschaft in dem Kaiserreich Taising oder Sina durch ihre Zweyte Gesandtschaft An den Unter-könig Singlamong und Feld-herrn Taising Lipoui: ausgeführet durch Joan van Kampen, und Constantin Nobel ... Als auch die Dritte Gesandtschaft An Konchi, Sinischen und Ost-Tartarischen Kaiser, verrichtet durch Pieter van Hoorn /* hrsg. von Olfert Dapper (Amsterdam: Jacob von Meurs, 1675), 44–5. Courtesy of Max Planck Institute of the History of Science.

These circumstances changed in 1624 when, lacking a solid territorial basis in the South China Sea and unable to penetrate the Chinese mainland, the Dutch managed to set up a factory, Zeelandia, in Formosa (modern Taiwan), not yet under Ming-Chinese jurisdiction (see Illustration 3.1). In the next two decades, the Dutch extended their control over the island's lowlands to the point where many local chieftains came to recognise their legal authority.[26]

[26] John E. Wills, 'De VOC en de Chinezen in China, Taiwan en Batavia in de 17e en 18e eeuw', in M. A. P. Meilink-Roelofsz (ed.), *De VOC in Azië* (Bussum, 1976), 168; and Leonard Blussé, 'De Chinese nachtmerrie. Een terugtocht en twee nederlagen', in Gerrit Knaap and Ger Teitler (eds.), *De Verenigde Oost-Indische Compagnie tussen oorlog en diplomatie* (Leiden, 2002), 209–37. A recent

Japan's growing wariness about the operations of foreign merchants on Japanese soil in this period benefited the Dutch as well. The English gave up on the island empire in 1623 and a year later the increasingly insular Japanese banned the Spanish from operating on their soil. In 1632–33, the Japanese authorities enacted a law forbidding (1) all ships other than those carrying both a 'red seal licence' (*shuinjo* 朱印) issued by the shogun and a 'permit' (*hosho* 奉書) written by the Senior Counsellor to land in Japan, and (2) Japanese nationals who lived in foreign countries for five years or more from returning to Japan. By 1639, following six years of further restrictions on foreign access to the island, the Portuguese, too, had their commercial privileges revoked, leaving only the Dutch trading with the Japanese.

Having consolidated its power base in Taiwan and increasingly free from serious competitors in Japan, the VOC no longer needed to attack Spanish and Chinese ships sailing between Manila and the Chinese mainland to acquire Chinese silk. Instead, the company in 1633 launched a triangular trade between Mainland China, Taiwan, and Japan, relying for the Chinese traffic on private Chinese merchants who shipped silk to Taiwan. The Dutch maintained this exchange until 1641, when they, too, found their access to the Japanese market restricted and were forced to relocate to the small island of Deshima in the Bay of Nagasaki (see Illustration 3.2). Their trade with Japan soared after 1635, when the value of their imports totalled Dfl. 1 million, and reached a peak in 1640 with Dfl. 6.29 million. Chinese silk in these years on average accounted for 88 per cent of all Dutch imports into Japan, while Japanese silver routinely made up more than 80 per cent of exports to China.[27] This severely limited the amount of Chinese silk available for the European market. As a result, the VOC directors in Amsterdam throughout the 1630s regularly ordered amounts of Chinese silk that were but one-tenth or even one-twentieth of what they sought to acquire in Iran.[28] After 1641, the VOC continued to supply Japan with Chinese silk but the quantity fell by more than 70 per cent.[29] The reasons for this steep decline are to be sought in the civil war that broke out in this period in silk-producing China.

account of the story of the Dutch in China in the seventeenth century is Aad van Amstel, *Barbaren, rebellen en mandarijnen. De VOC in de slag met China in de Gouden Eeuw* (Amsterdam, 2011).

[27] Kato Eiichi, 'The Japanese–Dutch Trade in the Formative Period of the Seclusion Policy. Particularly on the Raw Silk Trade by the Dutch Factory at Hirado, 1620–1640', *Acta Asiatica*, 30 (1976), 42–3; and Leonard Blussé, 'No Boats to China. The Dutch East India Company and the Changing Pattern of the China Sea Trade, 1635–1690', *Modern Asian Studies*, 30/1 (1996), 65.

[28] Glamann, *Dutch–Asiatic Trade*, 116.

[29] P. W. Klein, 'De Tonkinees–Japanse zijdehandel van de Verenigde Oostindische Compagnie in het inter-Aziatische verkeer in de 17e eeuw', in Willem Frijhoff and Minke Hiemstra (eds.), *Bewogen en Bewegen. De historicus in het spanningsveld tussen economie en cultuur* (Tilburg, 1986), 169, gives 72 per cent. Blussé, 'No Boats to China', 67, gives 78 per cent.

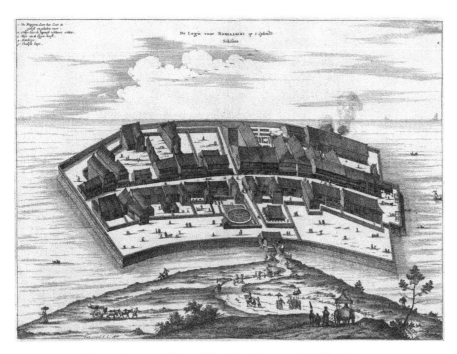

Illustration 3.2 View of Deshima, Japan, 1669: The Hague,
Koninklijke Bibliotheek, inv. no. KW 388A6.

Also, in 1641 the powerful Zheng clan in south China initiated direct exports
of silk to Japan, preventing other Chinese maritime merchants from sailing to
Taiwan. Thus, the Dutch at Zeelandia could no longer purchase large amounts
of Chinese silk, and the VOC shifted from Chinese silk to Tonkin and Bengal silk
to supply the Japanese market (see Map 3.2).[30]

Meanwhile, the Dutch managed to diversify their sources of raw silk by estab-
lishing commercial relations with the Dai Viet dynasties (1428–1804) ruling over
what is now modern Vietnam. In 1637, the first VOC ship arrived in Tonkin, in
the far north of the country, initiating a commercial relationship that primarily
involved raw silk. Most of this was transhipped to Japan, where it fetched higher
prices than Chinese silk, netting a handsome profit for the VOC. As in the case
of China, payment was effected in Japanese silver. The following year the VOC

[30] Teijirō Yamawaki, *Kaigai kōshōshi* [A History of Japan's Foreign Relations] (Tokyo, 1978),
186–7; and Kayoko Fujita, 'Metal Exports and Textile Imports of Tokugawa Japan in the 17th
Century: The South Asian Connection', in Kayoko Fujita, Shiro Momoki and Anthony Reid (eds.),
Offshore Asia. Maritime Interactions in Eastern Asia before Steamships (Singapore, 2013), 265.

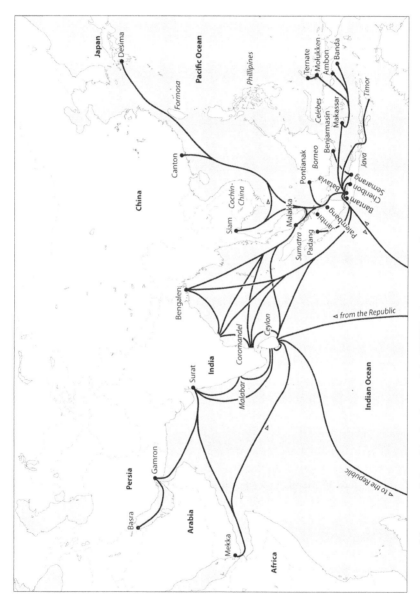

Map 3.2 Asian shipping lanes of the VOC in the seventeenth century, connecting VOC ports in Southeast Asia, China and Japan with India and the Middle East. Design: Julian Wickert.

imported Vietnamese silk worth more Dfl. 167,000 into Hirado, earning a profit upwards of 80 per cent. In the next two decades, the trade continued to flourish. Even though the Dutch met stiff competition from private Chinese maritime merchants engaged in the same trade, the VOC routinely made profits of 100 per cent or more on Vietnamese silk and the Tonkin–Japan trade became one of their most lucrative in Asia. The trade reached its peak of profitability in the period 1641–54, after which it declined. By the late 1640s, abuse by local authorities and misbehaviour by VOC personnel led to a deterioration of the relationship between the VOC and the Vietnamese, prompting the Dutch to end their military cooperation with the ruling powers and forcing them to move their trade factory to a site outside the capital. After the VOC sent an ambassador to Tonkin, relations improved to the point where the Dutch established a permanent factory in Tonkin in 1651. This proved to be a short-lived initiative, however. Increased pressure by the local authorities, growing political turmoil and rising prices as a result of natural disaster caused the export of silk to falter and eventually the Dutch suspended their activities in Vietnam.[31]

PERSISTENT PROBLEMS IN IRAN

The Safavid crown, meanwhile, continued to deliver silk to the European companies, albeit rarely the full volume stipulated in the contract with the VOC. Procuring silk in Iran and transporting it to the Persian Gulf coasts proved to be inherently problematic. Logistical difficulties were inevitably part of this. Most of Iran's silk originated in the heavily forested province of Gilan on the Caspian Sea littoral. Hot, humid, and located beyond the formidable Alborz mountain range that separates the Caspian provinces from the Iranian plateau, the area was difficult to access and out of reach for camels, so that transportation to Isfahan, Shah 'Abbas's capital and main commercial entrepôt, was complicated and costly. The problems did not end once goods arrived in Isfahan. The silk that the European companies had negotiated for still had to be transported to the Persian Gulf coast across yet more high mountain ranges and vast stretches of semi-desert. More ominously, it became clear early on that the Iranians would not allow their silk to be sold for commodities, as the Dutch and, to a lesser extent the English, had envisioned. As early as 1624 the *Heeren XVII* (Council

[31] Henriette Buggé, 'Silk to Japan: Sino–Dutch Competition in the Silk Trade to Japan, 1633–1685', *Itinerario*, 13/2 (1989), 34; Anh Tuan Hoang, *Silk for Silver: Dutch–Vietnamese Relations, 1637–1700* (Leiden, 2007), 66–106; 145ff., 150–1, 155, 231; and Naoko Iioka, 'The Rise and Fall of the Tonkin–Nagasaki Silk Trade during the Seventeenth Century', in Nagazumi Yōko (ed.), *Large and Broad: The Dutch Impact on Early Modern Asia. Essays in Honor of Leonard Blussé* (Tokyo, 2010), 46.

of Seventeen), the directors in Holland, ordered their agents in Surat, the VOC headquarters in western India, to forward spices to Iran, admonishing them that sending and spending cash was to be avoided at all costs. In the years to come they repeated this message ever more insistently. Their calls for frugality were frequently accompanied by complaints about the poor quality of silk, that it was mixed in with large amounts of rocks and dirt, and the fact that profits in Holland did not exceed 60 per cent.[32] But Shah 'Abbas, himself desperately short of funds, was equally insistent in his demands for cash.

Nor did matters improve with the shah's death in early 1629. Problems with impure and damp silk persisted well into the reign of his grandson and successor, Shah Safi (1629–42). Both the producers and the distributors of silk were notorious for their deceptive practices. The English traveller Jonas Hanway (1712–86) in the early eighteenth century criticised the producers for submitting inferior silk with 'many knits and coarse stuff sticking to the threads. The moss, or head of the silk, often appears fair to the eye, ... for it is a trick of the peasants of Ghilan, to hide the defects as they wind it off from the pod.'[33] This view was not new: a century earlier, Dutch and English merchants had voiced the same complaints. They suspected the Iranians of deliberately increasing the weight of bales by packing excessively wet silk and even sprinkling the bales with water, and expressed their frustration about what they saw as a deliberate practice of the shah – the delivery of silk in winter, when dampness was at its maximum.[34] Their solution to the problem was to leave the bales to dry in the sun upon arrival in Isfahan, constantly turning them over and weighing them every day, until they no longer lost weight, all the while trying to ignore protests by the *tahvildar*, the supervising official, who invariably preferred the bales to be weighed immediately and who would stop by every day to press the point.[35]

[32] Nationaal Archief, Dutch National Archives, The Hague (hereafter NA), VOC 314, Copiebrieven, Heeren XVII to Surat, December 1624, fol. 236; Heeren XVII to Visnich, Isfahan, 24 December 1624, fol. 255; VOC 315, copieboek, Heeren XVII to Batavia, 21 March 1629, unfol.; Heeren XVII to Batavia, 28 August 1629, unfol.; Heeren XVII to Batavia, 14 March 1630, unfol.

[33] Jonas Hanway, *An Historical Account of the British Trade over the Caspian Sea*, 4 vols (London, 1753), ii, 18.

[34] NA, VOC 1115, Overschie, Isfahan to Heeren XVII, 27 October 1634; British Library, London, India Office Records (hereafter, BL, IOR), E/3/54/6618, Bruce, Isfahan to London, 5 March 1699, unfol. The Dutch (and the English) in turn violated their arrangements with the Safavid authorities by hiding silver and gold specie in the bales of silk that they transported to the coast in an attempt to evade the tolls and taxes due on precious metal exports or, at times, the total ban on taking bullion out of the country. For this, see Rudi Matthee, Willem Floor and Patrick Clawson, *The Monetary History of Iran. From the Safavids to the Qajars* (London and New York, 2013), 81–96.

[35] NA, VOC 1611, 'Memorandum Hoogcamer to Castelijn, 31 May 1698', fol. 51.

Following Shah ʿAbbas's death, the royal silk export monopoly fell into abeyance, creating greater opportunities for private buying. Until 1629, the Dutch (and the English) had been unable to procure raw silk at the source in the Caspian provinces. But even when the monopoly became moot and private merchants received explicit permission to acquire silk at the source, the Dutch were very reluctant to go up to Gilan to make purchases. There were various reasons for this. One was that, in the area where it was cultivated, silk could only be collected in very small quantities – driving up overhead costs for the maritime companies. Another was the need for lavish gifts and bribes in the production area, which in turn raised prices and reduced profit. A third was the fact that silk bought on the spot in the Caspian provinces tended to be much more damp than it was upon arrival in Isfahan.[36] And finally, whereas other Iranian commodities were typically exchanged for European imports, silk was sold strictly for ready cash – silver coin. That is why the mint of Rasht, Gilan's main urban centre, was always ready to accept silver and why the coins it struck were of the finest alloy, to the point of being sold by weight.[37] All of these factors added up to the chartered companies' self-avowed inability to compete with the Julfan merchants. The latter, with lighter overhead costs, content with more modest profits, and relying on an extensive family network in their commercial operations, were nimbler and thus stronger, stronger even than the royal export monopoly, which they helped abolish with large gifts and bribes after the accession of Shah Safi following Shah ʿAbbas I's death.[38]

All this, but particularly the high prices and poor quality of the silk the Dutch received from the Safavid authorities, made the VOC directors interested in acquiring silk from alternative sources. As noted earlier, the importation of Chinese silk to Batavia and Amsterdam proved to be much more cost effective than trading in Iranian silk. In 1636, in response to a complaint about Iranian silk weighing less than recorded and the loss in profits this entailed, the VOC directors in Batavia wrote a memorandum to their superiors in Amsterdam, the *Heeren XVII*. Assuring the directors that they would look into the matter, the Batavia council also confirmed that Chinese silk yielded much better results.[39]

[36] NA, VOC 1324, 'Memorandum Sarcerius to Berkhout, May 1655', fol. 692 r–v.

[37] Fedor I. Soimonov, 'Auszug aus dem Tage-Buch des ehemahligen Schiff Hauptmanns und jetzigen geheimen Raths und Gouverneurs von Siberien, Herrn Fedor Iwanowitsch Soimonov, von seiner Schiffahrt der Caspische See', in G. F. Müller (ed.), *Sammlung russischer Geschichten* (St Petersburg, 1762), vii, 553–4. For more on the monetary situation in Safavid Iran, see Matthee, Floor and Clawson, *The Monetary History of Iran*, 13–135.

[38] Matthee, *The Politics of Trade*, 119ff. For the hemispheric reach of the New Julfan merchants, see Sebouh Aslanian, *From the Indian Ocean to the Mediterranean: The Global Trade Networks of Armenian Merchants from New Julfa* (Berkeley, 2011).

[39] Dunlop, *Bronnen tot de geschiedenis*, 600, Batavia to Heeren XVII, 28 December 1636.

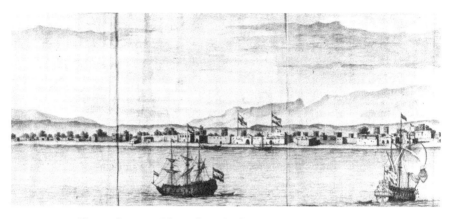

Illustration 3.3 View of Bandar 'Abbas c. 1704: The Hague,
Nationaal Archief, 1ste afdeling, 4. Aanwinsten 1891, no. 29.

A year and a half later, the *Heeren XVII*, complaining about the continually
high price of Iranian silk and the weight loss incurred during transportation,
confirmed that Chinese silk was more profitable. They speculated about the
possibility of buying only Chinese silk on account of its more even and consistent
quality, but cautioned that this presupposed a secure and stable supply from East
Asia. They also expressed concern about the possibility that diminishing Dutch
involvement in the Iranian silk business might benefit their main competitors,
the English.[40] Later that year the Amsterdam directors sent another missive to
Batavia, reiterating their suggestion to consider halting Iranian silk supplies,
and to make up the deficit with Chinese silk. At the same time, they criticised
their agents in Bandar 'Abbas (see Illustration 3.3) for underestimating the total
amount of available silk in Iran, and urged them to try and purchase silk at lower
prices, as long as payments could be effected with commodities and not cash.[41]

It is in this period that Bengal – in reality the combined region of Bengal,
Bihar, and Orissa, with the town of Cossimbazar (see Illustration 3.4) (today
Kasim Bazar) serving as entrepôt – came into focus as an alternative supplier of
high-quality silk. As early as 1630 the directors in Batavia sent a letter to Surat
ordering a sample of Bengal silk and, upon receiving it, forwarded part of it to
Holland, part to Japan (see Map 3.2).[42] A crucial moment in this switch is the
letter the VOC factory in Surat sent to Batavia in early 1639 inquiring about the

[40] *Ibid.*, 647, Heeren XVII to Batavia, 20 March 1638.
[41] *Ibid.*, 657–8, Heeren XVII to Batavia, 16 September 1638.
[42] NA, VOC 855, Batavia to Surat, 24 August 1630; and VOC 1099, Batavia to Heeren XVII, 7
March 1631, fol. 19.

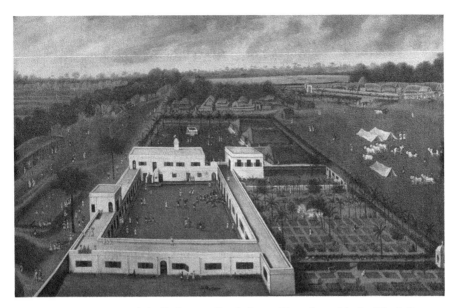

Illustration 3.4 VOC silk factory, Cossimbazar, Bengal, c. 1665, by Hendrik van Schuylenburgh: Amsterdam, Scheepvaartmuseum Inv. No. RB.0568.

possibility of the Iran factory sending specie to Surat instead of silk so that wares more profitable in Holland than Iranian silk could be purchased in India.[43] At the time there was no reaction to this suggestion, yet it reflected changing perceptions that would have momentous repercussions for future Dutch activities in Safavid Iran.

As of the early 1640s, the Dutch found it increasingly difficult to import Chinese silk into Japan. Since they were also facing low profits on Iranian silk in Europe owing to competition from Italian silk, the VOC decided to export Iranian (and Bengal silk) to Japan instead. The Iranian silk proved to be the less desirable of the two. It did not find any customers for the first few years and only when 13,062 kins (catties) or 3,945 pounds (at 604 g per kin/catty) were delivered in 1644 did Iranian silk yield a profit in Nagasaki of 50 per cent.[44] The Dutch, their appetite whetted, imported a much larger amount, 23,110 kins or 6,997 pounds in 1645. This proved to be the high point, for in 1646 the volume fell to 17,799

[43] NA, VOC 1132, Surat to Batavia, 20 April 1639, fol. 688v.
[44] W. Ph. Coolhaas (ed.), *Generale missiven van Gouverneurs-Generaal en Raden aan Heren XVII der Verenigde Oostindische Compagnie, ii: 1639–1655* (The Hague, 1964), 243. The figure of 13,062 kin is listed in Yamawaki, *Kaigai kōshōshi*, 199. Thanks to Fujita Kayoko for bringing this study to my attention.

kins or 5,375 pounds. In 1647 nothing was imported, and in 1648 a mere 488 kins or 295 pounds of Iranian silk made it to Japan.[45] Four years after initiating it, the VOC halted the practice of shipping Iranian silk to Japan on a regular basis, henceforth preferring to send much more profitable silk from Bengal. Until the end of the century, the Dutch made few efforts to revive the import of silk from Iran into Japan. In 1668, they imported 29,728 kins, or 8,978 pounds of Iranian silk to Nagasaki; but only 7,844 kins or 2,369 pounds were sold. In 1672, they sold 17,273 kins or 5,216 pounds, at a loss of 9 per cent. In 1697, the VOC sold 21,167 kins or 6,392 pounds at a profit of just 9 per cent. Iranian silk, uneven in quality and relatively high in price, proved to be unpopular among Japanese silk merchants.[46]

In the mid 1650s Bengal also supplanted Tonkin as the chief supplier of silk in the trade of the Dutch with Japan. The reason for this was stiff Chinese competition in the Tonkin market, in addition to the fact that Bengal silk had halved in price between 1651 and 1659, from Dfl. 5.89 per pound to Dfl. 2.68 per pound. As a result, the profits made on it steadily rose to almost 200 per cent. Tonkin silk, by contrast, lost its competitive edge in the same period, doubling in price from Dfl. 2.38 to Dfl. 4.97. In 1655 political problems in Vietnam temporarily halted all trade, providing a further incentive for the Dutch to diversify their silk supplies. The following year they turned to Bengal, initiating the shipment of Japanese silver to India in exchange for silk and textiles. In 1661 the Dutch factors in Japan expressed a desire to receive as much Bengali silk as the VOC could afford to send.[47] Between 1656 and 1672 Bengal silk constituted four-fifths of all Dutch silk exports to Japan.[48]

In early 1662, following a long siege, the Dutch were forced to give up their factory in Formosa, Fort Zeelandia, to the Manchu-Qing (1645–1912), the dynasty that had meanwhile come to power in Mainland China. This loss naturally threw their hard-won commercial links in the South China Sea into turmoil. It would prove to be the beginning of the end of the VOC exchange between China and Japan. In 1671 the direct trade with Dutch ships between Tonkin and Japan came to a halt, and from 1675 onward Tonkin became a liability for the Dutch. In the following decade, with the newly dominant Qing forces subduing the last stronghold of the Ming dynasty by seizing all of Formosa in 1683, conditions worsened even more. This was followed by a surge of the junk trade between

[45] Yamawaki, *Kaigai kōshōshi*, 199–200.

[46] *Ibid.*, 200–1.

[47] Hoang, *Silk for Silver*, 157–8.

[48] Om Prakash, *The Dutch East India Company and the Economy of Bengal*, 1630–1720 (Princeton, 1985), 123–5.

China and Japan, leading to new Japanese trade restrictions involving a discriminatory ceiling on commercial operations by the Dutch, who were henceforth only allowed to handle half as much as the Chinese. These developments effectively put a halt to Dutch involvement in the China trade.[49]

BACK TO IRAN, WITH RESERVATIONS

The political turmoil and economic disruption in East Asia should have led to a boom in silk exports from Iran – stable and at peace in this period – conducted by the Dutch and the English. That it did not is linked to a multiplicity of factors involving quality, prices, competition, and political complications, as well as the sheer inability of the Safavid court to procure raw silk on command.

By the early 1640s the Dutch, frustrated with a fixed price of 50 tumans per load at a time when silk prices in Europe were falling, the continuing Iranian demand for cash, the delays in delivery, and the persistent problems with underweight and impure silk foisted on them, decided to buy as little silk as possible in Iran and instead to maximise their export of bullion from the country. Successive shahs reacted to this resolve by throwing up obstacles to the unfettered bullion drain from their country, either by imposing outright bans or by subjecting exports to various fees and taxes.[50] They also refused to lower the amount of silk delivered to the VOC. The conflict this generated culminated in a brief war in 1645 between the VOC and the Safavids involving a failed Dutch attempt to seize the island of Qishm followed by a retreat from Bandar ʿAbbas and a blockade of the maritime entrance to the port. The stand-off was only broken when the VOC authorities resolved to send a high-level mission to Iran to renegotiate the silk contract of 1623.[51] Joan Cuneaus, who led the mission that left Batavia in 1651, the following year managed to conclude a new contract to be sure; but it was one that would haunt the VOC for decades to come, for it tied the Dutch to a fixed amount, 600 bales, at a price of 48 tumans per load, which was above market rate in all but years of great scarcity.[52] The EIC, weary of the business and the difficulties it entailed, gave up on Iranian silk in this period altogether. In 1648, more than a decade after the Dutch had started experimenting with silk from India, the EIC ordered

[49] Blussé, 'No Boats to China', 72–3.

[50] Matthee, Floor and Clawson, *Monetary History of Iran*, 78ff.

[51] Willem Floor and Mohammad H. Faghfoory, *The First Dutch–Persian Commercial Conflict. The Attack on Qeshm Island, 1654* (Costa Mesa, CA, 2004).

[52] See Cornelis Speelman, *Journaal der reis van den gezant der O.I. Compagnie Joan Cuneaus naar Perzië in 1651–1652*, ed. A. Hotz (Amsterdam, 1908).

their first samples of Bengali silk.[53] They soon switched completely to Indian silk, reducing their commercial involvement with Iran considerably in the process.

The Safavid state meanwhile faced growing monetary problems, which the grand viziers at the time, most notably Mohammad Beg (in office 1645–54), and Sheykh 'Ali Khan (in office 1669–89), actively sought to remedy by exploring multiple ways to enhance revenue for the crown. This included an increase in government control over the production and transportation of silk.[54] The Iranian authorities, nonetheless, rarely managed to supply the Dutch with the contractual silk quota. Several reasons account for this failure. One is that the silk business involved many interests, diluting the power required to harness resources and coordinate efforts toward centralised buying. More important was the perennial impecuniousness of the state, resulting in government buyers who, arriving in the production areas with little money, often found it impossible to compete with private buyers in their attempt to purchase significant amounts of silk.[55] In some years in the late seventeenth century the government may also have calculated that supplying silk to the Dutch was not very cost effective since it was more profitable in taxes and tolls to export it to Russia and the Levant.

It remains unclear whether these shifts in routes and destinations signalled a dramatic decrease in the total volume of Iran's silk exports, or whether Iranian raw silk merely diminished as a proportion of a growing overall supply to European markets. The dwindling volume carried via the maritime route is not a good measure of change, for this channel had never represented more than a small proportion of its total exports. The dramatic reduction in the volume of specie entering Iran from the Ottoman empire as of the 1660s suggests an equally dramatic fall in the amount of silk going in the other direction. Yet the fragmentary state of our knowledge of the actual silk traffic via the Levant in this period makes it impossible to be categorical about any long-term retrenchment before 1700. In his commercial manual titled *Le parfait négociant*, published in 1675, the French merchant Jacques Savary (1622–90) insists that annually nearly 400 bales of Iranian *sha'rbafi* and *legia* silk and some 100 bales of the *ardassin* grade – called 'ablaque' in France – arrived in Smyrna (modern Izmir) on the west coast of Anatolia, en route to the manufactories of Tours and other silk-weaving centres in France. But Savary also pointed to the high prices and meagre

[53] BL, IOR, E/3/20/2062, Swally to Company, 6 January 1648, fol. 21; see also William Foster (ed.), *The English Factories in India: 1646–1650. A Calendar of Documents in the India Office, Westminster* (Oxford, 1914), Vol. 8, 189, 646–50.

[54] Matthee, *The Politics of Trade*, 180–5.

[55] NA, VOC 1274, Van Dussen, Gamron to Heeren XVII, 10 September 1671, fol. 746b; VOC 1288, De Haeze, Gamron to Heeren XVII, 16 May 1672, fol. 924a.

profits yielded by Iranian silk.[56] The Russia link, in turn, saw a great upsurge as of the 1670s. Even though the supply via Russia never reached a critical volume, around the turn of the eighteenth century Iranian silk transported north was no longer only taken to Western Europe but also began to be used in Russia's fledgling manufacturing industry.[57]

The Dutch themselves, meanwhile, had less and less incentive to insist on large silk deliveries in Iran, and for years managed to take minimal amounts, bribing conniving government officials as the need arose. In the early 1680s, low prices for silk in Europe made Asian silk of any kind an unattractive import product. In 1682 Iranian silk disappeared from the VOC list of orders. Prices in Holland reached a nadir in 1685–6, when Iranian silk only fetched a price of Dfl 3.95 per pound in Amsterdam.[58]

By that time the VOC had entered into yet another conflict with the Safavid crown. In a replay of the events of 1648, hostilities in 1684 escalated to the point where Dutch forces occupied the island of Qishm while blockading maritime access to Bandar 'Abbas, thus scuppering their own trade as well. It took some seven years, acrimonious negotiations, and a high-level Dutch mission for the conflict to be resolved. But even after commercial relations resumed in 1691, leading to the considerable delivery of 675 bales that year, the supply of silk from Iran remained haphazard and intermittent. The VOC received no Iranian silk for several years thereafter, even as a war-related disruption in supplies from Italy and Ottoman lands created shortages and caused a spike in prices for Asian silk on European markets in 1693.[59] Only in 1695 were the Dutch once again supplied with silk, 783 bales, an unusually large volume. This proved to be an exception, for the volume dwindled to 149 bales in 1696, after which no deliveries were made until 1703. The years 1704–14, during which a grand total of some 450 bales were supplied to the VOC, proved to be the last decade the company shipped silk from Iran.[60]

THE END OF DUTCH SILK EXPORTS FROM IRAN

None of it mattered anymore, at least not for the European companies. Precisely at this time the VOC (and the EIC) definitively turned their attention to the Indian subcontinent and more particularly to Coromandel and Bengal, the origin

[56] Jacques Savary, *Le parfait négociant ou instruction générale pour ce qui regarde le commerce des marchandises de France, & des pays étrangers* (Paris, 1675), 715–16.
[57] Matthee, *The Politics of Trade*, 192–202.
[58] Glamann, *Dutch–Asiatic Trade*, 120–1, 126.
[59] BL, IOR, E3/51/6065, Brangwin, Isfahan to London, 6 August 1695, unfol.
[60] Matthee, *Politics of Trade*, 244–5.

of the decorative silk for which a craze had developed in Europe. As mentioned above, from 1655 Bengal raw silk began to replace silk from Tonkin in the VOC shipments to Japan. From the 1680s onward, Bengal became the principal supplier of Asian raw silk to Europe as well, netting handsome profits and causing complaints from the Levant Company about the EIC's 'counterfeit raw silk' imports into England.[61] By that time, Indian suppliers had learned not to reel silk of varying fineness together on the same skein but to separate coarse and fine threads.[62] Especially the demand for the so-called *tanny* grade accelerated in the later part of the century. Whereas in 1676–7 the 81,501 pounds of Iranian silk sold in Amsterdam still dwarfed the 14,227 pounds originating in Bengal, as of the 1690s raw silk from Iran typically accounted for 6 per cent of sales in volume and 4 per cent in value, while Bengal silk comprised 88 per cent and 90 per cent, respectively.[63] At that time the *Heeren XVII* typically requested a minimal supply of Iranian silk – if Isfahan insisted on supplying anything at all – while demanding 100,000 pounds of Indian silk.

In keeping with trade patterns in an age when the slow pace of travel meant that supply and demand rarely matched, silk imports from Bengal were prone to dramatic swings. The Sobha Singh Revolt of 1695–6 caused a severe disruption in the silk trade of Kasimbazar, hampering exports until 1704. This, among other reasons, momentarily prompted the Dutch to turn again to Iran.[64] But, as mentioned previously, the Safavid court, faced with a silkworm disease in the Caspian provinces, did not supply any silk to the VOC for years after 1696, so that the Dutch sent ships to Bandar 'Abbas in vain for three consecutive years.

In response to these developments, and in order to conclude a new silk treaty with the shah, in 1701 the Dutch sent a new trade mission to Iran. Jacobus Hoogcamer (n.d.), the head of the mission, accomplished most of the things he set out to although he did not achieve the renewal of the contract stipulating silk at 44 tumans per load. The Iranians argued that they would not be able to sell their silk at that price because of the high mortality in the production area – most likely because of an outbreak of the plague. Shah Soltan Hoseyn (r. 1694–1722) ultimately gave the Dutch three choices: they could take silk at 48 tumans per load; they could pay 44 tumans per load and disburse an additional annual gift to the crown, orr they could go up to the silk-producing areas themselves, in which

[61] K. N. Chaudhuri, *The Trading World of Asia and the English East India Company, 1660–1760* (Cambridge, 1978), 346.

[62] *Ibid.*, 346–7.

[63] These figures appear in Prakash, *Dutch East-India Company*, 217–18.

[64] *Ibid.*, 217. For the vicissitudes of Kasimbazar as the principal silk market in Bengal in this period, see Rila Mukherjee, 'The "Small World" of the Silk Merchant at Kasimbazar, India', in Rila Mukherjee (ed.), *Networks of the First Global Age 1400–1800* (Delhi, 2011), 205–61.

case they would have to abide by a yearly quota.[65] The Dutch chose the second option, to pay the lower price for silk and to offer an additional gift, resolving to keep the latter as small as possible. The contract also contained a clause that stipulated that if the Dutch did not want any silk they would still have to offer gifts. Only if the shah did not offer any silk would they be exempted from paying this 'recognition'.[66]

The new contract resulted in the supply of fewer than 200 bales the next year, but did not herald the resumption of substantial silk sales to the Dutch. Neither did the mission Batavia sent to Isfahan in 1716, following more than a decade of mutual incriminations about the terms under which the VOC could trade in Iran, in the course of which the 1701 accord became moot. Joan Joshua Ketelaar (1659–1718), the head of the mission, managed to have the accord reactivated. However, Iranian silk, made expensive by many years of pestilence in the production area, remained scarce and out of reach for the VOC.[67]

The long-term trend is clear. By the early eighteenth century the VOC had all but given up on Iranian silk. Still formally tied to a contract with the Safavid state, the Dutch tried to minimise deliveries in some years, and were unable to procure any in others. This does not mean that no more silk from Iran arrived in Europe. Supplies from Gilan continued to arrive in the port cities of the Levant, destined for manufacturing centres in Western Europe. As late as 1715, purchases in Aleppo by the English Turkey Company included silk from Shirvan and Georgia, suggesting that the overland trade had never ceased to function and, indeed, outlived the maritime trade.[68] Yet in the 1720s, as Safavid state power was crumbling, Iranian silk still proved hard to sell in the ports of the Levant due to its high price and the competition it faced from silk originating in China and Bengal.[69]

CONCLUSION

The story of Asian silk exports to Europe in the seventeenth century is a good example of pre-modern trade occasionally becoming 'voluminous enough to push large regions toward economic integration and thus to shape economic and social

[65] François Valentijn, *Oud en nieuw Oost-Indien* (Dordrecht, 1727), v, 281.

[66] *Ibid.*, 279–84.

[67] Matthee, *Politics of Trade*, 212–18.

[68] G. B. Hertz, 'The English Silk Industry in the Eighteenth Century', *English Historical Review*, 24 (1909), 711.

[69] Neše Erin, 'Trade, Traders and the State in Eighteenth-Century Erzurum', *New Perspectives on Turkey*, 6 (1991), 132.

structures across the boundary lines of societies and cultural regions'.[70] Raw silk from Asia had been traded across the Eurasian continent since the beginning of the first millennium. The traffic in silk had always been land-based, though, and the so-called Silk Road it followed had never constituted an unbroken link between China and Europe. It took the participation of the European maritime companies for the trade in Asian raw silk to become truly hemispheric, multipolar and mutually competitive, and for it to reach European markets directly, and in a substantial volume and a relatively predictable manner.

In the early seventeenth century the EIC and VOC entered the Iranian market, interested in the country's silk exports and, in the case of the EIC, in the 'whole quantity of silk made in these kingdoms'.[71] While the English counted on paying for Iranian silk with English woollen cloth and Indian commodities, the Dutch, intent on including Iran in their complex intra-Asian commercial network, hoped to purchase silk in exchange for Indian and Far Eastern spices. These hopes were quickly dashed by a Safavid ruler who refused to sell his silk for anything but cash and who proved to be adept at playing both parties against one another as well as against his own Armenian merchants.

Before long, both companies found themselves exporting relatively large quantities of Iranian silk. But, chafing under the terms of their contract with the Safavid state and in particular its inelastic price structure, as well as unhappy with the quality of Iranian silk and the persistent logistical problems entailed in procuring it, they soon began to explore alternative sources. They found these in various East Asian locales, most notably China and Vietnam. It did not take long for Chinese and Vietnamese silk to outperform silk from Iran. The best grades from the Caspian provinces were of very high quality, used for brocades and exclusively processed to serve the needs of the royal court, whereas most Iranian silk was average to mediocre, best suited as 'sewing silk'. Remote in origin and fraught with politics, procuring Iranian silk from the outset was a complicated affair, making it rather unattractive and uncompetitive in comparison with silk from East Asia.

For a few decades the Dutch managed to conduct a lucrative trade in high-quality Chinese and Vietnamese silk in exchange for Japanese bullion. But eventually, these alternative sources also became hugely problematic. As China descended into civil war in the 1640s and fierce competition cost them business in China, the Dutch substituted Chinese silk with Vietnamese silk. But before

[70] Jerry L. Bentley, 'Cross-Cultural Interaction and Periodization in World History', *American Historical Review*, 101 (1996), 754.

[71] William Foster (ed.), *Letters Received by the East India Company from Its Servants in the East*, vol. 5, *1617* (London, 1901), 35, 37, Connock, Persian Court to London, 4 August 1617.

the decade was out, relations between the VOC and the Vietnamese authorities soured. Even when they improved, political unrest and natural disaster caused prices to skyrocket, thus reducing the attractiveness of silk from Tonkin. Meanwhile, the Japanese imposed increasingly onerous restrictions on foreigners operating in their territory. Dutch commercial fortunes were dealt a final blow when, in 1662, Formosa fell to the Qing dynasty.[72]

This adversity in East Asia should have made Iran attractive again. Yet, instead of redoubling their efforts to acquire silk from the shah, the companies now turned to India. The EIC gave up on Iranian silk altogether in the early 1650s, to focus exclusively on Bengali silk. The VOC, more vested in the Iranian market beyond silk and tied to the Safavid court with a contract that made trading rights and privileges conditional upon the purchase of silk at fixed prices, continued to operate in Iran. Yet the Dutch, too, increasingly turned to higher quality, cheaper, more reliable silk from Bengal. The result was a steadily diminishing Western dependence on Iranian raw silk.

In the long term, the trade in Iranian silk was an interlude, a period 'when European manufacture had outgrown its own raw silk supplies, but before it had established firm control over overseas sources'.[73] The story of that control would play itself out in India, and it would be the English rather than the Dutch who secured it. The English were the ones who most successfully operated in eighteenth-century India, so that the 'Bengal silk trade enabled [them] to forge ahead in the 1730s after a century of struggle'.[74]

[72] Blussé, 'No Boats to China', 72–3.
[73] Edmund Herzig, 'The Iranian Raw Silk Trade and European Manufacture in the Seventeenth and Eighteenth Centuries', *Journal of European Economic History*, 19 (1990), 89.
[74] Holden Furber, *Rival Empires of Trade in the Orient, 1600–1800* (Minneapolis, 1976), 245.

4.

The Localisation of the Global:
Ottoman Silk Textiles and Markets, 1500–1790

Amanda Phillips

In the year 1650 in the Ottoman town of Bilecik in western Asia Minor, a man registered a complaint about a neighbour's unpaid debt at the sharia court.[1] The plaintiff testified to the collateral: ten pairs of cushions made of *çatma* (voided and brocaded figured velvet). Accordingly, the scribe recorded their respective values: five pairs worth twenty-eight pieces of silver, four pairs worth twenty-seven, and a single pair worth eighteen. This dispute between neighbours unites several elements which demonstrate several of the many facets of the making, selling, and buying of silk luxury textiles in the Ottoman empire. It illuminates the presence of various types of luxury silks and their various uses, including their role as household goods, alludes to the diverse qualities of textiles and their respective prices, and suggests the primary roles of Bilecik and its larger neighbouring city, Bursa, in the economy of silk and silk fabrics. The document itself – and its presence in a ledger which contains hundreds of cases which attest to the legal and material circumstances of the city – also shows how the massive legal apparatus of the empire interacted with textiles and markets, which were themselves part of a much wider world, extending from western Europe to South Asia and beyond.

This article, covering the period from around 1500 to 1790, reviews and complements evidence and arguments about Ottoman silk textile production and consumption made elsewhere, while also advancing new research and a suggestion for new methodologies. In doing so, it considers the consumption of luxury silks, here defined as compound weaves including *ḳaṭīfe* (plain velvet), *çatma* (voided and brocaded figured velvet), *kemḫā* (lampas with gilt brocading threads), *sīreng*

[1] Nalan Kılıç, '1650 Yılında Bursa (B 87 Nolu Mahkeme Siciline Göre)' (unpublished Master's thesis, Uludağ University, 2005), 169.

(lampas without gold brocading threads), *serāser* (a taqueté weave often referred to as cloth-of-gold), and contrasts those with *aṭlas* (satin) and *tafta* (taffeta, sometimes pure silk and sometimes a silk-and-cotton blend), and disaggregates both categories from the trade and use of plain, lightweight silks, while also comparing their consumption with that of substitutes, whether wool, fur, or mohair. My approach is both thematic and chronological, in order to integrate different types of sources and make sense of the shifting priorities of Ottoman merchants, weavers, and consumers, as well as those writing their histories. To accomplish this, the first part surveys some of the major narratives that have shaped the study of Ottoman silk production, the debates in the field, and the preoccupations of its scholars. In the second part, I analyse silk trading and weaving in view of luxury silk sales in the Ottoman and Italian polities of the eastern Mediterranean, clarifying the nature of that exchange in the late fifteenth and sixteenth centuries and scrutinising changes in consumption and fashion. The third part looks at Ottoman consumers, empire-wide; here, I suggest that shifts in consumption of luxury textiles impacted on the long-term survival of silk weaving in western Asia Minor, specifically in the city of Bursa. In conclusion, this essay considers the disappearance of all luxury silks except *çatma* from households in the eighteenth century, and looks at a possible case of import substitution, thus shifting the narrative east to the Indian Ocean.

OTTOMAN SILKS AND SCHOLARSHIP: STATE OF THE FIELD

Since the early days of the Turkish Republic (founded in 1923), scholars from Sarajevo to Baghdad to Britain have been mining the state and palace archives in Istanbul, correspondence and records held in Venice, Florence, and Genoa, accounts from Iran and India, and sources in Cairo, Damascus, Aleppo, and Greece for information about the nature of the Ottoman silk trade, as well as working in collections held at museums from North America to the Middle East. The geographical breadth of the sources and the numbers of scholars involved mirror the vast scope of the production, trade, and consumption networks common to most silk economies in the early modern era. The number of resulting studies is large and only a few key examples can be provided here.

Scholarship in English or French may be better known to European and North American audiences, but works in Turkish include some of the earliest and most substantial contributions, perhaps most importantly Fahri Dalsar's *Bursa'da İpekçilik* (1960).[2] The consumption and trade of silk is also addressed,

[2] Fahri Dalsar, *Bursa'da İpekçilik: Türk Sanayı ve Ticaret Tarihinde* (Istanbul, 1960) is chief among them, providing 322 documents about the silk trade and weaving gathered from court registers, palace correspondence, imperial orders and other sources.

if obliquely, in the hundreds of documents published in the journal *Belgeler*: palace ledgers, estate inventories, documents about trade with Venice and other polities – often printed in Latin transliteration – have proved extraordinarily useful sources for the social and economic historian. Other studies have incorporated documents about weaving, its products, and its legislation,[3] or tackled long-distance trade with India, greater Syria, Arabia, Russia, and the eastern Mediterranean,[4] or looked at the role of artisans in the silk industry in the city of Bursa.[5]

Several economic historians have focused on silk prices and specifically on how merchants and weavers in Bursa reacted to the vagaries of silk supply – chiefly reeled silk from northwest Persia, competition for that same silk on the part of Italian and French merchants, and the economic crises that marked the late sixteenth century. Dalsar was the first to suggest that the production of silk fabric in Bursa waxed and waned depending on the amount of reeled silk purchased by Frankish merchants, which in turn might have limited the quantity available to Ottoman artisans. This issue in particular was taken further in the 1980s by several other historians, especially those addressing the empire's place in the world economy.[6] Although interest in this debate may have faded, its legacy has impacted perceptions of Ottoman weaving, which is sometimes unfavourably compared with its counterparts in Italy and Iran. Until the late twentieth century, the related notion of 'decline' was inherent to many studies of the Ottoman empire and is only now slowly disappearing from historical debates.[7]

Art historical treatments of silk fabrics have an equally long history, in both Turkish and English.[8] The most recent large-scale work on Ottoman silks,

[3] Halil İnalcık, 'Harir', *Encyclopedia of Islam* (Leiden, 1971), iii, 213.

[4] Halil İnalcık, 'Bursa and the Commerce of the Levant', *Journal of the Economic and Social History of the Orient*, 3/2 (1960); here, he confines himself to the fifteenth century. Suraiya Faroqhi, 'Bursa at the Crossroads: Iranian Silk, European Competition and the Local Economy, 1470–1700', reprinted in Suraiya Faroqhi, *Making a Living on the Ottoman Lands, 1480 to 1820* (Istanbul, 1995).

[5] Suraiya Faroqhi, *Artisans of Empire: Crafts and Craftspeople under the Ottomans* (London, 2009).

[6] Ömer Lütfi Barkan, 'The Price Revolution of the Sixteenth Century: A Turning Point in the Economic History of the Near East', *International Journal of Middle East Studies*, 6/1 (1975); Murat Çizakça, 'A Short History of the Bursa Silk Industry (1500–1900)', *Journal of the Social and Economic History of the Orient*, 23/1–2 (1980); and chapters in Huri İslamoğlu-İnan (ed.), *The Ottoman Empire and the World Economy* (Cambridge, 1987).

[7] It still haunts the field of art history. See Amanda Phillips, 'The Historiography of Ottoman Velvets, 2011–1572: Scholars, Craftsmen, Consumers', *Journal of Art Historiography*, 6 (2012).

[8] Tahsin Öz, *Türk Kumaş ve Kadifeleri* (Istanbul, 1946); Öz, *Turkish Textiles and Velvets, XIV–XVI Centuries* (Ankara, 1950). The palace collections also inspired the publication of several more catalogues in the following decades.

İPEK, has followed an earlier approach used by Tahsin Öz, who was one of the first curators of the then newly-created Topkapı Palace Museum, for which he combined written records with extant fabrics to trace the history of weaving practices.[9] The book, written by four experts and edited by two more, mines Dalsar's work to provide a historical context for how the silk industry worked in Bursa and Constantinople; it also investigates the extensive use of silks by the sultan and his retinue and provides a wealth of new information about trade with the Russian court. Several more works from recent decades have focused on specific types of silks at the Topkapı Palace: one on garments and another on upholstery.[10] The consumption of luxury silks outside the palace, however, has not yet attracted an equal amount of attention.[11] Studies about household goods in Ottoman Damascus are somewhat further along due to three works by a team of French scholars working with inheritance inventories and other archival sources; the last in this series, *Des tissus et des hommes* (2005) addresses textiles, though it focuses mainly on merchants and artisans.[12] A single exhibition catalogue, *Çatma & Kemha*, considers several important later Ottoman objects, both imperial and otherwise.[13]

Despite decades of scholarship and groundbreaking publications, significant lacunae persist. Most works, and especially those using extant fabrics as sources, focus on silks in the late fifteenth and sixteenth centuries. Similarly, art historical works also tend to confine themselves to this period, in part because it is considered an apogee of aesthetic achievement. The same era is also the most extensively explored in terms of contact between the Ottomans and the Italian city-states, with special attention paid to Venice. Social and economic historians often extend their attention to the mid seventeenth or eighteenth century, but secondary literature on luxury textiles themselves in this period is lacking, perhaps because primary sources are less well known and less published. The

[9] Nurhan Atasoy, Walter B. Denny, Louise Mackie and Hülya Tezcan, *İPEK: The Crescent and the Rose, Imperial Ottoman Silks and Velvets* (Istanbul and London, 2001) provides an in-depth survey of extant Ottoman silks from the sixteenth and seventeenth centuries, including an important section on those which may be firmly dated.

[10] Several works – including unpublished theses – address luxury consumption in general; a forthcoming volume will do the same. Ahmet Ertuğ, Patricia Baker, Hülya Tezcan and Jennifer Wearden, *Silks for the Sultans: Ottoman Imperial Garments from the Topkapı Palace* (Istanbul, 1996); Hülya Tezcan and Sumiyo Okumura, *Textile Furnishings from the Topkapı Palace Museum* (Istanbul, 2007).

[11] Donald Quataert (ed.), *Consumption Studies and the History of the Ottoman Empire, 1550–1922* (Albany, 2000).

[12] Colette Establet and Jean-Paul Pascual, *Des tissus et des hommes, Damas vers 1700* (Damascus, 2005).

[13] Hülya Bilgi, *Çatma & Kemha: Ottoman Silk Textiles* (Istanbul, 2007).

uneven treatment may be due in part to gaps in the sources, and from the less than perfect survival of these later textiles themselves, but may also result from the flow of scholarly attention toward the oceanic connections of the seventeenth and eighteenth centuries, during which the Ottomans and their silks seem to have remained land-locked.[14]

SILK THREAD, SILK FABRIC:
EASTERN MEDITERRANEAN TRADE, 1500–1750

In the eastern Mediterranean, the markets and economies for silk thread and silk fabric followed different logics and forces. Scholarship considers the period between 1300 and 1550 a time of brisk commerce, mainly for Persian reeled silk and Italian silk fabrics.[15] Trade continued largely unabated, and even unchanged, as the city of Bursa became Ottoman in 1326 and Constantinople followed in 1453. Despite political ruptures, routes from the silk-producing regions of northwest Iran which passed through Trebizond were re-established, new routes via Erzincan, Ankara, and Bursa were given precedence by the Ottoman authorities, and routes via Mamluk Aleppo and Damascus continued unimpeded.[16] Tax revenues on reeled silk contributed significantly to the Ottoman treasury. The same may be said for the importation of Italian cloth, both silk and wool. A series of laws issued in the period of Sultan Mehmed II (r. 1444–46, 1451–81) addressed custom duties and the regulation of Frankish and Ottoman Muslim, Jewish and Christian merchants, all of whom were trading fabrics, silks, and spices in the Marmara region and beyond.[17]

[14] Faruk Tabak, *The Waning of the Mediterranean, 1550–1870: A Geohistorical Approach* (Baltimore, 2008).

[15] The best-known source is Giacomo Badoer, *Il Libro dei Conti di Giacomo Badoer (Constantinapoli 1436–40)*, ed. Umberto Dorini and Tommaso Bertelè (Rome, 1956). Badoer (died c. 1445) was a Venetian merchant in Constantinople; his transactions, recorded in several ledgers, involve not only his Ottoman and Byzantine counterparts, but also those from Florence, Genoa, and Iran.

[16] Luca Molà, *The Silk Industry of Renaissance Venice* (Baltimore and London, 2000), 57; David Jacoby, 'The Silk Trade of Late Byzantine Constantinople', in *İstanbul Üniversitesi 550. yıl, Uluslararası Bizans ve Osmanlı Sempozyumu (XV. Yüzyil): 30–31 Mayıs, 2003* (Istanbul, 2004), 129–44.

[17] Robert Anhegger and Halil İnalcık (ed.), *Ḳānūnnāme-i Sulṭānī Ber Mūceb-i ʿÖrf-i ʿOsmānī: II. Mehmed ve II. Bayezid Devirlerine ait Yasaḳnāme ve Ḳānūnnāmeler* (Ankara, 1956), 40–1, 47–8. The Ottoman adjective for the western European nations is 'Frankish' (*efrenc* or *firengī*). It is a general designation and is sometimes used alongside more specific geographical terms. It is used in the same way in this paper; see James Redhouse, *A Lexicon, Turkish and English* (London, 1884) for a basic definition.

Scholars who have discussed the eastern Mediterranean trade in reeled silk and silk textiles in the European medieval and Renaissance periods have pointed to the outposts of Genoa in the Black Sea, Florence in Athens, Venice in the Peloponnese, Crete, and Cyprus, all of which attest to the city-states' commitment to exchange with west Asian markets. Their reach peaked in the fourteenth and fifteenth centuries. The nature of trade shifted somewhat as the Ottomans slowly gained control of most Latin strongholds, as well as Mamluk territories in Syria and Egypt.

In the western Ottoman empire, Bursa and Constantinople were both centres for the trade of silk thread and fabrics, each with a scale for weighing goods and collecting dues and each with a *bedestan* (a large, enclosed, and secure market space) where traders could sell and store valuables. Both cities also hosted Frankish merchants who had settled there.[18] During the sixteenth century, a series of wars between the Ottomans and their Safavid rivals in Iran occasionally halted the transport of high-quality reeled silk, which was prized by both Ottoman and Frankish traders, from the Caspian provinces of Gilan and Mazandaran.[19] Sultan Selim I (r. 1512–20) enacted punitive embargoes on Iranian silk, but the resulting decrease in tax revenue prevented this from becoming long-term policy.[20] Silk trade and textile production in the eastern Mediterranean from the late sixteenth to the eighteenth century is much less discussed, as noted above, but both persisted and, according to some accounts, grew. Abundant records of reeled silk coming from Mount Lebanon to Bursa suggest a corresponding growth in textile making.[21] Ottoman artisans continued their silk weaving, invented new styles, and innovated new structures. As they had done all along, weavers reacted to changes in fashion and taste and altered their production in response to the new popularity of fabrics arriving from France, Iran, and especially, India.

Efforts to understand the trade in silk and cloth in any period are plagued by problems of ambiguous terminology and resulting misinterpretation. Incautious or perhaps optimistic translation may be at fault for some confusion; scholars have been eager to make Ottoman luxury silks part of an equal exchange of commodities. This problem is compounded by two related Ottoman terms, *akmişe* and *kumāş* (fine stuff), which can refer to any luxury textile: silk, wool, mohair, or even cotton, but are sometimes too narrowly translated into English

[18] Halil Sahillioğlu, 'Bursa Kadi Sicillerinde İç ve Dis Ödemeler Aracı Olarak 'Kitābü'l-Kadi' ve 'Süftece'ler', in Osman Okyar (ed.), *Türkiye İktisat Tarihi Semineri Metinler* (Ankara, 1975), 105.

[19] İnalcık, 'Harir'.

[20] Atasoy et al., *İPEK*, 156.

[21] Çizakça, 'A Short History'; Donald Quataert, 'The Silk Industry of Bursa, 1880–1914', in İslamoğlu-İnan (ed.), *The Ottoman Empire*.

as 'silk'. In this rendering of the term, the regulations governing the taxation of Frankish and Ottoman merchants seem to imply that the Franks were buying Ottoman silk textiles.[22] Scholars using these records and referencing the ledgers of Giacomo Badoer (d. after 1445?), for instance, write that merchants traded both Frankish and Ottoman fabric from Bursa to Edirne and Constantinople and occasionally beyond. Some writers have further inferred from the sources that the traders might have brought Ottoman luxury textiles back to Venice and sold them on the Italian market.[23] Closer scrutiny might instead reveal that the fabric was sold and resold within the Ottoman lands, or moved on to Damascus, Cairo, or even Cyprus.[24] Rarely did it reach Italy or western Europe.

In fact, Italian states and elites in Venice at times discouraged the importation of Ottoman silk fabric, albeit with mixed success.[25] Two even more powerful deterrents to the sale and purchase of Ottoman goods in Italy were related to one another. Italian consumers favoured readily available luxury silks from Venice, Genoa, Lucca, and Florence, expressly tailored to local and less-local budgets and tastes, over the heavy compound luxury silks from Ottoman Bursa or Constantinople, and, equally important, other commodities provided better exchange-value.[26] Badoer's ledger mentions pepper, cloves, and thread. In the late fifteenth century, Florentines in Bursa traded pepper and reeled silk, while local Ottoman and occasionally Persian merchants dealt in silk textiles.[27] And Genoese and Florentine documents mention wool-pile carpets and mohair or camlet – both of which were luxury goods made exclusively in the Middle East, neither of which had an Italian equivalent, and both of which are likely to be described as *akmişe* or *kumāş* in the Ottoman documents.[28] This situation remained largely unchanged at the turn of the sixteenth century, when Medici merchants in Constantinople exchanged woollens and small quantities of silk textiles for reeled

[22] Anhegger and İnalcık, *Ḳānūnnāme*, 40–1, 47–8.

[23] Kate Fleet, *European and Islamic Trade in the Early Ottoman State: The Merchants of Genoa and Turkey* (Cambridge, 1999), 95–111. Fleet writes, 'Expensive fabrics were imported into Anatolia which, in turn, was a producer and exporter both of raw materials and of expensive, worked tissues', 97.

[24] Şerafettin Turan, 'Venedik'te Türk Ticaret Merkezi', *Belleten*, 32/125–8 (1968); Cemal Kafadar, 'A Death in Venice (1575): Anatolian Muslim Merchants Trading in the Serenissima', *Journal of Turkish Studies*, 10 (1986).

[25] Molà, *Silk Industry of Renaissance Venice*, 262.

[26] *Ibid.*, 299.

[27] Sahillioglu, 'Bursa kadi', 108–09, 137–39; Halil Inalcık, 'Sources for Fifteenth-Century Turkish Economic and Social History', reprinted in Halil Inalcık, *The Middle East and the Balkans under the Ottomans* (Bloomington, 1993), 177–93.

[28] Badoer, *Il Libro*; Fleet, *European and Islamic Trade*. See also, Gertrude Randolph Bramlette Richards (ed.), *Florentine Merchants in the Age of the Medici* (Cambridge, MA, 1932).

silk, camlet, occasionally pepper, rhubarb, and pharmaceuticals as well as cash.[29] The accompanying letter from one of their factors captures the situation: as a special, personal commission, he sent two fine white camlets, a small carpet from Trebizond, and a single piece of silk cloth from Bursa, and advised the recipient to evade the tax authorities in Florence.[30] Carpets, mohair, spices and reeled silk found a ready market and fetched tidy profits and, unlike luxury silks, did not have to contend with local competition or import bans. Ottoman luxury silks were simply not exported to Italian cities in any substantial volume, though lighter weight silks such as *ormesini* and *ṣandāl* were, as Luca Molà has shown.[31]

The fact that few Ottoman luxury silks made their way to western Europe suggests that we should discard the idea that a shared textile aesthetic meant a vigorous and even trade of like objects. The acknowledgment that Ottoman luxury silks were not consumed in Italy also has historiographical importance for scholars researching the *longue durée*. This is because Ottoman silk textile production in the seventeenth and eighteenth centuries is often described as a pale reflection of its early glory (c. 1450–1590), during which time luxury fabrics made in Bursa and Constantinople were sought by traders and in turn by markets in Florence, Venice, and Persia.[32] The realisation that this narrative is largely a fiction neutralises one of the calumnies about later Ottoman silks because it shows that even during the heyday of the fifteenth and sixteenth centuries, most Ottoman weavers were working for the Ottoman sultan and for their own fellow subjects rather than for discerning markets abroad.[33]

INTERNATIONAL AND OTTOMAN TASTE AT THE COURT AND IN CONSTANTINOPLE, 1453–1600

Italian luxury silks, mostly from Venice and Florence, caught the Ottoman imagination and the eye of merchants like Badoer as well as sultans and their

[29] Maringhi's inventory, made on his bankruptcy in 1506, includes narrow-width silk textiles: satins, damasks, velvets, and brocades. Richards, *Florentine Merchants*, 189–90.

[30] Richards, *Florentine Merchants*, 62.

[31] Molà, *Silk Industry of Renaissance Venice*, 405. Atasoy et al. have also made this point, *İPEK*, 155.

[32] Much has been made of the presence of Bursa velvets at the palace of Shah Ismail in Tabriz during its sack by Sultan Selim I in 1514, but it is likely that they arrived there as part of a gift exchange rather than as objects of trade; Atasoy et al., *İPEK*, 161. A number of Ottoman luxury silks are found in the treasury of San Marco in Venice, because it was the repository for Ottoman diplomatic gifts, which again attests to diplomatic gift-giving rather than large-scale trade.

[33] The Ottomans sold a sizeable but not overwhelming number of silk fabrics, and velvets especially, to Poland and Russia, starting in the sixteenth century; see Suraiya Faroqhi's chapter in this volume; also, Atasoy et al., *İPEK*, 176–81; Dalsar, *Bursa'da İpekçilik*, 189–95.

vast households, as palace account books from the fifteenth and early sixteenth century verify.[34] Some of the earliest surviving Ottoman luxury textiles display a pan-Mediterranean aesthetic, which employs several layers of scrolling foliage, embellished with motifs of crowns, pomegranates and serrated leaves (Illustration 4.1). The palette is often deep red with gold accents in the form of brocading wefts (for *çatma* and *kemhā*) made of a very thin piece of flattened silver wire wound around a silk core. Technical similarities include the use of a five-end satin as the foundation for both *çatma* and *kemhā*, which is also found in the Safavid equivalents. Subtle differences in format and arrangement of motif as well as several technical features set the two types of textiles apart: Italian silks used several types of metallic thread (including purled or looped thread). Some Italian velvets, specifically, had two heights of pile in a single object as well as areas of uncut pile.[35] Ottoman velvets, without any known exception, however, employ a single height of pile, which is always cut.

Ottoman documents usually differentiated between local and imported silks. The palace consumed Frankish silks (often Florentine) in large quantities. Sixteenth- and early seventeenth-century ledgers reveal that the court most often ordered velvets (*çatma* and *kaṭīfe*) from Bursa, but favoured pricier Frankish *kemhā*.[36] In a representative instance from 1601, the palace ordered sets of cushions and pillows made of Bursa *çatma* and Frankish *kemhā*, both designed for use in one of the small pavilions on the palace grounds. The palace and members of the Ottoman elite also placed orders for bespoke Venetian fabrics, as in the case of Rüstem Pasha (d. 1561), who requested cushions for his daughter's dowry. The Queen Mother Nurbanu Sultan (d. 1583) asked for a new type of silk cushion and apparently provided a design, which has now been lost.[37]

Outside the palace, luxury silks became a part of the larger sphere as they were increasingly purchased by wealthy households in major cities. By the end of the 1480s, wealthy men and women in Bursa, including weavers, already owned sumptuous garments, some made of *kaṭīfe*, *çatma*, *kemhā* and *tafta*. In the first half of the sixteenth century, varieties of heavy-weight *çatma*, *kemhā*, *atlas*, and *dībā*, as well as *bürümcek* (a type of gauze) and *tafta* at a range of prices from different workshops and cities appear in estate inventories from Thrace and western Anatolia. A textile dealer in Edirne (d. 1548), whose shop was located

[34] See note 16 for Badoer and his ledgers. Ömer Lütfi Barkan, 'İstanbul Saraylarına ait Muhasebe Defterleri', *Belgeler*, 9/13 (1979), 298–380.

[35] It is likely that such Italian velvets also reached Asia. See Angela Sheng's chapter in this volume.

[36] Barkan, 'İstanbul Saraylarına', 15–18.

[37] Turan, 'Venedik'te', 252; Amanda Phillips, 'A Material Culture: Ottoman Velvets and their Owners, 1600–1750', *Muqarnas*, 31/1 (2014), 151–72.

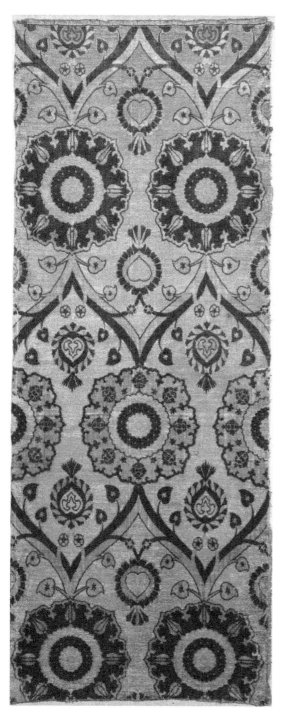

Illustration 4.1
Ottoman voided and brocaded
silk velvet (*çatma*) length,
c. 1550–70. Victoria & Albert
Museum, inv. 145-1891.
© Victoria and Albert
Museum, London.

in the cloth market, left rose-coloured *kemḫā* from Bursa and four garments of the same material, crimson Frankish *çatma* with two levels of pile, black *tafta*, *kaṭīfe*, another kind of *çatma*, and Persian *kemḫā* as well as other wool, cotton, and mohair textiles.[38] However, even the wealthiest Ottoman subjects found it beyond their means to imitate the palace's taste for costly Frankish *kemḫā* which by 1553 cost 400 silver pieces per bale, as opposed to 315 for local *kemḫā*, albeit this was made of 'broken' silk.[39] Frankish *çatma* is found in small quantities at astronomical prices compared with other silk textiles and wool-pile carpets.[40]

The use of both Frankish and local luxury silk textiles is only one example of another characteristic of Ottoman households at the turn of the seventeenth century – their concentration of goods from distant places. Wealthy men and women in the larger cities filled their homes with Chinese porcelain, Hungarian silver, Persian embroidered felts, and Italian, French, and English woollens.[41] In terms of textiles, large wool-pile carpets, often from Cairo, were often the most expensive. Felt floor-coverings worked with gold or coloured silk were also extraordinarily valuable, as estate inventories attest. Luxury silks were most often used for quilts and for cushions, including those in the widespread and enduring *çatma* format, which had a series of small lappet motifs at each end. Elegant variety, above all, marked the estates of the very richest: mohair, *serāser*, and *aṭlas* were among the diverse elements in the assortment of objects found in a well-appointed residence.

Estate inventories do not reflect how the styles of luxury silks changed, however. In the mid sixteenth century, the palace initiated a shift in imperial style, and the new and distinctively Ottoman idiom emerged in the arts, spanning architecture, architectural decoration, ceramics, manuscript painting and illumination, and, of course, textiles. Designers worked in palace workshops, sending cartoons, sketches, and even stencils to guide artisans working in craft centres across western Asia Minor. Architectural historian Gülru Necipoğlu, who has written extensively about the change, notes correspondence between

[38] Ömer Lütfi Barkan, 'Edirne Askeri Kassamına ait Tereke Defterleri', *Belgeler*, 3/5–6 (1966), 91–3. The records mention a wealth of Iranian and Indian textiles, as well as many which cannot be linked with a place of production.

[39] Murat Çizakça, 'Sixteenth–Seventeenth Century Inflation and the Bursa Silk Industry: A Pattern for Ottoman Industrial Decline' (unpublished Ph.D. thesis, University of Pennsylvania, 1978), Table 11, 157.

[40] Barkan, 'Edirne Kassamına', 136.

[41] Suraiya Faroqhi, 'The Material Culture of Global Connections: A Report on Current Research', *Turcica* 41 (2009), 401–31. Amanda Phillips, *Everyday Luxuries: Art and Objects in Ottoman Constantinople, 1600–1800* (Dortmund, 2016).

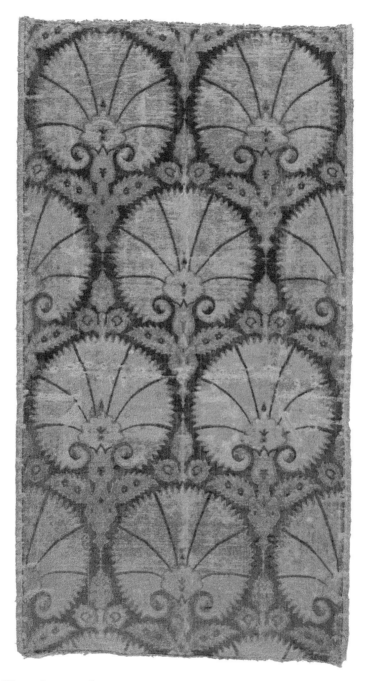

Illustration 4.2 Ottoman voided and brocaded silk velvet (*çatma*) length,
c. 1570–1600. Washington, DC, Textile Museum, inv. 1.52.

palace designers and textile workers in Bursa.[42] Conforming to this new imperially mandated style, silks from the second half of the sixteenth century, and *çatma* most especially, abandoned the curvilinear forms and layered ogives of earlier decades, replacing them with bold and isolated motifs that exploited and emphasised the mirror symmetries and repetitions made possible by the use of a drawloom and pattern-harness (Illustration 4.2). Each of the expensive figured silks (*çatma, kemḫā, serāser, sīreng*) had some degree of success in capturing the new decorative idiom. *Çatma*, above all, was especially suited to its aesthetic requirements. At the same time, though, the older models persisted, as seen in both extant objects and in other visual sources. Taste and patterns of consumption would change once again in the early decades of the seventeenth century, however, and even more radically a century after that.

AFFORDABLE SILKS ACROSS THE EMPIRE, 1600–1750

The same dispute between neighbours in the city of Bilecik in 1650 – an unpaid debt for which *çatma* cushions had been offered as a guarantee – exemplifies a long-term shift in the production and consumption of Ottoman silk textiles. Compiled in terse, pro-forma language, the document does not reveal why some of the *çatma* cushions were valued at more than others (at twenty-eight, twenty-seven or eighteen silver pieces), especially the last pair, which were expected to fetch a significantly lower price than their counterparts. Nor does it explain why these goods, and only these goods, were left as surety to begin with. Both omissions encourage us to consider three phenomena which characterise the Ottoman silk economy in the later seventeenth century and eighteenth centuries: (1) diversified quality of luxury silks, as represented in the prices mentioned in the court case; (2) disappearance of *çatma* in any format than that which was designed specifically for cushions; and (3) a shift in cushion styles themselves. The almost total absence of other luxury silk textiles (*kemḫā, sīreng* and *dībā*) and even the lesser *aṭlas* and *tafta* from records in the last part of the seventeenth and the eighteenth centuries may not be seen in this court case, but is evident in other documents and may in part be linked to the popularity of *çatma* cushions, the manufacture of which apparently eclipsed that of other weave structures.

[42] Dalsar, *Bursa'da İpekçilik*, 60; Gülru Necipoğlu, 'A Kanun for the State, a Canon for the Arts: Conceptualizing the Classical Synthesis of Ottoman Art and Architecture', in Gilles Veinstein (ed.), *Soliman le Magnifique et son temps* (Paris, 1992), 195–216.

In 1640, the sultan and his deputies issued a long list of fixed prices (*narḫ*) for a variety of goods and services available in Constantinople, including textiles.[43] The list was meant to protect consumers from unscrupulous merchants or extortionate service-providers. The list also set exacting – if difficult to enforce – standards for handicrafts including thread counts and thread qualities and materials for a number of categories of silk textiles. Several types of silk textiles came in three qualities (medium, high and very high): *serāser*, quilts made of two different kinds of *çatma* from Bilecik, crimson *çatma* cushions with or without decoration, both from Bursa, and Frankish figured *aṭlas*.[44] The origin was important: Constantinople produced only one quality of *çatma*, exceptionally heavily brocaded, which achieved parity with its Venetian equivalent. Crimson Frankish *kaṭīfe* was the most expensive in all categories, which echoes the high prices recorded a century earlier in the palace account books. Despite its unparalleled length, the 1640 *narḫ* list was not comprehensive, especially in terms of the qualities given. Extant Ottoman silk textiles from the mid seventeenth century show much more variety in thread counts, thread materials, and sizes than those permitted in the document.[45] Weavers also manipulated the number of colours, thread material and type, and amount of brocading weft thread in order to create less costly objects that maintained some of the éclat of their more luxurious counterparts.

The weavers of *çatma*, in particular, were adept at economising.[46] This cloth in its popular cushion-cover format makes an excellent test case for evaluating the consumption of luxury goods because it is easy to link the object and its written descriptor (*çatma yaṣdık yüzü*) and because both extant examples and records abound. Judging from a large sample of estate inventories, in 1740 the slightly less wealthy elites in the Ottoman city of Edirne possessed a greater number of these *çatma*s than their wealthier peers, but the men valuing the estates gave the *çatma*s owned by the more modest individuals a lower price. Their range of prices also increased. Extant *çatma*s, held in large numbers at the Victoria and Albert Museum and elsewhere, include examples which fall far short of the standards set and implied by the *narḫ* list and by standards set by the weavers themselves, which were sometimes registered at the sharia court. More importantly, the limited aesthetic success of their motifs and patterns, their size, and

[43] Mübahat S. Kütükoğlu, *Osmanlılarda Narh Müessesesi ve 1640 tarihli Narh Defteri* (Istanbul, 1983).

[44] *Ibid.*, 120–21, 172–76.

[45] Atasoy et al., *İPEK*, 323–40, give data for about thirty; dozens of documents attesting to quality regulation and its transgression are given in Dalsar, *Bursa'da İpekcilik*.

[46] See also, Phillips, 'A Material Culture'.

the disposition of the different colours of thread in these *çatma*s indicate that they were purposefully designed for men and women of more modest means.

The evident increase in the availability of all manners and prices of *çatma* cushions in the eighteenth century has a corollary in the decrease in other types of luxury silks available, apparent in both estate inventories and in extant textiles. Both *katīfe* and *çatma* in other non-cushion formats are absent from inventories of the 1740s. Turbans, quilts, horse-trappings and kaftans made of both types of silk appear in concentrations in the first half of the seventeenth century and on into the 1660s but decrease in numbers from the late seventeenth century onwards. *Kemhā* and *sīreng* also drop out of estate inventories and *aṭlas* becomes more scarce.[47] Extant objects suggest *serāser* weaving continued; much of this was probably commissioned or at least purchased by the palace, as this weave was often used for robes-of-honour.[48]

A set of estate inventories from the last decade of the eighteenth century made for a relatively elite tranche of Constantinopolitan subjects confirms the shift; *çatma* cushions are listed in entries that include other upholstered items such as quilt and mattress covers, bolsters, and other objects, all made of wool broadcloth rather than matching *çatma* or other silk fabrics.[49] The *çatma* cushion cover survived, and apparently thrived, while other upholstery uses of *çatma* did not. The same records suggest that the weaving of *bürümcük* continued and perhaps even increased. It was often used in clothing, and fashions also changed in the period around 1720, and again in subsequent decades.[50] Faroqhi has suggested that the weavers of Bursa, perhaps responding to demand, were able to survive and even redeem their livelihood by focusing on *çatma* cushion covers and *bürümcük*.[51]

The cushion cover's success as a pan-Ottoman luxury good may have been a result of its changing style as well as its wide range of qualities and price-points. As noted above, around 1560, a more Ottoman idiom had replaced the earlier Renaissance aesthetic in silk textiles as well as in other decorative arts. Characterised by rows of bold motifs and stylised blossoms, the style

[47] Records from a ledger made in Constantinople, 1700–01; Birol Çetin, 'Istanbul Askeri Kassamı'na Ait Hicri: 1112–1113 (M. 1700–1701) Tarihli Tereke Defteri' (unpublished Master's thesis, Istanbul University, 1992); a court case from Bursa in 1650 also confirms their existence, Dalsar, *Bursa'da İpekcilik*, 330.

[48] Amanda Phillips, 'Ottoman *Hil'at*: Between Commodity and Charisma', in Marios Hadjianastasios (ed.), *Frontiers of the Ottoman Imagination: Festschrift for Rhoads Murphey* (Leiden and Boston, 2014).

[49] Hasan Akdağ, 'Kassam Defteri (Havass-i Refi'a Mahkemesi 272 Numaralı, 1204–1206/1789–1791 Tarihli)' (unpublished Master's thesis, Istanbul University, 1995), 9, 41, 116, 147.

[50] Phillips, *Everyday Luxuries*, Chapter Four.

[51] Faroqhi, *Artisans of Empire*, 171.

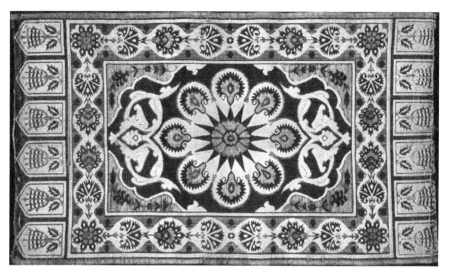

Illustration 4.3 Ottoman voided and brocaded silk velvet
(*çatma*) cushion cover, c. 1625–75. Victoria & Albert Museum,
inv. 4061-1856. © Victoria and Albert Museum, London.

was immediately identifiable with a courtly vision centred in Constantinople. However, in the second quarter of the seventeenth century, this emphatically Ottoman style gave way to new trends.[52] In *kemḫā* and *sīreng* textiles, it was replaced by floral sprays and bouquets, evenly across a plain field. In *çatma*, trellises grew around the rows of bold motifs. Formerly plain fields succumbed to profusions of smaller rosettes, leaves, rinceaux, and other blossoms. And after about 1650, *çatma* cushions used, almost exclusively, a format with a central medallion, surrounded by spandrels and a wide main border, all populated by small-scale floral forms (Illustration 4.3). The medallion might take one of several forms, but all were less emphatically Ottoman and more generally of eastern Mediterranean style. Several accompanying motifs were associated with the island of Chios, several with Cairo, several more echo the interlacing Renaissance forms found earlier, and others yet were derived directly from the bold courtly motifs of the later sixteenth century. The style drew on broader decorative traditions rather than the singular vision of a palace designer. The markets and consumption of the *çatma* cushions functioned similarly across Anatolia and Thrace and into Mesopotamia and northern Syria. A merchant who was ambushed near Aleppo is reported to have lost his life as well as a saddle-bag

[52] See the catalogue of datable Ottoman textiles in Atasoy et al., *İPEK*, 240–52.

full of Bilecik-style cushions, almost certainly made of *çatma*.[53] The cushion covers may have maintained their popularity due to this more general aesthetic, which made them palatable and even desirable throughout the Ottoman territories to the south and east.

BEYOND THE MEDITERRANEAN, 1720–90

The 1640 *narḫ* list was not issued only to protect the consumer and the craftsperson but also to emphasise the attention paid by the authorities to the minutiae of marketplace transactions; the Grand Vizier and other ministers intended it as a means to demonstrate the economic power of the sultan and his ability to provision the capital by attracting art and commodities from around the globe.[54] Alongside the costly Frankish *kemḫā*, more modest items can be found, including a type of warp-faced fabric called *kuṭnī* which used silk warps and cotton wefts and might have come from Yezd, Baghdad, or Masulipatam.[55] It is unclear how the three types of *kuṭnī* differed from one another, but the South Asian origin of the last is of particular interest.

The textile trade between the Ottoman empire and the subcontinent was established well before the fifteenth century. Access to the network for Anatolian Muslim merchants increased when the Ottomans became custodians of the shrines at Mecca and Medina in 1517 and assumed responsibility for the security and management of the huge annual caravans which took both pilgrims and merchants to the holy cities.[56] According to estate inventories from three great traders from Bursa and Constantinople who accompanied the caravan in the 1690s, the main purchase was Indian fabrics.[57] They bought printed cottons from Gujarat as well as fine cotton muslins.[58] However, each merchant also imported different silk-and-cotton blends, *tafta*, a striped stuff (*alaca*) from Ahmedabad,

[53] Rhoads Murphey, 'Syria's "Underdevelopment" under Ottoman Rule: Revisiting an Old Theme in the Light of New Evidence from the Court Records of Aleppo in the Eighteenth Century', in Jane Hathaway (ed.), *The Arab Lands in the Ottoman Era* (Minneapolis, 2009), 230, n. 35.

[54] Phillips, *Everyday Luxuries*, 37–41.

[55] Kütükoğlu, *Osmanlılarda Narh*, 112–21.

[56] The chronicler al-Jabarti (d. 1825) writes that in 1707 the delay of ships carrying textiles from India meant a delay in the Meccan caravan departing Cairo; Abd al-Rahman al-Jabarti's *History of Egypt: ʿAjāʾib al-Āthār fiʾl-Tarājim waʾl Akhbār*, eds. Thomas Philipp and Moshe Pearlmann (Stuttgart, 1994), I, 52.

[57] Colette Establet and Jean-Paul Pascual, *Ultime voyage pour la Mecque: les inventaires après décès de pèlerins morts à Damas vers 1700* (Damascus, 1998).

[58] The most comprehensive article is, Halil İnalcık, 'Osmanlı Pamuk Pazarı, Hindustan ve İngiltere: Pazar Rekabetinde Emek Maliyetinin Rolü', *ODTÜ Gelişme Dergisi*, 7/1 & 2 (1979), 1–65.

aṭlas, some of which was figured, *kuṭnī*, mentioned above, in this case probably from Damascus, and three types of another *tafta* which mixed cotton and silk called *karmasūt*, which was figured with flowers or woven with gold thread.[59] The name of this last fabric may derive from the town of Karamsad, near Ahmedabad.[60]

Over the course of the eighteenth century, estate inventories increasingly list quantities of fabrics from India, mainly *karmasūt*, which used a combination of cotton and silk as its material.[61] A man who died in the Eyüp district of Constantinople in 1790 left two fur garments covered in *karmasūt*, of wildly different values. A similar estate included flowered *karmasūt* garments of a more middling sort, without fur linings.[62] A sheikh who died while resident in a dervish-lodge left three worn *karmasūt* garments, all fur lined.[63] Judging from these records, as well as those from Damascus, it seems that *karmasūt* occupied the same niche as the luxury silks that were used earlier for garments, namely *kemḫā* and *sīreng*.

However, it is unclear whether the substitution of the silk-and-cotton *karmasūt* for higher quality silks was as complete as the inventories might imply. Place names given to fabrics are rarely entirely reliable. While the Meccan caravans discussed above were almost certainly bringing *karmasūt* traded across the Indian Ocean from South Asia, the fabric could also have had a more local origin. In 1747, the *kadi* in Bursa announced a new tax on the pressing and polishing of a range of cotton and silk fabrics, including *karmasūt*;[64] the tax contributed revenues to the treasury until the beginning of the nineteenth century.[65] A 1766 inventory of a great notable from Anatolia provides especially compelling evidence: a roll of *karmasūt* from South Asia valued at fourteen *para*, and another

[59] Each of these fabrics uses a slightly different configuration of a silk warp and cotton weft; taffeta is a plain-weave and may be all silk or, in some Ottoman incarnations, use a cotton warp, satin is warp-faced, *alaja* (or *alaca*) is striped.

[60] The term *karmasūt* appears repeatedly in Ottoman documents, but records for its production in India are elusive. It is possible that this is an Ottoman term for a textile type known by a different name in South Asian-, Persian-, and Arabic-language sources.

[61] Coşkun Yılmaz (ed.), *Istanbul Kadi Sicilleri, Galata Mahkemesi 65 Numaralı Sicil (H. 1051–1053 / M. 1641–44)* (Istanbul, 2010), 210 for a mid seventeenth-century record; Coşkun Yılmaz (ed.), *Istanbul Kadi Sicilleri, Bâb Mahkemesi 54 Numaralı Sicil (H. 1102 / M. 1691)* (Istanbul, 2010), 297 for the end of the century. Dalsar specifies the nature of the silk and cotton blend, *Bursa'da İpekcilik*, 43.

[62] Akdağ, 'Kassam Defteri', 40–5, 123–34.

[63] *Ibid.*, 128–29.

[64] Dalsar, *Bursa'da İpekcilik*, 348–49.

[65] Mehmed Genç, 'A Study of the Feasibility of Using Eighteenth-Century Ottoman Financial Records as an Indicator of Economic Activity', in İslamoğlu-İnan (ed.), *The Ottoman Empire*, Table 16.12.

Illustration 4.4 Two Ottoman voided and brocaded silk velvet (*çatma*) cushion covers, sewn together, c. 1720–1750. MAK – Austrian Museum of Applied Arts / Contemporary Art, Vienna, inv. T–5995; photograph: © MAK/Katrin Wißkirchen.

roll of local *karmasūt* valued at seven and a half.[66] The weavers in Bursa adapted their production again, agilely reacting to a demand for an imported fabric by weaving an equivalent for a ready market.

To date, no one has identified conclusively what *karmasūt* (whether Ottoman or South Asian) might look like or whether any examples might be extant. The Topkapı Palace Museum collection includes one robe made of a figured yellow-orange silk twill of Indian origin, with small flowers and leaves rendered in metal thread.[67] It may date to the eighteenth century, although it is difficult to be certain. If it is *karmasūt*, it is certainly of the most opulent kind, far surpassing the quality (and value) of those listed in the inventories.

[66] Gilles Veinstein, 'Commercial Relations between India and the Ottoman Empire (Late Fifteenth to Late Eighteenth Centuries): A Few Notes and Hypotheses', trans. Cyprian P. Blamires, in Sushil Chaudhury and Michel Morineau (eds.), *Merchants, Companies and Trade: Europe and Asia in the Early Modern Era* (Cambridge, 1999), 108.

[67] Topkapı Palace Museum 13/287; published in Ertuğ et al., *Silks for the Sultans*, 200. It is tentatively dated to the reign of Sultan Ahmed III (1703–30).

Outside the palace, the popularity of *karmasūt* may have spurred artisans and merchants to initiate their own local version and to make changes to other more familiar fabrics as well. In the decades between 1710 and 1740, an entirely new style of *çatma* upholstery emerged. It had a pale ground covered in metal brocading weft, blossoms and foliage rendered in brilliant colours of silk velvet pile, and in several cases, used motifs that appear to borrow from sprigged muslin (Illustration 4.4). This fourth and most radical of the shifts in the aesthetic of the *çatma*s responded directly to the appeal of *karmasūt* and other Indian fabrics and in doing so also provided Ottoman subjects with access to the new fashions of the global eighteenth century.

CONCLUSION

The interlocking cycles of silk production and consumption were not contained within the borders of the sultan's well-protected domains, and changes in textile topographies across the Ottoman lands can and should be linked to those of Italy and India and other parts of the world.[68] This article has shown several of the interactions between local, regional, and global economies. The fortunes of the Bursa weavers were linked not only to the supply of Persian reeled silk and Frankish demand for the same, but also to local competition from the weavers of Chios – as Faroqhi has shown in this volume – and to more distant and indirect competition from South Asia. Style and fashion must also be included in the equation; enthusiasm for an iconic Ottoman style flowered at one moment and subsequently withered, to be replaced by a taste for a more generic eastern Mediterranean aesthetic which apparently found favour in markets outside the capital city. As pale-ground silk-and-cotton blends from India, such as *karmasūt*, gained in popularity, Ottoman weavers responded by creating their own version, which then spread to other types of compound silks, including the ever-popular *çatma*.

Artefacts, rather than texts or lists, illustrate the sea changes of Ottoman style from the Renaissance modes of the early sixteenth century to the dazzling pale-ground Indian-inspired textiles of the eighteenth century (Illustrations 4.1 and 4.4). But in this article, I also make the case for a more integrated treatment of textiles and their economies, deploying the range of approaches demanded by the diverse sources necessary to comprehensive scholarship. Careful analysis of textile structures reveals shifts in techniques and practices, such as weavers

[68] 'The well-protected domains' is a standard way of referring to the empire's territory: *memālik-i maḥrūse*.

altering thread counts, thread colours, and even the size of the finished textile in order to expand their range of qualities and reach wider markets. Conversely, only written evidence, in the form of inventories, price lists, and customs registers, gives insight into economic phenomena such as the increased presence of South Asian *karmasūt*, its local equivalent, and their relative costs.

Finally, I suggest that scholarly investigations should consider many types of luxury textiles together, rather than limiting themselves to narrow ranges of figured compound weaves or even silks alone. The Ottoman elite favoured Frankish *kemḫā* but local *ḳaṭīfe* and *çatma*, which almost certainly impacted on the variety of types and qualities produced in workshops in Constantinople and Bursa. In a similar vein, the ascendance of *çatma* cushion covers from Bursa was balanced by a decrease in the weaving of other luxury silks, such as *ḳaṭīfe*, *sīreng*, and *kemḫā*, as well as lightweight *aṭlas*. Perhaps most saliently, the sharp increase in the use of *karmasūt* for outer garments suggests that it was substituted not only for other luxury silks or silk blends, but also for fine woollens and mohair.

The landscape of Ottoman luxury silks was shaped by many forces. Shifts in production and consumption, the vagaries of imports and exports of raw materials and finished goods, local and global preference for one style or another, state or local regulation, and more general political and economic trends such as periods of steep inflation, devaluation, or even revolt each play their respective roles. In the middle of the picture, though, reside the weavers, the merchants, and the customers, all of whom acted agilely in their own interests, often in a most enterprising and entirely modern manner.

PART II

European Developments

5.

Ottoman Silks and Their Markets at the Borders of the Empire, c. 1500–1800

Suraiya Faroqhi

This paper analyses the manufacture and consumption of silks within and beyond the Ottoman empire. In particular it considers the exportation of Ottoman silk cloth to a somewhat unexpected market, eastern and central Europe, and reviews its provincial manufacture, especially in Damascus, the island of Chios, Cairo, and elsewhere in Egypt. All of these issues may appear somewhat peripheral to historians whose main concern is with the central Ottoman elites' consumption and the commerce between the eastern and western halves of the Mediterranean. However, as Amanda Phillips's paper in this volume shows, during the Renaissance and post-Renaissance periods, Ottoman silk cloth was not greatly desired or valued by Italian or English traders. Sericulture and silk weaving in the Ottoman empire (1299–1923) flourished within its domestic market, while the Ottomans also exchanged goods with people living on its Northern and Central European borders.

Artefacts are an important source for this account.[1] As well as the work of Polish scholars such as the textile historian Beata Biedrońska Słotowa, this study is based upon the pioneering work of Nurhan Atasoy and her associates, particularly Lâle Uluç. Among other things, their studies have shown that – in spite

[1] Two exhibition catalogues are especially relevant: Türk ve İslâm Eserleri Müzesi, *Savaş ve Barış. 15–19 yüzyıl Osmanlı-Lehistan ilişkileri* (Istanbul, 1999), and Nazan Ölçer et al., *Distant Neighbour, Close Memories: 600 Years of Turkish–Polish Relations* (Istanbul, 2014), the latter of which is to commemorate the 600th anniversary of Ottoman–Turkish–Polish relations. Two richly-illustrated monographs are basic sources for all studies of Ottoman silk cloth: Nurhan Atasoy, Walter Denny, Louise W. Mackee, and Hülya Tezcan, *İpek. Imperial Ottoman Silks and Velvets* (London, 2001). I am most grateful to Hülya Tezcan for giving me a copy of this book. There is also the more recent, monumental work by Nurhan Atasoy and Lale Uluç, *Impressions of Ottoman Culture in Europe: 1453–1699* (Istanbul, 2012). All four publications are available in both Turkish and English.

of the many wars and destructive occupations Poland was subjected to in the nineteenth and twentieth centuries – a large number of Ottoman silks, mostly from the seventeenth century, still survive in Polish monasteries, convents, churches, and museums. Moreover, it is reasonable to assume that a significant number of other such artefacts must have perished, especially during the wholesale destruction of Warsaw during World War II.

PRODUCTION FOR EXPORT: RUSSIA AND POLAND

Ottoman silks were usually destined for the emphatically Muslim elite of the sultans' empire, but exportation meant that some silk cloths were manufactured for use by Christians, or even in Christian churches. Polish customers sometimes ordered such items. But perhaps the most dramatic pieces were those commissioned by subjects of the sultan who were also dignitaries of the Orthodox Church, which they presented at the tsars' court in Moscow. It is fortunate for historians that these 'gifts to the tsars' were meticulously recorded by the officials of these rulers and that the documentation survives to the present day, along with many of the artefacts.[2]

We may thus assume that the luxurious silks destined for the tsars' court and Russian high-level clergy represented a small branch of courtly production. The most valuable items were markers of privilege that never entered the market. Whether for use in a palace or a church, they were in all probability manufactured to order, in small numbers or even as unique items. Therefore, these products were not commercial items, like the cushions discussed by Amanda Phillips, or the relatively low-value silk known as *bürümcük* that was used to make shirts. According to the scholarly diplomat Joseph von Hammer-Purgstall (1774–1856) who visited Bursa in 1804, local producers continued selling these textiles in significant quantities even during the hard times of the Napoleonic Wars (1799–1815).[3] The situation was somewhat more complicated regarding silks that were

[2] In this case, too, exhibition catalogues are the principal secondary sources; unfortunately, my coverage of the topic is limited by the fact that I cannot access the literature in Russian or Polish. See Barry Shifman and Guy Walton, *Gifts to the Tsars, 1500–1700, Treasures from the Kremlin* (New York, 2001); Elena Yurievna Gagarina et al., *The Tsars and the East: Gifts from Turkey and Iran to the Moscow Kremlin* (Washington DC, 2009); Elena Yurievna Gagarina and İlber Ortaylı (eds.), *Treasures of the Moscow Kremlin at the Topkapı Palace* (Istanbul, 2010). The most recent addition is Amelia Peck (ed.), *Interwoven Globe: The Worldwide Textile Trade, 1500–1800* (New York and London, 2013), in which Ottoman and Safavid silks are discussed on 66–81. For a photograph that gives an idea of the riches in St Petersburg's Hermitage Museum, see Atasoy and Uluç, *Impressions of Ottoman Culture*, 80.

[3] Joseph von Hammer-Purgstall, *Umblick auf einer Reise von Constantinopel nach Brussa und dem Olympos und von da zurück über Nicäa und Nicomedien* (Pesth [today: Budapest], 1818),

sent to Poland. Merchants and Polish gentlemen temporarily staying in Istanbul took home items that might be considered attractive and prestigious in Poland, but were generally available in Istanbul's covered market or elsewhere. At the same time, richer members of the Polish nobility apparently had certain items made to order, these falling into the same category as the more famous 'gifts to the tsars'. That said, we must keep in mind the fact that the rich and heavy silks worn by sultans and viziers of the sixteenth century – the focus of most research into Ottoman textile history – were only available to a very small number of high-ranking dignitaries. Local rules of decorum must have made it impossible for the sultans' subjects to wear these textiles in public even if, by some fortunate circumstance, they managed to acquire them.

EXPORTS TO RUSSIA

In the second half of the sixteenth century Orthodox bishops, patriarchs, and representatives of the larger monasteries on Ottoman territory were already frequent visitors to the tsars' court. After all, the tsars were the only fully-independent Orthodox rulers still in power after the sultans had conquered all of south-eastern Europe and thus, for clergy officiating in the Ottoman lands, Moscow was a source of donations and patronage. When soliciting such support, it was essential to provide gifts in return so, as well as the famed jewellery made in Istanbul during the seventeenth century, the tsars and Orthodox Church dignitaries received silk textiles, often with religious images woven into them.

These items were so special because, in contrast to embroidery, which could be added onto silk which had originally served a secular purpose and been 'recycled' for ecclesiastical use, images woven into the fabric meant that the textile would never see any use except in religious services.[4] It was more time-consuming and thus expensive to weave such designs because, where embroidery could be done by many people at once, weaving could only be done by one single and highly skilled loom operator.

Unfortunately, we have no information about the artisans who produced these fabrics. Some of those working in Bursa must have been Christians or Jews, as a surviving *fatwa*, copied into the court records in 1595, suggests. This forbade Muslims from working for non-Muslims if there was work available in Muslim

VII–VIII, 69–70. For a discussion, compare this to Suraiya Faroqhi, 'Surviving in Difficult Times: The Cotton and Silk Trades in Bursa around 1800', in Suraiya Faroqhi (ed.), *Bread from the Lion's Mouth: Artisans Struggling for a Livelihood in Ottoman Cities* (New York and Oxford, 2015).

[4] For example, see Angelos Delivorrias and Dionissis Fotopoulos, *Greece at the Benaki Museum* (Athens, 1997), 309–10.

employers' shops.[5] This was because it would make Muslim workers subordinate to their employers, which would challenge the superior status of Islam – one of the central tenets of Ottoman governance. The existence of this rule suggests that some Muslims had previously worked for non-Muslim employers, although there is no record of this concerning silk weavers.

The locations of the workshops producing silks for ecclesiastical use also remain unknown.[6] According to an undated document, a Christian named Rüstem who had set up a workshop in an old church in central Bursa to weave cloth-of-gold – which was used for export luxury pieces – was taken to court by the local *metropolit*.[7] But this craft might also have been practised in Istanbul or smaller centres such as Bilecik,[8] while the decorative repertoire of ecclesiastical and secular textiles is also similar. Many copes used in Russian churches made an impact through the stylised floral patterns which were also used by the Ottoman palace (Illustration 5.1).[9] Other patterns also occurred: for instance, one liturgical robe (*sakkos*) with pearl embroidery 'made in Russia' encircling the shoulders and decorating the edges, featured an arrangement of carnations, hyacinths, and other flowers surrounding Mary and the Christ Child and other holy figures. On another piece, the inscriptions forming part of the pattern depict the two angels surrounding Mary and her child as Michael and Gabriel. Somewhat less obviously, this textile also features *çintamani*, a motif of Far Eastern origin which consists of three balls set in the shape of a pyramid, which was very popular in Ottoman textiles, used alone or together with other motifs.[10]

In contrast, other designs for church use seemingly avoided 'mixing' Orthodox and Ottoman traditions. A *sakkos* made from a textile that arrived in Moscow with two of the tsar's ambassadors on their return from Istanbul in 1634 featured images of Christ enthroned, very much in the Byzantine tradition.[11]

[5] Fahri Dalsar, *Bursa'da İpekçilik: Türk Sanayi ve Ticaret Tarihinde* (Istanbul, 1960), 321.

[6] *Ibid.*, 332.

[7] In the Orthodox Church, a *metropolit* ranks higher than a bishop or even archbishop.

[8] Atasoy et al., *İpek*, 175 makes the point that, by the later sixteenth century, standards in Bursa and Istanbul would have been more or less the same.

[9] Atasoy and Uluç, *Impressions of Ottoman Culture*, 82–3. Even to the inexperienced viewer, these decorations are recognisable as classical Ottoman motifs, see Gagarina and Ortaylı, *Treasures of the Moscow Kremlin*, 32–4. The *sakkos* had been made by order of Tsar Ivan the Terrible (1530–84) for the Cathedral of the Dormition in the Kremlin.

[10] http://sanatsozlugum.blogspot.com.tr/2011/11/cintamani.html (accessed 7 April 2014).

[11] Atasoy and Uluç, *Impressions of Ottoman Culture*, 79; Warren Woodfin, 'Orthodox Liturgical Textiles and Clerical Self-Referentiality', in Kate Dimitrova and Margaret Goehring (eds.), *Dressing the Part: Textiles as Propaganda in the Middle Ages* (Turnhout, 2014). On pages 44–5 Woodfin identifies this cloth as *seraser/taqueté* and the format of the enthroned Christ as 'Christ as high priest'.

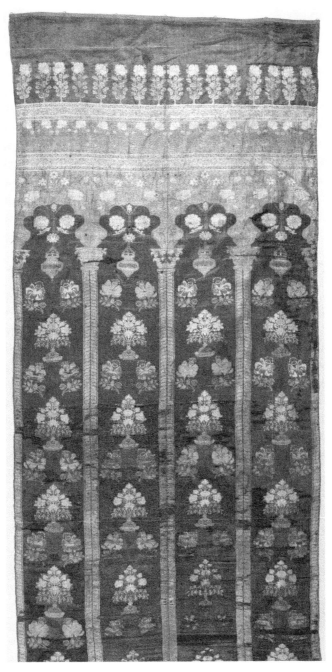

Illustration 5.1 Gold-woven silk fabric. Istanbul, 1550–1575.
Athens, Benaki Museum/Museum of Islamic Art.

We are left to wonder whether these different styles of textile design mainly emerged for technical reasons, such as varying workshop traditions, or if they corresponded to different understandings of what the 'proper' *ambiente* was for an Orthodox religious service.

The court wanted silk just as much as the Church. Ottoman silks from the late sixteenth and early seventeenth century clothed Tsar Ivan the Terrible (1530–84), who had acquired a number of valuable silks from the Ottoman merchant Mustafa Çelebi, including wide and narrow caftans and other state robes.[12] Mustafa Çelebi once carried a letter from Sultan Süleyman the Lawgiver (1520–66). We do not know whether this text was concerned only with the purchase of fine furs, which the sultans often sent 'state merchants' to Moscow to obtain, or whether perhaps it also broached political matters, given the Russian conquests of the Muslim khanates of Astrakhan and Kazan.[13] According to the Russian palace inventory, the Greek merchant Afanasy Dmitriev, who arrived at the Ottoman embassy in 1630, sold an elaborate curtain of red-and-gold velvet and brocade to the tsars' court in 1640, which has survived until today.[14]

Ottoman artisans were famous for their luxurious horse caparisons made of leather or metal, which were collected by the court in Moscow. These saddles might be covered in luxurious red velvet, or else a piece of expensive brocade might be placed over the saddle or even on top of an unsaddled horse. The Kremlin collections contain a very elaborate piece of this type, dating from the late seventeenth century.[15] Other kinds of saddlecloths of Ottoman workmanship, known as *cheprak* and intended to cover the horse's croup, were added to the tsars' treasury during the mid seventeenth century in such large numbers that one wonders if perhaps they had been ordered for a specific court function. But we also hear that a similarly elaborate *cheprak* had arrived as a present to the tsar in power at the time, sent by a Greek named Ivan Nastasov who lived in Istanbul. Perhaps this man was also a fur trader.[16]

[12] Gagarina and Ortaylı, *Treasures of the Moscow Kremlin*, 61. One of these textiles was later reused as a horse caparison, with the original garment's seams still visible.

[13] Alexandre Bennigsen and Chantal Lemercier-Quelquejay, 'Les marchands de la Cour ottomane et le commerce des fourrures moscovites dans la seconde moitié du XVIe siècle', *Cahiers du monde russe et soviétique*, 11/3 (1970), 363–90; Bennigsen and Lemercier-Quelquejay, 'La Moscovie, la Horde Nogay et le problème des communications entre l'Empire ottoman et l'Asie centrale en 1552/1556', *Turcica*, 8/2 (1976), 203–36.

[14] Gagarina and Ortaylı, *Treasures of the Moscow Kremlin*, 72.

[15] *Ibid.*, 74–5.

[16] *Ibid.*, 78–9.

EXPORTS TO POLAND

The seventeenth-century nobility of the Polish-Lithuanian Commonwealth made important purchases of Ottoman luxury fabrics because they opted for a 'Sarmatian' identity – based on the Iranian migrants who had settled in lands that today form Russia.[17] Perhaps the aim was to create an appearance that differed from their Western neighbours.[18] These same noblemen and elites defined their role as forming part of a defensive Christian wall (*antemurale Christianitatis*) against both the Ottoman and the Tatar armies. After the Counter-Reformation, adherence to the Catholic Church comprised a fundamental part of this identity as well. As Catholics, the Polish upper class and – to an increasing degree – the subjects of the Commonwealth as well, distinguished themselves from the Orthodox faith dominant in Russia, and from the Protestant churches to which most of the inhabitants of the neighbouring principalities of Brandenburg and Saxony adhered. But, at least in the seventeenth century, this Catholic identity did not imply that Polish noblemen and gentry should adopt the French fashion that was dominant in western Europe. By the eighteenth century some had adopted outfits *à la française*, but this change of fashion did not affect the overall popularity of Ottoman textiles.[19]

Clothes and arms essential to the projection of a 'Sarmatian' identity were either of Ottoman or Iranian origin.[20] Portraits of Polish gentlemen, some depicting the personage as he was in life and others showing the recently-deceased dignitary at his funeral, feature long jackets resembling caftans, fastened with round buttons slipped into braided loops, also known as frogging.[21] Even royalty followed this style, such as the young Prince Sigismund Kasimir (1640–47) who posed for his portrait in a jacket modelled on a caftan, standing on a carpet that had probably been imported from Iran (Illustration 5.2).[22] Caftan-style jackets were complemented by sashes with embroidered, loosely hanging

[17] 'Sarmatian'. *Encyclopaedia Britannica Online Academic Edition*, http://www.britannica.com/EBchecked/topic/524377/Sarmatian (accessed 18 November 2016). After emerging in Greek sources during the sixth century BCE, the Sarmatians remained active on the border of the Roman empire until the Hun and Goth migrations in the fifth century CE, when they were apparently assimilated into the newcomers.

[18] Atasoy and Uluç, *Impressions of Ottoman Culture*, 67, relaying a suggestion by the Polish scholar Beata Biedrońska Słotowa.

[19] *Ibid.*

[20] Archaeological study has revealed information about Sarmatian horsemanship and some of their jewellery. But even today's limited knowledge of Sarmatian material culture was not available in the seventeenth century.

[21] For an illustration, compare Atasoy and Uluç, *Impressions of Ottoman Culture*, 66–7.

[22] Peter Noever (ed.), *Global:Lab: Kunst als Botschaft, Asien und Europa / Art as a Message, Asia and Europe* (Ostfildern, 2009), 210.

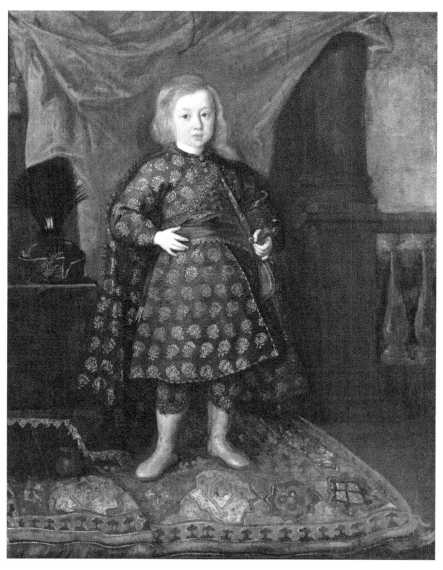

Illustration 5.2 *Prince Sigismund Kasimir of Poland (1640–1647)*,
134 x 98 cm, Vienna, KHM-Museumsverband.

edges. Outer garments lined with fur, which were fashionable at the Ottoman court, might also form part of a Polish gentleman's outfit. As an indication of their status, higher-level commanders (*hetman*) often carried a ceremonial mace, which strongly resembled the Ottoman *bozdoğan*.[23]

Thus, high-ranking Polish dignitaries may have owned significant numbers of silk textiles produced in the sultans' realm. The successful military leader Jan Sobieski (1629–96) owned a caftan of cloth-of-gold, red silk curtains, and other items of Ottoman workmanship, even before he became king in 1674.[24]

In contrast to Russia, officially sponsored Ottoman merchants seem to have been a rarity in Poland. Trade between the two polities was the province of private individuals, for whom dealing in silk formed only part of their business.[25] Polish traders planning to supply the royal court with silk cloth were already present in Bursa in the 1560s.[26] Armenian merchants organised regular trade exchanges between Istanbul and Lwow (today Lviv in Ukraine but in the seventeenth century part of the Polish–Lithuanian Commonwealth), importing a sizeable number of silk textiles as well.[27] Other imports were even less formal for, as attested in the Ottoman chancery registers (Mühimme Defterleri), the numerous members of the Polish ambassadors' retinues were active traders, even though their king prohibited the practice time and time again as being contrary to the dignity of embassies.[28]

Polish donors differed from their Orthodox counterparts in their relative lack of interest in silks with ecclesiastical designs woven into the fabric. The reasons for this attitude are worth exploring, as vestments used in Catholic services also often featured figures and scenes from the Bible and church tradition. If the vestments seen in exhibition catalogues are any indication, it seems that Polish patrons who wanted religious scenes depicted chose to have them executed by local embroiderers.[29] Secular wall hangings and cushion covers made of Ottoman cut velvet ultimately found their way into Polish church treasuries as fabrics for vestments. At times, the characteristic design of the original cushion

[23] Zdzisław Zygulski, 'The Impact of the Orient on the Culture of Old Poland', in Jan Ostrowski (ed.), *Land of the Winged Horseman. Art in Poland 1572–1764* (Alexandria VA, 1999).

[24] Atasoy and Uluç, *Impressions of Ottoman Culture*, 70–1.

[25] Mohair (*sof*) from Ankara and Aleppo was also popular with wealthy consumers.

[26] Dalsar, *Bursa'da İpekçilik*, 189–91; I owe this reference to Atasoy and Uluç, *Impressions of Ottoman Culture*, 66.

[27] Fernand Braudel, *Civilization and Capitalism*, ii: *The Wheels of Commerce*, trans. Siân Reynolds (London, 1979), 157.

[28] Dariusz Kołodziejczyk, 'Polish Embassies in Istanbul or How to Sponge on your Host without Losing your Self-Esteem', in Suraiya Faroqhi and Christoph Neumann (eds.), *The Illuminated Table, the Prosperous House: Food and Shelter in Ottoman Material Culture* (Istanbul, 2003), 51–8.

[29] As an example, compare this with Ölçer et al., *Distant Neighbour, Close Memories*, 143–4.

covers described by Amanda Phillips as local wares is clearly evident, with the niche-and-flower design which so often bordered the narrow sides of the rectangular cover reappearing in the shoulder section of the chasuble.

In both Poland and Russia, local patrons and artisans copied original imports from the Ottoman realm. In Poland, sashes were popular enough to warrant the effort.[30] Ottoman Armenians set up workshops in areas close to the Ottoman–Polish border, where they had access to Ottoman weavers, Muslim, Christian, or Jewish. The process by which this manufacture became acclimatised in Poland is verified by the inscriptions, sometimes including dates, that producers used to customise their own pieces. In the eighteenth century the town of Słuck (Slutsk) gained a reputation for its sashes, adapting Ottoman styles to suit local tastes. Beyond mundane matters of trade and recycling, the luxurious textiles that went to Cracow or Moscow seem to have bolstered the image of the sultans' realm as a source of high-quality luxury goods. This image partially persisted when the Ottoman empire fell into disarray and members of the Russian elite hoped that, one day, the tsars might conquer Istanbul.

AT THE EMPIRE'S BORDERS: MOLDAVIA, WALACHIA, AND TRANSYLVANIA

Since the mid fifteenth century, the three principalities of Moldavia, Walachia, and Transylvania (now in Romania) had been ruled by the Ottoman sultan, although the degree of control imposed varied widely, according to time and place. Walachia and Moldavia paid tribute to the sultans, although their payments were interrupted by a series of wars in the fifteenth and early sixteenth centuries.[31] Princes chosen from among the local nobility (*boyars*) governed the two principalities, and many of the successful candidates spent several years in Istanbul to guarantee the 'good behaviour' of their relatives. Only after the scholarly prince Demetrius Cantemir (1673–1723), *hospodar* of Moldavia, defected to support Peter the Great (1672–1725) did the Ottoman court appoint outsiders, who were chosen from a few influential Orthodox families resident in Istanbul, known as Phanariots.[32]

[30] Atasoy and Uluç, *Impressions of Ottoman Culture*, 67–9.

[31] Mihnea Berindei and Gilles Veinstein, *L'Empire ottoman et les pays roumains, 1544–1545* (Paris, 1987).

[32] These people resided in the Fener/Phanar quarter, where the remains of Demetrius Cantemir's house are also believed to be located. Transylvania's autonomy was lost during the Ottoman–Habsburg wars of 1683–99, when the imperial armies not only occupied the principality, but in the subsequent peace treaty, the Hapsburgs managed to hold on to their new possession.

Due to the long and intensive contact of the Moldavian and Walachian nobilities with Istanbul, wealthy men and women soon adopted the fashions of the Ottoman court.[33] The tomb cover of Maria of Mangup (1440–77) shows her wearing a caftan with long, purely decorative hanging sleeves, her arms passing through specially-cut slits. This artefact is of particular value since it is definitely dated 1477 while most extant Ottoman textiles are more recent. It shows that this fashion persisted over a long time, as a Moldavian prince buried in 1606 wears a similar caftan – although, admittedly, ceremonial robes tend to be far more conservative than everyday wear.[34] The double allegiance of Maria's milieu to both Ottoman and Byzantine models is apparent from her headdress, which has references to the crowns of Byzantine empresses, which are visible even to the lay person. Although the coffins of princes and princesses were made by local craftsmen, it is likely that the Ottoman elements that they feature so prominently were reflections of textiles that were once available in Moldavia and Walachia's royal residences, but which no longer exist.

SILKS IN DAMASCUS

Between 1686 and 1717, a specialised judge (*qadi*) known as the *qassām 'arabī* was responsible for recording the estates of 450 deceased people, many of whom had served in the Ottoman administration.[35] In Damascus, as all over the Ottoman realm, Islamic law determined the shares of the different inheritors; and in major cities it was customary to record the estate in detail if some or all of the heirs were absent from the city, or if they were children. On the other hand, the sultan's servants' belongings were given to the ruler, although it was customary to allow the deceased's family to negotiate for the return of at least some of their goods. However, Establet and Pascual's extremely thorough studies have not unearthed any such confiscations. Perhaps the volumes compiled by the *qassām 'askarī* of Damascus around 1700 merely indicated the notionally higher status of the sultan's servants, known as *'askar*, although some of them had purely administrative tasks. Establet and Pascual's research provides information about the trade in silk yarn and silk fabrics, through the numerous shops and workshops serving this purpose in Damascus. The local *qadis* made very detailed records

[33] Atasoy and Uluç, *Impressions of Ottoman Culture*, 37–56.

[34] *Ibid.*, 38, 42.

[35] Colette Establet and Jean-Paul Pascual, *Des tissus et des hommes: Damas, vers 1700* (Damascus, 2005), 12–14; Colette Establet and Jean-Paul Pascual, *La gent d'état dans la société ottomane damascène: les 'askar à la fin du XVIIe siècle* (Damascus, 2011), 9–10.

of the deceased people's domestic interiors and clothes chests ('wardrobes' in modern terminology), which give an insight into consumers of that time.

Ottoman documents show that Damascus had been a producer of textiles, particularly silk textiles, ever since the sixteenth century. The city's covered market (*bedestan*) was the centre of the silk trade, where dealers paid a stamp tax (*damga*) on the fabrics. Officials oversaw quality control, although they were evidently not very successful, as complaints concerning loose weaves and the use of inferior indigo continued to be made over the years. A document from the 1570s reveals varieties such as a light textile known as *bürümcük* and cotton-silk mixtures known as *kutni/kutnu*, expensive, robust all-silk fabrics known as *tafta*, as well as the more delicate *vale*.[36]

Damascene weavers benefited from a relatively accessible and regular supply of raw silk from nearby Tripoli in the late sixteenth century. This differentiated them from producers in Bursa or Istanbul, who suffered from a difficult and often endangered connection with suppliers in Iran.[37] The late seventeenth- and eighteenth-century registers refer to silk in Damascus being imported from Baalbek, Beirut, 'Ayn Dārā, and the region known as the Shūf. Indeed, by the 1650s, a Nuremberg merchant working for a Venetian master was able to buy silk in the Lebanese mountains.[38] About one third of all Damascene shops stocking silk offered yarn rather than fabric. As Damascus was not exporting raw silk to places such as Italy or other European regions during this period, it is probable that the city was a manufacturing centre of some significance.

Just as in seventeenth-century Bursa, women did some of the preparatory work, such as reeling, but the Damascus records only include minimal, indirect evidence of female artisans.[39] This is either because women's involvement in silk manufacture was marginal, or because the all-male scribes avoided recording their activities, since the status of a husband or father would be diminished if his female relatives were seen as having to earn a living.

The Damascus market in silk goods was impacted by the Islamic law that men were not supposed to wear silk, although Islamic scholars did reluctantly

[36] Suraiya Faroqhi, 'Textile Production in Rumeli and the Arab Provinces: Geographical Distribution and Internal Trade (1560–1650)', *Osmanlı Araştırmaları. Journal of Ottoman Studies*, I (1980), 61–83.

[37] Establet and Pascual, *Des tissus*, 235.

[38] Wolffgang Aigen, *Sieben Jahre in Aleppo (1656–63), ein Abschnitt aus den 'Reiß-Beschreibungen' des Wolffgang Aigen*, ed. Andreas Tietze (Vienna, 1980), 19.

[39] Establet and Pascual, *Des tissus*, 234; Dalsar, *Bursa'da İpekçilik*, 320 (dated 1574) and 396 (dated 1530). In the 1500s, some females also wove the light silk known as *vale*. On the scarcity of references to female artisans see: Colette Establet, 'Damascene Artisans around 1700', in Faroqhi (ed.), *Bread from the Lion's Mouth* (New York and Oxford, 2015), 88–107.

allow women to wear this luxurious fabric.[40] However, royal courts (including the Ottoman court) generally ignored this decree – except for the pious ruler Süleyman the Lawgiver, who in his later years replaced silk garments with items made from fine, shiny mohair.[41] Sitting on silken cushions was banned by the same prohibition, according to the Shafi'i school of law, to which most Damascenes adhered. Nonetheless, the Hanefis, who were dominant among the Turks and thus very influential, were more self-indulgent.[42] Velvet cushion covers 'made in Bursa or Damascus' remained popular among people who preferred to 'overlook' these restrictions.

Around 1700, pure silk wares were fairly common in the dwellings of wealthy Damascenes, although they were mainly owned by women. These included silk veils, belts, shirts, the wide trousers (*cintiyan*) worn under a caftan, and silk tunics dyed red that were particularly expensive and thus exclusive to a very small number of rich females.[43] The fashion for garments, home decorations, cushions, and cushion covers made of silk was imported from the central Ottoman lands, as the term *yastaqiyya*, derived from the Turkish word *yastık* (cushion), suggests. It is difficult to determine whether women were recorded as the owners of these items due to religious restrictions or, more simply, because household textiles usually belonged to the mistress of a house.[44]

Wealthy Damascene women also used the Ottoman silk fabric known as *hatayi* (or *hatay*), which was dark coloured and adorned with metallic threads. This textile was very pricey in both Damascus and Bursa, costing as much as the notoriously expensive *seraser*, a fabric that resembled brocade.[45] However, in Bursa, the high price did not impede its popularity among wealthy women, as 25 per cent of eighty inventories concerning females, dating between AH 1147 (1734–5 CE) and AH 1149 (1736–7 CE), contained *hatayı*. It is not clear where these Damascus *hatayı* were manufactured, though.

Women from affluent households embroidered their own silk textiles or delegated this job to their servants. Although the Armenian-Ottoman-Swedish author Mouradgea d'Ohsson (1740–1807) commented on the numerous

[40] Editorial Committee, 'Ḥarīr, introductory section', in the *Encyclopedia of Islam* (Leiden, 1971), iii, 209–10.

[41] Augerius Gislenius Busbequius, *Legationis turcicae epistolae quatuor*, ed. Zweder von Martels, trans. into Dutch by Michel Goldsteen (Hilversum, 1994), 90–1.

[42] Establet and Pascual, *Des tissus*, 272.

[43] *Ibid.*, 268–69.

[44] *Ibid.*, 271.

[45] Suraiya Faroqhi, 'Women, Wealth and Textiles in 1730s Bursa', in Elif Akçetin and Suraiya Faroqhi (eds.), *Living the Good Life: Consumption in the Qing and Ottoman Empires of the Eighteenth Century* (Leiden, 2019), 213–35.

embroideries (*mutarraz*) displayed in Ottoman households, the Damascus inventories mention few.[46] Embroidered textiles seem to have been most common in the nineteenth and early twentieth centuries in the central provinces as well, however, this might be just a false impression because the older pieces have been lost – or embroideries might, in fact, have become more widespread after about 1800.[47]

One characteristic form of decoration in Damascus silks was the *ikat*. Also used in India and Iran, this technique involves tying knots into yarn that is to be dyed prior to weaving, or covering specific sections of the yarn in wax or some other substance to prevent the dye from penetrating it. The dyer can repeat this procedure several times, preferably using progressively darker colours to produce yarn with regularly-changing colours. The yarn can be used for both warp and weft, to create predictable designs. Damascus manufacturers often gave the best-known patterns poetic names.[48]

SILK AND COTTON MIXTURES, IN DAMASCUS AND ELSEWHERE

Muslims in Damascus seems to have taken the rules limiting the consumption of pure silk much more seriously than their counterparts in Istanbul or Bursa; and, as in South India, numerous silk-cotton mixtures were sold in the city's textile shops. This fabric was woven in such a manner that the side which touched the body was cotton, while the outer surface was silk. This gave wearers the best of both worlds: they complied with religious scholars' teachings while, at the same time, showing off their wealth and refined taste. Hanefi scholars expressly permitted this solution. In addition, cotton was much cheaper than silk, so these mixed fabrics were suitable for people who had to watch their expenditure.

As well as the striped fabric called *alaca*, the fabric known as *kutni* (*kutnu* in modern Turkish) was also produced in Bursa. As textile terminologies varied a good deal from time to time and from place to place, however, the *kutni*s woven in these two centres may not have been the same. Nineteenth-, twentieth- and early twenty-first century counterparts have brightly-coloured stripes and, in some cases, certain stripes were decorated inside with something resembling a kilim design. Halil İnalcık states that Ottoman *kutnu* had some similarities to the Indian fabric known by the same term which was imported into the Ottoman empire, and notes that *kutnu* manufacturers from Syria revived its production

[46] Establet and Pascual, *Des tissus*, 283–4.

[47] Hülya Bilgi and İdil Zanbak, *Skill of the Hand, Delight of the Eye / Ottoman Embroideries in the Sadberk Hanım Museum Collection* (Istanbul, 2012).

[48] Dominique Chevallier, *Villes et travail en Syrie du XIXe au XXe siècle* (Paris, 1982).

and trade in Anatolia around 1900.[49] Production of this silk-cotton mix thus continued over the centuries and covered an area which stretched all the way from India, through Syria, to western Anatolia.[50]

PRODUCING SILKS ON THE ISLAND OF CHIOS

Most of the silk fabrics that were produced on the island of Chios before 1566 while it was still in Genoese possession were intended for 'home decoration' in the Ottoman empire. In the second half of the sixteenth century, certain weavers produced a cloth named *kemha*, which buyers might mistake for an Italian product. At the great circumcision festival in 1582, Chios satin featured among the gifts offered to the sultan, which indicates that it was a high-quality item.[51] Yet, from the late seventeenth century onwards, especially in the eighteenth century, the production of silk cloth increased considerably,[52] presumably linked to the prominence of contemporary Chios merchants in Izmir and Istanbul, who made a great deal of money selling textiles in the Ottoman capital. Some of the most successful sellers also established branches in European cities.[53]

As local raw silk supplies could not satisfy demand, merchants brought in additional material from Anatolia, especially from Bursa. In this later period, most of the silk cloth produced on the island was meant for 'home decoration' rather than for clothes; there are two such runners in the Topkapı Palace Museum – one almost four metres and the other nearly five metres long.[54] By the

[49] Halil İnalcık, *Türkiye Tekstil Tarihi üzerine araştırmalar* (Istanbul, 2008), 103, 111.

[50] This textile is still produced in south-eastern Turkey today, especially in factories located in the Gaziantep region, known as 'Ayntab' in Ottoman times, see İnalcık, *Türkiye Tekstil Tarihi*, 268–9. See also Donald Quataert, *Ottoman Manufacturing in the Age of the Industrial Revolution* (Cambridge, 1993).

[51] Dalsar, *Bursa'da İpekçilik*, 224 (the document is dated 1573). Atasoy et al., *İpek*, 174–5, discuss Chios silks and the available documentation, which is the foundation of all further research.

[52] Philip P. Argenti, *The Costumes of Chios. Their Development from the XVth to the XXth Century* (London, 1953), emphasises the existence of silk weaving in pre-Ottoman times. His book contains numerous images in colour and is now available online: http://eng.travelogues.gr/collection.php?view=26 (accessed 12 August 2015). See also Hülya Tezcan, 'Döşemede tarih: Sakız adasının Osmanlı ipeklileri', *Ev Tekstili Dergisi*, 2/7 (1995), 10–15. Ölçer et al. discuss two Chios pieces in Cracow and Gdansk in *Distant Neighbour, Close Memories*, 35, 304.

[53] Traian Stoianovich, 'The Conquering Balkan Orthodox Merchant', *Journal of Economic History*, 20 (1960), 234–313, 271.

[54] Hülya Tezcan and Sumiyo Okumura, *Textile Furnishings from the Topkapı Palace Museum* (Istanbul, 2007), 64–75. Rémi Labrusse (ed.), *Purs décors? Arts de l'Islam, regards du XIXe siècle* (Paris, 2007), 135. Auction houses also occasionally advertise Chios silk hangings, for instance the Bonham's auction in London in 2008: http://www.bonhams.com/auctions/16223/lot/208/ (accessed 19 October 2016).

middle of the eighteenth century, the Chios weavers were also producing sashes, which the Ottoman palace distributed to its pages on special occasions, although no surviving examples of these are known. The Topkapı Palace Museum holds an elegant prayer rug made by Chios workers, whose display niche only contains a small lamp and is otherwise plain, permitting the viewer to admire the delicately-adorned frame, which may have been inspired by the Safavid silks.[55] Two other pieces, from the mid eighteenth century, diverge from the normal prayer rug format in featuring a rather flat-domed structure as their principal element, set within the 'standard' niche pattern and accompanied by three arches that are also much flatter than is customary. The domed structure contains a flower vase but no lamp, further digressing from the standard prayer mat format.

Quite a few items made in Chios bear the dated stamp (*damga*) of an official who collected tax on the goods and may also have monitored their quality. These stamps are absent from most Ottoman silks, although we know that certain manufacturers were not above faking a stamp to escape taxation. Some Chios wall hangings were inspired by the style of prayer mats; or at least their Polish users interpreted them in this fashion. They are similar to the contemporaneous carpets woven in western Anatolia, for instance, the Gördes type. By the late seventeenth century, patrons and designers were no longer emphasising the religious significance of the arches, columns, and lamps that characterise prayer mats, often selling pieces of this kind to 'non-believers', and silk wall hangings – though not necessarily from Chios or with a prayer mat design – had become favoured decorative elements in wealthy Polish houses.[56] For instance, the rather over-elaborate design of the wall hanging owned by the Carmelite sisters of Cracow (dating from 1688), with its depictions of two domed mosques complete with minarets, is reminiscent of the 'island embroideries'.

SILKS FROM EGYPT

Cairo was a multicultural melting pot during the 1670s, as the Ottoman traveller Evliya Çelebi (1611–82) verified; at that time, he was a resident of the city. He mentioned the manufacture of a striped or mixed fabric (*alaca*) with silk in it that was woven in Dimyāt/Damietta, in Egypt.[57] For an Ottoman dignitary,

[55] Atasoy et al., *İpek*, 174–5.

[56] Ölçer et al., *Distant Neighbour, Close Memories*, 304; this comment was written by Beata Biedrońska Słotowa.

[57] Evliya Çelebi b Derviş Mehemmed Zıllı, *Evliya Çelebi Seyahatnâmesi, İstanbul Üniversitesi Kütüphanesi Türkçe Yazmalar 5973, Süleymaniye Kütüphanesi Pertev Paşa 462, Süleymaniye Kütüphanesi Hacı Beşir Ağa 452 Numaralı Yazmaların Mukayeseli Transkripsyonu – Dizini*, ed. Seyit

the most important product of Egyptian silk weavers was the *kisve*, the cover for the Ka'aba in Mecca that the pilgrimage caravan carried to the Holy City every year.[58] Evliya either witnessed in person, or else recorded on the basis of documents, the parade that received the *kisve* from the Cairo location where it had been woven, which the author called 'Yusuf Köşkü'. Thus, the people in the parade accompanied the silk textiles that would adorn the Ka'aba during the first stages of their long journey to Mecca.

Evliya briefly mentioned the weavers and their work. Evliya's figures must be taken with a grain of salt but, given the absence of other information, it is worth noting his assertion that seventy *kantar* of silk and three *kantar* of pure silver were used to weave the *kisve* in the late seventeenth century, which was financed by Queen Shadjar(at) al-Durr's (r. 1250) pious foundation.[59] Although Evliya did not mention any gold, it must have been used as well, because he recorded that the inscriptions were golden in colour. Presumably, the embroiderers had used thread enriched by gilt silver. While Evliya did not hesitate to admit that the money to pay for the *kisve* had been in place long before the Ottoman sultans appeared in the region, he took care to stress the sultan's gifts, which financed the inscribed 'belt' encircling the Ka'aba, the curtain covering the door and the cover for the Maqām İbrāhīm in the immediate vicinity of the Ka'aba; presumably, all of these items were made of silk. He also noted that, before the cover for the Ka'aba embarked on its journey, officials checked it to ensure that the silk and silver employed according to the accounts were really present in the textiles.

Before the parade, workmen fixed the cover for the Ka'aba door in a frame that was the same size as the opening it would cover in Mecca. The *kisve* was distributed across twenty round trays, while another twenty trays displayed the white cotton ropes that would ultimately hold the cover in place. Before leaving the vicinity of Cairo, the *kisve* was tested at a local sanctuary that was the same size as the Ka'aba. At this stage, men from North Africa carried the costly silks and received a good deal of respect from the locals on account of the blessings that their burden was believed to bestow on them.

Three hundred artisans were employed to weave these huge covers every year, and Evliya claimed that this painstaking endeavour gave them *cimroz* – that is, it damaged their eyesight. Another 300 people in seventeen dye-houses dyed

Ali Kahraman, Yücel Dağlı, and Robert Dankoff (Istanbul, 2007), x, 390. The traveller was more impressed by the rice grown in the hinterland of this town.

[58] *Ibid.*, 224–30.

[59] It is impossible to give the metric equivalent of the Egyptian *kantar/qintar* mentioned by Evliya Çelebi as, between the fifteenth and seventeenth centuries, five different *kantars* of widely diverging weights were in use: see Walter Hinz, *Islamische Masse und Gewichte: umgerechnet ins metrische System* (Leiden, 1955), 25.

the silk black (the author did not specify whether it was the yarn or the finished fabric which was dyed). This industry employing 600 craftsmen was a substantial enterprise and it is likely that the apprentices and other dependent workers were not included in the figures relayed by the Ottoman traveller.

In addition, there were artisans who made silk textiles for secular use. According to Evliya, 300 specialist weavers often produced carpets of silk, which had no equals except, perhaps, in Isfahan. In addition, 800 craftsmen made a variety of other silk fabrics, including velvets.[60]

'FOREIGN' SILK FABRICS COMPETING ON THE OTTOMAN MARKET

Many – if not most – silk textiles produced and sold in the Ottoman realm were either non-commercial or luxury objects which were only available to the rich. People who could purchase locally-produced luxuries might also have been tempted by imported silks. Admittedly, the latter must have arrived in small quantities, so our information about these is very limited indeed. While sixteenth-century sultans sometimes wore caftans made from Italian velvet, as is apparent from the collections in the Topkapı Palace Museum, the main source of imported silk textiles must have been Iran. Louise Mackie considers that silk carpets decorated with pearls and gemstones are likely to have been made by Iranian workers.[61] They were used on ceremonial occasions at the sultan's court, as seen in a late sixteenth-century miniature.[62]

Safavid court fashions up until the late seventeenth century featured numerous depictions of people and animals, or characters from popular stories such as Mecnun and Leyla or Hüsrev and Şirin. These had been notably absent from the silks of the Timurid period, which often featured small, fairly abstract designs worked in gilt thread, and also from the textiles produced under the late Safavids, when decorations once again became abstract and/or floral.[63] Ottoman

[60] Evliya Çelebi, x, 200. Robert Dankoff, *Armenian Loanwords in Turkish* (Wiesbaden, 1995), 98 defines this as 'rheumy-eyed'.

[61] Louise Mackee, 'Ottoman Kaftans with an Italian Identity', in Suraiya Faroqhi and Christoph Neumann (eds.), *The Illuminated Table, the Prosperous House: Food and Shelter in Ottoman Material Culture* (Istanbul, 2003), 219–29, see 222.

[62] However, a recent exhibition catalogue of Iranian items in the Topkapı Palace collection shows no such carpets; presumably the valuable pearls were sold long ago to pay for war-related costs. As an example, compare this with İsmail Baykal, 'Selim III Devrinde İmdad-ı sefer için Para Basılmak üzere Saraydan Verilen Altın ve Gümüş Avani Hakkında', *Tarih Vesikaları*, 3 (1944), 13, 36–50.

[63] Thomas T. Allsen, *Commodity and Exchange in the Mongol Empire: A Cultural History of Islamic Textiles* (Cambridge, 1997); Allgrove J. McDowell, 'Textiles', in Ronald W. Ferrier (ed.), *The*

silks, whether intended for the court or the general public, were often decorated with naturalistic tulips, hyacinths, and carnations, or else with abstract designs, but almost never with people or animals. We are left to question whether Iranian silks decorated with figures were considered acceptable in the relatively small Ottoman elite circles wealthy enough to afford them.

Prosperous Christian – and perhaps Jewish – merchants were potential customers for such silks, as seen in the famous early seventeenth-century 'Aleppo room' now in the Museum of Islamic Art in Berlin, which had originally been the property of a Christian trader. Moreover, given the presence of many Armenian-Iranian silk traders in Aleppo, a wealthy inhabitant of this city should have found it relatively easy to obtain Iranian silk fabric. It is, perhaps, even more remarkable that the Ottoman palace also still retains a number of Iranian figurative silks, which were diplomatic gifts and which the Ottoman palace officials felt were worth preserving.[64] Today in Karlsruhe, an Iranian textile of similar design to those still in the palace, dating from the early seventeenth century, shows a richly-dressed youth and an elderly beggar.[65] As the noblemen of Baden at this time had no direct relationship with the Ottoman court, this piece had probably been the property of an Ottoman dignitary who sold it, used it to pay a ransom, or had to leave it behind in the camp in Vienna.[66]

CONCLUSION

The early modern manufacture of Ottoman silk cloth could compare with that of China, India, or Iran; but few Ottoman textile studies focus on comparison. Florentine and Venetian silk weavers were also important competitors for the favours of the Ottoman elites, who comprised the limited market for such luxuries. A textile historian has recently estimated that Italian manufacturers produced more top-quality silks than Istanbul and Bursa taken together.[67] The

Arts of Persia (New Haven and London, 1989), 157–70.

[64] İlber Ortaylı et al., *Onbin Yılın İran Medeniyeti: İkibin Yıllık Ortak Miras* (Istanbul, 2009), 174–5, 234. I thank Dr Mehr Ali Newid (Munich) for pointing out that the horseman and the semi-nude woman combing her hair on p. 234 refer to the moment at which the Iranian ruler Hüsrev surprised Princess Şirin as she was bathing.

[65] http://www.tuerkenbeute.de/sam/sam_all/D200_02_de.php ('Alltagsgegenstände' section, accessed 19 November 2016).

[66] Ottoman fabrics often formed part of the ransom payments that freed military officers captured on the Hungarian frontier: see Árpád Nógradi, 'A List of Ransom for Ottoman Captives Imprisoned in Croatian Castles', in Géza Dávid and Pál Fodor (eds.), *Ransom Slavery along the Ottoman Borders: Early Fifteenth–Early Eighteenth Centuries* (Leiden, 2007), 34.

[67] Mackee, 'Ottoman Kaftans', 226. Mackee is one of the co-authors of Atasoy et al., *İpek*.

great number of silks exported to Moldavia, Walachia, Transylvania, Poland and Russia make it seem likely that Ottoman silks had a greater impact outside of the sultans' directly-controlled domains than was acknowledged by Nurhan Atasoy and her co-authors.[68] It was only in a later study, co-authored with Lâle Uluç, that the full impact of Ottoman textiles became visible.[69]

Perhaps these findings resemble those of historians of military technology. On the one hand, Ottoman producers of military hardware succeeded in holding their own but lagged behind in terms of innovation; on the other hand, soldiers in the sultans' armies were experts in the use of firearms who spread this knowledge to Sumatra, the principalities of India and, according to recent findings, even China.[70]

While Ottoman silk textiles were occasionally included in post-mortem inventories of elite figures from western or southern Europe, they had more of a curiosity value than real economic significance. As a result, commercial documents written by merchants from western and southern Europe do not reveal much about the sale of Ottoman silks. We do not yet know much about the exportation of Ottoman silks to Iran, but apparently some Ottoman administrators hoped that the expenditure involved in buying Iranian raw silk could be partly compensated for by selling silk cloth in this region.[71]

A review of provincial silk cloth manufacture, especially in Damascus, the island of Chios, and Cairo, shows that there is only limited information about the merchants' and weavers' procurement of raw silk, compared with the importation and sale of Iranian raw silk to English and other merchants in Aleppo and Izmir. But this latter trade is not strictly relevant, since the transactions involved did not directly affect Ottoman silk weaving. As for the indirect impact of increasing foreign demand upon raw silk prices and therefore on the economic survival of Bursa silk weavers during the late sixteenth century, Murat Çizakça's conclusions are well enough known to need no recapitulation.[72]

Research into the manufacture and consumption of luxury fabrics suffers from the lack of numerical data and the fact that the existing statistics may not be representative of what was available on the market in the sixteenth and

[68] Atasoy et al., *İpek*.

[69] Atasoy and Uluç, *Impressions of Ottoman Culture*.

[70] Gabor Ágoston, 'Avrupa-Asya arasında teknolojik diyalog ve Osmanlı İmparatorluğu: Barut çağında askeri teknoloji ve uzmanlık', in *Osmanlı'da Strateji ve Askeri Güç*, trans. M. Fatih Çalışır (Istanbul, 2012), 151–68, see 154 and 165.

[71] Dalsar, *Bursa'da İpekçilik*, 281.

[72] Murat Çizakça, 'Price History and the Bursa Silk Industry: A Study in Ottoman Industrial Decline, 1550–1650', in Huri Islamoğlu-Inan (ed.), *The Ottoman Empire and the World Economy* (Cambridge, 1987), 247–61.

seventeenth centuries. We are thus often reduced to drawing imprecise conclusions from anecdotal evidence. Colette Establet and Jean Paul Pasqual have recently reminded us of the uncomfortable truth that this procedure is of limited value, asserting that statistics alone can accurately reflect the production and consumption of a given society.[73] Although this claim is correct, the only source containing numerical data on such matters, namely the post-mortem inventories contained in the registers of local judges and used by numerous Ottoman historians, also provide a badly skewed picture. First of all, as we can only roughly estimate the populations of pre-nineteenth century Ottoman cities, we do not know what percentage of the urban inhabitants these inventories represent. Second, and more seriously, wealthy people's legacies were much more likely to be recorded than those of the poor. Historical research – including this chapter – will thus tend to exaggerate the quantities of silk cloth per head available to the population in any given period. There is, therefore, significant opportunity for future research in this area.

While the work of Atasoy and her co-authors, particularly Uluç, has transformed our view of Ottoman cultural impact beyond its empire's borders, we still know far too little about the activities of provincial silk manufactures. As well as in Damascus and Chios, silks were manufactured in the Balkans, and this could be explored in the future. Furthermore, Egypt, especially Cairo, was a centre of silk weaving, as shown by a recently-opened textile museum there. We still have much to learn about both the producers and the consumers of Ottoman silks, and thereby about the place that this branch of high-value production occupied in the world at large.

[73] The last volume in the series is Colette Establet and Jean Paul Pasqual, *La gent d'état dans la société ottomane damascène: les 'askar à la fin du XVIIe siècle* (Damascus, 2011).

6.

A Study in Contrasts: Silk Consumption in Italy and England during the Fifteenth and Sixteenth Centuries

Lisa Monnas

'They seem very uncouth, with not a single garment of silk to be seen', commented Ser Francesco di Ser Barone (1451–98) in a letter describing the Milanese ambassadors passing through Florence on their way to Rome to greet the newly elected Borgia pope, Alexander VI (1431–1503) in 1492.[1] At the beginning of the fifteenth century, the European aristocracy and some wealthier elements of society could, if they chose, dress and furnish their houses in silk, array their horses in it and wage war wearing plate armour or defensive doublets lined or covered in silk. Yet even the most privileged classes still had wardrobes and furnishings balanced between high-quality wool and silk. This changed over the course of the century, as silk came to be perceived less as a privileged luxury, and more as the essential attire of a gentleman, generating the disparaging comment above. There were, of course, local differences in the appetite for silk, depending upon social structure and customs, and the availability of the material. The following discussion contrasts silk consumption in Italy, the main European producer of silk fabrics at the time, with that of England, which manufactured only smaller silk items and relied entirely upon imports for textiles made of silk. Whereas in England, a unified kingdom and centralised administration, London was the main focus of trade and consumption, the Italian peninsula was composed of independent states, boasting several important weaving centres, and consumption was inevitably more varied and more diffuse.

[1] Ser Francesco di ser Barone in Florence to Ser Piero Bibbiena, 12 November 1492, cited in Alison Brown, 'Lorenzo de' Medici's New Men and Their Mores: The Changing Lifestyle of Quattrocento Florence', *Renaissance Studies*, 16/2 (2002), 128 and n. 54.

ITALIAN SILK: RAW MATERIALS AND FABRICS

In 1300, the Tuscan city of Lucca was the chief centre of silk weaving in Italy. During the fourteenth century, political instability and successive episodes of plague caused many Lucchese silk merchants and artisans to emigrate to other cities, initially Venice, Bologna, and Florence, and later Genoa. Although these cities had already begun to weave silk before 1300, the advance of silk weaving technology depended upon the availability of specialised equipment and skilled artisans, and the Lucchese diaspora proved crucial to the development of their silk industries.[2] Venice initially benefited the most from an influx of Lucchese weavers skilled in the production of figured silks. During the fifteenth century, Florence shifted its specialisation from making and finishing high-quality woollen cloth to the production of silk fabrics, especially brocaded cloths of gold.[3] This development was not only due to Lucchese immigration, but also to the initiative of the Florentines themselves, who were willing to invest in this new direction, importing expert makers of gold thread and specialist equipment, such as fine rods for velvet weaving.[4] During the fifteenth century, the silk industry of Lucca was overtaken in international importance by Venice, Florence, and Genoa. Within a century, silk weaving spread elsewhere in the peninsula, to Milan, Ferrara, Modena, Siena, and Perugia, as well as several lesser centres. During the sixteenth century, each major Italian centre of production employed between 2,000 and 4,000 looms for silk weaving, with a peak in Genoa of 10,000 looms in 1579.[5] By 1600, silk manufacture played a vital economic role along the entire Italian peninsula.[6]

Concerted efforts were made in Italy to expand the silk industry by promoting the cultivation of mulberry trees. In the region of Lucca, sericulture was initiated during the fourteenth century, and was subsequently taken up by the Florentines.[7] In 1527 the Venetian ambassador Marco Foscari estimated that the Florentine silk industry consumed 100,000 Florentine pounds of raw silk annually.[8] By the

[2] Sergio Tognetti, *Un industria di lusso al servizio del grande commercio: Il mercato dei drappi serici e della seta nella Firenze del Quattrocento* (Florence, 2002), 14–15.

[3] Tognetti, *Un industria di lusso*, passim; Florence Edler de Roover, *L'arte della seta a Firenze nei secoli XIV e XV*, Sergio Tognetti (ed.) (Florence, 1999), passim.

[4] For gold thread makers, see Edler de Roover, *L'arte della seta*, 87; Tognetti, *Un industria di lusso*, 17; for makers of velvet rods, Umberto Dorini (ed.), *Statuti dell'Arte di Por' Santa Maria del tempo della Repubblica* (Florence, 1934), 622.

[5] Luca Molà, *The Silk Industry of Renaissance Venice* (Baltimore and London, 2000), 18.

[6] *Ibid.*, ch. 1, 'A Changing Industrial Geography', 1–28, esp. 4–5.

[7] Francesco Battistini, 'La gelsibachicoltura e la trattura della seta in Toscana (secc. XIII–XVIII)', in Simonetta Cavaciocchi (ed.), *La Seta in Europa Secc. XIII–XX* (Florence, 1993), 295.

[8] Molà, *The Silk Industry of Renaissance Venice*, 18; the Florentine pound weighed 12 ounces (339 g), Ronald E. Zupko, *Italian Weights and Measures from the Middle Ages to the Nineteenth Century* (Philadelphia, 1981), 133.

Table 6.1 Types and prices of raw silk purchased by the firm of
Andrea Banchi in Florence, and their usage by the Banchi firm.

Date	Place of origin	Name of silk	Usage	Price per lb
1450s	The Romagna, Italy	Modigliana	Warps of all fabrics and velvet pile	3 f. 8s to 3 f. 12s
1438	Granada, Spain	Spanish	Multi-purpose	3 f. 6s to 3 f. 9s
1450s	The Abruzzi, Italy	d'Abruzzi	Warps, except warps of satin, taffeta, or velvet pile	3 f. 5s
1450s	The Marche, Italy	di Marca		3 f.
1450s	Asterabad, Caspian Sea area	Stravai	Warps of solid, cut-pile velvet and of voided satin velvet	2 f. 10s
1450s	Talich, Caspian Sea area	Talani	Not specified	2 f. 10s
1450s	Lahijan, Caspian Sea area	Leggi	Warp, weft and pile of velvet, damask weft	2 f. 5s
1454	Chios, Aegean Sea	from Chios	Not specified	2 f. 2s
1450s (?)	Calabria, Italy	Calabrese	Wefts of velvet	1 f. 12s
1450s	n/s	*filugello**	Used in making belts	not specified

* Floss silk, made from the short fibres of broken cocoons or from outer layers of cocoons, which was spun not thrown.
Currency: f. = *fiorini*; s. = *solidi*.
Source: Extracted from Florence Edler de Roover, 'Andrea Banchi, Florentine Silk Manufacturer and Merchant in the Fifteenth Century', *Studies in Medieval and Renaissance History*, 3 (1966), 223–85, esp. 237–9.

beginning of the seventeenth century, the amount of raw silk used annually in Florence alone reached over 206,000 pounds.[9] Domestic production could not, however, match the needs of the burgeoning silk industry. The silk manufacturer Andrea Banchi (1372–1462) employed raw silk from over nine different sources for his luxurious damasks and velvets (Table 6.1), ranging from the most expensive silk from the Romagna in Italy and from Spain, to medium priced silk from around the Caspian Sea, and the cheapest from Calabria in Southern Italy.[10]

[9] Molà, *The Silk Industry of Renaissance Venice*, 18.
[10] Florence Edler de Roover, 'Andrea Banchi: Florentine Silk Manufacturer and Merchant in the Fifteenth Century', *Studies in Medieval and Renaissance History*, 3 (1966), 223–85, esp. 237–9; Edler de Roover, *L'arte della seta a Firenze*, 25–9.

This eclecticism was not simply in order to obtain a sufficient quantity: different qualities of silk were needed to produce threads varying in strength, elasticity, and lustre, according to the type of fabric and to the role of each particular thread.

The English market dealt in much smaller amounts of raw silk for the production of narrow wares and fancy nets for the hair, as well as for embroidery. In 1440–1, hosting documents, surveying goods of foreign merchants imported to London, record raw silk and silk thread sold by Venetians mainly to silkwomen. The silk was priced by weight, by bundle, or as finished threads by 'paper'. These variations make the silk impossible to quantify precisely, but it is possible to identify some of the sources. There was, for example, *talany* and *leggi* silk from around the Caspian Sea, and also silk threads prepared in Paris.[11] The London Petty Customs accounts of 1480–1 record some 2,750 English pounds of Italian silk, imported mainly by the Buonvisi of Lucca and Hanseatic merchants.[12] Of this, 760 pounds was 'call' silk, suitable for women's headdresses made of silk netting, called 'cauls'. The rest was mostly prepared silk threads from Cologne, priced at 6s 8d per English pound.[13] In the 1440s these goods were taxed according to values estimated by the importers, but fixed values were eventually applied and these were set out in successive Books of Rates. A book issued in 1558, during the reign of Mary Tudor (r. 1553–8), lists raw silk and silk thread from, among others, Cologne, Paris, Granada, and elsewhere in Spain. Silk from around the Caspian Sea is no longer mentioned. Spanish silk was the most expensive.[14]

At the beginning of the fifteenth century, taffeta and *tartaryn* were the cheapest plain, tabby-woven silks. Sarsenet, another light silk, was possibly woven in twill. In the sixteenth century, *ormesino*, a silk of Levantine origin, came to be produced in Italy.[15] Next in price came satin. The most expensive of the plain silks was velvet, which required particular weaving skills to produce a smooth cut-silk pile and was extravagant in its use of materials: the pile warp for velvet was generally six times longer than the main warp. Among the figured silks, damask, a weave

[11] Helen Bradley (ed.), *The Views of the Hosts of Alien Merchants 1440–44* (Woodbridge, 2012), 6, 11, 15, 25, 36, 37, 41–3, 45, 48, 90, 91, 99, 126.

[12] The English pound weighed 16 ounces, 453.5 g.

[13] Henry S. Cobb, 'Textile Imports in the Fifteenth Century: The Evidence of Customs' Accounts 1480–81', *Costume*, 29 (1995), 1–11, esp. 7.

[14] Spanish silk, 26s 8d per pound of 12 ounces (339 g); coloured silk from Granada, 26s 8d, and black silk, 20s, both for a 16-ounce pound (435.5 g), T. S. Willan (ed.), *A Tudor Book of Rates* (Manchester, 1962), 54.

[15] Molà, *The Silk Industry of Renaissance Venice*, 405; mentioned in Padua as early as 1502, Giuliana Ericani and Paola Frattaroli (eds.), *Tessuti nel Veneto: Venezia e la Terraferma* (Verona, 1993), glossary by Michele A. Cortelazzo, Adriana da Rin and Paola Frattaroli, 22.

based on satin, was next in price (Illustration 6.1) followed by lampas silks, such as *baldacchino* (baldekyn), which was more complex in structure (Illustration 6.2).[16] Voided satin velvet, called *zetano vellutato* in Italy, was the cheapest of the figured velvets because the voided areas consumed less pile thread (Illustration 6.3). Conversely, the most expensive monochrome figured velvet, called *alto e basso* in Italy, or 'pile-on-pile' in England, had solid cut-silk pile woven in two heights (Illustration 6.4).

Cloths of gold and silver were another matter. Based upon one of the silk weaves described above, they were elaborated with either a metal brocading weft, inserted only where it formed the pattern, or a pattern weft shot across the entire width of the fabric. The expense depended on the quantity and quality of metal thread, whether it was a wrapped or a solid drawn wire thread, and, if wrapped, whether the wrapping was made of gilt animal matter (such as ox-gut membrane), or just metal, and whether the core was silk or linen. Table 6.2 offers prices drawn from the great wardrobe accounts of Henry VII of England (r. 1485–1509), in 1498–99, illustrating the relative values of some silk fabrics at the end of the fifteenth century. The most expensive item is a cloth of estate of Florentine 'cloth of gold of tissue' (as explained below) enriched with loops of metal thread, woven for Henry VII with his royal badges of Tudor roses and portcullises, priced at £11 per yard.[17]

There are just six colours of silk in Table 6.2. Black features most strongly, then crimson, purple, russet, tawny, green, and white. Apart from black, the most desirable colours for Renaissance silks were crimson (*cremisi* or *chermisi*) and two shades of purple called in Italy *paonazzo* ('peacock') or *morello* ('mulberry'; in England this colour was called 'murrey'). The most expensive colour was crimson, extracted from two species of tiny scale insects inhabiting wild grasslands, Polish cochineal (*Porphyrophora polonica*) (Linnaeus 1758) and Armenian cochineal (*Porphyrophora hamelii*) (Brandt 1833).[18] Harvesting was seasonal and laborious, and millions of insects were required to generate the

[16] For the interpretation of *baldacchino* (called in England 'baldekyn', or 'baudekyn') as a lampas silk, see Donald King and Monique King, 'Silk Weaves of Lucca in 1376', in Inger Estham and Margareta Nockert (eds.), *Opera Textilia Variorum Temporum: To Honour Agnes Geijer on Her Ninetieth Birthday 26th October 1988* (Stockholm, 1988), 67–76, esp. 68, 70 and 74, and ill. fig. 1; a monochrome damask has only one warp and weft, while a lampas silk has two warps, a main and a binding warp, and a minimum of two wefts, a main and a pattern weft.

[17] This furnishing cost altogether £522 10s, TNA, E101/413/15, f. 56v, discussed by Lisa Monnas in '"Plentie and Abundaunce": Henry VIII's Valuable Store of Textiles', in Maria Hayward and Philip Ward (eds.), *The Inventory of King Henry VIII: Volume II, Textiles and Dress* (London, 2012), 235–94, esp. 285.

[18] Dominique Cardon, *Natural Dyes: Sources, Tradition, Technology and Science* (London, 2007), 635–52.

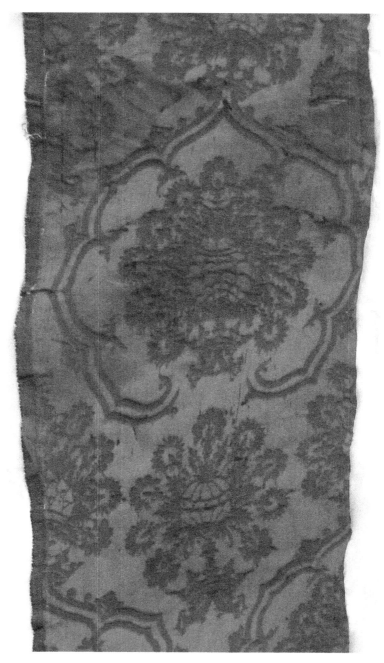

Illustration 6.1 Detail of a fragment of crimson silk damask. Italy, second
half of the fifteenth century, 71 x 31.3 cm. London, School of Historical
Dress, inv. no. THSD-Tex1-2015. Photo credit Lisa Monnas.

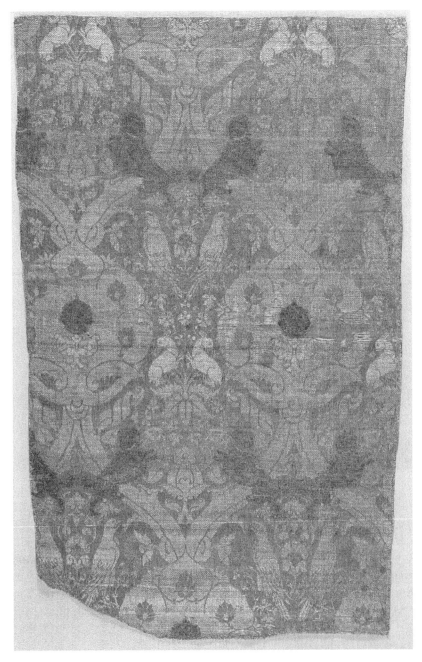

Illustration 6.2 Fragment of lampas silk, brocaded with gilt membrane wrapped thread, with birds, dogs and rabbits. Italy, first quarter of the fifteenth century, 66 x 43 cm. Riggisberg: Abegg–Stiftung inv. no. 457.

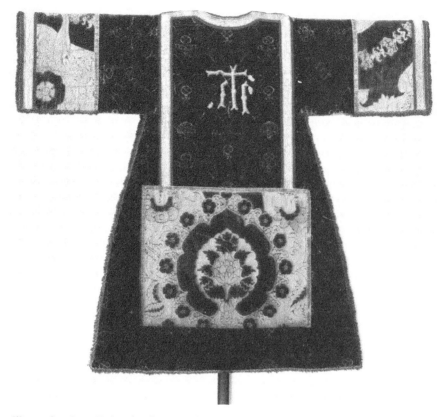

Illustration 6.3 Dalmatic of green voided satin velvet, with apparels of crimson velvet cloth of gold of tissue, and part of an applied embroidered monogram IHR. Italy, second half of the fifteenth century, 118 x 140 cm. Riggisberg: Abegg-Stiftung inv. no. 268.

crimson dye required by the Italian silk industry. According to one contemporary dyer's recipe, it took eight pounds of Armenian cochineal but half that amount of Polish cochineal to dye one pound of boiled silk crimson.[19] Purple was obtained with blue and red colourants, and when they involved scale-insect dyes, purple silks could be almost as costly as crimson.[20] The picture changed with the arrival in Europe of New World cochineal (*Dactilopius coccus* (O. Costa 1835)). These insects, living on cacti, could be farmed and harvested twice a year, thus yielding

[19] Giovanni Rebora (ed.), *Un Manuale di Tintoria del Quattrocento* (Milan, 1970), 126, ch. 138.

[20] For tariffs for dyeing silk in Florence in 1429, see Dorini, *Statuti dell'Arte di Por' Santa Maria*, 489–90.

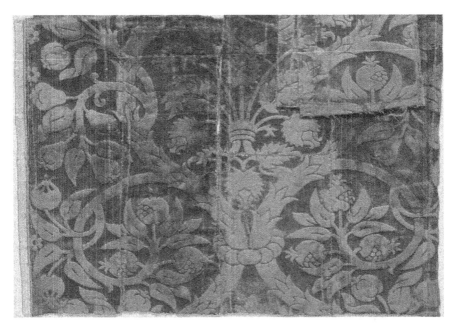

Illustration 6.4 Detail of a composite fragment of crimson
alto e basso velvet. Possibly Milan, late fifteenth or early sixteenth century.
Victoria and Albert Museum, 593-1884. © Victoria and Albert Museum, London.

more colour than the Old World species. Their introduction into the Italian silk
industry in the 1540s eventually brought down the price of crimson silk, which
consequently, over time, lost its exclusivity.[21]

DEVELOPMENTS IN SILK WEAVING

The fifteenth and sixteenth centuries corresponded to a period of innovation and
expansion in European silk weaving. Existing weaves were modified to create a
wealth of different fabrics. Damasks, originally monochrome, were elaborated
with brocading in silk and gold. The patterns of figured velvets grew progres-
sively larger until, by the mid fifteenth century, a single repeat could span an
entire loom width of around sixty centimetres, and measure around two metres
in height. In addition, new velvet weaves were developed, particularly in cloths
of gold and silver. Metallic weft loops were first introduced into velvets in the
1420s, and subsequently into other weaves. These fabrics enriched with loops

[21] Cardon, *Natural Dyes*, 619–32, esp. 630.

Table 6.2 Prices extracted from the accounts of Henry VII, 1498–1499.

Source	Supplier	Fabric	Colour	Price per yard
1a, f. 56v (1499)	Antonio Corsi	Cloth of estate made of cloth of gold of tissue	crimson	£11
1. p. 39	From store	*Velvet upon velvet hatched with gold	crimson	£2 13s 4d
1. p. 50	From store	*Tissue cloth of gold	n/a	40s
1. pp. 15, 16, 39	Tommaso Guinigi, Girolamo Buonvisi	**Velvet	crimson	30s
1. p. 40	Tommaso Guinigi	*Velvet	crimson	13s 4d
1. p. 13	Tommaso Guinigi	*Velvet	purple	£1 13s 4d
1. pp. 29, 54	From store	*Velvet	purple	15s
1. pp. 14, 23, 32, 42	Tommaso Guinigi	Velvet	black	18s
1. pp. 14, 15, 17, 19, 23, 31, 33, 45, 47, 48, 49, 54	Francesco and Tommaso Guinigi, William Bailey	Velvet	black	10s
1. p. 9	From store	Velvet	black	7s
1. p. 49	From store	Velvet	green	12s
1. p. 25	Girolamo Buonvisi	Damask	black	7s
1. p. 37	Tommaso Guinigi	Damask	black	6s 8d
1. p. 50	From store	Damask	tawny	7s
1. pp. 43, 50	Tommaso Guinigi	Damask	white	8s
1. p. 13	Girolamo Buonvisi	*Satin 'tinseled'	n/a	26s 8d
1. p. 24	Girolamo Buonvisi	*Satin hatched [with gold]	black	26s 8d
1. pp. 23, 33, 51	Tommaso Guinigi	Satin	black	11s
1. p. 39	From store	Satin	black	9s
1. pp. 16, 45	Lorenzo Buonvisi, Tommaso Guinigi	Satin	black	8s

Source	Supplier	Fabric	Colour	Price per yard
1. pp. 47, 52	From store	Satin	green	9s
1. p. 22	From store	Satin	green	6s
1. p. 47	Lorenzo Buonvisi	Satin	russet	6s 8d
1. p. 15	From store	Satin	tawny	12s
1. pp. 12, 25, 38	Lorenzo Buonvisi	Satin	tawny	6s 8d
1. p. 19	William Botry	Sarsenet	white	5s 4d
1. p. 14	Tommaso Guinigi	Sarsenet	black	5s
1. p. 49	Richard Lakyn	Sarsenet	black	4s 8d
1. pp. 38, 42	Tommaso Guinigi	Sarsenet	black	4s 4d
1. p. 47	Richard Lakyn	Sarsenet	black	4s
1. p. 47	Lorenzo Buonvisi	Sarsenet	tawny	4s 6d
1. p. 41	Francesco Guinigi	Sarsenet	white	4s 6d
1. p. 53	William Smith	Bolen (Bologna) sarsenet	n/a	2s
1. p. 45	Richard Lakyn	Bridges (Bruges) satin	n/a	3s
1. p. 37	Roger Bower	Bridges (Bruges) satin	n/a	2s 10d
1. p. 21	Lorenzo Buonvisi	Camlet	black	2s 6d

Notes:
* Only for the king. ** Only for the king and his children's clothing.

The Guinigi (spelt in the document 'Gwynys') and the Buonvisi were from Lucca; Antonio Corsi was Florentine; Bayley, Botry, Bower, Lakyn, and Smith were English mercers.

From store = of the great wardrobe.

Currency: £ = pounds (*libri*), s = shillings (*solidi*), d = pence (*denarii*). There were 20 shillings in a pound and 12d in a shilling. £1 sterling in 1500 was equivalent to over £486 in 2016.

Sources: 1. TNA, E36/209, particulars of the account of Sir Robert Lytton, keeper of the great wardrobe, 29 September 1498 to 29 September 1499, in Maria Hayward (ed.), *The Great Wardrobe Accounts of Henry VII and Henry VIII* (Woodbridge, 2012), 3–77.

1a. TNA, E101/414/16, account book of John Heron, treasurer of the chamber, 22 August 1497–21 August 1500.

were called *broccati riccio sopra riccio* ('loop over loop') in Italy and 'cloth of gold of tissue' in England (Illustration 6.3). The development of drawn wire threads fine enough to interweave with silk, first documented in Milan in 1458, opened new horizons in weaving cloth of gold or silver.[22] Their simplest expression was in a range of plain cloths with names such as *sfumati* or *telette*.[23] Wire threads were eventually used in combination with loops in metallic wrapped thread to create more elaborate cloths of gold – heavy fabrics with impressively large pattern repeats woven in velvet, lampas, and brocatelle.

The taste for these spectacular fabrics reached its zenith in the courts of Europe around the middle of the sixteenth century. During the second half of the century, they gave way to a range of lighter silks, paralleling the introduction of the new draperies in wool. These included plain silks like *ormesino*, and half-silks such as *ferrandina*.[24] Finer, delicate versions of the gold-looped brocatelles, woven as lampas silks with dainty motifs in one height of loops, on grounds shot with drawn wire thread, superseded the earlier, heavier versions. Infanta Isabella Clara Eugenia (1566–1636) is wearing the new lighter style in her portrait, c. 1585–90, by Alonso Sánchez Coello in the Museo del Prado, Madrid (Illustration 6.5).[25] Super-heavy cloths of gold and silver did continue to be used for furnishings: in the same portrait, one of the old-style brocades with a huge pattern provides a cloth of honour for the infanta. The large designs and stiff texture of these fabrics was equally suited to the simple forms of Western ecclesiastical vestments or of Turkish kaftans. Long after they ceased to be fashionable in Europe, they were still purchased for the Church, and may have been worn at the Turkish court into the seventeenth century.[26]

[22] Letter from Ludovico Gonzaga in Mantua to Vincenzo Scalona in Milan, 18 April 1458, Arturo Calzona, 'L'abito alla corte dei Gonzaga', in Dora Liscia Bemporad (ed.), *Il Costume nell'età del Rinascimento* (Florence, 1988), 225–52, esp. 236 and 244.

[23] *Sfumati* ('smoked' fabrics) appear in the Medici inventory of 1492, Marco Spallanzani and Giovanni Gaeta Bertelà (eds.), *Libro d'inventario dei beni di Lorenzo il Magnifico* (Florence, 1992), for example, 123, '*uno farsetto di raso biancho sfumato d'ariento*' ('a doublet of white satin 'smoked' with silver'); for *telette* and *sfumati* in Florentine silk-weaving statutes of 1512, see Dorini, *Statuti dell'Arte di Por' Santa Maria*, 733–4; for *telette* woven in the 1530s by the Florentine Jacopo de' Tedeschi, see Richard A. Goldthwaite, 'An Entrepreneurial Silk Weaver in Renaissance Italy', *I Tatti Studies*, 10 (2005), 69–126, esp. 83.

[24] *Ferrandina*, a half-silk with a wool weft, Molà, *The Silk Industry of Renaissance Venice*, 173–4, 404; a half-silk with a wool or cotton weft, Ericani and Frattaroli, *Tessuti nel Veneto*, glossary, 12.

[25] Chiara Buss (ed.), *Seta oro incarnadino: Lusso e devozione nella Lombarda spagnuola, Seta in Lombardia*, exhibition catalogue, Poldi Pezzoli Museum, Milan (Milan, 2012), 77.

[26] See the kaftan associated with Emperor Osman II (r. 1623–40), in the Topkapi Palace Museum, Hülye Tecan and Selma Delibas, *The Topkapi Saray Museum: Costumes, Embroideries and Other Textiles*, J. Michael Rogers (trans. and ed.) (London, 1986), cat. no. 42, ill. 15.

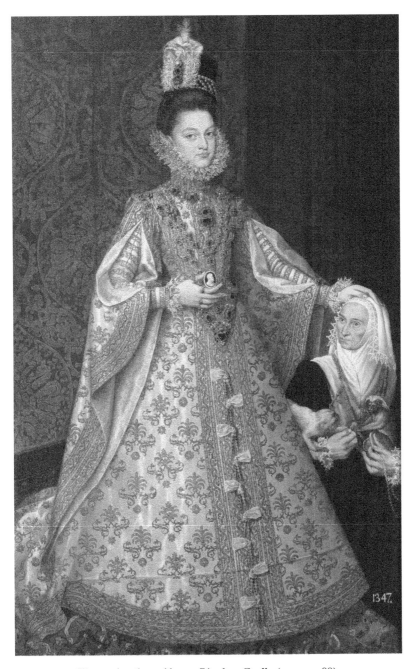

Illustration 6.5 Alonso Sánchez Coello (1531–1588),
Portrait of Isabella Clara Eugenia with Magdalena Ruiz, 1585–1588.
Oil on canvas, 207 x 129 cm. Madrid, Museo del Prado, no. P00861.

NARROW WARES

Silk was most widely used for embroidery and in the creation of narrow wares, such as ribbons, laces, girdles, and borders. These items were made throughout Europe, including within religious houses, and frequently on a commercial basis. Since they involved simple, small-scale equipment, they were also suitable for amateur production in the home. In Italy, cheaper silk fabrics and narrow wares were sold by *setaioli minuti* ('small' silk merchants) as opposed to the *setaioli grossi* (equivalent to English mercers) who dealt in high-end fabrics.

In England, 'silkwomen', often the wives of mercers, controlled the production and sale of narrow wares, which constituted an important domestic industry.[27] Sumptuary laws passed under Edward IV (r. 1461–70 and 1471–83) and Henry VIII (r. 1509–47) attempted to protect these native products from foreign imports. In 1463, the first of these statutes concerning 'articles of wrought silk' declared that 'divers Lombards and other Alien Strangers [...] intending to enrich themselves and to the detriment of the crafts' commended as 'virtuous occupations for women' were daily importing silk ribbons, and other silk trimmings, and were refusing to import raw silk 'to the final destruction of the said mysteries'.[28] Anyone found selling laces, corses (braids), ribbons, silk fringes, embroidered silk, purses, girdles, and other similar things would be fined £10 for each transgression. In the long term, these prohibitions proved ineffectual. This can be seen from the duty imposed upon a wide variety of silk items brought into England in the mid sixteenth century (Table 6.3), including ribbons and embroidered purses from Venice, silk and gold lace, and cauls and crippins (two types of nets).[29]

[27] M. K. Dale, 'The London Silkwomen of the Fifteenth Century', *Economic History Review*, 4 (1993),); Kay Lacey, 'The Production of "Narrow Wares" by Silkwomen in Fourteenth- and Fifteenth-Century England', *Textile History*, 18 (1987), 187–204; Anne F. Sutton, 'Alice Claver, Silkwoman', in Caroline M. Barron and Anne F. Sutton, *Medieval London Widows 1300–1500* (London, 1994), 129–42; Anne F. Sutton, 'Two Dozen More Silkwomen of Fifteenth-Century London', *The Riccardian*, 16 (2006), 46–58.

[28] Alexander Luders et al. (eds.), *The Statutes of the Realm: Printed by Command of His Majesty George the Third in Pursuance of an Address of the House of Commons of Great Britain [...] from Authentic Manuscripts and Original Records, 1275–1728*, 11 vols (London 1810–28), vol. 2, 395.

[29] David Mitchell in this volume.

Table 6.3 Narrow wares and other small finished silk items
imported into England listed in the Book of Rates, 1558.

Page	Item	Rateable value
15	Cauls of silk for children, the dozen	13s 4d
20	Crippins with silk, the dozen	£1** 6s 8d
	Crippins with gold, the dozen	£2
	Crippin partlets with gold	£6
	Crippin sleeves of gold, the pair	£8
28	Girdles of velvet gilt, the dozen	£3 6s 8d
	Girdles of velvet ungilt, the dozen	£2
29	Gloves of Canaria, Milan, and Venice wrought with silk or silver, the dozen	£1 10s
32	Hats of satin, each	6s 8d
	Hats of silk of French making, for men or women, the dozen	£1 10s
	Hats of velvet, each	10s
33	Hose of silk knit, the pair	£1 6s 8d
42	Nightcaps of velvet, the dozen	£1 10s
45	Passemin lace of gold or silver, the pound containing 12 ounces*	£5
	Passemin lace of silk, the gross of 12 dozen (144 pieces)	20s
	Passemin lace of silk and thread, the gross (144 pieces)	12s
63	Venice purses of leather, embroidered, the dozen	20s
	Venice purses of silk, embroidered or knit, the dozen	20s
	Venice riband, the dozen pieces	£1 6s 8d

* 12 ounces was the troy pound weight, used both in England and continental Europe.
** Currency: £1 in 1560 was equivalent to over £170 in 2016 (National Archives, Kew, currency converter).
Source: Extracted from T. S. Willan (ed.), *A Tudor Book of Rates* (Manchester, 1962).

THE CHURCH: A SPECIAL CASE

The writer Tommaso Garzoni (1549–89), observing the ubiquity of silk in Italy during the sixteenth century, asked,

> Does not silk adorn the umbrellas, the canopies, the chasubles, the copes, the pictures, the palliums, the sandals, the cassocks, the gloves, the maniples, the stoles, the burses, the veils for chalices, the lining for tabernacles, the cushions, the pulpits, and all other silks of the Church?[30]

Continuing a centuries-long tradition, during the Renaissance the Church was the single most consistent consumer of silk; clerics purchased items and the laity donated them. While the consumption of silk textiles among the affluent lay population verifiably increased, the widespread use of silk for ecclesiastical purposes was simply the continuation of an entrenched custom. Because church vestments were the trappings of office, rather than the private possessions of the celebrants, they were either implicitly or expressly exempted from restriction by sumptuary legislation.

The dichotomy between finery acceptable for church services and the modesty expected of the clergy in their secular capacity is clearly illustrated by a letter written by a Venetian scholar and diplomat, Vincenzo Quirini (1487–1514), suggesting reforms to Leo X (r. 1513–21) in the year of his accession as pope. Quirini advised that the pontiff, in his desire to placate the wrath of God and truly reform the Church, should start with himself. Among other things, all of the cloths of gold and silk currently adorning papal apartments should be removed and given to the Church to serve as liturgical ornaments, and be replaced by suitably coloured wool furnishings. He further recommended that members of the papal household should wear wool (*panni pavonazzi* or *rosati*) of a decent (i.e. long) length and non-secular in appearance.[31]

The steady demand for silk church vestments provided the backbone of trade for some silk firms.[32] Leonardo di Cipriano Spinelli's sales ledgers of 1463–5 record among his clients Pope Pius II and members of the senior clergy, including the cardinals of Constance, Mantua, Rouen, and Lerida, the bishop of Trent, and the archbishop of Arles.[33] Many of the finest silk vestments were

[30] Molà, *The Silk Industry of Renaissance Venice*, 89.

[31] Hubert Jedin, *Kirche des Glaubens, Kirche der Geschichte: Ausgewählte Aufsätze und Vorträge*, 2 vols (Freiburg, 1966), vol. 1, 165.

[32] For the Medici see Raymond de Roover, *The Rise and Decline of the Medici Bank 1397–1494* (Cambridge, MA, 1963), 190.

[33] Philip Jacks and William Caferro, *The Spinelli of Florence: Fortunes of a Renaissance Merchant Family* (University Park, PA, 2001), 88.

commissioned as gifts for a church or cathedral, intended for public worship in a form of conspicuous patronage. Unfortunately, most surviving examples have been altered or repaired, and all too often isolated pieces remain out of originally larger sets.[34] Among the most complete sets of the period is the one presented by Margherita Passerini in 1526 to the cathedral of Cortona in honour of her son, Cardinal Silvio Passerini (1469–1529), who may have commissioned it. The extant pieces comprise a chasuble, dalmatic, and tunicle, a cope, two stoles with maniples, a burse, an altar frontal, and two lectern covers. They are all made out of a sumptuous *riccio sopra riccio* brocaded cloth of gold woven in Florence. This specially commissioned fabric features the Passerini emblem of a bull, encircled by the Medici device of a large diamond ring in tribute to Passerini's patron the Medici Pope Leo X. The exquisite embroideries of these vestments, designed by Florentine artists, Raffaellino del Garbo (1466–1524), Andrea di Cosimo da Feltrini (1477–1548) and Andrea del Sarto (1486–1530), were created in the expensive *or nué* (shaded gold) technique, in which a ground of laid gold thread was artistically couched in coloured silks.[35]

Between 1498 and 1502, Henry VII ordered a magnificent set of vestments from Florence, comprising twenty-nine copes and mass vestments, which he bequeathed to Westminster Abbey in 1509. These were woven to shape out of crimson velvet cloth of gold of tissue in a design of his badges of the Tudor rose and the Beaufort portcullis, enriched with copious loops of silver and gold. Typically, the cloth of gold was imported, but a team of embroiderers in London created the orphreys.[36] Edward Hall (1496/7–1529), describing Henry VIII's chapel at the Field of the Cloth of Gold in 1520, observed that the orphreys were laden with pearls and precious stones.[37] Only a single cope, a much-altered chasuble, and a chalice veil survive from the original set. The cope has a replacement orphrey, without pearls or gemstones.[38]

Under Henry VIII the trade in silk vestments suffered severe disruption due to the beginnings of the Reformation, and especially the dissolution of the

[34] For example, the high mass vestments and altar frontal given by Pope Sixtus IV (r. 1471–84) to the Basilica di Sant'Antonio in Padua, now reduced to a chasuble and maniple, Lisa Monnas, 'The Vestments of Sixtus IV at Padua', *CIETA Bulletin*, 57–8 (1983), 104–26.

[35] Donata Devoti, 'Parato Passerini' in Marco Collata and Donato Devoti (eds.), *Arte aurea Aretina: Tesori dalle chiese di Cortona*, exhibition catalogue, Cortona, Palazzo Casali (Florence, 1987), 56–9.

[36] Lisa Monnas, 'New Documents for the Vestments of Henry VII at Stonyhurst College', *Burlington Magazine*, 131/1034 (1989), 345–49.

[37] Edward Hall, *The Union of Two Noble and Illustre Famelies of Lancastre and York*, ed. Henry Ellis (London, 1809), 606.

[38] These vestments belong to Stonyhurst College, Lancashire, and are on loan to the Victoria and Albert Museum, London.

monasteries in the 1530s, which freed an enormous quantity of vestments, either for the king to take for himself or else to be sold off. The Reformation gathered pace during the short reign of Edward VI (r. 1547–53). The *Book of Common Prayer*, introduced in 1552, required the celebrant to wear just a linen surplice, and to replace the stone altar with a simple communion table.[39] Some redundant vestments were concealed from official inspections. Many, such as the beautiful cope made for Richard Fox, bishop of Winchester (1447/8–1528), woven with Fox's emblem of a pelican and his motto EST DEO GRATIA, were converted into ornaments suitable for the new liturgical requirements, in this case, a cloth for a communion table.[40] Other vestments were sold off. William St Loe acquired several copes. His wife, Elizabeth, later countess of Shrewsbury (1527–1608), had them cut up to form appliqué designs on large, secular hangings, which are still extant today.[41]

SECULAR CLOTHING AND FURNISHINGS OF SILK

In Italy, where silk fabrics were manufactured in several weaving centres, they inevitably reached a wider group of people than in England. Because the Italian peninsula was divided into independent states, however, taste in dress and the consumption of silk were far from uniform. Sumptuary legislation, for example, which was centrally issued in England, was devised piecemeal by individual city-states in Italy. Although these laws were notoriously hard to enforce, and were frequently ineffectual, they nevertheless afford insights into the concerns of the governments passing them and the aspirations of the people who sought to wear luxury items.

A law passed in Bologna in January 1401 and its accompanying 'Register of the sealing of clothing', gives some idea of the range of silks available in Bologna at the time and their clientele.[42] According to this law, women were forbidden to wear any dress of figured velvet, or velvet with long pile, or any silk brocaded with gold or silver, or of wool or of silk 'woven or mixed' with gold or silver.

[39] Eamon Duffy, *The Stripping of the Altars: Traditional Religion in England 1400–1580* (New Haven and London, 1992), for the proscription of copes, 474; for the piecemeal wearing of copes after that, 492–3.

[40] Cinzia Maria Sicca, 'Fashioning the Tudor Court', in Maria Hayward and E. Kramer (eds.), *Textiles and Text: Re-establishing the Links between Archival and Object-based Research* (London, 2007), 19.

[41] Santina M. Levey, *The Embroideries at Hardwick Hall: A Catalogue* (The National Trust, 2007), 19, and 58–85, cat. nos. 1 A–E.

[42] Maria-Giuseppina Muzzarelli, *La legislazione suntuaria secoli XIII–XVI Emilia-Romagna* (Rome, 2002), 127–36.

Embroidery was forbidden and the use of fur was restricted.[43] The 'Register of the sealing of clothing', of January 1401 names 211 women who had submitted their forbidden clothing so they could pay the fine and have a seal affixed to each garment, in order to continue to be allowed to wear them.[44] Their garments include plain and figured velvets, *baldacchino*, satin, and damask, some embroidered with silk and others with silk fringes.[45] A few husbands' occupations are given, and the result is surprising. Although some women were from the highest echelons of society, others were the wives of a goldsmith, an apothecary, two shoemakers, and a butcher. Domina Jacoba, married to the goldsmith Mino Augustino, presented two garments, a dress of velvet dyed with *grana*, an expensive red dye from the kermes insect (called 'grain' in England), and with sleeves lined with squirrel backs; and another, of black velvet, whose sleeves were lined with squirrel bellies.[46] Domina Francesca, wife of the shoemaker Iohannes Ieronimi, had a *saccum* (gown) of costly crimson pile-on-pile velvet, with a fringe, and a neckline finished in gold thread and silk dyed in *grana*.[47]

Sumptuary laws in Italy and England accorded privileges to knights, but only in Italy were the professional classes singled out, specifically doctors of law and of medicine. In 1453, among other concessions, the wives or daughters of knights in Bologna were accorded the right to one dress of crimson velvet, and another in velvet of any other colour.[48] Doctors' wives and daughters, and members of the guilds of notaries, bankers, drapers and silk merchants (qualified as those who owned their businesses and did not work with their hands) shared this privilege. Nobles' wives were treated the same as those of doctors. Everyone else, except members of the four superior guilds, and butchers, apothecaries, wool merchants, second-hand clothing sellers, and goldsmiths, could have just one gown made in any colour other than the expensive colours of crimson or *morello*, lined with pured miniver, or taffeta that was not crimson.[49] Any of these privileged groups could have embroidery on one gown provided that it did not exceed 35 ducats for knights, 25 for doctors or nobles, and 12 ducats for members of the seven guilds.[50]

[43] *Ibid.*, 128–29.

[44] *Ibid.*, 136–47.

[45] For *baldacchino*, see note 16 above and Glossary.

[46] *Kermes vermilio* (Planchon, 1864), see Cardon, *Natural Dyes*, 610–19; Muzzarelli, *La legislazione suntuaria secoli XIII–XVI Emilia-Romagna*, 140, nos. 52 and 53.

[47] Muzzarelli, *La legislazione suntuaria secoli XIII–XVI Emilia-Romagna*, 141, no. 85.

[48] *Ibid.*, 150.

[49] Pured miniver was the bellies of the winter fur of the Northern squirrel, trimmed to show only the white fur.

[50] Muzzarelli, *La legislazione suntuaria XIII–XVI Emilia-Romagna*, 150–1.

In 1442, Filippo Maria Visconti (r. 1412–47) of Milan invited Piero di Bartolo, a silk entrepreneur from Florence, to set up there, a decisive move marking the beginnings of the Milanese silk industry.[51] Craftsmen from Liguria and Tuscany and silk workers of Venetian origin followed his lead.[52] By the reign of Galeazzo Maria Sforza (r. 1466–76), the ducal household was provided with substantial amounts of silk clothing. The ducal warrants reveal a court whose senior functionaries, including barbers and doctors, were dressed in liveries of velvet, damask, and satin. The Duke's forty chamberlains were splendidly dressed in velvet gowns (*gheleri*) with doublets (*zuponi*) of silver-brocaded silk, each given an additional gown of wool scarlet and a velvet doublet. The written orders concerning clothing for Galeazzo Maria's wife, his staff, his mistress, and diplomatic gifts, suggest that in a silk-weaving centre under absolute rule, anything was possible. His chamberlain, Gottardo Panigarola, was, for example, dispatched to look around Milan for pieces of silk damask, one in *beretino* colour and the other in white for his mistress, Lucia Marliani, Contessa di Melzo (1455–1522), but if they could not be found, he was to have them made 'in all perfection'.[53] The ducal spending on entertainments and luxuries, particularly fine fabrics, escalated: his annual expenditure on velvet alone reached the astronomical sum of 53,000 ducats in 1475.[54]

Ordinary Milanese citizens did not dress nearly so lavishly. The trousseaux of some women of good families contained only limited silk possessions. When Giacobina Resti, a well-born Milanese, married doctor of law Michele Trivulzio in 1420, her trousseau contained six wool gowns (*pellande*), four pairs of sleeves, two hoods, a girdle, and an amber necklace.[55] In 1486, Lucrezia Contadini brought as part of her dowry two gowns (*vestiti*), one of white silk damask and the other of *morello* wool, two mantles (*mantelline*), three overdresses (*socche*), a new fur, and two pairs of sleeves, one of which was of satin.[56]

By the fifteenth century, an extensive range of silk fabrics was produced in Venice, from simple taffetas and heavy pile-on-pile velvets to the finest cloths of gold, and the silk industry constituted a major source of finance and prestige for

[51] Francesca Leverotti, 'Organizzazione della corte sforzesca e produzione serica' in Chiara Buss (ed.), *Seta, oro cremisi: Segreti e tecnologia alla corte dei Visconti e degli Sforza*, exhibition catalogue, Milan, Poldi Pezzoli Museum (Milan, 2009), 18–24, esp. 18.

[52] Molà, *The Silk Industry of Renaissance Venice*, 6.

[53] G. Porro di Lambertenghi, 'Lettere di Galeazzo Maria Sforza duca di Milano', *Archivio Storico Lombardo*, series 5 (1878), 107–29, esp. 123–4.

[54] Leverotti, 'Organizzazione della corte sforzesca', 19.

[55] Maria Giuseppina Muzzarelli, 'Seta posseduta e seta consentita: Dalle aspirazioni individuali alle norme suntuarie nel basso medioevo' in Luca Molà, Reinhold C. Mueller and Claudio Zanier (eds.), *La seta in Italia dal Medioevo al Seicento: Dal baco al drappo* (Venice, 2000), 211–32, esp. 213.

[56] *Ibid.*, 213–14; with thanks to Jane Bridgeman for elucidating the term *socche*.

the Republic. Legislation forbidding the importation of foreign silks to Venice encouraged its inhabitants to choose domestically woven silk, moreover it is evident from diplomatic correspondence that the Republic's ambassadors were expected to be seen abroad wearing only Venetian silk.[57] It is equally apparent, from depictions in paintings, from survivals among church vestments, and from documents, that foreign silks did reach Venice, either as diplomatic gifts or sometimes by stealth.[58]

Venetian male dress was innately conservative. Citizens over the age of twenty-five were expected to adopt a monochrome, ankle-length, long-sleeved gown called a *toga* or a *vesta*. Its formality was judged according to the type and quality of the material, its colour, and the style of its sleeves, which, if they were wide 'ducal' sleeves could consume as much as six *braccia* (c. 3.8 m) per pair.[59] Most citizens had *veste* made either in plain black wool, or in more expensive camlet made of mohair imported from Turkey.[60] The most expensive wool gowns were made from scarlet cloth dyed with kermes.[61] Silk was always the most formal option, but only the doge and his family could wear cloth of gold freely.[62]

As the elected head of state, the doge not only enjoyed special privileges, but was also expected to uphold the dignity of the state through his choice of clothing. As early as the fourteenth century, the ducal oath of Andrea Contarini (r. 1368–82) stipulated that the doge should wear cloth of gold in public 'for the honour of the state'.[63] By the sixteenth century, the doge was expected to appear in public dressed in either silk or cloth of gold, and only to wear wool (either scarlet or *pavonazzo*) for official or personal mourning, or for attending services on Holy Thursday or

[57] Molà, *The Silk Industry of Venice*, 262–64; Lisa Monnas, 'Textiles and the Language of Diplomacy: Venice and Ottoman Turkey' in Juliane von Fircks and Regula Schorta (eds.), *Oriental Silk in Medieval Europe, Riggisberger Berichte 21* (Riggisberg, 2016), 329–44, esp. 339–40.

[58] A Spanish silk is depicted in Giovanni Bellini and Rocco Marconi's *Lamentation*, c. 1516, Venice, Galleria dell'Accademia, no. N.166/83; Lisa Monnas, *Merchants, Princes and Painters: Silk Fabrics in Italian and Northern Paintings, 1350–1550* (New Haven and London, 2008), figs. 251–2; Monnas, 'Textiles and the Language of Diplomacy', 331–2, 336–7, 341–3, fig. 8; Molà, *The Silk Industry of Renaissance Venice*, 262–4.

[59] Stella Mary Newton, *The Dress of the Venetians, 1495–1525* (Aldershot, 1988), 12.

[60] See, for example the clothing in Lorenzo Lotto, *Libro di spese diverse (1538–56), con aggiunta di lettere e d'altri documenti*, Pietro Zampetti (ed.) (Venice and Rome, 1969), 9, 61, 121, 155, 157, 163, 180, 181, 232, 233, 235, 237, 240, 241.

[61] For kermes, see note 46 above; for scarlet, see John H. Munro, 'The Medieval Scarlet and the Economics of Sartorial Splendour', in N. Harte and K. Ponting (eds.), *Cloth and Clothing in Medieval Europe: Essays in Memory of Professor E. Carus-Wilson*, Pasold Studies in Textile History II (London, 1983), 13–70.

[62] Giulio Bistort, *Il Magistrato alle Pompe nella Repubblica di Venezia. Studio Storico* (Venice, 1912), 296–97; Newton, *Dress of the Venetians*, 12, 51.

[63] Marino Sanuto, *Le Vite dei dogi, 1423–57*, Angela Cariacciolo Aricò (ed.) (Venice, 1999), 320.

Good Friday.[64] New knights were presented with a mantle and sometimes also a gown of cloth of gold for their investiture, and had the right to wear them thereafter.[65] Other citizens needed official permission to wear cloth of gold, but they were encouraged to dress sumptuously for state occasions, for which the luxury laws were regularly suspended.[66] Dürer's drawing perfectly illustrates a Venetian woman elegantly dressed for a festive occasion in silk and velvet cloth of gold of tissue (Illustration 6.6). These public shows of wealth could be deceptive, however, as second-hand clothing could be bought or hired for such displays.[67]

An inventory taken at the death of Lorenzo Correr (d. 1584), a Procurator of San Marco, affords a glimpse of the wardrobe of a member of the highest class of Venetian society at the end of the sixteenth century.[68] Correr possessed forty-nine long formal gowns (*veste*), with ten further *vestiti*, together with four mantles, six stoles, and other assorted items. Twelve gowns were made of camlet, one of black wool, six of *paonazzo* wool, and just one of woollen scarlet. Twenty-five of the *veste* were of silk, mainly satin, damask, and *ormesino*, with only four of plain velvet and four of *tabi*.[69] Many were lined with fur, but eight were lined with *ormesino* (presumably for summer wear), one with velvet, and one with cotton. Some of the mantles or cloaks were of the half-silk *ferrandina*. One stole was made of scarlet wool, two were of luxurious crimson *alto e basso* velvet, one of plain velvet, and one of cloth of gold. Crimson *alto e basso* stoles were the insignia of high office in Venice, worn by members of the Senate and the Procurators of San Marco, while a golden stole was the privilege of knighthood.

In Florence during the fifteenth century, the ethos of dress was different from that of either Milan or Venice as the early Medici, heading an oligarchy in the name of a republic, sought to project an image of 'first among equals', particularly under Cosimo il Vecchio (r. 1434–64). This changed after the restoration of the Medici in the sixteenth century, when they legitimised their rule through the acquisition of a ducal title. Although the fifteenth century was a time of growth for the Florentine silk industry, the majority of Florentine citizens still generally wore wool. Clothing was a major part of their expenditure. It has been estimated that out of an approximate annual income of 37 florins (c. 166 *lire di piccioli*), a skilled labourer might spend about 7½ florins to clothe himself in

[64] Newton, *Dress of the Venetians*, 28, 29.

[65] *Ibid.*, 18.

[66] Monnas, *Merchants, Princes and Painters*, 3–4.

[67] Molà, *The Silk Industry of Renaissance Venice*, 94–5.

[68] Pompeo Molmenti, *Venice: Its Individual Growth from the Earliest Beginnings to the Fall of the Republic*, 6 vols (London, 1906–08), vol. 4, inventory, 282–8; clothing, 283–4.

[69] *Tabi* was a simple tabby-weave silk, and in the sixteenth century also a plain cloth of gold, Dorini, *Statuti dell'arte di Por' Santa Maria*, 733–4.

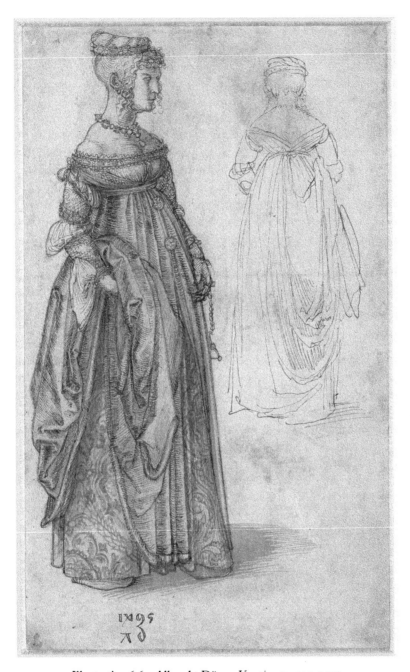

Illustration 6.6 Albrecht Dürer, *Venetian woman*, 1495.
Pen-and-ink and brush drawing in grey and black with light wash, on paper.
29 x 17.3 cm. Vienna, Grafische Sammlung Albertina, no. 30634r.

wool or linen.[70] There were exceptions, however. Some skilled weavers working for Andrea Banchi purchased silk fabric and trimmings for their wives. In 1457, Andrea's most talented weaver, Domenico di Michele, who created complex velvets brocaded with gold and could earn 165 florins (c. 740 *lire di piccioli*) a year, purchased one-and-a-half *braccia* (c. 87.5 cm) of voided satin velvet with crimson flowers for 22 *lire di piccioli* to make sleeves for his wife; and in 1462 he acquired a similar amount of black pile-on-pile velvet for her (16 *lire di piccioli*), together with some ribbon and fringing (4½ *lire di piccioli*).[71] In 1457, Simone di Bartolo, a satin weaver earning less than 40 florins a year, was even more extravagant, purchasing seven *braccia* of black silk damask for his wife for 40 *lire* 12 *soldi di piccioli*, equivalent to approximately a quarter of his annual pay.[72] These were infrequent purchases, only the wealthiest citizens could afford to wear silk on a regular basis, and even for them, wool remained the staple of everyday wear.[73]

A comparison of the clothing in two Medici inventories from the beginning and end of the fifteenth century predictably indicates an increase in their silk purchases. Not only is this in keeping with a general trend, but also Cosimo il Vecchio acquired a silk firm in 1438. An inventory taken in 1417 of the palace of Giovanni de' Bicci de' Medici (1360–1429) in the Via Larga, lists clothing for eleven members of his family living there.[74] Apart from headgear, there were 142 principal woollen garments, and only fifty of silk. A coffer belonging to Giovanni's daughter-in-law, Contessina, for example, contained seven dresses (*cioppe*) made of wool, one *cioppa* of crimson voided satin velvet brocaded with gold, and another of *morello* voided satin velvet, and two gowns (*cotte*) in damask and satin.[75] The inventory of the Medici palace at the death of Lorenzo de' Medici ('the Magnificent') (r. 1469–92) in 1492, listing his clothing and items belonging to other family members (some of whom had predeceased him), contains 99 principal woollen garments and 146 made of silk.[76] The most

[70] Jane Bridgeman, "Pagare le Pompe': Why Sumptuary Laws did not Work', in Letizia Panizza (ed.), *Women in Italian Renaissance Culture and Society* (Oxford, 2000), 209–26, esp. 216.

[71] Edler de Roover, *L'arte della seta*, earnings of 740 *lire* equated to c. 165 *fiorini*, 61; purchases, 80.

[72] Edler de Roover, *L'arte della seta*, purchases, 81; Simone's annual pay of 165 *lire di piccioli* equated with 37 florins, 56.

[73] For example, the inventory of Puccio Pucci's (1389–1449) house in Via de' Servi records 106 principal garments of wool, and 27 of silk, Carlo Merkel, 'I beni della famiglia di Puccio Pucci: Inventario del sec. XV illustrato', offprint from V. Rossi, *Miscellanea nuziale Rossi-Theiss* (Bergamo, 1897), 170–93.

[74] Marco Spallanzani (ed.), *Inventari Medicei 1417–65: Giovanni di Bicci, Cosimo e Lorenzo di Giovanni, Piero di Cosimo* (Florence, 1996), 3–72.

[75] *Ibid.*, 16–17; Contessina de' Bardi (c. 1390–1473) married Giovanni's son, Cosimo (later known as 'Il Vecchio') (1389–1464) in 1414.

[76] Spallanzani and Bertelà (eds.), *Libro d'Inventario*.

elaborate silk mentioned is a remnant of ten *braccia* of crimson velvet brocaded with gold with branches and garlands encircling the Medici arms, valued at 40 florins, comparable to a magnificent cope with a similar design, in the Museo degli Argenti in Florence.[77] 'There was a concentration of silk clothing in the chamber of Lorenzo's son, Piero'.[78] Among the finest items were two cloaks (*pitochi*), one made of red satin enriched with gold loops and lined with sable, another of *paonazzo* satin similarly enriched and quartered with black velvet, lined in deep blue taffeta.[79] This does not mean that Lorenzo and his family habitually wore silk: nineteen long wool gowns, coloured *paonazzo* and *rosato*, for smart everyday wear are listed in the 'large chamber of Lorenzo'.[80]

In the sixteenth century, Cosimo de' Medici (r. 1537–74), the first Duke of Florence, and his wife Eleonora di Toledo (1522–62), whom he married in 1539, presided over the city in princely style. At her death in 1562, Eleonora left a wardrobe of 100 principal items almost all made of silk.[81] The richly brocaded dress portrayed by Bronzino (Illustration 6.7) is perhaps her most famous garment, but this was an exception, worn only on state occasions. Eleonora otherwise favoured a simpler elegance.[82] Only six of the inventoried silks were enriched with gold loops and eight were of plain cloth of gold or silver. There was also one *vesta* of *paonazzo*-coloured pile-on-pile velvet. The rest were plain satin, velvet, damask, and *ormesino*, and almost a quarter of them were coloured tawny (*tanè*), ten were beige (*bigio*), seven *paonazzo*, six black, and only three in crimson. They were elegantly trimmed, with bands of fabric in contrasting textures, with gold embroidery, pearls, and other ornaments. A typical example is a sleeveless overdress (*saio*) of pale blue damask, with applied bands of matching velvet set with gold embroidery.[83]

Possibly the most lavish spending was reserved for furnishings.[84] In 1540, when Cosimo and Eleonora transferred their main residence from Via Larga to the Palazzo Vecchio, seat of the Florentine government, they draped the walls

[77] *Ibid.*, 120; after the fall of the Medici, the Medici armorials on this cope were covered with roundels embroidered with religious subjects, Christina Piacenti Aschengreen, *Il Museo degli Argenti a Firenze* (Florence, 1967), 40, pl. 10.

[78] Piero di Lorenzo de' Medici (r. 1464–69), son of Lorenzo 'the Magnificent'.

[79] Spallanzani and Bertelà (eds.), *Libro d'Inventario*, 86–7.

[80] This refers to Lorenzo di Piero ('the Magnificent'). *Ibid.*, 28.

[81] Roberta Orsi Landini and Bruna Niccoli, *Moda a Firenze 1540–80: Lo stile di Eleonora di Toledo e la sua influenza* (Florence, 2005), inventory 236–37; Eleonora wore less precious silks or wool for mourning, *ibid.*, 28.

[82] *Ibid.*, 25–8.

[83] *Una saia di domascho turchino con ricamo d'oro sopra velluto turchino*; this was given, after Eleonora's death, to the church of San Lorenzo in Florence, *ibid.*, 237.

[84] *Ibid.*, 24.

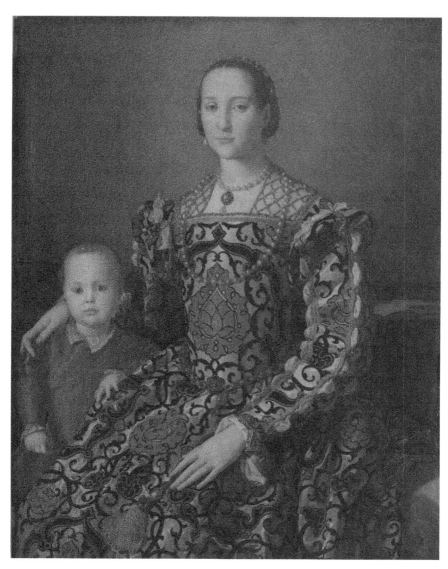

Illustration 6.7 Agnolo Bronzino, *Eleonora di Toledo with her son Giovanni de' Medici*, c. 1545. Oil on panel, 115 x 96 cm. Florence, Uffizi Gallery, no. 748.

with hangings of silk and cloth of gold. They patronised the leading silk weavers of Florence, such as Baccio Tolomei and Jacopo del Tedesco, and installed a cloth-of-gold weaver, Madonna Francesca di Donato, in a workshop in the palace itself, with her son-in-law as assistant. The Duchess's *salotto*, a small audience chamber, for instance, had red satin hangings, with gold ribbons covering the joins, and a throne canopy of crimson and gold velvet with silk and gold fringes.[85]

SILK AT THE ENGLISH COURT

Silk fabrics usually entered England through the ports of Southampton and London. Even those arriving in Southampton were channelled towards the capital, the chief market for silk in England, where consumption centred on the king and his court. By ancient right, dating from the twelfth century, the monarch had 'first sight and choice' of all luxury goods imported into England, including silk.[86]

At the beginning of the fifteenth century, the English royal family dressed in wool as well as silk, and still purchased a variety of lampas silks. In 1408–12, Henry IV (r. 1399–1413) acquired lengths of lampas cloth of gold called *raccamas*, as well as cloth of gold of Cyprus, and pure silk baldekyns.[87] For her marriage to King Eric VII of Denmark in 1406, Henry IV's daughter Philippa (1394–1430) was perhaps the last English princess to have several bridal garments of lampas silk.[88] Henry V (r. 1413–22) continued to purchase various lampas silks, but used them mainly for furnishings or ecclesiastical vestments.[89] His son, Henry VI (r. 1422–61 and 1470–71) purchased principally velvet, satin, and damask, and just one kind of lampas silk, baldekyn, and quantities of the plain, light silk, tartaryn. Taffeta, purchased in huge quantities in the previous century, features less in these accounts. Although by the mid fifteenth century the English kings and their families mostly wore silk, their households received mainly wool liveries, sometimes lined in summer with tartaryn silk.

[85] Rembrandt Duits, *Gold Brocade and Renaissance Painting: A Study in Material Culture* (London, 2008), 148–50.

[86] Anne F. Sutton, *The Mercery of London* (Aldershot, 2005), 1, 3 and 12.

[87] Lisa Monnas, 'Silk Cloths Purchased for the Great Wardrobe of the Kings of England 1352–1462', in Lisa Monnas and Hero Granger-Taylor (eds.), *Ancient and Medieval Textiles: Studies in Honour of Donald King, Textile History*, 20/2 (1989), 283–307, esp. 299, no. 17.

[88] TNA, E101/405/14 and E101/406/10; see W. Paley-Baildon, 'The Trousseau of Princess Philippa, Wife of Eric, King of Denmark, Norway and Sweden', *Archaeologia*, 67 (1916), 163–88.

[89] Monnas, 'Silk Cloths Purchased for the Great Wardrobe', 299, no. 18, for baldekyn see note 16 above and Glossary; for *raccamas*, a lampas cloth of gold, see King and King, *Silk Weaves of Lucca*, 68.

This may give the mistaken impression that only the king and his family wore silk, and that, moreover, a limited choice was available. In 1439, an act of parliament obliged foreign merchants to reside with English hosts, and to register their imported stock, their sales, and their purchases with these hosts.[90] These registers (the 'views of the hosts of alien merchants') tell a different story to the royal accounts showing that, in the 1440s, besides the fabrics favoured by the king, Italian merchants also imported various other silks brocaded with gold, including *ciclatouns* and imperials.[91] They sold some of these directly to members of the aristocracy and other wealthy citizens, and the rest to English merchants for resale.[92] One of their best clients was Hugh Dyke, mercer, vestment maker, and embroiderer, who purchased silks from Venetian and Lucchese merchants between 1441 and 1442 for a total of £1,314 17s 2d (Table 6.4). For those who could afford to dress in silk, it was usual to purchase unmade lengths of fabric, but there are occasional references to the sale of ready-made garments. In 1443, for example, three Venetians, Lorenzo Marcanova, Giovanni Manucci, and Jacopo Trotti, imported two gowns, one of velvet and the other of cloth of gold, and sold them for £29 13s 4d to the London mercer Robert Coggeshale.[93]

The inventory of Sir John Falstoff (1380–1459), taken at his death in 1459, records significant amounts of silk among the possessions of this distinguished courtier and Knight of the Garter. This included clothing and vestments made of silk and cloth of gold for his chapel.[94] Of the chief items of clothing, thirty-three were made of silk, twenty-five (including hose) were of wool, three of linen, and two of leather. Eleven gowns, thirteen jackets and doublets, and twenty-six hoods were made of costly fabrics, reflecting their wearer's high status. The two smartest gowns were of cloth of gold, one with wide sleeves, and the other with narrow. Two other gowns, ten jackets, two doublets, and a pair of brigandines

[90] Bradley (ed.), *Views of the Hosts*, ix–x, et passim.

[91] Imperials were lampas cloths of gold, but the structure of ciclatouns (called *cigattoni* in Italy) is uncertain, see King and King, *Silk Weaves of Lucca*, 68 and 74.

[92] For example, silk fabrics sold by Niccolo Micheli of Lucca in 1442 included 85¾ yards of red damask to the earl of Suffolk for £44 12s 10d, and a length of baldekyn to a vintner for 46s 8d (TNA, E128/31, rotulet 1); Bradley (ed.), *Views of the Hosts*, 69–70; note that the lampas silk baldekyn was not necessarily brocaded, but it is translated throughout *Views of the Hosts* as 'brocade'; for baldekyn, see note 16 above and Glossary.

[93] Bradley, *Views of the Hosts*, 17.

[94] James Gairdner (ed. and introd.), *The Paston Letters*, 6 vols in 1 (Gloucester, 1986, reprint from the Library Edition of 1904), vol. 3, no. 389, whole inventory, cols. 174–90; clothing cols. 175–8 and col. 186; vestments, col. 188.

Table 6.4 Purchases by Hugh Dyke, mercer, embroiderer,
and vestment-maker, 1440–1441.

Page	Date	Sellers	Type of Fabric	Amount	Price
9	17 May 1441	Lorenzo Marcanova, Giovanni Mannucci, and Jacopo Trotti of Venice	Cloth of gold of tissue	1 complete cloth	£102*
			Damask brocaded with gold	3 remnants	£74
			Baldekyn brocaded with gold	75 lengths	£280
37	1440	Bertucci Contarini of Venice	Venice gold	8 lb	£18 13s 4d
38	15 Nov. 1440		Baldekyn	23 lengths	£103 10s
			Baldekyn	6 lengths	£24
			Baldekyn	3 lengths	£8
			Baldekyn	1 length, short	£2 4s 10d
			Baldekyn	6 lengths	£27
			Baldekyn	6 lengths	£20
58	10 Oct. 1440–41	Giovanni Micheli, Felice da Fagnano and Alessandro Palastrello of Lucca	Blue velvet	47½ yards at £5 the length	£29 13s 9d
60	25 Mar. 1440–41		Pile-on-pile velvet	31 yards	£41 6s 3d
62	11 May 1441		Plain velvet	24 yards	£15
66	1441–42		Pile-on-pile velvet brocaded with gold	19 yards	£76
			Velvet	12 yards	£8
			Velvet	14 yards	£9 6s 8d
96	June 1441	Federico Corner and Carlo Contarini of Venice	Silk fabric	21 lengths	Altogether £478 2s 4d
			Baldekyn, various kinds	11 lengths	
			Baldekyn & ciclatoun	26 lengths	

*Currency: £1 sterling in 1440 was equivalent to over £470 in 2016.
The textile terminology given here is my own translation from the original documents, and differs from the printed text in Bradley, *The Views of the Hosts*.
Source: Helen Bradley (ed.), *The Views of the Hosts of Alien Merchants 1440–1444* (Woodbridge, 2012).

were made of velvet.[95] This was mostly plain, but one gown, jacket, and doublet were made out of pile-on-pile velvet.

The household accounts of John Howard (1425–85) offer a detailed picture of his expenditure on clothing in 1460s.[96] Howard, from a family of landed gentry with an estate in Suffolk, served as Treasurer of the Household and Keeper of the Wardrobe to Edward IV (r. 1461–70 and 1471–83), and became Duke of Norfolk under Richard III (r. 1483–85). While his household was generally dressed in wool, Howard himself wore wool and silk. His wool cloth was obtained locally, but his silk all came from London, mainly purchased from an Italian, Humphrey Gentile 'Lumbard'.[97] His largest purchase of silk, so expensive that it was paid for in three instalments, amounted to £96 8s 4d. This occurred in 1467, the year in which he represented the Duke of Norfolk as marshal of England at a great tournament, and also married his second wife, Margaret Chedworth (1436–94).[98] Among many items Howard presented to his bride were four richly furred gowns, two made of expensively dyed wool (in murrey and violet dyed with kermes), and two of velvet in crimson and green, plus further unused lengths of green velvet.[99]

In 1463 and 1483, Edward IV passed sumptuary laws attempting to confine silk to the aristocracy and the upper echelons of the gentry, while offering concessions to employees of the royal household.[100] The 1463 law stipulates that only those of the rank of a knight of the Garter and above could wear pile-on-pile velvet. People below that rank were not allowed to wear voided satin velvets, or imitations, stigmatised as 'counterfeits'.[101] Only a knight of the degree of a lord could dress in cloth of gold; only lords and above could wear purple silk, which was, in 1483, further restricted to the king and his immediate relatives.[102]

The first Tudor monarch Henry VII (r. 1485–1509) and his family dressed in silk and issued silk to their inner circle, such as the queen's gentlewomen. Most of the royal household, including some of its senior officers, were still given woollen liveries. Henry VII's great wardrobe account of 1498/99 lists seventeen principal garments made for the king, mainly of plain black velvet, with a couple

[95] Brigandines were arming doublets reinforced internally with small metal plates riveted to the fabric.

[96] Anne Crawford (ed.), *The Household Books of John Howard, Duke of Norfolk 1462–71, 1481–83* (Stroud, 1992).

[97] Silks purchased, *ibid.*, xix, I, 384, 404, 413, 431, 465–66, 534.

[98] *Ibid.*, xix and I, 413.

[99] BL, Add. ms 34,889, f. 51r; Gairdner, *The Paston Letters*, vol. 4, no. 658, 262–3.

[100] The gentry are defined as 'the social group below the peerage [including] knights, esquires and gentlemen, as well as the higher ranks of the merchant class', in Maria Hayward, *Rich Apparel: Clothing under the Law in Henry VIII's England* (Farnham, 2009), 49.

[101] Luders et al., *Statutes of the Realm*, vol. 2, 399.

[102] *Ibid.*, 399 (1463), 468 (1483).

of items made of purple and crimson velvet (Table 6.2).[103] Henry's taste for black velvet does not necessarily imply sobriety. Black velvet was the height of fashion and his was of the finest quality, costing 18s the yard, while black velvet issued to his household cost only 10s the yard. Similarly – and in line with Edward IV's sumptuary regulations – the king alone wore purple velvet at 33s per yard, and only the king and his children wore crimson velvet costing 30s per yard.[104] There were a few showier items in the account, such as a gown and demy-gown made of crimson pile-on-pile velvet 'hatched' with gold.[105] Many of these silks were supplied by four Lucchese merchants: Francesco and Tommaso Guinigi and Girolamo and Lorenzo Buonvisi, with some purchases from English mercers.[106]

The great wardrobe accounts do not, however, offer a complete account of Henry's expenditure. The separate chamber accounts detail the king's most extravagant purchases, such as the acquisition in 1499 of his fabulously expensive cloth of estate (Table 6.2), and the payments for his set of Florentine copes.[107] In a way that anticipates the spending pattern of Cosimo I de' Medici and Eleonora di Toledo, Henry was prepared to spend fabulous sums on cloth of gold destined for state furnishings and vestments to grace the most solemn occasions. He also wore cloth of gold himself, when occasion demanded. In his portrait (Illustration 6.8), commissioned in 1505 by Hermann Rinck (d. 1541), the agent of Emperor Maximilian I when Henry was considering marrying Maximilian's daughter, Margaret of Austria, he is represented wearing the collar of the imperial Order of the Golden Fleece and a suitably splendid cloth of gold.

King Henry VIII (r. 1509–47) dressed entirely in silk, apart from his linen shirts and underwear and green wool clothing for hunting and stalking. He even played tennis wearing velvet, using rackets with velvet grips.[108] Taffeta re-emerged as a fashionable silk in the sixteenth century. During the fourteenth century, costing between 10d and 6½d per ell (114.3 cm), it had been one of

[103] Account 29 September 1498 to 29 September 1499, TNA, E36/209; this account is published in Maria Hayward (ed.), *The Great Wardrobe Accounts of Henry VII and Henry VIII* (Woodbridge, 2012), 3–77.

[104] The purple velvet in Table 6.2, at 15s per yard, was used to garnish the king's taper for Mass, and to cover his horse harness; the crimson velvet, at 13s 4d, covered another horse harness.

[105] Hayward, *The Great Wardrobe Accounts*, 39.

[106] Tommaso and Francesco's surnames are transcribed as 'Gwynyf', transliterated as 'Gwyneth', in Hayward, *The Great Wardrobe Accounts*; looking at the document TNA, E36/209 and other contemporary accounts, I would transcribe this name as 'Guynys', an anglicisation of 'Guinigi', the famous family of Lucca.

[107] For the cloth of estate see note 17 above; for the copes, see note 36 above.

[108] Maria Hayward (ed. and commentary), *Dress at the Court of Henry VIII* (Leeds, 2007), 107–8.

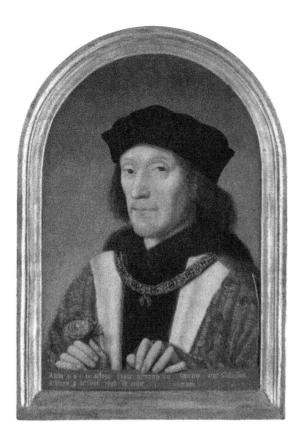

Illustration 6.8
Unknown artist,
Portrait of Henry VII,
dated 1505. Oil on panel,
42.5 x 30.5 cm. National
Portrait Gallery (NPG 416).
© National Portrait Gallery,
London.

the cheapest silks, frequently used for linings.[109] The taffeta worn by Henry VIII
cost 6s per yard (91.4 cm), and although he did have taffeta linings, he also had
outerwear made of it, such as the black taffeta frock, trimmed with black velvet
and embroidered in gold, listed in his inventory of 1547.[110] His taffeta mainly
came from Florence.[111] The Book of Rates of 1558 lists four qualities: 'levant
taffeta' was cheapest at 20d per yard, next came taffeta from Tours in France at

[109] Monnas, 'Silk Cloths Purchased for the Great Wardrobe', 302–4.
[110] Monnas, 'Plentie and Abundaunce', 248–9.
[111] Cinzia Maria Sicca, 'Consumption and Trade of Art between Italy and England in the
First Half of the Sixteenth Century: The London House of the Bardi and Cavalcanti Company',
Renaissance Studies, 16 (2002), 163–201; Cinzia Maria Sicca and Bruna Niccoli, 'La consom-
mation des produits de luxe à la cour de Henri VIII: Hans Holbein le jeune, ses modèles et leurs
fournisseurs florentins d'étoffes à la mode', in Christine Rolland (ed.), *Autour des van Loo: Peinture,
commerce des tissus et espionage en Europe (1250–1830)* (Mont Saint-Aignan, 2012), 83.

3s 4d per yard, then narrow Spanish taffeta at 4s per yard, and, dearest of all, taffeta of unspecified origin (Florentine?) at 6s 9d per yard.[112]

In 1536, Antonio Guidotti attempted to bring workers from Italy to Southampton to establish silk weaving in England, but this enterprise failed, and imports remained England's only source for silks and cloth of gold.[113] During the sixteenth century, the choice of silk fabrics available in England expanded. The Books of Rates and the royal wardrobe accounts list satin and damask from Ottoman Turkey and Caffa on the Black Sea (a Genoese possession from 1266, before it fell to Ottoman rule from 1475).[114] Half-silks such as 'Satin of Bruges' came from the Low Countries via Antwerp, together with sarsenet and taffeta from France. The finest imported fabrics continued to be Italian. Henry VIII's chief suppliers were the Florentines Giovanni Cavalcanti and Pierfrancesco de' Bardi, who provided many of the rich materials for his meeting with Francis I of France at the Field of Cloth of Gold in 1520.[115] In a way that parallels the ducal court in Florence, however, the most expensive cloths of gold and silver were only worn for special occasions, while the king most frequently wore satin, followed by velvet, damask, and taffeta.[116]

Henry VIII's younger daughter Elizabeth I (r. 1558–1603) was dressed in cloth of gold tissue for her coronation (converted from her sister's coronation dress) but increasingly preferred to have satin, or plain cloth of gold or silver, embroidered in silk and gold thread, worn with ruffs of the finest linen and lace.[117] These remarkable outfits, recorded in a succession of famous portraits, often carried allegorical messages, some highly personal, some generally alluding to the qualities of a good ruler. In 1600, three years before her death, Queen Elizabeth's wardrobes of robes contained over a thousand items of clothing. These were nearly all made of silk, such as velvet or plain cloth of silver, many of them embroidered, and even those few garments made of fine linen were usually embroidered with silk.[118] Less than ten items (including her coronation gown and mantle) were made of cloth of gold of tissue. In contrast with the 530⅛ yards of cloth of gold

[112] Willan, *Tudor Book of Rates*, 59.

[113] J. Brewer and J. Gairdner (eds.), *Letters and Papers Foreign and Domestic of the Reign of Henry VIII Preserved in the Public Record Office*, the British Museum and elsewhere, 21 vols (London, 1886–1910), vol. 13/1, 206.

[114] Caffa, originally a Greek settlement called Theodosia, was renamed Feodosiya after it was taken by the Russians in 1783.

[115] Monnas, 'Plentie and Abundaunce', 245–46; Sicca and Niccoli, 'La consommation des produits de luxe', 65–94; Hayward, *Dress at the Court of King Henry VIII*, 422–7.

[116] Hayward, *Rich Apparel*, 160–2, and Table 3.

[117] For the coronation gown, see Janet Arnold, 'The 'Coronation Portrait' of Queen Elizabeth I', *Burlington Magazine*, 120 (November, 1978), 727–41.

[118] Janet Arnold, *Queen Elizabeth's Wardrobe Unlock'd* (Leeds, 1988), 255–321 and 335–49.

of tissue left by Henry VIII at his death in 1547, there were just six remnants of heavy looped gold and silver tissue still in store in 1600.[119] Of these tissues, only one was subsequently made into a gown for the queen.[120] Four others were made into furnishings for the coronation of her successor, King James I (r. 1603–25).[121]

Patronage through exceptional gifts of expensive clothing is documented at the English court from at least the fourteenth century.[122] Under the Tudors, giving costly clothing, as opposed to normal liveries, became almost systematic, and included the distribution of garments discarded by the ruler.[123] This was a doubly convenient form of patronage since it enabled monarchs to make room for new items in their wardrobes, while bestowing visible favour upon individuals who counted it a point of honour to wear something previously worn by their sovereign. These coveted gifts were often worth staggering amounts. In July 1524, the earl of Anguysshe received from Henry VIII's wardrobe a gown of crimson satin lined with purple cloth of gold of tissue, with ruffed sleeves, valued at £166 13s 4d.[124] Even royal gifts received by the king could be recycled. A gown of purple velvet lined with white cloth of gold given to Henry by Francis I of France in 1520, valued at £110, was passed to Lord Morles three years later.[125] Lesser members of Henry VIII's household also received generous handouts. Between 1518 and 1520, William Wise, a groom of the wardrobe of robes, received over eleven items of clothing in velvet, damask, and satin.[126]

The gift-giving of Elizabeth I was equally substantial. She not only gave new garments, but also, when giving her own clothing, paid for its alteration to fit the recipient.[127] Conversely, family and courtiers presented silk tributes to Henry VIII and Elizabeth. Henry VIII received, for example, 'a jerkyn of purple velvet, with purple sleeves embroidered with Venice gold, and matching hose' from Sir Richard Cromwell in 1541.[128] Elizabeth received, if anything, even more

[119] These were: 574 yards (167 marked 'missing') in the secret wardrobe and 81⅝ yards in the great wardrobe, and 41½ yards in the revels store, Monnas, 'Plentie and Abundaunce', 263.

[120] Arnold, *Queen Elizabeth's Wardrobe Unlock'd*, 322, no. 6, 20 yards, made into a gown in 1602.

[121] *Ibid.*, 321, no. 3; 323, nos. 34, 38 and 39, totalling 41⅛ yards.

[122] Caroline Shenton, 'Edward III and the coup of 1330', in J. S. Bothwell (ed.), *The Age of Edward III* (Woodbridge and Rochester NY, 2001), 13–34, esp. 23–5.

[123] Hayward, *Dress at the Court of King Henry VIII*, 121–4; Arnold, *Queen Elizabeth's Wardrobe Unlock'd*, 98–100.

[124] Hayward, *Dress at the Court of Henry VIII*, 414, item B57.

[125] *Ibid.*, 415, item B68.

[126] Maria Hayward, 'Dressed to Rule: Henry VIII's Wardrobe and His Equipment for Hawk and Hound', in Maria Hayward and Philip Ward (eds.), *The Inventory of King Henry VIII: Volume II, Textiles and Dress* (London, 2012), 72, Table 1.

[127] Arnold, *Queen Elizabeth's Wardrobe Unlock'd*, 92–109.

[128] Hayward, *Dress at the Court of Henry VIII*, 123.

splendid clothing than her father, such as the (woman's) doublet of white satin, cut and embroidered all over with spangles of Venice gold, embellished with 'a passamain lace of Venice gold and plate', which she was given by Sir Francis Walsingham in 1589.[129]

A SIXTEENTH-CENTURY ENGLISH COURTIER'S PURCHASES FROM ABROAD: LADY LISLE

In 1529, Honor Grenville (1493/5–1566) married Arthur Plantagenet, Viscount Lisle (d. 1542), the acknowledged illegitimate son of Edward IV. Between 1533 and 1540 Viscount Lisle was the governor of Calais, an English enclave on the northern coast of France. The Lisles' correspondence from Calais records their steady stream of silk purchases through agents in England, France, and Antwerp.[130] Letters from John Husee, their London agent, show him diligently scouring the stocks of English and foreign merchants, sending samples and recommending them in terms of quality, price, design, and durability. On 15 July 1534, cloths of silver were available for between 18s and 28s per yard, but these he rejected as so visibly inferior that it 'shall never stand with your honour to wear [them]'. Instead, he sent samples of plain cloth of silver at 40s the yard, violet with knots of silver at 46s 8d, and one with a 'branched' design at 40s, but recommended the plain cloth of silver, which 'sheweth best in the piece'.[131] There were also practical considerations. In 1536, when commissioned to have a coat made of damask or another similar silk for Lady Lisle's son George, Husee had it made in velvet, explaining that the velvet was of such good quality that the coat would last five years, far longer than one made out of another, less robust silk.[132]

In autumn 1533, Lady Lisle obtained from 'St. Bawmis's Mart' at Antwerp, among other silks, twenty ells of black Genoese velvet.[133] Her purchase of this velvet is noteworthy because, in an attempt to protect the fledgling French silk industry, in 1533 King Francis I had imposed restrictions on the importation

[129] Arnold, *Queen Elizabeth's Wardrobe Unlock'd*, 318, no. 36.

[130] Muriel St. Clare Byrne (ed.), *The Lisle Letters*, 6 vols (Chicago, 1981).

[131] *Ibid.*, vol. 2, no. 230, 210–11, esp. 210.

[132] George was the son of Honor's first marriage to Sir John Basset, *ibid.*, vol. 3, no. 542, 96; see also Melanie Schuessler, '"She Hath Over Grown All She Ever Hath": Children's Clothing in the Lisle Letters, 1533–40', in Gale Owen-Crocker and Robin Netherton (eds.), *Medieval Clothing and Textiles*, vol. 3 (Woodbridge, 2007), 198.

[133] St. Clare Byrne, *Lisle Letters*, vol. 1, no. 106, 674–5; according to St. Clare Byrne (*ibid.*), this fair was held around the feast of St Rémi, 28 October; for the four great Brabant fairs known as Bamis Mart at Antwerp, starting in late August and lasting six weeks, see Harry S. Cobb (ed.), *The Overseas Trade of London: Exchequer Customs Accounts 1480–81* (London, 1990), xxxix–xl.

of Genoese silks to France.[134] Already, in July 1533, some velvets brought to Lyon from Genoa had been confiscated.[135] The enforcement of this law was not watertight, however, because it suited the king to offset his debts to Italian merchants trading in luxury goods by allowing them to import limited quantities of the proscribed materials. Hence on 14 September 1538, Gabriele Riccio, who was owed 4,694 *écus de soleil* for pearls sold to the king, was allowed to import into France 2,347 pieces of Genoese velvet in all colours, as well as other Genoese silks, without paying the import tax of 2 *écus de soleil* for each piece. In the following year, Francis offset another debt, for tapestries representing the *Story of Joshua*, by permitting Riccio to import eight cargoes of Genoese velvet duty-free.[136]

The consumption of silk fabrics within London, and by wealthy individuals in the provinces or abroad with access to London suppliers, was exceptional. The fifteenth-century letters of the Pastons, a family of Norfolk gentry, describe them dressing in wool, and finding even good quality wool hard to buy locally.[137] Their silk purchases usually consisted of trimmings.[138] In spite of sumptuary laws designed to restrict silk to the upper levels of society, during the sixteenth century some wealthy artisans and tradesmen were able to wear modest amounts of silk. Southampton was a major point of entry for luxury goods, second only to London, and the Italian 'nations' established in London stationed sub-consuls there to represent them. Southampton probate inventories reveal that local merchants stocked silk fabrics.[139] Some wealthy citizens below the rank of gentleman enjoyed imported luxuries such as 'Venice' and 'Turkey' carpets in their homes and wore clothing made of silk.[140]

CONCLUSION

Between 1400 and 1600 the expansion of silk weaving in Europe made it possible for more people in Italy and England to enjoy wearing silk than ever before. The range of fabrics increased, and tastes changed. Lampas silks, which had

[134] Molà, *The Silk Industry of Venice*, 265–7.

[135] Léon, Marquis de Laborde, *Les comptes des bâtiments du Roy (1528–71): Suivi de documents inédits sur les châteaux royaux et les beaux-arts du XVIe siècle*, 2 vols (Paris, 1877–80), vol. 2, 222.

[136] *Ibid.*, 376–7.

[137] Gairdner, *The Paston Letters*, vol. 4, no. 620, cols. 210–11.

[138] *Ibid.*, no. 789, cols. 122–23, esp. col. 122, 18 November 1471.

[139] Edward Roberts and Karen Parker (eds.), *Southampton Probate Inventories 1447–1575*, 2 vols (Southampton, 1992), vol. 2, no. 104, Richard Goddard (1573), 346–67, esp. 360, 366–7; no. 105, Reynolds House (1573), 371–84, esp. 372.

[140] *Ibid.*, vol. 1, Thomas Harrison, girdler (1554), no. 21, 53–61, esp. 56; John Fletcher, grocer (1562), no. 64, 179–84, esp. 182.

been ubiquitous in the fourteenth century, were superseded for clothing in the early fifteenth century by velvet, satin, and damask, although they remained in demand for furnishings and ecclesiastical vestments. As silk weavers grew more skilful, velvet and brocatelle cloths of gold grew increasingly complex, heavy and expensive until the taste for these exorbitant silks peaked during the second half of the sixteenth century, gradually giving way to lighter, more delicate versions. Silk clothing reached a wider client base earlier in Italy than it did in England, with the proviso that Italian consumers were encouraged to wear the products of their own cities. The finest silks imported into England were predominantly Italian, mainly from the prime weaving centres of Florence, Genoa, Lucca, and Venice. During the course of the sixteenth century, some damasks and satins came to England from the Ottoman empire, while plain silks like sarsenet and taffeta came from France and Spain, together with half-silks from the Low Countries. English consumers were, theoretically, free to choose from silk produced anywhere in the known world. In reality, they could be hampered by a lack of social eligibility under the law, or else by the limited stock available in local retail outlets (even in the capital), and always, like their Italian counterparts, by the limitations of their purse.

7.

'What d'ye lack Ladies?
Hoods, Ribbands, very fine silk stockings':
The Silk Trades in Restoration London[1]

David Mitchell

From the medieval period until the early eighteenth century, the most expensive and luxurious woven silk textiles – damasks, brocades, and velvets – were imported into England through the port of London; initially from Italy and Spain, and subsequently from France. Raw and thrown silk was also imported and used from the sixteenth century in embroidery and to weave narrow wares, together with certain plain silks and mixed fabrics, in London, Canterbury, and Norwich. Before the Civil Wars, raw silk was imported by the Levant Company which in 1638 was said to have 'grown to that height that [...] it is the most flourishing and beneficial Company [...] of any in England'.[2] At the Restoration (c. 1660–85), there was a step-change in the Company's business in raw silk from the Middle East, constituting about half of its imports, which soon doubled and had perhaps trebled by 1700. But what happened to this huge increase in raw silk?

Some bales were re-exported to the Continent and others bought by weavers in Canterbury and Norwich. A significant proportion remained in London where they were converted into silk stockings, ribbons, laces, braids, and buttons, as well as broad silks and mixed fabrics. Certain Levant merchants even became involved in the manufacture of some of these goods. Towards the end of the

[1] 'Elided' quotation from Thomas Shadwell's play *Bury-Fair* of 1689.

[2] L. Roberts, *Merchants Mappe of Commerce* (London, 1638), quoted in Robert Brenner, *Merchants and Revolution. Commercial Change, Political Conflict, and London's Overseas Traders, 1550–1653* (Cambridge, 1993), 4, fn. 1.

century, the supply of raw silk from the Levant was augmented by quantities of Bengal silk imported by the East India Company.

This chapter examines how these increasing supplies of silk were used and their impact upon the nature, scope, and organisation of the London textile trades including innovations in both product and process. Principal sources are the inventories of citizens concerned with the silk trades filed in the Court of Orphans, together with the commercial records of the Levant merchant, Jacob Turner.

ATTITUDES TO SILK

Attitudes towards silk shifted between the reign of Elizabeth I (1533–1603) and the restoration of Charles II in 1660. In 1554, four years before the Queen's accession, a new sumptuary act was passed, the latest in a long line of such legislation, principally concerned with the nature and cost of dress and in particular 'the dangers of sartorial variety masking social standing and undermining the hierarchical structure of society'.[3] The early acts were concerned with a wide variety of fabrics, fur, and gold and silver embroidery. In contrast, the 1554 Act was solely concerned with silk, prohibiting 'anyone earning less than £20 a year, or worth "in goodness" £200 [...] from wearing "any manner of silk in or upon his hat, bonnet, nightcap, girdle, hose, shoes, scabbard or spur leathers"'.[4] Despite these provisions, Philip Stubbes in 1583 complained that 'those which are neither of the nobility, gentility nor yeomanry [...] go daily in silks, velvets, satins, damasks, taffetas and such like, notwithstanding that they be both base by birth, mean by estate and servile by calling'.[5]

All sumptuary legislation was repealed in 1604 but there were several vain attempts to re-impose state control of dress up to 1656, although there was a shift in emphasis. The balance of trade became the new focus and was adjusted by giving encouragement to home producers and barriers to imports. In 1621, during the debate in parliament, Christopher Brooke (c. 1570–1628), the member for York, where his father was a wealthy cloth merchant, quoted 'the Scriptures against vanity and attacked "gaudy apparel"; contributing to the long attack on the wearing of silk, another member claimed that "God did not attire our first parents with excrements of worms", while a third member plaintively

[3] Negley B. Harte, 'Silk and Sumptuary Legislation in England', in Simonetta Cavaciocchi (ed.), *La seta in Europa, secc. XIII–XX* (Florence, 1993), 803.

[4] *Ibid.*, 812.

[5] Quoted *ibid.*, 803.

hoped of women that "laws may rule them though their husbands cannot"'.[6] At this time, King James I (r. in England from 1603) encouraged the establishment, albeit unsuccessfully, of a native silk industry with the cultivation of mulberry trees and silk worms. Some have seen the king's intervention as tipping the balance between 'moralizing prescription and legislation on the one hand and demand on the other [...] in favour of luxury consumption'.[7] Strident voices were raised on both sides of the debate throughout the century but increasingly luxury was discussed in terms of trade rather than morality. This was summed up by Nicholas Barbon (c. 1640–99) in 1690 when he stressed the importance of consumption, with clothing providing work for 'the glover, hosier, hatter, seamstress, tailor, and many more, with those that make the materials to deck it; as clothier, silk-weaver, lace-maker, ribbon-weaver'.[8]

This changing view of consumption and luxury must have benefited the silk industry although it is unclear whether there was any causal link between economic growth and social attitudes. Despite these changes, however, Peter Linebaugh still sees some of the tensions from the sixteenth century surviving into the eighteenth when silk had 'become proverbial as the class insignia of idleness, artifice and deception [...] a fabric of haughty demand and a [...] labour of cringing subservience'; sentiments echoed in a bitter proverb of 1732, 'We are all Adam's children, but Silk makes the Difference'.[9]

SILK IMPORTS AND PROCESSING

Although estimates of the size of the London silk industry vary greatly, there is agreement that there was remarkable growth in the second half of the seventeenth century. Robert Brenner states that the imports of raw silk, in thousands of pounds by weight, were around 120 in 1621, rising to 220 in 1640 and 300 in 1663.[10] Phyllis Deane and William Cole's analysis gave £550,000, or two and a half times the estimate for 1640.[11] The impact of the growth of the industry is

[6] Negley B. Harte, 'State Control of Dress and Social Change in Pre-Industrial England', in D. C. Coleman and A. H. John (eds.), *Trade, Government and Economy in Pre-Industrial England* (London, 1976), 149.

[7] Linda Levy Peck, *Consuming Splendor: Society and Culture in Seventeenth-Century England* (Cambridge, 2005), 3.

[8] *Ibid.*, 8.

[9] Peter Linebaugh, *The London Hanged. Crime and Civil Society in the Eighteenth Century* (London, 1991), 9–10.

[10] Brenner, *Merchants and Revolution*, 25 (using A. M. Millard's figures).

[11] Phyllis Deane and W. A. Cole, *British Economic Growth 1688–1959. Trends and Structure* (Cambridge, 1964), 51, Table 15. In contrast to this rate of growth and particularly to Susan Whyman's comments that the Levant trade, 'trebled or even quadrupled in the 1660s'. Susan E.

Table 7.1 Specialty identified at end of apprenticeship
in the Dyers' Company, 1660–1684.

SPECIALTY	1660–1664		1665–1669		1670–1674		1675–1679		1680–1684	
	No.	%	No.	%	No.	%	No.	%	No.	%
Dyer	88	91	82	70	46	64	38	28	20	25
Dyer of hats	–	–	5	3	1	1	12	9	3	4
Dyer of linen	3	3	4	4	2	3	17	12	6	7
Dyer of silk	1	1	11	9	14	19	53	38	30	37
Dyer of stocken	–	–	1	1	–	–	4	3	6	7
Dyer of stuffe	–	–	1	1	2	3	5	4	6	7
Other	5	5	14	11	7	10	9	6	10	13
Totals	97	100	118	100	72	100	138	100	81	100

The author is very grateful to Dr Roger Feldman for permission to reproduce this table.

dramatically shown by apprentices taking their freedom in the Dyers' Company; within the period 1665–69 just 9 per cent became 'dyers of silk' but only ten years later it was 38 per cent (Table 7.1). At the same time, new specialist categories appeared: 'dyers of stockings' and 'dyers of stuff'.

Peter Earle calculated that there were some 10,000 looms in London in the early eighteenth century and that 40,000 to 50,000 people were employed in the silk industry, although noting that some earlier estimates were much higher.[12] He also described the distinct geography of the silk and allied trades, starting with wire-drawing in St Giles Cripplegate: 'the beginning of the great weaving belt of north and east London. Weaving mainly of silk was the city's biggest industry and the homes of weavers stretched through Shoreditch and Bishopsgate into Spitalfields and Stepney.'[13]

After the Restoration, Levant Company or 'Turkey' merchants imported large quantities of raw silk together with goat's wool and dyestuffs from Aleppo and then from Smyrna [Izmir].[14] Armenian caravans transported the silk on the

Whyman, *Sociability and Power in Late-Stuart England* (Oxford, 1999), 51. Levy Peck sees imports of raw silk only double over the same period. Levy Peck, *Consuming Splendor*, 85.

[12] Peter Earle, *The Making of the English Middle Class. Business, Society and Family Life in London, 1660–1730* (Berkeley, 1989), 20.

[13] Peter Earle, *A City Full of People. Men and Women of London 1650–1750* (London, 1994), 15.

[14] For background to the trade, see Gwilym Ambrose, 'English Traders at Aleppo (1658–1756)', *Economic History Review*, 3/2 (1931); Richard Grassby, *The English Gentleman in Trade. The Life and Works of Sir Dudley North 1641–1691* (Oxford, 1994); Whyman, *Sociability and Power*.

lengthy journey from north-western Persia where it was cultivated in the area of Shirvan. The French *savant* Antoine Galland visited Smyrna and described in 1678 the four types of Persian silk that were available, 'Soie legis bourme, qu'on appelle sorbassi, soie dite ordinaire, soie Ardassine, soie Ardasse'.[15] A recent commentator, Elena Frangakis-Syrett, notes, 'four types of Persian silk were brought to Smyrna: very fine *sherbassi*; *legis*, which was third-quality *sherbassi*; *ardassine*, which was of a similar colour but of lower quality than *sherbassi*; and *ardasse*, a coarse silk'.[16] (Confusingly English merchants and throwsters referred to Galland's *legis bourme* as 'Burma Legee').[17] 'Turkey' merchants mainly imported Persian 'Sherbasse', 'Legee' and 'Ardass' together with some Ottoman or 'White silk', cultivated in Syria, Anatolia, and the former Greek islands. On their return voyage to England, some ships docked at Messina in Sicily and Livorno in Tuscany to purchase fine quality Italian thrown silk particularly 'organzine', essential for the warps of certain broad silks.

Some bales of Persian silk were re-exported from London to the Continent although many were sold to silkmen in the city. Silkmen employed throwsters and silk dyers as subcontractors to process the raw silk which they then supplied to narrow and broad weavers, stocking knitters, and embroiderers. There was a degree of specialisation among silkmen with distinct variation in the nature and prices of their stock: for example, Ezekiel Wallis had an extensive stock of some forty thrown silks ranging from scarlet Bologna at £3 per pound to 'sad coloured' spun and pink 'sleave' silk at 6s 6d per pound.[18] In contrast, Richard Clay's most expensive silk thread was crimson fine Legee at 26s per pound while much of his stock was cheap sleeve or spun silk at 3s to 8s per pound.[19] Some silkmen also engaged in manufacture; Samuel Southen had stocks of silk thread similar to Ezekiel Wallis but also silk stockings, ribbons and 'tabby'; a plain broad silk slightly stronger and thicker than taffeta.[20] Certain of these men drove

[15] Antoine Galland, *Le Voyage à Smyrne. Un manuscrit d'Antoine Galland (1678)* Frederic Bauden (ed.) (Paris, 2000), 152.

[16] Elena Frangakis-Syrett, *The Commerce of Smyrna in the Eighteenth Century (1700–1820)* (Athens, 1992), 224.

[17] London Metropolitan Archives, Orphans Court Inventory (hereafter OCInv.; NB these are probate inventories prepared shortly after death) 807, William Stobart 1672. Burma Legee at 20s per great lb [of 24 oz], Sherbasie at 21s, Ardass 15s. Henry Roseveare (ed.), *Markets and Merchants of the Late Seventeenth Century. The Morescoe-David Letters 1668–1680* (Oxford, 1987), no. 337, 11 Dec. 1676.

[18] OCInv. 345, Ezekiel Wallis 1667. 'Sad colour' was possibly a dark olive green.

[19] OCInv. 965, Richard Clay 1674. 'Spun silk' was spun on the wheel from short 'waste' filaments.

[20] OCInv. 803, Samuel Southen 1665: 160 pairs of stockings; some 90 pieces of ribbon; '760 lb of Tabee and silk in workmens hands to make it', £242.

a considerable trade, such as Daniel Nicholl who owed the throwster Mordecai Fromanteel nearly £1,000 at his death in 1681.[21]

Walter Stern wrote that silk throwing comprised a large number of processes:

> but in essence is the twisting of several fibres of raw silk into hard and even thread [...]. At the outset, the material is delicate and vulnerable; the completion of throwing should leave it strong and elastic. The three end products [...] are singles, tram and organzine, singles being the first stage of any kind of thrown silk, tram the loosely twisted thread used for the weft, organzine the elaborately processed thread necessary for the warp. It was the production of organzine which the Italians had brought to a high degree of perfection, and it is generally believed that, before Sir Thomas Lombe established his water mill in the early eighteenth century, English silk throwers could produce only singles and tram, whereas organzine had to be imported from Italy.[22]

In 1629, on their incorporation as a Company, silk throwsters in London used both 'Italian' and 'English' spindles. Stern suggested that organzine was possibly thrown using Italian spindles and singles and tram using English spindles. In the second half of the century, these descriptions were replaced by, single and double, 'Dutch' and 'English mills', although the difference between them is unclear. Two patents were filed towards the end of the century for 'Instruments' or 'Engines for winding silk': by John Joachim Becher in 1681 and John Barkstead in 1690.[23] The latter's invention seems to have been successful for, in Barkstead's inventory, he was owed a debt of £370 'For Shares in the Silk Engine'.[24] Perhaps Barkstead's engine threw 'hard thrown silk' suitable for the warps of certain silk and mixed fabrics. Nevertheless, it is salutary to note Joshua Gee's (1698–1748) comments in *The Trade and Navigation of Great-Britain*, published in 1729 but written some years earlier:

> The *Turkey* [Persian] Silk is only fit for the Shute [weft] of our fine Damasks, and other coloured Silks, and for making Silk Stockings, Galloons, and Silver and Gold Lace; but not proper for the Warp of any Silk, not being fine enough,

[21] OCInv. 1759, Daniel Nicholl 1681: total sum £8,132, debts owing to £10,395, debts owing by £2,579. He purchased raw silk from Jacob Turner: The National Archives, Kew (hereafter TNA), C104/44 Pt.1. 1677, Waste Book, p. 164, one bale Ardass, 7 March 1680/1.

[22] Walter M. Stern, 'The Trade, Art or Mystery of Silk Throwers of the City of London in the Seventeenth Century', *Guildhall Miscellany*, 1/6 (1956), 26. For technical study, see W. English, 'A Study of the Driving Mechanisms in the Early Circular Throwing Machines', *Textile History*, 2 (1971).

[23] Bennet Woodcroft, *An Alphabetical Index of Patentees of Inventions: 1617–1852* (London, 1854).

[24] OCInv. 2260, John Barkstead 1694. He had traded as an overseas merchant but was retired by 1694 with ready money at £8,554 out of a total sum of £10,783.

nor even enough for Organzine, or double twisted Silk, that being all *Italian*; nor indeed even enough for the Shute or Woof of black Lustrings, Alamodes or Paduasoys, the Shute of that being also *Italian*.

Later he writes, 'As we have but one Water-Engine for throwing [organzine] Silk in the Kingdom [...] it would be a Matter of the greatest Consequence [...] to have three or four more erected, according to the Model of that at *Derby*' (referring to Lombe's mill of 1718).[25]

Many London throwsters had modest trades and mainly worked as subcontractors but a few had large enterprises, buying raw silk directly from Levant merchants which they processed from extensive premises with a number of mills: Thomas Bates, in partnership with Samuel Phillimore in Whitechapel in 1706, had three workshops equipped with twelve double Dutch mills and five English mills. The partnership was owed £23,600 by a hundred debtors including Gee, who was a merchant as well as an economic commentator.[26]

NARROW WARES

Eric Kerridge noted that, around 1600, most silk workers in London were of Flemish or Walloon descent and mainly earned their living by weaving 'narrowwares': 'made and sold in penny widths up to six pennies wide such as tapes, ribbons, garters, fringes, tassels, galloons, girdles, inkles, cauls, trimmings, gimps, hatbands, braids, and livery and other laces'.[27] As silver pennies were about half an inch in diameter, the widths ranged from half an inch to three inches [12.7 mm to 76 mm] although later in the century wider ribbons were available in a range of widths up to eighteen pennies or nine inches [228 mm]. These narrow wares were mostly woven on small table-top looms which required little strength to operate with the result that 'many poore children [were] sett on worke by the same, and old men likewise have got their liveings by workeinge upon the said single looms and kept themselves and their families from begging and idleness' (Illustration 7.1).[28] To weave complex designs in either ribbons or laces, a small drawloom was used, essentially a scaled-down version of that for

[25] Joshua Gee, *The Trade and Navigation of Great-Britain* (London, 1729, 4th edn, 1738, reprinted New York, 1969), 13, 140.

[26] OCInv. 2798, Thomas Bates 1706: mills valued at £109, a mean of £6 8s (most mills in the inventory sample were valued between £4 and £7). Raw and thrown silk at £6,676. Debtors included Thomas Drake, £678, possibly the stocking trimmer who made silk stockings for Jacob Turner. Gee owed him £249.

[27] Eric Kerridge, *Textile Manufactures in Early Modern England* (Manchester, 1985), 24.

[28] From Weavers' Company records quoted *ibid.*, 198.

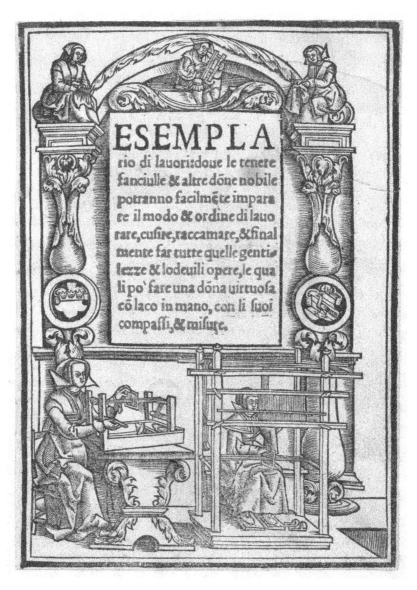

Illustration 7.1 Two looms including a small table-top loom on the frontispiece to the pattern; Nicolò Zoppino. *Esemplario di lavori dove le tenere fanciulle et altre donne nobile potranno facilmente imparare il modo et ordine di lavorare, cusire, raccamare et finalmente far tutte quelle gentilezze et lodevoli opere, lequali può fare una donna virtuosa con l'aco in mano, con li suoi compassi et misure. – "Au fol. sign. Aii r°": Alli virtuosi et gentilissimi lettori Nicolò Zoppino S. P. D. – "À la fin": Finisce il libro intitulato Esemplario de lavori, stampato in Vinegia per Nicolò d'Aristotile detto Zoppino, MDXXX, del mese di marzo* (Venice, 1529). New York, The Metropolitan Museum of Art, Rogers Fund, 1921.

silk damask; eighteenth-century examples are illustrated in the *passementerie* section of *L'Encyclopédie*.[29]

At the Restoration, there was a degree of specialisation among narrow weavers with some concentrating upon the production of ribbons and gartering whilst others wove laces and fringes. Ribbon weavers typically owned half a dozen small hand-looms, valued together with their 'appurtenances' at about 10 shillings each (Table 7.2).[30] There are few descriptions although William Pyle had '5 high lesse looms & 2 plaine looms': 'high lesse' presumably referring to looms with vertical warps or *haut lice*. Most ribbon weavers were of modest means and seem to have operated by buying silk thread from silkmen, sometimes having it dyed themselves, and selling the finished ribbons either to a haberdasher of small wares or to an 'exchangeman'.[31] In contrast, Stephen Proctor, who wove both ribbons and silver gartering, also kept a shop in the Royal Exchange.[32]

Few appear to have owned a 'Dutch' or 'engine-loom' which cost in the region of £10. In the Dutch Republic, 'ribbon weaving was revolutionized by the appearance of the ribbon frame, patented in 1604, which permitted a single worker to weave twelve ribbons at a time (and twice as many by 1670). It was widely adopted in all the main textile centres of Holland by the late 1660s.'[33] This type of loom was apparently brought to England by immigrant weavers, reflected in a petition to the Weavers' Company in 1616 which urged that aliens,

> should entertain English apprentices and servants to learn these trades, the neglect thereof giveth them advantage to keep their misteries to themselves, which hath made them bold of late to devise engines for working of tape, lace, ribbon and such, wherein one man doth more among them more than seven English men can do, so that their cheap sale of these commodities beggareth all our English artificers of that trade and enricheth them.[34]

[29] Jacques Proust (ed.), *L'Encyclopédie. Diderot et D'Alembert* (Paris, 1985), 541–9.

[30] London Metropolitan Archives (hereafter LMA), Mayor's Court, MC1/124, William Hooker 1659, nine looms with mean value of 5s 6d; OCInv. 747, John Cooper 1665, three looms; OCInv. 626, John Carter 1670, six looms with mean value of 10s 9d; OCInv. 1112, Thomas Newman 1675, two old looms; OCInv. 1544, William Pyle 1677, seven looms with mean value of 11s 5d; OCInv. 2560, Emmanuel Bucknell 1703, six looms.

[31] Those that kept shops on the Royal or New Exchange were known as 'exchangemen' or 'exchangewomen' and sometimes as 'milliners'.

[32] OCInv. 1545, Stephen Proctor 1680.

[33] Karel Davids, 'Technological Change and the Economic Expansion of the Dutch Republic, 1580–1680', in Karel Davids and Leo Noordegraaf (eds.), *The Dutch Economy in the Golden Age* (Amsterdam, 1993), 89.

[34] Cited in Tim Harris, *London Crowds in the Reign of Charles II. Propaganda and Politics from the Restoration until the Exclusion Crisis* (Cambridge, 1987), 199–200.

Table 7.2 Selected inventories of weavers and framework knitters, 1660–1710.

Date	Name	Location	Trade Goods & Gear £	Total Sum £	Debts Owing To £	Debts Owing By £	OCInv Ref.*
RIBBON WEAVERS							
1665	John COOPER	Trinity Minories	251	398	96	53	747
1670	John CARTER	Bishopsgate St.	59	124	194	234	626
1675	Thomas NEWMAN	St Giles Cripplegate	213	376	1207	482	1112
1677	William PYLE	Bishopsgate St.	57	84	10	–	1544
1678	Jonathan CATLIN	Bridewell	158	348	1043	172	1429
1679	Isabell TAPSELL	St Giles Cripplegate	217	317	1196	223	1428
1680	Stephen PROCTOR	Barge Yard, Bucklersbury	3015	3428	2938	1387	1545
1685	Daniel NEALL	St Giles Cripplegate	302	457	–	180	2073
1703	Emm. BUCKNELL	St Buttolph Bishopsgate	704	792	895	512	2560
LACE & FRINGE WEAVERS							
1665	William KIDDER	St Buttolph Bishopsgate	76	288	39	189	53
1665	Thomas WILSON	Moorfields	480	1256	685	693	598
1672	Nicholas RUSSELL	Westminster	227	1904	909	939	864
1673	Wm RICHARDSON	Dukes Place	71	565	27	156	888
1697	John LONG	Bridewell	251	3503	1125	180	2279
1699	Nich. PENDLEBURY	Lombard St	552	1359	176	1011	2364
1701	John ROLFE	Foster Lane	231	909	108	16	2382
1706	Nicholas SPICER	Warwick Lane	220	1302	5	65	2741

BROAD WEAVERS

1665	Thomas MARRIOT	Little Moorfields	424	1656	432	305	306
1665	Jacob SUMERS	Stepney	255	359	457	523	27
1670	Barak TUSTIAN	St Giles Cripplegate	89	608	–	–	605
1707	Joshua SABIN	St Buttolph Bishopsgate	788	2483	227	775	2779
1709	Abraham PEARCE	St Buttolph Bishopsgate	1623	1735	1372	1476	2960

FRAMEWORK KNITTERS

1665	Richard AUSTIN	Bermondsey	34	50	–	–	3306**
1673	William HARDY	Minories	123	804	643	120	840
1688	George EAST	Shoreditch	101	264	20	–	7878**
1708	Thomas PAGE	Allhallows-in-the-Wall	1123	4042	503	4006	2858

*London Metropolitan Archives, Probate inventories from the Court of Orphans.
**The National Archives, Kew, class Probate 4.

Complaints continued and in 1638 Charles I (r. 1625–41) included in 'his letters patent granted to the Weavers' Company an express prohibition on the use of engine-looms'.[35] This seems to have had little lasting effect for, after the Restoration, the weavers continued to protest and a bill to ban their use was subsequently discussed in Parliament. This was vigorously opposed by the owners of engine-looms and the bill came to nothing. The frustration of the hand-weavers led to large-scale co-ordinated riots in August 1675 which resulted in at least eighty-five engine-looms belonging to twenty-four different owners being dragged into the streets and ceremonially burnt. According to the indictments following the disturbances, each loom had a value of some £10.[36]

Silk ribbons were widely used throughout the seventeenth century for clothing as well as for upholstery and packing expensive goods. They were available in a variety of widths, qualities, patterns and colours, and were generally sold by the piece, defined principally by their widths. Certain ribbons were further defined by their structure or the type of silk from which they were woven, such as taffeta or satin, Ardass or Ferret. Plain taffeta ribbons were cheaper than satin ribbons, although some were apparently patterned, probably with stripes or checks like a number of broad taffetas (Illustration 7.2).[37] Ribbons were also described by colour, black and coloured ribbons were of a similar price but scarlet, 'dyed in grain', was more expensive owing to the cost of cochineal: Isabel Tapsell had eight-penny ribbon in colours at 5s 6d the piece, black at 6s but scarlet at 9s.[38] 'Love' ribbon, which was cheaper than taffeta or ordinary silk ribbon, was also woven in various widths, and in addition, there were 'figured ribbons' and 'silk and silver fancyes'.[39]

Gartering ribbon was also produced in several widths, colours and qualities and varied considerably in price: Anthony Lacon had gartering at 7¼d per yard and Edward Coote at 10d, whereas Proctor had silver gartering ranging in value

[35] *Ibid.*, 195.

[36] *Ibid.*, 193 fn. 23; eighty looms valued at £783 10s, i.e. a mean of £9 16s.

[37] OCInv. 282, Thomas Strong 1666; 1d 'taffety' ribbons at 2s the piece with satin at 4s 6d. OCInv. 1060, John Winne 1674, mentions 'plaine' taffeta ribbons, which implies that some were patterned. For taffetas, see Florence M. Montgomery, *Textiles in America, 1650–1870* (New York, 1984), 358–60. For the purposes of this article, it is assumed that all pieces of ribbon noted in a particular inventory were of the same length, although it is unclear whether ribbons were produced in pieces of a standard length. Thus, all the price comparisons have to be treated with circumspection. Very few ribbons in the documents were priced per yard. All prices are based on £1 = 20s = 240d.

[38] OCInv. 1428, Isabel Tapsell 1679: probably the widow of Thomas Tapsell, ribbon weaver.

[39] OCInv. 1392, Robert Leech 1678. OCInv. 1268, John Aylworth 1676. The nature of 'Love' ribbon is unknown.

Illustration 7.2 Ivory self-patterned silk sixpenny ribbon (4 cm wide) at the waist of an English doublet, 1635–1640. Victoria and Albert Museum no. 347-1905. © Victoria and Albert Museum, London.

from 4s 6d to 16s 8d per yard.[40] Such costly material was clearly to satisfy an elite market, being similar in value to the silk and silver ribbons supplied to Queen Mary in 1694: blue and silver ribbon at 8s per yard and blue, gold, and silver at 22s.[41]

Although gartering had a specific purpose, other ribbons had many uses for decorating or fastening clothing, shoes, and gloves. In her portrait by Cornelius

[40] OCInv. 889, Edward Coote 1673. OCInv. 1140, Anthony Lacon 1675; 155 yards of gartering and 16 pairs of garters at £5 12s 9d, or some 187 yards giving a value of 7¼d per yard. In the self portrait of Sir Nathaniel Bacon of c. 1620, his garters of dark blue and silver ribbon seem to be wound twice above his calf and tied in a knot with two free ends – such a garter needs about a yard of ribbon, see Aileen Ribeiro, *Fashion and Fiction. Dress in Art and Literature in Stuart England* (New Haven, 2005), plate 19. OCInv. 1545, Stephen Proctor 1680: 115 yards silver gartering £25 6s or 4s 5d/yd; 231½ yards, £100 16s or 9s 5d/yd; 667 yards, £555 or 16s 8d/yd. He also had ribbon at 18d, 2s, 3s, 3s 6d, and 4s per yard but the widths were not specified.

[41] *Ibid.*, 293.

Johnson (1593–1661), Margaret Holliday, Lady Hungerford (d. 1672), wears 'a bodice and skirt of red silk embroidered in gold and silver and spangles, and a black overgown tied with striped ribbon at the waist; the same ribbon keeps in place the paned and padded figure-of-eight sleeves'.[42] A bow of the striped yellow silk and silver ribbon fastens the end of the carcenet of diamonds set in gold which loops over her shoulder (Illustration 7.3).[43]

Margaret Cavendish (1623–73), Duchess of Newcastle, maintained that men were no less enthusiastic in bedecking themselves with ribbons than the fairer sex, 'are not Men more perfumed, curled, and powdred than Women? And more various colours, and greater quantities of ribbins ty'd and set upon their hats, cloaths, gloves, boots, shoes, and belts, than Women on their heads and gowns.'[44] Petticoat breeches, worn during the 1660s and 1670s, were a particular vehicle for the display of myriads of ribbons. The diarist and horticulturalist John Evelyn (1620–1709) spied:

> a fine silken thing [...] walking the other day through *Westminster Hall*, that had as much Ribbon about him as would have plundered six shops, and set up twenty country pedlars [...] A Fregat newly rigg'd kept not half such a clatter in a storme, as this Puppets streamers did when the wind was in his shrouds; the motion was wonderful to behold, and the well chosen Colours were Red, Orange, and Blew, of well gum'd Sattin which argu'd a happy fancy.[45]

In the painting *The Ball at the Hague* of 1660, Charles II (r. 1660–85) is shown dancing. He is clad in black petticoat breeches garnished with red ribbons and with knots of ribbons on his shoulders and at his cuffs and on the bows of his shoes (Illustration 7.4).[46] After his restoration, Charles continued to wear sombre 'cloth colours' such as grey, black or 'sad' colour, but these were often enlivened by ribbons with strongly contrasting colours such as the 'grey cloth suit and coat lined with tabby with a garniture of black, white, lemon, and scarlet ribbons ordered in 1665'.[47]

[42] *Ibid.*, 119.

[43] A carcenet is a jewelled chain, necklace or collar.

[44] Margaret Cavendish, *Natures Pictures* (London, 1656), quoted in Ribeiro, *Fashion and Fiction*, 202.

[45] William Bray (ed.), 'Tyrannus or the Mode: In a Discourse of Sumptuary Laws', [2nd edn., 1661], in *Memoirs of John Evelyn*, vol. 2 (London, 1818), 325.

[46] See Maria Hayward, 'Going Dutch? How Far Did Charles II's Exile in the Netherlands Shape His Wardrobe, 1646–66?', in Johannes Pietsch and Anna Jolly (eds.), *Netherlandish Fashion in the Seventeenth Century*, Riggisberger Berichte 19 (Riggisberg, 2012), 124. Ribeiro, *Fashion and Fiction*, 217–19.

[47] Hayward, 'Going Dutch?', 127.

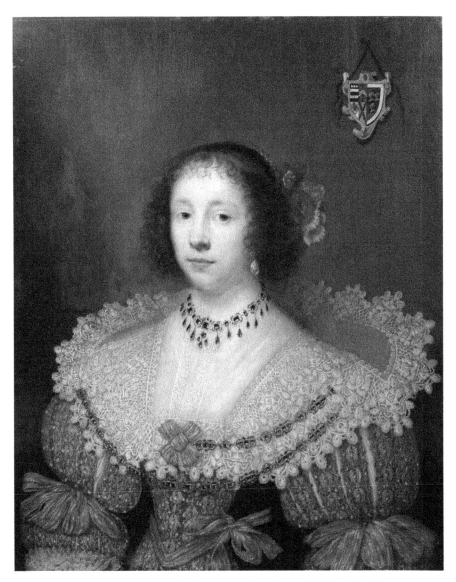

Illustration 7.3 Portrait of Margaret, daughter of William Hallyday,
Lord Mayor of London, and wife to Sir Edward Hungerford MP,
by Cornelius Johnson, 1631, oil on panel. © Historic England Archive.

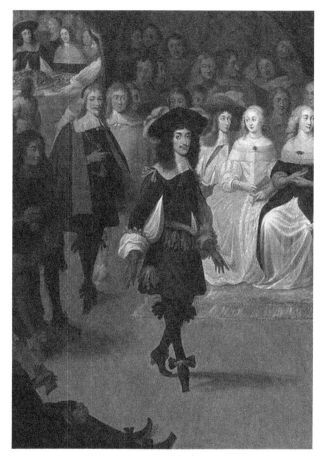

Illustration 7.4 Detail of Charles II dancing at the Hague,
by Hieronymous Janssens, 1660, oil on panel, RCIN 400525,
Royal Collection Trust / © Her Majesty Queen Elizabeth II 2017.

The 'middling sort' also wore silk ribbons to decorate their clothes as well
as silk laces and points to fasten together pieces of clothing and shoes. Large
quantities of ribbons and other silk accessories were used to furnish mourning
clothes: for the funeral of the carman Robert Campion in 1676, his son Thomas
was given in addition to 'a sute of cloths', 'a Mourning Shoulder Knott, a
Mourning hatband and a payre of blacke Mourning Shooestrings'.[48] Such knots
could be bought ready-made: Lacon had in stock 'a parcel of slight sattins, Silver

[48] OCInv. 1337, Robert Campion 1678.

Ribbons & knots made up'.[49] Ribbons were also prominent on more joyous occasions such as the reception of Charles II on his return to London from his royal progress, when the Goldsmiths' Company provided twenty-eight riders, in 'velvet coats and gold chains', each given three yards of ribbon 'of the Company's colours crimson and yellow and the like quantities of ribbon for the riders to put to the horses heads'.[50]

Silk ribbons were also used in packing parcels of various goods including broadcloths for export and expensive boxes of sweetmeats for customers at home and abroad. The packing of cloths was important both for safety in transit and appeal to the potential customer on arrival. This was particularly important for expensive broadcloths shipped to the Levant, some of which were destined to be taken across Anatolia to Persia by caravan. Factors were very conscious of both considerations.

> I could wish your cloth had bin something handsomer made up [...] And a good outside and appearance doth something win upon & preingage though not chate [cheat] the iudgement. [...] Cloth keeping best in bales which will require your care to see imbaled in good canvas [...] and to cover all over with Brown paper to keepe out the dust [...] your silke tillets give content which if [you] finde chargeable [you] may trimme only halfe your cloth therewith.[51]

In response to such requests the best English broadcloths were wrapped in sarcenet tillets tied with silk ribbons and then 'imbaled' in fives with canvas and packthread.[52]

Apart from ribbon weavers, other narrow weavers produced laces, braids and fringes which were widely used to decorate both clothing and upholstery (Illustration 7.5). Certain of these were made wholly of silk whilst others incorporated metal threads of silver or silver gilt, some of which were flatted wire wound onto a silk core. The proportion of silk imports used in their manufacture could not have been large but it must have increased with the significant growth from the Restoration in the production of both silk and gold and silver laces.

[49] OCInv. 1140, Anthony Lacon 1675.

[50] London, Goldsmiths' Company Court Book 4, f. 20, 29 September 1663.

[51] TNA, SP110/12; Levant Company Correspondence 1669, f. 2v, 15 Jan. 1668/9 and f. 14v, 29 April 1671.

[52] Richard Boylston, packer, owed 'George Hancocke for Ribbon' £28 13s, OCInv. 1092, Richard Boylston 1674. Jacob Turner packed some red and wine-coloured broadcloth, in sarcenet with broad taffeta ribbons. The packer John Daniel had 'ferritt Ribboning' at 5s per yd, OCInv. 2106, John Daniel 1689. For further details of the costs of packing, David M. Mitchell, '"Good Hot Pressing Is the Life of All Cloth": Dyeing, Clothfinishing and Related Textile Trades in London, 1650–1700', in Herman Diederiks and Marjan Balkestein (eds.), *Occupational Titles and Their Classification: The Case of the Textile Trade in Past Times* (St Katharinen, 1995), 166–7.

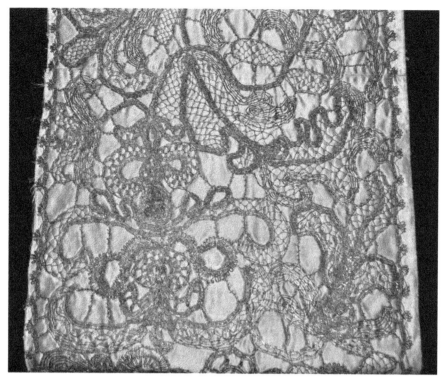

Illustration 7.5 Gold gimp lace applied to gold satin bed hangings,
late seventeenth century, probably English, private collection.

Indeed, there was concern at the squandering of the country's wealth on such
fripperies. John Evelyn wrote in 1661 of 'the impolitick wast which this promis-
cuous Bravery draws along with it; that no less than *two Millions* of treasure (as I
am informed) has [...] been lost in Gold and Silver *Lace*'.[53]

Although little black and coloured silk lace has survived, contemporary
documents indicate that it was fashionable and was manufactured in significant
quantities. It was worn by both men and women; Samuel Pepys (1633–1703)
recorded that 'it was a glorious sight to see Mrs Stewart in black, and white lace –
and her head and shoulders dressed with diamonds' and on another occasion, that
'the hands of my vest and tunic [were] laced with silk lace of the colour of my suit'.[54]

[53] Quoted in Santina M. Levey, *Lace: A History* (London, 1983), 38.
[54] *The Diary of Samuel Pepys*, Robert Latham and William Matthews (eds.) (London, 1970–83),
vol. 7, 372, 1 Nov. 1666; vol. 9, 201, 17 May 1668. Pepys is referring to Frances Teresa Stewart, later
Duchess of Richmond and Lennox (1647–1702).

BROAD WEAVING

The broad weaving of silk fabrics and mixtures of silk, linen, and worsted yarns was brought to England by Flemish and Walloon refugees in the sixteenth century.[55] Because of concerns at the scale and nature of immigration into London from the Low Countries and France, the government, from time to time, carried out surveys or 'Returns of Strangers'. That for 1618 contained a number of silk weavers; some 134 in Bishopsgate Ward alone of whom a few were termed 'Tuftaffetty' or 'Taffetty' weavers.[56] Taffeta was a thin plain weave of silk which also formed the ground of tuftaffeta; a velour with tufts of silk or of yarn in which silk was mingled.[57] The Return of 1635 listed some 650 stranger weavers in the City of London and its suburbs, mostly thought to have been narrow weavers although some were clearly broad weavers as a few were described as weavers of taffeta, tuftaffeta, mohair, plush, or velvet.[58] The Weavers' Company did not admit strangers as freemen but granted them three forms of association: foreign masters, who could bind apprentices and run independent businesses; foreign weavers or 'brothers' who were allowed to work independently but not set up as householders; and journeymen who were not permitted to work independently.[59] Between 1661 and 1694, at least 686 men were admitted: 238 masters, 26 brothers, and 422 journeymen.

In 1619, four cases for debt totalling £525 were brought before the Mayor's Court against Francis Rigbourg, silkweaver of Canterbury. The schedules of his goods contained fifteen items: only one was solely of silk, 'blacke & white & yellow sticht taffata', the other fourteen were mixed fabrics, figurettos, purled and wrought grograms, silk says, and silk rashes.[60] It seems a similar range of fabrics was being woven in London at this period.[61] From the Restoration, the few broad weavers in the inventory sample all produced mixed fabrics as well as some

[55] These fabrics, at 21 ins and sometimes 27 ins wide, were broad in comparison with narrow wares but not with broadcloths or linen damask tablecloths.

[56] R. E. G. Kirk and E. F. Kirk (eds.), *Returns of Aliens 1588–1625*, Huguenot Society of London, vol. 10, part 3 (Aberdeen, 1907).

[57] Kerridge, *Textile Manufactures*, 76.

[58] Irene Scouloudi (ed.), *Returns of Strangers in the Metropolis, 1593, 1627, 1635, 1639*, Huguenot Society of London, Vol. 57 (London, 1985); Kerridge, *Textile Manufactures*, 24.

[59] Harris, *London Crowds*, 199.

[60] LMA, Mayor's Court, MC1/34.4, 34.5, 35.5 and 35.8, Francis Rigbourg 1619; taffeta 3s 8d/yd; figuretto 2s 8d/yd; purled grogram 6s 8d/yd; wrought grogram 7s/yd; silk says 3s 2d/yd. There was also a case against a Peter Rigbourg for a debt of £40 with a schedule of just purled and wrought grosgrams. LMA, Mayor's Court MC1/35.21.

[61] See Natalie Rothstein, 'Canterbury and London: The Silk Industry in the Late Seventeenth Century', *Textile History*, 20/1 (1989).

broad silks (Table 7.2). Thomas Marriott in 1664 owned eight looms and wove some expensive gold and silver stuffs along with silk plush and watered tabby.[62] A year later, Jacob Sumers was recorded as having six looms and similar stocks of silks and mixed fabrics and the materials to weave them, thrown and spun silk, and grogram and 'Scotch' yarn. He bought his own silk and sent it to be dyed – a throwster and three silk dyers were among his creditors – and then sold the finished fabrics directly to mercers, eight of whom were among his debtors.[63] Early in the next century, Joshua Sabin made some slight silks and worsteds but mostly inexpensive mixed fabrics of silk with mohair or worsted yarn.[64]

Clearly, good quality plain silks were woven in the city; a pamphlet of 1674 declared that 'in Spitalfields and London suburbs the production of silk, satin, and velvet arrived at great perfection'.[65] Subsequently, there was an increase in the production of figured or 'flowered silks' – damasks and brocades – as well as lustrings and alamodes. In 1685, the steward of Lord Grey bought a gold and blue brocade costing the considerable sum of £3 15s per yard for which he claimed 'Coach hire' as 'I was att all ye greate shops in Towne and went as far as Spittlefeilds & Shoreditch to see silkes att ye Weavers upon ye Frame before I pitcht upon that which you had'.[66]

The growth in London of weaving hair camlet and silk mohair was clearly important in using the increasing quantities of silk and goat's wool imported by Levant Company merchants after the Restoration. Two qualities of goat's wool were imported: the better was 'Angora' from Ankara (given as *Angouri* on Blaeu's map of 1662) and the other was 'Begbazar' from Beypazar, a town to the west of Ankara.[67] The variation in price between camlet and mohair was owing to the quality and proportions of their raw materials of silk and grogram yarn as well as

[62] OCInv. 306, Thomas Marriott 1664. Gold stuff 18s/yd; silver stuff 10s/yd; silk plush 10s/yd; coloured silk 7s 6d/yd; watered tabby 6s/ell.

[63] OCInv. 27, Jacob Sumers 1665. Silk plush 8s/yd; ferrandine 6s 8d/yd; mohair 3s 8d/yd; thread velvet 7s 6d/yd; thread plush 5s/yd.

[64] OCInv. 2779, Joshua Sabin 1707. Hair plush 3s 6d/yd; prunello and ferrandine 3s/yd; russells 1s 8d/yd; worsted plaid 1s 4d/yd; satinet 1s 2d/yd. He bought grogram yarn from Jacob Turner in 1692. His father, Joshua Sabin was one of the three men using 'Tape Loomes to weave Silke Ribbons' named in a petition from the Weavers' Company to the Privy Council in December 1675, following the riots and burning of engine looms in the August of that year. Richard M. Dunn, 'The London Weavers' Riot of 1675', *Guildhall Studies in London History*, 1 (1973–75), 33.

[65] Anonymous, *The True English Interest* (London, 1674), quoted in Levy Peck, *Consuming Splendor*, 109.

[66] TNA, SP110/12, Ossulton papers 1684–85; Account ... by Harry Ireton for Lord Grey.

[67] John Goss (ed.), *Blaeu's The Grand Atlas* ([Amsterdam, 1662] London, 1990), *Turcicum Imperium*, 202; TNA, C104/44 Pt.1. 1677. He paid 4s 4d/lb to 5s 4d/lb for Angora; 2s 9d/lb to 3s 4d/lb for Begbazar. After it was thrown grogram yarn cost 3s 6d/lb for short skein, 4s 6d for long skein and 5s 8d/lb for superfine. Persian goat's wool cost 2s/lb.

their widths and the cost of dyeing, certain reds and blacks were more expensive than other colours.[68] The increase in their production was reflected in the establishment of specialist stuff dyers in the Dyers' Company; for example, only one apprentice taking his freedom from 1665–69 was identified as a 'dyer of stuffe' but there were five in 1675–79 (Table 7.1).

Many camlets and mohairs had watered designs produced by the use of a calendar – essentially a very large mangle consisting of a box with a loading of several tons which was pulled over rollers on a flat bed. To produce watered and waved patterns on stuffs, the fabric was wound in particular ways onto one of the rollers. On a visit to Tours in 1644, John Evelyn 'went to see their manufactures in silk, their pressing and watering the grograms and camlets, with weights of an extraordinary poise, put into a rolling-engine'.[69] Eight years later he 'went to see the manner of chamletting silk and grograms at one M. La Dorees in Morefields' who possibly introduced the process into England. Natalie Rothstein observed that 'the system of watering by calendar developed in England proved superior to that used in Lyons and possibly in Tours'.[70] This view is supported by the two distinct types used in London: the 'English calendar', operated by horse power, costing £10 to £15, and the simpler 'Dutch calendar', costing £4 to £7.[71] The English calendar was probably developed in London. An illustration in *L'Encyclopédie* entitled 'Calandre Royale ou Calandre Angloise' shows a calendar fitting the description in William Bosworth's inventory of 1673, 'English Kalender & rowling boards scrayes & Horse post with pully post rope & Loading' (Illustration 7.6). Calenderers largely traded as specialist sub-contractors although some dyers who apparently specialised in dyeing stuffs owned calendars, such as Philip Hudson in Bow in 1665.[72]

Hair camlet and silk mohair were used for both clothing and upholstery.[73] From the 1670s they were increasingly found in expensively furnished bedchambers in

[68] OCInv. 506, William Paulett 1666, hair camlet at 4s; OCInv. 815, John Allen 1673, hair camlet at 5s; OCInv. 92, John Moore 1670, silk mohair at 3s; TNA, E154/4/34, Daniel Waldo 1661, broad rich mohair at 7s 6d per yard.

[69] Quoted in Montgomery, *Textiles in America*, 188.

[70] Quoted in Kerridge, *Textile Manufactures*, 129.

[71] See OCInv. 853, William Bosworth 1673; OCInv. 1224, George Phinnis 1675; and OCInv. 1693, William Case 1681. Professor Karel Davids has brought to my attention a Dutch patent of 1640 for a calendar; the process seems to have been continuous, which implies that the fabric was fed through fixed rollers.

[72] OCInv. 295, Philip Hudson 1665. His calendar was presumably of the Dutch type as it was valued with other goods at £5.

[73] Worsted camlets, which were much cheaper than hair camlets, were used in more modestly furnished bedrooms. OCInv. 92, John Moore 1670, 16d/yd; OCInv. 301, Thomas Cole 1667, 13d; OCInv. 931, John Ewens 1673, broad 18d.

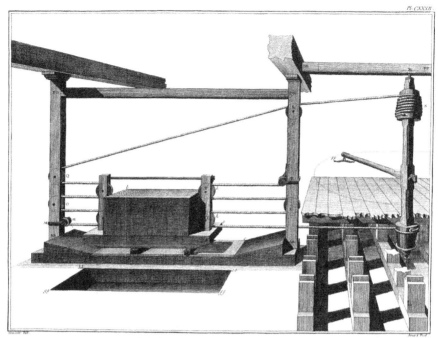

Soierie, Calandre Royale ou Calandre Angloise ?

Illustration 7.6 An English Calendar showing the horse post to the right;
Planche CXXXII, signéer. Soierie, Calandre royale ou Calandre angloise. In: *Encyclopédie,
ou dictionnaire raisonné des sciences, des arts et des métiers, Nouvelle impression en
facsimile de la première édeition de 1751–1780*, Denis Diderot and Jean le Rond
d'Alembert (eds) (Friedrich Frommann Verlag, Stuttgart: 1967), vol. 32, p. 38.
Courtesy of the Max Planck Institute for the History of Science, Berlin.

London houses (Table 7.3).[74] Between 1660 and 1674, it is striking just 3 per cent
of the bedding in inventories was camlet and mohair compared with 57 per cent
in broadcloth and serge. In contrast, between 1690 and 1704, camlet and mohair
constituted 44 per cent but broadcloth and serge just 9 per cent. At the same
time, there was an increase in the use of broad silks, particularly of silk damask.

In England, these mixed fabrics were also used for summer clothing, as Pepys
noted on May Day 1669,

[74] For more details of this analysis see David M. Mitchell, 'Fashions in Bed and Room
Hangings in London, 1660–1735', in Anna Jolly (ed.), *Furnishing Textiles. Studies on Seventeenth-
and Eighteenth-Century Interior Decoration*, Riggisberger Berichte 17 (Riggisberg, 2009) and David
M. Mitchell, '"My Purple Will Be Too Sad for that Melancholy Room": Furnishings for Interiors
in London and Paris, 1660–1735', *Textile History*, 40/1 (2009).

Table 7.3 Bed hangings in London 1660–1704: rooms valued at more than £30.

Fabric type	1660–1674 %	1675–1689 %	1690–1704 %
Cloth	34	16	8
Serge	23	7	1
Wrought/Embroidered	21	11	17
Silk/Damask/Velvet	10	26	21
Camlet	3	15	10
Mohair	0	17	34
Others	9	8	9
Total	100	100	100
Number of beds	96	94	90

Source: analysis of Orphans Court Inventories, currently held at the London Metropolitan Archives.

Up betimes, called up my tailor, and there first put on a summer suit this year – but not my fine one of flowered tabby vest and coloured camelott tunic, because it was too fine with the gold lace at the hands, that I was afeared to be seen in it – but put on the stuff-suit I made the last year which is now repaired.[75]

SILK STOCKING KNITTING

Another trade that used quantities of silk was the manufacture of silk stockings using the stocking knitting frame. This has been described as 'probably the most sophisticated textile machine in common use in western civilization in the seventeenth and eighteenth centuries' and 'was said to be composed of more than 2000 parts'.[76] The stocking frame was first devised in 1589 by William Lee (died c. 1615), a Cambridge-educated son of a substantial Nottinghamshire yeoman. In studies of Lee and the stocking frame, several writers have emphasised that the machine required a number of significant modifications before it became both efficient and economic. The frame seems to have been modified early in the next century and again during the 1650s when several attempts were made

[75] *The Diary of Samuel Pepys*, ix: 202.

[76] Peta Lewis, 'William Lee's Stocking Frame. Technical Evolution and Economic Viability 1589–1750', *Textile History*, 17/2 (1986), 129.

to smuggle the improved frames abroad.[77] This was also the decade when the framework knitters became incorporated as a company. None the less, the knitting frame was not widely known. John Evelyn, who was much interested in scientific and technological innovation, noted on 3 May 1661, 'I went to see the wonderful engine for weaving silk stockings said to have been the invention of an Oxford scholar forty years since'.[78] Further modifications were indicated by the statement in Parliament in 1692, that the stocking-frame 'has been recently much improved'.[79] The growth in productive capacity in London from the Restoration was considerable, with estimates of 400 to 500 stocking frames in 1660 rising to 2,500 in 1730.[80]

There were several patterns of production during the second half of the seventeenth century. Many framework knitters were poor and often had their raw materials supplied by others, such as Richard Austin who owned four frames and had stocks of worsted stockings with two pairs of 'silk stockyngs w^ch are kept for the person that delivered the silk to be woven' (Table 7.2).[81] George East had a more substantial trade with nine stocking frames and again knitted both silk and worsted stockings as well as black silk gloves. He seems to have bought his own silk and worsted yarn.[82] In both cases, their capital investment in stocking frames, which were valued at between £8 and £9 each, constituted a significant proportion of their assets.[83] In contrast, Thomas Page had an extensive business with silk stockings and thrown silk in stock valued at £1,020. His frames were estimated at just £11 but he had nearly 100 lbs of 'silk in workmens hands'. As he was free of the Framework Knitters' Company, it is likely he started as a workman but when his trade grew he relied on sub-contractors.[84]

Several types of silk stockings were made but most are characterised as either long or short, and men's or women's. Their quality and price depended upon

[77] Joan Thirsk, 'Knitting and Knitware, c. 1500–1780', in David Jenkins (ed.), *The Cambridge History of Western Textiles* (Cambridge, 2003), i: 576.

[78] *John Evelyn's Diary*, Philip Francis (ed.) (London, 1963), 127. In fact, Cambridge and seventy years since.

[79] Thirsk, 'Knitting and Knitware', 579.

[80] Some frames may have been used for worsted stockings although the majority appear to have been used to knit silk stockings. Thirsk, 'Knitting and Knitware', 596; S. D. Chapman, 'The Genesis of the British Hosiery Industry 1600–1750', *Textile History*, 3 (1972), 8; Earle, *The Making of the English Middle Class*, 20.

[81] TNA, PROB4/3306, Richard Austin 1665: equipment £34, total sum £50.

[82] TNA, PROB4/7878, George East 1688: frames £91, total sum £264.

[83] Stocking frames varied in size; Thomas Carter who was sued for debt in the Mayor's Court owned three frames all 'very defective & want recrewting', including one 13 ins in breadth valued at £8 and another 10½ ins at £6, LMA, MC1/197A.82, Thomas Carter 1680.

[84] OCInv. 2858, Thomas Page 1708: 2590 pairs of stockings, 51¾ lbs silk, 'silk in workmens hands' 95 lb 4 oz at 18s/lb.

three factors: the quality of the silk, the weight of silk per pair, and their colour. They typically cost between 5s and 10s per pair. The finest silk stockings were more expensive; the fashionable tailor William Watts charged the king 20s per pair for black silk stockings and the Duke of Buckingham (1628–87) 14s for pearl-coloured ones. The hosier Charles Rich similarly charged 14s for a pair of 'Rich scarlett silk hose' for the page of the Duke of Monmouth (1649–85).[85]

Stockings, like other items of clothing, were subject to the 'fantastical folly of fashion'; in 1595, Philip Stubbes wrote of women's stockings of 'wanton light colours, green, red, white, russet, tawny [...], cunningly knit and curiously indented in every point with quirks, clocks, open seam and everything else'. He described the most outrageous examples that 'no sober chaste Christian can hardly, without suspicion of lightness, at any time wear'.[86] In 1669, Pepys bought Cousin Turner, for her valentine, 'a pair of green silk stockings and garters and shoe-strings'; presumably of the same or toning colours. About this time, the Duke of York, the future King James II (r. 1685–89), was reported to have said 'there was no hope for a leg unless it was clothed in green'.[87] In Paris, stockings had more exotic labels although, at this remove, it is impossible to put a colour to a name: perhaps the Duke had in mind 'Amorous desire' or 'Mortal Sin' rather than 'Sad Friend' or 'Lost Time'.[88]

Colour choice was equally important for men. In February 1682, Jacob Turner shipped a parcel of silk hose to Cadiz consisting of eight colours: 46 per cent being 'Cloth colours', 22 per cent 'Isabella' and 14 per cent 'Pearl'. The next year, a larger parcel contained eighteen different colours with just 11 per cent 'Cloth colours', 13 per cent 'Pearl' but 35 per cent 'Pink'.[89] Clearly the most fashionable blades in Mexico City in 1684 sported pink, London-made silk stockings. Nevertheless, in 1688 William and Francis Hall, factors in Jamaica who supplied the Spanish market, asked Thomas Brailsford 'to send blue, purple, and scarlet hose which were in high demand but [...] to avoid [...] carnation-coloured hose which were out of vogue'.[90]

[85] TNA, C113/31, Tailors' bills, Part 1, 18 Feb. 1671–2, 10 Feb 1667–8: Part 6, 24 Mar. 1673–4.

[86] Joan Thirsk, 'The Fantastical Folly of Fashion; the English Stocking Knitting Industry, 1500–1700', in N. B. Harte and K. G. Ponting (eds.), *Textile History and Economic History* (Manchester, 1973), 58.

[87] *The Diary of Samuel Pepys*, ix: 449 and fn. 1.

[88] Chapman, 'The Genesis of the British Hosiery Industry', 9.

[89] 'Isabella' was between off-white and light tan. TNA, C104/44 Pt.1. 1677, Invoice Book, 24 Feb. 1681–2, 630 pairs, 15 Dec. 1683, 3690 pairs.

[90] Nuala Zahedieh, 'London and the Colonial Consumer in the Late Seventeenth Century', *Economic History Review*, 47/2 (1994), 257.

As in the production of lace and mixed fabrics, growth in stocking manufacture was signalled by the appearance of specialist equipment and artisans: frames for packing stockings as well as stocking dyers (Table 7.1).[91]

THE INVOLVEMENT OF MERCHANTS IN MANUFACTURE

The Levant Company only admitted 'mere merchants', thereby excluding retailers, manufacturers and artisans; prospective entrants were carefully scrutinised, 'weeding out those who had no firm proof that they had given up their old business'.[92] It is ironic; therefore, that two of its leading members, Jacob Turner and merchant and political economist Sir Dudley North (1641–91), should form partnerships to manufacture silk ribbons, mixed fabrics, and silk stockings which they then exported to the Iberian peninsula.

In 1681, Turner recorded two payments for 'Weaving Engines', presumably Dutch looms which he bought for the use of narrow weavers to whom he provided silk in exchange for ribbons. 'William White, weaver in Monmouth Street', for example, was given 'Bolonia silk 56lb 8oz at 18s to be paid in workmanship of ribbons' and was subsequently paid £57 1s for 'weaving, winding & Dying silk'.[93] Contracts were also let to several broad weavers, providing the raw materials of thrown silk and grogram yarn 'to worke out' as 'Camblettes' or 'Silke Mohayres'. Charles Cassell and Peter Snee produced hair camlets; John Meere and Peter Carpenter wove silk mohairs; while Thomas Knight in Vine Court, Spitalfields, made both fabrics.[94] The hair camlets appear to have had warps of Italian organzine silk with wefts of grogram yarn of the better 'Angora' quality; for example, in July 1684, Knight was provided with 'Naples' silk and grogram yarn and was paid 1s 10d per yard for 'Winding, Weaving, Dying, Callendring & Boyling' of seven pieces.[95] He was also supplied with the same quality grogram yarn together with cheaper 'Legee' silk to weave silk mohair for which he was paid

[91] OCInv. 2045, Thomas Cawcutt 1686, hotpresser, owned 'a packing press, skrew and a frame for packing stockings'. OCInv. 1869, Henry Fendall 1689, owed Mr Hauton for stocking pressing £3 9s 8d.

[92] Brenner, *Merchants and Revolution*, 87.

[93] TNA, C104/44 Pt.1. 1677, Waste book, 5*. Note that the numbering starts anew in Jan. 1685–86. 30 Mar. 1686; 14*, 16 Feb. 1686–7.

[94] TNA, C104/44 Pt.1. 1677, Invoice Book, 140, 14 Oct. 1682. Meere was one of a number of weavers who moved from Canterbury to London at about this time, being noted in 1682 in Brick Lane (probably the Brick Lane in Spitalfields rather than that off Old Street). Previously John Meere of Canterbury had bought from Turner both 'Begbezar' grogram yarn and 'Smirna Orsoy' silk, 53, 31 May 1679; 109, 23 April 1681.

[95] TNA, C104/44 Pt.1. 1677, Waste Book, 175, Naples silk 26s 8d/lb; grogram yarn 4s 6d/lb; 7 pieces 307¾yds. Legee silk 18s/lb.

at the lower rate of 1s 2d per yard. The weaving structures were not described although the proportion of hair to silk was higher for camlet, which was generally more expensive than mohair, valued at about 5s per yard with mohair at about 3s 2d per yard.[96]

Turner also organised the production of silk stockings, employing a variety of subcontractors for throwing, dyeing, knitting, finishing, and packing. On 26 May 1685, he contracted:

> Thomas Drake Silke Stocking Trimmer to deliver him 300li [lb] Antioch silke thrown into Tram at 14s/li to be paid in Silke Stockings of 2¼ oz/pr at 4s 9d/pr – the silke to be delivered in 3 months and all the stockings received in 6 months.

On 12 June, Drake was given a further 300 pounds, 'to be paid in silke stockings [...] answerable to [the] former contract'.[97] This was a considerable undertaking as some 4200 pairs of stockings were needed in three months. As a framework knitter could make two or three pairs a week, Drake would have had to employ subcontractors with at least 110 frames.[98] Turner also had a contract jointly with the throwster Nathaniel Crabb and the stocking trimmer William Moody in which bales of silk were to be 'paid' in stockings at specified dates and a similar arrangement with another duo of Mathias Mellish and William Bennett. A simpler contract was made with the throwster, Barton Holyday, who was given two bales of Aleppo silk, '319 lb at 16s per lb to be paid in stockings at 6s 8d per pair'.[99]

Most of the production was of men's stockings woven, not with Persian silk but 'white' or 'Ottomam silk': 'Antoch', 'Aleppo' or 'Scio Tram'. A typical pair weighed 2¼ oz, valued at 5s 4d. A minority were of black hose woven with more expensive silk – 'Messina' or 'Scio Orsoy' – those of 4½ oz being valued at 9s 6d per pair. Black stockings were dyed and glazed after they had been woven but the others were woven of dyed silk thread. William Bennett was paid 10d per pound for dyeing silk in ordinary colours but 3s per pound for pink, dyed 'in the grain' with cochineal.[100]

[96] TNA, C104/44 Pt.1. 1677, Invoice Book, 164, 20 Dec. 1683, Voyage to Cadiz.

[97] TNA, C104/44 Pt.1. 1677, Waste Book, 190, 191.

[98] Chapman, 'The Genesis of the British Hosiery Industry', 11.

[99] TNA, C104/44 Pt.1. 1677, Waste Book, 5*.

[100] TNA, C104/44 Pt.1. 1677, Waste Book, 14*, 17 Feb. 1686–7. Turner's Cadiz factor recorded against a 'voyage to Mexico, Cutcheneal [cochineal] bought in the West Indies in barter for ribbons & silk stockings'.

The partnership of the merchants Thomas and James Brailsford also produced stockings on a considerable scale. At his death in 1678, James had large stocks of raw and dyed silk, stockings, and thrown silk in the hands of 41 framework knitters. Clearly, rather than using a stocking trimmer, he organised the whole process himself as he left debts to the throwster, Thomas Colborne, and to the silk dyers, William Greene, and Thomas George.[101]

Most of Turner's silk stockings were sent initially to James Richards, his factor at Cadiz, with more than 6,500 pairs valued at some £2,000 being exported in both 1682 and 1683.[102] From 1680, the two great convoys, the *flota* and the *galleones* which had previously assembled at Seville, left from the Bay of Cadiz for New Spain in the Americas. It seems that in 1678 the Brailsfords also sent their stockings via this traditional route as they were owed nearly £9,000 by English merchants in Cadiz, across the bay at Port Santa Maria and at Seville.[103] Some stockings may have been destined for Brazil, for the Brailsfords were also owed more than £2,000 by factors in Lisbon. Subsequently, William and Francis Hall established their trade at Port Royal in Jamaica to act for themselves and a number of English merchants including their uncle, Thomas Brailsford. In 1690, Thomas Knight, Brailsford's factor at Cadiz, also moved to Jamaica. From this period, clandestine Spanish trade through Jamaica grew with a resulting decline in English trade through Cadiz.[104] As early as 1675, 'Peter Beckford a Port Royal merchant reckoned that the direct route using the Caribbean entrepôt reduced shipping and freight charges to half what they were by the traditional roundabout route through Old Spain'.[105] Turner sent a parcel of 224 pairs of stockings directly to Jamaica in 1683; at 6s and 8s a pair they were more expensive than many of those sent to Cadiz and may have been intended to satisfy demand in Port Royal rather than in Mexico. The town was renowned for conspicuous consumption: 'a cooper's wife shall go forth in the best flowered silk and in the best silver and gold lace that England can afford' and the gentry and merchant elite live 'in the height of splendour in full ease and plenty being sumptuous arrayed'.[106]

[101] OCInv. 1337, James Brailsford 1678. Stocks: 927 lb raw and dyed silk at £820; 2339 pair silk stockings at £820. Silk in the hands of forty-one knitters valued at £441. Owed Colborne £366 in partnership; Greene £71 and George £91 solely.

[102] TNA, C104/44 Pt.1. 1677, Invoice Book.

[103] El Puerto Santa Maria was also known to English merchants as Port St Mary.

[104] Nuala Zahedieh, 'The Merchants of Port Royal, Jamaica, and the Spanish Contraband Trade, 1655–92', *William and Mary Quarterly*, 3rd series, 43/3 (1986), 573, 593.

[105] Beckford was the father of the future governor of Jamaica, *ibid.*, 587.

[106] *Ibid.*, 253.

SALES OF BROAD AND NARROW SILK WARES

Broad silks and mixed fabrics, together with some worsted and woollen fabrics such as serge and shalloon, were sold by mercers in Cheapside and elsewhere in the City although some retailers followed the movement of gentry housing to the west and establishing their trade in Fleet Street or the Strand. Some drove a considerable trade: at his death in 1675, Robert Williams in Gracechurch Street had stock valued at £3,560, comprised of eleven different silks with quantities of tabby, lustring, and sarcenet; eight mixed fabrics of silk with hair or worsted, notably ferrandine, camlet and mohair; and thirteen worsted and woollen fabrics. He had invested in leasehold property and shipping and lived in style with a coach and horses. Unfortunately he had overreached himself, for he was apparently insolvent at his death, leaving a total sum of some £17,400 but net debts of nearly £24,000.[107]

At about the same time, John Rawlinson's stock had a similar profile: thirteen different silks; fifteen mixed silk with hair or worsted; and twelve worsted and woollen fabrics. His more expensive silks were imported and included Genoese and Dutch velvets, and Florentine and French satins.[108] Early in the next century, Neville Leman in partnership with Nathaniel Cooper in Fleet Street had trade goods valued at £5,900. Like those of Williams and Rawlinson, their trade goods were comprised of silks, mixed fabrics, and some worsteds and woollens. Their holdings of silk, however, were quite different for they had extensive stocks of 'rich gold and silver brocades' together with damasks and velvets: their silks representing 56 per cent of the parcels in number but 82 per cent by value.[109] Leman catered for the top of the market but Nathaniel and John Houlton, who also had an extensive trade, sold ribbons, laces, buttons, and sewing silk as well as silks and mixed fabrics. The numbers of their creditors illustrated the breadth of the business and the skill necessary to succeed in such a venture: there were 45 suppliers, including nine each for silks, mixed fabrics, and narrow wares, seven for buttons and twelve sub-contractors for dyeing, pressing, and calendaring.[110]

Ribbons found a number of outlets. Some were sold by ribbon weavers such as Stephen Procter, who had a workshop and warehouse in Barge Yard off Bucklersbury; which was near his shop on the Royal Exchange. At his death in 1680, Procter had a number of trade debtors, supplied through his warehouse,

[107] OCInv. 1302, Robert Williams 1675.

[108] OCInv. 1754, John Rawlinson 1681. Although the silks were 40 per cent by number of his 134 parcels, they represented 51 per cent by value. Trade goods £2,776, total sum £7,647, debts owed to £8,554; debts owed by £1,495.

[109] OCInv. 2417, Neville Leman 1702.

[110] OCInv. 2419, Nathaniel Houlton 1701.

and many women debtors who had purchased ribbons, laces and trimmings on the Exchange, including the wives of the city elite and the nobility.[111] Other ribbon weavers sold their wares largely to lacemen. On his death in 1675, Thomas Newman was owed £754 by John Aylworth, a laceman in Cheapside.[112] Aylworth died the next year and his inventory records a debt to Susanna Newman and another to the ribbon weaver Daniel Neal.[113] In 1673, Aylworth had owed the lace weaver William Richardson some £200, presumably for galloon lace.[114] Lacemen like Aylworth as well as Nicholas Wildbore and William Kirwood in Lombard Street all had stocks valued in excess of £1,000 although the celebrated coterie in Paternoster Row seems to have carried less.[115] Campbell wrote that,

> A Lace-man must have a well lined pocket to furnish his Shop [...] His chief Talent ought to lie in a nice taste in Patterns of Lace. He ought to speak fluently [...] to entertain the Ladies; and to be the Master of a handsome Bow and Cringe; should be able to hand a Lady to and from her Coach politely, without being seized with the Palpitation of the Heart at the Touch of a delicate Hand, a well-turned and much exposed Limb, or a handsome Face.[116]

It appears that a sizeable proportion of the silk stockings knitted in London were exported, mostly to the Iberian peninsula, bound principally for Mexico or Brazil. Apart from the trade of Turner and the Brailsfords, Thomas Davitts and Henry Fendall also exported quantities of hose. Davitts apparently originally worked as a throwster but at his death in 1678 was shipping stockings to factors in the Bay of Cadiz and importing sherry and Canary wine.[117] In 1681, Fendall had stocks of several types of stockings and nineteen 'adventures sent to sea'. One of these, 'of silk, thread, cotton and worsted hose and gloves', was dispatched to 'Mr Newham & Clark' who may be identified with the Lisbon factors, Leonard Newham and John Clarke to whom William Jennings had sent quantities of gold

[111] Lady Lethieullier owed 28s and the Duchess of Buckingham some £83. OCInv. 1545, Stephen Procter 1680.

[112] OCInv. 1112, Thomas Newman 1675.

[113] OCInv. 1268, John Aylworth. Susanna Newman was owed £706 and Daniel Neal £168.

[114] OCInv. 888, William Richardson 1673.

[115] OCInv. 308, Nicholas Wildbore 1664; OCInv. 1388, William Kirwood 1676. For Paternoster Row see, OCInv. 905, Edward Ringe 1673; OCInv. 950, Richard Bolt 1674, OCInv. 1465, Edmund Lewis 1678.

[116] R. Campbell, *The London Tradesman* ([London 1747] facsimile ed. 1969), 147.

[117] OCInv. 1367 and 1584, inv and account, Thomas Davitts 1678 and 1680. He had three 'old Throwing Mills and materials belonging to the trade' in his workshop. Hose valued at £483, wine £653, he was owed £837 by factors in Cadiz and Port St Mary. His executors included payments in their accounts in 1680 to Anthony Betts, stocking trimmer, and Will Clarke, stocking maker.

and silver lace some years earlier.[118] For London customers, there were specialist hosiers such as George Calcott in the Strand who sold silk stockings and other knitted silk wares 'as wascoates, drawers, Trowsers and Gloves' as well as worsted and woollen hose, and cotton and thread goods.[119]

Stockings, ribbons and lace were all found among the goods sold in the small but fashionable shops in both the Royal and the New Exchange. Count Magalotti (1637–1712), who accompanied the future Grand Duke of Tuscany, Cosimo III (r. 1670–1723) to London in 1669, described the New Exchange in the Strand:

> Two long and double galleries, one above the other, in which are [...] great numbers of very rich shops of drapers and mercers, filled with goods of every kind, and with manufactures of the most beautiful description. These are, for the most part, under the care of well-dressed women, who are busily employed in work; although many are served by young men, called apprentices.[120]

Samuel Pepys was even more struck by the 'exchangewomen', describing the beauty who sold him a pair of cotton stockings as 'one of the prettiest and most modest-looked woman that ever I did see'.[121]

The curmudgeonly Frenchman Samuel Sorbière (1615–70) also visited the New Exchange in 1663, but claimed that 'the Old-Exchange [Royal Exchange] with its Four Galleries only, claims the Preference before it, and these Galleries are Built over the Place where the Merchants meet'.[122] A perception of the romance of overseas trade and its exotic merchandise was reflected in the engraving of the Royal Exchange by Wencelaus Hollar (1607–77) of 1644. Within the title cartouche is a list of its treasures; 'Arabian odurs, Silkes from *SERES* heere, Pearles, Sables, Fine linen, Jewels'.[123]

[118] OCInv. 1869, Henry Fendall 1681. OCInv. 1183, 1645 and 1782, inv. and accounts, 1676 etc., William Jennings, 1681 account, valued at £543 13s 4d. Jennings was an overseas merchant who seems to have been involved in the manufacture of gold and silver lace as, apart from his exports of lace, he held stocks of gold and silver wire and silk thread valued at £368.

[119] OCInv. 1790, George Calcott 1680.

[120] Count Lorenzo Magalotti, *Travels of Cosmo the Third, Grand Duke of Tuscany, through England, during the Reign of King Charles the Second* (London, 1821), 295.

[121] *The Diary of Samuel Pepys*, vol. 6, 73, 4 Apr. 1665.

[122] Mons. [Samuel] Sorbière, *A Voyage to England* ([Epistle Dedicatory, Paris, 12 Dec 1663] London, 1709), 14.

[123] Graham Parry, *Hollar's England a Mid-Seventeenth-Century View* (Salisbury, 1980), plate 51.

CONCLUSION

The emergence of Spitalfields as a celebrated centre for the production of fashionable patterned silks in the early eighteenth century has tended to obscure the importance of silk dress accessories not only to the economy of London but also in the perceptions of its citizens. In the middle of the seventeenth century, Robert Herrick (1591–1674) wrote,

> Ribbands, Roses, Rings
> Gloves, Garters, Stockings, Shooes and Strings
> Of Winning Colours shall move
> Others to Lust but me to Love.[124]

The economic necessities of trade and employment, heightened by the Plague of 1665 and the Great Fire a year later, overcame lingering moral objections to luxury and conspicuous consumption – still being voiced in the middle of the century – to the benefit of the silk manufactures in the city. Unfortunately, surviving documents do not enable a statistical analysis to be made, either of the size of particular sectors within the silk trades or of the proportion of raw silk imports they utilised. Although broad silks, particularly taffeta, satin, and sarcenet, were woven in some quantity, it seems the production of ribbons, lace, passementerie, mixed fabrics, and silk stockings used the bulk of raw silk imports between 1660 and 1690.

There were a number of innovations in both product and process: in the types of fabrics woven; in the development of the stocking frame and English calendar; the adoption of the Dutch ribbon loom and attempts to improve the throwing of silk. Immigrants were instrumental in introducing some of these innovations and arrangements made for their formal association with the Weavers' Company must have helped in this regard. It also provided a conduit for the transfer of skill to native craftsmen and reflected the expansion of silk weaving in the city. In contrast, other companies in trades without significant growth were fierce in their opposition to the strangers.[125] The involvement of 'mere merchants' in manufacture marks a cultural shift possibly driven by the demands of a fickle, fashionable market. Levant merchants were very aware of its foibles for their cloth exports had three distinct markets: Turkey, Persia, and the Greek Islands,

[124] Cit. in Ribeiro, *Fashion and Fiction*, 133.

[125] See David M. Mitchell, "'It Will Be Easy To Make Money". Merchant Strangers in London, 1550–1680', in C. Lesger and L. Noordegraaf (eds.), *Entrepreneurs and Entrepreneurship in Early Modern Times. Merchants and Industrialists within the Orbit of the Dutch Staple Market* (The Hague, 1995), 119–45.

each with quite different requirements as to colour and finish. Thus trouble at the Ottoman court, revolts on the caravan route to Persia, or a poor crop of currants in the Islands could dramatically alter the nature of demand.[126] Similar considerations presumably applied to the markets in Mexico and Brazil for ribbons, stockings, and silk mohair.

A notable feature of English manufacture, in stark contrast to France, was a concentration on middling quality at middling prices; doubtless in response to the market at home as well as overseas. In view of the earlier heated debates and efforts to impose sumptuary legislation, the comment of the French author of *A Character of England* of 1659 is instructive,

> it is not an easy matter to distinguish the *Ladie* from the *Chamber maid*; Servants being suffered in this brave Country to go clad like their Mistrisses, a thing neither decent, nor permitted in France, where they may wear neither *Lace*, nor *Silke*.[127]

[126] The need for a quick response to changing demand was probably the main reason for the growth of dyeing and cloth finishing in London at this period although the cloth was woven in provincial centres. See David Mitchell, 'Levantine Demand and the London Textile Trades, 1650–1730', *CIETA Bulletin*, 80 (2003), 49–59.

[127] Anonymous, *A Character of England. As It Was Lately Presented in a Letter, to a Noble Man of France* (London, 1659), 43.

APPENDIX: INVENTORY REFERENCES

(LMA Orphans Court unless indicated otherwise; MC is LMA, Mayor's Court; TNA is the National Archives)

Surname	FName	Year	Comp.	Trade	Ref.
Allen	John	1673	Merch. Taylor	Upholsterer	815
Austin	Richard	1665	Painter Stainer	Framework Knitter	TNA, PROB4/3306
Aylworth	John	1676	Leatherseller	Haberdasher	1268
Barkstead	John	1694	Mercer	Overseas Merchant	2260
Bates	Thomas	1706	Silk Thrower	Silk Thrower	2798
Bilden	George	1673	Blacksmith	Upholsterer	895
Bolt	Richard	1674	Grocer	Laceman	950
Bosworth	William	1673	Clothworker	Calenderer	853
Boylston	Richard	1674	Clothworker	Packer & Cloth Merch.	1092
Brailsford	James	1678	Haberdasher	Overseas Merchant	1337
Browne	Francis	1673	Mercer	Laceman	913
Bruce	Thomas	1672	Draper	Laceman	106
Bucknell	Emmanuel	1703	Weaver	Ribbon Weaver	2560
Calcott	George	1680	Haberdasher	Haberdasher	1790
Campion	Robert	1678	Carman	Carman	1337
Carter	John	1670	Weaver	Ribbon Weaver	626
Carter	Thomas	1680	Fram. Knitter	Framework Knitter	MC, 1/197A.82
Case	William	1681	Clothworker	Calenderer	1693
Catlin	Jonathan	1678	Merch. Taylor	Ribbon Weaver	1429
Cawcutt	Thomas	1686	Clothworker	Clothworker	2045
Clay	Richard	1674	Draper	Silkman	965
Cole	Thomas	1667	Painter Stainer	Mercer	301
Cooper	John	1665	Ironmonger	Ribbon Weaver	747
Coote	Edward	1673	Leatherseller	Haberdasher	889
Daniel	John	1689	Unknown	Packer	2106
Davitts	Thomas	1678	Merch. Taylor	Stocking Trimmer?	1367 & 1584
East	George	1668	Fram. Knitter	Framework Knitter	TNA, PROB4/7878

Surname	FName	Year	Comp.	Trade	Ref.
Ewens	John	1673	Vintner	Mercer	931
Fendall	Henry	1681	Cutler	Stocking Trimmer?	1869
Hardy	William	1673	Apothecary	Apoth. & Stocking Tr.	840
Hooker	William	1659	Unknown	Ribbon Weaver	MC1/124
Houlton	Nathaniel	1700	Unknown	Mercer	2419
Hudson	Philip	1665	Dyer	Dyer	295
Jennings	William	1676	Weaver	Overseas Merchant	1183,1645 & 1782
Kidder	William	1665	Unknown	Lace Weaver	53
Kirwood	William	1677	Draper	Laceman	1388
Knowles	Charles	1704	Coachmaker	Coachmaker	MC, 1/210.78
Lacon	Anthony	1675	Merch. Taylor	Haberdasher	1140
Leech	Robert	1678	Clothworker	Laceman	1392
Leman	Neville	1702	Dyer	Mercer	2417
Lewis	Edmund	1678	Haberdasher	Laceman	1465
Long	John	1697	Weaver	Lace Weaver	2279
Marriott	Thomas	1665	Weaver	Broad Weaver	306
Moore	John	1670	Merch. Taylor	Mercer [Stuffman]	92
Moore	Thomas	1696	Mercer	Laceman	2237
Neal	Daniel	1685	Weaver	Ribbon Weaver	2037
Newman	Thomas	1675	Leatherseller	Ribbon Weaver	1112
Nicholl	Daniel	1681	Vintner	Silkman	1759
Page	Thomas	1708	Fram. Knitter	Framework Knitter	2858
Parris	William	1681	Draper	Upholsterer	1734
Paulett	William	1666	Haberdasher	Draper	506
Pearce	Abraham	1709	Weaver	Broad Weaver	2906
Pendlebury	Nicholas	1699	Merch. Taylor	Lace Weaver	2364
Phinnis	George	1675	Clothworker	Calenderer	1224
Procter	Stephen	1680	Weaver	Ribbon Weaver	1545
Pyle	William	1677	Weaver	Ribbon Weaver	1544
Rawlinson	John	1681	Haberdasher	Mercer	1754
Richardson	William	1673	Weaver	Lace Weaver	888
Ridges	William	1670	Skinner	Upholsterer	692

Surname	FName	Year	Comp.	Trade	Ref.
Rigbourg	Francis	1619	not applicable	Canterbury Silkweaver	MC, 1/34&35
Ringe	Edward	1673	Merch. Taylor	Laceman	905
Rolfe	John	1701	Merch. Taylor	Lace Weaver?	2382
Russell	Nicholas	1672	Weaver	Lace Weaver	864
Sabin	Joshua	1707	Weaver	Broad Weaver	2779
Southen	Samuel	1665	Vintner	Silkman	803
Spicer	Nicholas	1706	Merch. Taylor	Lace Weaver	2741
Stobart	William	1672	Draper	Levant Merchant	807
Strong	Thomas	1666	Haberdasher	Haberdasher	282
Sumers	Jacob	1665	Clothworker	Broad Weaver	27
Sykes	Samuel	1679	Upholder	Upholsterer	692
Tapsell	Isabel	1679	Widow	Ribbon seller	1428
Tustian	Barak	1670	Weaver	Weaver	605
Waldo	Daniel	1661	Clothworker	Mercer	16
Waldo	Daniel	1661	Clothworker	Mercer	TNA, E154/4/34
Wallis	Ezekiel	1667	Mercer	Silkman	345
Wildbore	Nicholas	1664	Draper	Laceman	308
Williams	Robert	1676	Unknown	Mercer	1302
Wilson	Thomas	1665	Weaver	Lace Weaver	598
Winne	John	1674	Haberdasher	Haberdasher	1060
Young	John	1670	Draper	Upholsterer	671

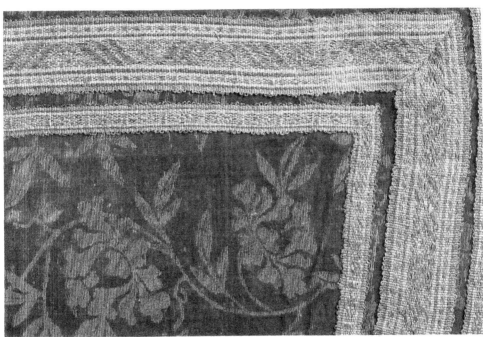

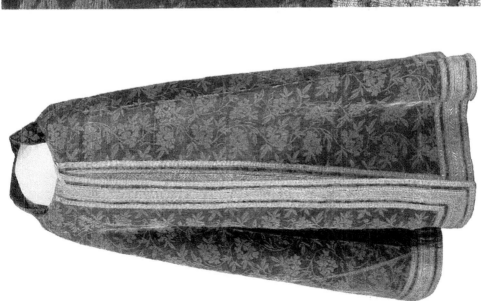

Illustration 2.3 Mantle made of Chinese velvet at the Uesugi Shinto shrine, Yonezawa, Yamagata Prefecture, Japan, dated 1574 (L.: 114.5 cm). Source: Ogasawara Sae (ed.), *Nihon no senshoku* (Japanese Weaving and Dyeing), Vol. 4 *Yokan hakusai no senshoku* (Weaving and Dyeing Imported From Abroad) (Tokyo, Chuo koron sha, 1983), 64–65, Illustration 39 and 40, http://www.nobunaga-lab.com/labo/07_ibutu/07-02_ihin/23_hata/hata.html.

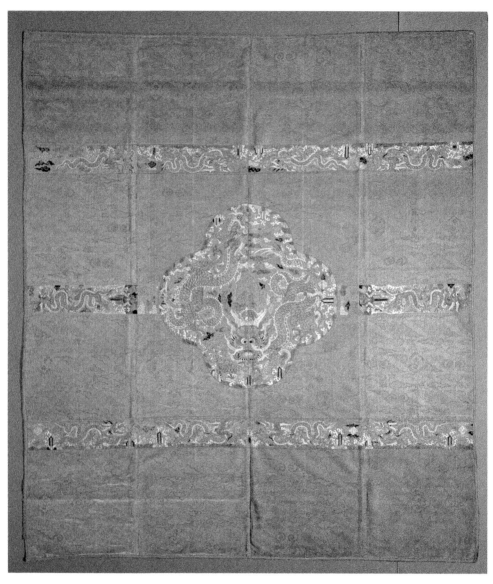

Illustration 2.4 Ming Dragon Robe, solid ciselé, embroidered,
early seventeenth century. From Harold Burnham, *Chinese Velvet*,
Acc. No. 956.67.2 (Toronto, Royal Ontario Museum, 1959), Pl. IV.
Reproduced by permission of the Royal Ontario Museum © ROM.

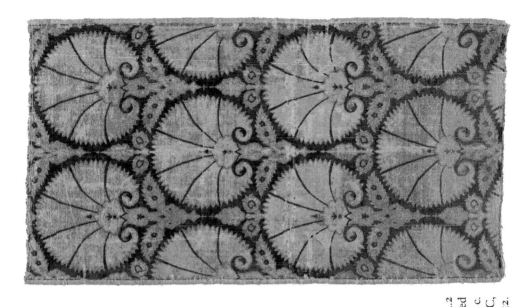

Illustration 4.1
Ottoman voided and brocaded silk velvet (*çatma*) length, c. 1550–70. Victoria & Albert Museum, inv. 145-1891. © Victoria and Albert Museum, London.

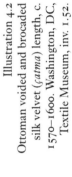

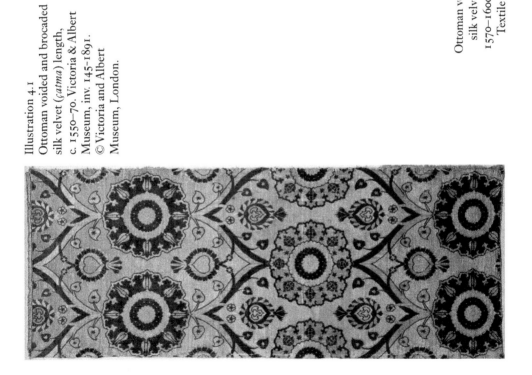

Illustration 4.2
Ottoman voided and brocaded silk velvet (*çatma*) length, c. 1570–1600. Washington, DC, Textile Museum, inv. 1.52.

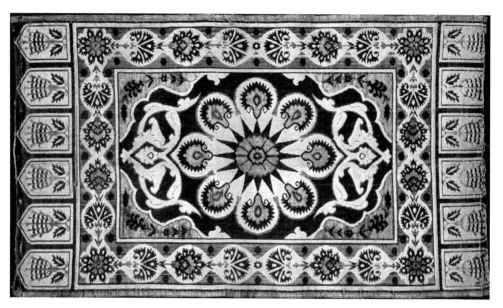

Illustration 4.3 Ottoman voided and brocaded silk velvet (*çatma*) cushion cover, c. 1625–75. Victoria & Albert Museum, inv. 4061-1856. © Victoria and Albert Museum, London.

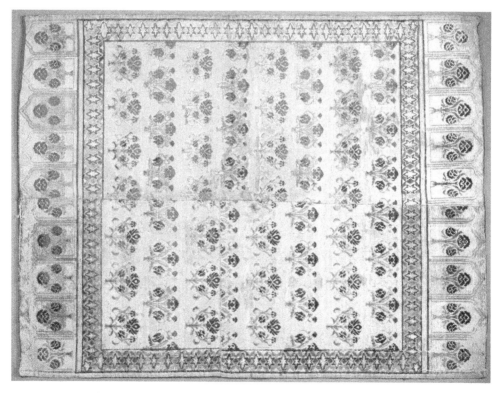

Illustration 4.4 Two Ottoman voided and brocaded silk velvet (*çatma*) cushion covers, sewn together, c. 1720–1750. MAK – Austrian Museum of Applied Arts / Contemporary Art, Vienna, inv. T–5995; photograph: © MAK/Katrin Wißkirchen.

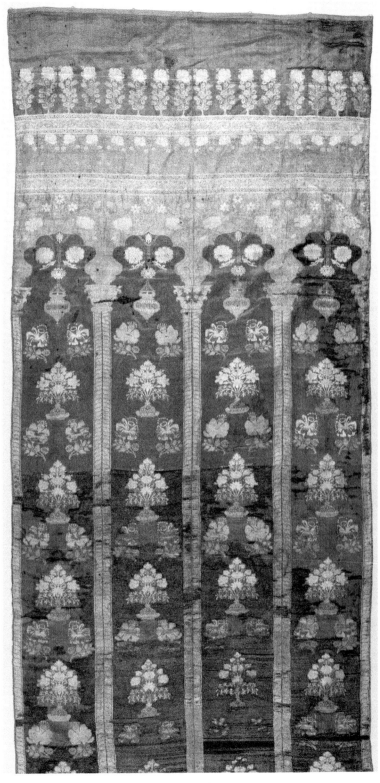

Illustration 5.1 Gold-woven silk fabric. Istanbul, 1550–1575.
Athens, Benaki Museum/Museum of Islamic Art.

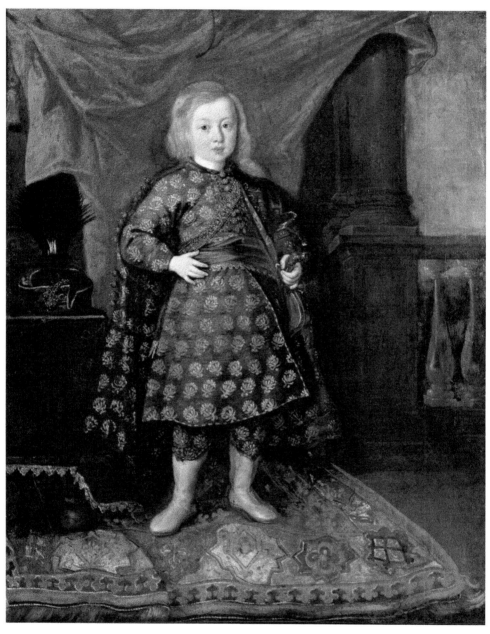

Illustration 5.2 *Prince Sigismund Kasimir of Poland (1640–1647)*,
134 x 98 cm, Vienna, KHM-Museumsverband.

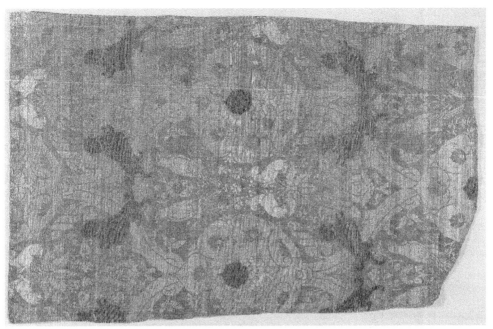

Illustration 6.1
Detail of a fragment of crimson silk damask. Italy, second half of the fifteenth century, 71 x 31.3 cm. London, School of Historical Dress, inv. no. THSD-Text-2015. Photo credit Lisa Monnas.

Illustration 6.2
Fragment of lampas silk, brocaded with gilt membrane wrapped thread, with birds, dogs and rabbits. Italy, first quarter of the fifteenth century, 66 x 43 cm. Riggisberg: Abegg-Stiftung inv. no. 457.

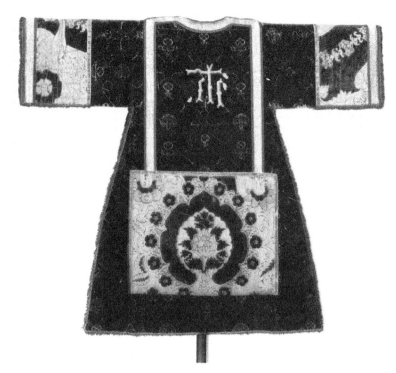

Illustration 6.3 Dalmatic of green voided satin velvet, with apparels of crimson velvet cloth of gold of tissue, and part of an applied embroidered monogram IHR. Italy, second half of the fifteenth century, 118 x 140 cm. Riggisberg: Abegg-Stiftung inv. no. 268.

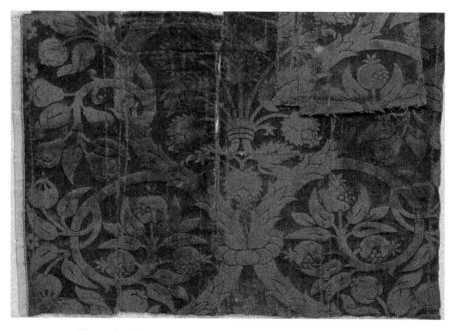

Illustration 6.4 Detail of a composite fragment of crimson *alto e basso* velvet. Possibly Milan, late fifteenth or early sixteenth century. Victoria and Albert Museum, 593-1884. © Victoria and Albert Museum, London.

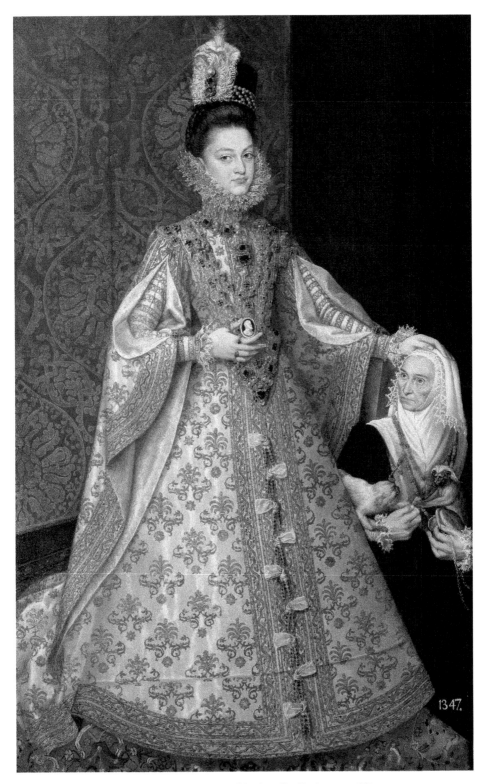

Illustration 6.5 Alonso Sánchez Coello (1531–1588),
Portrait of Isabella Clara Eugenia with Magdalena Ruiz, 1585–1588.
Oil on canvas, 207 x 129 cm. Madrid, Museo del Prado, no. P00861.

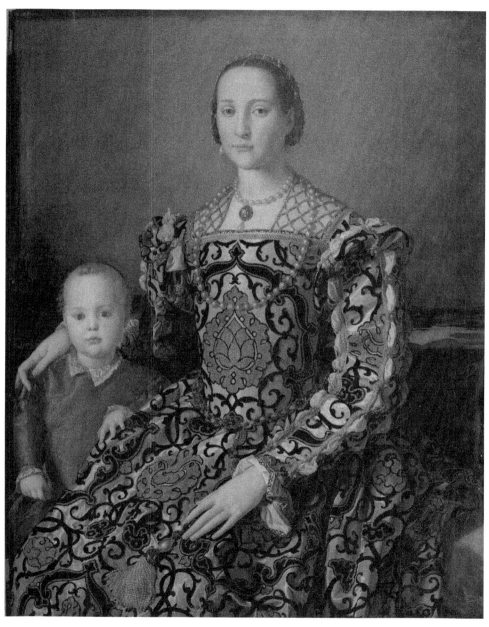

Illustration 6.7 Agnolo Bronzino, *Eleonora di Toledo with her son Giovanni de' Medici*, c. 1545. Oil on panel, 115 x 96 cm. Florence, Uffizi Gallery, no. 748.

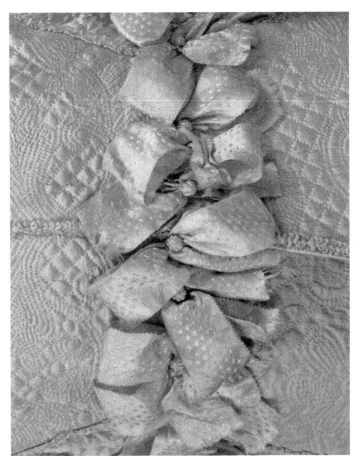

Illustration 7.2 Ivory self-patterned silk 6 penny ribbon (4 cm wide) at the waist of an English doublet, 1635–1640. Victoria and Albert Museum (347–1905). © Victoria and Albert Museum, London.

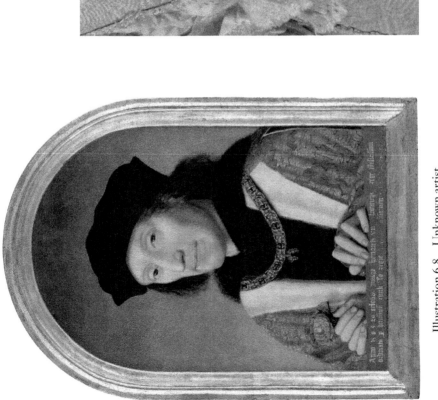

Illustration 6.8 Unknown artist, *Portrait of Henry VII*, dated 1505. Oil on panel, 42.5 x 30.5 cm. National Portrait Gallery (NPG 416). © National Portrait Gallery, London.

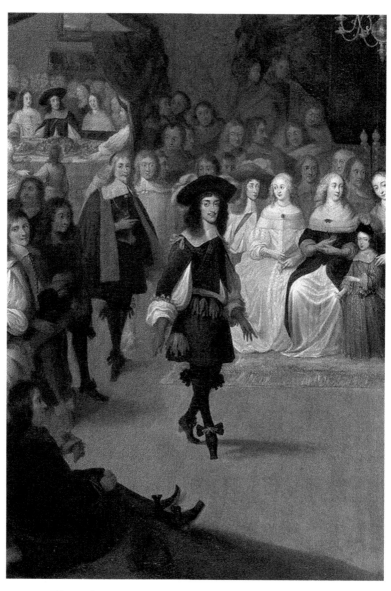

Illustration 7.4 Detail of Charles II dancing at the Hague,
by Hieronymous Janssens, 1660, oil on panel, RCIN 400525,
Royal Collection Trust / © Her Majesty Queen Elizabeth II 2017.

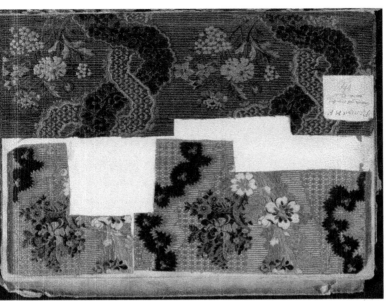

Illustration 8.2 Page from French merchant's sample book showing some complex brocaded patterns for *cannellés broché*, Lyon, c. 1763–1764. Victoria and Albert Museum, no. T.373-1972, f. 25v. Acquired with the help of Marks and Spencer Ltd and the Worshipful Company of Weavers, © Victoria and Albert Museum, London.

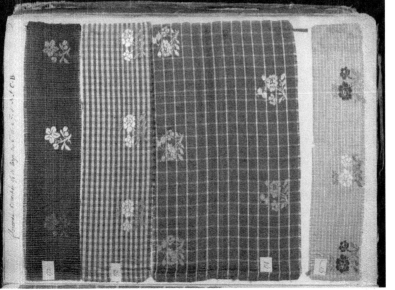

Illustration 8.1 Page from French merchant's sample book showing some simple patterns for *florences brochés*, nos. 172–175. Lyon, c. 1763–1764. Victoria and Albert Museum, no. T.373-1972, f. 9v. Acquired with the help of Marks and Spencer Ltd and the Worshipful Company of Weavers, © Victoria and Albert Museum, London.

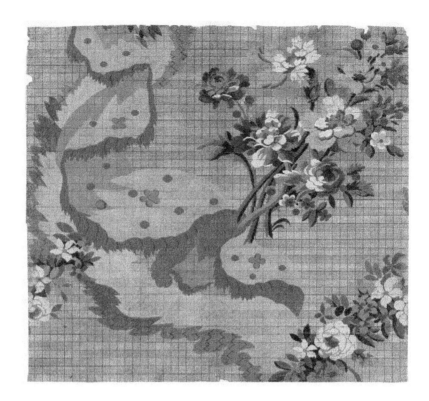

Illustrations 8.7 and 8.8 *Mise-en-carte* (recto and verso) for a *gros de tours en dorures et nuences*, probably by Daniel Symiand, for L. Galy, Gallien et cie., No. 850, dated 8 July 1763. Gouache and ink on engraving. 48 x 51.8 cm. © Victoria and Albert Museum, London, no. T.413-1972.

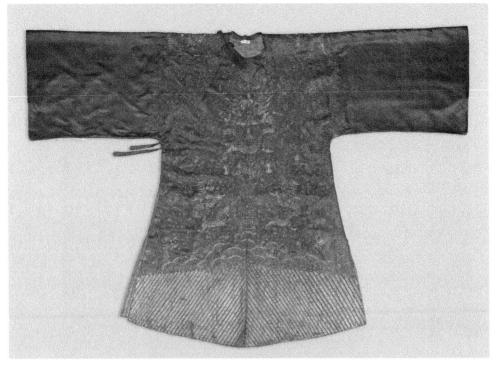

Illustration 9.1 Red satin tunic embroidered with gold and Chinese dragons, Qing Dynasty, between 1726 and 1800. Museo Nacional de Artes Decorativas. Photo credit: Masú del Amo Rodríguez, Museo Nacional de Artes Decorativas, Madrid.

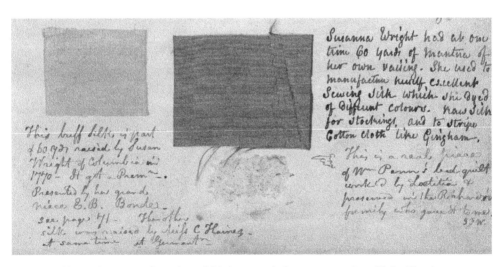

Illustration 10.2 Swatches of fabric appended to a manuscript of John Fanning Watson, 'Extra-Illustrated Autograph Manuscript of "Annals of Philadelphia," Germantown, 1823' Library Company of Philadelphia. LCP Print Room: *Annals of Philadelphia*, John F. Watson, Yi 2 / 1069.F., Box 1.

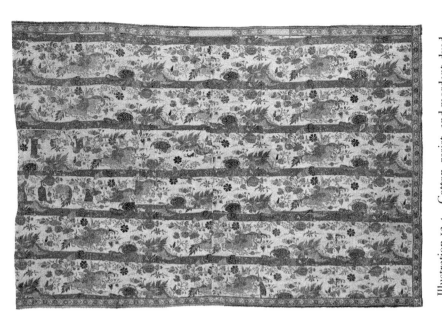

Illustration 13.4 Cotton, resist- and mordant-dyed dress or furnishing fabric. Produced on the Coromandel Coast, India, c. 1715–1725.
© Victoria and Albert Museum, London, 342 to B-1898.

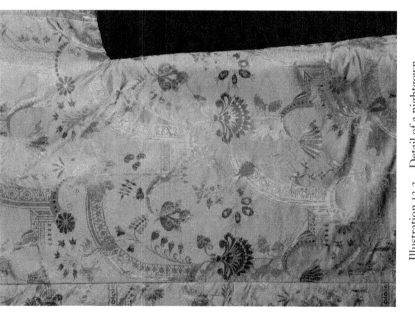

Illustration 13.3 Detail of a nightgown. Silk satin, interlined with wool, and lined with silk. Produced in Spitalfields, London. Woven in 1707–1708 and made into a garment in 1707–1720.
© Victoria and Albert Museum, London, no. T.281-1983.

PART III

Global Exchange

8.

From Design Studio to Marketplace: Products, Agents, and Methods of Distribution in the Lyons Silk Manufactures, 1660–1789

Lesley Ellis Miller

On 11 April 1764, the Court Book of the London Weavers Company, containing the minutes of the court's sessions, recorded:

> a very valuable seizure […] of a very large *porte feuille* or book of patterns of French silks of all sorts to the amount of several thousands from 3/6 and 5/– per yard and upwards consisting of gold and silver brocades, silver tissues, flowered velvets, Peruvians, lutestrings, clouded and plain of all sorts and colours, grosgrams, serges, tissues, painted sarcenets and satins, etc.[1]

The court decided to publish a short account of this seizure and duly drafted a paragraph for the *Daily Advertiser* and *Gazetteer*.[2] Subsequently, and significantly, a report in the *London Chronicle* on the seizure deemed only certain silks worthy of commentary – those with patterns, all of which cost over five shillings per yard.[3] Also significant was the hope expressed that these patterns (silks) would 'be preserved for the benefit of our silk manufacturers'.[4]

[1] Guildhall Library, London, ms 4655/16, Court minutes of the London Weavers Company, Wednesday, 11 April 1764, f. 340. The sums per yard are 3 shillings and 6 pence, and 5 shillings, respectively. The sample book is now housed in the Victoria and Albert Museum, inv. T.373-1972. It is published in full in Lesley Ellis Miller, *Selling Silks. A Merchant's Sample Book of 1764* (London, 2014).

[2] Guildhall Library, ms 4655/16, f. 340.

[3] *London Chronicle*, April 1764. A gown required about 10–20 yards at this time.

[4] Natalie Rothstein, 'The English Market for French Silks', *CIETA Bulletin*, 17/35 (1972), 32–94; Natalie Rothstein, *Silk Designs of the Eighteenth Century* (London, 1990); Miller, *Selling Silks*.

With that intention, the London Weavers Company took steps to make sure that the book did not disappear into oblivion, acquiring it for the sum of £50 from Customs on 27 June 1764. The clerk fetched it, and on 18 July the court set about organising viewings by company members. The book was locked away, the Renter Bailiff, the Clerk, and John Baker (1693–1783), a distinguished weaver of flowered silks, being the only men entrusted with keys. Access was restricted but the court allowed inspection of the book by appointment, from 1 August onwards, twice a week for up to six silk freemen manufacturers of the company at a time. No more is known about how this system worked, whether appointments were made and, if so, by whom and with what results.

No doubt the major slump that hit the French and English trades the following year focused Company (and press) attention on other matters.[5] In that same year, 1765, a Select Committee of the House of Commons was set up to investigate the plight of the English silk industry and to propose remedies.[6] This investigation revealed much about the likely intention behind the saving and showing of the confiscated textile samples. The redoubtable Robert Trott, 'Examiner, Searcher and Stamper of Foreign Silks at the Custom House', who had been responsible for seizing the book, gave evidence.[7]

Two key issues arise from this episode and alert us to the impact of fashion on commercial practices (here, by 'fashion', I mean seasonal changes in the patterns on silks). Months after the end of the Seven Years War (1756–63), French silk merchants had already resumed effective distribution of their silks legally – as well as illegally – to England.[8] Their methods included the very visible means of selling via large and weighty sample books. The annotations on such books

[5] A series of court mournings contributed to a dip in the trade, which was exacerbated by failing harvests. See Bréghot de Lut (ed.), *Le Livre de raison de Jacques-Charles Dutillieu* (Lyons, 1886). Dutillieu comments on these unfavourable circumstances as do correspondents in the bankruptcy papers in the Archives départementales du Rhône (hereafter ADR), and the minutes of the Chambre de Commerce, as well as English testimony.

[6] British Parliamentary Papers (hereafter BPP), *Journal of House of Commons*, vol. 30 (4 March 1765), 208–15.

[7] BPP, 208. He was employed to pursue French silks that had entered the country without paying duty, a challenging task as it was difficult to distinguish between French and Italian silks, especially those of Lyons and Genoa. It was important to do so as the French paid 50 per cent duty in comparison with the 30 per cent paid by the Italians. Trott told the Select Committee that seizures seldom led to a trial. Other witnesses, including the weavers Mr [John] Sabatiere (d. 1780) and John Baker, thought illegal importation of French silks 'very great', the former observing that a number of the French silks he had known were imported as Italian, the latter confirming the 'great Number of Seizures [...] many of which he had been sent for to examine, and found them to be *French*'.

[8] The war may have disrupted the flow temporarily, but did not prevent smuggling.

immediately revealed their origins.[9] This method of circulation contrasted with that of anonymous lengths of silk bearing no distinguishing label that could be imported in the luggage of respectable travellers, as well as through the efforts of smugglers.

Secondly, the London Weavers Company believed that the importation of French silks was detrimental to English manufacturing. They therefore reimbursed the expenses incurred by Customs Officer Robert Trott seizing foreign silks and prosecuting the offending parties. Trott plied his trade in the seaports and in the London mercers' shops, and found his task difficult. French silks were clearly desirable to British consumers (commercial and private) even if the characteristics that made them desirable were rather elusive; there was clearly nothing striking in the physical nature of the silk fabrics that allowed Trott (a non-weaver) to distinguish between products – even if an experienced weaver thought he could do so.[10] Certainly, French silks were often perceived to be 'better' or more fashionable.

From a Lyonnais perspective, offering previews of new patterns on silks several months ahead of their launch on the market was an innovative sales method. It was, however, already causing concern among members of the Silk Weaving Guild (*Grande Fabrique*) and the Chambre de Commerce, who noted that samples provided their competitors with all the information they needed to copy French products: the nature of yarns, the disposition of warp and weft, as well as patterns, in other words much more than a design on paper might indicate.[11] The seizure of the sample book reveals that their fears were justified,

[9] All merchants' sample books from Lyons seem to have had similar dimensions (or that is what the surviving material evidence suggests). They are quite different from the small, pocket-size books that contained the Norwich stuffs being sold to the Spanish market at the same time, as, for example, Victoria and Albert Museum (hereafter V&A) Museum no. 67-1885: worsted sample cards, John Kelly of Norwich, 1763, or the woollen swatches circulated in this way in France. Gérard Gayot, 'Different Uses of Cloth Samples in the Manufactures of Elbeuf, Sedan and Verviers in the Eighteenth Century' (unpublished paper, delivered at 'Textile Sample Books Reassessed: Commerce, Communication and Culture', conference organised by the University of Southampton at Winchester, June 2000).

[10] For silks, the most common form of identification would have been the lead seals attached to the end of a piece of fabric. Once these had been removed, the silk was a truly anonymous product despite its high value as a luxury fabric.

[11] Copying dyestuffs would have been impossible, however. Lesley Ellis Miller, 'Innovation and Industrial Espionage in Eighteenth-Century France: An Investigation of the Selling of Silks through Samples', *Journal of Design History*, 12/3 (1999); Carlo Poni, 'Fashion as Flexible Production: The Strategies of the Lyons Silk Merchants in the Eighteenth Century', in Charles F. Sabel and Jonathan Zeitlin (eds.), *World of Possibilities: Flexibility and Mass Production in Western Industrialization* (Cambridge, 1999), 51, 53–4. Bibliothèque municipale de Lyon (hereafter BML), ms 354461 'Mémoire sur l'envoi des échantillons de la Fabrique de Lyons', 1760; ms 113923 'Arrêt de la Cour de Parlement qui homologue la délibération de la Communauté des maîtres-marchands

for while English manufacturers bewailed the insidious infiltration of French silk samples, they were also happy to benefit from them – and not just via this particular sample book or this isolated event. In the evidence given before the Select Committee, London mercers in particular explained why allowing the legal import of French silks was good for English manufacturers:

> The few *French* Silks which are now imported are more for the Sake of Patterns, for the Improvement of our Manufacture, than any Profit arising thereby. That for every Piece of *French* Silk he imports, he can get the Sight of 100 Patterns at least, upon which the Pattern Drawers here improve.[12]

No doubt this was the fate of the sample book, as London manufacturers made their appointments to view its contents. The sample book that so exercised the London Company of Weavers in 1764 stimulates reflections on how new silk products were created in Lyons, who was responsible for their creation and distribution in and beyond the city, the skills they needed and the methods by which they won their clients (Illustrations 8.1 and 8.2).[13] A key question is the extent to which Lyonnais strategies and actions were innovative and original, spawning new trades with very particular specialisms. This chapter aims to facilitate comparison with other times, places and people, and also to draw attention to how different types of products may have determined courses of action or manufacturing and commercial practices – and may have informed technological experimentation. The cultural background of the practitioners of these new trades is of particular interest. After a brief overview of the existing literature on fashion and Lyonnais silks, the focus shifts to an analysis of the role of design and designers in the manufactures, and from there to the role of sales and salesmen.

et maîtres-ouvriers fabriquans en étoffe d'or, d'argent et de soie de la ville de Lyon … concernant la prohibition de l'envoi des échantillons des mêmes étoffes hors ladite ville, du 14 mai 1765'; ms 113925, 'Arrêt de la cour de parlement qui permet aux syndics-jurés et maîtres gardes de la Communauté des fabriquans en étoffes d'or … d'établir un commis au bureau de la régie de Paris à l'effet de visites et perquisitions des échantillons de leur fabrique, qui pourroient y être envoyés en contravention; et de faire des recherches chez tous les dessinateurs de fabriquans, commis, et autres de la ville de Lyons, logés à Paris et chez tous particuliers soupçonnés de recevoir lesdits échantillons et d'en favoriser l'exportation, etc., du 6 mars, 1766'; Archives de la Chambre de Commerce et d'Industrie de Lyon, Délibérations, 1760–66, ff. 9–15v.

12 BPP, *Journal of House of Commons*, 211: evidence given by William Pickart, mercer.

13 V&A Museum, no. T.373-1972: French merchant's sample book of 1764. On identification of this book, see Rothstein, 'The English Market for French Silks'; Natalie Rothstein, 'L'organisation du commerce des soieries en France et en Angleterre au XVIIIe siècle d'après un livre de commissions Lyonnais conservé au Victoria et Albert Museum de Londres', *Le monde alpin et rhodanien*, 2–3 (1991): *Les filières de la soierie lyonnaise*, 85–92; Miller, *Selling Silks*.

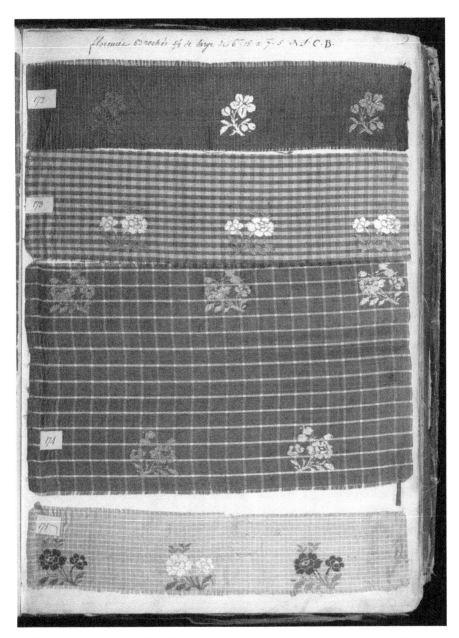

Illustration 8.1 Page from French merchant's sample book showing some simple patterns for *florences brochés*, nos. 172–175. Lyon, c. 1763–1764. Victoria and Albert Museum, no. T.373-1972, f. 9v. Acquired with the help of Marks and Spencer Ltd and the Worshipful Company of Weavers, © Victoria and Albert Museum, London.

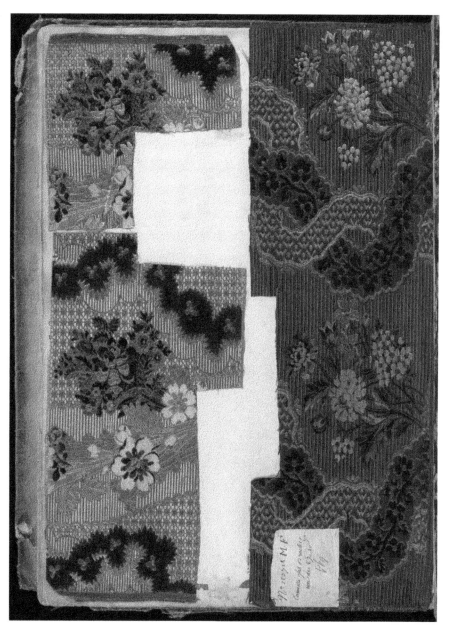

Illustration 8.2 Page from French merchant's sample book showing some complex
brocaded patterns for *cannellé broché*, Lyon, c. 1763–1764. Victoria and Albert
Museum, no. T.373-1972, f. 25v. Acquired with the help of Marks and Spencer Ltd
and the Worshipful Company of Weavers, © Victoria and Albert Museum, London.

HISTORIOGRAPHY

It is not new to draw attention to the prominence of silk manufacturing in Lyons – nor to the role fashion played in figured silk products. Scholars have long identified and analysed regional economic and artistic achievement, and social and industrial structures.[14] The role of fashion in a broader European context and the singularity of Lyons over other centres were notably foregrounded in 1965 in the pioneering publication *Baroque and Rococo Silks* by Peter Thornton.[15] Written from the perspective of a decorative arts historian and museum curator, this book's mission was to create a tool that would allow others to identify and date surviving silks through their patterns. Thornton provided important documentary evidence of the particularities of Lyons relative to other silk weaving centres inside and outside France, pointing out the importance of silk designers in France and their connections with Paris, the marketplace for many of their silks.[16] He dated the advent of an annual design cycle to the end of the seventeenth century.

Subsequently, Carlo Poni, who became aware of Thornton's work towards the end of his own extensive research, discussed the development of the fashion system from the end of the seventeenth century in France and the strategies of Lyonnais silk merchants within the context of economic models. He demonstrated how certain twentieth-century concepts could aid the understanding of the 'formation of the capitalist market and of entrepreneurial strategies', outlining persuasively how changes in fashion 'can best be understood using the concepts of flexible production, monopolistic competition, and barriers to entry'.[17] In the case of Lyonnais silk manufacturing, flexible specialisation was characterised by the coordination of a network of many small workshops equipped with looms, which could produce a variety of fabrics. These fabrics were intended for different consumers – those with the means to acquire fashionable goods on

[14] Justin Godart, *L'ouvrier en soie* (Geneva, [1899] 1976); Etienne Pariset, *Histoire de la fabrique lyonnaise* (Lyons, 1901); Etienne Leroudier, *Les dessinateurs et la soierie lyonnaise au XVIIIe siècle* (Lyons, 1908); Louis Gueneau, *Lyon et le commerce de la soie* (Lyons, 1923); Louis Trenard, *Lyon: De l'Encyclopédie au Préromantisme* (Lyons, 1959); Maurice Garden, *Lyon et les lyonnais au XVIIIe siècle* (Lille, 1970); Jean Peyrot, 'Les techniques du commerce de soies au XVIIIe siècle à travers les documents commerciaux et comptables des fabricants de soieries', *Bulletin du Centre d'Histoire Économique et Sociale de la Région Lyonnaise*, 1 (1973), 29–49; Pierre Cayez, *Métiers Jacquard et Hauts Fourneaux* (Lyons, 1978); André Pelletier, Jacques Rossiaud, Françoise Bayard and Pierre Cayez (eds.), *Histoire de Lyon des origines à nos jours*, 2nd edn (Lyons, 2007).

[15] Peter K. Thornton, *Baroque and Rococo Silks* (London, 1965).

[16] Avignon, Nîmes, Tours and Paris; Amsterdam, Berlin and Vienna, Copenhagen and Stockholm, Florence, Genoa, Naples and Venice, London and Dublin, Talavera de la Reina and Valencia. Thornton, *Baroque and Rococo Silks*, 30–78.

[17] Poni, 'Fashion as Flexible Production', 38.

a regular basis, from the courtier to the upper artisan.[18] The fabrics produced could be adapted to suit demand reasonably easily. The agents of change on whom Poni focused were the powerbrokers – the silk merchants and merchant manufacturers who were already 'integrated into the elites of power and taste' and made strategic decisions about new products. Through analysis of debates and disputes around trade and guild legislation and contemporary economists' commentaries on how the silk trade worked, he noted the emergence of Lyons as the premier centre of silk manufacturing in Europe, the dialogue that producers entered into with consumers in developing a cycle of seasonal fashions, and the repercussions of their decisions – how the acceleration in fashionable change led to sales methods which facilitated copying.[19] He was disappointed not to have discovered exactly when 'Paris fashions made in Lyons' (*modes de Paris faites à Lyon*) began, although his suggested starting point was around 1675.[20]

My own research has run parallel to Poni's exploration. As a design historian, my intention is to explore and evaluate 'fashion design' within the manufacturing process, to chart the emergence of designers as agents in Lyonnais manufacturing success in both domestic and international markets, and to consider the skills and expertise they developed over a life-time in silk manufacturing, and the extent to which they could become 'powerbrokers'. I thus consider whether designing was an end in itself or a stepping-stone to more remunerative and higher status employment. Crucial in this evaluation is a consideration of how and with whom designers negotiated consumer demand.[21] This research, therefore, shifts the emphasis away from the merchant manufacturers who have dominated economic history to date, the weavers who have dominated social history, and the inventors who have dominated the history of technology.[22] Suffice it to say that merchants

[18] Daniel Roche, *The Culture of Clothing. Dress and Fashion in the Ancien Régime* (Cambridge, 1989), especially 67–150.

[19] Lesley Ellis Miller, 'Paris–Lyon–Paris: Dialogue in the Design and Distribution of Patterned Silks in the Eighteenth Century', in Robert Fox and Anthony Turner (eds.), *Luxury Trades and Consumerism in Ancien Régime Paris: Studies in the History of the Skilled Workforce* (Aldershot, 1998), 139–67.

[20] Poni, 'Fashion as Flexible Production', 69–70; John Styles, 'Fashion and Innovation in Early Modern Europe', in Evelyn Welch (ed.), *Fashioning the Early Modern: Dress, Textiles, and Innovation in Europe, 1500–1800* (Oxford, 2017), 33–55.

[21] This research has been based on analysis not only of guild, commercial, parish and notarial archives, but also of surviving examples of material culture, from designs and woven textiles to the sample books used to sell silks. Lesley Ellis Miller, 'Designers in the Lyons Silk Industry, 1712–87' (unpublished Ph.D. thesis, Brighton Polytechnic, 1988).

[22] Recent work by Liliane Hilaire-Pérez and Daryl Hafter has addressed different issues relating to invention, corporate cooperation and gender. Liliane Hilaire-Pérez, *L'Invention technique au siècle des Lumières* (Paris, 2000); Liliane Hilaire-Pérez, 'Inventing in a World of Guilds: Silk Fabrics in Eighteenth-Century Lyon', in Stephan R. Epstein and Maarten Prak (eds.), *Guilds, Innovation, and*

and merchant manufacturers were the men with the capital to acquire the raw materials (silk, metal and designs), have them prepared, and put them out to weavers who were paid piece rates to weave them up. They also managed the distribution of the end product to markets well beyond the boundaries of Lyons and its region. Their relations with designers and salesmen were correspondingly significant.

While dating the advent of the fashion system was not an end in itself, certain indicative dates have emerged from this research while examining the documents relating to the practitioners of two trades that sit on either side of the manufacturing process: designers (before) and salesmen (after), both tellingly referenced in the frontispieces to the volumes of the Silk Weaving Guild's inventory of papers at the end of the century (Illustrations 8.3 and 8.4). Fashion design and new sales methods were inextricably linked, and provided opportunities for men (and women, in the case of design, at least) who might not have had the financial means of merchants or merchant manufacturers, but who were in possession of certain 'cultural capital' that might offer advancement. Both had contact with retailers and other customers, as well as manufacturers, and seem to have worked either freelance or as employees or partners in silk manufacturing partnerships.[23] In 1788, the first city directory for Lyons recorded eighty freelance designers, and fifty-nine freelance *commissionaires* of whom twenty-nine were in partnerships. In the meantime, there were about one hundred major merchant manufacturers (*marchands fabricants*) and sixty merchant bankers (*marchands banquiers*).[24] The chronology of salesmen is not dissimilar to that of designers. While the French Inspector General of the Manufactures for the King at the Paris Customs, Jacques Savary des Bruslons (1657–1716), described several different varieties of salesman (*commissionaires*) in *Le parfait négociant* in 1675, the Lyonnais former manufacturer and city magistrate Jean François Genève (1706–76), with the advantage of hindsight, dated the rise of their *commissionaires* to about 1718, and the associated practice of sending out preview samples of new design ranges to the 1740s.[25]

the European Economy, 1400–1800 (Cambridge, 2008), 232–63; Daryl Hafter, *Women and Work in Pre-industrial France* (Philadelphia, 2007).

[23] It was no coincidence that when the city archivist in Lyons put together the inventory of the papers of the Silk Weaving Guild at the end of the eighteenth century, he commissioned a frontispiece for each of the three volumes to represent the tentacles of the trade: vol. I was devoted to weaving, vol. II to designing, and vol. III to selling.

[24] *Indicateur alphabétique ... de la ville de Lyon pour l'année 1788* (Lyons, 1787).

[25] Miller, 'Innovation and Industrial Espionage'. The first new guild regulations date to 1667. The second decade of the eighteenth century was about fifty years after Louis XIV (1638–1715) and his first minister Jean Baptiste Colbert (1619–83) began to privilege Lyons over other French silk-weaving centres, about forty years after the quality of Lyonnais-made silks seems to have begun to

ARTIS EORUM CONCORDIA NATURAM SUPERAT

Illustrations 8.3 and 8.4 Frontispieces to 'Inventaire des archives de la Grande fabrique de soie, 1536–1785': vol. 2, 'The alliance of their art surpasses nature', and vol. 3, 'As long as extravagance reigns, the manufactures will survive'. Drawings, ink on paper. Courtesy of the Archives Municipales de Lyon.

QUAMDIU REGNABIT LUXUS. TAMDIU
FABRICA SUBSISTET.

The first textual and material evidence dates to this period, too – a partnership contract and designs on paper.[26] Jacques Rigolet (1683–1751), active as a designer in 1714, officially registered as a *marchand fabricant* in 1716, some nineteen years after having begun what was usually a ten-year weaving apprenticeship. He chose to do so when he formed a partnership with two Parisians, merchants who were keen to make use of his design and manufacturing credentials. They provided the capital, while Rigolet promised to apply himself 'as much to designs as to their execution, weavers' work and other ordinary tasks of the [manufacturing] partnership'. This contract is clear about design as being integral to the whole process of manufacturing and indicates essentially what made Rigolet attractive to the Parisians.[27] It is intriguing that Rigolet wished to retain his title as designer once he entered the privileged position of merchant manufacturer, the most prestigious role in the Silk Weaving Guild.

DESIGN AND DESIGNERS FOR FASHION SILKS

Rigolet's decision to retain his designer status drew attention to particular skills that many manufacturers did not possess, namely the ability to draw and to make designs. He was, in fact, making both drawings and designs for some of the most elaborate and expensive woven silk, incorporating not only silk but

challenge Italian products, and about thirty years after the French crown had begun to replace its Italian commissions for furnishing silks with those made in Lyons.

[26] Poni, 'Fashion as Flexible Production', 69–70, cites Savary's comment on annual fashions as a starting point (*Le parfait négociant*, 1675); Corinne Thépaut-Cabasset (ed.), *L'Esprit des modes au Grand Siècle* (Paris, 2010). As we know from Marco Belfanti's recent work, fashion was not purely a European phenomenon, nor necessarily restricted to the early modern period. Marco Belfanti, 'Was Fashion a European Invention?', *Journal of Global History*, 3/3 (2008), 419–43.

[27] Archives municipales de Lyon (hereafter AML), HH597, 'Registre des maîtres', f. 253; HH621, 'Registre des marchands reçus', no. 557; ADR, 8B137, 'Formation de société', 12 April 1721 (five years after the event), f. 19. Designs by a Rigolet survive in the Bibliothèque nationale, dating from the mid to late 1720s. They are for the most expensive types of silks and gold brocades, very intricate in their motifs. Rigolet formed a partnership with Jean Fargues (n.d.) and Jean Baptiste Alissan (n.d.) in Paris, and François Debargues (n.d.) 'in order to set up and manufacture fabrics of silk, gold, silver and others' in October 1716 for ten years under the name of François Debargues et compe with capital investment of 100,000 *livres* from Fargues and Alissan through whom silks were to be sold in Paris; two thirds of the profits to go to Fargues and Alissan and one sixth to each of the Lyonnais; annual withdrawals of 1200 *livres* each; the Parisian house had to occupy fifty to sixty looms and the Lyonnais were not permitted to sell in Paris except through it; the Parisians were free to become involved in other firms, the Lyonnais were not; Debargues bought materials and was the signatory in Lyons. He was named in a copyright dispute between Bron Carré et Monlong and Cadory et Ganin (his employers) in 1716.

also metal threads in very complex patterns.[28] He could not have acquired these skills without learning to draw, a skill not learnt in weaving workshops, but rather under the tutelage of a drawing master, painter, or designer. Design – as opposed to drawing *tout court* – could only be learnt under the guidance of a designer, that is, someone who understood the materials used in silks and the structures of fabrics, and who could therefore convert ideas and freehand sketches into a suitable technical drawing or *mise-en-carte*. The technical drawing was the plan from which the weaver mounted his loom. Illustrations 8.5 and 8.6 show the representation of freehand and technical drawing in a late eighteenth-century publication. Rigolet, having served a weaving apprenticeship, knew how looms were mounted, as well as how to draw.[29]

Drawing was a crucial skill for the successful creation of patterns for the seasonal fashion trade and by the eighteenth century designers advertised this specialisation. What then was the relationship between designers and merchant manufacturers, and to what extent did the latter drive change? In the main, this question has been answered by turning to the first description of silk design and silk designers to come into the public sphere in France. Written by Antoine Nicolas Joubert de l'Hiberderie (1715–70), a native of Antibes in the south of France, *Le dessinateur pour les étoffes d'or, d'argent et de soie* was published in Paris in 1765 despite the reservations of the Silk Weaving Guild in Lyons. There is also plenty of evidence in the Lyonnais archives of diverse working practices.[30]

According to Joubert, until the late 1750s training had been a rather arbitrary affair. Because designers needed to know how to draw and how to weave, to have knowledge of the state of the market and preferably contact with the tastemakers in Paris, they often combined all or part of a weaving apprenticeship with private classes in drawing, in Lyons or at the Gobelins in Paris. Joubert lauded the public school of drawing that had been established in Lyons in 1756 for the benefit of those who could not afford private lessons.[31] By implication, those who went into the trade before this date had to have come from financially secure families or

[28] Bibliothèque nationale de France (hereafter BN), Cabinet des estampes, Lh44a, M253924 'Persienne en deux dorure de Mr Rigaulais', mid 1720s, papier vernis; M254006 'Gros de tours blanc broché nué de Mr Rigolet', c. late 1720s, papier vernis.

[29] No *mise-en-carte* seems to survive from this date, though many do for the 1760s–80s.

[30] Anne-Marie Wiederkehr, 'Le dessinateur pour les étoffes d'or, d'argent et de soie' (unpublished thesis, Université de Lyon II, 1981); Lesley Ellis Miller, 'Representing Silk Design: Nicolas Joubert de l'Hiberderie and *Le dessinateur pour les étoffes d'or, d'argent et de soie* (Paris, 1765)', *Journal of Design History*, 17/1 (2004).

[31] Marie-Félicie Perez, 'Soufflot et la création de l'école de dessin de Lyons, 1751–80', in *Soufflot et l'architecture des lumières*, École nationale supérieure des beaux-arts/CNRS (Paris, 1980), 108–13; Lesley Ellis Miller, 'Education and the Silk Designer: A Model for Success?', in Christine Boydell and Mary Schoeser (eds.), *Disentangling Textiles* (London, 2002), 185–94.

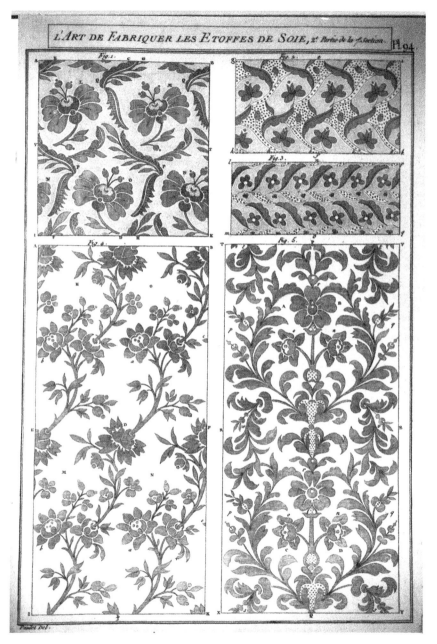

Illustrations 8.5 and 8.6 Jean Paulet, *L'art du fabricant d'étoffes de soie. Description des arts et métiers* (Paris: Académie Royale des Sciences, 1789), second part of 7th section, Plates 194 (freehand sketches) and 196 (point paper designs/ *mises-en-carte*), details. Courtesy of the Abegg-Stiftung, Riggisberg.

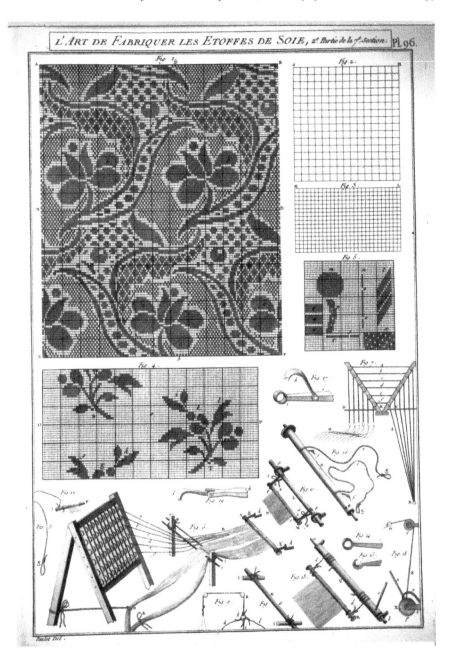

L'ART DE FABRIQUER LES ETOFFES DE SOIE, 2.ᵉ Partie de la 1.ᵉ Section. Pl. 96.

have found suitable sponsors in order to gain the cultural capital they required for the job. Jean Guichot (1719–85) was probably a good example – he learned about silk manufacturing through his father, a successful merchant manufacturer and bourgeois, rather than via apprenticeship. Educated at the Grand Collège in Lyons, he finished his training at the Gobelins in Paris, thus laying the foundations for his future contact with Paris and the court. When he returned to Lyons in 1740, he did so as an employee of Mongirod et Rubis, *marchands fabricants* who provided board and lodgings, paid for his materials, and in addition offered him an annual salary which rose from 500 to 1000 *livres* over five years.[32]

This training opened up three possible forms of employment, according to experience and means: as an employee in a silk partnership, as a freelance designer, or as a partner in a silk weaving firm (i.e., as a merchant manufacturer). This last was not achieved overnight, requiring a similar period of 'apprenticeship' to that required by a master weaver, albeit gaining different skills. Jean Baptiste Meunier (b. 1736) was a typical example of the first of these situations. Meunier's father, an agricultural labourer in the Bugey, apprenticed his son at the age of eighteen to master weaver Aimé Bredon (b. 1726) in November 1754. Meunier duly completed his apprenticeship five years later, and registered as a journeyman in January 1760.[33] A year later, presumably when he reached his majority, he became a designer in the firm of Gabriel Aymard et Teste fils *marchands fabricants*. In his contract he promised to work for them exclusively for a salary which rose incrementally from 3000 *livres* in the first year to 4000 *livres* in the fifth and final year – considerably more than a weaver could expect to earn in a year. Meunier's contract controlled his activities, stipulating that he had to make any changes to his designs that his manufacturers wanted and that he had to ask their permission if he wanted to make any designs or *mises-en-carte* outside the partnership's design studio.[34]

Surviving silk designs from other partnerships underline the power relations evident in Meunier's contract. Initial sketches and later *mises-en-carte* are not signed by the designer (as a painting would have been by this date). The former may be annotated to show from whom they came, while, in contrast, the latter (Illustrations 8.7 and 8.8) bear the manufacturers' name on the reverse (i.e., that

[32] Archives Nationales de France, Minutier Central, Etude XXIII 509: 30 May 1740 Conventions.

[33] AML, HH572, 'Registre des compagnons', ff. 96–7; HH589, 'Registre des apprentis', f. 488; ADR, 3E9435 Dugueyt (Lyon): 17 November 1754, Aprentissage.

[34] ADR, 8B1043 Fonds Meunier: 1 February 1761 'Conventions Meunier/Eymard et Teste'. The sum was to be paid quarterly and was to include board and lodgings. By 1763 he was experiencing problems in satisfying them, and by 1764 he was applying to the Sénéchaussée to intervene in their dispute.

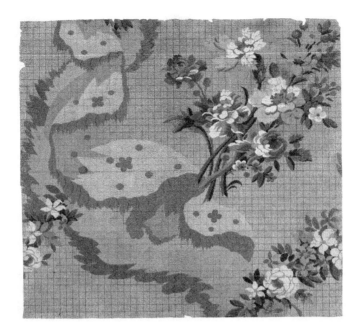

Illustrations 8.7 and 8.8 *Mise-en-carte* (recto and verso) for a *gros de tours en dorures et nuences*, probably by Daniel Symiand, for L. Galy, Gallien et cie., No. 850, dated 8 July 1763. Gouache and ink on engraving. 48 x 51.8 cm. © Victoria and Albert Museum, London, no. T.413-1972.

of the person who owned the design rather than the person who actually made it). Freelance designers (*dessinateurs publics*) were similarly invisible in their work: they made designs speculatively for sale to manufacturers who often could not afford to employ a full-time designer. They thus received payment for each piece of work, after which they had no right to offer it to anyone else.

Entering a manufacturing partnership transformed designers into merchant manufacturers in their own right, or *négociants*. They thus joined Poni's 'power brokers'. While this status usually had to be earned by completing a full weaving apprenticeship, or by marrying a master's daughter, the guild could be flexible. From at least the 1720s, *par ordonnance consulaire* the guild waived its usual requirements in order to reward those with talent. Design seems to have been among the most frequently recognised talents during the eighteenth century, although often talent needed to be accompanied by a number of years serving as a senior designer and with the money to pay the registration fees for entry to apprentice, journeyman, master, and merchant status all at the same time.[35] In many of the initial partnerships formed between merchant manufacturers and designers-turned-merchant manufacturers, the designer did not bring any capital, only his design skills. By the time he made his next partnership, however, he could usually bring capital as well as talent. In 1752, for example, François Suleau dit Lassaveur (1714–57) formed a new partnership with Jean Duperrel (b. 1724), *marchand fabricant*, under the name Jean Duperrel et Lassaveur. Duperrel invested 30,000 *livres* in capital while Suleau promised to 'provide all the designs necessary for the workshop and not to make available [to others] on any condition whatsoever my sketches or my ideas on pain of a 2000 *livres* fine'. Duperrel provided shop space. Annually, he withdrew 5000 *livres* in salary, while Suleau withdrew 2000 *livres*.[36]

These kinds of partnerships (and some contracts with designer employees) tended to stipulate a trip to Paris at least once a year for the designer, all expenses paid (sometimes for as long as three months). During such visits designers were expected to write home regularly with the latest news of factors affecting the market for silks and also to send designs. To research the designs they spent time in the fashionable mercers' shops, and visiting art and natural history collections open to the public and, of course, the Royal Manufactories at the Gobelins and Sèvres.[37] Their role seems on some levels very reactive, an interpretation of what

[35] AML, HH569 and HH570, 'Livres des ordonnances consulaires', 1743–90.
[36] ADR, 3E3095 Brenot (Lyons): 26 February 1757, Testament.
[37] For example, René Marie Lamy in the 1720s and Claude Camille Aubert in the late 1740s. ADR, 8B1218 Fonds de Vitry et Gayet, Liasse I Lettres; 3E3866 Dalier (Lyon): 11 October 1753, Acte d'apport de société Aubert/Pernon.

they thought clients might like. In keeping their eyes and ears open and acting as conduits of fashion intelligence, they acted in a similar way to the salesmen who, several months after the designers' work went into production, undertook to sell it in the marketplace.[38]

SELLING SILKS AND SALESMEN

If designers were kept active adapting to the requirements of the market and attending to the advice of their merchant manufacturers or their mercer clients, salesmen complemented their efforts. Surprisingly, however, the selling practices of Lyonnais merchants have received relatively little attention. 'Selling' and design shared certain forms of knowledge, and there is evidence that designers could make very good salesmen because they were able to convey information through both words and drawings. Language and social skills were a further advantage, and designers were often well-educated men.

It is perhaps important to stress that the Lyonnais silk manufacturers were dependent on external markets and had a highly developed sense of who their clients were and how to ensure their custom. Situated at some distance from its markets, the city had certain geographic and economic advantages. It sat at the confluence of two navigable rivers, held a royal privilege to host fairs three times a year from the early fifteenth century onwards, and invested in an increasingly sophisticated postal system from the early seventeenth century.[39] Lyons had shone as a commercial city since the sixteenth century, and was well used to importing and exporting goods. Its merchants thus had well-established networks of correspondents across Europe.

The guiding Lyonnais strategy for capturing new markets for its silks was expressed strikingly and simply in a petition drawn up by the Lyonnais manufacturer Barnier in 1730:

> The consumption of the [French] court has always been the principal objective of this trade. It is the court which by its decisions on matters of taste and fashion authorises novelties which without its sanction would not find favour.

[38] For example, the designer Achard wrote to his manufacturer Marin Fiard (n.d.) in 1769, informing him of the coming festivities for the marriage of the Dauphin: 'I won't tell you anything of this part of the world, except that there is lots of poverty. I believe that there is also in Lyons. I think that the marriage of the Dauphin will give you work [...] I hope that you will have some part. Here one is preparing for the holiday [...]'. ADR, 8B876 Fonds Fiard, Liasse I, letter dated 27 December 1769.

[39] Françoise Bayard, 'Des foires aux brocarts', in Pelletier, Rossiaud, Bayard and Cayez (eds.), *Histoire de Lyon*.

It is the court which by its taste and magnificence serves as a model for all foreign courts [...]. The court is imitated by Paris which is in turn imitated by the provinces [...] and this imitation of the court which sits perfectly with folk of rank in Paris has passed down to the petite bourgeoisie who scrupulously wear court mourning, as if this bourgeoisie had the honour of being related to the crowned heads and princes to whose memory the court pays this tribute.[40]

This was no abstract principle. Lyonnais commercial correspondence throughout this period testifies to the cultivation of these 'trendsetters', and their success. The French king was 'converted' to Lyonnais silks by the 1680s. Successive monarchs showcased at Versailles and in Paris their commissions from Lyons of silks for royal furnishing projects and for personal adornment. Tourists were invited to visit the Royal Wardrobe (*Gardemeuble*) stores, where textiles not currently furnishing palaces were kept.[41] Indeed, Lyonnais commercial correspondence suggests that about 45 per cent of their French sales were in Paris.[42] Evidence of sales is clear as is expansion into new export markets. But how did the Lyonnais maintain their client base while acquiring more – especially after the 1730s when many other court cities were setting up their own enterprises and when imported printed cottons and lightweight silks from Asia were providing additional competition?

There were four key methods in this period: one passive, the others active; one traditional, the others more innovative – or at least this is how the Lyonnais saw them: first, the use of fairs; second, the use of correspondence; third, the use of print; and finally, the use of travelling salesmen.[43] Of these methods, fairs were well established by the sixteenth century and flourished into the eighteenth century, and so do not really merit comment here. Nor does the expansion in print culture, which allowed the Lyonnais to develop awareness of their 'brand' abroad via the commercial press (the *Affiches* and *Almanachs des marchands et négociants*), and, on an individual or 'corporate' basis via the use of handlists and trade cards. The engraved imagery tended to emphasise the good reputation and

[40] BN, ms fr. 11855, 'Mémoire Général sur la Manufacture d'étoffes de soye, or et argent qui se fabriquent dans la ville de Lyons, écrit en janvier 1731', ff. 29–31.

[41] Pierre Arizzoli-Clémentel and Chantal Gastinel-Coural, *Soieries de Lyon: Commandes royales du XVIIIe siècle* (Lyons, 1988), 69.

[42] Bayard, 'Des foires aux brocarts', 493–5. The major Atlantic and Mediterranean ports were the next most significant, while a large proportion of remaining sales were in the area surrounding Lyons, with boundaries that ran from Besançon to Clermont-Ferrand, Toulouse, Perpignan, Montpellier, Marseilles, Grenoble and the valleys of the Saône and Rhône, the Languedoc and Provence.

[43] BML, ms 354461, 'Mémoire sur l'envoi des échantillons de la Fabrique de Lyons', 1760; ms 113923, 'Arrêt de la Cour de Parlement; ms 113925, 'Arrêt de la cour de parlement'; Archives de la Chambre de Commerce et d'Industrie de Lyon, Délibérations, 1760–66, ff. 9–15v.

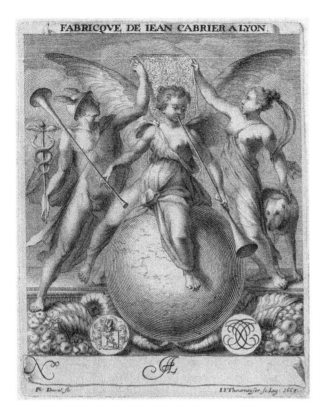

FABRICQVE DE IEAN CABRIER A LYON.

Illustration 8.9
Trade card for silk
manufacturer Jean
Cabrier of Lyon, 1668.
Waddesdon Rothschild
Collection, 3686.1.24.38.

reliability of the manufacturer whom the trade card represented, or an association with impressive patrons (Illustrations 8.9 and 8.10). The so-called fashion press was still in its infancy and did not apparently do much for the Lyonnais textile manufacturers.[44]

Correspondence, as seen in the case of designers, was embedded in the system. Many manufacturers and merchants had contacts in other cities and other countries, with many making short visits of a month or so to important contacts during the year or receiving them in Lyons during fairs or at other times of year – or making use of the designated agents of particular crowned heads. By the end of the century the kings of Poland, Spain, and Sardinia, the Empress of Russia, the Duke of Modena and, in 1788, the Elector of Saxony, all had agents resident in Lyons. The prolific correspondence of manufacturers dwells on the price, quality, and colours of fabrics, and was occasionally accompanied by

[44] Jennifer Jones, *Sexing la Mode: Gender, Fashion and Commercial Culture in Old Regime France* (Oxford, 2004).

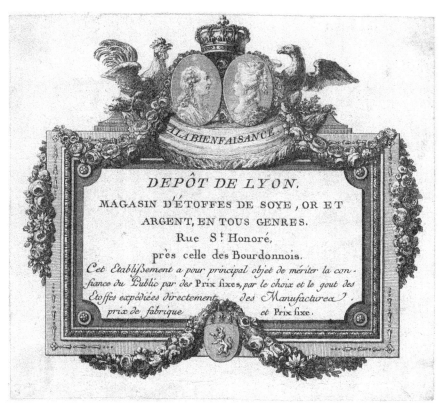

Illustration 8.10 Trade card for the retail outlet set up by the manufacturers of Lyon in Paris under royal patronage, c. 1780. Waddesdon Rothschild Collection, 3686.2.20.49.

fabric samples. This was easy in the case of simple silks – plain, spotted, striped, checked – but not for those with a very defined motif whose pattern repeat might only be visible in a sample half an ell in length. Trust played an enormous part in the requests for silks, and the reputation or experience of the manufacturer was significant in these long-distance exchanges. For example, Léon Guillaume du Tillol (1711–74), Minister of the Duchy of Parma, wrote to Jean Baptiste Mauro, agent of Philip, Duke of Parma (1720–65) in Lyon, in 1767, in a typically trusting fashion:

> Here is an order for which I need your taste, or that of Mlle Mauro [agent's daughter]. I want you to choose a fabric length of 22 ells for a court dress. It must work for the theatre; so you must make your judgment thinking about the effect of light [...]. It must be a *gros de tours* in one of these colours: either deep

green or dark pink, or a strong blue, or grey. It must have a distinctive design with strong textural effects in gold or silver and coloured silks.[45]

Finally, travelling salesmen (and cards and books of samples) seem to have been a later development, which emerged once the system of seasonal change in designs was well established. Selling or marketing roles, just like design roles, were built into different types of partnership in the Silk Weaving Guild. The basic difference between merchants who traditionally went in search of custom and these travellers was the frequency and intensity of their travels, the ground covered, and their ability to serve many more than one master. The aforementioned sample book of 1764 represents the products of twenty-nine Lyonnais manufacturers (Illustrations 8.1 and 8.2).[46] As in the case of design, selling was a trade that could be practised either freelance or as an employee or partner in a business devoted to either the commissioning and sale of silk goods (without manufacturing capacity) or to a manufacturing and selling partnership. These were the men who took sample books and crates with them and were then sent more goods on request. They were the all-important human contact between manufacturer and client. As such their skills were multiple, and their ability to mingle successfully with potential clients was important.

The salesman Bonaventure Carret who died at the age of 42 in 1779 offers a nice example of the range of social and commercial skills required. Carret was active in three successive partnerships between 1762 and 1779. Each was a *commerce de commission* (that is, they commissioned fabrics rather than making finished articles). They specialised in silk textiles for furnishings, gowns, waistcoats, gloves, stockings, and ribbons – a range of silks and silk products that embraced everything from the simplest to the most elaborate techniques and materials. The partnership concentrated on a specific geographic area, which comprised forty-one major and medium-sized towns, and one region (Suriname). These towns were mainly in northern Europe; the north of France dominated, while Switzerland, Germany, the Netherlands and Belgium (Provinces-Unies) were regular customers and ports of call.

Carret was the *voyageur de commerce*.[47] The majority of his trips were four to six months in length, but he also made longer trips of seven to nine months, his

[45] Du Tillol in Parma to Jean Baptiste Mauro, agent of the Duke of Parma in Lyons, 1767. Mauro was on a retainer of 4,800 *livres* per annum. Cited in Henri Bédarida, *Parme et la France: de 1748 à 1789* (Geneva, 1977), 287.

[46] See note 1 above.

[47] Françoise Bayard, 'L'Europe de Bonaventure Carret et de ses associés, marchands lyonnais au XVIIIe siècle', in Albrecht Burkardt, Gilles Bertrand, and Yves Krumenacker (eds.), *Commerce, voyage et expérience religieuse XVIe–XVIIIe siècles* (Rennes, 2007), 55–80.

longest being twenty-one months (1776–78). He covered much ground, often going straight to Amsterdam via Paris and then returning by a circuit through Flanders and the north of France. His role was threefold: to show samples of silks and fashionable objects to clients, collect due payments, and contact suppliers. Therefore, he had to be in touch with numerous clients and also his partners, to whom he sent orders every day: in March 1767 he underlined the rigours of his lot: 'I have been up since six in the morning, I pounded the streets all day and I am writing to you at the moment at 2.26am. I go out again at seven o'clock to deal with other orders [...]'.[48] Other letters, however, reveal his taste for theatre-going and womanising – both potentially considered as 'work' rather than purely pleasure in the context of his job. His correspondence reveals just how cultivated a man he was, always up-to-date with the most recent books and events – he was no doubt an entertaining companion.

Carret and his associates rigorously applied the cardinal rule articulated by Barnier in 1730 (see above). He focused exclusively on the ruling classes and on merchant peers, and was rather scathing about smaller shopkeepers. The former, he noted, were tremendously important as only they would be able to afford *le grand riche*, the most expensive fabrics, and thus set the fashions. His social skills, social and commercial network, powers of observation on cultural difference, and his knowledge of Lyonnais production all contributed to his success. Thus, in 1767, he advised on appropriate shades of a furnishing textile for a Dutch client:

> a Chinese or bucolic design in several colours of silk [...] it must be with a blue or yellow ground but <u>not</u> a red or green or cerise ground because Dutch women do not use rouge and these grounds in an apartment make them seem too pale [...][49]

Carret's approach and background were not dissimilar to those of another Lyonnais who survived rather longer and did rather better, François Grognard (1748–1823). Born into a merchant manufacturing family, Grognard became a designer, then agent of the King of Poland in Lyons, salesman in Russia, and partner in the highly prestigious firm of Camille Pernon et cie, supplier of many royal houses in the years just preceding, during, and after the French Revolution. He finished his career in Paris, first representing Pernon (1753–1808), and later as one of the men in charge of the Imperial Wardrobe (*Mobilier Impérial*). Grognard's recommendations to Pernon during his eighteen-month sojourn in

[48] *Ibid.*, 60.

[49] Request for a furnishing textile for Amsterdam, Bonaventure Carret to his partners, 14 March 1767. ADR, 8 B 730–12.

Madrid underline how personal contact, managed by a tenacious, often grumpy, and not always scrupulously moral representative, were invaluable in cementing commercial relations. He was quite happy to steal any samples that came into his hands, use them to acquire orders and have those orders executed by Pernon. Having begun to communicate with his Spanish court clients, he advised his manufacturer to write in Spanish, as 'if you intend to continue working with Spain, then you must have one of your employees learn Spanish, so that bills can be sent in Spanish, as well as your other correspondence'.[50] Further guidelines for his manufacturer came from experience that could not be gained except in the field. They summarised key facets of good business practice with regard to pleasing the client: the unquestioning delivery of what was requested (even if it clashed with French notions of good taste); speedy and reliable delivery of goods for the date requested (a service for which Spanish manufacturers were not renowned); due attention to the quality of the goods, as customers were knowledgeable; the supply of samples of the new ranges (*assortiments*) at least four times a year, all in the latest Parisian taste, and in a variety that enabled the royal family to acquire silks that were different from the rest of the court.[51]

CONCLUSION

In recent years, the power of fashion in shaping economies, societies, and cultures has become a subject of serious historical enquiry. This essay has offered an introduction to how fashion might have impacted upon the design and commercial practices of the silk manufacturers of eighteenth-century Lyons. It has presented some elements of the investigation, collaboration and communication that went into manufacturing and selling fashion silks, introducing men working in two lesser known trades that came into their own during this period: designing and selling.

If manufacturers and merchants 'used annual product differentiation as a strategic weapon', both the artistic or painterly skills and technical knowledge of designers, as well as the cultural network, *savoir faire*, and *savoir vivre* of a new breed of salesmen who sought to extend Lyonnais markets, were crucial to their success in achieving these ends.[52] While *commissionaires* sat firmly in the commercial orbit of manufacturers, designers enjoyed a sometimes ambiguous

[50] BML, ms 1923, Grognard to Pernon, 14 May 1788.
[51] BML, ms 1923, Grognard to Pernon, 1787–1803. For transcriptions of a large part of this correspondence, see Arizzoli-Clémentel and Gastinel-Coural, *Soieries de Lyon*, 98–101.
[52] Poni, 'Fashion as Flexible Production', 39.

position on the edge between silk manufacturing and the practice of fine art. Their status might well be compared with that of the *peintres du roi* in Paris who supplied the royal manufactures with models for tapestries and ceramics and with the members of the less prestigious guild of St Luc, who acted as painters and decorators. Both 'institutions' supplied Lyons with designers and designs throughout the period. Even when local citizens, and later the municipal authorities, developed home talent, Lyonnais silks remained 'Paris fashion made in Lyons'.

9.

The Manila Galleon and the Reception of Chinese Silk in New Spain, c. 1550–1650

José L. Gasch-Tomás

In 1629, Pedro Cortés (1565–1629) IV, marquis of the Valle de Oaxaca of the viceroyalty of New Spain and grandson of the conqueror Hernán Cortés (1485–1547), died. He was buried alongside his grandfather in a lavish ceremony. The mourners were garbed in black silk textiles originating from Ming China (1368–1645) and Castile, and cotton from New Spain, one of the two viceroyalties of the Spanish Empire in the Americas – the other was the viceroyalty of Peru.[1] The canopy was also woven from cotton and silk. The coffin was richly decorated with black silk and taffeta from Mixteca, the geographical area located in the current Mexican states of Oaxaca, Guerrero, and Puebla.[2] According to Woodrow W. Borah, this is one of the last references to silk produced in New Spain until it is mentioned again in the eighteenth century.[3] Historians of the colonial American textile industry furthermore agree that the introduction of Chinese silk via the Manila Galleon route into American markets was one of the main causes of the decline of New Spanish sericulture, which flourished around 1540–90.[4]

In 1565, the Spaniards conquered most of the Philippines and opened the commercial route of the Manila Galleon, linking Acapulco, on the western coast of New Spain, with Manila and the commercial area of East Asia for 250 years. Almost every year between 1565 and 1815 several galleons crossed the Pacific

[1] By the Americas, this chapter means the territories in North, Central and South America under the command of the Spanish Empire.

[2] Lucas Alamán, *Disertaciones sobre la historia de la republica megicana* (Mexico, 1844), ii: 74–6; Woodrow W. Borah, *Silk Raising in Colonial Mexico* (Berkeley, 1943), 101.

[3] Borah, *Silk Raising*, 87–101. Borah's work on New Spanish silk during the colonial period is still an essential reference in historiography on American silk.

[4] Jan Bazant repeated this argument in Jan Bazant, 'Evolución de la industria textil poblana (1544–1845)', *Historia Mexicana*, 13/4 (1964), 482.

Ocean from the Philippines to New Spain full of Asian goods, mostly Chinese silk, and on their return to Asia stopped in at Manila laden with silver from Mexico.[5] At the end of the sixteenth century the Manila Galleon route, which reached the apogee of its use in the first decades of the seventeenth century, was the main channel of supply to meet New Spain's demand for silk.[6] How much silk on the New Spain market originated from China and how much from the Americas? What silk products were in demand in New Spain? Analysis provides a mixed answer; while Chinese silk dominated American markets from the end of the sixteenth century, some Chinese imports were less coveted. Such subtle variations in market structures and the evolution of silk culture in sixteenth- and early seventeenth-century New Spain prompted this review of the widely accepted narrative whereby local American silk was replaced by Chinese imports. This chapter discusses trade and silk imports into New Spain from China, Castile, and Italy, in relation to matters of taste among the New Spanish elite.

Following the history of silk in New Spain during the sixteenth and the seventeenth centuries, this chapter examines how taste and fashion reflected the rise and fall of New Spanish sericulture, the eruption of Chinese silk, the development of silk and dye industries in New Spain, and the influence of Chinese and European silk imports. The tastes of New Spanish elites were formed by the confluence of cultural settings and access to silk from several continents. Shedding light on the impact of Chinese silk on the New Spanish silk culture shows the competitiveness of Chinese silk in markets far from its centre of production.

This chapter concentrates on the period from about 1550 to 1650, distinguishing between the flourishing years of native sericulture and silk industry in New Spain (especially in the area of Mixteca), 1550–90, and the period of decline, 1590–1650. The analytical focus is on wholesale exchanges of silk, Chinese and European, deduced from cargo lists of silk bought and sold in Mexico City, the capital and main economic centre of New Spain. Such lists can be found in two types of notarial records: payment obligations (*cartas de obligación de pago*) and the probate inventories (*inventarios post-mortem*) of merchants, retailers, silk tailors, and weavers. Payment obligations and probate inventories contain valuable information about silk cargos imported, traded, and consumed in

[5] William L. Schurtz, *El Galeón de Manila* (Madrid, 1992); Carmen Yuste López, *El Comercio de la Nueva España con Filipinas, 1590–1785* (Mexico, 1984). For silk trade, see Dennis O. Flynn and Arturo Giráldez, 'Arbitrage, China, and World Trade in the Early Modern Period', *Journal of Economic and Social History of the Orient*, 38/4 (1995), 429–48.

[6] Pierre Chaunu, *Les Philippines et le Pacifique des Iberiques (XVIe, XVIIe, XVIIIe siècles). Introduction méthodologique et indices d'activité* (Paris, 1960), 100 and 106.

New Spain: their quantity, geographical origin, value, type of silk, colour, and, sometimes although infrequently, types of decorated silk fabrics such as damasks and finished garments.[7]

SILK IN NEW SPAIN BEFORE THE MANILA GALLEONS

Silk production was irrelevant to the economy and culture of the Americas by the seventeenth century. However, in the mid sixteenth century there was nothing to suggest that this trade would decline. Around 1550, New Spanish silk seemed to be on the verge of dominating the market for elite clothing for the entire American continent. The favourable climate of some areas of the Americas, the economic and cultural environment, and the transmission of silk culture from the Iberian Peninsula, all indicated that silk would become an important product for both domestic and external markets of New Spain.

The Iberian Peninsula, along with Italy, was one of the main European centres of silk production during the Middle Ages. The Islamic presence in part of the Iberian territories had much to do with it. The continuity between silk production in al-Andalus and production under the Christian kingdoms of Iberia was especially evident in places such as Valencia, Murcia, Cordoba, and above all Granada, where the *mudéjares* (Muslims allowed to live with their religion and habits within Christian states) and later the *moriscos* (Muslims who were forced to convert to Christianity but kept their habits and sometimes, clandestinely, their religion) had a stronger presence. In areas where the Muslim legacy was more prevalent there were continuities in techniques of silk production, thread, and weave, and motifs of clothing as well as legal regulation of their production and commercialisation.[8] Furthermore, the new market demands and the different technical and mercantile stimuli fostered silk manufacture in the central areas of the Iberian Peninsula from the end of the Middle Ages to the beginning of the

[7] The two sources are slightly different. Whereas payment obligations register the wholesale buying and selling of goods, probate inventories record the possessions of people at the end of their lives. Unless the goods of the deceased were later sold in public auction, probate inventories do not record buying and selling. However, the presence of valued cargos of silk to be sold among the probates of merchants, retailers, and weavers can be computed alongside data contained in payment obligations, since the type of information is the same: cargo lists of silk at wholesale market value. Regarding methodological precautions in the use of probate inventories as a source for consumption studies, see Lorna Weatherill, *Consumer Behaviour and Material Culture in Britain, 1660–1760* (London, 1988), 201–7.

[8] Germán Navarro, *El despegue de la industria sedera en la Valencia del siglo XV* (Valencia, 1992), 29–38; Manuel Garzón Pareja, *La industria sedera en España. El arte de la seda de Granada* (Granada, 1972), 243–52.

early modern era.[9] Likewise, the Italian influence on Iberian silk production was important, although different, depending on the silk centres. It reached firstly and most strongly Mediterranean cities like Barcelona, Valencia, and Murcia around the mid fifteenth century. Over time, the presence of Italian artisans, generally from Genoa, became increasingly noticeable in the larger Spanish cities. Italian workers succeeded in dominating part of the Spanish industry due to their superior skill in the manufacturing of fabrics, mostly of pure silk, which merged with Muslim traditions of producing silk cloths mixed with other fibres.[10] These different factors fostered a continuous growth of Castile's silk industry during the sixteenth century, which was comparable to the general economic growth of the country.[11] In this context, Spaniards started to transfer their silk culture to the territories on the other side of the Atlantic Ocean.

The introduction of sericulture in the Americas hinged on climatic conditions during the first quarter of the sixteenth century. The first royal administrators, Francisco de Bobadilla (d. 1502) and Christopher Columbus (1451–1506), carried out fruitless attempts on the Caribbean island of Hispaniola. The second attempt took place when a judge (*oidor*) of the royal tribunal (*audiencia*) of Hispaniola received royal approval to settle the new lands and introduce silk raising on the east coast of present-day Florida. Rebellious groups of native Americans impeded the growth of mulberry trees or any other crop and hence this attempt failed too.[12]

Suitable prerequisites of climate and labour supply were finally found in New Spain. Famous colonial figures such as Hernán Cortés and his enemy, the judge of the first *audiencia* of the viceroyalty, Diego Delgadillo (d. 1533), both claimed responsibility for the introduction of sericulture to New Spain. Others like Gonzalo de las Casas, who was the first to compile a treatise about silk production in New Spain, maintains that his ancestors pioneered sericulture in the viceroyalty.[13] However, there was no extensive silk raising in New Spain until 1537, when the brothers Juan, Francisco, and Hernando Marín from Murcia, one of the main silk regions of the Iberian Peninsula, requested permission from the viceroy to produce silk in the village Tejúpam of Mixteca where mulberry trees were cultivated. The approach of the three brothers was comprehensive: they organised houses to raise silkworms, taught natives to collect silkworms and

[9] Miguel A. Ladero Quesada, 'La producción de seda en España medieval. Siglos XIII–XVI', in Simonetta Cavaciocchi (ed.), *La seta in Europa, secc. XIII–XX* (Florence, 1993), 125–39.

[10] Luca Molà, *The Silk Industry of Renaissance Venice* (Baltimore, 2000), 21–2.

[11] Bartolomé Yun-Casalilla, *Marte contra Minerva. El precio del Imperio español, c. 1450–1600* (Barcelona, 2004), 156–73.

[12] Borah, *Silk Raising*, 1–4.

[13] Gonzalo de las Casas, *Arte nuevo para criar seda*, ed. A. Garrido Aranda (Granada, 1996).

wind cocoons, and were ready to pay a fifth part of their profits to the crown. The project succeeded after less than five years and by 1545 sericulture had reached a commercial scale across Mixteca. Soon the regions of Mixteca Alta and the valley of Oaxaca achieved a reputation as centres of silk production. Dominican friars played an essential role in spreading silk from Tejúpam to other villages of the region. Native Americans worked with zeal in the trade since they saw it as a new way to get resources to pay tributes.[14]

Stimulated by a rapidly developing sericulture, silk processing crafts quickly took root in New Spain, emanating from the capital city. In the beginning, Mexico City monopolised silk looms. The capital city's attempts to restrict silk dying and weaving to Spanish artisans, however, proved unfeasible. Puebla de los Ángeles, the second largest city of the viceroyalty, allowed unregulated sericulture and craftwork until 1569, while in Mexico City the first silk guild had been regulated in 1542.[15] By the second half of the sixteenth century, Puebla, which had long been known for goods such as glazed ceramics and tiles, had become a serious competitor to Mexico City due to the low prices of Puebla's manufactured silk.[16]

This prosperous period in the history of New Spain lasted until around 1590. From that moment on, decline became a constant companion of Mixteca's economy, soon affecting other silk producing areas of New Spain. Woodrow Borah adduces two main reasons for this decline. First, the spread of European diseases such as smallpox – Mixteca suffered, for instance, a disastrous epidemic in 1575–77 – severely impacted the demographics of the native population. Second, competitive Ming-Chinese imports from Manila flooded the market.[17] Silk produced in New Spain practically disappeared overnight. From the end of the sixteenth century onwards most silk in New Spain originated from Ming China.

CHINESE AND EUROPEAN SILK IN NEW SPAIN

The silk-for-American-silver trade between Ming China and New Spain via the Manila Galleon route proliferated from the 1580s. At this time a series of

[14] Woodrow W. Borah, 'El origen de la sericultura en la Mixteca Alta', *Historia Mexicana*, 13/1 (1963), 1–17; William B. Taylor, 'Town and Country in the Valley of Oaxaca', in Ida Altman and James Lockhart (eds.), *Provinces of Early Mexico. Variants of Spanish American Regional Evolution* (Los Angeles, 1976), 66–9.

[15] Bazant, 'Evolución de la industria textil', 473–82.

[16] Peter Boyd-Bowman, 'Spanish and European Textiles in Sixteenth Century Mexico', *The Americas*, 29/3 (1973), 334–58; Bazant, 'Evolución de la industria textil', 473–82.

[17] The refusal to raise silk on the part of some native American groups as a result of the continuous extortions by officials and priests was a third reason, although probably less important, especially compared to the effects of the demographic fall on silk raising: Borah, *Silk Raising*, 87–101.

changes in the Spanish fiscal administration of the Philippines transformed Manila and its hinterland from a society of commercial agriculture to one involved in international trade.[18] Ming silk flooded the silk market of New Spain. In a more nuanced view, however, we can see important differences between raw silk and silk thread on the one hand, and silk fabrics and silk cloths on the other. In fact some segments of the New Spanish silk market even resisted Ming Chinese products for cultural reasons.[19] Plurality is a good word to define the early seventeenth-century silk culture.

Although a large number of entries in the payment obligations and probate inventories of Mexican merchants, tailors, and weavers do not record the origin of the silk, it seems clear from such documents that most of the raw silk and silk thread in Mexico City was from Ming China (Table 9.1). Chinese silk came to the market as bundled silk (*seda en mazo*), floss silk (*seda floja*), hairy silk (*seda de pelos*), twisted silk (*seda torcida*), weft silk (*seda de tramas* or *seda de tramillas*), and *quina* silk (*seda de quina*).[20] Bundled silk and floss silk were cheap by comparison because they had only been spun and probably still kept the sericin of silkworms.[21] The most expensive were the skeins of finer yarns: twisted silk, weft silk and *quina* silk, all of which had been twisted.

The presence of Chinese pre-dyed (often black, blue, and red) silk threads is indicative of the shifting importance that Chinese silk had for the development of silk and dye industries in New Spain. Different types of silk with twisted yarns entered the market at an early date, some of which were dyed in their place of origin – Ming China. Soon similar yarns were being dyed and woven in New Spanish workshops indicating a skilful adaptation on the part of the New Spain

[18] Luis Alonso Álvarez, 'El modelo colonial en los primeros siglos. Producción agraria e inter-mediación comercial: azar y necesidad en la especialización de Manila como entrepôt entre Asia y América, 1565–93', in María D. Elizalde Pérez-Grueso (ed.), *Las relaciones entre España y Filipinas. Siglos XVI–XX* (Madrid, 2002), 37–8; Luis Alonso Álvarez, 'Don Quijote en el Pacífico: La construcción del proyecto español en Asia, 1591–1606', *Revista de Historia Económica – Journal of Iberian and Latin America Economic History*, 23/S1 (2005), 241–74.

[19] By raw silk I am referring to untreated silk as reeled from a cocoon, and silk thread refers to silk spun and twisted into thread or yarn. In this latter case silk thread may or may not be dyed. Raw silk and silk thread was usually piled up into rolls or wads. By silk fabrics and cloths I am referring to silk which had been spun into semi-finished textiles such as taffeta, velvet, damask or satin, to mention but a few of the best known.

[20] *Quina* silk is a type of silk yarn from China, the most expensive of all, which I have not been able to identify. *Quina* silk was a high-quality silk yarn imported from China which was twisted and probably boiled too.

[21] Rosa M. Dávila Corona et al., *Diccionario histórico de telas y tejidos. Castellano–Catalán* (Salamanca, 2004).

Table 9.1 Value of raw silk and silk thread in New Spain
per origin (in per cent), c. 1590–1630.

Origin of Raw Silk and Silk Thread in New Spain 1590–1630	percentage of value (%)
China	57.1
New Spain	1.2
Origin not recorded	41.7
Total	100

Number of records: 43.
Sources: *Archivo Histórico de las Notarías del DF*, Notaries: Juan Bautista Moreno, Andrés Moreno, Juan Pérez de Rivera, José Rodríguez, and Juan Porras de Farfán. Some notarial records were located in the archive itself, but most are collated in Ivonne Mijares, ed., *Catálogo de protocolos del Archivo General de Notarías de la Ciudad de México, volumen II* (Mexico, 2005). Note: Since the data of silk cargo values covers 40 years, effects of inflation on the sample's data has been corrected by deflating nominal values of silk with a series of maize prices (maize was the basic staple of New Spain), and with the intrinsic value (quantity of silver grams) of the Spanish Dollar or 'piece of eight' (the main coin of the Americas, the Spanish Dollar or piece of eight, was altered by the Crown from 1627 onwards). The base year is 1611–15. Series of maize prices have been collected by Richard L. Garner and can be seen at http://www.insidemydesk.com/hdd.html, and at http://www.iisg.nl/hpw/data.php#southamerica. Series of intrinsic value (quantity of grams) per 1 piece of eight in New Spain have been collected by Leticia Arroyo Abad (2005) and can be seen at http://www.iisg.nl/hpw/data.php#southamerica.

weaving and dye trades.[22] Although Chinese yarn importation put pressure on native sericulture, the influx of Chinese raw silk, silk thread, and silk fabrics also had some positive effects, spurring desires and fashions and thus also the development of the silk processing and dyeing trades of New Spain.

Control over the Manila galleons, the silk and dye industries, and the rest of the flourishing economic sectors of the colonial economy was held by Spaniards and white Creoles. By 1600 the ordinances of Mexico's silk guild prohibited blacks and mulattoes from learning the practice of such crafts, exempting only native Americans. White craftsmen hence held crucial positions in the silk industry in Mexico City, as well as in Puebla and Oaxaca, while native Americans, cheaper and easier to control, laboured in the workshops. Only in the reeling

[22] When Melchor García de los Reyes, shopkeeper of Mexico City, died in 1625, all the merchandise of his shop was sold in a public auction. Everything was bought by the merchant Martín Fernández de Yturrios. Among his goods there were 3 pounds 12 ounces of floss silk and 3 and a half pounds of hairy silk which the notary explicitly mentioned had been dyed in Mexico: Archivo de las Notarías del DF, Mexico (henceforth ANotDF), Notary Andrés Moreno (374), vol. 2476, 179–90.

of the cocoons into thread and then re-spinning this thread, did the Indians minimally compete with white craftsmen.[23]

When the colonial government opened the Manila Galleon route it did so partly to ensure that the control of the silk and dye industries stayed in white hands.[24] By that time many Mexican tailors and weavers were already thriving on the growing supply of cheaper silk yarn brought by the Manila galleons, to the extent that in some cases they could afford to arrange independent orders with merchants travelling to the Philippines.[25] After the expansion of the Manila Galleon trade, silk manufacturers in Mexico City, Puebla, and Oaxaca employed more than 14,000 people.[26]

Both the supply of new types of silk from East Asia and the expansion of Atlantic trade[27] contributed to the growth of production, commercialisation, and trade of New Spanish dyestuffs. These included cochineal dye and indigo, from which Chinese silk thread and silk fabrics such as taffetas and damasks were dyed with crimson and blue hues.[28]

The influx of Chinese fabrics, though less significant than that of thread, affected the dress codes and fashions of New Spanish elites. The most important and known silk fabrics which circulated in New Spain, such as *chaúl*, damask, *gasa*, satin, taffeta and velvet, originated from China.[29] Some of these fabrics, for instance, *chaúles* and damasks, had been dyed and patterned with Chinese motifs in China. The strong colours of the *chaúles* pieces, which were dyed blue, and the fact that silks such as damasks were spun and embroidered with Chinese motifs, had a major impact on fashions among the elites of New Spain.[30] Castilian fashions featuring flowers generally ranked high among Creole American elites.

[23] Borah, *Silk Raising*, 32–7.

[24] Arturo Girladez, *The Age of Trade: The Manila Galleons and the Dawn of the Global Economy*, 43, and 146 emphasises the significance of silk but suggests that the opening of other routes may have also played a role.

[25] Archivo General de Indias (hereafter AGI), Contratación, 242, N.1, R.5; AGI, Contratación, 487, N.1, R.25.

[26] Borah, *Silk Raising*, 90.

[27] Eufemio Lorenzo Sanz, *Comercio de España con América en la época de Felipe II. Tomo I: los mercaderes y el tráfico indiano* (Valladolid, 1986), 545–601.

[28] Raymond Lee, 'Cochineal Production and Trade in New Spain to 1600', *The Americas*, 4 (1948), 449–73; Barbro Dahlgren, *La grana cochinilla* (Mexico, 1963); María Justina Sarabia Viejo, *La grana y el añil: técnicas tintóreas en México y América Central* (Seville, 1994).

[29] *Chaúl* was a type of matt silk, usually blue, and *gasa* a fabric of clear and fine silk: Dávila Corona et al., *Diccionario histórico*, 61 and 94.

[30] In some cases, lists of cargos contained in the notarial documents record that Chinese silk was decorated with 'spring' (*primavera*), referring to silks decorated with coloured flowers: ANotDF, Notary Andrés Moreno (374), vol. 2468, 190.

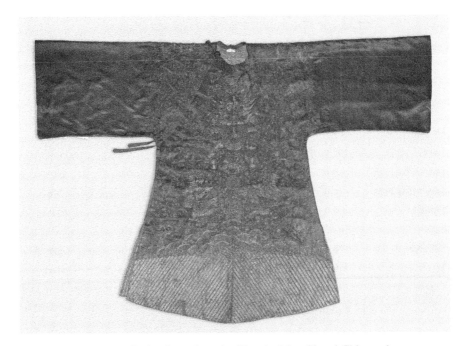

Illustration 9.1 Red satin tunic embroidered with gold and Chinese dragons,
Qing Dynasty, between 1726 and 1800. Museo Nacional de Artes Decorativas.
Photo credit: Masú del Amo Rodríguez, Museo Nacional de Artes Decorativas, Madrid.

In many cases the flowers – lotus or chrysanthemums or small peach blossoms –
were of East Asian origin (Illustration 9.1).[31]

Some fabrics, such as New Spanish taffeta and some minor types of silk fabrics
and cloths, which the Chinese did not export, such as bouclé (*rizo*), ribbon
(*listón*), and *picote*, nevertheless survived, nuancing the narrative of the complete
and absolute success of Chinese silk in the New Spanish market (Table 9.2).
Such survivors indicate the richness and plurality of New Spain's silk market,
and the global character of fashion in that period in which elite tastes could easily
combine Castilian, Italian, and Ming-Chinese elements in ornamental dress and
accessories.

[31] Virginia Armella de Aspe, 'La influencia asiática en la indumentaria novohispana', in María
C. Barrón (ed.), *La presencia novohispana en el Pacífico insular* (Mexico, 1992), 51–64; Virginia
Armella de Aspe, 'El traje civil', in Virginia Armella de Aspe et al. (eds.), *La historia de México a
través de la indumentaria* (Mexico, 1988), 77–8; José L. Gasch-Tomás, 'Asian Silk, Porcelain and
Material Culture in the Definition of Mexican and Andalusian Elites, c. 1565–1630', in Bartolomé
Yun-Casalilla and Bethany Aram (eds.), *Global Goods and the Spanish Empire, 1492–1824:
Circulation, Resistance and Diversity* (Houndmills, Basingstoke, 2014).

Table 9.2 Value of silk fabrics per type and origin in
New Spain (in per cent), c. 1591–1630.

	China	Castile	Italy	New Spain	n.a.
Bouclé *(rizo)*	0.0	95.2	0.0	0.0	4.8
Chaúl	100.0	0.0	0.0	0.0	0.0
Damask	86.2	3.3	0.0	0.0	10.5
Gasa	100.0	0.0	0.0	0.0	0.0
Gorgorán	56.8	0.0	0.0	0.0	43.2
Listón (ribbon)	0.0	14.0	79.1	0.0	6.9
Picote	0.0	33.0	0.0	0.0	67.0
Satin	94.6	1.6	3.8	0.0	0.0
Taffeta	58.4	1.4	0.0	32.6	7.6
Velvet	36.1	1.9	0.4	3.5	58.0

Number of records: 43.
For sources and notes see table 9.1.

Bouclé, a sort of velvet used in Castile to decorate parts of garments, such as sleeves, and to tailor hats (*gorras* and *monteras*), is a good example.[32] The popularity of Castilian bouclé in New Spain was likely associated with the Castilian taste for bouclé hats and sleeves. Likewise, the characteristic shine of some types of Castilian silk, such as *picote*, was also popular among wealthy New Spaniards. Produced in Castilian cities, notably Cordoba, Seville, and Granada, *picote* was dyed black and was commonly used for mourning ceremonies.[33] The substantial presence of Castilian *picote* documented in the registers, as well as bouclé, suggests that elites in New Spain considered it important to uphold traditions in mourning dress. Bouclé continued to be used alongside other black silks of Chinese origins such as velvet. At the funeral of Pedro Cortés mentioned at the opening of this chapter, it is likely that both Castilian *picote* and Chinese velvet were used in the ceremony and for the attire of participants.

The popularity of Italian silk *listones* (ribbons) between the mid sixteenth century and the early seventeenth century was another feature of New Spanish dress fashions[34] that was passed on to the Americas. These ribbons of tightly

[32] Carmen Bernis, *El traje y los tipos sociales en El Quijote* (Madrid, 2001), 150, 186 and 277.
[33] Dávila Corona et al., *Diccionario histórico*, 153; Bernis, *El traje*, 280.
[34] Carmen Bernis, *Indumentaria española en tiempos de Carlos V* (Madrid, 1962), 27–8.

woven silk were used to decorate women's dresses.[35] Bartolomé Yun-Casalilla suggests that the importance of Italian silk products such as *listones* in New Spain should not be understood as a result of the crisis of seventeenth-century Castilian industry, since Castile's silk industry crisis took place later than in other economic sectors, well into the seventeenth century. Instead, the notable presence of Italian *listones* in New Spanish documents demonstrates a cultural liking that Chinese silk producers were not aware of, or, because their trade was prospering anyway, not willing to react to. Hence the demand for decorative silk ribbons in New Spain was mostly covered by Italian production (Illustration 9.2).[36]

Silk stockings and cloaks exemplify the significance of traditions in this era's global trade and fashion. In the case of silk stockings we can see garb elements from Europe and China converging in New Spain, influenced by the importation of finished silk garments from both continents, Europe and Asia.[37] Both male and female Creoles of New Spain also regularly wore Italian stockings (*medias*) after they became popular among European elites there during the second half of the sixteenth century.[38] Such imports originated from Naples and, to a lesser extent, Genoa and Milan.[39] Of all the Castilian silk garments imported to New Spain, cloaks clearly stood out as a significant part of traditional Castilian female dress during the sixteenth and seventeenth centuries. Both rich and humble women wore big cloaks that enveloped them from head to toe. Upper social groups, in some cases, at times, wore cloaks of transparent textiles (the so-called *mantos de soplillo*).[40] In conclusion, we can see this as a mixture of old and new. The presence of silk cloaks from Toledo, Granada, and Seville, alongside Chinese damasks, *chaúles*, and stockings, New Spanish taffeta, and Italian *listones* and stockings, among many other types of silk and garments in Mexican notarial records, illustrate the extent to which Chinese silk supremacy in the silk culture

[35] Bernis, *El traje*, 448.

[36] Bartolomé Yun-Casalilla, 'The American Empire and the Spanish Economy: An Institutional and Regional Perspective', *Revista de Historia Económica-Journal of Iberian and Latin American Economic History*, 16/1 (1998), 132.

[37] ANotDF, Notary Juan Pérez de Rivera (497), vol. 3360, 141–6; Notary Juan Pérez de Rivera (497), vol. 3362, 260–2; Notary Juan Pérez de Rivera (497), vol. 3362, 262–4; Notary Juan Bautista Moreno (375), vol. 2483, 199–205; AGI, Contratación, 503B, N.13, 31; ANotDF, Notary Juan Pérez de Rivera, Num. Reg. 3266, Libro 10, 264–66; Notary Juan Pérez de Rivera, Num. Reg. 3267, Libro 10, 267.

[38] Bernis, *El traje*, 262.

[39] ANotDF, Notary Andrés Moreno (374), vol. 2476, 179–90; Notary Juan Pérez de Rivera (497), vol. 3362 bis I, 486; Notary Juan Pérez de Rivera (497), vol. 3362, 157; Notary Juan Pérez de Rivera, Num. Reg. 2450, 401–3; Notary Juan Pérez de Rivera, Num. Reg. 2926, Libro 8, 486; Notary Juan Pérez de Rivera, Num. Reg. 3855, Libro 11, 159–60.

[40] Bernis, *El traje*, 246–56.

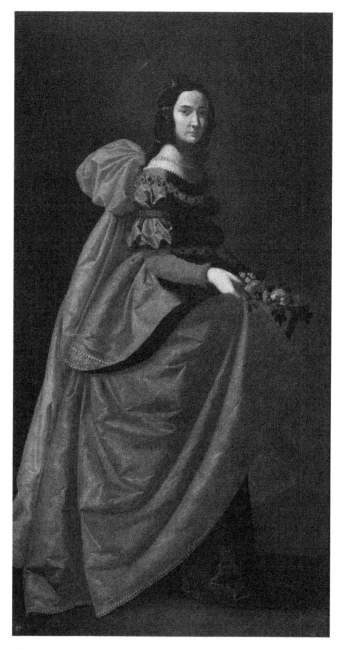

Illustration 9.2 Francisco de Zurbarán, *Santa Isabel de Portugal*,
1635. Museo del Palacio Real, Madrid. The saint is wearing garb
typical of a wealthy Hispanic woman in the early seventeenth century,
including an Italian silk *listón* (ribbon) popular in New Spain.

and garb fashions of New Spanish elites was accompanied by a considerable number of traditional silk types, ornaments, and garments produced in New Spain and, above all, Castile and Italy during the first decades of the seventeenth century.[41]

CONCLUSION

Historians who have studied silk production in New Spain, from Woodrow W. Borah to Jan Bazant, have rightly analysed the rise and fall of New Spanish sericulture and the displacement of American silk by Chinese silk from the sixteenth century onwards. Sericulture flourished from the 1540s to the 1580s in New Spain, especially in Mixteca, but also in Mexico City and above all in Puebla de los Ángeles. Demographic shifts in the native American population and thus the lack of cheap labour, as well as the strong competition of Ming silk imports into New Spain via the Manila galleons, hit local New Spain sericulture hard, hindering its further development for the next century. At the same time the importation of Chinese silk sustained and even propelled the silk and dye industries, especially in Mexico City.

Clearly Ming Chinese silk laded on Manila galleons dominated the New Spanish silk market, and such importation influenced the dress fashions and taste of New Spanish elites. To speak of an absolute supremacy of Chinese silk in the late sixteenth- and seventeenth-century New Spanish silk culture, however, as Borah has done, is an exaggeration and distortion.[42] While the dominance of Ming-Chinese raw silk and silk thread, both in quantity and quality, remains uncontested, it was less comprehensive with regard to the production and market of silk fabrics, ornaments, and garments due to cultural likings and local fashions. The detailed analysis of the circulation and exchange of silk by types and origins suggests that fashion became a mixture of innovative and traditional elements, sometimes favouring exotic, sometimes familiar elements. Ming-Chinese colours and decorative stamps of silk ornaments and garment styles hence coexisted and merged with other styles and decorative forms from Castile and Italy in New Spain. The silk culture of New Spain in the late sixteenth and first half of the seventeenth century manifested a cultural plurality from at least three different continents – the Americas, Europe, and China – forming a sturdy and new global thread.

[41] ANotDF, Notary Andrés Moreno (374), vol. 2464, 29–30; Notary Andrés Moreno (374), vol. 2476, 179–90; Notary Juan Pérez de Rivera (497), vol. 3362, 157; Notary Juan Pérez de Rivera, Num. Reg. 3183, Libro 10, 172–74.

[42] Borah, *Silk Raising*.

10.

'The Honour of the Thing': Silk Culture in Eighteenth-Century Pennsylvania

Ben Marsh

In 1769 Sabina Blandenburgh Rumsey (1707–79) determined to turn her hand to silk-raising at her house on the Bohemia River in Cecil County, Maryland. She wrote,

> [...] having been presented with Pullein [an Irish author] on the Culture of Silk, and some Eggs of the Georgian Worms, I deposited them in a Room on the South-East Part of our House, the second Floor, where the Frosts of March could not affect them, nor was the Place so warm, that they would hatch before Food from the Mulberry could be procured to nourish the Worms.

She compared her worms and silk with 'those of a neighbouring Lady, who had no Method of procuring the white Mulberry Leaves with Convenience'. Rumsey recorded how until the point of reeling,

> the Business had been easy, indeed pleasing to me; you know it must be agreeable to one to see 2000 Labourers [her worms] engaged in one's immediate Interest, I the sole Proprietress, and Finery the intended Consequence.

The trial did not end so enjoyably, and Rumsey finished her letter explaining that 'the Steam of the hot Water determined me against raising more Silk'. However, she observed that should there emerge the incentive of an additional colonial premium in Pennsylvania, it 'may make me alter my Resolution, not from Avarice, believe me, Sir, but the Honour of the Thing'.[1] Rumsey's short letter, published in the *Pennsylvania Gazette* (in 1770), self-consciously drew

[1] For all quotes above see *The Pennsylvania Gazette*, 11 January 1770 (invitation for information); 29 March 1770 (letter from Rumsey to Charles Thomson).

attention to some key issues connected to the pursuit of colonial American silk: local interest and determination, globally-sourced literature and resources, environmental and labour constraints, and, beneath them all, the uncomfortable motivational trio of finery, avarice, and honour.

Between the sixteenth and eighteenth centuries, European colonial powers actively sought to harness the populations and natural resources of the Americas to their national agendas of self-advancement: through competition for souls, for subjects, for domination of the oceans, and for the control of production, exchange, and markets. Their confidence and faith strengthened by early experiences that seemed to bespeak untold riches and divine sanction, they readily projected metropolitan designs onto these new worlds. Fairly quickly, they demonstrated the New World's capacity for producing commodities that revolutionised European consumption, and the Atlantic world became a hub for the cross-fertilisation of cultivars, peoples, techniques, and knowledge systems. These converged, perhaps most dynamically and most tragically, in the development of the 'plantation' system, with its intensive exploitation of African labour in the service of the production of exotic commodities which Europeans increasingly craved but could not effectively cultivate at home: sugar, coffee, dyestuffs, tobacco, rice, and cotton.[2] These successful commodities and the story of their production and consumption have rightly attracted a huge amount of scholarship. But this leaves the question: what of the Atlantic commercial failures? Prominent among these was the production of silk, a commodity imported and used in increasing abundance, the global appetite for which promised great rewards to any who could secure cheap supplies.

This chapter pulls together references in official colonial records, correspondence, and other sources to bring to light some of the attempts at silk cultivation in the mid-Atlantic colony of Pennsylvania during the eighteenth century. Sabina Rumsey followed thousands of colonial forebears when she hatched her silkworm eggs: some limited produce was exported from sixteenth-century New Spain, seventeenth-century Virginia, South Carolina (from the 1680s), and Georgia (from the 1730s). But Rumsey's resolution was part of a new wave of American sericulture that washed across the more northerly regions of Pennsylvania and New England in the years between the 1750s and 1800s – unlikely locations whose unique experiments straddled the American Revolution. As elsewhere in British America, in Pennsylvania there is evidence of longstanding interest and wide-ranging

[2] For an overview of the American system of plantation, see Trevor Burnard, *Planters, Merchants and Slaves: Plantation Societies in British America 1650–1820* (Chicago, 2015). Sugar became a model for plantation. See, for instance, J. H. Galloway, *The Sugar Cane Industry: An Historical Geography from its Origins to 1914* (Cambridge, 2005), ch. 5.

investment in sericulture, which shows that American raw silk production was more than just a utopian metropolitan fantasy dreamed up by mercantilists in the Board of Trade. Silk made a strong showing here, even in such ill-suited environments, because it seduced into its orbit an odd mélange of willing experimenters: naturalists and botanists, Enlightenment associations, and entrepreneurs, as well as ordinary farmers and working women.[3] These Americans could not rely to any meaningful degree on experience or expertise gathered from silk-raising regions in Europe or further East, but were forced to fumble and improvise, voraciously digesting and sharing printed works and seeking to construct networks and mechanisms of self-improvement. What is more, silk enthusiasts in Pennsylvania had to surmount particular hurdles because the region had Quaker roots that expressly repudiated luxury and ostentation. Like the Puritans before them, many Quakers arriving from the late seventeenth century sought to escape persecution and the corrupting evils of Old World vanity. The Quakers strove to rediscover austerity, simplicity, and godliness, and to regenerate themselves. From an early stage silk's moral properties were therefore debated, and would be brought into even sharper focus by the advent of the American Revolution and its accompanying republican turn away from British imports and Old World excesses.[4]

This essay argues that sericulture in Pennsylvania was pushed forward by distinctive networks of enthusiasts who were largely removed from the interests of the state. They were neither public actors (such as colonial officials) nor entirely private actors (such as planters or entrepreneurs), and were able to draw on international scientific and intellectual capital to construct new initiatives – in many ways a function of the increasingly connected and cosmopolitan nature of the maturing American colonies in the eighteenth century. These initiatives were not just pipe dreams but culminated in real, meaningful production, and this production was eventually oriented towards the domestic economy, typically in the form of sewing silk. Whereas the silk pushers tended to be public intellectuals of one sort or another, the silk growers were overwhelmingly female workers within middling households. Finally, to follow this sporadic experimentation is to better appreciate

[3] These experiments and the literature supporting them would be revisited and extended in the nineteenth century, when a host of journals and agricultural societies supported efforts at American sericulture, and women became more central to industrial manufacturing enterprises. See Ben Marsh, 'The Republic's New Clothes: Making Silk in the Antebellum United States', *Agricultural History*, 86/4 (2012), 206–34; Jacqueline Field, Marjorie Senechal and Madelyn Shaw, *American Silk, 1830–1930: Entrepreneurs and Artifacts* (Lubbock, 2007); Bonnie Stephenoff, *Their Father's Daughters: Silk Mill Workers in Northeastern Pennsylvania, 1880–1960* (Selinsgrove, 1999).

[4] For discussions of Quaker consumption, see: Deborah E. Kraak, '"Just Imported from London": English Silks in 18th-century Philadelphia', in Regula Schorta (ed.), *Eighteenth-Century Silks: The Industries of England and Northern Europe* (Riggisberg, 2000), 114. On attitudes to dress, see: Jack D. Marietta, *The Reformation of American Quakerism, 1748–83* (Philadelphia, 1984).

that it was not only the consumption and trade of silk that was dramatically globalising in the eighteenth century but also the production of silk. Americans put European botanical theories and reeling technologies to the test: they sought to improve them, to reinterpret Chinese diagrams, to hire specialists from Italy and the East Indies. This may not have been commercially successful innovation (in the sense of changing wider patterns of trade and output), but it was meaningful innovation nonetheless. For, as with the consumption and display of finished silks, the production of raw silk carried real meaning for individuals. The production of homespun silk had the capacity to sooth concerns about enjoying luxury, and to challenge commercial dependency. The finery and the avarice became someone else's, and only the honour remained. It is my wider contention that this contributed to an 'Americanisation'[5] of US sericulture in the early nineteenth century.

GOVERNORS AND COLONIAL SERICULTURE IN THE SEVENTEENTH TO EIGHTEENTH CENTURIES

The first colonists to propose sericulture in the mid-Atlantic were actually the Swedes, whose governor Johan Printz (1592–1663) arrived on the Delaware in 1643 with a royal commission instructing him to 'raise silk worms' among other activities.[6] Printz was dismissive of this objective, stating huffily that he had 'not been able to find an opportunity' and opining that the climate of New Sweden was too cold 'for keeping in that country a large quantity of silkworms'.[7] But colonial authorities insisted that silk be pursued experimentally, citing first-hand evidence of the existence of mulberry trees in the region and reports from English Virginia where silk was also being pursued. Printz's successor as governor, Johan Rising (1617–72), was interrupted by the seizure of New Sweden by the Dutch in 1655 before he could 'observe whether or not the climate will allow that silk worms can be reared, since enough mulberry trees grow there, from which silk to great advantage may in the future be obtained'.[8]

[5] By this phrase I mean not that global sericulture was influenced by the USA, but rather that American agents 'inculturated' silk production, applying notions of American exceptionalism to it.

[6] Hampton L. Carson, 'Dutch and Swedish Settlements on the Delaware', *The Pennsylvania Magazine of History and Biography*, 33/1 (1909), 10. A brief mention of New Sweden silk's failure can be found in Randall M. Miller and William Pencak, *Pennsylvania: A History of the Commonwealth* (University Park, 2002), 50.

[7] Amandus Johnson (ed.), *The Instruction for Johan Printz, Governor of New Sweden* (Philadelphia, 1930), 90, para. 21; 112, para. 7; 129, para. 3.

[8] Amandus Johnson, *The Swedish Settlements on the Delaware, 1638–64* (Baltimore, 1969), ii: 744. On contemporary Virginia, see Charles E. Hatch, Jr., 'Mulberry Trees and Silkworms: Sericulture in Early Virginia', *The Virginia Magazine of History and Biography*, 65 (1957), 3–61.

Throughout the seventeenth and eighteenth centuries, the presence of indigenous American mulberry trees (*Morus rubra*) in conjunction with assumptions about latitude and climate were held to be firm indicators that sericulture could flourish in the mid-Atlantic. When King Charles II (1630–85) granted a colonial charter to the prominent English Quaker William Penn (1644–1718) in 1681, the proprietor gave explicit recognition to silk as a colonial objective. Penn noted in a propaganda piece that the province lay at

> about the Latitude of Naples in Italy, or Mompellier in France. [...] The Commodities that the Country is thought to be capable of, are Silk, Flax, Hemp, Wine, Sider, Woad, Madder.[9]

Penn agreed twenty 'Certain Conditions or Concessions' with his major landowners in 1681, among which was the stipulation that 'in clearing the ground, care be taken to leave One acre of trees for every five acres cleared, especially to preserve oak and mulberries, for silk and shipping'.[10] That these positive commercial ambitions followed negative rules about 'Pride in apparel' demonstrated that settlers quite happily separated views of silk as a raw product from views of silks as luxurious finished goods – and they would return to this distinction when it suited them.

Given that life on the colonial frontier between 1680 and 1730 was typically hardscrabble and spartan, relatively small quantities of silk circulated – though it remained highly valued as a status indicator, and was quickly adapted to New World circumstances. Early settlers especially craved 'silk to sew withal' as requested explicitly by George Haworth (1676–1724) in his letter home in 1704.[11] Silk also became more frequently used in diplomatic exchanges with the Iroquois Indians, whose five representatives were presented with fine silk stockings, silk garters, and silk handkerchiefs instead of wampum belts (strings of shell beads signalling cultural worth) in 1722.[12] Silk handkerchiefs attached to

[9] Albert Cook Myers, *Narratives of Early Pennsylvania, West New Jersey and Delaware, 1630–1707* (New York, 1912), 207.

[10] Samuel Hazard, *Hazard's Register of Pennsylvania, Devoted to the Preservation of Facts and Documents, and Every Kind of Useful Information Respecting the State of Pennsylvania* (Philadelphia, 1828), i: 28.

[11] Letter from George Haworth, Bucks County, to family, Hapton, England, dated 14 May 1701. 'Early Letters from Pennsylvania, 1699–1722', *The Pennsylvania Magazine of History and Biography*, 37 (1913), 332–33. Haworth urged those following him across to 'bring stores of good cloth' and also noted that there were 'several sorts of grapes and strawberries plenty and mulberries and whimberries'.

[12] Minutes of meeting, Philadelphia, 11 May 1722 (items listed on p. 169), in Samuel Hazard (ed.), *Minutes of the Provincial Council of Pennsylvania from the Organization to the Termination of the Proprietary Government. [Mar. 10, 1683–Sept. 27, 1775]* (Philadelphia, 1852), iii: 167–70. For

a stick were used from time to time as signals of safe conduct on the frontier, their meaning explained symbolically as for wiping tears away and thereby recognising prior grievances. In 1756, for instance, Conrad Weiser (1696–1760) ordered two Indian messengers to 'carry a Silk Handkerchief upon a Stick on their Return, and that only two should come before and keep the path'. In earlier periods Indians possessing silk goods were sometimes assumed to have acquired them by criminal means, as when six Indians 'with several p[ar]ts of women's attire, viz: a Petticoat, White silk hood, Lace, &c' were suspected of murder during a hunting trip in 1702.[13] By the 1740s, the settler population were enjoying growing access to European-made and East India-imported silks, though still not in prodigious volume, as shown in an advert in the *Pennsylvania Gazette* (published from 1728) which announced that a paduasoy (a rich or embossed silk fabric) bonnet lined with black silk had been '[l]ent or taken by Mistake', and that 'being the Second the Owner has lately lost, she has none now to wear'.[14] The increasing array of silk goods imported and their growing cost no doubt sharpened Pennsylvanians' interest in cultivating the raw material.[15]

The first active top-down encouragement of sericulture in Pennsylvania occurred in 1726, when new governor Patrick Gordon (1644–1736) gave a speech to the general assembly. Gordon discussed plans for economic growth and new products, proposing silk because,

> Providence seems now to have pointed out one Method more for employing Even the mean & weak, as well as others of both sexes to considerable advantage [...] nothing perhaps may better deserve the Notice & Encouragement of the Legislature.[16]

Gordon went on to develop his arguments, emphasising that 'no Climate in the World is found to agree better with the Silkworm'. He recognised that '[a]s the Business is new, People will naturally be backward in falling into the Practice', but pointed out that 'all Manufactures were so at first', including

other examples, see v: 84 (twelve silk handkerchiefs); vii: 490 (large silk cloth); xi: 332 (twelve silk handkerchiefs).

[13] *Ibid.*, 2: 70, vii: 34. For wider thoughts and figures on the textile trade with Native Americans, which was dominated by woollens, see Robert S. DuPlessis, 'Cloth and the Emergence of the Atlantic Economy', in Peter A. Coclanis (ed.), *The Atlantic Economy during the Seventeenth and Eighteenth Centuries: Organization, Operation, Practice, and Personnel* (Columbia, SC, 2005).

[14] *Pennsylvania Gazette* (Philadelphia), 23 April 1741.

[15] For the best surveys of the patterns of consumption of silks in Pennsylvania, see Kraak, 'Just Imported from London'.

[16] Hazard (ed.), *Minutes of the Provincial Council of Pennsylvania*, iii: 265.

West Indian sugar (the ideal model for Atlantic colonists).[17] By 1734, Gordon informed the Board of Trade that 'some amongst us have shown how practicable a design of this kind is, by making small quantities' and that the silkworm thrived well. Its quality seemed equal 'in goodness and fineness to the best from France or Italy' and the principal problem was that 'persons are wanting to lead us into the way of winding it from the balls [...] the most difficult part of the work'.[18] The case was built around environmental fit, commercial advantage to Britain, and labour efficiency. News of these experiments does not seem to have produced legislation in the Assembly, but it gave credence to silk projects being undertaken elsewhere in the colonies, not least because the British Board of Trade was becoming increasingly efficient and integrated in its Atlantic operations. Generous patronage was offered in Georgia and South Carolina in the 1730s and 1740s, where filatures were set up, bounties offered on cocoon and raw silk production, and experts employed.[19] What seems to have tipped Pennsylvania into a more sustained and active commitment to sericulture was the addition of an extra variable from the 1760s: scientific interest and the rise of Enlightenment associations.

QUAKERS, ENLIGHTENMENT, AND SILK IN PHILADELPHIA

As a function of its dramatic commercial growth, religious toleration, and mixed population, Philadelphia developed a distinctive identity by the mid eighteenth century – evolving a vibrant print culture and expansive public sphere and discursive society. This manifested itself in an array of Enlightenment associations that spanned natural science, commerce, agriculture and the arts, including, most famously, the American Philosophical Society.[20] In 1768 this Society heard Quaker Moses Bartram (1732–1809) (one of a famous family of naturalists) read his entomological paper on 'the Native Silk Worms of North-America'. Bartram described his experiments and gave a firm recommendation to cultivate silkworms, though tellingly he had not yet attempted to unwind the cocoons he had raised. Nonetheless, they appeared to him 'much easier raised than the Italian or foreign silk worms. I did not lose one by sickness.' He was

[17] Pennsylvania Archives, 4th ser., vol. 1: 'Papers of the Governors, 1681–1747', 476.

[18] Hazard, *Minutes of the Provincial Council of Pennsylvania*, iii: 584–5.

[19] Ben Marsh, 'Silk Hopes in Colonial South Carolina', *Journal of Southern History*, 78/4 (2012); Madelyn Shaw, 'Silk in Georgia, 1732–1840: From Sericulture to Status Symbol', in Ashley Callahan (ed.), *Decorative Arts in Georgia: Historic Sites, Historic Contents* (Athens, 2008), 59–78; Giuseppe Chicco, *La seta in Piemonte, 1650–1800. Un sistema industriale d'ancien regime* (Milan, 1995), 80–92.

[20] Brooke Hindle, *The Pursuit of Science in Revolutionary America, 1735–89* (Chapel Hill, 1956).

gratified that they 'hatch[ed] so late in the spring that they are not subject to be hurt by the frost. Neither lightnings nor thunder disturb them, as they are said to do foreign worms.' Bartram's proud characterisation of the native worms offered a contribution to arguments that had long been raging about whether the Americas were inherently degenerative, challenging the notion that the New World was a site of comparative natural poverty, whose environment eroded Old World flora and fauna (following the influential naturalist and encyclopaedic author Georges Louis Leclerc, comte de Buffon, 1707–88).[21] Other scientists engaged with silkworms and the properties of raw silk in their discussions and experiments on electricity.[22] Leading intellectual figures in the northern colonies shared information, such as prints sent to Ezra Stiles (1727–95) in Rhode Island that were copied from 'Chinese Pictures Concerning the Produce of Silk' and led to a debate on whether 'the Translator of the Chinese Titles, has sometimes guess'd and mistaken the Design of the Print'.[23]

From the late 1760s, silk was treated as a 'public-spirited' design which had the capacity to merge social, scientific, and technological progress in Pennsylvania with commercial and industrial development in Britain. The public were notified in the popular almanac 'Poor Richard Improved' that 'One Million of Trees disposed into Mulberry Walks, in Pennsylvania, would in a few Years, enable a yearly Remittance to Great-Britain of a Million Sterling, and no Ways interfere with the other necessary Branches of Labour in the Community'.[24] The vehicle for considerable uptake of silk-raising in Pennsylvania was the Society for Promoting Useful Knowledge. The Society's president, Benjamin Franklin (1706–90), did an impressive job of pulling the strings via correspondence since he was based in London from 1764 to 1775. Indeed, his English residency no

[21] Richard William Judd, *The Untilled Garden: Natural History and the Spirit of Conservation in America, 1740–1840* (New York, 2009), 58, 70, and 106–7.

[22] See, for example, the various experiments involving the properties of raw and wrought silk described in letters of Benjamin Franklin to Peter Collinson, Philadelphia, September 1753; to John Lining, New York, 14 April 1757; and to Ebenezer Kinnersley, London, 28 July 1759, all listed in The Packard Institute of Humanities: The Papers of Benjamin Franklin, http://www.franklinpapers.org (*Franklin Papers Online*).

[23] They tried to triangulate the prints against the descriptions given in Jean-Baptiste Du Halde, *General History of China: Containing a Geographical, Historical, Chronological, Political and Physical Description of the Empire of China* ... (London: J. Watts, 1741). Benjamin Franklin also promised to transcribe and share 'some Accounts of the Silk in Italy'. Franklin to Ezra Stiles, Philadelphia, 12 December 1763, and 19 June 1764 in *Franklin Papers Online*. An Englishman linked to the debates about these prints was the Quaker physician John Fothergill (1712–80), who owned an extensive botanical garden in Upton, London. Richard H. Fox, *Dr. John Fothergill and His Friends: Chapters in Eighteenth Century Life* (London, 1919), 214.

[24] Benjamin Franklin, *Poor Richard Improved: Being an Almanack and Ephemeris ... for the Year of our Lord 1765* (Philadelphia, 1764).

doubt helped him to appreciate the scale of the domestic silk industry there and its insatiable demand for raw silk – he is known, for instance, to have visited the Englishman Sir Thomas Lombe's (1685–1736) famous silk throwing mill at Derby (then run by manufacturer Thomas Bennet).[25] Franklin began by sending over literature. French treatises arrived for physician Cadwalader Evans (1762–1841), and extracts were translated and shared among the Society's members. One of them was certainly by Pierre-Augustin Boissier, abbé de Sauvages (1710–95), one of two prominent Languedocian botanist brothers, born in the silk-raising centre of Alès – where Louis Pasteur (1822–95) would later undertake his ground-breaking research into silkworm diseases. The abbé de Sauvages himself had twice journeyed to Italy to study sericulture, and his detailed work on the subject introduced a rationalism and empirical aspect that was credited with improving silkworm practices in eighteenth-century France. Armed with such information, Cadwalader Evans enlisted support from like-minded Pennsylvanians, quirkily proposing at first that a premium on cocoons might be defrayed by a tax upon dogs, 'whose great number is become a nu[i]sance'.[26]

Most agreed that the best course of action was to establish a public filature in Philadelphia and to promote the growth of sufficient mulberry trees. The plans for Pennsylvania, unusually, sought to draw on lessons learnt previously in the colonies. For instance, the idea of offering premiums for mulberries was withdrawn because of the 'experience of a neighbouring government'. Silkworm eggs were to be sought from existent stocks in Georgia and Carolina. But the Society's plans hit a roadblock upon discovering that the Assembly was unwilling to fund them. Undeterred, the Society restructured its ambitions and, confident of popular support among middling and wealthy Philadelphians, went about raising a public subscription and establishing a stock company. The movement was led by, as Brooke Hindle put it, the 'very men who were most anxious to use science to advance the material welfare of the colonies'.[27]

The limits of space preclude a detailed exposition of their operations here, but it is fair to say that between 1770 and 1775 (the outbreak of the War of Independence) the company made notable progress. They commissioned publications and stocks of trees and worms, assured a market for colonial cocoons, built and equipped a filature, hired managers (including Piedmontese-born Giuseppe

[25] Journal of Jonathan Williams, Jr., of 'His Tour with Franklin and Others through Northern England', 28 May 1771, in *Franklin Papers Online*.

[26] Franklin to Cadwalader Evans, London, 7 September 1769, 8 September 1769, 17 March 1770; Cadwalader Evans to Benjamin Franklin, Philadelphia, 15 July 1769, 27 November 1769; in *Franklin Papers Online*. Boissier de Sauvages, *Mémoires sur l'éducation des vers à soie* ... (Nismes, 1763).

[27] Hindle, *The Pursuit of Science in Revolutionary America*, 201.

The MANAGERS OF THE CONTRIBUTIONS FOR PRO-
MOTING THE CULTURE OF SILK, having finally determined
the PREMIUMS offered, for raising the greateft Number of *Cocoons*,
and for REELING THE BEST SILK, for the Year 1772, hereby
inform the *Claimants* who have not yet applied, that on Applica-
tion to the Managers, they may receive the Reward annexed to
their refpective Names, viz.

Widow Stoner, Lancafter County,	72,800 Cocoons,	£ 15	0	0
James Millhoufe, Chefter Co.	41,820	10	0	0
Richard Gorman, Ditto,	34,850	6	0	0
William Hill, Philadelphia Co.	31,330	3	0	0
Phœbe Trimble, Chefter County,	29,059	3	0	0
Lewis Valaret, Philadelphia Co.	25,000	3	0	0
Cafper Farkney, Lancafter Co.	22,845	3	0	0
Mary Parker, Chefter County,	22,700	3	0	0
Catherine Steimer, Lancafter Co.	21,800	3	0	0
Mary Bifhop, Chefter County,	21,479	a Silk Reel.		
Lucia Hinton, Bucks County,	20,000	Ditto.		
James Wright, Lancafter Co.	17,600	Ditto.		
Caleb Harrifon, Chefter County,	16,500	Ditto.		

Rebecca Park, Lancafter County, for the beft Sam-
ple of reeled Silk, - - - £ 3 0 0
Jofeph Ferree, Lancafter County, for 2d beft Ditto, 2 0 0
Phœbe Cornthwaite, Bucks Co. for 3d beft Ditto, 1 0 0
A Lift of Premiums, *with the* Prices *propofed to be given for Co-*
coons, for the Year 1773, *will fhortly be publifhed.*
 N. B. Thofe Perfons who propofe raifing Silk-worms the en-
fuing Seafon, and may want a Supply of Eggs, will be furnifhed
therewith gratis, by a fpeedy Application to JOHN KAIGHN, in
Second-ftreet.
 ⁎ The City Wardens will attend at the Court-Houfe, on
Friday, the 19th Inftant, to hear fuch Perfons as may choofe to
appeal, on Account of their Rates in the Watch and Lamp Tax;
and, as this is the fecond Day allowed for that Purpofe, the War-
dens intend to clofe the Tax Books at Six o' Clock in the Even-
ing of that Day; after which no Appeal for the prefent Tax can
be heard.
 ☞ *The Piece figned by* John Johnfon, *and* Thomas Nedroe,
will be inferted in our next.

Illustration 10.1
Detail from page 3 of
the *Pennsylvania Gazette*
(March 17, 1773, Numb.
2308) containing a listing
of the prize-winning
cocoon harvesters in
Pennsylvania that year.
The Library Company
of Philadelphia.

Ottolenghi, c. 1711–75), and set up elaborate mechanisms for awarding prizes
and premiums (Illustration 10.1).[28] All of this was achieved in the face of the
particular constraints that impinged upon colonial sericulturists. Sourcing eggs
was a perennial problem, as when they discovered to their dismay that the careful
packaging of a tin can shipped from Cadiz, containing silkworm eggs from the
Spanish interior, had not prevented the eggs from hatching due to the heat in
the ship's cabin. Specialists were also difficult to locate. Had the reeling expert
Ottolenghi not been willing to move north from Georgia, plans were afoot to
'procure you such a Hand from Italy, a great Silk Merchant here having offered
me his Assistance for that purpose if wanted'.[29] Bivoltine yields were attempted

[28] For an account of Ottolenghi's origins and move to Georgia from 1752, see Chicco, *La seta in
Piemonte*, 88–90; obituary, Savannah, *Georgia Gazette*, 5 July 1775.
[29] Franklin to Cadwalader Evans, London, 27 August 1770; Cadwalader Evans to Franklin,
Philadelphia, 4 May 1771, *Franklin Papers Online*.

in the second year, but the second crops were found to be much smaller and of poor quality. In spite of such obstacles, a tone of cautious optimism was apparent. Humphry Marshall (1722–1801), a farmer-botanist in Chester County, noted:

> Our people Seems to make a great Noise about raising Silk how it will turn out I Know not. But I think not very Well this Season because We have had a severe frost So late this Spring as to kill the first Shooting of the Budds of our Mulberry.[30]

Likewise the Quaker merchant Thomas Gilphin (1728–78) stated in 1770 that 'The silk business is in a fair way and I am convinced will be of consequence if attended to'.[31] In fact, the take-up of production soon threatened to exhaust the company's capital, and in 1772 the Pennsylvania Assembly agreed to appropriate £1,000 on the condition that an equal sum were raised by popular subscription – though this had the damaging side-effect that out-of-state producers like Sabina Rumsey were no longer eligible for many premiums.[32]

KNOWLEDGE EXCHANGE AND THE PRODUCTS OF SILK

So what do we know about what was produced by these silk raisers? Samples from the first year were eagerly shipped to experts in London for their opinion on its quality. One Mr Walpole valued the silk at over 18 shillings per pound, advised on some imperfections, and promised to procure the best eggs from Valencia and 'some Reelers from Italy'. But the managers explained they had already:

> hired a Languedocian to superintend the Filature next season [who was] born and bred in the middle of a silk country [...] and having been in the East Indies, has some knowledge of their method and management of it also.[33]

A Mr Patterson offered extraordinarily detailed feedback on the specimens, recommending for instance that the water be changed more frequently in the basins, that they adjust the number of cocoons reeled off in the thread, and that

[30] Humphry Marshall to Franklin, Chester County, 28 May 1770, *Franklin Papers Online*. Marshall explicitly linked this interest to the revolutionary movement, hoping that 'there Will Be Such a Spirit of resentment Raised in the people of America against Being Brought under Slavery to a British Ministry, that Would impose Burdens on them; that they Won't Easily forget it But remember to be Industrious to Manifacture Every article that they Conveniently Can that is Necessary for their own Consumption'.

[31] Thomas Gilpin to Franklin, Philadelphia, 21 September 1770, *Franklin Papers Online*.

[32] Some two fifths of the premium payments went to New Jersey residents in 1771, for instance.

[33] Franklin to Cadwalader Evans, London, 10 February 1771; Cadwalader Evans to Franklin, Philadelphia, 4 May 1771, *Franklin Papers Online*.

they should stick with the Piedmontese reel and aim for an 'Italian' smell which
he described as 'the natural smell of the Silk when prepared in perfection'.
Dispute over the best technology persisted, and at the insistence of Samuel
Pullein (1713–84) that 'his Reel, as lately improved, is better than what you reel
with', Franklin had one made under his direction and shipped across so that the
filature managers could 'judge of it'.[34]

If global insights were being sought for American production and technology,
so too do the experiments show the extension of American influences abroad.
Pennsylvanians found out from the Austrian ambassador, an Italian, that in Italy
they had lately been using the stalks of 'Indian corn' (maize – once the staple
grain of indigenous Americans) to make grates on which to feed their worms.
New publications printed in America also attracted European attention, as when
the physician Dr John Morgan (1735–89) produced a paper in July 1775, only a
few weeks after the outbreak of the American War of Independence, entitled 'The
Whole Process of the Silk-Worm, from the Egg to the Cocon', based on material
procured in manuscript from Italy by two London silk merchants, Messrs
Hare and Skinner. And whereas one Italian-born Georgia filature manager was
lured up to Philadelphia, another counterpart, the East India Company's newly
appointed superintendent for raw silk, Pickering Robinson (n.d.), would cross
oceans to carry his experience of British imperial sericulture in the Atlantic to
the manufactories being set up in Bengal.[35]

The various technical and specialist insights into Pennsylvanian silk clearly
helped for, by 1773, a broker described it as much 'improv'd in the Winding
Part, and that some of it is equal to almost any brought to Market here'. Franklin
noted 'our Silk is in high Credit; we may therefore hope for rising Prices, the
Manufacturers being at first doubtful of a new Commodity, not knowing till
Trial has been made how it will work'. After 1771 the top-end Pennsylvania
raw silk tended to be priced only a few pence beneath Piedmontese organzine,
a remarkable achievement. As one Leicester manufacturer put it, according to
Franklin, '[t]here wants no Improvement in it [...] there wants only Quantity'.[36]
One reason for the small quantity exported to London was that, unlike many
earlier Board of Trade initiatives, the Pennsylvania filature was not geared

[34] Franklin to Cadwalader Evans, London, 4 July 1771; Franklin to the 'Managers of the
Philadelphia Silk Filature', London [Before May 10, 1772], *Franklin Papers Online*.

[35] Robinson left the Georgia filature in 1753. On the manufactories, see Karolina Hutkova's
chapter in this volume and Roberto Davini, 'Bengali Raw Silk, the East India Company and the
European Global Market, 1770–1833', *Journal of Global History*, 4/1 (2009).

[36] Franklin to Cadwalader Evans, London, 6 April 1773; Franklin to the 'Managers of the
Philadelphia Silk Filature', London, 14 July 1773, *Franklin Papers Online*; 'Extract of a Letter from
Leicester', *Pennsylvania Gazette*, 14 June 1771.

exclusively for export, but made provision to return reeled silk to the cocoon raisers for their own use. Indeed, in 1770 (the first year of operations) the silk reeled at the filature was offered for public sale within the colony instead of being exported. Even the leftover product, 'all the floss and refuse Cocoons', was to be auctioned, suggesting that there was at least some interest in home-processing waste silk (presumably by hand-combing and spinning).[37] The home market was always a significant feature of Pennsylvanian production, as shown by Humphry Marshall's observation in 1771:

> there is Numbers of people that raises Silk reels it them Selves and mixes it With Worsted Which makes Good Sort of Crape Which Some of our people have made themselves Cloathes of already.[38]

POLITICS AND THE HOMESPUN INDUSTRIES

The growing appetite for homespun silk among Pennsylvanians owed much to two distinct but overlapping motivations of 'honour' in the 1770s, and this chapter will conclude with an illustration of each of these impulses in action. Firstly, it fitted well with an era of reform as many Quakers lamented the pollution of the Society of Friends and sought to return to notions of simplicity. This was a period marked by divisions within the Pennsylvania Quaker gentry, and many followed reformist impulses to eschew lavish imported finery and return to original principles. Dressing plainly (with rustic styles and colours) was both a socio-religious statement and a fashion statement with long roots, one noted in the 1740s by Swedish naturalist Pehr Kalm (1716–79) who was quick to spot that '[a]lthough [Quakers] pretend not to have their clothes made after the latest fashion, or wear cuffs and be dressed as gaily as others, they strangely enough have their garments made of the finest and costliest material that can be produced'.[39] By the 1760s, material produced or manufactured at home, including silk, was accruing its own value. One of the first winners of the Silk Company prizes was Susanna Wright (1697–1784), a Quaker spinster poet, botanist, legal scholar, and business owner from the rural district of Lancaster County, who had long been active in silk-raising and generated 18,000 cocoons in 1773. A manuscript account of her method was discovered twenty years after her death, full of local tips – warning, for instance, that a small species of ants

[37] *Pennsylvania Gazette*, 6 December 1770.

[38] Humphry Marshall to Franklin, Chester County, 27 November 1771, *Franklin Papers Online*.

[39] Quakers were major purchasers of changeable fabrics, both in silk and wool, perhaps because changeable fabrics provided a way of introducing colour variation without adding the worldly patterns Quakers were warned against in Yearly Meetings.

'very common in Pennsylvania, is peculiarly destructive to the silk-worm'.[40] One diarist described Wright, although very accomplished and refined, as 'dressed very plain [...] her dress was of no consequence to her'.[41] But this was a misperception, for Wright's correspondence showed an intense interest in clothing. Her authority on silk production and home manufacture led to her being sent silk samples by others to comment on, including her Quaker friend and fellow poet Milcah Martha Moore (1740–1829), who apologised for the 'imperfect production' but was clearly proud to send 'a p[ai]r of silk garters rais'd, dyed & wove in our own House'. The output of such Quaker women was oriented towards the immediate household economy, and a home-manufactured finished product, home-dyed with new recipes (Illustration 10.2).[42]

The household producers of such silk homespun did not necessarily have ambitions in step with wider political economies, but their activities overlapped with a second and more dominant motivation of 'honour' that reached beyond Quakers and beyond Pennsylvania. The push for silk production starting in the 1760s coincided with the breakdown in imperial relations before and during the American Revolution (1765–83), which involved colonial boycotts, sumptuary guidelines, and wartime commercial collapse. While the republican upheavals predictably compromised imports of finished silk – a fibre so historically associated with luxury, extravagance, and status – production of the raw material was quickly adapted to revolutionary agendas. Benjamin Franklin and other enthusiasts recognised very early the advantage in the event of a break with Britain. In 1769 he wrote, 'When once you can raise plenty of Silk, you may have Manufactures enow from hence'. On several occasions silk filatures were described in terms suggestive of a covert first step towards wider manufactures (which were largely proscribed under colonial law, and explicitly so in relation to textile machinery in 1774). While Pennsylvanians publicly celebrated that 'the Article of Raw Silk may shortly become a valuable Remittance from hence

[40] Susanna Wright, 'Directions for the Management of Silk-Worms', *Philadelphia Medical and Physical Journal*, 11/1 (1804), 103–7; *Pennsylvania Gazette*, 17 March 1773; Franklin to James Wright, London, 9 July 1759, *Franklin Papers Online*. 'Susanna Wright had at one time 60 yards of mantua of her own raising. She used to manufacture herself excellent sewing silk which she dyed of different colors. Raw silk for stockings, and to stripe cotton cloth like Gingham': John Fanning Watson, *Annals of Philadelphia and Pennsylvania, in the Olden Time ...* (Philadelphia, 1870), 2: 437–8.

[41] The Historical Society of Pennsylvania, Deborah Norris Logan Diaries, 1815–39 (Collection 380), manuscript sketch of Susanna Wright, 19 March 1822.

[42] Letter from M. Moore to Susanna Wright, Philadelphia, 20 February 1771, in 'Notes and Queries', *The Pennsylvania Magazine of History and Biography*, 38/1 (1914), 123–4. A prize-winning, changeable lilac-coloured silk with warp yarns made from Pennsylvania silk is documented in a manuscript copy of 'Annals of Philadelphia', a memoir of the city first published by John Fanning Watson in 1830. The cloth was apparently used for a Quaker woman's 1774 wedding gown.

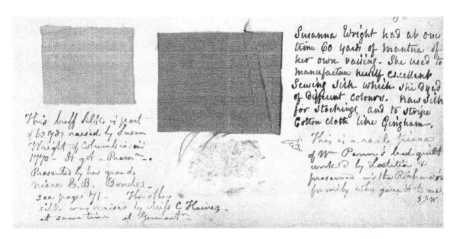

Illustration 10.2 Swatches of fabric appended to a manuscript of John
Fanning Watson, 'Extra-Illustrated Autograph Manuscript of "Annals of
Philadelphia," Germantown, 1823' Library Company of Philadelphia.
LCP Print Room: *Annals of Philadelphia*, John F. Watson, Yi 2 / 1069.F., Box 1.

to Great-Britain' in the summer of 1771, 'in Payment of the Manufactures we
receive from our Mother Country', Franklin privately used telling expressions to
describe his hopes for persevering 'in the silk Business till they have conquer'd
all Difficulties. *By Diligence and Patience the Mouse ate in twain the Cable.*' By
1773 Franklin was more explicit in his words and actions, recommending a
Quaker Spitalfields silk weaver to the Silk Company, noting 'I should think it not
amiss to begin early the laying a Foundation for the future Manufacture of it'.[43]

As resistance turned to revolution, Pennsylvanians' patriotism found expression
in their pointed celebration of silk homespun. Franklin promised to 'honour much
every young Lady that I find on my Return dress'd in Silk of their own raising',
while his daughter thanked him for having Pennsylvanian produce worked up in
Spitalfields into a 'French Grey Ducape', declaring, 'I never knew what it was to
be proud of a new Garment before. This I shall wear with pride and pleasure.'[44]
During the War of Independence, even as Franklin was posturing at the French
court in exaggeratedly humble frontiersman garb, he was liaising with British,
French, and Italian artisans with a view to accelerating silk production and

[43] Franklin to Cadwalader Evans, London, 7 September 1769 and 4 July 1771; Franklin to the
'Managers of the Philadelphia Silk Filature', London, 15 March 1773, *Franklin Papers Online*.

[44] Franklin to Deborah Franklin, London, 28 January 1772; Sarah Bache to Franklin,
Philadelphia, 30 October 1773; see also Franklin to Rebecca Haydock, London, 5 February 1772,
Franklin Papers Online.

manufacturing in the new United States.[45] Perhaps the links between experimental production and patriotism were best encapsulated in the symbolic redirection of Pennsylvanian produce in response to political ruptures. In 1772, the British Queen Charlotte (1744–1818) agreed to have Pennsylvanian silk worked up and promised to wear it on the occasion of the King's birthday. In 1779 Pennsylvanian silk was on its way across the Atlantic to the French Queen Marie Antoinette (1755–93, queen of France 1774–91), intended to 'shew what can be sent from America to the Looms of France'. Within a few decades, a twelve-foot by six-foot US silk flag woven in Philadelphia out of American-raised cocoons was presented to the House of Representatives and draped over a statue of the revolutionary hero Marie-Joseph Gilbert de Motier, marquis de Lafayette (1757–1834). Sabina Rumsey's motivational trio of finery, avarice, and honour, then, especially when combined with the changing virtues of 'homespun', turned out to be capable of sustaining investment and localised American silk production for longer than many had expected.

CONCLUSION: THE GLOBAL KNOWLEDGE ECONOMY OF SILK

Such was the state of global demand for silk fabrics by the mid eighteenth century that silkworms and their accompanying literature and technology were arriving in unlikely places. Pennsylvania was only one of a number of projecting regions to take up the challenge in the era – including other sites in the Americas, and plenty of European regions from whose populations the colonists originated, such as Sweden, Ireland, and German-speaking states. What made the Pennsylvania trials distinctive was their peculiar triangulation of an intellectual public domain (especially in Philadelphia), homespun ideology (of both Quakerism and later republicanism), and international ambitions. This meant that, though they received less direct support from the state or trading companies than other projects, they were able to draw creatively on local interests and international connections to sustain efforts. Pennsylvania's experience with transplanting thousands of mulberry trees, and bringing the culture of silkworms to a wholly unfamiliar colonial labour force, gives us a measure of how interwoven the global knowledge economy of silk was by the 1770s. Americans would remain more important as consumers than as producers of the thread of global desire, but the challenge of local production itself prompted them to develop expertise, technology, and connections, and to articulate their nationalism in new ways.

[45] See, for example, various correspondence with Penide (Lyon), Maroteau (Tournay), Giordana (Turin), Charvet (Serrières), Royle (Stockport), and Clegg (Spitalfields) in *Franklin Papers Online*.

A Global Transfer of Silk Reeling Technologies: The English East India Company and the Bengal Silk Industry

Karolina Hutková

Stiff competition in the global silk trade in the early modern period (c. 1500–1789) spurred technological innovation and new forms of labour organisation. Technology transfers played a key role. One example is the transfer of Piedmontese reeling technologies to Bengal. The English East India Company (EIC) saw the potential for high returns on raw silk from Bengal because the British silk weaving industry relied on imports for its raw material. However, Bengalese silk thread was uneven and of low quality and challenged British weaving technologies. In response, the EIC decided to adopt the Piedmontese system of silk reeling, the most advanced in Europe at the time.

The knowledge transfer envisioned and implemented by the EIC was global in nature: the expertise originated in Italy, its transmission to Bengal was managed from London, silk reeling machines were produced in England and Bengal, the silk experts that oversaw the adoption of the technology in Bengal came from Italy and England, and attempts were made to introduce silkworms from both Italy and China. This chapter studies the transfer of Piedmontese technologies to Bengal and the position of Bengal raw silk on the British market. In particular, I focus on the adoption of techniques, and the resulting changes brought about in sericulture and silk reeling.

BRITISH INITIATIVES TO INTRODUCE SILK
PROCESSING TECHNOLOGIES IN BENGAL

European politicians and elites influenced by mercantilist ideals considered the production of silk to be of strategic importance.[1] Silk manufacture produced goods of high value and generated revenues through taxation. Moreover, domestic production of silk textiles prevented the outflow of bullion to Asia to pay for imported fabrics. Thanks to government support, silk fabrics were among the principal British export goods from the seventeenth to the early nineteenth centuries. As raw silk production was impossible in the British Isles, all raw materials had to be imported from continental Europe or Asia. This trade expanded in particular in the second half of the eighteenth century. Silk was quantitatively the most important raw material imported into Britain in the 1750s and 1760s.[2] It was at this time that Bengal – by then controlled by the EIC – emerged as a key area of raw silk production for the expanding British silk industry. In order to accommodate Bengal raw silk production to the demands of the British silk weaving sector, however, the EIC relied on the adoption of new reeling technologies.

By the eighteenth century the market for raw silk had achieved a truly global scale, as pointed out by Kayoko Fujita's paper in this volume. The EIC was not the first to attempt to introduce new methods of silk reeling into regions controlled directly or indirectly by the British crown. The Trustees for the Establishment of the Colony of Georgia and the Virginia Company, a company chartered by King James I (r. 1603–25) in 1606, for instance, had also made efforts to import sericulture and silk processing technologies into the British colonies in North America.[3] The British government directly supported these attempts by supplying mulberry trees and silkworms and by exempting raw silk from import duties.[4] The EIC's attempts to increase the importation of Bengal raw silk into Britain must therefore be considered in the framework of other colonial initiatives guided by a similar logic. In contrast to the attempts made to adopt sericulture and silk reeling in North America, silk production in Bengal

[1] See, for instance, Luca Molà, *The Silk Industry in Renaissance Venice* (Baltimore, 2000), 34–6; Debin Ma, 'The Great Silk Exchange: How the World Was Connected and Developed', in Debin Ma (ed.), *Textiles in the Pacific, 1500–1900. The Pacific World: Lands, Peoples and History of the Pacific, 1500–1900* (Aldershot, 2005), 4 and 25; Mary Schoeser, *Silk* (New Haven, 2007), 13–14.

[2] B. R. Mitchell, *British Historical Statistics* (Cambridge, 1988), 463. The imports of raw, thrown, and waste silk in the period 1750–60 surpassed even the imports of flax and hemp.

[3] Ben Marsh in this volume.

[4] In 1749 an Act was passed through Parliament which exempted raw silk from Carolina and Georgia from export duties. Ben Marsh, *Georgia's Frontier Women: Female Fortunes in a Southern Colony* (Athens, GA, 2007), 28.

was successful. Moreover, it was the only project that was carried out in a country already producing raw silk.

The wild or *tussor* variety of silk had been used for textile production in Bengal for centuries before mulberry silk culture was introduced in the fifteenth century.[5] By the seventeenth century India had long been producing both raw and finished silks for domestic use and to a lesser extent for export. As British legislation in 1699, 1702, and 1720 curtailed the importation of finished silk fabrics into Britain, the EIC increasingly focused on the importation of raw silk from this market.[6] The Company nevertheless continued trading in Bengal silk fabrics, most of which were legally re-exported, particularly to the North American colonies.[7] The major raw silk producing region of India in the seventeenth and eighteenth centuries was Bengal, which supplied most of the Mughal empire (1526–40; 1555–1857 CE). Contemporary travel accounts often create a misleading impression when they suggest that Bengal was the centre of production of high-quality raw silk, confusing raw silk with finished silk fabrics.[8] It was only in the case of cotton textiles that producers in India had superior knowledge of finishing processes.[9]

Bengal lagged behind other world areas in methods of both sericulture and silk reeling. Local practices had negative consequences on mulberry cultivation, silkworm feeding, and husbandry.[10] Bengal silk workers encountered major problems in reeling silk filaments of different lengths and fineness together in the

[5] Frank Warner, *The Silk Industry of the United Kingdom: Its Origin and Development* (London, 1921), 378.

[6] K. N. Chaudhuri, *The Trading World of Asia and the English East India Company, 1660–1760* (Cambridge, 1978), 344. Prior to 1757 the Company was interested in both wrought and raw silk, it was only after 1757 that it started to focus mainly on raw silk. Indrajit Ray, 'The Silk Industry in Bengal during Colonial Rule: The "Deindustrialisation" Thesis Revisited', *Indian Economic Social History Review* 42/3 (2005), 340.

[7] Natalie Rothstein, *Spitalfields Silk* (London, 1975), 1–2. In theory, all imported silk fabrics were re-exported. However, during some periods smuggling and illegal sale of silk increased. Ray, 'Silk Industry in Bengal during Colonial Rule', 344–5 and 359–64.

[8] François Bernier, *Travels in the Mogul Empire* (London, 1826), vol. 1, 439; Jean-Baptiste Tavernier also shows admiration for Indian silks. Jean-Baptiste Tavernier, *Travels in India* (London, 1889), vol. 2, 2–4.

[9] See Prasannan Parthasarathi, 'Cotton Textiles in the Indian Subcontinent, 1200–1800', in Giorgio Riello and Prasannan Parthasarathi (eds.), *Spinning World: A Global History of Cotton Textiles, 1200–1850* (Oxford, 2009), 17–42.

[10] British Library (BL), India Office Records (IOR), Bombay (Misc. Public Documents, etc.), 1793.m.17: 'Letter from Giuseppe Mutti to John Bell Esquire on 20th October 1838', India Office Records and Private Papers, 5–7. See also the analysis of sericulture from 1779 by Mr Atkinson, resident at Jungypore, cited in full in J. Geoghegan, *Some Account of Silk in India, Especially of the Various Attempts to Encourage and Extend Sericulture in that Country* (Calcutta, 1872), 7.

same skein. Often colours were mixed or silk threads were dirty or unfit for use.[11] As a consequence many silk skeins contained silk made of single, double, triple, or even quadruple parts. Overall Bengal raw silk failed to attain many of the key attributes of good quality silk such as lightness, and even quality of silk thread in terms of fineness, smoothness, and strength.[12] The silk had to be re-reeled before it could be used for throwing or weaving in Britain. Its use in Europe was limited to haberdashery, in particular ribbons, and often it was unfit even for such production.[13] The quality of Bengal raw silk available to British industry was often so inadequate that at times it threatened to halt the trade altogether.[14] The Court in London, as the principal managerial body of the EIC, commented that:

> the Badness of the Raw Silk has been of late the occasion of constant complaint and unless it is provided cheaper and better that once valuable article can have no share in our Trade.[15]

The EIC countered by having the silk re-reeled before sending it to Europe. Yet even the re-reeled silk was not necessarily sellable in Britain.

In a further attempt to improve the quality of raw silk, the EIC consulted a silk specialist from Europe, the silk manufacturer Richard Wilder (d. 1765), who travelled to Bengal in 1757.[16] Wilder was succeeded by another specialist, Joseph Pouchon (dates unknown), but neither managed to improve the quality of local Bengal raw silk. The key problem was that the EIC was unable to enforce even the slightest change to reeling practices under the established putting-out

[11] BL, IOR, 'Letter from Giuseppe Mutti', 7. Chaudhuri, *Trading World of Asia*, 346. However, it would be a mistake to suppose that filaments of different fineness and length were reeled into one skein only in Bengal. It seems that these problems were connected with household reeling in general, especially in regions where incentives for high-quality silk production were wanting. For instance, low-quality raw silk was also reeled by households in Provence, France. See: Paris, Archives Nationales, Serie F12, F12 677A.

[12] BL, IOR/E/4/616: 'Bengal Raw Silk to be Investigated by Richard Wilder, 25 March 1757', India Office Records and Private Papers, 557.

[13] Royal Society of Arts, London, SC/EL/2/31, *Third Report of the Committee of Warehouses of the East-India Company relative to Extending the Trade on Bengal Raw-Silk* (London, 1795), 6–7 and 11–14.

[14] London School of Economics and Political Science Library (LSE) Archives, W7204, *Reports and Documents Connected with the Proceedings of the East-India Company in regard to the Culture and Manufacture of Cotton-wool, Raw Silk, and Indigo in India* (London, 1836), iv.

[15] BL, IOR/E/4/616: 'Bengal Raw Silk Investigated by Richard Wilder, 25 March 1757', India Office Records and Private Papers, 656.

[16] *Ibid.*: 'Bengal Raw Silk to be Investigated by Richard Wilder', Bengal Supplement 25 March, 1757, 557–60.

system.[17] For example, Wilder and Pouchon suggested changing the system of knotting silk. This proposal was strongly opposed by the reelers, who refused to implement any new techniques and deserted their work.[18] Consequently, the consultants rarely got past the stage of experimentation and were unable to improve the quality of Bengal raw silk.[19]

THE PIEDMONTESE SYSTEM IN BENGAL

By the 1750s, the EIC realised that without an improvement in quality Bengal raw silk would never be competitive on the British market. Spurred by the mounting dissatisfaction of British silk weavers and encouraged by the belief that the 'Piedmontese technology [had] a universal capacity to upgrade local production', the EIC decided to transfer Italian reeling techniques to Bengal (Illustration 11.1).[20]

Exactly when the Piedmontese reeling machine was invented is unknown.[21] Reeling machines were well documented in the second half of the seventeenth century and the Kingdom of Savoy made their use compulsory in 1667.[22] The reeling machine's main technical innovation lay in a system for crossing silk threads that brought about several benefits as it helped to 'squeeze water from

[17] LSE Archives, W7204, *Reports and Documents*, v; BL, IOR/G/23/13, 'Factory Records: Kasimbazar, 1757–59', India Office Records and Private Papers, 7 October 1758, 108. The putting-out system is closely linked with proto-industrialisation. The concept of proto-industrialisation was developed by Franklin Mendels and is based on the growth of market-oriented but traditionally organised rural industries in Europe before the Industrial Revolution. Without a putting-out system merchants or merchant-manufacturers subcontracted certain manufacturing activities to offsite workshops or households, often in rural areas, in order to decrease labour costs, Franklin Mendels, 'Protoindustrialization: The First Phase of the Industrialization Process', *Journal of Economic History*, 32/1 (1972), 241–5. The putting-out system varied in different parts of Europe. Thus, it is no surprise that it is still disputed whether the concept can also be applied to pre-modern Asia. In the case of the silk industry it is possible to argue along the lines of Frank Perlin, who argued that the system of organisation of production in pre-colonial South Asia was similar to that of the rural industries of Europe. Frank Perlin, 'Proto-Industrialization and Pre-Colonial South Asia', *Past and Present*, 98/1 (1983), 84–94.

[18] BL, IOR/G/23/13, 7 October 1758, 108.

[19] LSE Archives, W7204, *Reports and Documents*, v; BL, IOR/G/23/13: 7 October 1758, 108.

[20] Roberto Davini, 'A Global Supremacy: The Worldwide Hegemony of the Piedmontese Reeling Technologies, 1720s–1830s', in Anna Guagnini and Luca Molà (eds.) *History of Technology*, vol. 32 (London, 2014), 90–1.

[21] The silk reeling machine depicted in Illustration 11.1 represents a modified version of the machine from the 1830s. Although of a later date, like the Piedmontese reeling machine, it is not steam-powered.

[22] Claudio Zanier, 'Pre-Modern European Silk Technology and East Asia: Who Imported What?', in Ma (ed.), *Textiles in the Pacific*, 128. Subsequent decrees detailed which reeling machines should have been used and their modifications in the eighteenth century.

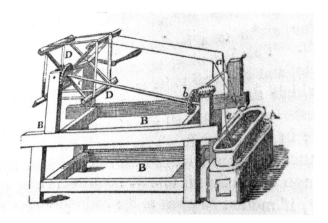

Illustration 11.1 Piedmontese Reeling Machine as depicted in Lardner's *Treatise* (1832)
Source: Dionysius Lardner, *A Treatise on the Origin, Progressive Improvement, and Present State of the Silk Manufacture* (Philadelphia: Carey & Lea Chestnut Street, 1832), p. 155.

the threads, remove impurities, render the thread more round, and compact the filaments in the thread'.[23]

There is no surviving image of the reeling machine used in Bengal. According to an 1838 EIC publication, the machinery used was identical to that described in Dionysius Lardner's (1793–1859) *Cabinet Cyclopædia* (published 1829–46). The image in the *Cabinet Cyclopædia* did not contain a double-crossing implement, however, which was the central innovation of the Piedmontese reeling machine. Lardner's work, as well as other contemporary sources on silk, shows a lack of knowledge in Britain about double-crossing in silk reeling. Yet double-crossing machines were introduced to Bengal as early as the 1770s, thanks to the fact that James Wiss (n.d.), the main silk specialist employed by the EIC, was familiar with the machines used in Piedmont.[24]

The image illustrates a reeling machine consisting of three parts: component A depicts the boiler (or basin), B the frame, and D the reel. A fire heated the water in the basin in which the cocoons were placed so that the gummy substance binding the filaments would temporarily dissolve. Filaments were gathered through the reel (D) that consisted of wheels with a defined number of teeth, cogwheels, and staves. A double-crossing machine was used to make sure that the thread did not have any lumps.[25] Reels and wheels had to be constructed with

[23] *Ibid.*, 130, 142 and 146–9.
[24] LSE Archives, W7204, *Reports and Documents*, 16.
[25] BL, IOR/E/4/625, 9 April 1777, 209; IOR/E/4/627, 12 July 1782, 349; IOR/E/1/65, ff. 440–441v: 20 December 1779, 440.

a defined number of teeth to enable the reeling of high-quality silk thread of different dimensions. The staves had to be set at a defined distance from each other in order to reel silk thread in the dimension generally demanded by the European market: 40 inches long and 80 inches in circumference.[26]

Initially, all the equipment was produced in the town of Novi near the region of Piedmont and transported to Bengal.[27] From the second half of the 1770s, British workshops produced models of the equipment and sent them to Bengal where copies were made.[28] From 1769 to 1796 the EIC sent 3,825 sets of cog wheels and 3,833 double-crossing machines to Bengal.[29]

Reeling machines required considerable capital investment, the costs were too high for household use. In Piedmont, the introduction of reeling machines substantially changed the organisation of production. By the late seventeenth century reeling was done in filatures – factory-like establishments.[30] Filatures had a hierarchical structure of management; reelers were supervised and had to submit to factory discipline. Reeling silk in filatures was meant to ensure a high quality of reeled silk as well as an increase in the productivity of reelers.[31]

Bricks and wood such as bamboo, teak and malaca were used for the buildings as it was necessary to use materials which were able to stand up to the monsoon climate.[32] The first filatures were established in the principal silk producing regions of Bengal, in Bauleah, Commercolly, and Kasimbazar. The Commercolly filature had the largest capacity with 208 furnaces.[33] The Bauleah and Kasimbazar filatures had 104 furnaces each.[34] Each furnace was furnished with three reels accommodating an equal number of reelers.[35] The costs of setting up a filature were significant, amounting in Bauleah, Commercolly, and Kasimbazar to an estimated 284,287 sicca rupees (£30,798).[36]

[26] BL, IOR/E/4/626, 12 May 1780, 105; IOR/E/1/66, ff. 422–424v: 'Letters 212–13', 10 May 1780, 424.

[27] BL, IOR/E/4/620, 27 January 1771, 396.

[28] BL, IOR/E/4/625, 14 July 1779, 485–6; IOR/E/4/626, 12 May 1780, 107; IOR/E/4/640, 25 June 1793, 523.

[29] BL, IOR/E/4/626, 12 May 1780, 99; IOR/E/4/625, 14 July 1779, 484; IOR/E/4/629, 8 July 1785, 91.

[30] BL, IOR/E/4/629, 8 July 1785, 6–7, 15.

[31] BL, IOR/G/23/13: 'Factory Records: Kasimbazar, 1757–59', 15.

[32] Roberto Davini, 'Una Conquista incerta: la compagnia inglese delle Indie e la seta del Bengala, 1769–1833' (unpublished Ph.D. thesis: European University Institute, 2004), 230–2 and 247.

[33] BL, IOR/E/4/625, 9 April 1779, 131–9; IOR/E/1/61, ff. 355–357v: 3 September 1777, 356–7.

[34] BL, IOR/E/1/61, ff. 355–357v: 3 September 1777, 357.

[35] BL, IOR/E/1/61, ff. 486–487v: 18 November 1777, 486.

[36] BL, IOR/E/4/625, 9 April 1779, 131–2.

FOREIGN SILK SPECIALISTS IN BENGAL

The EIC relied on foreign specialists to set up the filatures, supervise their building, and retrain silk reelers in the new reeling method. Their role was so essential to the success of the transfer that the EIC continued to depend on their knowledge after the initial setting-up phase. Silk specialists worked as supervisors of the EIC's silk trade in both Bengal and London.

In 1769 the EIC contracted three European silk specialists – James Wiss from Italy, Pickering Robinson from England, and William Aubert from France – to become superintendents of the EIC's silk investment in Bengal and to set up silk filatures.[37] Aubert died before he took up his post in Bengal. Robinson already had experience in transferring the Piedmontese reeling method to a new environment – his contribution to silk production in North America is mentioned by Ben Marsh in this volume. He had been entrusted by the Trustees of the Georgia colony to promote silk production there.[38] Wiss, though, had the largest impact on EIC silk manufacturing. As he was acquainted with Piedmontese reeling methods, his experience made him a very valuable servant of the EIC in Bengal. He was instrumental in the introduction of the double-crossing machines and planned modifications of the reeling machinery to adapt it to the Bengal climate.[39] Wiss worked for the EIC in Bengal until 1777. Each of the superintendents was accompanied by reelers or mechanics to assist him in training the Bengalese workforce to use the Piedmontese reeling technology.[40]

The superintendents were first stationed in Puddapar, Bauleah, and Rungpore, the principal silk *aurungs* (processing regions) of Kasimbazar.[41] Once silk filatures were established in their respective *aurungs*, they were moved to other silk *aurungs* in order to 'encourage a spirit of emulation [so] that the method of spinning and drawing the silk as practiced at Novi [...] should be entirely

[37] LSE Archives, W7204, *Reports and Documents*; Goldsmiths' Library of Economic Literature, Senate House Library, University of London [GL], 1795, f. 16280, *Reports of the Committee of Warehouses of the East-India Company relative to Extending the Trade on Bengal Raw-Silk* (London, 1795), xi; BL, IOR/E/4/619, 31 January 1770, 655–6.

[38] Marsh, *Georgia's Frontier Women*, 60.

[39] BL, IOR/E/1/63, ff. 158–160v: 'Letters 70–1 James Wiss in London to the Court Making Proposals Relating to Alterations in the Filature of Raw Silk at Calcutta', 28 October 1778; IOR/E/4/625, 14 July 1779, 484–6.

[40] James Wiss, a resident of Piedmont, was accompanied by four Italian reelers (J. Rugiero, Dominicus, C. Bricola and Augustus Della Casa). Pickering Robinson was accompanied by three Italians (Francis Clerici, Pielo [sic] Spera and Paulo [sic] Erva). William Aubert was accompanied by three reelers from Languedoc (Anthony Broche, Anthony Burgnier and John Peter Angoia) and by the mechanic James Demarin. LSE Archives, W7204, *Reports and Documents*, xi.

[41] BL, IOR/E/4/619, 31 January 1770, 658.

adopted throughout the whole Country'.[42] The silk specialists and mechanics were successful in their tasks and the first filatures, in Bauleah, Commercolly, and Kasimbazar, started to produce silk in 1773.[43] The EIC seem to have been satisfied with the silk specialists; James Wiss, for instance, was given a gratuity of £1,000 for his services in Bengal.[44]

Originally the EIC had intended to contract silk specialists only until filatures were built across Bengal and the EIC's servants were capable of overseeing the production of filature silk themselves. The EIC's Court in London repeatedly stated that they wished 'to see some of our Junior Servants initiated to render them perfectly capable of improving the quality of a chapter of such national consequence'.[45] But the services of the silk specialists proved indispensable as, even after the implementation of the Piedmontese method, the raw silk was of sub-standard quality. Again, the EIC decided 'to consult those persons who, from their long practice and experience in that branch of business, might be enabled to give us assistance, by suggesting proper observations and directions on the subject'.[46]

The Company also employed silk specialists in London. Their principal role was to assess and report on the quality of the silk imported from Bengal, help identify the causes for the deficiencies of the production of raw silk unsuitable for the British market, and recommend solutions. The creation of a formal position was suggested by James Wiss himself:

> I still believe that an Inspector of the Bengal Raw Silk at your Warehouses here [London], may supply the place of a Superintendent General in Bengal, if not exactly to all Intents and purposes, at least very Essentially; particularly being acquainted with the quality of Cocoons in Bengal at the different seasons of the year, he may make choice of samples of such Italian silks as may be imitable at each Factory, and have them fixed as the standards by which the spinners ought to Work; and by examining the produce of every Factory separately, and making his remarks, this Inspector will find out from whence the defects originate and point the means of avoiding them.[47]

[42] BL, IOR/E/4/620, 23 March 1770, 28.

[43] The filature in Kasimbazar with 208 furnaces was producing approximately 20,565 sm. lbs. in the period 1773–79. IOR/E/4/625, 9 April 1779, 131–2.

[44] *Ibid.*, 133–4.

[45] BL, IOR/E/4/621, 7 April 1773, 471.

[46] BL, IOR/E/4/623, 4 July 1777, 635.

[47] BL, IOR/E/1/63, ff. 90–91v: 'Letter 41 James Wiss in London to Sir George Wombwell Proposing the Appointment of an Inspector of the Bengal Raw Silk and Offering His Services for Such a Post', 8 September 1778, 90.

Upon his return to Europe Wiss was appointed Inspector of the Bengal Raw Silk in London in 1777 and 'continued in the EIC's home service for many years'.[48] Throughout the 1780s and 1790s Wiss and a 'Mr Tatlock' undertook this role.[49]

The principal role of the Inspectors in London was to create instructions for the silk filatures in Bengal, to specify best and worst practices, and to discuss trade in raw silk and the cost of production of filature-reeled silk.[50] On his return to London from Bengal, Wiss provided guidelines based on his experience. These became an essential reference source that was still published by the EIC in 1836. As the Court in London put it, 'by due attention to proper rules, and to the various means of improvement herein suggested, the greatest degrees of perfection will soon be attained'.[51]

The original version of the Wiss guidelines of 1777 and the version published in 1807 are extensive and provide precise directives for the directors of the filatures and overseers in Bengal. Wiss started with basics such as the necessity of supplies of clear water and dry wood because clean water was essential for the brilliance of the silk and dry wood kept the water in the basins boiling steadily. The guidelines include topics such as the storage of cocoons, how to avoid cocoons fermenting, how to use ovens to kill the moths inside the cocoons and the like. The guidelines specified the number of cocoons that were to be used for reeling in each bund and considered the differing quality of cocoons over the rearing season.[52]

The overseers were directed not 'to insist on more work being done in a day than is found practicable'.[53] On the one hand, slow reelers were not to be penalised as this would lead them to favour quantity over quality. On the other hand, the overseer was directed to ensure that reelers worked efficiently. At the beginning of each season, all of the overseers and the director of the factory were to observe the most capable reelers as they produced a sample of the season's

[48] LSE Archives, W7204, *Reports and Documents*, xvii, and 16; BL, IOR/E/4/625, 9 April 1777, 171. The post of Inspector of the Bengal Raw Silk in London was accompanied by the creation of the post of Superintendent General in Bengal as well as by the posts of Superintendents of Warehouses in Calcutta.

[49] Mr Tatlock was the silk specialist most often mentioned after James Wiss. However, it seems that Tatlock was not given the same level of trust as Wiss. For instance, Tatlock did not have access to the EIC's trade and procurement records and he was only allowed to inspect the bales of raw silk imported to London. BL, IOR/E/4/635, 19 May 1790, 804.

[50] See, for instance: BL, IOR/E/1/63, ff. 158–160v: 'Letters 70–1 James Wiss in London to the Court making Proposals Relating to Alterations in the Filature of Raw Silk at Calcutta, Related papers attached', 24 October 1778, 158–9; IOR/E/1/66, ff. 550–552v: 'Letters 278–79 James Wiss in London to the Court Relating to Silk Manufacture and Orders for Equipment', 10 June 1780, 550–2.

[51] BL, IOR/E/4/625, 'Mr. Wiss Superintendent of Silk Trade, 9 September, 1777', 198.

[52] *Ibid.*, 173–205.

[53] *Ibid.*, 206.

production.[54] The overseers and the director of the filature needed to ensure that the sample would be of very high quality and that everyone involved in overseeing production would be aware of the quality expected. The guidelines also insisted all silk be labelled with the name of the overseer and the director of the filature in order to guarantee direct responsibility for the quality of the produced silk.

CHANGES IN ORGANISATION OF LABOUR, PROCUREMENT, AND SERICULTURE

The adoption of the Piedmontese technology inevitably altered the procurement and organisation of labour in Bengal silk production. These changes had marginal reverberations in the organisation of sericulture as production methods in sericulture were not very affected by the new reeling system and no EIC attempts to implement changes to sericultural practices ever got past the stage of experimentation. The same cannot be said of reeling. Prior to the implementation of the Piedmontese system, reeling was carried out in households by its members or by male reelers travelling around Bengal during the cocoon harvest season. The raw silk was then sold on the local market or purchased by intermediary merchants on behalf of the EIC. Under the new system, however, reeling was done in filatures under strict supervision. It appears that reelers were mainly paid piece wages.[55] The Court in London specified one overseer for every forty furnaces (120 reelers) as was the rule in Italy.[56] Yet in reality numbers differed.[57]

The changes in reeling also affected procurement. The EIC now procured cocoons instead of reeled silk. At the beginning of each season, *pycars* – contracted agents described by the EIC as 'men […] who go around the country collecting [cocoons]' – received advances to pay the *chassars* – peasants involved in sericulture.[58] The storage and processing of cocoons became the task of filatures since

[54] *Ibid.*, 208.

[55] This was a major difference compared with how reelers were paid in filatures in Piedmont, where they were paid time wages. This was supposed to incentivise the reelers to favour quality over quantity of production. Roberto Davini, 'The History of Bengali Raw Silk as Interplay between the Company Bahadur, the Bengali Local Economy and Society, and the Universal Italian Model, c. 1750–c. 1830', Commodities of Empire Project, Working Paper 6 (2008), 15.

[56] BL, IOR/E/4/625, 9 April 1777, 219.

[57] *Ibid.*, 176–212.

[58] Before the implementation of the Piedmontese system, the EIC relied on several merchant agents to procure raw silk for the European market. After the new system was adopted, the Company only relied on contractors for the procurement of cocoons. At the beginning of each season, *pycars* were given advances intended for the peasants, the *chassars*. These advances were supposed to enable the peasants to buy silkworm eggs. BL, IOR/E/4/630, 21 July 1786, 548. The *chassars* were often

the introduction of the Piedmontese system was accompanied by the practice of using ovens to kill the moths inside the cocoons.[59] Upon arrival at the filature, cocoons were placed in the oven and then cleaned.[60] The aim was to improve the quality of cocoons and the EIC paid special attention to the guidelines on the storage of cocoons. In particular, it was emphasised that only 'good cocoons', meaning cocoons that had not undergone fermentation – a process of decomposition – were to be used for reeling in the Bengalese filatures.[61]

In Piedmont the introduction of the new system did have reverberations in sericulture as it compelled Piedmontese 'producers to raise cocoon quality'.[62] The EIC though made no serious attempt to alter sericulture in Bengal. The EIC's silk specialists pointed out that sericultural practices were no less problematic than those of silk reeling. One of the silk specialists contended that 'notwithstanding the ability of workmen, perfect silk cannot be reeled from bad cocoons'.[63]

According to the EIC's silk specialists, several ineffective practices employed in Indian sericulture negatively affected the quality of the cocoons. Among such practices were the training of mulberry as a shrub; opposition to feeding the worms with mulberry tree leaves; economising on mulberry leaves consumption; keeping worms crowded on mats and the method of killing the moth inside a cocoon; as well as the improper handling of silkworms and eggs facilitating their 'degeneration'.[64] Cultivating a mulberry shrub instead of a tree was based on the widespread belief that mulberry trees would otherwise not survive the climatic conditions of Bengal. Experiments by the EIC's silk specialist Giuseppe Mutti (d. 1850), who proved that mulberry trees could be cultivated in Deccan, showed this to be incorrect. Mutti considered this practice the most serious obstacle to getting better quality cocoons as the shrub's yield was much lower than that of a tree. In addition, shrubs were labour intensive and necessitated high land input.[65]

The EIC, deterred by the high investment of time and money that it would require, never attempted to alter sericulture. Also many doubted that the EIC's

unwilling to sell cocoons to the Company because they could earn more if they reeled the cocoons and sold the silk thread on the local markets. Davini, 'Una Conquista incerta', 47.

[59] Previously cocoons had been exposed to the sun. BL, IOR/E/4/625, 9 April 1777, 177–200.

[60] *Ibid.*, 199–200, 220.

[61] *Ibid.*, 173–84.

[62] Zanier, 'Pre-Modern European Silk Technology and East Asia', 139.

[63] BL, IOR, 'Letter from Giuseppe Mutti.

[64] *Ibid.*, 5–7; Atkinson, as cited in Geoghegan, *Some Account of Silk in India*, 7.

[65] The practice of cultivating mulberries as shrubs was also criticised by James Frushard, the superintendent of silk investment in the 1780s. IOR, Bombay (Misc. Public Documents, etc.), 1793.m.17: 'Letter from Giuseppe Mutti', 5; West Bengal State Archive, BoT (Comm) Prcds 13 January 1789: Observations of the Superintendent of Silk Investment, as cited in Davini, 'Una Conquista incerta', 67.

influence would reach far enough to effect a change. For instance, Mr Atkinson championed a method of establishing 'breeding houses or nurseries under the inspection of silk agents for the purpose of rearing cocoons for supplying the filature'.[66] George Williamson, a former servant of the EIC in Bengal, proposed appropriating the land around filatures for the cultivation of mulberry trees with huts to rear silkworms on the grounds.[67] He also wanted the EIC to employ whole families: men for mulberry cultivation, women for the silkworm rearing and children for silk reeling.[68] Numerous documents underline the EIC's inability to influence local production and trade patterns and hence the rearing of silkworms, which remained a household activity in Bengal until the nineteenth century, as it did in other regions of the world.[69]

The EIC's only attempt to get directly involved in sericulture was when it tried to introduce foreign breeds of silkworms, in particular Italian and Chinese kinds. These efforts never progressed beyond the stage of experimentation. Eggs dispatched from Europe hatched on the way and the worms starved because a regular supply of leaves could not be provided.[70] Attempts to introduce silkworms from China equally failed.[71]

Instead of focusing on sericultural practices that it could not alter, the EIC concentrated on issues in which it could effect a change, such as the storage of cocoons which could impact the quantity of silk thread and qualities such as colour and consequently the EIC's profits:

> Supposing a quantity of Cocoons, this taken care of produce 1000 lb. of good Silk; the same quantity, and of the same kind, not carefully placed, not frequently turned, will probably not produce 950 lb., perhaps not near so much, of inferior Silk, indifferent in quality, and defective in colour; for Cocoons neglected will grow mouldy, and from this will originate all the evils above specified respecting Silk spun from damaged Cocoons. It will not be in the power of the Spinners to prevent Silk made from such Cocoons from being discoloured; the Contractors will get nothing by it; and the Company

[66] Atkinson, as cited in Geoghegan, *Some Account of Silk in India*, 7.

[67] GL, 1775 fol., Williamson, *Proposals*, 17–18.

[68] *Ibid.*, 18.

[69] LSE Archives, W7204, *Reports and Documents*, xxxiv. Giovanni Federico has argued that the principal reasons for sericulture to remain a household activity were its labour intensity and the high costs of supervision that centralisation of sericultural production would incur. Giovanni Federico, *An Economic History of the Silk Industry, 1830–1930* (Cambridge, 1997), 16.

[70] In this respect the EIC cites the problems encountered in the attempt to bring sericulture to St Helena. Most of the silkworms died during the journey due to lack of nourishment. LSE Archives, W7204, *Reports and Documents*, xv–xiv.

[71] Geoghegan, *Some Account of Silk in India*, 5–7.

will loose the profit, which they would otherwise gain, upon Silk made from good Cocoons.[72]

The Court ordered the removal of 'every Cocoon that is bruised, or in which the Worm has been squashed' as it 'will spoil as many good Cocoons as come in contact with it; and all such Cocoons will grow mouldy, foul the water in the Pan exceedingly; and infallibly cause the Silk to be of bad Colour'.[73]

CONCLUSION

This chapter focuses on the topic of technology transfers. Looking at technology transfer illustrates some of the global interconnections in the early modern silk industry, in particular, the role of silk specialists in transmitting technologies. Silk specialists made exchanges between adjacent regions possible. For example, Robinson applied his knowledge of sericulture and silk reeling in both North America and Bengal. Wiss played a key role in transferring the knowledge of Piedmontese reeling machinery to Bengal. These knowledge transmissions were coordinated by settler organisations and trading companies in North America and the EIC in Bengal. This illustrates the keen interest of the English to tailor silk production in foreign regions under their rule to the needs of their domestic silk weaving sector. The EIC was the major actor and its activities were based on the pursuit of profits, knowledge of the domestic political economy and development of global markets.

In the 1760s, the EIC was interested in expanding the exports of Bengal raw silk which proved to be of insufficient quality. To improve the situation they transferred the Piedmontese system of reeling as they believed that considerable improvement to the quality of reeled silk could be achieved by the adoption of the Piedmontese reeling machine, along with the centralisation of production in filatures and supervision of reelers. This necessitated changes in the organisation of labour and procurement. Foreign silk specialists who made themselves indispensable to the EIC became crucial to the implementation of the new techniques.

The EIC's involvement in sericulture never got beyond the experimental stage. The Court's reluctance to get involved in the control of sericulture should be seen as part of the EIC's general procurement policy, which favoured the procurement of finished products over direct involvement in production.[74] The involvement in silk reeling was an exception motivated by the belief in a profitable and promising market for good quality Bengal raw silk.

[72] *Ibid.*, 182–4.
[73] *Ibid.*, 172–4.
[74] BL, IOR/E/4/630, 12 April 1786, 272.

12.

Changing Silk Culture in Early Modern Japan: On Foreign Trade and the Development of 'National' Fashion from the Sixteenth to the Nineteenth Century[1]

Fujita Kayoko

Tokugawa Japan (1603–1868) was in political and economic turmoil when Philipp Franz von Siebold, a former resident physician at the Dutch factory on Deshima Island in Nagasaki (1823–28), returned to the country in 1859 as an adviser to the Nederlandsche Handel-Maatschappij (Netherlands Trading Society). After being expelled from the Tokugawa Shogunate in 1828 for trying to smuggle detailed maps of the country overseas, he quickly established a solid reputation in Europe as a scholar of Japan through his seven-volume *Nippon* (1832–52), a definitive work of exhaustive scholarship on Japanese ethnography. During von Siebold's two service periods in Japan, the elaborate and artistic craftsmanship of Japanese silk textiles caught his attention. Pieces of silk textiles and silk threads that he brought home as scientific and commercial samples can still be found in the collection at the Japan Museum Sieboldhuis in Leiden, South Holland. In addition to its beauty, von Siebold recognised the great potential market value of Japanese silk in Europe. In his petition to Louis-Napoléon Bonaparte III (1808–73) to promote French–Japanese trade, entitled 'Projet de société inter-nationale pour l'éxploitation industrielle et commerciale du Japon' (Paris, 26 November 1865), he emphasised that raw silk was already the most important export item from Japan and that the excellent quality of its hand-woven silk textiles and embroidery made them eminently suitable for the European market.[2]

[1] This work was supported by the Japan Society for the Promotion of Science (JSPS) KAKENHI Grant Numbers 24652138 and 90454983.
 [2] Miyazaki Michio, 'Shīboruto no Nihon Kaikoku Kindaika eno Kōken' [von Siebold's Contribution to the Opening and Modernisation of Japan], in Yanai Kenji and Miyazaki Michio (eds.), *Shīboruto to Nihon no Kaikoku Kindaika* (Tokyo, 1997), 297–9.

As von Siebold observed, immediately after the Tokugawa shogun was forced to sign the Treaty of Amity and Commerce to open the national market to trade with the United States in 1858, silkworm eggs and raw silk became major export items to America and Europe.[3] In 1872, the newly established Meiji government (1868–1912) founded the National Tomioka Silk Mill, the first modern model silk-reeling factory in Japan, to introduce and spread modern machine silk-reeling technology in the Empire of Japan (1868–1947). Thus, export-oriented raw silk production became the nexus of the newly industrialising economy of Japan for the following eighty or more years.[4]

This raises the question of how Japan successfully achieved the transformation from silk importer to silk exporter in just two and a half centuries. The knowledgeable von Siebold was well aware that the Dutch East India Company (de Verenigde Oostindische Compagnie, henceforth VOC, 1602–1799) enjoyed its heyday in the first half of the seventeenth century by supplying silk yarn and fabrics to Japan from diverse production locations across Asia.[5] During this time, the central government in Edo (current Tokyo) prohibited overseas navigation by ordinary Japanese, limited contact with foreigners to four designated gateways, and placed the country's overseas trade under strict control. Without direct technology transfer from places with a well-established sericulture and silk industry such as China, it is of interest to understand how Japanese raw silk and textile producers accomplished such artistic and technical excellence to find markets for their products in the West in the mid-nineteenth century.

This chapter traces the long and complex processes through which the silk industry of Tokugawa Japan 'de-sinicised' itself through technological development and import substitution at a time when Japan's overseas trade was declining.[6] First, I examine the long-term statistics of silk products, with a

[3] Itō Tomoo, *Kinu* [Silk], vol. 1 (Tokyo, 1992), 293–94.

[4] Itō, *Kinu*, vol. 1, 308–9. Yamazawa Ippei, 'Kiito Yushutsu to Nihon no Keizai Hatten' [Japanese Silk Exports and Economic Development], *Hitotsubashi Daigaku Kenkyū Nenpō Keizaigaku Kenkyū*, 19 (1975), 57–9. The Tomioka silk mill (in present-day Gunma Prefecture) was inscribed on the UNESCO World Cultural Heritage list in June 2014. See the Tomioka silk mill website at http://www.tomioka-silk.jp/hp/en/index.html.

[5] Philipp Franz von Siebold, 'Abteilung VI, Landwirtschaft, Kunstfleits und Handel', *Nippon: Archiv zur Beschreibung von Japan und dessen Neben- und Schutzländern Jezo mit dem südlichen Kurilen, Sachalin, Korea und den Liukin-Inseln*, vol. 2 (Würzburg and Leipzig, 1897), 146–72 and 194–206, passim.

[6] This chapter builds on and extends my 2004 conference paper published in 2013. It develops the arguments regarding the mutual or reciprocal relationship between the trade with East and South Asia and the progress in import substitution during the Edo period. Some materials in this chapter are reproduced from Fujita Kayoko, 'Metal Exports and Textile Imports of Tokugawa Japan in the Seventeenth Century: The South Asian Connection', in Fujita Kayoko, Momoki Shiro

particular emphasis on silk yarn, imported to the four trading gateways fixed by the Shogunate (that is, Nagasaki, Matsumae, Tsushima and Satsuma) from some of the major production places in Asia (that is, China, Vietnam, Persia and India) by diverse agents (that is, the Chinese, the Portuguese, the VOC, the Ainu and the Japanese), in comparison with the growing domestic production of silk during the Edo period. Second, I consider the role of silk production and consumption in the progress of the urban and agrarian economies, bearing in mind the hierarchical social structure and cultural value systems of early modern Japan.

EARLY DEVELOPMENT OF KYOTO-CENTRED TEXTILE CULTURE UNDER THE INFLUENCE OF CHINA

From an early period, the Chinese empires exerted a powerful influence on Japan's silk consumption and production.[7] In 702 CE, with the enactment of the Taihō Code 大宝律令 modelled after the centralised administrative system of the Tang dynasty (618–906), a governmental textile office (*Oribe no Tsukasa* 織部司) was founded in Heijōkyō (present-day Nara) to administer the production of silk textiles, namely, *nishiki* 錦 (brocade), *aya* 綾 (twill), *ra* 羅 (thin silk) and *tsumugi* 紬 (pongee), as well as fabric dyeing, in order to meet the demand from the imperial court and aristocracy.[8] Kyoto became the centre of silk textile production after the textile office relocated to the Heiankyō imperial capital in 794. Silk production was promoted in diverse parts of ancient Japan, as silk yarns and fabrics were means of tax payment in the newly established tax system modelled after imperial China. The Engi-shiki 延喜式 (Procedures of the Engi Era) code, compiled in 927, records forty-eight silk producing provinces out of the sixty-one forming the Japanese archipelago.[9] In concert with the decline of the ancient centralised government system from the mid-Heian period (794–1185) onward, some of the artisans employed by governmental craft

and Anthony Reid (eds.), *Offshore Asia: Maritime Interactions in Eastern Asia before Steamships* (Singapore, 2013), 259–76.

[7] The earliest evidence of sericulture and silk weaving in Japan can be found at various archaeological sites from the early Yayoi period (c. 400 BCE), chiefly in northern Kyushu. The origin of Japan's sericulture, either from central China or via Korea, remains a matter of dispute. Nunome Junrō, *Kinu to Nuno no Kōkogaku* [The Archaeology of Silk and Textiles] (Tokyo, 1988), 20–1; Jonathan Edward Kidder, *Himiko and Japan's Elusive Chiefdom of Yamatai: Archaeology, History, and Mythology* (Honolulu, 2007), 90–1.

[8] While the Taihō Code that was compiled in 701 does not survive, the regulations related to the textile office are available from the the Yōrō Code (757) that is considered to be a limited revision of its precursor. Itō, *Kinu*, 88–9, 97–8, and 123–25.

[9] Itō, *Kinu*, 116–17.

centres ventured into their own businesses, and manufacturing techniques such as dyeing and loom-weaving spread across the provinces of Japan.[10]

In spite of the spread of silk farming and weaving across Japan, throughout the medieval period it was Chinese silk fabrics of high quality imported from Song and Yuan China that were highly appreciated among the upper classes, including aristocrats and warriors. From the early fifteenth century onwards, silk textiles were among the most important imports to Muromachi Japan (1336–1573) along with copper coins and porcelain as part of the official tribute trade with the Ming dynasty (1368–1645).[11]

At the same time, one cannot overlook the changing preferences in silk products among Japanese high-class consumers prior to the silk boom after the end of the century-long Warring States period (1467–1568). Sasaki Gin'ya points out that, during the latter half of the fifteenth century, the ruling elite started to prefer textiles made in Japan and woven from Chinese or domestically-produced silk yarn rather than imported Chinese textiles.[12]

TRADE CONNECTIONS WITH CHINA AND INDIA IN THE PRE-TOKUGAWA PERIOD

Demand for imported silk goods, namely silk yarn, significantly increased in Japan in the second half of the sixteenth century. Many factors, particularly the rising global demand for silver and the end of the incessant civil wars that had divided Japan politically, economically, and socially since the beginning of the Ōnin War (1467–77), contributed to this consumer trend.

Japan's growing production of silver enabled a rapid increase in the importation of Chinese silk yarn in the sixteenth century. Japan became the largest supplier of silver to the Ming by the 1540s, following the discovery of the Ōmori silver deposits in Iwami province in 1526. Thanks to Japanese and Chinese maritime traders, large amounts of silver flowed into China, primarily to purchase Chinese raw silk.[13]

In addition, the Portuguese, who first arrived in Japan in 1543, joined the profitable trade of Japanese silver and Chinese silks in competition with local traders. After the Ming authorised the Portuguese to establish a trading post at

[10] Itō, *Kinu*, 184–6.

[11] Itō, *Kinu*, 189–91, and Mori Katsumi, *Zokuzoku Nissō Bōeki no Kenkyū* [Studies of Japan–Song Trade, vol. 3] (Tokyo, 1975), 127 and 133–4.

[12] Sasaki Gin'ya, *Nihon Chūsei no Ryūtsū to Taigai Kankei* [Foreign Relations and Domestic Trade in Medieval Japan] (Tokyo, 1994), 65.

[13] Sasaki, *Nihon Chūsei*, 70.

Macau in 1557 and the Spanish founded their own colonial outpost at Manila in 1571, European traders started to purchase Chinese silks with Spanish American silver. This formed the basis of the early seventeenth-century international commercial boom in maritime East Asia. As a result, Ming China became the 'ultimate sink' of the world's silver when the Ming dynasty lifted the ban on private maritime trade in 1567.[14]

It should also be noted that the sharp increase in silk yarn imports was triggered by the importation to Japan of the advanced Chinese techniques of silk-weaving that had been admired by the world for centuries. Technology transfer took diverse forms, ranging from the importing of looms to direct technical guidance by Chinese craftsmen (it was only in the Edo period that the entrance of foreigners into the shogunate's territory was restricted). For example, in the second half of the sixteenth century, Chinese weavers transmitted the techniques for weaving *kinran* 金襴 (gold brocade), *donsu* 緞子 (damask), and *chirimen* 縮緬 (crepe) in the Ming styles to Sakai, one of Japan's largest international ports. The new techniques and designs were then transferred to nearby Kyoto, namely the Nishijin district, by Japanese weavers who had fled the devastated imperial capital and taken shelter in Sakai during the Ōnin War.[15] In short, as the historian Tashiro Kazui suggests, from the latter half of the sixteenth century Japanese consumers started to prefer home-woven textiles (made from imported silk threads) to imported Chinese silk textiles. The introduction of new manufacturing technologies and the establishment of profitable systems of mass production enabled the Japanese silk weaving industry to produce a diverse range of quality silk textiles.[16]

From the mid sixteenth century, large supplies of Chinese silk yarn, particularly of *shiraito* 白糸 (literally 'white threads') or high-quality mulberry raw silk yarn (that is, white, thin, and highly uniform in quality), were the result of the emergence of new consumers and consumption trends. Since the ancient period, the use of silk garments had been monopolised by the old regime elite – aristocrats, monks and priests, and later the rising warrior class. But with the arrival of Iberian traders and the restoration of peace under the reigns of two samurai

[14] For details of which, see Richard von Glahn, 'Cycles of Silver in Chinese Monetary History', in B. K. L. So (ed.), *The Economic History of Lower Yangzi Delta in Late Imperial China: Connecting Money, Markets, and Institutions* (London, 2013), 31–44.

[15] Tsuranuki Hidetaka, *Nihon Kinsei Senshokugyō Hattatsushi no Kenkyū* [A Study of the Historical Development of the Dyeing and Weaving Industries in Early Modern Japan] (Kyoto, 1994), 7–8.

[16] Tashiro Kazui, 'Tokugawa Jidai no Bōeki' [Foreign Trade in the Tokugawa Period], in Hayami Akira and Miyamoto Matao (eds.), *Nihon Keizaishi*, vol. 1, *Keizai Shakai no Seiritsu* (Tokyo, 1988), 133–6.

lords, Oda Nobunaga 織田 信長 (1534–82) and Toyotomi Hideyoshi 豊臣 秀吉 (1537–98), the Azuchi-Momoyama period (c. 1568–1603) witnessed the birth of a town-dwelling merchant class whose wealth fostered a new urban, secular, and luxurious culture in western Japan.[17]

The annual amount of raw silk imported in the latter half of the sixteenth century was, according to the estimates by Tashiro Kazui, enough to produce at least 100,000 pieces of kimonos for adults. Although precise figures to cover all the trade agencies' imports are hard to obtain, some documentary evidence allows us to estimate the total demand in raw materials in Japan's domestic market during the heyday of Chinese silk yarn imports. For example, the Portuguese, who almost fully monopolised Japan's external commerce in the late sixteenth century, are said to have imported 1,000–2,500 *picul*s (60–150 tons) of raw silk per year. Japan's annual demand for raw silk is estimated to have risen to 3,000–3,500 *picul*s (180–210 tons) around 1615 and to 3,000–4,000 *picul*s (180–240 tons) in the 1630s.[18] Assuming that four kilogrammes of raw silk were required to produce three pieces of kimono, the 4,000 *picul*s of raw silk said to have been the upper limit of annual supply in the 1630s could have produced an astonishing 180,000 kimono pieces.[19] To sum up, the consumption of textiles made from imported Chinese silk yarn was not restricted to the traditional upper classes, but spread to the nouveau riche with lower social status.

This new demand spurred the unique development of the *kosode*-style 小袖 garment, which is now considered the archetype of the kimono or Japanese traditional costume that assumed its final shape during the Edo period and became commonly used by people of every class in the hierarchical society. *Kosode*, literally meaning 'small sleeve openings', was originally worn by common people as daily clothing that served as both underwear and outer garment. It was also used as underwear among the court nobles under the decorative upper-garment called *ōsode* 大袖 (big sleeve openings) from the late Heian period.[20]

[17] On the social and cultural developments during the Azuchi-Momoyama period, see, for example, Haga Kōshirō, *Azuchi Momoyama Jidai no Bunka* [The Culture of the Azuchi-Momoyama Period], 2nd edn (Tokyo, 1965).

[18] Tashiro, 'Tokugawa Jidai no Bōeki', 132–3. The import quantities are originally from Takase Kōichirō, 'Makao–Nagasaki kan Bōeki no Sōtorihikidaka/Kiito Torihikiryō/Kiito Kakaku' [The Turnover, the Amount and the Price of Raw Silk of the Portuguese Trade at Nagasaki in the Sixteenth and Seventeenth Centuries], *Shakaikeizaishigaku*, 48/1 (1982), 62 and 65, and Iwao Seiichi, 'Kinsei Nisshi Bōeki ni Kansuru Sūryōteki Kōsatsu' [A Study on the Chinese Trade with Japan in the XVIIth Century – Chiefly on Their Volume and Quantity], *Shigaku Zasshi*, 62/11 (1953), 27. One *picul* (60 kilograms) equals 100 catty or kin.

[19] Tashiro, 'Tokugawa Jidai no Bōeki', 165, no. 8.

[20] Maruyama Nobuhiko, *Edo Mōdo no Tanjō: Mon'yō no Ryūkō to Sutā Eshi* [The Birth of Edo à la Mode: The Trends in Kosode Kimono Motifs and Celebrity Designers] (Tokyo, 2008), 26.

In the following Kamakura (1185–1333) and Muromachi periods (1336–1573), the ruling warrior class wore *kosode* garments mainly in the private sphere, while they donned the *ōsode* in the public arena of court and government as a visual representation of their new political authority.[21]

The Ōnin War, which initiated a long period of civil war (1467–1590), was a major turning point in the country's cultural politics as well. With the further dwindling of aristocratic power and the massive influx of Chinese raw silk, the warriors started to wear *kosode* – now made with a silk fabric with raised patterns and embroidery – in public spaces.[22] Furthermore, the wealthy townsmen developed a sumptuous life style in the urban environment of Kyoto, Osaka, and other cities in the Kansai region. Rich commoners who enjoyed rising social status began to replace their simple *kosode* of linen with elaborately crafted silk *kosode*, which were decorated with newly developed ornamentation techniques such as *surihaku* 摺箔 (impressed gold or silver foil on fabric) or *nuihaku* 縫箔 (embroidery and impressed gold or silver foil on fabric) in combination with embroidery and *shibori* 絞り (tie-dyeing).[23]

THE TOKUGAWA SHOGUNATE'S FOREIGN TRADE AND NEW CLOTHING CULTURE

After the gradual centralisation of foreign relations during the reigns of his predecessors Oda and Toyotomi, the state unifier Tokugawa Ieyasu 徳川 家康 (1543–1616) and his sons launched a new state-controlled system of foreign relations in the early seventeenth century. Today, it is commonly understood that the foreign policy of Tokugawa Japan, which used to be termed *sakoku* 鎖国 or 'seclusion policy' in pre-1980s historiography, was a variant of the Chinese *haijin* 海禁 system, a state-controlled system of foreign trade and diplomacy.[24] As in the Chinese model, in *sakoku* the central government monopolised diplomacy and decided where, with whom, and at which ports within the central government's

[21] Nagasaki Iwao, *Kosode kara Kimono e* [From Kosode to Kimono] (Tokyo, 2002), 19–20.

[22] *Ibid.*, 20–1 and 28.

[23] *Ibid.*, 20, 28, and 30–3.

[24] Since the central administration as well as ordinary people came to regard the set of regulations as an indestructible ancestral law (*sohō* 祖法) around the 1650s and 1660s, the shogunate's entrenched system of foreign relations was called a seclusion policy (*sakoku*) with its attendant *negative* connotation during the decline of the Tokugawa regime in the mid nineteenth century. Nakamura Tadashi, *Kinsei Nagasaki Bōekishi no Kenkyū* [A Study of the History of Foreign Trade in Early Modern Nagasaki] (Tokyo, 1988), 173–5. For this turn in Japanese historiography, see Ronald Toby, *State and Diplomacy in Early Modern Japan: Asia in the Development of the Tokugawa Bakufu* (Princeton: Princeton University Press, 1984), particularly chapter 1, and Arano Yasunori, 'The Formation of a Japanocentric World Order', *International Journal of Asian Studies* 2/2 (2005).

territory or the lordly domains foreign trade should be conducted. A series of decrees issued in the 1630s by the Edo government outlined the foreign relations of the now-unified polity. Viewing Christianity as a potential threat to the stability of his country, the Tokugawa shogun prohibited his subjects from travelling abroad in 1635 and banned Portuguese ships from entering Japan in 1639.

It should be emphasised that throughout the Edo period, Japan's external relations – including foreign trade and diplomacy – were maintained through the principles of *bakuhan-sei* 幕藩制 – the system of political and economic co-existence of the Tokugawa central government (*bakufu* 幕府) and local autonomous domains (*han* 藩). Contact with foreigners was only permitted via the 'four portals' (*yottsu no kuchi* 四つの口), which were: Nagasaki (with Chinese and Dutch maritime traders), Tsushima (with the Kingdom of Korea), Satsuma (with the Kingdom of Ryukyu), and Matsumae (with the Ainu in Ezochi).[25] This system remained in place until the US–Japan Treaty of Amity and Friendship of 1854, which further opened the two ports of Hakodate (in current Hokkaido) and Shimoda (Shizuoka) to foreign trade. Nagasaki was the only *bakufu* territory among the four. At the other three gateways, the *daimyō* or 'lord' of each domain dealt with practical matters regarding diplomacy and commerce as a service (*yaku* 役) to the Tokugawa shogun.[26]

Silk products were imported into the Japanese archipelago via each of these four gateways. Situated in different geopolitical settings, the characteristics of the foreign trade conducted at each gateway differed, which resulted in the formation of a unique silk culture in Tokugawa Japan. (1) Nagasaki, with the presence of European merchants, was essentially the only port through which silk yarn and fabrics produced in south and west Asia were imported. (2) Tsushima and Satsuma became prominent in the importation of Chinese raw silk due to diminishing trade at Nagasaki, particularly from the late seventeenth century on, using their respective connections with Korea and Ryukyu, both of which had tributary relations with Qing China. (3) Matsumae provided Japan with high-quality Chinese silk textiles and garments obtained through its trade with the Ainu in Japan's northern frontier or Ezochi (Hokkaido, the Kuril Islands, and the southern half of Sakhalin).

[25] A conceptual map of international relations in early modern East Asia can be found in the online article by Arano Yasunori, who originally proposed the '*yottsu no kuchi*' thesis in his book, *Kinsei Nihon to Higashi Azia* [Early Modern Japan and East Asia] (Tokyo, 1988). Arano Yasunori, 'Foreign Relations in Early Modern Japan: Exploding the Myth of National Seclusion', http://www.nippon.com/en/features/c00104/ (accessed 14 July 2014), Table 12.1.

[26] For the basic structure of Tokugawa diplomacy and foreign trade, see Arano, 'Foreign Relations', and Bruce Batten, *To the End of Japan: Premodern Frontiers, Boundaries, and Interactions* (Honolulu, 2003), 42–8.

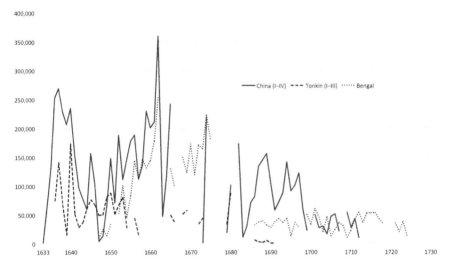

Figure 12.1 The amount of silk yarns in D22:E23 produced in diverse places in Asia and imported into Japan through the two gateways of Nagasaki and Tsushima by Portuguese, Chinese, and Dutch traders, and Tsushima-*han*.

Sources: To Nagasaki (including the VOC to Hirado until 1640): VOC: Negotie Journalen, NFJ 836–61, and Facturen, NFJ 763–88, National Archief Den Haag, Netherlands. Some figures are adopted from Yamawaki 1977, Tables 32 and 33, pp. 199–204. Chinese ships from China: Iwao 1953, Table X, p. 28, and Yamawaki 1964, Table 18, p. 229. Chinese ships from Tonkin: Iwao 1953, p. 27, Nagazumi 1987, pp. 50–51, and Nagazumi 1992, Table 5, p. 36. Portuguese: Takase 1982, pp. 67–8. To Tsushima: Tsushima-han: Tashiro 1981, Table II–13, p. 281.

Note: 100 catties or kins equals one picul.

The figures show the volume of silk yarn produced in various places in Asia and imported into Japan through the two gateways of Nagasaki and Tsushima by the Portuguese, Chinese, and Dutch traders, and Tsushima-*han*. Figure 12.1 and Table 12.1 cover a hundred-year period commencing in 1633, when the shogun relaxed a five-year-old embargo against the Dutch at the Hirado factory (1609–40).[27] The principal sources for total annual volumes of the diverse types of silk yarn imported by Chinese and Portuguese ships are the diaries maintained by their business rival, the VOC in Hirado and Nagasaki, although data for some

[27] The VOC established a trade post in Hirado (in current Nagasaki prefecture) in 1609. In 1641, the Tokugawa government ordered the Dutch to relocate the factory from Hirado to the artificial island of Dejima in the port town of Nagasaki. Figure 12.1 includes the volume of silk yarns imported to Hirado.

Table 12.1 The amount of silk yarns in *piculs* produced in diverse places in Asia and imported into Japan through the two gateways of Nagasaki and Tsushima by Portuguese, Chinese, and Dutch traders, and Tsushima-*han*.

Year	China I (VOC)	China II (Chinese ships)	China III (Tsushima)	China IV (Portuguese)	Tonkin I (VOC)	Tonkin II (Chinese ships)	Tonkin III (Portuguese)	Bengal (VOC)	Persia (VOC)	Quinam (VOC)
	1,676				0			0		0
	64,390				23,052			0		
	130,949				0			0		
	166,544			85,882.5	21,513		53,343	0		
	149,669	15,000		104,340.0	53,695		87,431	0		
	193,190			36,450.0	51,349		15,908	0		
	146,289	60,670			15,243			0		
1640	152,231	91,902			163,997	9,350		0		0
	71,630	113,355			55,996	20,750		310	0	0
	42,243	57,377			35,824			0		0
	28,924	53,046			42,989	580		0	0	0
	17,853	49,506			70,897			0	13,052	0
	43,948	138,261			91,475	1,300		0	23,110	0
	4,008	105,075			66,805	3,700		0	17,799	0
	4,549				67,150			11,629	0	5
	0	13,559			52,274			0	488	0
	754	92,564			59,780	26,500		0	0	117
1650	9,569	166,886			59,553	30,500		34,870	0	0
	71,157					120,827			0	

Year	China I (VOC)	China II (Chinese ships)	China III (Tsushima)	China IV (Portuguese)	Tonkin I (VOC)	Tonkin II (Chinese ships)	Tonkin III (Portuguese)	Bengal (VOC)	Persia (VOC)	Quinam (VOC)
	586	187,500			67,284			52,522	0	0
	159	142,481			52,879	30,700		97,969	0	0
	6,020	139,631			29,180			45,386	0	0
	0	177,784			0			81,077	0	180
	0	188,651			46,013			139,482	0	0
	0	112,384			14,685			109,703	0	0
	0	135,720			0			144,683	0	0
	0	229,891			29,604			132,142	0	0
1660	0	201,383			0			156,718	0	0
		211,427						178,888		0
		359,771						255,858		0
		47,614								
		119,208								0
	79,244	163,042			49,202			130,032	0	0
	0	50,000			36,854			97,694	0	0
		220,000								0
	0	133,282			51,740			149,838	7,844	0
	1,042	190,853			57,665			123,488	0	0
1670	0				0			172,849	0	
	0	50,000			0			119,966	0	
	0				34,447			171,317	17,273	

Year	China I (VOC)	China II (Chinese ships)	China III (Tsushima)	China IV (Portuguese)	Tonkin I (VOC)	Tonkin II (Chinese ships)	Tonkin III (Portuguese)	Bengal (VOC)	Persia (VOC)	Quinam (VOC)
	1,817				44,393			164,504	o	o
		220,000						223,424		
		133,282						179,874		o
	o				37,510			71,694	o	
1680	19,421	190,853			34,147			72,024	o	
		173,323	30,396					124,470		o
		11,291	71,435							o
	4,960		77,265		6,368			32,573	o	o
	4,941		129,178		3,317			37,467	o	o
	2,471	40,520	102,119		2,467			39,304	o	o
	5,423		150,678		5,591			32,044	o	o
1690	6,950		98,910		1,208			28,300	o	o
	o		58,226		901			38,020	o	o
	5,485		66,915		0			43,507	o	o
	7,012		81,514		5,209			36,864	o	o

Year	China I (VOC)	China II (Chinese ships)	China III (Tsushima)	China IV (Portuguese)	Tonkin I (VOC)	Tonkin II (Chinese ships)	Tonkin III (Portuguese)	Bengal (VOC)	Persia (VOC)	Quinam (VOC)
	227		141,382		0			43,551	0	
	2,291		89,479		1,314			13,657	0	
	2,292		99,056		0			36,594	0	
	0	45,671	77,051		3,424			28,311	21,167	0
		11,618	47,973							
1700			23,264					50,381		
			0					33,537		
			50,467					60,700		
	289		27,277					45,732		
	544		29,913					20,895		
	743		15,945					46,259		
	414		47,057					13,421		
	0		51,325					24,583		
	0		21,771					36,250		
	0		19,290					30,822		
	0		13,559					11,006		
1710	0	40,800	4,124					22,953		
	0	23,850						42,845		
	0	43,280						54,142		
	0	10,122						36,666		
	0							53,062		

Year	China I (VOC)	China II (Chinese ships)	China III (Tsushima)	China IV (Portuguese)	Tonkin I (VOC)	Tonkin II (Chinese ships)	Tonkin III (Portuguese)	Bengal (VOC)	Persia (VOC)	Quinam (VOC)
	0	0						53,181		
		342						53,263		
	0							42,321		
	0							33,806		
1720		7,691								
	0							35,585		
	0							20,807		
	0	6,128						38,298		
	0							13,358		
	0							0		
	0	8,549						25,830		
	0							0		
1730		23,500								

Sources: To Nagasaki (including the VOC to Hirado until 1640): The Hague, National Archive of the Netherlands, VOC: Negotie Journalen, NFJ 836–61, and Facturen, NFJ 763–88. Chinese ships from China: Iwao, 'Kinsei Nisshi Bōeki', Table X, 28, and Yamawaki Teijirō, *Nagasaki no Tōjin Bōeki* [Chinese Trade in Nagasaki] (Tokyo, 1964), Table 18, 229. Chinese ships from Tonkin: Nagazumi, 'Nihon–Tonkin Bōeki', Table 5, 36. Portuguese: Takase, 'Makao–Nagasaki', Table 2, 67–8. To Tsushima: Tsushima-*han*: Tashiro, *Kinsei Nitchō*, Table II–13, 281.

years are missing.[28] The Dutch were certainly good at collecting intelligence, but it was impossible for them to coax all the details of their rivals' business from Japanese traders, local officials, and interpreters. For this reason, it is particularly difficult to reconstruct the trade in the crucial decade of the 1630s. The volumes of Chinese *shiraito* yarn (white raw silk) that Tsushima imported from Korea are based on the *han*'s business accounting books.[29]

At a glance, we can recognise long-term trends in Japan's silk import trade, commencing with the promulgation of the so-called seclusion edicts in the 1630s, up to the age of the government-initiated import substitution of silk in the eighteenth century. The figures include the volumes of silk imported by the Portuguese during the last three years of their presence in Japan (1636–38), but data preceding 1639 are sporadic.[30] Figures on the quantity of silk imported by Japanese maritime traders before 1635 (the year in which the Tokugawa shogunate issued its ban on Japanese ships sailing abroad) are also missing.

A further important limitation in Table 12.1 is the lack of reliable quantification of the silk imported into Japan from the Kingdom of Ryukyu through the gateway of Satsuma. From the 1620s onwards, the Shimazu clan of Satsuma – which invaded Ryukyu in 1609 with Tokugawa permission – invested a large amount of silver, which they borrowed from Japanese merchants in Kamigata (the Kyoto and Osaka area) – in the Ryukyu–China trade, particularly for the purchase of high-quality Chinese raw silk.[31] Nicolaes Couckebacker, the Dutch captain in Hirado (1633–9), recorded in his diary of September 1636 that a junk ship had safely returned to Ryukyu from China with a cargo of 1,000 *picul*s (60 tons) of silk yarn.[32] Compared with silk imports by other trade agencies in the same year (1,665 *picul*s by the VOC and 859 *picul*s by the Portuguese), we can grasp the magnitude of the Ryukyu trade. Despite the obvious importance of

[28] The details of each type of yarn and the functions of different types of imported yarn in Japan's textile manufacturing can be found in Yamawaki Teijirō's definitive work on silk and cotton in Tokugawa Japan. Yamawaki Teijirō, *Kinu to Momen no Edo Jidai* [Silk and Cotton in the Edo Period] (Tokyo, 2002), 47–61.

[29] According to Tashiro, *shiraito* represented 99 per cent of the silk yarn imported by Tsushima. The small volume of yellow silk yarn imports is therefore omitted from Figure 12.1. Tashiro Kazui, *Kinsei Nitchō Tsūkō Bōekishi no Kenkyū* [Diplomacy and Trade between Japan and Korea in the Early Modern Period] (Tokyo, 1981), 282.

[30] Takase, 'Makao–Nagasaki', 66–7.

[31] Maehira Fusaaki, 'Ryūkyū Bōeki no Kōzō to Ryūtsū Nettowāku' [The Structure of Trade and Distribution Networks of the Ryukyu Kingdom], in Tomiyama Kazuyuki (ed.), *Ryūkyū–Okinawa-shi no Sekai* (Kyoto, 2003), 121.

[32] Maehira, 'Ryūkyū Bōeki', 124. The original source is the diaries of Nicolaes Couckebacker, 6 and 7 September 1636, in *Dagregisters gehouden bij de opperhoofden van het Nederlandsche Factorij in Japan*, vol. II (Tokyo, 1974), 115.

Chinese silk yarns from Ryukyu, however, reliable long-term statistical data are not available for this trade.[33]

Silk yarns, from China in particular, were undeniably in high demand in early Tokugawa Japan.[34] Until the late 1980s, the dominant view among scholars was that the success of import substitution at home had allowed the Tokugawa shogunate to close its doors to the outside world in the 1630s.[35] However, although there were temporary fluctuations in the 1640s – caused by market turmoil in Kamigata resulting from erratic weather and nationwide crop failure – Figure 12.2 clearly indicates that it was not until the latter half of the seventeenth century that the influx of foreign silk yarns began to decrease.[36] It is now widely accepted that the shogun finally decided to expel Portuguese traders in 1639 only after the Dutch captain of the Hirado factory had assured the shogunate's cabinet officials that the VOC would be able to supply all the Chinese products required by Japan, such as 'silk, silk goods, medicines, and dried goods'.[37] It is also known that the Tokugawa government requested Tsushima to increase Chinese silk yarn and textile imports through trade with Joseon Korea (1392–1897).[38] In other words, although the Tokugawa shogunate failed to restore diplomatic ties with China – which had broken down due to Toyotomi's invasions of its tributary state of Korea (1592–98) – Japan still maintained close contact with the China-centred

[33] The volume of silk imports by Chinese ships in 1636 is unavailable.

[34] 'Chinese' silk yarn imports in Figure 12.1 (China I–IV) include a variety of types of silk yarn, differing in quality, colour, and texture (e.g. with or without twisting). For changes in types of silk yarn imported by Chinese and Dutch ships in the seventeenth century, see Table 7 in Tsuranuki, *Nihon Kinsei Senshokugyō*, 58–9. Note also that they may include silk yarns that were, in fact, not produced in China since the 'Chinese ships' in Japanese records (categorised as *Tōsen*) were junks from ports in South China and Taiwan as well as countries in Southeast Asia. Silk from Tonkin (Tonkin I–III) is shown as a separate category since Tonkin was a major supplier of silk yarn to Japan, particularly in the seventeenth century. For the Chinese junk trade in Tokugawa Japan, see Ishii Yoneo, *The Junk Trade from Southeast Asia: Translation from the Tōsen Fusetsu-Gaki, 1674–1723* (Singapore, 1998).

[35] For example, Immanuel Wallerstein (1974) explains, citing Trevor-Roper's 'The Jesuits in Japan' (1966), that the Japanese 'grew uncomfortable with the Jesuits, and it was possible now for Japan to withdraw from the world, especially since indigenous manufacturers were eliminating the need for Chinese silk'. Immanuel Wallerstein, *The Modern World-System I: Capitalist Agriculture and the Origins of the European World-Economy in the Sixteenth Century* (New York, 1974), 342. As seen in recent works by Japanese scholars, it was around the mid eighteenth century that the local demand was finally fulfilled by domestically produced silk yarns of sufficient quality and quantity.

[36] For the Kan'ei Famine (1642–43) and its impact on the society and economy of the early Tokugawa shogunate, see Yamamoto Hirobumi, *Kan'ei Jidai* [The Kan'ei Era] (Tokyo, 1989).

[37] Diaries of François Caron, 20 and 22 May 1639, in *Dagregisters gehouden bij de opperhoofden van het Nederlandsche Factorij in Japan*, vol. IV (Tokyo, 1981), 49–50 and 53–6.

[38] This did not work out smoothly due to the continuous upheavals in the transition from the Ming to the Qing around 1645. Tashiro, *Kinsei Nitchō*, 279.

regional economy through the importation of silk (and, in return, the outflow of precious metals and copper).

The unmatched quality of Chinese raw silk was highly appreciated by Japanese silk manufacturers, yet price remained a concern. In 1604, the Tokugawa shogun allowed Japanese silk merchants in the three shogunal cities of Kyoto, Sakai, and Nagasaki to establish a cartel called Itowappu Nakama 糸割符仲間 (Guild of Raw Silk Merchants), which was given a monopoly on the purchase of white Chinese silk thread from Portuguese traders at a price set by the buyers. The two cities of Edo and Osaka joined the Itowappu system in 1631. Chinese silks imported by the Chinese and the VOC were also placed under this management system, in 1633 and 1635 respectively. As a consequence, foreign traders sought raw silk produced in Tonkin (Vietnam) and other areas for the Japanese market, in an attempt to avoid the fixed price of Chinese raw silk.[39]

The VOC brought a fundamental change to the century-old exchange of Chinese silk for Japanese silver. In 1632, the Tokugawa government allowed the VOC to resume commerce in Japan following the settlement of a conflict between the Dutch and a Japanese trader at the entrepôt in Taiwan in 1628. With the disappearance of their Japanese rivals in 1635 and the expulsion of the Portuguese in 1639, the VOC's trade in Chinese raw silk for the Japanese market blossomed. However, the Dutch had to find different sources for silk after Chinese maritime traders in South China refused to sell their profitable silk cargoes to the VOC's Taiwan factory, the base for the company's commercial activities in East Asia from 1625 to 1662, preferring to sell them directly to Japan.[40] From the end of the 1630s, therefore, the VOC devoted its full attention to establishing Indian silks and cottons on the Japanese market. The VOC shipped Japanese silver from the Hirado (open 1609–40) and Nagasaki factories (1641–1859) to Taiwan, and then forwarded a large portion of it, along with Chinese gold, to ports west of Malacca to fund the company's intra-Asian trade.[41]

This was a striking departure from the China-centred economic system of East Asia, based as it was on the Chinese world-order and its trading networks, in which Japan had been involved for centuries. Japan's textile manufacturing industry had never previously experienced structural connection with the Indian

[39] For the importance of Tonkin silk for seventeenth-century Japan, see: Nagazumi Yōko, '17seiki Chūki no Nihon–Tonkin Bōeki ni tsuite' [The Tonkinese–Japanese Trade in the Mid-Seventeenth Century], *Jōsai Daigaku Daigakuin Kenkyū Nenpō*, 8 (1992), and Hoang Anh Tuan, 'The Export Trade (I): Tonkinese Silk for Japan', *Silk for Silver: Dutch–Vietnamese Relations, 1637–1700* (Leiden, 2007), 143–64.

[40] Nagazumi Yōko, *Kinsei Shoki no Gaikō* [Diplomacy at the Beginning of the Early Modern Period] (Tokyo, 1990), 183–5.

[41] Fujita, 'The South Asian Connection', 265–7.

Ocean economic zone through a large-scale and continuous influx of South Asian primary materials into its realm, although the constant supply of South Asian fabrics had already been initiated in the mid sixteenth century by the Portuguese. For centuries, high-quality Chinese silk yarn was an especially prized commodity for Japanese producers of high-end silk textiles. Thus, the VOC had to send silk thread to Japan from various places of production in Asia, such as Quinam, Tonkin, and Persia, in a process of trial and error, until Japanese textile makers and consumers finally found satisfaction with the merchandise from Bengal.[42] The rapid growth of high-quality Bengali silk yarn imports was observed in 1655, when the Tokugawa government abolished the Itowappu or government-authorised cartel of silk merchants and introduced direct trade (*aitai shihō* 相対仕法) between Japanese and foreign traders.

At this stage, Kyoto was the largest consumer of foreign silk thread. Following the destruction of the district during the Ōnin War, the Nishijin district was re-established and became prominent in Japan's silk weaving industry, as independent weavers set up private studios there. Nishijin flourished with the increasing demand from the upper strata of society, including the new rich and townsmen who had gained economic power after the Warring States period. Yamawaki estimates that approximately 2,000 *picul*s (120 tons) of silk yarn at least were used annually in Nishijin and other textile-producing areas in Kyoto during the 1640s and 1650s.[43]

We should note that weavers in Nishijin were enthusiastic about adopting the new technologies that had been developed in China throughout the seventeenth century, although direct technology transfer by Chinese artisans and craftsmen was no longer possible due to the shogun's national policy. There are records of the import of Chinese drawlooms for brocade weaving, called in Japanese *sorahiki-bata* 空引機 (or *taka-bata* 高機 handloom with *sorahiki* 空引 equipment),[44] from Suzhou, China, by Chinese ships to Nagasaki, probably

[42] For changes in the places of origin of silk yarns brought by the Dutch to Tokugawa Japan, see P. W. Klein, 'De Tonkinees–Japanse zijdehandel van de Verenigde Oostindische Compagnie en het inter-Aziatische verkeer in de 17e eeuw', in W. Frijhoff and M. Hiemstra (eds.), *Bewogen en bewegen: de historicus in het spanningsveld tussen economie en cultuur* (Tilburg, 1986); Om Prakash, *The Dutch East India Company and the Economy of Bengal, 1630–1720* (Princeton, 1985); Hoang, *Silk for Silver*; Fujita, 'The South Asian Connection'. See also Rudolph Matthee's paper in this volume.

[43] Yamawaki, *Kinu to Momen*, 28.

[44] Tamara Hareven explains the traditional silk weaving procedure with *sorahiki-bata* before the introduction of the French jacquard system as follows: 'In the original human "jacquard" system, the weaver's wife or child sat on the second tier of the wooden drawloom and manipulated the warp by hand, selecting and batching the strands of the warp that had to be clustered in various configurations in order to determine the design'. Tamara K. Hareven, *The Silk Weavers of Kyoto: Family and Work in a Changing Traditional Industry* (Berkeley, 2002), 42.

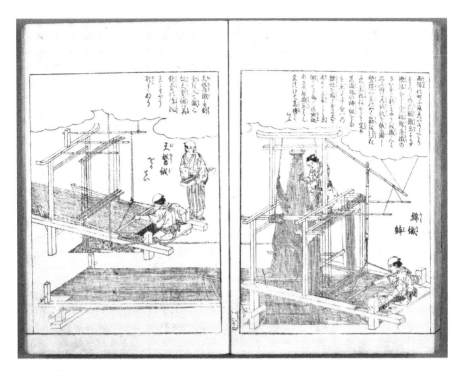

Illustration 12.1 Weaving a brocade on a *sorahiki-bata* handloom (right)
and weaving a velvet (left). Illustrations from *Miyako Meisho Zue* [A Pictorial
Guidebook to Kyoto], volume 1, by Akisato Ritō and Takehara Shunchōsai,
1780. Waseda University Library, Bunko30 E0214.

during the 1640s to 1660s (Illustration 12.1). The introduction of this new
weaving machine widened the variety of silk textiles that could be woven with
imported silk yarn.[45] It was only in the early eighteenth century that the silk-
weaving industry in other regions such as Kiryū and Ashikaga in eastern Japan
broke Nishijin's monopoly by incorporating *sorahiki*-style weaving machines.[46]

The widening range of textiles from the late sixteenth century onward,
including *kinran* (gold brocade), *donsu* (damask), *shusu* 繻子 (satin), and *chirimen*
(crepe), was closely associated with technological developments led by Japanese
craftsmen. Tsuranuki suggests that the declining volume of imported twist yarns
(*yoriito* 撚糸) and fabrics made from twist yarns during the first half of the seven-
teenth century might have been due to an increase in the domestic production

[45] Yamawaki, *Kinu to Momen*, 88–9.
[46] *Ibid.*, 89–90.

of various twist yarns, although the existence of *hatchō* 八丁, twisting machines with multiple spindles that made large-scale production of twist yarn possible, cannot be confirmed by historical evidence until the early eighteenth century.[47]

In fact, the development of yarn twisting machines was essential to achieve mass production of *chirimen* crepe made from hard twist yarn, which became the most popular fabric for clothes of both genders in the cultural efflorescence of the Kamigara area during the Genroku period (1688–1707).[48] The sumptuary law of 1683, which prohibited specific ornamental techniques for women's clothes, that is, *kinsha* 金紗 (silk fabrics interwoven with gilt threads), *nui* 縫 (embroidery), and *sō-kanoko* 惣鹿子 (covering the entire kimono with dapple tie-dyeing), ironically contributed to the emergence of early modern trends in luxurious clothing design and culture, with a particular preference for *chirimen* crepe with woven and dyed motifs. The development of Japanese dyeing arts inspired by hand-dyed fabrics from South Asia, such as Yūzen-zome 友禅染 (silk dyeing with rice paste coating) in the late seventeenth century, and *sarasa* 更紗 (stencil-dyed/printed calico) and *shima* 縞 (stripes) in the eighteenth century, could only be accomplished by the combination of technological innovation in reeling and weaving and the growth of affluent and fashion-conscious townspeople.[49]

FROM FOREIGN TO DOMESTIC MARKETS: IMPORT SUBSTITUTION AND THE DWINDLING IMPORT OF SILK YARN

While dwindling silver production and an increase in demand for money had caused concern for several decades, in the 1660s the Tokugawa government began to take measures to reduce the outflow of precious metals, which became inextricably linked with the reduction in the silk-yarn import trade. At the turn of the seventeenth century, the Tokugawa central government encouraged the collection of imported and home-grown silk yarns in Nishijin where there

[47] Tsuranuki, *Nihon Kinsei Senshokugyō*, 92–4, and Yamawaki, *Kinu to Momen*, 56–7 and 90.

[48] Tsuranuki, *Nihon Kinsei Senshokugyō*, 149.

[49] For a list of women's clothes mentioned above, see 'On'na Irui Seikin no Shinajina' [A List of Prohibited Female Clothing Items] (1683) in Hōseishi Gakkai (ed.), *Tokugawa Kinreikō* [A Collection of Tokugawa Prohibition Edicts], series I, vol. 6 (Tokyo: Sōbunsha, 1959), 3765. For the survey of the introduction and development of Indian aspects in Japan's textile tradition, see the second half of Fujita Kayoko, 'Japan Indianized: The Material Culture of Imported Textiles in Japan, 1550–1850', in Giorgio Riello and Prasannan Parthasarathi (eds.), *The Spinning World: A Global History of Cotton Textile, 1250–1850* (Oxford, 2009). See Tsuranuki, *Nihon Kinsei Senshokugyō*, 136–7, and Maruyama, *Edo Mōdo*, 161, for further explanations of the development of Japanese dyeing arts.

was a shortage of thread as a raw material. At the same time, both the central government and local governments of various domains promoted the production of raw silk on their soil. Successful import substitution in Japan took place in the mid eighteenth century, concurrent with the geographic spread of silk manufacturing regions and the development of a unique kimono culture that was supported in particular by well-to-do townspeople and peasants.

When the depletion of resources in Japanese mines and the massive outflow of precious metals became the issue *du jour*, the central government in Edo became aware of the necessity of securing sufficient monetary metal to maintain its domestic gold and silver currencies. From the second half of the seventeenth century on, the shogunate took various measures to reduce metal outflow, which inevitably affected the trade of the then largest import item – silk yarn. The government's countermeasures included: an embargo on gold (1664); a ban on silver export (1668) and the promotion of copper export; the introduction of a taxation trade or sale price setting system (1672); a quantitative restriction on Japan's foreign trade at Nagasaki; the reestablishment of the Itowappu guild; the limitation of silk imports (1685); repeated currency debasement (from 1695); and a limitation on the number of trading vessels (1715).

Dutch and Chinese traders in Nagasaki responded to the 1668 prohibition on silver exports in various ways. The VOC managed the situation smoothly, by switching their staple from Chinese to Bengali silk. This was feasible since the VOC had already shifted the emphasis of their commercial activities during the 1640s and 1650s from the silver-oriented Chinese market to markets in South Asia (Figure 12.1), where gold and copper were more profitable.[50] However, because of the above-mentioned trade restrictions, particularly the increase in gold prices in 1672 and the debasement of gold coin in 1695, the Dutch could no longer make sufficient profit from Bengali silk yarn.[51] The final recorded Bengali silk import to Nagasaki was in 1747.

At the same time, in 1668, the Chinese made a plea to the governor of Nagasaki for the resumption of silver exports, which was granted in 1672.[52] Since the domestic silk-weaving industry was still eager for high-quality Chinese thread, the shogunate promoted the exportation of bar copper in 1695 to make up for the lack of silver. Difficulties in storing copper ingots in Nagasaki caused by

[50] With a particular emphasis on the British market, Karolina Hutková examines the role of the English East India Company, the VOC's great rival, in global trade in Bengali silk. See Hutková's chapter in this volume.

[51] Prakash, *The Economy of Bengal*, 135–41, and Suzuki Yasuko, *Kinsei Nichiran Bōeki no Kenkyū* [A Study of the Japan–Netherlands Trade by the Dutch East India Company (VOC) in the 17th and 18th Centuries] (Kyoto, 2004), 242.

[52] Fujita, 'The South Asian Connection', 270–1.

declining copper production and increasing demand for copper cash in domestic markets seem to have also affected the import trade of Chinese silk in Nagasaki.[53]

The domestic production of silk yarn seems to have increased slowly throughout the seventeenth century as the manufacturers of high-grade textiles continued to have reservations about the quality of home-made silk compared with Chinese *shiraito* threads. The first recorded delivery of domestic silk yarn to Kyoto from two provinces in the vicinity was in the Kan'ei era (1624–44). Other silk-producing provinces followed during the Meireki era (1655–57).[54] During the second half of the seventeenth century, after the sharp decline in imports of Chinese and Bengali silk-yarn, the silk textile industry of Japan, particularly the weaving of quality fabrics in Nishijin, Kyoto, was faced with a serious shortage of white raw silk. One contributing factor was the surrender of the Zheng regime in Taiwan to the Qing in 1683. The Zheng regime had been the major intermediary for silk exports from South China to Japan. The sudden lack of Chinese silk yarn seems to have spurred the use of domestic silk.[55]

The contraction of the silk trade in Nagasaki affected the relative importance of Chinese silk yarn imported by Tsushima-*han* (Figure 12.2).[56] The volume of this silk trade increased rapidly from the mid 1680s and reached a peak of 1,500 *picul*s (90 tons) in 1689.[57] Although the quantity of Chinese silk yarn imported on Chinese ships to Nagasaki in the late seventeenth century is unclear due to the lack of long-term trade records, a careful examination of surviving data shows that Tsushima was the largest supplier of Chinese white silk yarn to the leading manufacturers of high-end silk textiles in Japan.[58] At the same time, Satsuma's silk import trade was sluggish since the purchase of silk and silk goods by Ryukyuan ships in Fuzhou in Fujian Province had been declining due to the erratic supply and high price of these commodities at the port.[59]

The year 1713 was epoch-making for Japan's silk industry. Observing the contraction of the silk trade at all shogunal gateways, the central government in Edo ordered the weavers in Kyoto to use Japanese silk thread together with imported silk and also encouraged sericulture and silk thread reeling in *daimyō* domains throughout Japan. In its decree, the government explained that textile

[53] For the detailed analysis of the collection and export of Japanese copper in the late seventeenth century, see Yao Keisuke, *Kinsei Oranda Bōeki to Sakoku* [The Dutch Trade and National Seclusion in Early Modern Japan] (Tokyo, 1998), particularly chapter 3.

[54] Itō, *Kinu*, 226–7.

[55] Yamawaki, *Kinu to Momen*, 32–3.

[56] Tashiro, *Kinsei Nitchō*, 329–30.

[57] *Ibid.*, 280.

[58] *Ibid.*, 282.

[59] Maehira, 'Ryūkyū Bōeki', 125.

manufacturers in Kyoto were losing their jobs due to diminishing imports of silk yarns to Nagasaki.[60]

This was the first case of the Tokugawa government making serious attempts to promote domestic silk-yarn production to make up the shortfall in foreign silk. As a result of continuous economic growth since the previous century, a highly developed consumer society had emerged. This consumer culture had been accompanied by the flowering of popular material culture, not only in the ancient cultural centre of Kamigata but also in the new capital of Edo, in smaller cities, and even rural areas. Thanks to promotional efforts by both central and local governments, sericulture and silk reeling flourished throughout the country (which also ignited the rise of silk weaving in diverse provinces, eventually leading to the relative decline of Kyoto's position). In 1725, a silk-yarn wholesaler in Kyoto explained to the governor of Kyoto:

> In recent years, the import of [Chinese] silk yarn from Korea and Ryukyu has been decreasing along with the import of Chinese silk yarn at the Nagasaki gateway. However, weavers and craftsmen of silk goods and ornaments in Nishijin no longer suffer [from the shortage of materials] since many provinces in Japan have been producing silk yarn for the last few decades.[61]

As Tashiro has demonstrated, the completion of this import substitution process was finally achieved in the mid eighteenth century.[62] Until a sufficient supply of high-quality domestic silk yarn was secured, the silk-goods manufacturers, including the weavers of high-end textiles, remained reliant on the ever-diminishing supply of Chinese silk yarn imported from Korea via Tsushima.

This section concludes with a note on the flow of Chinese silk products that entered Tokugawa Japan via the northernmost gateway of Matsumae. Trade was managed in the Matsumae entrepôt through inter-ethnic interaction with the Ainu in Ezochi (*Ainu Moshir* in their language, which included modern-day Hokkaido and further northern islands). It is difficult to grasp the entire structure of the importation of high-quality silk goods, that is, silk robes and rolls of silk fabrics, through this port due to the lack of statistical data. However, based on the few existing records on the Japanese side, it is safe to conclude that no silk thread was imported through this route. The Ainu had access to woven silk products produced in South China through their trade with the so-called

[60] Itō, *Kinu*, 227–8.
[61] 'The Response to the Enquiry by the Kyoto Magistrate from Silk Merchants of Itoya-machi' (1725), Mitsui Bunko, ms zoku 1508–1, quoted in Yamawaki, *Kinu to Momen*, 33.
[62] Tashiro, 'Tokugawa Jidai no Bōeki', 158.

Santan or diverse ethnic groups in Sakhalin and the Amur River region.[63] Among
the various items brought into Japan via the Matsumae gate, silk textiles and the
formal court robes of the Qing state officials, collectively called *Ezo nishiki* or
'brocade of Ezo', were the most admired and highly valued as artistic objects
among the Japanese population in northern Honshu as well as in curio markets
throughout Japan. It is estimated that several hundred metres of such luxurious
silk textile products were imported to Japan via this route in the first half of the
nineteenth century.[64] Today, approximately fifty pieces of *Ezo nishiki* survive in
museums and private collections in Japan.[65]

THE CHARACTERISTICS OF TOKUGAWA CLOTHING
CULTURE IN COMPARISON WITH JOSEON KOREA

To understand the uniqueness of Japan's textile culture in the historical East
Asian world, it might be useful to compare Tokugawa Japan with its closest
neighbouring Kingdom, Joseon Korea, focusing on the ways in which diplomacy
and commerce with China affected each country's material culture. These two
small neighbours of the Chinese empire were directly and indirectly exposed to
China's dominant political, economic, and cultural forces, until the traditional
Sino-centred international order dissolved in the nineteenth century in the face
of the Western system of diplomacy and trade agreements between nations.

First, silk culture in both countries had been heavily influenced since ancient
times by Chinese systems of silk production and consumption. Among many
traditional fibre products, such as hemp, ramie, and cotton, silk was used exclu-
sively for the clothing of ruling elites, namely, the imperial family and court
officials. Records show that no later than the end of the fifth century, the states
on the Korean Peninsula began to introduce a detailed set of dress regulations
following the Chinese model, with a hierarchy of colour, texture, and ornamen-
tation. Such dress codes served to distinguish the nobles from the general

[63] The long distribution channel for *Ezo nishiki* from the silk-producing lower Yangzi region to
Japan is traced in the Hokkaido Shimbun Press (ed.), *Ezo Nishiki no Kita Michi* [The Silk Brocade
Roads of Ezo] (Sapporo, 1991).

[64] For the estimated volume of silk imports via this route, see Sasaki Shirō, *Hoppō kara Kita
Kōekimin: Kinu to Kegawa to Santan-jin* [Traders from the North: Silk, Fur, and the Santan People]
(Tokyo, 1996), 183–6.

[65] Nakamura Kazuyuki and Oda Hirotaka, 'Ezo Nishiki to Kita no Shiruku Rōdo' [Ezo Brocade
and the Northern Silk Road], in Emori Susumu, Oguchi Masashi, and Sawato Hirosato (eds.),
Hokutō Ajia no Naka no Ainu Sekai [The World of the Ainu in Northeastern Asia] (Tokyo: Iwata
Shoin, 2008), 827.

population. Additional regulations were imposed upon members of the ruling classes corresponding to their court rank.[66]

Japan and Korea gradually developed contrasting characteristics of clothing cultures, most notably from the sixteenth century onwards, as Suzuki Chikae states:

> In the Korean Peninsula [during the Joseon Dynasty], in contrast to Japan, where dyeing techniques such as Yuzen dyeing and tie-dyeing were treasured, a distinctive clothing culture evolved, characterised by the appreciation of the subtle nuances of weavings, the exquisite combinations of colours, and a wide variety of motifs decorated with embroidery and gold leaf [translation mine].[67]

This does not necessarily mean that Korea was cut off from the dynamic global exchanges of woven cargoes in the early modern world, in particular, the South Asian and later European textiles that stimulated Japanese artisans to innovate and invent new dyeing techniques. While the Joseon dynasty's restrictions on its people's contact with the outside world may have been even more rigid than Tokugawa's maritime prohibition policy – Joseon actually prohibited European traders from setting foot on its soil – trade goods still trickled in. Records show, in fact, that the administration of the VOC felt quite bitter that commodities they had brought to Nagasaki, such as pepper, spices, and various forest products, were re-exported to Korea via Tsushima. Some re-imported products were then sent even farther away, to Beijing, through Korea's tributary trade.[68] Thus, the issue was not the lack of intercultural contact (even if such contact was limited) but rather that social and cultural conditions prevented Korean clothing culture from developing in a certain direction.

[66] The Three Kingdoms of Korea (Goguryeo, Baekje, and Silla) are considered to have established imperial court dress codes around the turn of the fifth century. However, it is beyond the scope of this paper to deal with the details of early dress codes for Korean imperial courts and aristocracy. For more details, see chapters 1 and 3 in Sugimoto Masatoshi, *Kankoku no Fukushoku: Fukushoku kara Mita Nikkan Hikaku Bunkaron* [Korean Dress and Fashion: A Comparison of Japanese and Korean Culture from the Perspective of Their Dress] (Tokyo, 1983).

[67] Suzuki Chikae, 'Chōsen Ōchō no Nuno to Ori' [Textiles and Weaving of the Joseon Dynasty], in Chang Sook Hwan (ed.), *Chōsen Ōchō no Ishō to Sōshingu* (Kyoto, 2007), 146.

[68] General Missive of the Governor-General and Council of the Indies in Batavia to the Gentlemen Seventeen in Amsterdam in 1669, quoted in Nicolaas Witsen, *Noord en Oost Tartaryen: Behelzende eene beschryving van verscheidene Tartersche en nabuurige gewesten, in de noorder en oostelykste deelen van Aziën en Europa; zedert naauwkeurig onderzoek van veele jaaren, en eigen ondervinding ontworpen, beschreven, geteekent, en in 't licht gegeven*, vol. 1 (Amsterdam, 1785), 46; Patriasche Missive of the Gentlemen Seventeen in Amsterdam to the Governor-General and Council of the Indies in Batavia, 15 May 1671, National Archives of the Netherlands, ms VOC 319, ff. 305v–306r.

Along with differences in the natural environment and the difficulty of obtaining certain dyes, Sugimoto Masatoshi emphasises the decisive role played by the Korean ruling system in determining clothing and fashion. First, successive dynasties in Korea established what each class, from the nobles to the commoners, could wear by repeatedly promulgating clothing codes that prescribed every possible detail, such as material, texture, and colour. In Japan the long-term decentralisation of political power and the vigorous growth of the non-elite classes' economic power from the mid sixteenth century meant that the sumptuary laws, particularly those issued by the Tokugawa government, failed to halt the emergence and development of a consumer society in which textile makers constantly provided merchandise with new colours, motifs, ornamentations, and textures to entice buyers. Second, unlike the Shogunate, which broke off diplomatic relations with the Ming and Qing dynasties, Joseon Korea remained a vassal state to the Chinese dynasties, which inevitably meant that the suzerain empires exercised a strong and continuous influence on the norms of the kingdom's material culture.[69] To sum up, Korea's historically-constructed geopolitical and social environment restricted society from opportunities to explore cultural diversity and development beyond the prescribed and hierarchical dress codes.

CONCLUSION

The silk culture of pre-industrial Japan established during the Tokugawa period reflects the multi-layered nature of Japanese civilisation itself. The country's system of silk production and consumption was deeply affected by the Chinese culture of silk, since sericulture and silk production were first transferred from the continent in the prehistoric period. It achieved further sophistication after the introduction of China's imperial system of governing, in which silk played an integral role as a means of taxation and social identification. The political, economic, and cultural influences of Chinese silk never faded in the Kyoto-centred elite culture of Japan throughout the medieval period. Even after the political separation of the Tokugawa shogunate from the Sinic world, Japan was still deeply involved in the China-centred networks of commerce through its trade with China's tributary states and ethnic groups until the age of imperialism and colonialism in the mid nineteenth century.

The process of 'de-sinisation' of Japan's silk culture seems to have been ignited in part by changes in the global, regional, and local economic environment from

[69] Sugimoto, *Kankoku no Fukushoku*, 158–67.

the sixteenth century onwards. This paper has focused on two aspects of this process, that is, the import substitution of Chinese raw silk and silk fabrics and the development of Japanese designs and motifs in the textile industry. The long process of import substitution was achieved in the mid eighteenth century through technological innovation and improvements by Japanese farmers and craftsmen in sericulture, silk reeling, spinning, twisting, processing, and weaving, combined with direct and indirect transfers of technologies from advanced centres of silk production in East Asia.

As to the latter, it is essential to understand that the emergence and development of a distinctive kimono culture in Tokugawa Japan, which tends to be seen as having been incubated within a secluded country, was by nature the result of early modern globalisation, including Japan's intercultural encounters with Europeans. We see the influences of South Asian textiles brought by European and Chinese traders in the motifs and ornamental techniques of Tokugawa silk culture, which is now widely considered Japan's 'national' and 'traditional' culture. The main driving force of this cultural hybridisation and amalgamation was by no means the elite class of warriors and nobles, but the enterprising commoners with wealth and economic power in urban places and villages who were relatively free from the existing cultural values and norms.

13.

Textile Spheres: Silk in a Global and Comparative Context

Giorgio Riello

Economic historian Negley Harte once famously wrote that 'silk did not slip into the minds of Europeans as easily as it did on to their bodies'.[1] Harte's epigram addresses the allure that silk textiles have had for Europeans since the Middle Ages. He underlines the complex relationships between consumer demand, attempts at state control (such as sumptuary laws) and the long-standing quest to develop a viable silk industry in the British Isles and continental Europe. Harte also discussed the relationship between silk and other textiles. Consumers could choose fabrics made from four types of fibre: wool, flax and hemp (for linen), cotton, and silk. Yet their choice was based on more than personal preference. Fabrics made of each fibre came in a range of prices: linens and cottons were the cheapest, followed by woollens and the more expensive silks. Each fabric was also associated with specific virtues and functions: the whiteness of linen evoked an entire universe of meaning around cleanliness, hygiene, and purity that in Europe made this fibre particularly suitable for underwear, shirting, and table and bed linen.[2] The sturdiness of woollens was instead associated with outerwear and in particular with an idea of rusticity that was current in the eighteenth-century Anglo-Saxon world.[3] The lustre of silk, its particularly complex weaves

[1] Negley B. Harte, 'Silk and Sumptuary Legislation in England', in Simonetta Cavaciocchi (ed.), *La seta in Europa, secc. XIII–XX* (Florence, 1993), 801.

[2] Simon Schama, *The Embarrassment of Riches: An Interpretation of Dutch Culture in the Golden Age* (London, 1987), esp. 375–97; Hester C. Dibbits, 'Between Society and Family Values: The Linen Cupboard in Early-Modern Households', in Anton Schuurman and Pieter Spierenburg (eds.), *Private Domain, Public Inquiry: Families and Life-Styles in the Netherlands and Europe, 1550 to the Present* (Hilversum, 1996), 125–45.

[3] Beverley Lemire, 'Fashion and Tradition: Wearing Wool in England during the Consumer Revolution, c. 1660–1820', in Giovanni Luigi Fontana and Gérard Beverly Gayot (eds.), *Wool: Products and Markets (13th–20th century)* (Padua, 2004), 573–94.

and sophisticated texture, was associated with the world of ceremonial and courtly dress and the consuming habits of the elites though, as other contributions in this volume underline, over time silk also came to assume a range of uses among the more general population.

None of the four key fibres was universally used in the early modern world. Historians have emphasised the omnipresence of cotton textiles in Asia, Europe, and the Americas in the eighteenth century, but several studies based on probate inventories show that calicoes and chintzes were not as common as one might have thought in European and American wardrobes at least until the final decades of the eighteenth century.[4] Linen was popular in Europe, accounting perhaps for half of all textile yardage consumed in the continent in the early modern period but its use was less widespread in several parts of Asia. Similarly woollen textiles were widely used in Europe and North America but much less appreciated in East Asia where the top position was effectively held by silk.[5] While silk consumption in East Asia was high, the same cannot be said of Europe. In the early modern West, silk production was a sector producing relatively small quantities of costly fabrics. This does not mean that silk production was unimportant – actually quite the opposite; what characterised silk was the high value per unit, capital intensity and luxury status that made it one of the most sought-after items of consumption across Eurasia and beyond.[6]

Each of four fibres had a different overall trajectory in the early modern period. Unlike woollens and linens, silks, and cottons have been seen as embodying global narratives of trade, consumption, and industrialisation. Indeed, cotton textiles were as crucial to the rise of the factory system in the Industrial Revolution

[4] There are differing interpretations of the role of cotton in early modern Europe and North America. See: Beverly Lemire, 'Fashioning Cottons: Asian Trade, Domestic Industry and Consumer Demand, 1660–1780', in David T. Jenkins (ed.), *The Cambridge History of Western Textiles*, vol. 1 (Cambridge, 2003), 493–512; John Styles, 'What Were Cottons for in the Industrial Revolution?', in Giorgio Riello and Prasannan Parthasarathi (eds.), *The Spinning World: A Global History of Cotton Textiles, 1200–1850* (Oxford, 2009), 307–26; John Styles, *The Dress of the People: Everyday Fashion in Eighteenth-Century England* (London and New Haven, 2007), 109–32; Anne E. McCants, 'Modest Households and Globally Traded Textiles: Evidence from Amsterdam Household Inventories', in Laura Cruz and Joel Mokyr (eds.), *The Birth of Modern Europe: Culture and Economy, 1400–1800. Essays in Honour of Jan de Vries* (Leiden and Boston, 2010), 124–6; and on the American markets Robert DuPlessis, *The Material Atlantic: Clothing, Commerce, and Colonization in the Atlantic World, 1650–1800* (Cambridge, 2015), esp. chs. 5–7.

[5] This was not necessarily true of Japan, where high-quality European woollens were much appreciated. Amelia Peck (ed.), *Interwoven Globe: The Worldwide Textile Trade, 1500–1800* (New York, 2013), 34.

[6] Giorgio Riello, 'Fabricating the Domestic: The Material Culture of Textiles and the Social Life of the Home in Early Modern Europe', in Beverly Lemire (ed.), *The Force of Fashion in Politics and Society: Global Perspectives from Early Modern to Contemporary Times* (Aldershot, 2010), 41–65.

as silks were in courtly rituals in Imperial China or Renaissance Italy. The importance of cotton and silk is seen in the fact that they transcended specific places or nations and by doing so helped to shape global trade, production technologies, and patterns of consumption across the pre-modern world. In contrast, the histories of woollens and linens have been narrated mostly within frameworks of analysis that emphasise their importance for national economies and trade within the European continent and later the Americas.

TEXTILE SPHERES AND THEIR DIFFUSIONS

The cultivation and manufacturing of the four main natural textiles was never equally distributed across the globe. I have elsewhere introduced the concept of 'textile spheres': areas of origin of textile specialisation that were maintained over the centuries.[7] Silk was first developed as a product and an item of trade and consumption in (present-day) eastern China already in Antiquity. South Asia did not emerge as world leader in the production of cotton textiles until after 1000 CE. More or less at the same time western Europe came to specialise in the production of woollen textiles (Map 13.1). Linen production remained more geographically diffused, although parts of eastern and southern Europe emerged as key areas of production in the medieval and early modern periods.

This is a very approximate characterisation that needs at least three disclaimers. First, the origin of each of these world 'poles' of textile specialisation depended on climate and resource endowment. The woollen industry of Western Europe developed on the strength of the continent's reservoir of wool-producing sheep. Though sheep and other wool-producing animals, such as goats, were present in other parts of Eurasia (in particular Central Asia), it was in Europe that large areas of land were specifically deployed to feed millions of sheep. Areas of specialisation were created, for example, in the British Isles where wool and wool textile production remained the most important manufacturing and export sector for the best part of six centuries.[8] India relied instead on a long-standing engagement with raw cotton, a crop that was cultivated in different parts of the subcontinent and characterised the agrarian economy in many areas. By 1000 CE

[7] Giorgio Riello, 'The World of Textiles in Three Spheres: European Woollens, Indian Cotton and Chinese Silks, 1300–1700', in Marie-Louise Nosch, Zhao Feng and Lotika Varadarajan (eds.), *Global Textile Encounters* (Oxford and Philadelphia, 2014), 93–106.

[8] Fontana and Gayot (eds.), *Wool: Products and Markets*; John Munro, 'Medieval Woollens: Western European Woollen Industries and their Struggles for International Markets, c. 1000–1500', in Jenkins (ed.), *The Cambridge History of Western Textiles*, vol. 1, 228–324; Herman Van der Wee, 'The Western European Woollen Industries, 1500–1750', *ibid.*, 397–472.

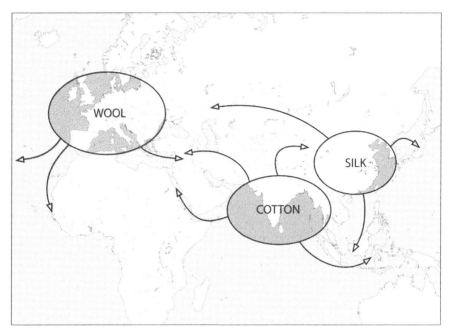

Map 13.1 The three areas of textiles and their trade in the
medieval and early modern world. Design: Julian Wickert.

cotton cultivation was present in the Middle East and slowly diffusing to East
Asia, but did not spread to Europe, as the climate was unsuitable.[9]

Second, the chronology of trade development in each of these 'textile
spheres' was different. By drawing on local supplies of silkworms, East Asia
developed a large-scale silk industry in Antiquity. By 1000 CE this had developed
into a Eurasian trade. The long-distance circulation of silk textiles started well
before that of any other fabric. In the first millennium BCE China was already an
exporter of silk textiles and both ancient Greek and Roman consumers enjoyed
the sensuous pleasure of Asian silks.[10] By the later Middle Ages, 'Tartar' cloths
from Central Asia were treasured by Italian princes and prelates.[11] India emerged
as a leader in cotton textile manufacturing only after 1000 CE though cotton

 [9] Giorgio Riello, *Cotton: The Fabric that Made the Modern World* (Cambridge, 2013), ch. 3.
 [10] See Debin Ma, 'The Great Silk Exchange: How the World was Connected and Developed',
in Dennis Flynn, L. Frost and A. J. H. Lantham (eds.), *Pacific Centuries: Pacific Rim History since
the Sixteenth Century* (London, 1999), 1–30.
 [11] See Roxann Prazniak, 'Siena on the Silk Roads: Ambrogio Lorenzetti and the Mongol Global
Century, 1250–1350', *Journal of World History*, 21/2 (2010), 177–8.

textiles from the Indian subcontinent were traded both westwards to the Red Sea and eastwards to East and Southeast Asia before that date.[12] And finally Europe's woollen production achieved an intercontinental scale only with the opening of the Atlantic commercial routes in the seventeenth and eighteenth centuries.[13] To a certain extent this was also the case for linen, though the pattern of trade of this cheaper cloth remained predominantly internal to Europe, with trade to Africa and the Americas developing in the seventeenth and eighteenth centuries.[14]

Finally, none of the four textile spheres remained confined to the original area of specialisation. Trade initiated a process of what we might call 'reverse engineering'. First, finished products were traded, then a specific area started manufacturing imitations using imported intermediate materials (silk yarn) and finally replaced the entire productive process by producing the source material (in the case of silk by mastering sericulture). Clearly trade was the rational response to a global specialisation of production with products in high demand fetching premium prices outside their respective 'spheres' where they were appreciated as something different (exotic) and uncommon (rare). But such an explanation only partially accounts for the success of different cloths. This is because consumers do not just appreciate the properties of the fibre itself (sheen for silks, warmth for woollens, softness for cotton, and the coolness of linen) but also the cloth produced from such fibres.[15] The least successful of the four fibres were linen and wool. In Europe, linen was gradually replaced by cotton from the second half of the eighteenth up to the end of the nineteenth century. Partially because of its labour-intensive processing, by the twentieth century the use of linen was confined to specific garments (summer suits and dresses) and today accounts for a small percentage of all textiles. Wool was somewhat more successful: it came to significantly influence the sartorial habits of neo-Europeans in the Americas

[12] Ruth Barnes, *Indian Block-Printed Textiles in Egypt. The Newberry Collection in the Ashmolean Museum, Oxford* (Oxford, 1997); Ruth Barnes, 'Introduction', in Ruth Barnes (ed.), *Textiles in Indian Ocean Societies* (London and New York, 2005), 1–10.

[13] See for instance Stanley D. Chapman, 'British Marketing Enterprise: The Changing Roles of Merchants, Manufacturers, and Financiers, 1700–1860', in Stanley D. Chapman (ed.), *The Textile Industries. Volume 2: Cotton, Linen, Wool and Worsted* (London and New York, 1997), 287–310; D. T. Jenkins and K. G. Ponting, *The British Wool Textile Industry, 1770–1914* (London, 1982) and the classic by K. G. Ponting, *The Wool Trade: Past and Present* (Manchester and London, 1961).

[14] Negley B. Harte, 'British Linen Trade with the United States in the Eighteenth and Nineteenth Centuries', in *Textiles in Trade* (Washington, 1990), 15–23; Leslie Clarkson, 'The Linen Industry in Early Modern Europe', in Jenkins (ed.), *The Cambridge History of Western Textiles*, vol. 1, 473–92; Brenda Collins and Philip Ollerenshaw, 'The European Linen Industry since the Middle Ages', in Brenda Collins and Philip Ollerenshaw (eds.), *The European Linen Industry in Historical Perspective* (Oxford, 2003), 1–42; Robert DuPlessis, 'Transatlantic Textiles: European Linens in the Cloth Culture of Colonial North America', *ibid.*, 123–37.

[15] Riello, 'World of Textiles in Three Spheres', 94–5.

and Australasia, though its appeal in Asia remained confined to the Middle East or to very high grades of fine woollens sold in China or Japan. It was only with the adoption of western dress at the end of the nineteenth century that woollens became an item of widespread consumption in East and South Asia.[16] In contrast the global diffusion of the trade, production and consumption of silk and cotton textiles is often intertwined with that of the so-called 'first global age'. But why was this the case and where do the stories of cotton and silk diverge?

GLOBAL DIFFUSION

In 1590 Jan Van Der Straet (1523–1605) better known as Stradanus, a Flemish mannerist artist who lived in Florence for part of his life, published *Vermis Sericus*, a series of six prints illustrating the history and techniques of silk production in Europe. The first image after the title page depicts the arrival of silk manufacturing in the West. Emperor Justinian (r. 527–605 CE) is shown on horseback receiving the first imported silkworm cocoons from two Nestorian monks (Illustration 13.1). According to the backstory, the monks had smuggled the silkworm eggs into the Byzantine empire (330–1453) and the moment is presented as the foundation of the silk industry in Europe. The other images in the series comprise the rearing of silkworms and the reeling of silk (Illustration 13.2). In fact, the images are based on a well-established apocryphal story that has never been confirmed as historical fact: that raw silk production started in the Byzantine empire under Emperor Justinian. Unfortunately, the first confirmed historical source witnessing raw silk production in Constantinople is no older than the ninth or tenth century.

As in the case of cotton, the transfer of sericulture was a lengthy and sometimes ineffective process that clearly cannot be ascribed to a single event. In non-monsoon areas where mulberry trees were scarce, it might take decades for silk production to become a viable productive activity. Starting from present-day northern China, sericulture moved to Korea and central Asia (Khotan) and probably to India (where a local variety of silkworm was already known) around 300–200 BCE. A second phase in around 300–400 CE allowed sericulture to be transferred to south China where the city of Suzhou later emerged as one of the most important centres of silk textile production.[17] The arrival of sericulture in Byzantium, possibly in the sixth century,

[16] Wilbur Zelinsky, 'Globalization Reconsidered: The Historical Geography of Modern Western Male Attire', *Journal of Cultural Geography*, 22/1 (2004), 83–134. See also Robert Ross, *Clothing: A Global History* (Cambridge, 2007).

[17] Christine Moll-Murata, 'Chinese Guilds from the Seventeenth to the Twentieth Centuries: An Overview', *International Review of Social History*, 53 Supplement (2008), 227.

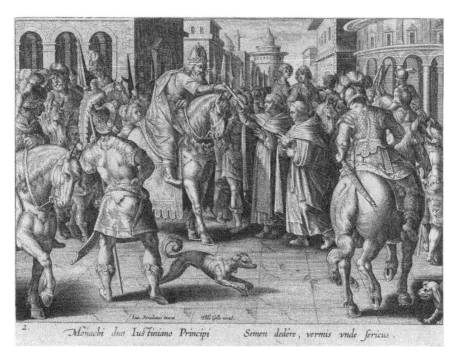

Illustration 13.1 Emperor Justinian Receiving the First Imported Silkworm Eggs
from Nestorian Monks, Plate 2 from *The Introduction of the Silkworm [Vermis Sericus]*.
Print by Karel van Mallery (Antwerp, 1571–1545 Antwerp), after Jan van der Straet,
called Stradanus, published by Philipp Galle. c. 1595. The Metropolitan Museum
of Art, The Elisha Whittelsey Collection, The Elisha Whittelsey Fund, 1950.

is therefore only one step in a process of global transfer, perhaps not as important
for the creation of a European silk industry as Stradanus wanted us to believe. In
fact, a further phase from the ninth to eleventh centuries saw Muslim expansion
into North Africa and southern Europe bring silk production to Spain and Sicily.
Eventually sericulture expanded to Italy in the fifteenth and sixteenth centuries,
to France and central Europe in the late fourteenth and fifteenth centuries, and to
Latin America in the sixteenth century.[18]

The spread of the production of raw materials facilitated more trade and
interaction as, for several reasons, none of the new areas of silk production
became totally self-sufficient. While the diffusion of raw cotton cultivation was
a botanical and agrarian matter, that of silk required both flora and fauna: the

[18] Luca Molà, *The Silk Industry of Renaissance Venice* (Baltimore, 2000), 1–28. Giovanni
Federico, *An Economic History of Silk Industry, 1830–1930* (Cambridge, 1997), 3–4.

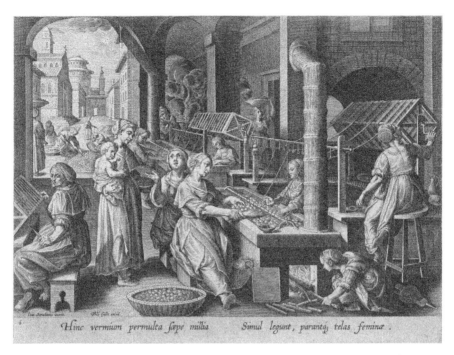

Illustration 13.2 The Reeling of Silk, Plate 6 from *The Introduction of
the Silkworm [Vermis Sericus]*. Print by Karel van Mallery (Antwerp,
1571–1545 Antwerp), after Jan Van Der Straet, called Stradanus, published
by Philipp Galle. c. 1595. The Metropolitan Museum of Art, Gift of
Georgiana W. Sargent, in memory of John Osborne Sargent, 1924.

transplantation of mulberry trees and the successful hatching of silkworm eggs
and rearing of silkworms. Even promising starts did not necessarily assure great
things to come. In the mid sixteenth century, Spanish America promised to be a
new cradle of silk production thanks to its conducive climate and the successful
transplantation of sericulture. Yet the project for the creation of an American
silk industry stalled. Competition from European and especially Chinese silks
became a major barrier to the development of a viable industry.[19]

A further characteristic of silk production up until the nineteenth century is
that sericulture was always closely linked with silk reeling. Unlike raw cotton,
which was moved intercontinentally without any need for processing in the areas
of cultivation, silk production was both an agrarian and a manufacturing activity.
Cocoons had to be placed in basins with water heated to 90 degrees centigrade

[19] See the chapter by José L. Gasch-Tomás in this volume.

to unwind the silk; they were then transferred to more tepid water and their filaments were drawn together in what is known as reeling. Unlike short cotton fibres, which can be spun even months after they are plucked from the tree and cleaned, long silk filaments require immediate processing in order not to spoil the quality of the silk itself. Utilising the naturally occurring gum *sericin* a twisting force is applied to create a stronger thread. The sophistication of these stages of production and the later throwing of silk have no equivalent in the making of cotton, wool, or linen. Indeed, the complexity and immediacy of this process explains why silk could not develop as a plantation crop but was confined by the integration of sericulture and the first productive phase of reeling.

TECHNOLOGIES

Unlike silk, cotton textile production relied on very simple spinning tools: a hand-operated ginning (*chobkin*), the simple bow (*naddaf*) for removing the impurities from the cotton fibre, spindles and later simple spinning wheels and eventually treadle-operated multi-spinning wheels (such as those adopted in twelfth-century China) and water-powered spinning wheels.[20] Cotton looms also remained simple, often light enough to be transportable by mobile Indian weavers. Such technologies did not require complex forms of organisation; women in the countryside could both pick the cotton and spin it, men wove on a single loom. Eventually long-distance sourcing of raw cotton (as for instance raw cotton cultivated in the New World) led to specialisation in spinning. Proto-industrial organisation of weaving was present in India in the so-called weaving villages that specialised in the production of specific types of cloth. Yet, the organisation of cotton weaving remained strongly connected with the household economy.

This was not the case for silk: the sector was from its earliest beginnings a capital-intensive activity and often at the forefront of technological innovation. Silk throwing is the term used for all the operations of twisting and doubling by which fine raw silk threads are turned into more substantial silk yarn. The number of threads that are doubled together and the amount of twist put on them determines the type of fabric produced from the yarn.[21] Unlike silk reeling, which had relatively little variation across space and time, throwing was an area of continuous and precocious technological innovation. Large-scale machinery appeared very early in the silk sector. A machine for reeling silk was perfected in

[20] Riello, *Cotton*, 49–56.
[21] I thank Karolina Hutkova for sharing her in-depth knowledge of the complex processes of production of silk.

the Northern Sung era (960–1127 CE).[22] It is unclear whether the silk throwing technologies that developed in Europe related to those adopted in East and other parts of Asia. Silk-throwing mills powered by waterwheels appeared in Italy in the thirteenth century and a series of variants were perfected in the following centuries.[23]

If sericulture and reeling remained relatively connected to the agrarian world, often in the form of mixed agrarian practices and by-employment for women, silk throwing and silk weaving became urban occupations organised by guilds. In the cities of northern Italy, for instance, the *setaioli* (merchant entrepreneurs dealing in silk cloth) were among the most powerful guilds and competed with the *lanaioli* (wool processing guilds). At the end of the Middle Ages, silk manufacturing came to characterise the economies of large southern European cities such as Venice and Bologna, and later in the seventeenth and eighteenth centuries those of metropolises such as Lyon and London.[24] Peter Earle tells us that in the early eighteenth century, 10,000 looms were active in London in the silk trade and these gave work to possibly 50,000 people.[25] Bologna in the sixteenth century had 350 silk vats and produced 100,000 pounds of silk yarn a year.[26]

Bologna owed its position as one of the largest silk production centres in Europe to its celebrated throwing machine, the Bolognese *filatoio*, which, according to Carlo Poni, was the most efficient machine of its kind in Europe.[27] Replicas of the Bolognese throwing machines at the Museo dell'Impresa Industriale in Bologna show the scale of such early modern machinery.[28] Analysis and detailed consideration of the evolution of the *filatoio* highlights a distinctive

[22] Mark Elvin, *The Pattern of the Chinese Past: A Social and Economic Interpretation* (Stanford, CA, 1973), 194.

[23] Richard Leslie Hills, *Power in the Industrial Revolution* (Manchester, 1970), 29.

[24] On Italy see: Mola, *The Silk Industry of Renaissance Venice*. On the Italian silk industry see also: Luca Mola, Reinhold C. Mueller and Claudio Zanier (eds.), *La seta in Italia dal Medioevo al Seicento: dal baco al drappo* (Venice, 2000); Lisa Monnas, *Merchants, Princes, and Painters: Silk Fabrics in Italian and Northern Paintings, 1300–1500* (New Haven and London, 2008); Carlo Poni, *La seta in Italia: una grande industria prima della rivoluzione industriale*, ed. by Vivian R. Gruder, Edmund Leites, and Roberto Scazzieri (Bologna, 2009). For London see the work by Natalie Rothstein and for Lyons the work by Lesley E. Miller, including her chapter in this volume.

[25] Peter Earle, *The Making of the English Middle Class. Business, Society and Family Life in London, 1660–1730* (London, 1989), 20.

[26] Antonio di Paolo Masini, *Bologna Perlustrata. Terza impressione notabilmente accresciuta* (Bologna, 1666), vol. 2, 375.

[27] Carlo Poni, 'The Circular Silk Mill: A Factory before the Industrial Revolution in Early Modern Europe', *History of Technology*, 21 (1999), 65–85.

[28] For an image of a replica throwing machine, see: http://www.museibologna.it/patrimonioindustriale/didattica/53076/offset/0/id/53418.

character of the silk sector: the fact that there was no technological convergence. Solutions adopted by the industry in different areas of the world, near or far, were not identical. Unlike cotton machinery, which was later strictly protected and improved over time in a linear sequence, silk displayed a more variegated palette of technological solutions. The *filatoio* is a prime example as, according to Poni's evidence, the technologies adopted by two nearby cities, Milan and Genoa, differed, if not markedly, surely strikingly from the Bolognese model in terms of different phases of production.[29]

A second characteristic of the silk sector was the high level of technological transfer through codified and craftsmen's knowledge, as well as industrial espionage. Unlike cotton production, where technological transfer remained minimal until the eighteenth century, technology in silk processing followed an early modern pattern of continuous transfers and adaptations, notwithstanding laws preventing the stealing of technology. In 1598, for instance, Cesare Dolcino and Giovanni de Fradino were condemned (in absentia) to death by the city of Bologna for their part in transferring the Bolognese silk throwing technology to the city of Trento in northern Italy.[30] Notwithstanding these draconian measures, the rise of silk production within Europe and across Eurasia was heavily dependent on technological transfer. The silk-throwing mills that were introduced in Amsterdam in 1605 were possibly based on an Italian model but it remains unclear whether they were variations borrowed via Portugal or the southern Netherlands. We also know that the later large-scale silk-throwing mills (with 130–150 spindles) introduced in the Netherlands around 1680 were built by Italians.[31] Human capital mattered. In 1721 John Lombe (1693–1739) and his half-brother Thomas (b. 1685) set up a large silk throwing mill in Derby that employed over 300 workers using Italian technology. The Bolognese silk-throwing mills were well known and plans for their construction were already circulating a century before the Lombe brothers. Yet as with most technologies they needed skilled workmen to make them work. Unable to lure skilled Italian craftsmen to England, the Lombe brothers resorted to spending the best part of two years in Italy learning exactly how such machines were constructed and worked.[32] Theirs was a work of industrial espionage, an activity that was common well into the eighteenth century. Another example is Jean-Antoine Nollet's (1700–70) journey

[29] Carlo Poni, 'All'origine del sistema di fabbrica: tecnologie e organizzazione produttiva dei mulini da seta nell'Italia settentrionale (secc. XVII–XVIII)', *Rivista Storica Italiana* 88/3 (1976), 444–97.

[30] *Ibid.*, 455.

[31] Karel Davids, *The Rise and Decline of Dutch Technological Leadership: Technology, Economy and Culture in the Netherlands, 1350–1800* (Leiden and Boston, 2008), 151–2.

[32] Jan de Vries, *The Economy of Europe in an Age of Crisis, 1600–1750* (Cambridge, 1976), 88.

to Piedmont in 1749, sponsored by the French Bureau de Commerce to gather intelligence of silk manufacturing.[33] The case of Nollet alerts us to a third and important characteristic in the development of the silk sector, especially in early modern Europe: the importance of the sector in national economies and the consequent control that states and empires exercised in developing sericulture, silk manufacturing, and trade.

The rhetoric commonly used was one of facilitating the employment of poor women and children and of import substitution of the expensive textiles procured from other nations, an argument later adopted by the supporters of a national cotton textile industry as well. What was distinctive in the case of silk was that such argumentation was used much earlier than in other textile sectors and was strongly connected to international competition in the textile sector. For instance, when in 1609 James I of England (1566–1625) gave his support to the publication of William Stallenge's *Instructions for the Increasing of Mulberrie Trees*, he explained that:

> our brother the French King hath, since his coming to that Crown, both begun and brought to perfection the making of silks in his country, whereby he hath won to himself honour, and to his subjects a marvellous increase of wealth. [We] would account it no little happiness to us if the same work [...] might in our time produce the fruits which there it has done.[34]

Further encouragement could be given through the granting of export bounties, the abolishment of duties, or the ban of imports altogether. These were all measures adopted by the English government in the eighteenth century under the pressure of the powerful lobby of the London silk weavers.[35] In fact it is often forgotten that the so-called calico ban in England and some continental European nations from the 1680s to the 1750s did not just concern the importation and consumption of Asian cotton textiles but also included silk textiles. The large scale of silk manufacturing, its technological sophistication and the uncompromised support of national government however begs the question as to why today silk consumption represents at best 5 per cent of all textiles. In comparison, more than half of all textiles consumed in the world today are cottons or mixed cotton fabrics. Is this simply the result of consumer taste – the

[33] Paola Bertucci, 'Enlightened Secrets: Silk, Intelligent Travel, and Industrial Espionage in Eighteenth-Century France', *Technology and Culture*, 54/4 (2013), 820–52.

[34] Cited in Linda Levy Peck, *Consuming Splendor: Society and Culture in Seventeenth-Century England* (Cambridge, 2005), 93.

[35] Ralph Davis, 'The Rise of Protection in England, 1789–86', *Economic History Review*, 19/2 (1966), 314.

fact that consumers preferred cheaper and softer cotton to more expensive and glossy silks? Or has it to do with the elasticity of supply or raw materials and the fact that cotton textile production could expand thanks to large-scale production of raw material through slave labour and in a plantation system? All of the above-mentioned factors are important but two other issues should not be overlooked: the different technological trajectories of cotton and silk production and their distinctive relationships to what we might call 'decoration'.

OF SILK AND COTTON

As with all manufacturing sectors of pre-industrial economies, silk production in Eurasia and beyond was characterised by phases of local expansion followed by stasis and decline. The case of Italy is emblematic: silk allowed entire cities to grow rich, as in the case of Bologna and several other Italian cities of the fifteenth and sixteenth centuries. Yet by the time of the so-called 'crisis of the seventeenth century' – the economic downturn that affected most of Eurasia in the early to mid seventeenth century – and even earlier with the first great plague of 1578–80, silk workers dispersed into the countryside.[36] Silk embodied a pre-industrial pattern based on a geographic shift of leading areas of silk manufacturing that was part and parcel of the continuously renewing nature of the sector both in terms of technologies and products. Like cotton textile production in pre-industrial India, silk manufacturing in Italy, France or China was heavily reliant on a balance of employment across agrarian and manufacturing sectors and on the production of different fibres and cloths. For instance, the relative decline of silk manufacturing in the seventeenth century in Italy coincided with the expansion of the woollen industry to replace English imports.[37] The development of cotton manufacturing in several parts of Europe as well as in Anatolia (for instance, the area of Bursa) in the late seventeenth and early eighteenth centuries might have also contributed to the depression of silk production.[38]

There was also a tension between the export of finished cloth and the export of raw silk or silk yarn. The Italian peninsula, for instance, had been a large exporter of finished silk cloth but with the crisis of the seventeenth century and

[36] Carlo Marco Belfanti, 'Rural Manufactures and Rural Proto-industries in the "Italy of the Cities" from the Sixteenth through the Eighteenth Century', *Continuity & Change*, 8/2 (1993), 257–8.

[37] Maureen Fennell Mazzaoui, 'The Cotton Industry of Northern Italy in the Late Middle Ages: 1150–1450', *Journal of Economic History*, 32/1 (1972), 280–1.

[38] Murat Çizakça, 'Price History and the Bursa Silk Industry: A Study in Ottoman Industrial Decline', *Journal of Economic History*, 40/3 (1980), 543.

the emergence of new silk-weaving countries such as France, England, and the central European states, Italy became an international provider of raw silk.[39] In comparison, the production of raw cotton, at least for the rising European industry, was totally confined to plantations in the Americas after 1750. These areas had no chance of – indeed were prevented from – developing any industrial activity. The spatial compression of the silk chain of production might have therefore hindered its long-term industrial development through a global articulation.

Unlike cotton or wool for which the very source (animal or plant) made a difference to the quality and price of the material (raw or spun), in the case of silk the process itself had major repercussions on the quality of the yarn. The fame of the Bolognese *filatoio*, for instance, was attributed not just to the comprehensiveness of its processes but also to the strict quality control in Italian proto-factories.[40] Poni underlines an important characteristic of silk technology applicable to both silk-throwing machines and looms; they were flexible enough to allow the production of different yarns and cloths. Variety – in terms of intermediate and finished products – was surely the response to an articulated consumer demand but could only be achieved through technological solutions that allowed flexible specialisation.[41] In the case of satin, variety in texture and colour and the ability to contrast and complement hues was obtained through complex systems of weaves. With velvets and lampas additional warps and wefts formed a pattern, and weaves created contrasting textures and a three-dimensional effect. The result was an enormous variety of textiles ranging from plain silks such as tabby, twill, satin, and velvets to figured silks such as twill, lampas, and damask. Cotton textiles were a rather more uniform category in comparison. Yarn and cloth varied in fineness but the key variance among cottons was the size of the cloth and the type of decoration. The process of weaving was, if anything, rather straightforward for cotton textiles and, as mentioned earlier, the Indian pit-loom remained a simple piece of equipment. Silk used instead complex drawlooms with heald and figure harnesses that required sophisticated craftsmanship and up to four assistants for each weaver. Threads had to be moved and additional warps and wefts inserted.[42]

[39] See Lisa Monnas, this volume.

[40] Walter English, 'The Textile Industry: Silk Production and Manufacture, 1750–1900', in Charles Singer (ed.), *A History of Technology IV: Industrial Revolution, 1750–1900* (Oxford, 1958), 310.

[41] Poni, 'All'origine del sistema di fabbrica', esp. 448–9.

[42] Robert Flanagan, 'Figured Fabrics', in Charles Singer (ed.), *A History of Technology III: From Renaissance to the Industrial Revolution, 1500–1750* (Oxford, 1957), 187.

In addition, silk and cotton developed rather divergent aesthetic trajectories. Whilst silk was appreciated for its lustre, complex weaves, and heavy decoration, cotton came to be appreciated because it was soft, light, and colour fast.[43] Let us consider two deceptively similar types of cloth. Illustration 13.3 is an example of 'bizarre silk', figured silk cloth with asymmetrical patterns popular in Europe in the seventeenth and eighteenth centuries. It was woven in Spitalfields in East London, an area that at the time was emerging as a leading centre for silk textile design and weaving in Europe. The silk combined architectural and floral motifs in large repeats to form a sense of the exotic suitable for an informal men's robe (a banyan) inspired by Japanese kimonos first given as diplomatic gifts to servants of the Dutch East India Company in the mid seventeenth century.[44] This was a European fabric attempting to appear oriental. Conversely, Illustration 13.4 shows an Indian cotton fabric attempting to look like a European silk cloth. It is a resist- and mordant-dyed cotton produced on the Coromandel Coast of India and more or less coeval with the Spitalfields silk.

Both fabrics are small masterpieces in their own right. Yet we should not be drawn to any facile conclusions about their relationship. Whilst the silk (Illustration 13.3) was patterned through the medium of weaving, the cotton (Illustration 13.4) was painted and possibly printed. This is a fundamental and important difference that might explain some key differences between cotton and silk textiles.[45] Europe and China excelled in the creation of design through the mediums of weaving and embroidering (Figure 13.1 in dark grey). Embroidery was one of the most common occupations in early modern Europe and Ming and Qing China and gave work to thousands of professionals and millions of women. Patterning through weaving was the result of increasingly complex silk looms, the most complicated being those used for the production of expensive velvets with multiple wefts. Textile 'design' was created through the weaving of the yarn, the mixing of fibres, and the use of different colours.

The decoration of a cotton cloth in India could have not been more different: here design was created through dyeing, printing and painting (Figure 13.1 in light grey), a process that entailed a completely different set of skills based on knowledge of dyes, mordants (to fix the colour), processes of waxing the cloth, bleaching it, and of course the carving of wood blocks. The difference between

[43] I am returning here to an argument that I initially developed in Riello, 'The World of Textiles in Three Spheres'.

[44] Beverly Lemire, 'Fashioning Global Trade: Indian Textiles, Gender Meanings and European Consumers, 1500–1800', in Giorgio Riello and Tirthankar Roy (eds.), *How India Clothed the World: The World of South Asian Textiles, 1500–1800* (Leiden and Boston, 2009), 365–90.

[45] Giorgio Riello, 'Asian Knowledge and the Development of Calico Printing in Europe in the Seventeenth and Eighteenth Centuries', *Journal of Global History*, 5/1 (2010), 1–29.

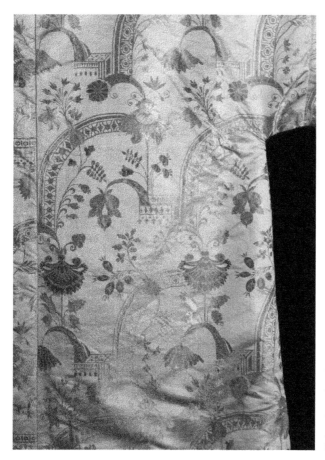

Illustration 13.3
Detail of a nightgown.
Silk satin, interlined
with wool, and lined
with silk. Produced in
Spitalfields, London.
Woven in 1707–1708
and made into a
garment in 1707–1720.
© Victoria and Albert
Museum, London,
no. T.281-1983.

a woven and a printed textile is not just one of beauty but also of technical processes and craftsmanship. To set up a loom was an expensive and time-consuming activity. This explains why in Europe a textile's abundance of colour and complexity of design was partially an indicator of its value. Any change in textile design was expensive as it implied weeks, if not months, of work in setting up the loom. By contrast printing, painting, and dyeing were more flexible. The dyes used in cotton printing were relatively cheap and could be found in abundance near places of cotton textile manufacturing; one had to simply change the mordant to create new shades and colours.

Cotton fibre was more suitable than flax, hemp, wool, or silk for absorbing dyes and printing on the cloth. Starting in India, the processes of printing and painting on cotton were adopted by other areas of Asia where cotton cultivation and textile manufacturing developed around the year 1000 CE. In the later Middle

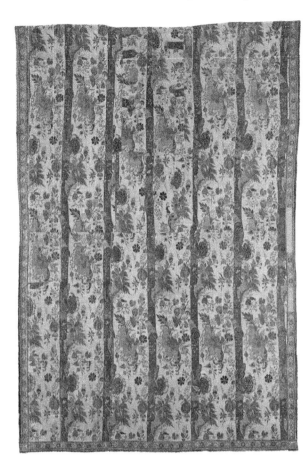

Illustration 13.4
Cotton, resist- and
mordant-dyed dress
or furnishing fabric.
Produced on the
Coromandel Coast, India,
c. 1715–1725. © Victoria
and Albert Museum,
London, 342 to B-1898.

Ages, European cloth workers (in the area of present-day Germany) attempted to engage in the technique of printing using woollen cloth, but the experiment was not successful. The lack of cotton or familiarity with cotton textiles made the process of printing difficult to learn and replicate. It was only after the importation of cottons from Asia and the learning of the process in India between the last quarter of the seventeenth and the first quarter of the eighteenth century that Europe first produced printed textiles. By 1675, linens, fustians, and white Indian cotton cloths were printed in the many printworks that appeared across Europe.[46]

[46] See among the many: Stanley D. Chapman and Serge Chassagne, *European Textile Printers in the Eighteenth Century: A Study of Peel and Oberkampf* (London, 1981); Stanley D. Chapman, 'Quality versus Quantity in the Industrial Revolution: The Case of Textile Printing', *Northern*

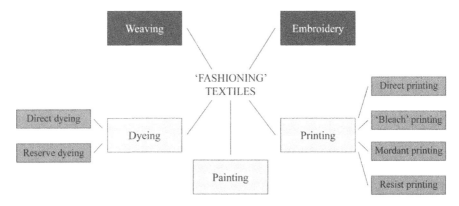

Figure 13.1 Creating design on cloth in early modern Eurasia.

If variety was achieved in silk through the medium of technological adoption in both throwing and weaving, in cotton spinning and weaving produced a more standard product. In India spindle spinning allowed the production of fine yarn to be used for muslin but the true differentiation between products was the result of finishing and the quality of the printing, painting, and pencilling of a piece of cloth. This set apart a beautiful and expensive *palampore* with its complex patterns and vivid colours from a cheap *niccanees* or Guinea cloth destined for the slave market of the Atlantic Ocean. Printing was also a flexible process. Variety was achieved through continuous alteration in colour and pattern. It is undeniable that this responded to the demands of fashion.[47] Even if silk design inaugurated a standardisation of the fashion cycle in the late seventeenth-century Europe, cotton facilitated an expansion that included a much wider stratum of society.[48] Cotton became 'fashion's favourite', to borrow Beverly Lemire's expression, partially thanks to the specific process of decoration of the cloth.[49]

History, 21 (1985), 175–92; Robert Fox and Agustí Nieto-Galan (eds.), *Natural Dyestuffs and Industrial Culture in Europe, 1750–1880* (Canton, MA, 1999); Serge Chassagne, 'Calico Printing in Europe before 1780', in Jenkins (ed.), *The Cambridge History of Western Textiles*, vol. 1, 513–27; Riello, *Cotton*, ch. 8.

 [47] Beverly Lemire and Giorgio Riello, 'East and West: Textiles and Fashion in Early Modern Europe', *Journal of Social History*, 41/4 (2008), 887–916.

 [48] John Styles, 'Fashion and Innovation in Early Modern Europe', in Evelyn Welch (ed.), *Fashioning the Early Modern: Dress, Textiles, and Innovation in Europe, 1500–1800* (Oxford, 2016), 33–56.

 [49] Beverly Lemire, *Fashion's Favourite: The Cotton Trade and the Consumer in Britain, 1660–1800* (Oxford, 1991).

CONCLUSION

This contribution has attempted to compare the trajectories of the four main early modern fibres. In particular, silk and cotton textiles entered global circuits of trade and consumption, yet their trajectories were distinctively different. Whilst cotton succeeded in becoming a consumer good around the world, silk remained an important but small sector producing sophisticated textiles for a more restricted clientele. The two fibres shared common features but were also characterised by important differences. The case for the distinctiveness of cotton as the quintessential 'industrial fibre' can be questioned by the fact that silk mechanised its production process much earlier than cotton. Indeed the silk sector was at the forefront of technological innovation until the end of the pre-industrial period. By comparison cotton production relied on simple technologies and on the capacity to compartmentalise its process of production. Yet neither the raw material production, nor the production of yarn can fully explain the substantive difference between cottons and silks. I suggest that we should instead pay more attention to how design and decoration is achieved on cloth. Whilst silk relied on weaving, design on cotton was achieved through the more flexible process of printing. What might appear as a minor dissimilarity revealed itself to be a major point of difference in the stories of silk and cotton.

Glossary

akmişe – fine stuffs.

aksun – a type of painted Chinese silk.

alaca/alaja – striped stuff, cotton and silk.

alamode – lightweight, glossy silk fabric used in the manufacture of scarfs, hoods, etc.

alto e basso (**'pile-on-pile'**) – monochrome velvet with solid cut-silk pile, woven in two heights.

angora – good-quality goat's wool imported from Ankara.

Antheraea – a genus of moths used for silk production. The principal silkworm moth is *Bombyx mori*.

ardas – least desirable export grade of silk, also called *shirvani* silk.

ardasse – a coarse silk.

ardassin – silk from Iran.

ardassine – of a similar colour but of lower quality than *sherbassi*.

aṭlas – satin.

aurung – a textile producing area.

baldacchino (**baldekyn/baudekyn**) – lampas silk whose name derives from the medieval Italian name for Baghdad; it can be monochrome or polychrome, woven with a pattern weft of gold thread, or brocaded with gold.

Bombycidae – family of moths, among them *Bombyx mori*.

bedestan – covered, secured market.

beypazar – goat's wool imported from Beypazar, a town to the west of Ankara.

binding warp – secondary warp that binds pattern or brocading wefts, thus making a supplementary binding.

boluo 桲樆 – a variety of oak tree grown on fallow and hilly land for wild silkworm pasturing.

Bombyx mori – silkworm of the mulberry tree.

bouclé (*rizo*) – a weave effect of massed loops, used in Castile to decorate parts of garments, such as sleeves, and to tailor hats.

brocade – in the eighteenth century fabrics patterned with brocading wefts (see below) were called brocades; they might incorporate both silk and metal threads.

brocading weft – supplementary weft added to create a pattern. Its movement is limited to the width of the area where it is required and it does not travel from selvage to selvage.

bund – a silk rearing season.

bürümcük – light-weight, relatively low-value silk, often used to make shirts.

canmu 蠶母 – female worker in charge of rearing silkworms in China.

canwang 蠶網 – silkworm net.

çatma – voided and brocaded figured velvet.

chassar – peasant rearing silkworms in Bengal.

chaúl – type of matt silk, usually blue.

chirimen 縮緬 – crepe, Japanese.

chokbin – hand-operated ginning, a spinning tool in cotton textile production.

cloth of gold – fabric interwoven with gold thread, see *seräser*.

cocoon – cocoons produced by *Bombyx mori* silkworms are constituted by one single filament whose length, prior to twentieth-century improvement, was around 400 to 600 metres. Several cocoon filaments are joined together (with no twisting whatsoever) in the reeling process in order to form a silk thread.

country-wound silk – silk reeled according to the local method used in eighteenth-century Bengal.

cut tuft (*jian rong* 剪茸) – (textile) with cut loops.

damask – figured weave, based on twill or satin, with a single warp and weft, whose binding points are strategically reversed to form a pattern. See satin damask; twill damask.

dībā – heavy silk with brocading wefts.

dibahe chin – Chinese brocade.

dican 地蠶 – 'silkworm farm on earth', older silkworms bred directly on the earth in order to extend the breeding space.

ferrandina ('**ferrandine**') – half-silk, with a wool or cotton weft.

ferret – type of silk.

filatoio/torcitoio – huge wooden machinery for twisting (throwing) raw silk threads. Could be human/animal operated (100/200 fuses each) or hydraulic (up to 2000 fuses each, up to 9 metres high). Appeared first in Lucca (Italy), thirteenth century. Later Bologna (Italy) became a large centre for twisting silk into veil threads. From the 1670s onward Piedmont had scores of hydraulic silk twisting mills with many *filatoi* each, producing mostly organzine (see below) for export. The Derby silk twisting mill (1719) copied a Piedmontese original of the 1680s.

filature – factory-type establishment for reeling silk.

filature-wound silk – term used for the silk reeled in the English East India Company's filatures in Bengal.

donsu 緞子 – damask, Japanese.

gaiji jin 改機錦 – '*jin* woven on improved looms', a compound silk weave using four layers of warp instead of five.

gasa – fabric of clear and fine silk.

geremsud – see *karmasūt*.

grosgran/grosgram/grogram/grosgrain – in the eighteenth century, a hard-wearing silk and wool material.

gros de tours – a plain woven silk with warps and wefts doubled to make a sturdier fabric.

guang su duan juan 光素緞絹 – 'smooth silk satins and plain silks'.

hatayi (*hatay*) – Ottoman silk fabric, dark coloured and adorned with metallic threads.

hatchō nenshiki 八丁撚糸機 – Japanese yarn twisting machines with multiple spindles (*hatchō*).

high warp loom – loom with vertical warps or *haute lisse*.

himroo **cloth** – mixture of cotton and silk.

hu sang 湖桑 – high-quality mulberry tree, by 1840 named 'domestic mulberry' (*jiasang* 家桑).

huaisu 懷素 – thin silks.

huazhi 花織 – patterned silks.

ikat – characteristic form of decoration in Damascus silks, refers to a variety of cloths which are tie-dyed before being stretched on the loom.

Itowappu Nakama 糸割符仲間 – guild of raw silk thread merchants from five shogunal cities authorised by the Tokugawa shoguns, Japanese.

jamdani **silks** – silks popular in Mughal India during the period of the Deccani Sultanates.

jin 錦 – non-brocaded silks where the patterning is achieved by supplementary weft; general term for patterned silks first woven in the warp-faced compound tabby in China's antiquity (fourth century BCE); the structure evolved to include weft-faced compound tabby (*taqueté*), warp-faced compound twill, and weft-faced compound twill (*samitum*) by the eighth century – all loosely referred to as *jin* silk.

jin jin 金錦 – loose term for patterned silks with gold made for banquet robes, Mongolian.

jinwen zhicheng pusa 錦紋織成菩薩 – silk banner woven in the polychrome *jin* with an image of a bodhisattva.

jinxianzhi 金線織 – 'silks woven with gold threads'.

karmasūt – taffeta, sometimes figured.

kaṭīfe – plain velvet.

kemḫā – lampas with gilt brocading threads.

khazz – Persian silk.

kinran 金襴 – gold brocade, Japanese.

kinsha 金紗 – silk fabrics interwoven with gilt threads, Japanese.

knotting of silk – method proposed by the English East India Company's silk specialists to rectify the inequality of threads of country-wound silk to make the threads more round.

konikkai paṭṭu – description is unclear as this silk variety is no longer woven.

kosode 小袖 – literally 'small sleeve openings', a garment that became the archetype of Japanese traditional *kimono* clothes.

kumāṣ – fine stuffs.

kuṭnī/*kutnu* – plain, dark-coloured cotton and silk textile.

lampas weave – figured weave in which the ground is formed by a main warp and a ground weft, the pattern is composed of one or more pattern wefts, with optional brocading wefts, tied by a supplementary binding warp.

legia – high-quality silk from Iran, originated in Lahijan, also called *kharvari* or *laji* silk.

legis – third-quality *sherbassi*.

legis bourme – referred to as 'Burma legee' by English merchants and throwsters, type of legis silk almost completely white in colour.

lu sang 魯桑 – *lu*-mulberry tree (as known in Chinese literature), later classified as *Morus multicaulis* L., a species of mulberry from Shandong.

luo 羅 – silk gauze.

lustring/lutestring – lightweight and very glossy plain weave silk.

maestra (f) – master, title given to women expert silk-reelers.

mashroo **cloth** – mixture of cotton and silk, with cotton warp threads on top, and a soft silken weft.

Morus alba – white mulberry; of Chinese origin, introduced in the Mediterranean from early fifteenth century, starting from northern Italy. White mulberry was easier to propagate than black mulberry, easier to prune, and adapted to different soils, it produced more and larger, more tender, leaves to feed silkworms.

Morus nigra – black mulberry.

Morus rubra – red mulberry.

multivoltine – silkworms capable of reproducing several times within a single year.

nacaud – term used for reelers employed in the re-reeling of country-wound silk.

naddaf – simple bow for removing impurities from the cotton fibre, a spinning tool in the cotton textile production.

narḥ – term for list of fixed or administrative prices issued periodically by the Ottoman sultan.

nasîj (*nashishi* 納石失) – gold silks patterned with two sets of weft, also favoured by the Mongol elite.

nuihaku 縫箔 – embroidery and impressed gold or silver foil on fabric, Japanese.

nui 縫 – embroidery, Japanese.

organzine – high-quality twisted (thrown) silk thread to be used as warp in very fine silk fabrics. It was produced mainly by hydraulic operated *filatoi* (see). It required high-quality and uniform raw silk (see) threads to start with. The threads were coupled and twisted, and then twisted once more in the opposite direction. From the late seventeenth century to the early nineteenth most organzine was produced in Piedmont (northern Italy).

ormesino – lightweight relatively inexpensive silk, of Levantine origin but woven in Italy during the sixteenth century.

paduasoy – rich or embossed silk fabric.

paithani **sarees** – made of silk from the sixteenth or seventeenth centuries.

paithani **silk** – pure silk, woven in and around the region of Paithan (today the Aurangabad district of Maharashtra) and the Deccan Traps.

palampore – type of hand-painted and mordant-dyed bed cover that was made in India for the export market during the eighteenth century and very early nineteenth century.

pattavala pattu – refers to tie-dyed silk which is still woven today in the entire belt from Gujarat and Andhra to Karnataka.

pattavali pattu/patola – tie-dyed type of silk or cotton cloth, popular during the period of the Vijayanagar empire.

pattern weft – weft, auxiliary to the ground weft, passed from selvage to selvage to form a pattern.

pattu saliyar – 'silk Saliyar', 'Saliyar' identifies the inhabitants of Tamil Nadu (state of India).

pattunulkarar – those who work with silk thread.

Patvegar – community of silk weavers in the South Kanara sub-region of Karnataka, India.

persienne – figured silk in which both the ground weave and brocading wefts create the pattern.

peruvian – fabric of the drogue family, with a small textural pattern.

picote – type of Castilian silk, commonly used for mourning ceremonies, dyed in black.

pycar – merchant acting as intermediary of the English East India Company who advanced money to *chassar*s and procured cocoons at the end of the rearing season in Bengal.

qi 綺 – warp-faced silk with a pattern in 3/1 twill.

qiemianli (怯綿里) – kind of silk made for monochrome banquet robes.

qirong jin 起絨錦 – warp-faced compound tabby with pile loops in the warp.

quansang 拳桑 – type of dwarf tree, 'fist'-shaped.

quina – high-quality silk yarn imported from China which was twisted and probably boiled, too.

raw silk – commercial term to indicate reeled *Bombyx mori* silk threads, usually sold in hanks/skeins of various diameter and weight; could be used as such on looms for silk fabrics although in Europe, from the Middle Ages onwards, it was mostly twisted either in trams or in warp threads before being used on the loom.

rong (絨) – (fabric) soft as down feather.

rongbei jin (絨背錦)/*toubei jin* (透背錦) – not the same as *qirong jin*, a compound weave with multiple wefts, each weft a different colour, the long weft floats can be cut to form a soft, furry surface.

ṣandāl – lightweight silk textile.

sante/sandai – pure cotton cloth.

sarcenet/sarsenet – a fine, soft fabric, often of silk, made in plain or twill weave and used especially for linings.

sarasa 更紗 – stencil-dyed/printed calico in Japanese.

satin – plain silk weave, based on an irregular twill of more than four ends, usually five or eight, whose long warp floats present a smooth, glossy surface, with a dull reverse.

satin damask – figured silk, in which the binding points of a satin weave are strategically reversed to form a pattern by contrasting the glossy and dull faces of the satin.

satin damask, polychrome – a satin damask that has a warp and weft of contrasting colours. See also satin damask, brocaded.

satin damask, brocaded – a satin damask with one or more brocading wefts, tied by the main warp.

seda floja – floss silk, or silk that has not been twisted.

seda de pelo – long-pile silk typically used in embroideries, laces, ribbons, plaits, fringes, and other dress ornaments.

seda torcida – twisted silk, or silk of twisted yarns.

seda de tramas – either a variant of or a synonym for twisted silk (*seda torcida*).

sella pattu – type of silk, which seems to have been the most popular and prized during the period of the Vijayanagar empire.

serāser – taqueté, a weft-faced compound weave.

serge – a weave, and by extension, a fabric in which the warp and weft interlace to create a diagonal rib; originally a twill-woven woollen cloth in England, its price depending upon the quality of the weft.

sericin – protein created by *Bombyx mori* which coats the extruded silk filaments to form the cocoon (see above). Sericin is gummy and lets silk filaments stick together in the process of reeling without any need to twist them. In order to better dye silk threads, most sericin must be removed either by hot water bathing or by the use of some sort of soapy matter.

seta greggia (grezza)/soie grege – see raw silk.

setaioli – silk merchants in northern Italy.

setaioli grossi – equivalent to English mercers, who dealt in high-end silk fabrics in Italy.

setaioli minuti – the 'small' silk merchants, who sold cheaper silk fabrics and narrow wares in Italy.

shaʻrbafi – (weaving) silk from Gilan, best quality and most expensive silk.

shalloon – lightweight twilled fabric of wool or worsted.

shenbo tang 神帛堂 – Hall of Ritual Silks, place of silk production for ritual purposes.

sherbassi – type of very fine silk.

shibori 絞り – tie-dyeing, Japanese.

shima 縞 – stripes, Japanese.

shiraito 白糸 – literally 'white threads', a high-quality raw silk yarn often imported from China, Japanese.

shou gan sangye 收乾桑葉 – dried mulberry leaves, suggested as food for silkworms.

shusu 繻子 – satin, Japanese.

silk reeling – process by which silk filaments are unwound from cocoons (immersed in hot water) and joined together (without any twisting) to form a thread which is rolled up on a revolving reel. The diameter of the reel determines the diameter of the raw silk hank/skein.

single – silk yarn formed from single thread with a single twist.

sīreng – lampas without gilt brocading threads.

sō-kanoko 惣鹿子 – decoration technique to cover the entire *kimono* with dapple tie-dyeing, Japanese.

sorahiki-bata 空引機 – drawloom, with a device called *sorahiki* to manipulate the warp threads manually, Japanese.

spun silk – when cocoons are not fit for reeling, they may be carded instead; the short pieces of filament so obtained are then spun into a silk thread, whose market value is much inferior to reeled silk; the term 'spun silk' is often incorrectly used to indicate raw silk.

surihaku 摺箔 – impressed gold or silver foil on fabric, Japanese.

tafta – 'taffeta', a plain tabby-woven fabric made from silk, and by extension, a fabric made in a plain weave.

tanny – grade of silk.

tartaryn – tabby-woven silk.

thrown silk – the term, nowadays obsolete, indicated the twisted silk threads used in silk weaving either as trams or as warps (with different types and rate of twisting each); the twisting mostly took place on the *filatoio* (see above), but could be achieved by simpler tools too, albeit with much lower quality of the final product.

tissue – a weave and by extension a fabric, woven with a pattern with weft floats; called lampas in French (see above).

toga/vesta – monochrome ankle-length, long-sleeved gown.

tram – double-twisted silk yarns.

twill damask – damask (see above) based on a four-end twill (or a 3/1 twill.)

univoltine – silkworms that are born in spring, produce eggs after roughly two months of larval life and these eggs hatch in the spring of the following year.

vale – delicate silk.

velvet/*velours* (French) – the Latin source *villosus*, meaning fleecy, describes the soft texture of velvet fabric but not its technical structure; cut-pile velvet is a fabric with a ground weave of tabby, twill, or satin, with a pile formed by an extra pile warp that is passed over grooved rods to form loops that are cut, and then the rods withdrawn as weaving progresses, to leave cut pile.

velvet with uncut pile – velvet (see above), in which the pile warp is passed over smooth rods, which are witrawn as weaving progresses, leaving uncut loops.

venpattu – cream or off-white silk, considered as ritually pure.

Vermis Sericus – series of six prints illustrating the history and techniques of silk production in Europe, published by Jan Van Der Straet.

weft-pattern lampas – lampas in which the pattern is created by pattern wefts.

weft-pattern tabby – tabby in which the pattern is created by pattern wefts; The supplementary wefts could be bound by binding warps or by some ground warps (*à liage repris*).

winding – term used interchangeably with reeling in the English East India Company's documents.

woduan 倭缎 – Japanese satin.

yoriito 撚糸 – twist yarns, Japanese.

yunzhi 雲織 – 'cloud-patterned silks'.

Yūzen-zome 友禅染 – a type of silk dyeing with rice paste coating attributed to the Japanese artist Miyazaki Yūzensai.

zarbaft – shot silk.

Zhang-velvet (*Zhang rong* 漳絨) – 'zhang' refers to its place of manufacture, Zhangzhou.

zhe 柘 – leaves of the silkworm thorn tree, *Cudrania triloba*, which could serve as a substitute food for silkworms.

zhi doufen, mifen 製豆粉米粉 – bean and rice flour, suggested as food for silkworms.

zhuanghua jin 妆花錦 – satins with brocaded patterns.

zunchou 遵紬 – Zunyi silk cloth.

Bibliography

MANUSCRIPT SOURCES

Archives de la Chambre de Commerce et d'Industrie de Lyon (CCI Lyon)

CCI Lyon, Déliberations, 1760–66

Archives départementales du Rhône (ADR)

ADR, 3E3095 Brenot (Lyon): 26 February 1757 Testament
ADR, 8B1218 Fonds de Vitry et Gayet, Liasse I Lettres
ADR, 3E3866 Dalier (Lyon): 11 October 1753 Acte d'apport de société Aubert/
　　Pernon
ADR, 3E9435 Dugueyt (Lyon): 17 November 1754 Aprentissage
ADR, 8B1043 Fonds Meunier: 1 February 1761 'Conventions Meunier/Eymard
　　et Teste'

Archives municipales de Lyon (AML)

AML HH572, 'Registre des compagnons'
AML, HH589, 'Registre des apprentis'
AML HH569–70 'Livres des ordonnances consulaires', 1743–90

Archives nationales de France (AN), Paris

AN, Serie F12, 677A

Archivo General de Indias (AGI), Seville

AGI, Contratación, 242, N.1, R.5
AGI, Contratación, 487, N.1, R.25
AGI, Contratación, 503B, N.13, 31

Archivo de las Notarías del DF, Mexico (ANotDF)

ANotDF, Notary Andrés Moreno (374–5)
ANotDF, Notary Juan Pérez de Rivera (497)

Bibliothèque municipale de Lyon (BML)

BML, ms 354461 'Mémoire sur l'envoi des échantillons de la Fabrique de Lyons', 1760
BML, ms 113923 'Arrêt de la Cour de Parlement qui homologue la délibération […]'
BML, ms 113925 'Arrêt de la Cour de Parlement qui permet aux syndics-jurés […]'
BML, ms 1923 Grognard to Pernon, 14 May 1788

Bibliothèque nationale de France (BN), Paris

BN, Lh44a, M253924 'Persienne en deux dorure de Mr Rigaulais'
BN, Lh44a, M254006 'Gros de tours blanc broché nué de Mr Rigolet'
BN, ms fr. 11855 'Mémoire général sur la Manufacture d'étoffes de soye […]'

Goldsmiths' Library of Economic Literature, Senate House Library, University of London (GL)

GL 1795 fol. 16280, *Reports of the Committee of Warehouses of the East-India Company relative to Extending the Trade on Bengal Raw-Silk* (London, 1795)

Guildhall Library, London

Ms. 4655/16, Court Minutes of London Weavers Company

The Historical Society of Pennsylvania, Philadelphia

Logan Family Papers, Collection 380, Deborah Norris Logan Diaries, 1815–39

British Library (BL), London: India Office Records (IOR)

BL, IOR Bombay (Misc. Public Documents, etc.), 1793.m.17: 'Letter from Giuseppe Mutti to John Bell Esquire on 20th October 1838', India Office Records and Private Papers
BL, IOR/E/1/61, ff. 355–357v: 3 September 1777, ff. 486–487v: 18 November 1777
BL, IOR/E/1/63, ff. 90–91v: 'Letter 41 James Wiss in London to Sir George Wombwell Proposing the Appointment of an Inspector of the Bengal Raw Silk and Offering His Services for Such a Post', 8 September 1778
BL, IOR/E/1/63, ff. 158–160v: 'Letters 70–1 James Wiss in London to the Court making Proposals Relating to Alterations in the Filature of Raw Silk at Calcutta, Related papers attached', 24 October 1778
BL, IOR/E/1/65, ff. 440–441v: 20 December 1779
BL, IOR/E/1/66, ff. 422–424v: Letters 212–13, 10 May 1780; ff. 550–52v: Letters 278–9, 'James Wiss in London to the Court Relating to Silk Manufacture and Orders for Equipment'

BL, IOR/E/3/20/2062, Swally to Company, 6 January 1648

BL, IOR/E3/51/6065, Brangwin, Isfahan to London, 6 August 1695

BL, IOR/E/3/54/6618, Bruce, Isfahan to London, 5 March 1699

BL, IOR/E/4/616, 'Bengal Raw Silk to be Investigated by Richard Wilder, 25 March 1757'

BL, IOR/E/4/619, 31 January 1770

BL, IOR/E/4/620, 27 January 1771; 23 March 1770, 28

BL, IOR/E/4/621, 7 April 1773, 471

BL, IOR/E/4/623, 4 July 1777, 635

BL, IOR/E/4/625, 9 April 1777, 173–205, 206, 208, 220; 9 April 1779, 131–2, 133–4; 14 July 1779; 'Mr. Wiss Superintendent of Silk Trade, 9 September, 1777', 198

BL, IOR/E/4/626, 12 May 1780

BL, IOR/E/4/627, 12 July 1782

BL, IOR/E/4/629, 8 July 1785

BL, IOR/E/4/630, 12 April 1786, 272; 21 July, 1786

BL, IOR/E/4/635, 19 May 1790

BL, IOR/G/23/13 Factory Records: Kasimbazar, 1757–59

London Metropolitan Archives (LMA), Mayor's Court (MC)

LMA, MC1/34.4, Francis Rigbourg 1619

LMA, MC1/34.5, Francis Rigbourg 1619

LMA, MC1/35.5, Francis Rigbourg 1619

LMA, MC1/35.8, Francis Rigbourg 1619

LMA, MC1/35.21

LMA, MC1/124, William Hooker 1659

London Metropolitan Archives (LMA), Orphans Court Inventory (OCInv.)

LMA, OCInv. 27, Jacob Sumers 1665

LMA, OCInv. 92, John Moore 1670

LMA, OCInv. 282, Thomas Strong 1666

LMA, OCInv. 295, Philip Hudson 1665

LMA, OCInv. 301, Thomas Cole 1667

LMA, OCInv. 306, Thomas Marriott 1664

LMA, OCInv. 308, Nicholas Wildbore 1664

LMA, OCInv. 506, William Paulett 1666

LMA, OCInv. 626, John Carter 1670

LMA, OCInv. 747, John Cooper 1665

LMA, OCInv. 815, John Allen 1673

LMA, OCInv. 853, William Bosworth 1673

LMA, OCInv. 888, William Richardson 1673

LMA, OCInv. 889, Edward Coote 1673

LMA, OCInv. 905, Edward Ringe 1673

LMA, OCInv. 950, Richard Bolt 1674
LMA, OCInv. 931, John Ewens 1673
LMA, OCInv. 1060, John Winne 1674
LMA, OCInv. 1092, Richard Boylston 1674
LMA, OCInv. 1112, Thomas Newman 1675
LMA, OCInv. 1140, Anthony Lacon 1675
LMA, OCInv. 1183, William Jennings, 1681
LMA, OCInv. 1224, George Phinnis 1675
LMA, OCInv. 1268, John Aylworth 1676
LMA, OCInv. 1302, Robert Williams 1675
LMA, OCInv. 1337, James Brailsford 1678
LMA, OCInv. 1337, Robert Campion 1678
LMA, OCInv. 1367, Thomas Davitts 1678
LMA, OCInv. 1388, William Kirwood 1676
LMA, OCInv. 1392, Robert Leech
LMA, OCInv. 1428, Isabel Tapsell 1679
LMA, OCInv. 1465, Edmund Lewis 1678
LMA, OCInv. 1544, William Pyle 1677
LMA, OCInv. 1545, Stephen Proctor 1680
LMA, OCInv. 1584, Thomas Davitts 1680
LMA, OCInv. 1645, William Jennings, 1681
LMA, OCInv. 1693, William Case 1681
LMA, OCInv. 1754, John Rawlinson 1681
LMA, OCInv. 1782, William Jennings, 1681
LMA, OCInv. 1790, George Calcott 1680
LMA, OCInv. 1869, Henry Fendall 1681, 1689
LMA, OCInv. 2045, Thomas Cawcutt 1686
LMA, OCInv. 2417, Neville Leman 1702
LMA, OCInv. 2419, Nathaniel Houlton 1701
LMA, OCInv. 2779, Joshua Sabin 1707
LMA, OCInv. 2858, Thomas Page 1708

London School of Economics and Political Science (LSE) Library, London

LSE Archives, W7204: East India Company. *Reports and Documents* [...]

Nationaal Archief, Dutch National Archives (NA), The Hague

NA, VOC 314, Copiebrieven, Heeren XVII to Surat, December 1624, fol. 236; Heeren XVII to Visnich, Isfahan, 24 December 1624, fol. 255
NA, VOC 315, copieboek, Heeren XVII to Batavia, 21 March 1629, unfol.; Heeren XVII to Batavia, 28 August 1629, unfol.; Heeren XVII to Batavia, 14 March 1630, unfol.
NA, VOC 855, Batavia to Surat, 24 August 1630
NA, VOC 1099, Batavia to Heeren XVII, 7 March 1631, fol. 19

NA, VOC 1115, Overschie, Isfahan to Heeren XVII, 27 October 1634

NA, VOC 1132, Surat to Batavia, 20 April 1639, fol. 688v

NA, VOC 1274, Van Dussen, Gamron to Heeren XVII, 10 September 1671, fol. 746b

NA, VOC 1288, De Haeze, Gamron to Heeren XVII, 16 May 1672, fol. 924a

NA, VOC 1324, 'Memorandum Sarcerius to Berkhout, May 1655', fol. 692r–v

NA, VOC 1611, 'Memorandum Hoogcamer to Castelijn, 31 May 1698', fol. 51

The National Archives (TNA), London

TNA, C113/31

TNA, E36/209

TNA, E101/405/14

TNA, E101/406/10

TNA, E101/413/15

TNA, E154/4/34

TNA, SP110/12

TNA, C104/44, Part 1, Mellish v Turner, 1663–1690, Account books and correspondence of Jacob Turner, merchant: Smyrna

Royal Society of Arts, London

SC/EL/2/31, 'Third Report of the Committee of Warehouses of the East-India Company relative to Extending the Trade on Bengal Raw-Silk'

Victoria and Albert Museum (V&A Museum), London

V&A Museum no. T.373-1972: French merchant's sample book of 1764

Yale University

The Papers of Benjamin Franklin, http://franklinpapers.org/franklin/

BOOKS

Aigen, Wolffgang, *Sieben Jahre in Aleppo, 1656–1663: ein Abschnitt aus den 'Reiss-Beschreibungen' des Wolffgang Aigen*, ed. by Andreas Tietze (Vienna: Verlag des Verbandes der wissenschaftlichen Gesellschaften Österreichs, 1980).

Alamán, Lucas, *Disertaciones sobre la historia de la república megicana* (Mexico: Lara, 1844).

Allsen, Thomas T., *Commodity and Exchange in the Mongol Empire: A Cultural History of Islamic Textiles*, Cambridge Studies in Islamic Civilization (Cambridge: Cambridge University Press, 1997).

Amstel, Aad van, *Barbaren, Rebellen en Mandarijnen. De VOC in de slag met China in de Gouden Eeuw* (Amsterdam: Thoeris, 2011).

Anhegger, Robert, and Halil İnalcık (eds.), *Ḳānūnnāme-i Sulṭanī Ber Mūceb-I ʿOrf-i ʿOsmānī: II. Mehmed ve II. Bayezid Devirlerine ait Yasaḳnāme ve Ḳānūnnāmeler* (Ankara, 1956).

Anonymous, *A Character of England. As It Was Lately Presented in a Letter, to a Noble Man of France* (London, 1659).

Arano Yasunori 荒野泰典, *Kinsei Nihon to Higashi Azia* 近世日本と東アジア [Early Modern Japan and East Asia] (Tokyo: University of Tokyo Press, 1988).

Argenti, Philip P., *The Costumes of Chios, Their Development from the XVth to the XXth Century* (London: Batsford, 1953).

Arizzoli-Clémentel, Pierre, and Chantal Gastinel-Coural, *Soieries de Lyon: Commandes royales du XVIIIe siècle*, Les dossiers du Musée des Tissus, 2 (Lyon: Musée historique des tissus, 1988).

Arnold, Janet, *Queen Elizabeth's Wardrobe Unlock'd: The Inventories of the Wardrobe of Robes Prepared in July 1600, Edited from Stowe MS 557 in the British Library, MS LR 2/121 in the Public Record Office, London, and MS V.b.72 in the Folger Shakespeare Library, Washington DC* (Leeds: Maney, 1988).

Ashtor, Eliyahu, *Levant Trade in the Middle Ages* (Princeton: Princeton University Press, 1983).

Aslanian, Sebouh, *From the Indian Ocean to the Mediterranean: The Global Trade Networks of Armenian Merchants from New Julfa* (Berkeley: University of California Press, 2011).

Atasoy, Nurhan et al., *İPEK: The Crescent & the Rose: Imperial Ottoman Silks and Velvets*, ed. by Julian Raby and Alison Effeny (Istanbul: TEB İletişim and Azimuth Editions Ltd., 2001).

Atasoy, Nurhan, Lâle Uluç, and Turkish Cultural Foundation, *Impressions of Ottoman Culture in Europe, 1453–1699* (Istanbul: Armaggan, 2012).

Badoer, Giacomo, *Il Libro dei Conti di Giacomo Badoer (Constantinapoli 1436–40)*, ed. Umberto Dorini and Tommaso Bertelè (Rome, 1956).

Bai Shouyi 白壽彝, *Zhongguo Huihui Minzushi* 中國回回民族史 [A History of Chinese Muslims] (Beijing: Zhonghua Shuju, 2003).

Barnes, Ruth, *Indian Block-Printed Textiles in Egypt: The Newberry Collection in the Ashmolean Museum, Oxford* (Oxford: Ashmolean Museum, University of Oxford, 1997).

Batten, Bruce L., *To the Ends of Japan* (Honolulu: University of Hawai'i Press, 2003).

Becker, John S., and Donald Wagner, *Pattern and Loom: A Practical Study of the Development of Weaving Techniques in China, Western Asia and Europe* (Copenhagen: Rhodos, 1987).

Bédarida, Henri, *Parme et la France: de 1748 à 1789* (Geneva: Slatkine, 1977).

Beijing shi Changping qu Shisanling tequ banshichu 北京市昌平區十三陵特區辦事處編, *Dingling Chutu Wenwu Tudian* 定陵出土文物圖典 [Catalogue of Cultural Relics Unearthed from Ding Ling] (Beijing: Beijing meishu sheying chubanshe, 2006).

Berindei, Mihnea, and Gilles Veinstein, *L'empire ottoman et les pays roumains, 1544–1545: Étude et documents*, Studies in Ottoman Documents Pertaining to the Ukraine and the Black Sea Countries, 1 (Paris: Editions de l'Ecole des hautes études en sciences sociales; Harvard Ukrainian Research Institute, 1987).

Bernier, François, *Travels in the Mogul Empire* (London: W. Pickering, 1826).

Bernis, Carmen, *El traje y los tipos sociales en El Quijote* (Madrid: Ediciones El Viso, 2001).

——, *Indumentaria española en tiempos de Carlos V* (Madrid: Instituto Diego Velazquez, del Consejo Superior de Investigaciones Científicas, 1962).

Bilgi, Hülya, *Çatma & Kemha: Ottoman Silk Textiles* (Istanbul, 2007).

Bilgi, Hülya, and İdil Zanbak (eds.), *Skill of the Hand, Delight of the Eye: Ottoman Embroideries in the Sadberk Hanım Museum Collection* (Istanbul: Sadberk Hanim Museum, 2012).

Bistort, Giulio, *Il Magistrato alle pompe nella Repubblica di Venezia. Studio Storico* (Venice, 1912).

Blaeu, Joan, *Blaeu's The Grand Atlas of the 17th Century World*, ed. by John Goss (London: Studio Editions, 1990).

The Book of Poetry, trans. by James Legge (New York: Paragon Books, 1967).

Borah, Woodrow Wilson, *Silk Raising in Colonial Mexico* (Berkeley: University of California Press, 1943).

Boyle, John Andrew, *The Cambridge History of Iran* (Cambridge: Cambridge University Press, 1968).

Bradley, Helen (ed.), *The Views of the Hosts of Alien Merchants 1440–44*, London Record Society, 46 (Woodbridge: Boydell & Brewer, 2012).

Braudel, Fernand, *The Mediterranean and the Mediterranean World in the Age of Philip II*, trans. by Siân Reynolds (Berkeley: University of California Press, 1995).

——, *The Wheels of Commerce: Civilization and Capitalism, 15th–18th Centuries*, trans. by Siân Reynolds (London: Collins/Fontana, 1979).

Bray, Francesca, *Technology and Gender: Fabrics of Power in Late Imperial China* (Berkeley: University of California Press, 1997).

Bray, Francesca, and Joseph Needham, *Science and Civilisation in China, Vol. VI. Biology and Biological Technology, Part 2. Agriculture* (Cambridge: Cambridge University Press, 1984).

Brenner, Robert, *Merchants and Revolution: Commercial Change, Political Conflict, and London's Overseas Traders, 1550–1653* (Cambridge: Cambridge University Press, 1993).

Brewer, John S., and James Gairdner (eds.), *Letters and Papers Foreign and Domestic of the Reign of Henry VIII Preserved in the Public Record Office*, 13 vols (London: Longman, 1886).

Brook, Timothy, *The Confusions of Pleasure: Commerce and Culture in Ming China* (Berkeley: University of California Press, 1998).

Brooke, Hindle, *The Pursuit of Science in Revolutionary America* (Chapel Hill: University of North Carolina Press, 1956).

Burnard, Trevor, *Planters, Merchants, and Slaves: Plantation Societies in British America, 1650–1820* (Chicago: University of Chicago Press, 2015).

Burnham, Dorothy K., *Warp and Weft: A Textile Terminology* (Toronto: Royal Ontario Museum, 1980).

Burnham, Harold, *Chinese Velvet* (Toronto: University of Toronto Press, 1959).

Busbequius, Augerius Gislenius, *Vier brieven over het gezantschap naar Turkije*, ed. by Zweder von Martels, trans. by Michel Goldsteen (Hilversum: Verloren, 1994).

Buss, Chiara (ed.), *Seta oro incarnadino: Lusso e devozione nella Lombardia spagnola* (Milan: ISAL, 2012).

Byrne, Muriel St Clare (ed.), *The Lisle Letters* (Chicago: University of Chicago Press, 1981).

Cameron, Nigel, *Barbarians and Mandarins: Thirteen Centuries of Western Travelers in China* (Chicago and London: University of Chicago Press, 1970).

Cammann, Schuyler R. V., *China's Dragon Robes* (Chicago: Art Media Resources, 1952).

Campbell, R., *The London Tradesman* (Newton Abbot: David & Charles, 1969).

Cardon, Dominique, *Natural Dyes: Sources, Tradition, Technology and Science* (London: Archetype, 2007).

Casas, Gonzalo de las, *Arte nuevo para criar seda*, ed. by Antonio Garrido Aranda (Granada: Universidad de Granada, 1996).

Cayez, Pierre, *Métiers jacquard et hauts fourneaux: aux origines de l'industrie lyonnaise* (Lyon: Presses universitaires de Lyon, 1978).

Chapman, Stanley D., and Serge Chassagne, *European Textile Printers in the Eighteenth Century: A Study of Peel and Oberkampf*, Pasold Studies in Textile History (London: Heinemann Educational Books, 1981).

Chaudhuri, Kirti Narayan, *The Trading World of Asia and the English East India Company, 1660–1760* (Cambridge: Cambridge University Press, 1978).

Chaunu, Pierre, *Les Philippines et le Pacifique des Ibériques: XVIe, XVIIe, XVIIIe siècles. Introduction méthodologique et indices d'activité*, Ecole pratique des hautes etudes: Section 6, Centre de Recherches Historiques: Ports, Routes, Trafics, 11, 2 vols (Paris: S.E.V.P.E.N., 1960).

Chen Gaohua 陳高華 et al. (eds.), *Yuan Dianzhang* 元典章 [Collection of Statutes and Substatutes of the Yuan] (Tianjin: Tianjin guji chubanshe, 2011).

Chen Juanjuan 陳娟娟, and Huang Nengfu 黃能馥, *Zhongguo fuzhuang shi* 中國服裝史 [History of Chinese Clothing] (Beijing: Zhongguo lüyou chubanshe, 2001).

Chen Menglei 陳夢雷, and Jiang Tingxi 蔣廷錫, *Gujin Tushu Jicheng* 古今圖書集成 [A Collection of Books of Ancient and Modern Times] (Shanghai: Zhonghua shuju, [1726] 1934).

Chen Weiji 陳維稷 (ed.), *Zhongguo Fangzhi Kexue Jishu Shi - gudai Bufen* 中國紡織科學技術史 – 古代部分 [The History of Chinese Textile Science and Technology, Ancient Part] (Beijing: Kexue chubanshe, 1984).

Chevallier, Dominique, *Villes et travail en Syrie: du XIXe au XXe siècle* (Paris: G.-P. Maisonneuve & Larose, 1982).

Chicco, Giuseppe, *La seta in Piemonte 1650–1800. Un sistema industriale d'ancien regime* (Milan: Franci Angeli, 1995).

Chin, Tamara T., *Savage Exchange: Han Imperialism, Chinese Literary Style, and the Economic Imagination*, Harvard-Yenching Institute Monograph Series, 94 (Cambridge, MA: Harvard University Press, 2014).

Clark, Hugh R., *Community, Trade and Networks: Southern Fujian Province from the Third to the Thirteenth Century* (Cambridge and New York: Cambridge University Press, 1991).

Clunas, Craig, *Screen of Kings: Royal Art and Power in Ming China* (London: Reaktion Books, 2013).

——, *Empire of Great Brightness: Visual and Material Cultures of Ming China, 1368–1644* (Honolulu: University of Hawai'i Press, 2007).

——, *Superfluous Things: Material Culture and Social Status in Early Modern China* (Urbana, IL: University of Illinois Press, 1991).

Clunas, Craig, and Jessica Harrison-Hall, *Ming: 50 Years that Changed China* (London: British Museum Press, 2014).

Cobb, Henry S., *The Overseas Trade of London. Exchequer Customs Accounts, 1480–81* (London: London Record Society, 1990).

Colenbrander, Sjoukje, *When Weaving Flourished: The Silk Industry in Amsterdam and Haarlem, 1585–1750* (Amsterdam: Aronson Publishers, 2013).

Coolhaas, W. Ph. (ed.), *Generale Missiven van Gouverneurs-Generaal En Raden Aan Heren XVII Der Verenigde Oostindische Compagnie, Ii: 1639–1655* (The Hague: Nijhoff, 1964).

Crawford, Anne, *The Household Books of John Howard, Duke of Norfolk, 1462–1471, 1481–1483* (Stroud: A. Sutton for Richard III & Yorkist History Trust, 1992).

Dahlgren, Barbro, *La Grana Cochinilla* (México: UNAM, 1963).

Daloz, Jean-Pascal, *The Sociology of Elite Distinction: From Theoretical to Comparative Perspectives* (London: Palgrave Macmillan, 2010).

Dalsar, Fahri, *Bursa'da İpekçilik: Türk sanayi ve ticaret tarihinde* (İstanbul: İstanbul Üniversitesi, İktisat Fakültesi, 1960).

Dankoff, Robert, *Armenian Loanwords in Turkish* (Wiesbaden: Harrassowitz, 1995).

Davids, Karel, *The Rise and Decline of Dutch Technological Leadership: Technology, Economy and Culture in the Netherlands, 1350–1800* (Leiden: Brill, 2008).

Dávila Corona, Rosa María, Montserrat Durán Pujol, and Máximo García Fernández, *Diccionario histórico de telas y tejidos. Castellano–Catalán* (Salamanca: Junta de Castilla y León, 2004).

Deane, Phyllis, and William Alan Cole, *British Economic Growth, 1688–1959: Trends and Structure* (Cambridge: Cambridge University Press, 1964).

Delivorrias, Angelos, and Dionissis Fotopoulos, *Greece at the Benaki Museum* (Athens: Benaki Museum, 1997).

Dennis, Joseph, *Writing, Publishing, and Reading Local Gazetteers in Imperial China, 1100–1700* (Cambridge, MA: Harvard University Asia Center, 2015).

Diner, Helen, *Seide: eine kleine Kulturgeschichte* (Leipzig: Herbert Eisentraut, 1949).

Dong Fuheng 董復亨, *Wanli Zhangqiu xianzhi* 萬曆章邱縣志 [Gazetteer of Zhangqiu County of the Wanli era] (Beijing: Guojia tu shu guan chubanshe, [1596] 2013).

Dorini, Umberto (ed.), *Statuti dell'Arte di Por Santa Maria del tempo della Repubblica* (Florence: Leo S. Olschki, 1934).

Du Halde, Jean-Baptiste, *General History of China: Containing a Geographical, Historical, Chronological, Political and Physical Description of the Empire of China ...*, 4 vols (London: J. Watts, 1741).

Du, Yongtao, *The Order of Places: Translocal Practices of the Huizhou Merchants in Late Imperial China* (Leiden: Brill, 2015).

Duffy, Eamon, *The Stripping of the Altars: Traditional Religion in England, c. 1400– c. 1580* (New Haven and London: Yale University Press, 1992).

Duits, Rembrandt, *Gold Brocade and Renaissance Painting: A Study in Material Culture* (London: Pindar Press, 2008).

Dunlop, H., *Bronnen Tot de Geschiedenis der Oost-Indisch Compagnie in Perzië* (The Hague: Nijhoff, 1930).

DuPlessis, Robert S., *The Material Atlantic. Clothing, Commerce, and Colonization in the Atlantic World, 1650–1800* (Cambridge: Cambridge University Press, 2015).

Earle, Peter, *A City Full of People: Men and Women of London 1650–1750* (London: Methuen, 1994).

——, *The Making of the English Middle Class: Business, Society, and Family Life in London, 1660–1730* (Berkeley: University of California Press, 1989).

Edler de Roover, Florence, *L'arte della seta a Firenze nei secoli XIV e XV*, ed. by Sergio Tognetti (Florence: Olschki, 1999).

Elvin, Mark, *The Pattern of the Chinese Past: A Social and Economic Interpretation* (Stanford, CA: Stanford University Press, 1973).

Emmerick, Ronald E., *Tibetan Texts concerning Khotan* (London: Oxford University Press, 1967).

Ertuğ, Ahmet, Patricia Baker, Hülya Tezcan and Jennifer Wearden, *Silks for the Sultans: Ottoman Imperial Garments from the Topkapı Palace* (Istanbul, 1996).

Establet, Colette, and Jean-Paul Pascual, *La gent d'état dans la société ottomane damascène: les 'askar à la fin du XVIIe siècle* (Damascus: Institut français du Proche-Orient, 2011).

——, *Ultime voyage pour la Mecque: les inventaires après décès de pèlerins morts à Damas vers 1700* (Damascus, 1998).

Evelyn, John, *John Evelyn's Diary*, ed. by Philip. Francis (London: The Folio Society, 1963).

Fan Jinmin 范金民, *Ming Qing Jiangnan shangye de fazhan* 明清江南商業的發展 [The Development of Jiangnan's Economy during the Ming and Qing Reign] (Nanjing: Nanjing University Publishing House, 1998).

Fan Jinmin 范金民, and Jin Wen 金文, *Jiangnan Sichoushi Yanjiu* 江南絲綢史研究 [Research on the History of Silk in Jiangnan] (Beijing: Nongye chubanshe, 1993).

Fang Ruyi 方汝翼, *Zengxiu Dengzhou fuzhi* 增修登州府志 [Expanded Gazetteer of Dengzhou (Guangxu era)], in *Zhongguo fangzhi jicheng: Shandong fuxian zhi ji* 中國地方志集成: 山東府縣志輯 [Collected Gazetteers of China: Gazetteers of Shandong] (Nanjing: Feng huang chubanshe, [1881] 2004).

Farmer, Edward L., *Zhu Yuanzhang and Early Ming Legislation: The Reordering of Chinese Society following the Era of Mongol Rule* (Leiden: Brill, 1995).

Fava-Verde, Jean-François, *Silk and Innovation: The Jacquard Loom in the Age of the Industrial Revolution* (Histancia, 2011).

Federico, Giovanni, *An Economic History of the Silk Industry, 1830–1930* (Cambridge: Cambridge University Press, 1997).

Fei, Si-yen, *Negotiating Urban Space: Urbanization and Late Ming Nanjing* (Cambridge, MA: Harvard University Asia Center, 2009).

Field, Jacqueline, Marjorie Senechal, and Madelyn Shaw, *American Silk, 1830–1930: Entrepreneurs and Artifacts* (Lubbock, TX: Texas Tech University Press, 2007).

Finnane, Antonia, *Changing Clothes in China: Fashion, History, Nation* (New York: Columbia University Press, 2008).

von Fircks, Juliane, and Regula Schorta (eds.), *Oriental Silks in Medieval Europe* (Riggisberg: Abegg-Stiftung, 2016).

Fleet, Kate, *European and Islamic Trade in the Early Ottoman State: The Merchants of Genoa and Turkey* (Cambridge: Cambridge University Press, 1999).

Floor, Willem, and Mohammad H. Faghfoory, *The First Dutch–Persian Commercial Conflict: The Attack on Qeshm Island, 1654* (Costa Mesa, CA: Mazda, 2004).

Fontana, Giovanni L., and Gérard Gayot (eds.), *Wool: Products and Markets (13th–20th Century)* (Padua: CLEUP, 2004).

Foster, William (ed.), *Letters Received by the East India Company from Its Servants in the East, vol. V, 1617* (London: Sampson Low, Marston & Co., 1901).

——, *The English Factories in India: 1646–1650. A Calendar of Documents in the India Office, Westminster* (Oxford: Clarendon Press, 1914).

Fox, Richard Hingston, *Dr. John Fothergill and His Friends: Chapters in Eighteenth Century Life* (London: Macmillan, 1919).

Fox, Robert, and Agustí Nieto-Galan (eds.), *Natural Dyestuffs and Industrial Culture in Europe, 1750–1880* (Canton, MA: Science History Publications, 1999).

Frangakis-Syrett, Elena, *The Commerce of Smyrna in the Eighteenth Century (1700–1820)* (Athens: Centre for Asia Minor Studies, 1992).

Franklin, Benjamin, *Poor Richard Improved: Being an Almanack and Ephemeris … for the Year of Our Lord 1765* (Philadelphia: Franklin and Hall, 1764).

Frattaroli, Paola, and Giuliana Ericani (eds.), *Tessuti nel Veneto: Venezia e la terraferma* (Verona: Banca Popolare di Verona, 1993).

Furber, Holden, *Rival Empires of Trade in the Orient, 1600–1800* (Minneapolis: University of Minnesota Press, 1976).

Fujian sheng bowuguan 福建省博物馆, *Fuzhou Nan Song Huang Sheng Mu* 福州南宋黄昇墓 [The Southern Song Tomb of Huang Sheng in Fuzhou] (Beijing: Wenwu chubanshe, 1982).

Gagarina, Elena Yurievna (ed.), *The Tsars and the East: Gifts from Turkey and Iran in the Moscow Kremlin* (Washington DC: Thames & Hudson, 2009).

Gagarina, Elena Yurievna, and İlber Ortaylı (eds.), *Treasures of the Moscow Kremlin at the Topkapı Palace* (Istanbul: Topkapı Palace Museum, 2010).

Gairdner, James (ed.), *The Paston Letters* (Gloucester: Alan Sutton, 1986).

Galland, Antoine, *Le voyage à Smyrne: un manuscrit d'Antoine Galland, 1678: contenant Smyrne ancienne et moderne et des extraits du Voyage fait en Levant*, ed. by Frédéric Bauden (Paris: Editions Chandeigne, 2000).

Galloway, Jack H., *The Sugar Cane Industry: An Historical Geography from Its Origins to 1914*, Cambridge Studies in Historical Geography, 12 (New York: Cambridge University Press, 2005).

Garden, Maurice, *Lyon et les lyonnais au XVIIIe siècle* (Paris: Les Belles-Lettres, 1970).

Garzón Pareja, Manuel, *La industria sedera en España. El arte de la seda de Granada* (Granada: Archivo de la Real Chancillería, 1972).

Gee, Joshua, *The Trade and Navigation of Great-Britain Considered* (New York: A. M. Kelley, 1969 [1738]).

Geijer, Agnes, *A History of Textile Art* (London: W. S. Maney, 1979).

Geoghegan, J., *Some Account of Silk in India, Especially of the Various Attempts to Encourage and Extend Sericulture in that Country* (Calcutta: Department of Revenue and Agriculture, 1872).

Gerritsen, Anne, and Giorgio Riello (eds.), *Writing Material Culture History* (London: Bloomsbury, 2014).

Giraldez, Arturo, *The Age of Trade: The Manila Galleons and the Dawn of the Global Economy*, Exploring World History (Lanham, MD: Rowman & Littlefield, 2015).

Glamann, Kristof, *Dutch–Asiatic Trade, 1620–1740* (Copenhagen and The Hague: Danish Science Press, 1958).

Godart, Justin, *L'ouvrier en soie: monographie du tisseur lyonnais: Étude historique, économique et sociale* (Lyon: Bernoux et Cumin, 1899; repr. Geneva: Slatkine-Megariotis, 1976).

Grassby, Richard, *The English Gentleman in Trade: The Life and Works of Sir Dudley North, 1641–1691* (Oxford and New York: Oxford University Press, 1994).

Gueneau, Louis, *Lyon et le commerce de la soie* (Lyon: Bascou, 1923).

Hafter, Daryl, *Women and Work in Pre-Industrial France* (Philadelphia: Penn State University Press, 2007).

Haga Kōshirō 芳賀幸四郎, *Azuchi Momoyama Jidai No Bunka* 安土桃山時代の文化 [The Culture of the Azuchi-Momoyama Period], 2nd edn (Tokyo: Shibundō, 1965).

Hammer-Purgstall, Joseph von, *Umblick auf einer Reise von Constantinopel nach Brussa und dem Olympos und von da zurück über Nicäa und Nicomedien: Mit Kupfern, Karten und Inschriften* (Pesth: Adolf Hartleben, 1818).

Hammers, Roslyn Lee, *Pictures of Tilling and Weaving: Art, Labor, and Technology in Song and Yuan China* (Hong Kong: Hong Kong University Press, 2011).

Hanway, Jonas, *An Historical Account of the British Trade over the Caspian Sea*, 4 vols (London: Dodsley, 1753).

Hareven, Tamara, *The Silk Weavers of Kyoto: Family and Work in a Changing Traditional Industry* (Berkeley: University of California Press, 2002).

Harris, Tim, *London Crowds in the Reign of Charles II: Propaganda and Politics from the Restoration until the Exclusion Crisis* (Cambridge and New York: Cambridge University Press, 1987).

Hayward, Maria (ed.), *Dress at the Court of King Henry VIII* (Leeds: Maney, 2007).

——, *Rich Apparel: Clothing and the Law in Henry VIII's England* (Farnham: Ashgate, 2009).

——, *The Great Wardrobe Accounts of Henry VII and Henry VIII*, London Record Society, 47 (Woodbridge: Boydell & Brewer, 2012).

Hazard, Samuel, *Hazard's Register of Pennsylvania, Devoted to the Preservation of Facts and Documents, and Every Kind of Useful Information Respecting the State of Pennsylvania* (Philadelphia: W. F. Geddes, 1828).

——, *Minutes of the Provincial Council of Pennsylvania from the Organization to the Termination of the Proprietary Government [Mar. 10, 1683–Sept. 27, 1775]*, 10 vols (Philadelphia: J. Severns, 1852).

Hazzi, Joseph (Ritter von), *Letter from James Mease: Transmitting a Treatise on the Rearing of Silkworms* (Washington: Duff Green, 1828).

He Shijin 何士晉, *Gongbu Changku Xuzhi* 工部廠庫須知 [Noteworthy Information about the Factories and Storehouses of the Ministry of Works] (Taipei: Zheng zhong, [1615] 1985).

Hilaire-Pérez, Liliane, *L'Invention technique au siècle des lumières* (Paris: Éditions Albin Michel, 2000).

Hills, Richard Leslie, *Power in the Industrial Revolution* (Manchester: Manchester University Press, 1970).

Hinz, Walther, *Islamische Masse und Gewichte: Umgerechnet ins metrische System* (Leiden: Brill, 1955).

Hoang, Anh Tuan, *Silk for Silver: Dutch–Vietnamese Relations, 1637–1700* (Leiden: Brill, 2007).

Hokkaido Shimbun Press 北海道新聞社, *Ezo Nishiki No Kita Michi* 蝦夷錦の来た道 [The Silk Brocade Roads of Ezo] (Sapporo: Hokkaido Shimbun Press, 1991).

Hu Dan 胡丹 (ed.), *Mingdai huanguan shiliao changbian* 明代宦官史料長編 [Compilation of Historical Sources on Ming Eunuchs] (Nanjing: Fenghuang chubanshe, 2014).

Hucker, Charles, *A Dictionary of Official Titles in Imperial China* (Stanford: Stanford University Press, 1985).

Hunan sheng bowuguan 湖南省博物館, and Zhongguo kexue yuan kaogu yanjiusuo 中國科學院考古研究所, *Changsha Mawangdui yihao Han mu* 長沙馬王堆一號漢墓 [Number One Han Tomb at Mawangdui, Changsha] (Beijing: Wenwu chubanshe, 1973).

İnalcık, Halil, *Türkiye Tekstil Tarihi Üzerine Araştırmalar* (Istanbul: İş Bankası Kültür Yayınları, 2008).

Indicateur Alphabétique … de la ville de Lyon pour l'année 1788 (Lyon, 1787).

Ishii, Yoneo, *The Junk Trade from Southeast Asia: Translation from the Tosen Fusetsu-Gaki, 1674–1723* (Singapore: Institute of Southeast Asian Studies, 1998).

Itō Tomoo 伊藤智夫, *Kinu* 絹 [Silk] (Tokyo: Hosei University Press, 1992).

Jacks, Philip, and William Caferro, *The Spinelli of Florence: Fortunes of a Renaissance Merchant Family* (University Park, PA: Penn State University Press, 2001).

Jacoby, David, *Byzantium, Latin Romania and the Mediterranean*, Variorum Collected Studies Series, 703 (Aldershot: Ashgate, 2001).

Jedin, Hubert, *Kirche des Glaubens, Kirche der Geschichte. Ausgewählte Aufsätze und Vorträge* (Freiburg: Herder, 1966).

Jenkins, D. T., and Kenneth G. Ponting, *The British Wool Textile Industry, 1770–1914* (London: Heinemann Educational Books and Pasold Research Fund, 1982).

Jiang, Yonglin, *The Mandate of Heaven and 'The Great Ming Code'* (Seattle: University of Washington Press, 2011).

Jin Guoping 金國平, *Xili Dongjian: Zhong Pu Zaoqi Jiechu Zhuixi* 西力東漸: 中葡早期接觸追昔 [Western Forces Press Close: A Recall of the Early Relations between the Chinese and the Portuguese] (Macau: Aomen jijin hui, 2000).

Jin Guoping 金國平, and Wu Zhilang 吳志良, *Zaoqi Aomen Shi Lun* 早期澳門史論 [The History of Early Macau] (Guangzhou: Guangdong renmin chubanshe, 2007).

Johnson, Amandus (ed.), *The Instruction for Johan Printz, Governor of New Sweden* (Philadelphia: The Swedish Colonial Society, 1930).

——, *The Swedish Settlements on the Delaware, 1638–1664* (Baltimore: Genealogical Pub. Co., 1969).

Jones, Jennifer, *Sexing La Mode: Gender, Fashion and Commercial Culture in Old Regime France* (Oxford: Berg, 2004).

Judd, Richard William, *The Untilled Garden: Natural History and the Spirit of Conservation in America, 1740–1840* (New York: Cambridge University Press, 2009).

Kerridge, Eric, *Textile Manufactures in Early Modern England* (Manchester: Manchester University Press, 1985).

Kidder, Jonathan Edward, *Himiko and Japan's Elusive Chiefdom of Yamatai: Archaeology, History, and Mythology* (Honolulu: University of Hawai'i Press, 2007).

Kirk, R. E. G., and E. F. Kirk (eds.), *Returns of Aliens 1588–1625*, Huguenot Society of London, 10 (Aberdeen, 1907).

Knaap, Gerrit, and Ger Teitler, *De Verenigde Oost-Indische Compagnie Tussen Oorlog en Diplomatie* (Leiden: KITLV Uitgeverij, 2002).

Komaroff, Linda, *Gifts of the Sultan: The Arts of Giving at the Islamic Court* (New Haven: Yale University Press, 2011).

Kuhn, Dieter (ed.), *Chinese Silks* (New Haven: Yale University Press, 2012).

Kuhn, Dieter, and Joseph Needham, *Science and Civilisation in China, Vol. V, Chemistry and Chemical Technology, Part 9. Textile Technology: Spinning and Reeling* (Cambridge: Cambridge University Press, 1988).

Laborde, Léon Marquis de, *Les Comptes des bâtiments du roy (1528–71): suivi de documents inédits sur les châteaux royaux et les beaux-arts du xvie siècle*, 2 vols (Paris: J. Baur Libraire de la Société, 1877).

Labrusse, Rémi (ed.), *Purs décors? Arts de l'islam, regards du XIXe siècle: collections des arts décoratifs* (Paris: Arts décoratifs, Musée du Louvre, 2007).

Laven, Mary, *Missions to China: Matteo Ricci and the Jesuit Encounter with the East* (London: Faber and Faber, 2011).

Lemire, Beverly, *Fashion's Favourite: The Cotton Trade and the Consumer in Britain, 1660–1800* (Oxford: Oxford University Press, 1991).

Leroudier, Etienne, *Les dessinateurs et la soierie lyonnaise au XVIIIe siècle* (Lyon: Impr. de A. Rey, 1908).

Levey, Santina M., *Lace: A History* (London and Leeds: Victoria & Albert Museum; W. S. Maney, 1983).

——, *The Embroideries at Hardwick Hall: A Catalogue* (London: National Trust, 2007).

Li Donghua 李東華, *Quanzhou yu Woguo zhonggu de haishang jiaotong* 泉州與我國中古的海上交通 [Quanzhou and the Maritime Traffic During China's Middle Period] (Taipei: Taiwan xuesheng shuju, 1986).

Li Dongyang 李東陽, *Xiaozong Shilu* 孝宗實錄 [Veritable Records of Emperor Xiaozong (1487–1505)], in *Ming Shilu* 明實錄 [Veritable Records of the Ming Dynasty] (Taipei: Zhongyang yanjiuyuan lishi yuyan yanjiusuo, 1962).

——, *Da Ming hui dian* 大明會典 [Collected Statutes of the Ming Dynasty] (Taipei: Zhongwen shuju, 1963).

Li Dongyang 李東陽, and Shen Shixing 申時行, *Da Ming hui dian* 大明會典 [Collected Statutes of the Ming Dynasty] (Yangzhou: Guangling shushe, [1587] 2007).

Li Jifu 李吉甫, *Yuanhe juxian tuzhi* 元和郡縣圖志 [Maps and Gazetteers of the Provinces and Counties in the Yuanhe Reign Period, 806–20 CE] (Beijing: Zhonghua shuju, 1983).

Li Renfu 李仁溥, *Zhongguo gudai fangzhishi gao* 中國古代紡織史稿 [Draft History of Ancient Chinese Textiles] (Changsha: Yuelu shushe, 1983).

Li Xian 李賢, Chen Wen 陳文, and Peng Shi 彭時, *Ming Yingzong Shilu* 明英宗實錄 [Veritable Records of Emperor Yingzong (1436–49)], in *Ming Shilu* 明實錄 [Veritable Records of the Ming Dynasty] (Taipei: Zhongyang yanjiuyuan lishi yuyan yanjiusuo, 1962).

Lin Jinshui 林金水, and Xie Bizhen 謝必震 (eds.), *Fujian duiwai wenhua jiaoliushi* 福建對外文化交流史 [The History of External Relations in Fujian] (Fuzhou: Fujian jiaoyu chubanshe, 1997).

Lin Zisheng 林子昇, *Shiliu zhi shiba shiji Aomen yu Zhongguo zhi guanxi* 十六至十八世紀澳門與中國之關係 [The Relationship between Macau and China from the Sixteenth to the Eighteenth Century] (Macau: Aomen jijin hui, 1998).

Linebaugh, Peter, *The London Hanged: Crime and Civil Society in the Eighteenth Century* (London: Lane, 1991).

Long, Pamela O., *Openness, Secrecy, Authorship: Technical Arts and the Culture of Knowledge from Antiquity to the Renaissance* (Baltimore: Johns Hopkins University Press, 2001).

Lorenzo Sanz, Eufemio, *Comercio de España con América en la época de Felipe II*, 2 vols (Valladolid: Diputación Provincial de Valladolid, 1986).

Lotto, Lorenzo, *Libro di spese diverse (1538–56), con aggiunta di lettere e d'altri documenti*, ed. by Pietro Zampetti (Venice and Rome: Istituto per la collaborazione culturale, 1969).

Lu Yi 陸釴 et al., *Shandong tongzhi* 山東通志 [Comprehensive Gazetteer of Shandong Province], in Zhu Dingling 朱鼎玲 et al. (eds.), *Tianyige cang Mingdai fangzhi xuankan xubian* 天一閣藏明代方志選刊續編 (Shanghai: Shanghai shudian, [1533] 1990), vol. 51, 497 (*juan 8*, *wuchan*, 1a).

Luo Tingquan 羅廷權, *Tongzhi Chengdu xian zhi* 同治成都縣志 [Gazetteer of Chengdu County in the Tongzhi Era] (Taipei: Taiwan xue sheng shuju, [1873] 1971).

de Lut, Bréghot (ed.), *Le Livre de Raison de Jacques-Charles Dutillieu* (Lyon, 1886).

Lu Yi 陸釴 et al., *Shandong tongzhi* 山東通志 [Comprehensive Gazetteer of Shandong Province], in Zhu Dingling 朱鼎玲 et al. (eds.), *Tianyige cang Mingdai fangzhi xuankan xubian* 天一閣藏明代方志選刊續編 (Shanghai: Shanghai shudian, [1533] 1990).

Ma, Debin (ed.), *Textiles in the Pacific, 1500–1900. The Pacific World: Lands, Peoples and History of the Pacific, 1500–1900* (Aldershot: Ashgate, 2005).

Ma Duanlin 馬端臨, *Wenxian tong kao* 文獻通考 [Comprehensive Examination of Literature] (Beijing: Zhonghua shuju, [1324] 1986).

Magalotti, Lorenzo, *Travels of Cosmo the Third, Grand Duke of Tuscany, through England, during the Reign of King Charles the Second (1669)* (London: J. Mawman, 1821).

Mansel, Philip, *Constantinople: City of the World's Desire, 1453–1924* (London: John Murray, 1995).

Marietta, Jack D., *The Reformation of American Quakerism, 1748–83* (Philadelphia: University of Pennsylvania Press, 1984).

Marsh, Ben, *Georgia's Frontier Women: Female Fortunes in a Southern Colony* (Athens, GA: University of Georgia Press, 2007).

Maruyama Nobuhiko 丸山伸彦, *Edo Mōdo No Tanjō: Mon'yō No Ryūkō to Sutā Eshi* 江戸モードの誕生 – 文様の流行とスター絵師 [The Birth of Edo à la

mode: The Trends in Kosode Kimono Motifs and Celebrity Designers] (Tokyo: Kadokawa Gakugei Shuppan, 2008).

Masini, Antonio di Paolo, *Bologna perlustrata. Terza impressione notabilmente accresciuta*, 3 vols (Bologna: Benacci, 1666).

Matthee, Rudi, Willem Floor, and Patrick Clawson, *The Monetary History of Iran: From the Safavids to the Qajars* (London: I.B.Tauris, 2013).

Matthee, Rudolph P., *The Politics of Trade in Safavid Iran: Silk for Silver, 1600–1730* (Cambridge: Cambridge University Press, 1999).

——, *The Politics of Trade in Safavid Iran: Silk for Silver, 1600–1730*, Cambridge Studies in Islamic Civilization (Cambridge University Press, 2006).

Miller, Lesley Ellis, *Selling Silks. A Merchant's Sample Book of 1764* (London: Victoria & Albert Museum, 2014).

Miller, Randall M., and William Pencak, *Pennsylvania: A History of the Commonwealth* (University Park, PA: Penn State University Press, 2002).

Mingdai fangzhi xuan 明代方志選 [Selected Gazetteers of the Ming Dynasty] (Taipei: Taiwan xue sheng shuju, 1965).

Mitchell, B. R., *British Historical Statistics* (Cambridge: Cambridge University Press, 1988).

Molà, Luca, *The Silk Industry of Renaissance Venice* (Baltimore: Johns Hopkins University Press, 2000).

Molà, Luca, Reinhold C. Mueller, and Claudio Zanier (eds.), *La seta in Italia dal Medioevo al Seicento: dal baco al drappo* (Venice: Marsilio, 2000).

Monnas, Lisa, *Merchants, Princes and Painters: Silk Fabrics in Italian and Northern Paintings, 1300–1550* (New Haven and London: Yale University Press, 2008).

——, *Renaissance Velvets* (London: V&A Publishing, 2012).

Montgomery, Florence M., *Textiles in America, 1650–1870: A Dictionary Based on Original Documents: Prints and Paintings, Commercial Records, American Merchants' Papers, Shopkeepers' Advertisements, and Pattern Books with Original Swatches of Cloth* (New York: Norton, 1984).

Mori Katsumi 森克己, *Zokuzoku Nissō Bōeki No Kenkyū* 続々日宋貿易の研究 [The Studies of Japan–Song Trade] (Tokyo: Kokusho Kankōkai, 1975).

Muzzarelli, Maria Giuseppina, *La Legislazione suntuaria: secoli XIII–XVI: Emilia Romagna* (Rome: Ministero per i beni e le attività culturali, Direzione generale per gli archivi, 2002).

Myers, Albert Cook, *Narratives of Early Pennsylvania, West New Jersey and Delaware, 1630–1707* (New York: C. Scribner's Sons, 1912).

Nagasaki Iwao 長崎巖, *Kosode Kara Kimono E* 小袖からきものへ [From Kosode to Kimono] (Tokyo: Gyōsei, 2002).

Nagazumi Yōko 永積洋子, *Kinsei Shoki No Gaikō* 近世初期の外交 [Diplomacy at the Beginning of the Early Modern Period] (Tokyo: Sōbunsha, 1990).

Nakamura Tadashi 中村質, *Kinsei Nagasaki Bōekishi No Kenkyū* 近世長崎貿易史の研究 [A Study of the History of Foreign Trade in Early Modern Nagasaki] (Tokyo: Yoshikawa Kōbunkan, 1988).

Navarro Espinach, Germán, *El despegue de la industria sedera en la Valencia del siglo XV* (Valencia: Generalitat Valenciana, 1992).

Newton, Stella Mary, *The Dress of the Venetians, 1495–1525* (Aldershot: Ashgate, 1988).

Noever, Peter (ed.), *Global: Lab: Kunst als Botschaft, Asien und Europa, 1500–1700 / Art as a Message, Asia and Europe, 1500–1700* (Ostfildern: Hatje Cantz, 2009).

Nosch, Marie-Louise, Feng Zhao, and Lotika Varadarajan (eds.), *Global Textile Encounters*, Ancient Textiles (Philadelphia: Oxbow Books, 2015).

Nunome Junrō 布目順郎, *Kinu to Nuno No Kōkogaku* 絹と布の考古学 [The Archaeology of Silk and Textiles] (Tokyo: Yūzankaku, 1988).

Ogasawara Sae 小笠原小枝, *Nihon No Senshoku* 日本の染織 [Japanese Weaving and Dyeing] (Tokyo: Chuokoronsha, 1983).

Ogawa, Morihiro, *Art of the Samurai: Japanese Arms and Armor, 1156–1968* (New York: Metropolitan Museum of Art, 2009).

Ogawa, Tamaki 小川環樹, *Shi Ji En* 新字源 [A New Source of Characters] (Tokyo: Kadokawa Shoten, 1987).

Ölçer, Nazan, et al., *Distant Neighbour, Close Memories: 600 Years of Turkish–Polish Relations* [Exhibition catalogue] (Istanbul: Sakip Sabanci Muzesi, Kultur ve Turizm Bakanligi, 2014).

Orsi Landini, Roberta, and Bruna Niccoli, *Moda a Firenze, 1540–1580: lo stile di Eleonora di Toledo e la sua influenza* (Florence: Pagliai Polistampa, 2005).

Ortaylı, İlber, *Onbin Yılın İran Medeniyeti: İkibin Yıllık Ortak Miras* (Istanbul, 2009).

Öz, Tahsin, *Türk Kumaş ve Kadifeleri* (Istanbul, 1946).

——, *Turkish Textiles and Velvets, XIV–XVI Centuries* (Ankara, 1950).

Pariset, Etienne, *Histoire de la fabrique lyonnaise: Etude sur le régime social et économique de l'industrie de la soie à Lyon, depuis le XVIe siècle* (Lyon: A. Rey, 1901).

Parry, Graham, *Hollar's England: A Mid-Seventeenth Century View* (Salisbury: Russell, 1980).

Peck, Amelia (ed.), *Interwoven Globe: The Worldwide Textile Trade, 1500–1800* (New York: Metropolitan Museum of Art, 2013).

Peck, Linda Levy, *Consuming Splendor: Society and Culture in Seventeenth-Century England* (Cambridge: Cambridge University Press, 2005).

Pelletier, André, Jacques Rossiaud, Françoise Bayard, and Pierre Cayez (eds.), *Histoire de Lyon des origines à nos jours*, 2nd edn (Lyon: Éditions Horvath, 2007).

Peng Daya, *Hei-Ta Shih-Lüeh, Kurzer Bericht Über Die Schwarzen Tatan*, in Peter Olbricht and Elisabeth Pinks (eds. and trans.), *Meng-Ta Pei-Lu und Hei-Ta Shih-Lüeh. Chinesische Gesandtenberichte Über Die Frühen Mongolen, 1221 und 1237* (Wiesbaden: Harrassowitz, 1980).

Pepys, Samuel, *The Diary of Samuel Pepys: A New and Complete Transcription*, ed. by Robert Latham and William Matthews, 11 vols (London: Bell, 1970).

Piacenti Aschengreen, Cristina, *Il Museo degli argenti a Firenze* (Florence: Cassa di Risparmio, 1967).

Podreider, Fanny, *Storia dei tessuti d'arte in Italia, secoli XII–XVII* (Bergamo: Istituto italiano d'arti grafiche, 1928).

Pomeranz, Kenneth, *The Great Divergence: China, Europe, and the Making of the Modern World Economy* (Princeton: Princeton University Press, 2000).

Poni, Carlo, *La seta in Italia: una grande industria prima della rivoluzione industriale*, ed. by Vivian R Gruder, Edmund Leites, and Roberto Scazzieri (Bologna: Il mulino, 2009).

Ponting, Kenneth G., *The Wool Trade: Past and Present* (Manchester: Columbine Press, 1961).

Prakash, Om, *The Dutch East India Company and the Economy of Bengal, 1630–1720* (Princeton: Princeton University Press, 1985).

Proust, Jacques, and Denis Diderot (eds.), *L'Encyclopédie de Diderot et d'Alembert: planches et commentaires* (Paris: Hachette, 1985).

Quataert, Donald, *Ottoman Manufacturing in the Age of the Industrial Revolution* (Cambridge and New York: Cambridge University Press, 1993).

Ribeiro, Aileen, *Fashion and Fiction: Dress in Art and Literature in Stuart England* (New Haven: Yale University Press, 2005).

Richards, Gertrude Randolph Bramlette (ed.), *Florentine Merchants in the Age of the Medici* (Cambridge, MA, 1932).

Riello, Giorgio, *Cotton: The Fabric that Made the Modern World* (Cambridge: Cambridge University Press, 2013).

Riello, Giorgio, and Tirthankar Roy (eds.), *How India Clothed the World: The World of South Asian Textiles, 1500–1850* (Leiden: Brill, 2009).

Roberts, Edward, and Karen Parker (eds.), *Southampton Probate Inventories, 1447–1575*, 2 vols (Southampton: Southampton University Press, 1992).

Robinson, David, *Bandits, Eunuchs and the Son of Heaven: Rebellion and the Economy of Violence in Mid-Ming China* (Honolulu: University of Hawai'i Press, 2001).

Roche, Daniel, *The Culture of Clothing. Dress and Fashion in the Ancien Régime* (Cambridge: Cambridge University Press, 1989).

Roe, Thomas, *The Embassy of Sir Thomas Roe to the Court of the Great Mogul, 1615–1619*, ed. William Foster (London, 1899).

de Roover, Raymond, *The Rise and Decline of the Medici Bank 1397–1494* (Cambridge, MA: Harvard University Press, 1963).

Roseveare, Henry, *Markets and Merchants of the Late Seventeenth Century. The Morescoe-David Letters 1668–1680* (Oxford: Oxford University Press, 1987).

Ross, Robert, *Clothing: A Global History* (Cambridge: Polity, 2007).

Rothstein, Natalie, *Silk Designs of the Eighteenth Century in the Collection of the Victoria and Albert Museum, London: With a Complete Catalogue* (London: Thames and Hudson, 1990).

——, *Spitalfields Silks* (London: HM Stationery Office, 1975).

Sanuto, Marino, *Le Vite dei Dogi, 1423–57*, ed. by Angela Cariacciolo Aricò (Venice, 1999).

Sarabia Viejo, María Justina, *La grana y el añil: técnicas tintóreas en México y América Central* (Seville: Escuela de Estudios Hispano-Americanos de Sevilla, 1994).

Sasaki Gin'ya 佐々木銀弥, *Nihon Chūsei No Ryūtsū to Taigai Kankei* 日本中世の流通と対外関係 [Foreign Relations and Domestic Trade in Medieval Japan] (Tokyo: Yoshikawa Kōbunkan, 1994).

Sasaki Shirō 佐々木史郎, *Hoppō Kara Kita Kōekimin: Kinu to Kegawa to Santan-Jin* 北方から来た交易民 – 絹と毛皮とサンタン人 [Traders from the North: Silk, Fur, and the Santan People] (Tokyo: NHK Publishing, 1996).

de Sauvages, Boissier, *Mémoires sur l'éducation des vers à soie* ... (Nismes: Michel Gaude, 1763).

Savary, Jacques, *Le parfait négociant ou instruction générale pour ce qui regarde le commerce des marchandises de france, & des pays étrangers* (Paris: Jean Guignard, 1675).

Schäfer, Dagmar, *Des Kaisers Seidene Kleider: Staatliche Seidenmanufakturen in Der Ming-Zeit (1368–1644)* (Heidelberg: Edition Forum, 1998).

——, *The Crafting of 10,000 Things: Knowledge and Technology in Seventeenth-Century China* (Chicago and London: University of Chicago Press, 2011).

Schama, Simon, *The Embarrassment of Riches: An Interpretation of Dutch Culture in the Golden Age* (London: Collins, 1987).

Schoeser, Mary, *Silk* (New Haven: Yale University Press, 2007).

Schurtz, William Lytle, *El galeón de Manila*, trans. by Pedro Ortiz Armengol (Madrid: Ediciones de Cultura Hispánica, 1992).

Scott, James C., *Seeing Like a State: How Certain Schemes to Improve the Human Condition Have Failed* (New Haven: Yale University Press, 1998).

Scott, Philippa, *The Book of Silk* (London: Thames and Hudson, 1993).

Scouloudi, Irene, *Returns of Strangers in the Metropolis, 1593, 1627, 1635, 1639: A Study of an Active Minority* (London: Huguenot Society of London, 1985).

Shanghai shi Fangzhi Kexue Yanjiuyuan 上海市紡織科學研究院, and Shanghai shi Sichou Gongyegongsi Wenwu Yanjiuzu 上海市絲綢工業公司文物研究組, *Changsha Mawangdui yihao Hanmu chutu fangzhipin de yanjiu* 長沙馬王堆一号汉墓出土紡織品的研究 [Research on Textiles Excavated from Number One Han Tomb of Mawandui] (Beijing: Wenwu chubanshe, 1980).

Shang shu 尚書 [Book of Documents] (Beijing: Zhonghua shuju, 2009).

Shifman, Barry, and Guy Walton, *Gifts to the Tsars 1500–1700: Treasures from the Kremlin* (New York: Harry N. Abrams, 2001).

Shipp, Steve, *Macau, China: A Political History of the Portuguese Colony's Transition to Chinese Rule* (Jefferson, NC: McFarland, 1997).

Siebold, Philipp Franz von, and Alexander von Siebold, *Abteilung VI, Landwirtschaft, Kunstfleits und Handel; Nippon: Archiv zur Beschreibung von Japan und Dessen Neben-und Schutzländern Jezo Mit Den Südlichen Kurilen, Sachalin, Korea und Den Liukiu-Inseln.*, ed. by Heinrich Philipp Siebold (Leipzig: Verlag der KuK Hofbuchhandlung von Leo Woerl, 1897).

Song Lian 宋濂, *Yuan shi* 元史 [History of the Yuan Dynasty] (Taipei: Taiwan shangwu yinshuguan, [1369] 1981).

——, *Yuan shi* 元史 [History of the Yuan Dynasty] (Beijing: Zhong hua shuju, 1983).

Song Yingxing 宋應星, *Tiangong Kaiwu* 天工開物 [The Works of Heaven and the Inception of Things], ed. by Zhong Guangyan 鍾廣言 (Beijing: Zhonghua shuju, 1978).

Sorbière, Samuel, Thomas Sprat, and François Graverol, *A Voyage to England: Containing Many Things Relating to the State of Learning, Religion, and Other Curiosities of That Kingdom* (London: J. Woodward, 1709).

Spallanzani, Marco, *Inventari medicei, 1417–1465: Giovanni di Bicci, Cosimo e Lorenzo di Giovanni, Piero di Cosimo* (Florence: Associazione 'Amici del Bargello', 1996).

Spallanzani, Marco, and Giovanna Gaeta Bertelà (eds.), *Libro d'inventario dei beni di Lorenzo il Magnifico* (Florence: Associazione Amici del Bargello, 1992).

Speelman, Cornelis, *Journaal der Reis van den Gezant der O.I. Compagnie Joan Cuneaus Naar Perzië in 1651–1652*, ed. by A. Hotz (Amsterdam: Müller, 1908).

Spence, Jonathan, *The Memory Palace of Matteo Ricci* (New York: Viking, 1984).

——, *Ts'ao Yin and the K'ang-Hsi Emperor: Bondservant and Master* (New Haven: Yale University Press, 1996).

Steensgaard, Niels, *The Asian Trade Revolution of the Seventeenth Century: The East India Companies and the Decline of the Caravan Trade* (Chicago: University of Chicago Press, 1973).

Stephenoff, Bonnie, *Their Father's Daughters: Silk Mill Workers in Northeastern Pennsylvania, 1880–1960* (Selinsgrove: Susquehanna University Press, 1999).

Stuard, Susan Mosher, *Gilding the Market: Luxury and Fashion in Fourteenth-Century Italy* (Philadelphia: University of Pennsylvania Press, 2006).

Styles, John, *The Dress of the People: Everyday Fashion in Eighteenth-Century England* (London and New Haven: Yale University Press, 2007).

Sugimoto Masatoshi 杉本正年, *Kankoku no Fukushoku: Fukushoku kara Mita Nikkan Hikaku Bunkaron* 韓国の服飾 – 服飾からみた日韓比較文化論 [Korean Dress and Fashion: A Comparison of Japanese and Korean Culture from the Perspective of Their Dress] (Tokyo: Bunka Gakuen Bunka Publishing Bureau, 1983).

Sutton, Anne F., *The Mercery of London: Trade, Goods and People, 1130–1578* (Aldershot: Ashgate, 2005).

Suzuki Yasuko 鈴木康子, *Kinsei Nichiran Bōeki No Kenkyū* 近世日蘭貿易の研究 [A Study of the Japan–Netherlands Trade by the Dutch East India Company (VOC) in the 17th and 18th Centuries] (Kyoto: Shibunkaku Shuppan, 2004).

Tabak, Faruk, *The Waning of the Mediterranean, 1550–1870: A Geohistorical Approach* (Baltimore, 2008).

Tao Zongyi 陶宗儀, *Nancun chuogeng lu* 南村輟耕錄 [Notes While Resting from Farmwork] (Beijing, [1366] 1959, Wujin Yuan keben).

Tashiro Kazui 田代和生, *Kinsei Nitchō Tsūkō Bōekishi No Kenkyū* 近世日朝通交貿易史の研究 [Diplomacy and Trade between Japan and Korea in the Early Modern Period] (Tokyo: Sōbunsha, 1981).

Tavernier, Jean-Baptiste, *Travels in India*, 2 vols (London: Macmillan and Co., 1889).

Tecan, Hülye, and Selma Delibas, *The Topkapi Saray Museum: Costumes, Embroideries and Other Textiles*, trans. by and ed. J. Michael Rogers (London: Thames & Hudson, 1986).

Tellier, Luc-Normand, *Urban World History: An Economic and Geographical Perspective* (Quebec: Presses de l'Université du Québec, 2009).

Tezcan, Hülya, and Sumiyo Okumura (eds.), *Textile Furnishings from the Topkapı Palace Museum* (Istanbul: Vehbi Koç Vakfı, 2007).

Thépaut-Cabasset, Corinne (ed.), *L'Esprit des modes au Grand Siècle* (Paris: Comité des travaux historiques et scientifiques, 2010).

Thornton, Peter, *Baroque and Rococo Silks* (London: Faber and Faber, 1965).

Toby, Ronald P. (ed.), *State and Diplomacy in Early Modern Japan: Asia in the Development of the Tokugawa Bakufu* (Princeton: Princeton University Press, 1984).

Tognetti, Sergio, *Un industria di lusso al servizio del grande commercio: Il mercato dei drappi serici e della seta nella Firenze del Quattrocento* (Florence: Olschki, 2002).

Tong Shuye 童書業, *Zhongguo Shougongye Shangye Fazhan Shi* 中國手工業商業 發展史 [History of the Development of Chinese Handicrafts and Industries] (Jinan: Qilu shushe, 1981).

Trenard, Louis, *De l'encyclopédie au Préromantisme* (Lyon, 1959).

Tsai, Shih-shan Henry, *The Eunuchs in the Ming Dynasty* (Albany, NY: State University of New York Press, 1996).

Tu Shufang 屠叔方, *Jianwen chaoye huibian* 建文朝野彙編 [Account of Jianwen Vacating His Throne] (Beijing: Shumu wenxian chubanshe, [1598] 1988).

Türk ve İslâm Eserleri Müzesi, *Savaş ve barış: 15–19 yüzyıl Osmanlı-Lehistan İlişkileri* (Istanbul: Kültür Bakanlığı, 1999).

Vainker, Shelagh J., *Chinese Silk: A Cultural History* (London and New Brunswick, NJ: British Museum Press; in association with Rutgers University Press, 2004).

Valentijn, François, *Oud En Nieuw Oost-Indien* (Dordrecht and Amsterdam: J. van Braam, 1727).

de Vries, Jan, *The Economy of Europe in an Age of Crisis, 1600–1750* (Cambridge: Cambridge University Press, 1976).

Wallerstein, Immanuel, *The Modern World-System I: Capitalist Agriculture and the Origins of the European World-Economy in the Sixteenth Century* (New York: Academic Press, 1974).

Walsh, Michael John, *Sacred Economies: Buddhist Monasticism and Territoriality in Medieval China* (New York: Columbia University Press, 2010).

Wang Pu 王溥, *Tang huiyao* 唐會要 [Institutional History of the Tang] (Beijing: Zhonghua shuju, [961] 1955).

Wang Qi 王圻, *Xu Wenxian tongkao* 續文獻通考 [Extended Comprehensive Examination of Literature] (Taipei: Wen hai chubanshe, [1603] 1979).

Wang Shixing 王士性, *Guang zhi yi* 廣志繹 [Geography of China] (Beijing: Zhong hua shuju, [1662] 1981).

Wang Zengfang 王贈芳, and Cheng Guan 成瓘, *Ji'nan Fuzhi* 濟南府志 [Gazetteer of Ji'nan (Daoguang Era)] (Taiwan: Taiwan xuesheng shuju, 1968).

Wang Zhen 王禎, *Nongshu* 農書 [Agricultural Book] (Beijing: Zhonghua shuju, [1300] 1956).

Warner, Frank, *The Silk Industry of the United Kingdom. Its Origin and Development* (London: Drane's, 1921).

Watson, John Fanning, *Annals of Philadelphia and Pennsylvania, in the Olden Time …*, 3 vols (Philadelphia, 1870).

Watt, James C. Y. et al., *China: Dawn of a Golden Age, 200–750 AD* (New York: Metropolitan Museum of Art, 2004).

Watt, James C. Y., and Anne E. Wardwell (eds.), *When Silk Was Gold: Central Asian and Chinese Textiles* (New York: Metropolitan Museum of Art, 1997).

Weatherill, Lorna, *Consumer Behaviour and Material Culture in Britain, 1660–1760* (London: Routledge, 1988).

Whyman, Susan E., *Sociability and Power in Late-Stuart England* (Oxford: Oxford University Press, 1999).

Willan, Thomas Stuart (ed.), *A Tudor Book of Rates* (Manchester: Manchester University Press, 1962).

Witsen, Nicolaas, *Noord En Oost Tartaryen: Behelzende Eene Beschryving van Verscheidene Tartersche En Nabuurige Gewesten, in de Noorder En Oostelykste Deelen van Aziën En Europa; Zedert Naauwkeurig Onderzoek van Veele Jaaren, En Eigen Ondervinding Ontworpen, Beschreven, Geteekent, En in 't Licht Gegeven* (Amsterdam: M. Schalekamp, 1785).

Wood, Frances, *Did Marco Polo Go to China?* (London: Westview Press, 1995).

Woodcroft, Bennet, *Alphabetical Index of Patentees of Inventions from March 2, 1617 … to October 1, 1852* (London: Eyre & Spottiswoode, 1854).

Wu Yunjia 吳允嘉 (ed.), *Tianshui bingshanlu* 天水冰山錄 [Record of Heavenly Dew and Ice-Capped Mountain], Congshu Jicheng (Shanghai: Shangwu yinshuguan, 1937).

Xia Xie 夏燮 (ed.), *Ming Tongjian* 明通鑑 [The Comprehensive Mirror of the Ming] (Beijing: Zhonghua shuju, 1980).

Xia Yuanji 夏原吉, *Ming Taizu shilu* 明太祖實錄 [Veritable Records of Emperor Taizu (1368–1398)]', in *Ming shilu* 明實錄 [Veritable Records of the Ming Dynasty] (Taipei: Zhongyang yanjiuyuan lishi yuyan yanjiusuo, 1962–66, reprint 1972 [1418]).

Xie Guozhen 謝國楨, *Mingdai shehui jingji shiliao xuanbian* 明代社會經濟史料選編 [Selected Extant Texts on the Social and Economic History of the Ming Dynasty] (Fuzhou: Fujian renmin chubanshe, 1980).

Xu Xiaowang 徐曉望 (ed.), *Fujian Tongshi* 福建通史 [A General History of Fujian Province] (Fuzhou: Fujian renmin chubanshe, 2006).

Yamamoto Hirobumi 山本博文, *Kan'ei jidai* 寛永時代 [The Kan'ei Era] (Tokyo: Yoshikawa Kōbunkan, 1989).

Yamawaki Teijirō 山脇悌二郎, *Kinu to momen no Edo Jidai* 絹と木綿の江戸時代 [Silk and Cotton in the Edo Period] (Tokyo: Yoshikawa Kōbunkan, 2002).

Yan Kejia 晏可佳, *Zhongguo tianzhujiao jianshi* 中國天主教簡史 [A Brief History of the Roman Catholic Church in China] (Beijing: Zongjiao wenhua chubanshe, 2001).

Yang Sizhen 楊思震, *Baoning Fuzhi* 保寧府志 [Local Gazetteer of Baoning] (Ming Jiajing jian keben 明嘉靖間刻本, 1543).

Yanzhou fu wuchan kao 兗州府物產考 [Examination of the Local Products of Yanzhou], in Chen Menglei 陳夢雷 (ed.), *Gujin Tushu Jicheng* 古今圖書集成 [A Collection of Books of Ancient and Modern Times] (Shanghai: Zhonghua shuju, 1934).

Yao Keisuke 八百啓介, *Kinsei Oranda Bōeki to Sakoku* 近世オランダ貿易と鎖国 [The Dutch Trade and National Seclusion in Early Modern Japan] (Tokyo: Yoshikawa Kōbunkan, 1998).

Yu Ruji 俞汝楫, *Libu zhigao* 禮部志稿 [Draft Monograph of the Ministry of Rites] (Beijing, 2003, Siku quanshu version).

Yu Xilu 俞希魯, *Zhishun Zhenjiang zhi* 至順鎮江志 [Zhenjiang Gazetteer of the Zhishun era] (Taipei: Taiwan shangwu yinshuguan, 1981).

Yuan Xuanping 袁宣萍, and Zhao Feng 趙豐, *Zhongguo sichou wenhua shi* 中國絲綢文化史 [The History of Chinese Silk Culture] (Jinan: Shandong meishu chubanshe, 2009).

Yun-Casalilla, Bartolomé, *Marte contra Minerva: el precio del imperio español, c. 1450–1600* (Barcelona: Crítica, 2004).

Yuste López, Carmen, *El comercio de la Nueva España con Filipinas, 1590–1785* (México: Inst. Nacional de Antropología e Historia, 1984).

Zeng Jian 曾鑑, and Lin Sijin 林思進, *Huayang xianzhi* 華陽縣志 [Local Gazetteer of Huayang County], in *Sichuan fangzhi zhiyi* 四川方志之一 [Local Gazetteers of Sichuan] (Taipei: Taiwan xuesheng shuju, 1967).

Zhang Tingyu 張廷玉, *Mingshi* 明史 [History of the Ming] (Beijing: Zhonghua shuju, [1736] 1974).

Zhang Xuan 張鉉, *Zhida Jinling xinzhi* 至大金陵新志 [Record of Jinling (i.e. Nanjing), Newly Compiled in the Zhida Era] (Shanghai: Shanghai guji chubanshe, [1344] 2003).

Zhao Feng 趙豐, *Sichou yishushi* 絲綢藝術史 [A History of Silk Art] (Hangzhou: Zhejiang meishu xueyuan chubanshe, 1992).

——, *Styles from the Steppes: Silk Costumes and Textiles from the Liao and Yuan Periods, 10th to 13th Century* (London: Anna Maria Rossi and Fabio Rossi, 2004).

——, *Zhongguo sichou tongshi* 中國絲綢通史 [The General History of Chinese Silk] (Suzhou: Suzhou daxue chubanshe, 2005).

——, *The Silk Road: A Road of Silk* (Hangzhou: Donghua University Press, 2016).

Zhao Feng 趙豐, and Jin Lin 金琳, *Fangzhi kaogu* 紡織考古 [Textile Archaeology] (Beijing: Wenwu chubanshe, 2007).

Zhongguo shehui kexue yuan kaogu suo 中國社會科學院考古所, *Dingling* 定陵 [Ding Ling, the Imperial Tomb of the Ming Dynasty] (Beijing: Wenwu chubanshe, 1990).

Zhu Jianmin 朱建民 (ed.), *Bai na ben er shi si shi* 百衲本二十四史 [Twenty-Four Histories, Baina Edition] (Taipei: Taiwan shangwu yinshuguan, 1981).

Zupko, Ronald Edward, *Italian Weights and Measures from the Middle Ages to the Nineteenth Century* (Philadelphia: American Philosophical Society, 1981).

ARTICLES AND ESSAYS

Ágoston, Gabor, 'Avrupa-Asya Arasında Teknolojik Diyalog ve Osmanlı İmparatorluğu: Barut Çağında Askeri Teknoloji ve Uzmanlık', in Gabor Ágoston (ed.), *Osmanlı'da Strateji ve Askeri Güç*, trans. by M. Fatih Çalışır (Istanbul: Timaş, 2012).

Alonso Álvarez, Luis, 'Don Quijote en el Pacífico: La Construcción del proyecto español en Asia, 1591–1606', *Revista de Historia Económica / Journal of Iberian and Latin American Economic History*, 23/Supplement S1 (2005), 241–74.

Alonso Álvarez, Luis Alonso, 'El modelo colonial en los primeros siglos. Producción agraria e intermediación comercial: azar y necesidad en la especialización de Manila como entrepôt entre Asia y América, 1565–1593', in María Dolores Elizalde Pérez-Grueso (ed.), *Las relaciones entre España y Filipinas, siglos XVI–XX* (Madrid: Consejo Superior de Investigaciones Científicas, 2002), 37–48.

Ambrose, Gwilym, 'English Traders at Aleppo (1658–1756)', *Economic History Review*, 3/2 (1931), 246–67.

Arano, Yasunori, 'Foreign Relations in Early Modern Japan: Exploding the Myth of National Seclusion', 18 January 2013, http://www.nippon.com/en/features/c00104/ (accessed 14 July 2014).

Armella de Aspe, Virginia, 'El traje civil', in Teresa Castelló Yturbide et al. (eds), *La historia de México a través de la indumentaria* (Mexico: Inversora Bursátil, 1988), 77–8.

——, 'La influencia asiática en la indumentaria novohispana', in María Cristina Barrón (ed.), *La presencia novohispana en el Pacífico insular* (México: Universidad Iberoamericana, 1992), 51–64.

Arnold, Janet, 'The "Coronation Portrait" of Queen Elizabeth I', *Burlington Magazine*, 120/908 (1978), 727–41.

Bai Gang 白鋼, 'Yuan Shi Shiliao Yaoji Gaishu' 元史史料要籍概述 [Overview of Historical Sources on the Yuan Dynasty], *Lishi Jiaoxue*, 2 (1981), 43–51.

Barkan, Ömer Lutfi, 'Edirne Askeri Kassamına Ait Tereke Defterleri', *Belgeler*, 3/5–6 (1966), 91–3.

——, 'İstanbul Saraylarına Ait Muhasebe Defterleri', *Belgeler*, 9/13 (1979), 298–380.

Barkan, Ömer Lutfi, trans. by Justin McCarthy, 'The Price Revolution of the Sixteenth Century: A Turning Point in the Economic History of the Near East', *International Journal of Middle East Studies*, 6/1 (1975), 3–28.

Barnes, Ruth, 'Introduction', in Ruth Barnes (ed.), *Textiles in Indian Ocean Societies* (London: Taylor and Francis, 2005), 1–9.

Battistini, Francesco, 'La Gelsibachicoltura e la trattura della seta in Toscana (Secc. XIII–XVIII)', in Simonetta Cavaciocchi (ed.), *La seta in Europa, secc. XIII–XX*, Istituto internazionale di storia economica 'F. Datini', Prato, serie II, Atti delle 'Settimane di Studi' e altri convegni, 24 (Florence: Le Monnier, 1993), 293–9.

Bayard, Françoise, 'L'Europe de Bonaventure Carret et de ses associés, marchands lyonnais au xviiie siècles', in Albrecht Burkardt, Gilles Bertrand, and Yves Krumenacker (eds.), *Commerce, voyage et expérience religieuse XVIe–XVIIIe siècles* (Rennes: Presses universitaires de Rennes, 2007), 55–86.

Baykal, İsmail, 'Selim III Devrinde İmdad-I Sefer İçin Para Basılmak Üzere Saraydan Verilen Altın ve Gümüş Avani Hakkında', *Tarih Vesikaları*, 3/13 (1944), 36–50.

Bazant, Jan, 'Evolución de la industria textil poblana (1544–1845)', *Historia Mexicana*, 13/4 (1964), 473–516.

Belfanti, Carlo Marco, 'Rural Manufactures and Rural Proto-Industries in the "Italy of the Cities" from the Sixteenth through the Eighteenth Century', *Continuity & Change*, 8/2 (1993), 253–80.

Belfanti, Marco, 'Was Fashion a European Invention?', *Journal of Global History*, 3/3 (2008), 419–43.

Bennigsen, Alexandre, and Chantal Lemercier-Quelquejay, 'La Moscovie, la Horde Nogay et le problème des communications entre l'Empire Ottoman et l'Asie Centrale en 1552/1556', *Turcica*, 8/2 (1976), 203–36.

——, 'Les Marchands de la Cour ottomane et le commerce des fourrures moscovites dans la seconde moitié du XVIe siècle', *Cahiers du monde russe et soviétique*, 11/3 (1970), 363–90.

Bentley, Jerry L., 'Cross-Cultural Interaction and Periodization in World History', *American Historical Review*, 101/3 (1996), 749–70.

Bertucci, Paola, 'Enlightened Secrets: Silk, Intelligent Travel, and Industrial Espionage in Eighteenth-Century France', *Technology and Culture*, 54/4 (2013), 820–52.

Blussé, Leonard, 'De Chinese Nachtmerrie: Eenterugtocht En Twee Nederlagen', in Gerrit Knaap and Ger Teitler (eds.), *De Verenigde Oost-Indische Compagnie: Tussenoorlog En Diplomatie*, Vol. 197 (Leiden: KITLV Uitgeverij, 2002), 209–38.

——, 'No Boats to China. The Dutch East India Company and the Changing Pattern of the China Sea Trade, 1635–1690', *Modern Asian Studies*, 30/1 (1996), 51–76.

Borah, Woodrow Wilson, 'El origen de la sericultura en la Mixteca Alta', *Historia Mexicana*, 13/1 (1963), 1–17.

Boyd-Bowman, Peter, 'Spanish and European Textiles in Sixteenth Century Mexico', *The Americas*, 29/3 (1973), 334–58.

Brett, K. B., 'A Ming Dragon Robe', *Bulletin of the Division of Art and Archaeology of the Royal Ontario Museum*, 27 (1958), 9–14.

Bridgeman, Jane, '"Pagare Le Pompe": Why Sumptuary Laws Did Not Work', in Letizia Panizza (ed.), *Women in Italian Renaissance Culture and Society* (Oxford: European Humanities Research Centre, 2000), 209–26.

Brown, Alison, 'Lorenzo De' Medici's New Men and Their Mores: The Changing Lifestyle of Quattrocento Florence', *Renaissance Studies*, 16/2 (2002), 113–42.

Buggé, Henriette, 'Silk to Japan: Sino–Dutch Competition in the Silk Trade to Japan, 1633–1685', *Itinerario*, 13/2 (1989), 25–44.

Burnham, Harold, 'Chinese Velvets, a Technical Study', *Art and Archaeology Division of the Royal Ontario Museum–Occasional Papers*, 2 (1959).

Calzona, Arturo, 'L'abito alla corte dei Gonzaga', in Dora Liscia Bemporad (ed.), *Il costume nell'età del Rinascimento* (Florence: Edifir, 1988), 225–52.

Carson, Hampton L., 'Dutch and Swedish Settlements on the Delaware', *The Pennsylvania Magazine of History and Biography*, 33/1 (1909), 1–21.

Chapman, Stanley D., 'British Marketing Enterprise: The Changing Roles of Merchants, Manufacturers, and Financiers, 1700–1860', in Stanley D. Chapman (ed.), *The Textile Industries. Volume 2: Cotton, Linen, Wool and Worsted*, Vol. 2 (London: I.B.Tauris, 1997), 287–310.

——, 'Quality versus Quantity in the Industrial Revolution: The Case of Textile Printing', *Northern History*, 21 (1985), 175–92.

——, 'The Genesis of the British Hosiery Industry, 1600–1750', *Textile History*, 3 (1972), 7–50.

Chassagne, Serge, 'Calico Printing in Europe before 1780', in David Jenkins (ed.), *The Cambridge History of Western Textiles*, Vol. 1 (Cambridge: Cambridge University Press, 2003), 513–27.

——, 'Le commerce international de la soie et des soieries à Lyon au XVIIIe siècle', in Maria-Anne Privat Savigny (ed.), *Lyon et le reste du monde* (Milan, forthcoming).

Chen BuYun, 'Material Girls: Silk and Self-Fashioning in Tang China (618–907)', *Fashion Theory*, 21/1 (2017), 5–33.

Chen Juanjuan 陳娟娟, 'Mingdai de sichou yishu' 明代的絲綢藝術 [Silk Art of the Ming Era], *Gugong bowuyuan yuankan*, 55/1 (1992), 56–76, 100–1.

Chin, Tamara T., 'The Invention of the Silk Road in China', *Critical Inquiry*, 40/1 (2013), 194–219.

Çizakça, Murat, 'A Short History of the Bursa Silk Industry (1500–1900)', *Journal of the Economic and Social History of the Orient*, 23/1 (1980), 142–52.

——, 'Price History and the Bursa Silk Industry: A Study in Ottoman Industrial Decline', *Journal of Economic History*, 40/3 (1980), 533–50.

——, 'Price History and the Bursa Silk Industry: A Study in Ottoman Industrial Decline, 1550–1650', in Huri Islamoğlu-Inan (ed.), *The Ottoman Empire and the World Economy* (Cambridge: Cambridge University Press, 1987), 247–61.

Clarkson, Leslie, 'The Linen Industry in Early Modern Europe', in David Jenkins (ed.), *The Cambridge History of Western Textiles*, Vol. 1 (Cambridge: Cambridge University Press, 2003), 473–92.

Cobb, Henry S., 'Textile Imports in the Fifteenth Century: The Evidence of Customs Accounts', *Costume*, 29/1 (1995), 1–11.

Collins, Brenda, and Philip Ollerenshaw, 'The European Linen Industry since the Middle Ages', in Brenda Collins and Philip Ollerenshaw (eds.), *The European Linen Industry in Historical Perspective* (Oxford: Oxford University Press, 2003), 1–42.

Dale, M. K., 'London Silkwomen of the Fifteenth Century', *Economic History Review*, 4/1 (1933), 324–35.

Dang, Baohai, 'The Plait-Line Robe: A Costume of Ancient Mongolia', *Central Asiatic Journal*, 47/2 (2003), 198–216.

Davids, Karel, 'Technological Change and the Economic Expansion of the Dutch Republic, 1580–1680', in Karel Davids and Leo Noordegraaf (eds.), *The Dutch Economy in the Golden Age* (Amsterdam: Nederlandsch Economisch-Historisch Archief, 1993), 79–105.

Davini, Roberto, 'Bengali Raw Silk, the East India Company and the European Global Market, 1770–1833', *Journal of Global History*, 4/1 (2009), 57–79.

——, 'A Global Supremacy: The Worldwide Hegemony of the Piedmontese Reeling Technologies, 1720s–1830s', in Anna Guagnini and Luca Molà (eds.), *History of Technology*, Vol. 32 (London: Bloomsbury, 2014), 87–104.

——, 'The History of Bengali Raw Silk as Interplay between the Company Bahadur, the Bengali Local Economy and Society, and the Universal Italian Model, c. 1750–c. 1830', *Commodities of Empire Project Working Paper* 6 (2008), https://commoditiesofempire.org.uk/publications/.

Davis, Ralph, 'The Rise of Protection in England, 1789–86', *Economic History Review*, 19/2 (1966), 306–17.

Desrosiers, Sophie, 'Sur l'origine d'un tissu qui a participé à la fortune de Venise: Le velours de soie', in Luca Molà, Reinhold C. Mueller, and Claudio Zanier (eds.), *La seta in Italia dal Medioevo al Seicento: dal baco al drappo* (Venice: Marsilio, 2000), 35–61.

Devoti, Donato, 'Parato Passerini', in Marco Collata and Donato Devoti (eds.), *Arte Aurea Aretina: Tesori dalle chiese di Cortona* (Florence: Spes, 1987), 56–82.

Di Lambertenghi, G. Porro, 'Lettere di Galeazzo Maria Sforza duca di Milano', *Archivio Storico Lombardo*, series 5 (1878), 107–29.

'Diaries of François Caron, 20 and 22 May 1639', *Dagregisters Gehouden Bij de Opperhoofden van Het Nederlandsche Factorij in Japan*, Vol. 4 (Tokyo, 1981), 53–6.

'Diaries of Nicolaes Couckebacker, 6 and 7 September 1636', *Dagregisters Gehouden Bij de Opperhoofden van Het Nederlandsche Factorij in Japan*, Vol. 2 (Tokyo, 1974), 115.

Dibbits, Hester C., 'Between Society and Family Values: The Linen Cupboard in Early-Modern Households', in Anton Schuurman and Pieter Spierenburg (eds.), *Private Domain, Public Inquiry: Families and Life-Styles in the Netherlands and Europe, 1550 to the Present* (Hilversum: Verloren, 1996), 125–45.

Dunn, Richard, 'The London Weavers' Riot of 1675', *Guildhall Studies in London History*, 1 (1973), 13–23.

DuPlessis, Robert, 'Transatlantic Textiles: European Linens in the Cloth Culture of Colonial North America', in Brenda Collins and Philip Ollerenshaw (eds.), *The European Linen Industry in Historical Perspective* (Oxford: Oxford University Press, 2003), 123–37.

——, 'Cloth and the Emergence of the Atlantic Economy', in Peter A. Coclanis (ed.), *The Atlantic Economy during the Seventeenth and Eighteenth Centuries: Organization, Operation, Practice, and Personnel* (Columbia, SC: University of South Carolina Press, 2005), 72–94.

'Early Letters from Pennsylvania, 1699–1722', *The Pennsylvania Magazine of History and Biography*, 37/3 (1913), 330–40.

Edler de Roover, Florence, 'Andrea Banchi: Florentine Silk Manufacturer and Merchant in the Fifteenth Century', *Studies in Medieval and Renaissance History*, 3 (1966), 223–85.

Eiichi, Kato, 'The Japanese–Dutch Trade in the Formative Period of the Seclusion Policy. Particularly on the Raw Silk Trade by the Dutch Factory at Hirado, 1620–1640', *Acta Asiatica*, 30/1 (1976), 34–84.

English, Walter, 'The Textile Industry: Silk Production and Manufacture, 1750–1900', in Charles Singer (ed.), *History of Technology IV: Industrial Revolution, 1750–1900* (Oxford: Oxford University Press, 1958), 308–27.

——, 'A Study of the Driving Mechanisms in the Early Circular Throwing Machines', *Textile History*, 2 (1971), 65–75.

Erin, Neşe, 'Trade, Traders and the State in Eighteenth-Century Erzurum', *New Perspectives on Turkey*, 6 (1991), 123–49.

Establet, Colette, 'Damascene Artisans around 1700', in Suraiya Faroqhi (ed.), *Bread from the Lion's Mouth: Artisans Struggling for a Livelihood in Ottoman Cities* (New York: Berghahn, 2015), 88–107.

'Extract of a Letter from Leicester', *Pennsylvania Gazette*, 14 June 1771.

Faroqhi, Suraiya, 'Bursa at the Crossroads: Iranian Silk, European Competition and the Local Economy, 1470–1700', in Suraiya Faroqhi (ed.), *Making a Living in the Ottoman Lands, 1480 to 1820* (Istanbul: Isis Press, 1995), 113–48.

——, 'The Material Culture of Global Connections: A Report on Current Research', *Turcica* 41 (2009), 401–31.

——, 'Surviving in Difficult Times: The Cotton and Silk Trades in Bursa around 1800', in Suraiya Faroqhi (ed.), *Bread from the Lion's Mouth: Artisans Struggling for a Livelihood in Ottoman Cities* (New York: Berghahn, 2015), 136–56.

——, 'Textile Production in Rumeli and the Arab Provinces: Geographical Distribution and Internal Trade (1560–1650)', *Osmanlı Araştırmaları, Journal of Ottoman Studies*, 1 (1980), 61–83.

——, 'Women, Wealth and Textiles in 1730s Bursa', in Elif Akçetin and Suraiya Faroqhi (eds.), *Living the Good Life: Consumption in the Qing and Ottoman Empires of the Eighteenth Century* (Leiden, 2019), 213–35.

Fei Zhu 費著, 'Shujin pu' 蜀锦谱 [Treatise on Sichuan's Brocades], in *Zhonghua Meishu congshu* 中華美術叢書 [Collection of China's Art Books], Vol. 13 (Beijing: Beijing guji chubanshe, 1998), 247–54.

Feltham, Heleanor, 'Justinian and the International Silk Trade', *Sino-Platonic Papers*, 194 (2009), 1–40.

——, 'Lions, Silks and Silver: The Influence of Sasanian Persia', *Sino-Platonic Papers*, 206 (2010), 1–51.

Flanagan, Robert, 'Figured Fabrics', in Charles Singer (ed.), *A History of Technology III: From Renaissance to the Industrial Revolution, 1500–1750* (Oxford: Oxford University Press, 1957), 187–205.

Floor, Willem, 'The Dutch and the Persian Silk Trade', in Charles Melville (ed.), *Safavid Persia: The History and Politics of an Islamic Society* (London: I.B.Tauris, 1996), 323–68.

Flynn, Dennis O., 'Comparing the Tokugawa Shogunate with Hapsburg Spain: Two Silver-Based Empires in a Global Setting', in James Tracy (ed.), *The Political Economy of Merchant Empires: State Power and World Trade* (Cambridge: Cambridge University Press, 1991), 332–59.

Flynn, Dennis O., and Arturo Giraldez, 'Arbitrage, China, and World Trade in the Early Modern Period', *Journal of the Economic and Social History of the Orient*, 38/4 (1995), 429–48.

Franklin, Benjamin, 'From Benjamin Franklin esq. Philadelphia to P. Collinson, 21 Dec. 1752', *Philosophical Transactions of the Royal Society*, 47 (1752), 553–8.

Fujita, Kayoko, 'Japan Indianized: The Material Culture of Imported Textiles in Japan, 1550–1850', in Giorgio Riello and Prasannan Parthasarathi (eds.), *The Spinning World: A Global History of Cotton Textiles, 1280–1850* (Oxford: Oxford University Press, 2009), 181–204.

Fujita, Kayoko, and Anthony Reid, 'Metal Exports and Textile Imports of Tokugawa Japan in the Seventeenth Century: The South Asian Connection', in Kayoko Fujita and Momoki Shiro (eds.), *Offshore Asia: Maritime Interactions in Eastern Asia before Steamships* (Singapore: Institute of Southeast Asian Studies, 2013), 259–76.

Gasch-Tomás, José Luis, 'Asian Silk, Porcelain and Material Culture in the Definition of Mexican and Andalusian Elites, c. 1565–1630', in Bartolomé Yun-Casalilla and Bethany Aram (eds.), *Global Goods and the Spanish Empire, 1492–1824* (Houndmills, Basingstoke: Palgrave Macmillan, 2014), 153–73.

Genç, Mehmed, 'A Study of the Feasibility of Using Eighteenth-Century Ottoman Financial Records as in Indicator of Economic Activity', in Huri İslamoğlu-İnan (ed.), *The Ottoman Empire and the World Economy* (Cambridge: Cambridge University Press, 1987), 345–73.

von Glahn, Richard, 'Myth and Reality of China's Seventeenth-Century Monetary Crisis', *Journal of Economic History*, 56/2 (1996), 429–54.

——, 'Cycles of Silver in Chinese Monetary History', in Billy K. L. So (ed.), *The Economic History of Lower Yangzi Delta in Late Imperial China: Connecting Money, Markets, and Institutions* (London: Routledge, 2013), 17–71.

Goldthwaite, Richard A., 'An Entrepreneurial Silk Weaver in Renaissance Italy', *I Tatti Studies: Essays in the Renaissance*, 10 (2005), 69–126.

Good, I. L., J. W. Kenoyer, and R. H. Meadow, 'New Evidence for Early Silk in the Indus Civilization', *Archaeometry*, 3/51 (2009), 457–66.

Guo Shengbo 郭聲波, 'Lishi Shiqi Sichuan Cansang Shiye de Xingshuai' 歷史時期四川蠶桑事業的興衰 [Historical Periodization of the Rise and Fall of Sichuan's Sericulture], *Zhongguo Nongshi*, 3/21 (2002), 9–19.

Habib, Irfan, 'Mughal India', in Tapan Raychaudhuri and Irfan Habib (eds.), *The Cambridge Economic History of India, Vol. I c. 1200–c. 1750* (Cambridge: Cambridge University Press, 1982), 214–25.

Hann, M. A., 'Origins of Central Asian Silk Ikats', *The Research Journal of the Costume Culture*, 21/5 (2013), 780–91.

Harris, P. R., 'An Aleppo Merchant's Letterbook', *British Museum Quarterly*, 22 (1960), 64–9.

Harte, Negley B., 'British Linen Trade with the United States in the Eighteenth and Nineteenth Centuries', *Textiles in Trade: Proceedings of the Textile Society of America Biennial Symposium, September 14–16, 1990, Washington* (Washington: Textile Society of America, 1990), 15–23.

——, 'Silk and Sumptuary Legislation in England', in Simonetta Cavaciocchi (ed.), *La seta in Europa, secc. XIII–XX*, Istituto internazionale di storia economica 'F. Datini', Prato, serie II, Atti delle 'Settimane di Studi' e altri Convegni, 24 (Florence: Le Monnier, 1993), 801–16.

——, 'State Control of Dress and Social Change in Pre-Industrial England', in Donald Cuthbert Coleman and Arthur Henry John (eds.), *Trade, Government & Economy in Pre-Industrial England* (London: Weidenfeld & Nicolson, 1976), 132–64.

Hatch, Charles E. Jr., 'Mulberry Trees and Silkworms: Sericulture in Early Virginia', *The Virginia Magazine of History and Biography*, 65 (1957), 3–61.

Hayward, Maria, 'Dressed to Rule: Henry VIII's Wardrobe and His Equipment for Hawk and Hound', in Maria Hayward and Philip Ward (eds.), *The Inventory of King Henry VIII: Volume II, Textiles and Dress* (London: Harvey Miller, 2012), 67–108.

——, 'Going Dutch? How Far Did Charles II's Exile in the Netherlands Shape His Wardrobe, 1646–1666?', in Johannes Pietsch and Anna Jolly (eds.), *Netherlandish Fashion in the Seventeenth Century* (Riggisberg: Abegg Stiftung, 2012), 119–28.

Hertz, G. B., 'The English Silk Industry in the Eighteenth Century', *English Historical Review*, 24 (1909), 710–27.

Herzig, Edmund, 'The Iranian Raw Silk Trade and European Manufacture in the Seventeenth and Eighteenth Centuries', *Journal of European Economic History*, 19/1 (1990), 73–89.

Hilaire-Pérez, Liliane, 'Inventing in a World of Guilds: Silk Fabrics in Eighteenth-Century Lyon', in Stephan R. Epstein and Maarten Prak (eds.), *Guilds, Innovation, and the European Economy, 1400–1800* (Cambridge: Cambridge University Press, 2008), 232–63.

Hu Dan 胡丹, 'Hongwu Chao Neifu Guanzhi Zhi Bian Yu Ming Chu de Huanquan' 洪武朝內府官制之變與明初的宦權 [Changes in the Management of the Palace Treasury and the Power of Eunuchs in the Hongwu Period], *Shixue Yuekan*, 5 (2008), 41–7.

——(ed.), *Mingdai huanguan shiliao changbian* 明代宦官史料長編 [Compilation of Historical Sources on Ming Eunuchs] (Nanjing: Fenghuang chubanshe, 2014).

Huo Wei 霍巍, 'Lun Jiangxi Mingdai houqi fanwang muzang de xingzhi yanbian' 論江西明代後期藩王墓葬的形制演變 [On the Evolution of the Structure of Late-Ming Prince's Tombs in Jiangxi], *Dongnan Wenhua*, 1 (1991), 96–101.

İnalcık, Halil, 'Bursa and the Commerce of the Levant', *Journal of the Economic and Social History of the Orient*, 3/2 (1960), 131–47.

——, 'Harir', in Bernard Lewis, V. L. Ménage, and Joseph Schacht (eds.), *Encyclopedia of Islam. Second Edition*, Vol. III (Leiden, 1971).

——, 'Osmanlı Pamuk Pazarı, Hindustan ve İngiltere: Pazar Rekabetinde Emek Maliyetinin Rolü', *ODTÜ Gelişme Dergisi*, 7/1&2 (1979), 1–65.

——, 'Sources for Fifteenth-Century Turkish Economic and Social History', *The Middle East and the Balkans under the Ottomans* (Bloomington: Indiana University Press, 1993), 177–93.

Iwao Seiichi 岩生成一, 'Kinsei Nisshi Bōeki Ni Kansuru Sūryōteki Kōsatsu' 近世日支貿易に関する数量的考察 [A Study on the Chinese Trade with Japan in the XVIIth Century, Chiefly on Their Volume and Quantity], *Shigaku Zasshi*, 62/11 (1953), 981–1020.

Jacoby, David, 'Cypriot Gold Thread in Late Medieval Silk Weaving and Embroidery', in Susan B. Edgington and Helen J. Nicholson (eds.), *Deeds Done Beyond the Sea: Essays on William of Tyre, Cyprus and the Military Orders Presented to Peter Edbury* (Aldershot: Ashgate, 2014), 101–14.

——, 'Oriental Silks Go West: A Declining Trade in the Late Middle Ages', *Islamic Artifacts in the Mediterranean World: Trade, Gift Exchange and Artistic Transfer* (Venice: Marsilio, 2010), 71–88.

——, 'Silk Economics and Cross-Cultural Artistic Interaction: Byzantium, the Muslim World and the Christian West', *Dumbarton Oaks Papers*, 58 (2004), 197–240.

——, 'The Silk Trade of Late Byzantine Constantinople', in *İstanbul Üniversitesi 550. yıl, Uluslararası Bizans ve Osmanlı Sempozyumu (XV. Yüzyil): 30–31 Mayıs, 2003* (Istanbul, 2004), 129–44.

Jiang Dianchao 江甸朝 and Yu Dezhang 余德章, 'Chengdu Baimasi di liu hao Ming mu qingli Jianbao' 成都白馬寺第六號明墓清理簡報 [Excavation report of the tomb no. 6 of the Baima Temple Chengdu], *Wenwu*, 10 (1956), 42–9.

Jiang, Yonglin, 'In the Name of "Taizu": The Construction of Zhu Yuanzhang's Legal Philosophy and Chinese Cultural Identity in the Veritable Records of Taizu', *T'oung Pao*, 96/4–5 (2010), 408–70.

Jiang Youlong 蔣猷龍, 'Shu qian nian lai woguo sang can zai jiayang xia de yanbian' 數千年來我國桑蠶在家養下的演變 [Thousands of Years of Evolution in Raising Domesticated Silkworms in China]', *Acta Entomologica Sinica*, 20/2 (1977).

Kafadar, Cemal, 'A Death in Venice (1575): Anatolian Muslim Merchants Trading in the Serenissima', *Journal of Turkish Studies*, 10 (1986), 191–217.

Kerlouégan, Jérome, 'Printing for Prestige? Publishing and Publications by Ming Princes (Part 1–4)', *East Asian Publishing and Society*, 1–2 (2011), 39–73, 105–44, 3–75, 109–98.

King, Donald, and Monique King, 'Silk Weaves of Lucca in 1376', in Inger Estham and Margareta Nockert (eds.), *Opera Textilia Variorum Temporum: To Honour Agnes Geijer on Her Ninetieth Birthday 26th October 1988* (Stockholm: Statens historiska museum, 1988).

Kirchweger, Franz, 'The Coronation Robes of the Holy Roman Empire in the Middle Ages: Some Remarks on Their Form, Function and Use', in Evelyn Wetter (ed.), *Iconography of Liturgical Textiles in the Middle Ages*, Riggisberger Berichte series, 18 (Riggisberg: Abegg Stiftung, 2010), 103–16.

Klein, P. W., 'De Tonkinees–Japanse Zijdehandel van de Verenigde Oostindische Compagnie in Het Inter-Aziatische Verkeer in de 17e Eeuw', in Willem Frijhoff and Minke Hiemstra (eds.), *Bewogen En Bewegen. De Historicus in Het Spanningsveld Tussen Economie En Cultuur* (Tilburg: Gianotten, 1986), 152–77.

Kołodziejczyk, Dariusz, 'Polish Embassies in Istanbul or How to Sponge on Your Host without Losing Your Self-Esteem', in Suraiya Faroqhi and Christoph Neumann (eds.), *The Illuminated Table, the Prosperous House: Food and Shelter in Ottoman Material Culture* (Istanbul: Orient-Institut and Ergon, 2003), 51–8.

Kraak, Deborah E., '"Just Imported From London": English Silks in 18th-Century Philadelphia', in Regula Schorta (ed.), *Eighteenth-Century Silks: The Industries of England and Northern Europe* (Riggisberg, 2000), 109–19.

Kuhn, Dieter, 'The Silk Workshops of the Shang Dynasty, 16th–11th Century BC', in Hu Daoding (ed.), *Explorations in the History of Science and Technology in China* (Shanghai: Shanghai Chinese Classics, 1982), 367–408.

——, 'Fashionable Weaves and Ingenious Craftsmanship', in Dieter Kuhn (ed.), *Chinese Silks* (New Haven: Yale University Press, 2012), 1–65.

Lacey, Kay, 'The Production of "Narrow Wares" by Silkwomen in Fourteenth- and Fifteenth-Century England', *Textile History*, 18/2 (1987), 187–204.

Ladero Quesada, Miguel A., 'La producción de seda en España medieval. Siglos XIII–XVI', in Simonetta Cavaciocchi (ed.), *La seta in Europa, secc. XIII–XX*, Istituto internazionale di storia economica 'F. Datini', Prato, serie II, Atti delle 'Settimane di Studi' e altri Convegni, 24 (Florence: Le Monnier, 1993), 125–39.

Lee, Raymond L., 'Cochineal Production and Trade in New Spain to 1600', *The Americas*, 4/4 (1948), 449–73.

Lemire, Beverly, 'Fashion and Tradition: Wearing Wool in England during the Consumer Revolution, c. 1660–1820', in Giovanni Luigi Fontana and Gérard Gayot (eds.), *Wool: Products and Markets (13th–20th Century)* (Padua: CLEUP, 2004), 573–94.

——, 'Fashioning Cottons: Asian Trade, Domestic Industry and Consumer Demand, 1660–1780', in David T. Jenkins (ed.), *The Cambridge History of Western Textiles*, Vol. 1, 2 vols (Cambridge: Cambridge University Press, 2003), 493–512.

——, 'Fashioning Global Trade: Indian Textiles, Gender Meanings and European Consumers, 1500–1800', in Giorgio Riello and Tirthankar Roy (eds.), *How India Clothed the World: The World of South Asian Textiles, 1500–1800* (Leiden: Brill, 2009), 365–90.

Lemire, Beverly, and Giorgio Riello, 'East and West: Textiles and Fashion in Early Modern Europe', *Journal of Social History*, 41/4 (2008), 887–916.

Leverotti, Francesca, 'Organizzazione della corte sforzesca e produzione serica', in Chiara Buss (ed.), *Seta, oro cremisi: segreti e tecnologia alla corte dei Visconti e degli Sforza* (Milan, 2009).

Lewis, Peta, 'William Lee's Stocking Frame: Technical Evolution and Economic Viability 1589–1750', *Textile History*, 17/2 (1986), 129–47.

Li, Renchuan, 'Fukien's Private Sea Trade in the 16th and 17th Centuries', in Eduard B. Vermeer (ed.), *Development and Decline of Fukien Province in the 17th and 18th Centuries* (Leiden: Brill, 1990), 163–73.

Li Yi 李怡, 'Tangdai dui Mingdai guanyuan changfu yingxiang kaoban' 唐代對明代官員常服影響考辨 [On the Influence of the Tang Dynasty to the Official Daily Dress in the Ming Dynasty], *Zhejiang fangzhi fuzhuang zhiye jishu xueyuan xuebao*, 12/1 (2013), 54–8.

Li Zhitan 李之檀, Chen Xiaosu 陳曉蘇, and Kong Fanyun 孔繁雲, 'Zhengui de Ming dai fushi ziliao: "Ming gong guanfu yizhang tu" zhengli yanjiu zhaji' 珍貴的明代服飾資料:《明宮冠服儀仗圖》整理研究札記 [Notes of Ming Gong Guan Fu Yi Zhang Tu: Pictures of Court Costumes and Manners in Ming Dynasty China], *Yishu sheji yanjiu*, 1 (2014), 23–8.

Liu Lin 刘林, Yu Jiadong 余家栋 and Xu Zhifan 许智范, 'Jiangxi Nancheng Ming Yixuan wang Zhu Yiyin fufu hezangmu' 江西南城明益宣王朱翊鈏夫妇合葬墓 [The Tomb of the Yixuan Prince Zhu Yiyin and His Wife in Nancheng County, Jiangxi], *Wenwu*, 8 (1982), 16–28, 100–1.

——, 'Jiangxi Nancheng Ming Yiding wang Zhu Youmu mu fa jue jianbao' 江西南城明益定王朱由木墓發掘簡報 [Brief of the Excavation of the Tomb of Yiding Prince Zhu Youmu in Nancheng County, Jiangxi]', *Wenwu*, 2 (1983), 56–64, 102.

Liu Yi 劉毅, 'Tangji yilai diwang shisuhua zangyi yongpin tanwei' 唐季以來帝王世俗化葬儀用品探微 [The Exploration of Imperial Secularised Funeral Supplies since the Late Tang Dynasty], *Nanfang wenwu*, 1 (2012), 65–73.

Liu Yonghua 劉永華, 'Mingdai Jiangji Zhidu Xia Jianghu de Huji Yu Yingyi shitai. Jian lun wangchao zhidu yu minzhong shenghuo de guanxi' 明代匠籍制度下匠戶的戶籍與應役實態——兼論王朝制度與民眾生活的關系 [Internal Structure and Labor Services of Artisan Households during the Ming Period: Toward an Interpretation of the Relationship between Imperial Institutions and Social Life], *Xiamen Daxue Xuebao*, 2 (2014), 50–7.

Luo Qingxiao 羅青霄, 'Zhangzhou Fuzhi' 漳州府志 [Gazetteer of Zhangzhou], in Peng Ze 彭澤 (ed.), *Mingdai Fangzhi Xuan* 明代方志選 [Selected Gazetteers of the Ming Dynasty] (Taipei: Taiwan xuesheng shuju, 1965).

Ma, Debin, 'The Great Silk Exchange: How the World Was Connected and Developed', in Dennis Flynn, Lionel Frost, and A. J. H. Lantham (eds.), *Pacific Centuries: Pacific Rim History since the Sixteenth Century* (London: Routledge, 1999), 1–30.

——, 'The Great Silk Exchange: How the World Was Connected and Developed', in Debin Ma (ed.), *Textiles in the Pacific, 1500–1900* (Aldershot: Ashgate, 2005).

——, 'The Modern Silk Road: The Global Raw-Silk Market, 1850–1930', *Journal of Economic History*, 56/2 (1996), 330–55.

Mackie, Louise W., 'Ottoman Kaftans with an Italian Identity', in Suraiya Faroqhi and Christoph Neumann (eds.), *The Illuminated Table, the Prosperous House: Food and Shelter in Ottoman Material Culture* (Istanbul: Orient-Institut and Ergon, 2003).

Maehira Fusaaki 真栄平房昭, 'Ryūkyū Bōeki No Kōzō to Ryūtsū Nettowāku' 琉球貿易の構造と流通ネットワーク [The Structure of Trade and Distribution Networks of the Ryukyu Kingdom], in Tomiyama Kazuyuki 豊見山和行 (ed.), *Ryūkyū–Okinawa-Shi No Sekai* 琉球–沖縄史の世界 [The World of History of the Ryukyu Kingdom and Okinawa] (Kyoto: Yoshikawa Kōbunkan, 2003), 116–66.

Marsh, Ben, 'Silk Hopes in Colonial South Carolina', *Journal of Southern History*, 78/4 (2012), 807–54.

——, 'The Republic's New Clothes: Making Silk in the Antebellum United States', *Agricultural History*, 86/4 (2012), 206–34.

Matthee, Rudi, 'The Politics of Protection: European Missionaries in Iran during the Reign of Shah 'Abbas I (1587–1629)', *Contacts and Controversies between Muslims, Jews and Christians in the Ottoman Empire and Pre-Modern Iran* (Würzburg: Ergon-Verlag, 2010).

Matthiesen, Otto Heinz, 'Die Versuche zur Erschliessung eines Handelsweges Danzig-Kurland-Moskau-Asien besonders für Seide, 1640–55', *Jahrbücher der Geschichte Osteuropas*, 3 (1938), 533–67.

Mau, Chuan-hui, 'Les progrès de la sériciculture sous les Yuan (XIIIe–XIVe siècles) d'après le Nongsang jiyao 農桑輯要', *Revue de Synthèse*, 2 (2010), 193–217.

Mazzaoui, Maureen Fennell, 'The Cotton Industry of Northern Italy in the Late Middle Ages: 1150–1450', *Journal of Economic History*, 32/1 (1972), 262–86.

McCants, Anne E., 'Modest Households and Globally Traded Textiles: Evidence from Amsterdam Household Inventories', in Laura Cruz and Joel Mokyr (eds.), *The Birth of Modern Europe: Culture and Economy, 1400–1800. Essays in Honor of Jan de Vries* (Leiden: Brill, 2010), 109–32.

McDowell, Allgrove J., 'Textiles', in Ronald W. Ferrier (ed.), *The Arts of Persia* (New Haven: Yale University Press, 1989), 157–70.

Meilink-Roelofsz, M. A. P., 'The Structures of Trade in the Sixteenth and Seventeenth Centuries: Niels Steensgaard's *Carracks, Caravans and Companies. A Critical Appraisal*', *Mare Luso-Indicum*, 4 (1980), 1–43.

Mendels, Franklin, 'Protoindustrialization: The First Phase of the Industrialization Process', *Journal of Economic History*, 32/1 (1972), 241–61.

Merkel, Carlo, 'I beni della famiglia di Puccio Pucci: Inventario del sec. XV illustrato', *Miscellanea Nuziale Rossi-Theiss* (Bergamo, 1897).

Miller, Lesley Ellis, 'Education and the Silk Designer: A Model for Success?', in Christine Boydell and Mary Schoeser (eds.), *Disentangling Textiles* (London: Middlesex University Press, 2002), 185–94.

——, 'Innovation and Industrial Espionage in Eighteenth-Century France: An Investigation of the Selling of Silks through Samples', *Journal of Design History*, 12/3 (1999), 271–92.

——, 'Paris–Lyon–Paris: Dialogue in the Design and Distribution of Patterned Silks in the Eighteenth Century', in Robert Fox and Anthony Turner (eds.), *Luxury Trades and Consumerism in Ancien Régime Paris: Studies in the History of the Skilled Workforce* (Aldershot: Ashgate, 1998), 139–67.

——, 'Representing Silk Design: Nicolas Joubert de l'Hiberderie and *Le Dessinateur pour les étoffes d'or, d'argent et de soie* (Paris, 1765)', *Journal of Design History*, 17/1 (2004), 29–53.

Mitchell, David, 'Fashions in Bed and Room Hangings in London, 1660–1735', in Anna Jolly (ed.), *Furnishing Textiles. Studies on Seventeenth- and Eighteenth-Century Interior Decoration* (Riggisberg: Abegg Stiftung, 2009), 21–34.

——, '"Good Hot Pressing Is the Life of All Cloth": Dyeing, Clothfinishing and Related Textile Trades in London, 1650–1700', in Herman Diederiks and Marjan Balkestein (eds.), *Occupational Titles and Their Classification: The Case of the Textile Trade in Past Times* (St. Katharinen: Scripta Mercaturae, 1995), 153–75.

——, '"It Will Be Easy To Make Money". Merchant Strangers in London, 1550–1680', in Clé Lesger and Leo Noordegraaf (eds.), *Entrepreneurs and Entrepreneurship in Early Modern Times. Merchants and Industrialists within the Orbit of the Dutch Staple Market* (The Hague: Stichting Hollandse Historische Reeks, 1995), 119–45.

——, 'Levantine Demand and the London Textile Trades, 1650–1730', *CIETA Bulletin*, 80 (2003), 49–59.

——, '"My Purple Will Be Too Sad for That Melancholy Room": Furnishings for Interiors in London and Paris, 1660–1735', *Textile History*, 40/1 (2009), 3–28.

Miyazaki Michio 宮崎道生, 'Shīboruto No Nihon Kaikoku Kindaika Eno Kōken' シーボルトの日本開国・近代化への貢献 [von Siebold's Contribution to the Opening and Modernisation of Japan], in Yanai Kenji 箭内健次 and Miyazaki Michio 宮崎道生 (eds.), *Shīboruto to Nihon No Kaikoku Kindaika* シーボルトと日本の開国近代化 [Siebold and Japan's Opening and Modernization] (Tokyo: Zoku Gunsho Ruijū Kanseikai, 1997), 265–309.

Moll-Murata, Christine, 'Chinese Guilds from the Seventeenth to the Twentieth Centuries: An Overview', *International Review of Social History*, 53 Supplement (2008), 213–47.

Monnas, Lisa, 'Loom Widths and Selvedges Prescribed by Italian Silk Weaving Statutes 1265–1512: A Preliminary Investigation', *CIETA Bulletin*, 66 (1988), 35–44.

——, 'New Documents for the Vestments of Henry VII at Stonyhurst College', *Burlington Magazine*, 131 / 1034 (1989), 345–49.

——, '"Plentie and Abundaunce": Henry VIII's Valuable Store of Textiles', in Maria Hayward and Philip Ward (eds.), *The Inventory of King Henry VIII: Volume II, Textiles and Dress* (London, 2012), 235–94.

——, 'Silk Cloths Purchased for the Great Wardrobe of the Kings of England 1352–1462', in Lisa Monnas and Hero Granger-Taylor (eds.), *Ancient and Medieval Textiles: Studies in Honour of Donald King. Textile History*, 20/2 (1989), 283–307.

——, 'Textiles and the Language of Diplomacy: Venice and Ottoman Turkey', in Juliane von Fircks and Regula Schorta (eds.), *Oriental Silks in Medieval Europe* (Riggisberg: Abegg-Stiftung, 2016), 329–44.

——, 'The Vestments of Sixtus IV at Padua', *CIETA Bulletin*, 57/8 (1983), 104–26.

Mukherjee, Rila, 'The "Small World" of the Silk Merchant at Kasimbazar, India', in Rila Mukherjee (ed.), *Networks of the First Global Age 1400–1800* (Delhi, 2011).

Munro, John, 'Medieval Woollens: Western European Woollen Industries and Their Struggles for International Markets, c. 1000–1500', in David Jenkins (ed.), *The Cambridge History of Western Textiles*, Vol. 1 (Cambridge: Cambridge University Press, 2003), 228–324.

Munro, John H., 'The Medieval Scarlet and the Economics of Sartorial Splendour', in N. Harte and K. Ponting (eds.), *Cloth and Clothing in Medieval Europe: Essays in Memory of Professor E. Carus-Wilson*, Pasold Studies in Textile History II (London: Heinemann Educational Books, 1983), 13–70.

Murphey, Rhoads, 'Syria's "Underdevelopment" under Ottoman Rule: Revisiting an Old Theme in the Light of New Evidence from the Court Records of Aleppo in the Eighteenth Century', in Jane Hathaway (ed.), *The Arab Lands in the Ottoman Era* (Minneapolis: Center for Early Modern History, 2010), 209–30.

Muzzarelli, Maria Giuseppina, 'Seta posseduta e seta consentita: dalle aspirazioni individuali alle norme suntuarie nel basso medioevo', in Luca Molà, Reinhold

C. Mueller, and Claudio Zanier (eds.) *La seta in Italia dal Medioevo al Seicento: dal baco al drappo* (Venice: Marsilio, 2000), 211–32.

Nagazumi Yōko 永積洋子, '17seiki Chūki No Nihon–Tonkin Bōeki Ni Tsuite 17 世紀中期の日本・トンキン貿易について [The Tonkinese–Japanese Trade in the Mid-Seventeenth Century], *Jōsai Daigaku Daigakuin Kenkyū Nenpō*, 8 (1992), 21–46.

Nakamura Kazuyuki 中村和之, and Hirotaka Oda 寛貴小田, 'Ezo Nishiki to Kita No Shiruku Rōdo 蝦夷錦と北のシルクロード [Ezo Brocade and the Northern Silk Road], in Emori Susumu 榎森進, Oguchi Masashi 小口雅史, and Sawato Hirosato 沢登寛聡 (eds.), *Hokutō Ajia No Naka No Ainu Sekai* 北東アジアのなかのアイヌ世界 [The World of the Ainu in Northeastern Asia] (Tokyo: Iwata Shoin, 2008), 827–43.

Naoko Iioka, 'The Rise and Fall of the Tonkin–Nagasaki Silk Trade during the Seventeenth Century', in Nagazumi Yōko (ed.), *Large and Broad: The Dutch Impact on Early Modern Asia. Essays in Honor of Leonard Blussé* (Tokyo: The Toyo Bunko, 2010), 46–61.

Necipoğlu, Gülru, 'A Kanun for the State, a Canon for the Arts: Conceptualizing the Classical Synthesis of Ottoman Art and Architecture', in Gilles Veinstein (ed.), *Soliman le Magnifique et son temps* (Paris: La Documentation française, 1992), 195–216.

Nierop, L. van, 'De Zijdenijverheid van Amsterdam Historisch Geschetst', *Tijdschrift voor Geschiedenis*, 45 (1930), 18–40, 151–72.

Nógradi, Árpád, 'A List of Ransom for Ottoman Captives Imprisoned in Croatian Castles', in Géza Dávid and Pál Fodor (eds.), *Ransom Slavery along the Ottoman Borders: Early Fifteenth–Early Eighteenth Centuries* (Leiden: Brill, 2007), 27–34.

'Notes and Queries', *The Pennsylvania Magazine of History and Biography*, 38/1 (1914), 123–4.

'On'na Irui Seikin No Shinajina 女衣類制禁の品々 [A List of Prohibited Female Clothing Items] (1683)', in Hōseishi Gakkai 法制史學會 (ed.), *Tokugawa Kinreikō* 德川禁令考 [A Collection of Tokugawa Prohibition Edicts], Vol. 2 (Tokyo: Sōbunsha, 1959).

Paley-Baildon, W., 'The Trousseau of Princess Philippa, Wife of Eric, King of Denmark, Norway and Sweden', *Archeologia*, 67 (1916), 163–88.

Parker, Grant, 'Ex Oriente Luxuria: Indian Commodities and Roman Experience', *Journal of the Economic and Social History of the Orient*, 45/1 (2002), 40–95.

Parthasarathi, Prasannan, 'Cotton Textiles in the Indian Subcontinent, 1200–1800', in Giorgio Riello and Prasannan Parthasarathi (eds.), *The Spinning World: A Global History of Cotton Textiles, 1200–1850* (Oxford: Oxford University Press, 2009), 17–42.

Peng Zeyi 彭澤益, 'Cong Mingdai guanying zhizao de jingying fangshi kan Jiangnan sizhiye shengchan de xingzhi' 從明代官營織造的經營方式看 江南絲織業生產的性質 [The Nature of Jiangnan's Silk Trade Viewed in the Light of Managerial Patterns in Ming Dynasty State-Owned Weaving Production], in Nanjing daxue lishi xi Ming Qing shi yanjiushi

南京大學歷史系明清史研究室 (ed.), *Ming Qing Zibenzhuyi Mengya Yanjiu Lunwenji* 明清資本主義萌芽研究論文集 [Essays Investigating the Sprouts of Capitalism during the Ming and Qing Era] (Shanghai: Shanghai renmin chubanshe, 1981), 307–44.

Perez, Marie-Félicie, 'Soufflot et la création de l'École de Dessin de Lyon, 1751–1780', in Université de Lyon II. Institut d'histoire de l'art (ed.), *Soufflot et l'architecture des Lumières*, Vol. 7 (Paris: Ministere de l'environnement et du cadre de vie, Direction de l'architecture: Centre national de la recherche scientifique, 1980), 80–100.

Perlin, Frank, 'Proto-Industrialization and Pre-Colonial South Asia', *Past & Present*, 98/1 (1983), 30–95.

Petech, Luciano, 'Les marchands italiens dans l'empire Mongol', *Journal Asiatique*, 250 (1962), 550–1.

Peyrot, Jean, 'Les techniques du commerce de soies au XVIIIe siècle à travers les documents commerciaux et comptables des fabricants de soieries', *Bulletin du Centre d'histoire économique et sociale de la Région Lyonnaise*, 1 (1973), 29–49.

Phillips, Amanda, 'A Material Culture: Ottoman Velvets and Their Owners, 1600–1750', *Muqarnas*, 31/1 (2014), 151–72.

——, 'Ottoman *Hil'at*: Between Commodity and Charisma', in Marios Hadjianastasios (ed.), *Frontiers of the Ottoman Imagination: Festschrift for Rhoads Murphey* (Boston and Leiden: Brill, 2014), 111–38.

——, 'The Historiography of Ottoman Velvets, 2011–1572: Scholars, Craftsmen, Consumers', *Journal of Art Historiography*, 6 (2012), 1–26.

Poni, Carlo, 'All'origine del sistema di fabbrica: Tecnologie e organizzazione produttiva dei mulini da seta nell'Italia settentrionale (secc. XVII–XVIII)', *Rivista Storica Italiana*, 88/3 (1976), 444–97.

——, 'Fashion as Flexible Production: The Strategies of the Lyons Silk Merchants in the Eighteenth Century', in Charles F. Sabel and Jonathan Zeitlin (eds.), *World of Possibilities: Flexibility and Mass Production in Western Industrialization* (Cambridge: Cambridge University Press, 1999), 37–74.

——, 'The Circular Silk Mill: A Factory before the Industrial Revolution in Early Modern Europe', *History of Technology*, 21 (1999), 65–85.

Prazniak, Roxann, 'Siena on the Silk Roads: Ambrogio Lorenzetti and the Mongol Global Century, 1250–1350', *Journal of World History*, 21/2 (2010), 177–217.

Quataert, Donald, 'The Silk Industry of Bursa, 1880–1914', in Huri İslamoğlu-İnan (ed.), *The Ottoman Empire and the World Economy* (Cambridge: Cambridge University Press, 1987), 284–99.

Ray, Indrajit, 'The Silk Industry in Bengal during Colonial Rule: The "Deindustrialisation" Thesis Revisited', *Indian Economic Social History Review*, 42/3 (2005), 339–75.

Riello, Giorgio, 'Asian Knowledge and the Development of Calico Printing in Europe in the Seventeenth and Eighteenth Centuries', *Journal of Global History*, 5/1 (2010), 1–29.

——, 'Fabricating the Domestic: The Material Culture of Textiles and the Social Life of the Home in Early Modern Europe', in Beverly Lemire (ed.), *The Force of Fashion in Politics and Society: Global Perspectives from Early Modern to Contemporary Times* (Aldershot: Ashgate, 2010), 41–65.

——, 'The World of Textiles in Three Spheres: European Woollens, Indian Cotton and Chinese Silks, 1300–1700', in Marie-Louise Nosch, Zhao Feng, and Lotika Varadarajan (eds.), *Global Textile Encounters* (Oxford: Oxbow Books, 2014), 93–106.

Rittenhouse, David, 'Transactions of the American Philosophical Society', *The Monthly Review*, 2 [by Owen Ruffhead, printed for R. Griffiths, vol. 76 (Jan.–June 1787)], 143–4.

Robinson, David, 'Images of Subject Mongols under the Ming Dynasty', *Late Imperial China*, 25/1 (2004), 59–123.

——, 'Princely Courts of the Ming Dynasty', *Ming Studies*, 65 (2012), 1–12.

Rothstein, Natalie, 'Canterbury and London: The Silk Industry in the Late Seventeenth Century', *Textile History*, 20/1 (1989), 33–47.

——, 'Joseph Dandridge: Naturalist and Silk Designer', *East London Papers*, 9/2 (1966), 101–18.

——, 'L'organisation du commerce des soieries en France et en Angleterre au XVIIIe siècle d'après un livre de commissions lyonnais conservé au Victoria et Albert Museum de Londres', *Le Monde Alpin et Rhodanien*, 2/3 (1991), 85–92.

——, 'The English Market for French Silks', *CIETA Bulletin*, 17/35 (1972), 32–44.

Sahillioğlu, Halil, 'Bursa Kadi Sicillerinde Iç ve Dis Ödemeler Aracı Olarak "Kitābü"l-Kadi' ve "Süftece"ler', in Osman Okyar (ed.), *Türkiye İktisat Tarihi Semineri Metinler* (Ankara: Hacettepe Üniversitesi, 1975), 103–44.

'Sarmatian', *Encyclopedia Britannica Online Academic Edition*, (n.d.), http://www.britannica.com/EBchecked/topic/524377/Sarmatian (accessed 4 July 2014).

Schäfer, Dagmar, 'Peripheral Matters: Selvage/Chef de Piece Inscriptions on Chinese Silk Textiles', *UC Davis Law Review*, 47/2 (2013), 705–33.

Schneewind, Sarah, 'Visions and Revisions: Village Policies of the Ming Founder in Seven Phases', *T'oung Pao*, 87/4–5 (2001), 334–36.

Schuessler, Melanie, '"She Hath Over Grown All She Ever Hath": Children's Clothing in the Lisle Letters, 1533–40', in Gale Owen-Crocker and Robin Netherton (eds.), *Medieval Clothing and Textiles*, Vol. 3 (Woodbridge: Boydell and Brewer, 2007), 181–200.

Shaw, Madelyn, 'Silk in Georgia, 1732–1840: From Sericulture to Status Symbol', in Ashley Callaghan (ed.), *Decorative Arts in Georgia: Historic Sites, Historic Contexts* (Athens, GA: Georgia Museum of Art, 2008), 59–78.

Shandong sheng bowu guan 山東省博物館, 'Fajue Ming Zhu Tan mu jishi' 發掘明朱檀墓紀實 [Excavation Report of Zhu Tan's Tomb], *Wenwu*, 5 (1972), 29–36.

Sheng, Angela, 'Innovations in Textile Techniques on China's Northwest Frontier, 500–700 AD', *Asia Major*, 11/2 (1998), 117–60.

——, 'Why Ancient Silk Is Still Gold: Issues in Chinese Textile History', *Ars Orientalis*, 29 (1999), 147–68.

Shenton, Caroline, 'Edward III and the Coup of 1330', in J. S. Bothwell (ed.), *The Age of Edward III* (York: York Medieval Press, 2001), 13–34.

Sicca, Cinzia Maria, 'Consumption and Trade of Art between Italy and England in the First Half of the Sixteenth Century: The London House of the Bardi and Cavalcanti Company', *Renaissance Studies*, 16 (2002), 163–201.

——, 'Fashioning the Tudor Court', in Maria Hayward and E. Kramer (eds.), *Textiles and Text: Re-Establishing the Links between Archival and Object-Based Research*, AHRC Research Centre for Textile Conservation and Textile Studies. Third annual Conference 11–13 July 2006 (London, 2007), 93–104.

Sicca, Cinzia Maria, and Bruna Niccoli, 'La consommation des produits de luxe à la cour de Henri VIII: Hans Holbein le jeune, ses modèles et leurs fournisseurs florentins d'étoffes à la mode', in Christine Rolland (ed.), *Autour des van Loo: Peinture, commerce des tissus et espionage en Europe (1250–1830)* (Mont Saint-Agnan: Publications des universités de Rouen et du Havre, 2012), 65–94.

Soimonov, Fedor I., 'Auszug aus dem Tage-Buch des ehemahligen Schiff Hauptmanns und jetzigen geheimen Raths und Gouverneurs von Siberien, Herrn Fedor Iwanowitsch Soimonov, von seiner Schiffahrt der Caspische See', in G. F. Müller (ed.), *Sammlung russischer Geschichten* (St Petersburg, 1762).

Stern, Walter M., 'The Trade, Art or Mystery of Silk Throwers of the City of London in the Seventeenth Century', *Guildhall Miscellany*, 1/6 (1956), 25–8.

Stoianovich, Traian, 'The Conquering Balkan Orthodox Merchant', *Journal of Economic History*, 20/2 (1960), 234–313.

Styles, John, 'Fashion and Innovation in Early Modern Europe', in Evelyn Welch (ed.), *Fashioning the Early Modern: Dress, Textiles, and Innovation in Europe, 1500–1800* (Oxford: Oxford University Press, 2017), 33–56.

——, 'What Were Cottons for in the Industrial Revolution?', in Giorgio Riello and Prasannan Parthasarathi (eds.), *The Spinning World: A Global History of Cotton Textiles, 1200–1850* (Oxford: Oxford University Press, 2009), 307–26.

Sutton, Anne F., 'Alice Claver, Silkwoman', in Caroline M. Barron and Anne F. Sutton (eds.), *Medieval London Widows 1300–1500* (London: Hambledon Press, 1994).

——, 'Two Dozen More Silkwomen of Fifteenth-Century London', *The Riccardian*, 16 (2006), 46–58.

Suzhou shi bowuguan 蘇州市博物館, 'Suzhou Huqiu Wang Xijue Mu Qingli Jilue' 蘇州虎丘王錫爵墓清理紀略 [A Brief Record of Sorting the [Finds] from Wang Xijue's Tomb at Huqiu in Suzhou], *Wenwu*, 3 (1975), 51–6.

Suzhou shi wenguan hui 蘇州市文管會, and Suzhou shi bowu guan 蘇州市博物館, 'Suzhou Wu Zhang Shicheng Mu Caoshi Mu Qingli Jianbao' 蘇州吳张士诚母曹氏墓清理簡報 [A Brief Report on the Tomb of a Woman with the Surname Cao, Mother of Zhang Shicheng of Wu of Suzhou], in Suzhou diqu wenhua ju 蘇州地區文化局, Suzhou shi wenwu guanli weiyuan hui 蘇州市文物管理委員會, and Suzhou bowu guan 蘇州博物館 (eds.),

Suzhou Wenwu Ziliao Xuanbian 蘇州文物資料選編 [Selected Information about Suzhou's Cultural Relics] (Suzhou: n.p., 1980), 129–34.

Suzuki Chikae 鈴木千香枝, 'Chōsen Ōchō No Nuno to Ori' 朝鮮王朝の布と織り [Textiles and Weaving of the Joseon Dynasty], in Chang Sook Hwan (ed.), *Chōsen Ōchō No Ishō to Sōshingu* 朝鮮王朝の衣装と装身具 [Korean Costume and Accessories from the Joseon Dynasty] (Kyoto: Tankōsha, 2007), 144–46.

Takase Kōichirō 高瀬弘一郎, 'Makao–Nagasaki Kan Bōeki No Sōtorihikidaka/ Kiito Torihkikiryō/Kiito Kakaku' マカオ=長崎間貿易の総取引高・生糸取引量・生糸価格 [The Turnover, Amount and the Price of Raw Silk of the Portuguese Trade at Nagasaki in the Sixteenth and Seventeenth Centuries], *Shakaikeizaishigaku*, 48/1 (1982), 51–84, 127–28.

Tang Shuqiong 唐淑瓊 and Ren Xiguang 任錫光, 'Sichuan Huayang Ming Taijian Mu Qingli Jianbao' 四川華陽明太監墓清理簡報 [Excavation Report of Ming Eunuchs from Huayang, Sichuan], *Kaogu Tongxun*, 3 (1957), 43–9.

Tanimoto, Masayuki, 'Introduction and Diffusion: How Did Useful and Reliable Knowledge Feature in the Industrial Development of Early Modern Japan?', *Technology and Culture*, special issue, 'The History of Technology in Global Perspective', edited by Simona Valeriani and Dagmar Schäfer (forthcoming).

Tashiro Kazui 田代和生, 'Tokugawa Jidai No Bōeki' 徳川時代の貿易 [Foreign Trade in the Tokugawa Period], in Hayami Akira 速水融 and Miyamoto Matao 宮本又郎 (eds.), *Nihon Keizaishi*, Vol. 1 (Tokyo: Iwanami Shoten, 1988), 129–70.

Taylor, William B., 'Town and Country in the Valley of Oaxaca', in Ida Altman and James Lockhart (eds.), *Provinces in Early Mexico. Variants of Spanish American Regional Evolution* (Los Angeles, 1976), 63–94.

Tezcan, Hülya, 'Döşemede Tarih: Sakız Adasının Osmanlı Ipeklileri', *Ev Tekstili Dergisi*, 2/7 (1995), 10–15.

Thirsk, Joan, 'Knitting and Knitware, c. 1500–1780', in David Jenkins (ed.), *The Cambridge History of Western Textiles*, Vol. 1, 2 vols (Cambridge: Cambridge University Press, 2003), 562–84.

——, 'The Fantastical Folly of Fashion; the English Stocking Knitting Industry, 1500–1700', in Negley B. Harte and Kenneth G. Ponting (eds.), *Textile History and Economic History: Essays in Honour of Julia de Lacy Mann* (Manchester: University of Manchester Press, 1973), 50–73.

Tomory, Leslie, 'Water Technology in Eighteenth-Century London: The London Bridge Waterworks', *Urban History*, 42/3 (2015), 381–404.

Trentmann, Frank, 'Beyond Consumerism: New Historical Perspectives on Consumption', *Journal of Contemporary History*, 39/3 (2004), 373–401.

Turan, Serafettin, 'Venedik'te Türk Ticaret Merkezi', *Belleten*, 32/125–8 (1968), 247–81.

Van der Wee, Herman, 'The Western European Woollen Industries, 1500–1750', in David Jenkins (ed.), *The Cambridge History of Western Textiles*, Vol. 1, 2 vols (Cambridge: Cambridge University Press, 2003), 397–472.

Veinstein, Gilles, 'Commercial Relations between India and the Ottoman Empire (Late Fifteenth to Late Eighteenth Centuries): A Few Notes and Hypotheses', in Sushil Chaudhury and Michel Morineau (eds.), *Merchants, Companies and Trade: Europe and Asia in the Early Modern Era*, trans. by Cyprian P. Blamires (Cambridge: Cambridge University Press, 1999), 95–115.

Wang Xiang 王翔, 'Zhonguo sichou shengchan quyu de tuiyi' 中國絲綢生產區域的推移 [Regional Shifts in Sericulture in China], *Caijing luncong*, 117/4 (2005), 89–96.

Wang Xuan 王軒, 'Zouxian Yuandai Li Yu'an mu qingli jianbao' 鄒縣元代李裕庵墓清理簡報 [Preliminary Excavation Report of the Yuan Dynastic Li Yu'an from Zou County], *Wenwu*, 4 (1978), 14–20.

Watt, James C. Y., and Anne E. Wardwell (eds.)., 'Luxury-Silk Weaving under the Mongols', *When Silk Was Gold: Central Asian and Chinese Textiles* (New York: Metropolitan Museum of Art, 1997), 127–64.

Wei Wenjing 魏文靜, Xia Weizhong 夏维中 and Wang Liang 汪亮, 'Cong Suizao Renwu Kan Mingdai Difang Zhizao de Xingshuai Bianqian' 從歲造任務看明代地方織造的興衰變遷 [Discussions on Development and Decline of Local Weaving in Ming Dynasty from Annual Manufacturing Task], *Sichou*, 51/3 (2014), 60–5.

Wills, John E., 'De VOC en de Chinezen in China, Taiwan en Batavia in de 17e en 18e Eeuw', in M. A. P. Meilink-Roelofsz (ed.), *De VOC in Azië* (Bussum: Fibula-Van Dishoeck, 1976), 157–92.

Woodfin, Warren, 'Orthodox Liturgical Textiles and Clerical Self-Referentiality', in Kate Dimitrova and Margaret Goehring (eds.), *Dressing the Part: Textiles as Propaganda in the Middle Ages* (Turnhout: Brepols, 2014), 31–51.

Wright, Susanna, 'Directions for the Management of Silk-Worms', *Philadelphia Medical and Physical Journal*, I/Part 1 (1804), 103–7.

Yamazawa Ippei 山澤逸平, 'Kiito Yushutsu to Nihon No Keizai Hatten 生糸輸出と日本の経済発展 [Japanese Silk Exports and Economic Development], *Hitotsubashi Daigaku Kenkyū Nenpō Keizaigaku Kenkyū*, 19 (1975), 57–76.

Yang Jiqing 楊積慶, 'Yu Xilu qiren' 俞希魯其人 [On Yu Xilu], *Zhenjiang shizhuan xuebao*, 4 (1987), 98–100.

Yasunori, Arano, 'The Formation of a Japanocentric World Order', *International Journal of Asian Studies*, 2/2 (2005), 185–216.

Yoshida, Masako, '16–17 Seiki O Chūshin to Suru Chūgoku Kōeki to Hakurai Some Ōhin No Juyō [Chinese Trade in the Sixteenth and Seventeenth Centuries and the Acceptance of Imported Textiles in Japan], *Kyōto Shiritsu Geijutsu Daigaku Bijutsugakubu Kenkyū Kiyō*, 51 (2007), 27–38.

——, 'A Structural Analysis of Ming and Qing Dynasty Velvet', *Tama Art College Bulletin*, 14 (1999), 49–59.

——, 'The Embroidered Velvet Jinbaori Jacket Purportedly Owned by Toyotomi Hideyoshi: Its Place of Production, Date, and Background', *Bijutsuhi*, 59/1 (2009), 1–16.

——, 'The Formation of Velvets in China: A Study of Velvet-Related Terminology in Chinese Documents', *Hata*, 5 (1998), 35–47.

Yu Ruji 俞汝楫, *Libu zhigao* 禮部志稿 [Draft Monograph of the Ministry of Rites] (Beijing, 2003, *Siku quanshu* version).

Yuan Ruiqin 原瑞琴, 'Da Ming huidian banben kaoshu' 大明會典版本考述 [Inquiry on the Editions of the Da Ming huidian], *Zhongguo shehui kexue yuan yanjiusheng xuebao*, 181/1 (2011), 136–40.

Yuan Zujie 原祖傑, 'Dressing for Power: Rite, Costume, and State Authority in Ming Dynasty China', *Frontiers of History in China*, 2/2 (2007), 181–212.

——, 'Huangquan Yu Lizhi: Yi Mingdai Fuzhi de Xingshuai Wei Zhongxin' 皇權與禮制: 以明代服制的興衰為中心 [Imperial Power and Ceremonial System: The Rise and Fall of Costume System in the Ming Dynasty], *Qiushi Xuekan*, 5 (2008), 126–31.

Yun-Casalilla, Bartolomé, 'The American Empire and the Spanish Economy: An Institutional and Regional Perspective', *Revista de Historia Económica / Journal of Iberian and Latin American Economic History*, 16/1 (1998), 123–56.

Zahedieh, Nuala, 'London and the Colonial Consumer in the Late Seventeenth Century', *Economic History Review (London)*, 47/2 (1994), 239–61.

——, 'The Merchants of Port Royal, Jamaica, and the Spanish Contraband Trade, 1655–1692', *The William and Mary Quarterly*, 43/4 (1986), 570–93.

Zanier, Claudio, 'Pre-Modern European Silk Technology and East Asia: Who Imported What?', in Debin Ma (ed.), *Textiles in the Pacific, 1500–1900* (Aldershot: Ashgate, 2005), 105–90.

Zhang Qin 張琴, 'Sichuan Mingdai muzang shitan' 四川明代墓葬試探 [Probing Ming Tombs in Sichuan], *Xue lilun*, 14 (2012), 183–4.

Zhang Tianju 張天琚, 'Mingdai Shu wangfu gouchen' 明代蜀王府鉤沉 [The Shu Princely Residence of the Ming Dynasty]', *Wenwu jian ding yu jian shang*, 2 (2015), 100–6.

Zhao Feng 趙豐, 'Meng Yuan Longpao de Leixing Ji Diwei' 蒙元龍袍的類型及地位 [Role and Styles of the Mongolian Yuan Dynastic Dragon Robes], *Wenwu*, 8 (2006), 85–96.

Zelinsky, Wilbur, 'Globalization Reconsidered: The Historical Geography of Modern Western Male Attire', *Journal of Cultural Geography*, 22/1 (2004), 83–134.

Zygulski, Zdzisław, 'The Impact of the Orient on the Culture of Old Poland', in Jan Ostrowski (ed.), *Land of the Winged Horseman. Art in Poland 1572–1764* (Alexandria VA: Art Service International with Yale University Press, 1999).

UNPUBLISHED THESES AND PAPERS

Akdağ, Hasan, 'Kassam Defteri (Havass-I Refi'a Mahkemesi 272 Numaralı, 1204–1206/1789–1791 Tarihli)' (unpublished Master's thesis: Istanbul University, 1995).

Çetin, Birol, 'Istanbul Askeri Kassamı'na Ait Hicri: 1112–1113 (M. 1700–1701) Tarihli Tereke Defteri' (unpublished Master's thesis: Istanbul University, 1992).

Çizakça, Murat, 'Sixteenth–Seventeenth Century Inflation and the Bursa Silk Industry: A Pattern for Ottoman Industrial Decline' (unpublished Ph.D. thesis: University of Pennsylvania, 1978).

Davini, Roberto, 'Una conquista incerta: la Compagnia inglese delle Indie e la seta del Bengala (1769–1833)' (unpublished Ph.D. thesis: European University Institute, 2004).

Gayot, Gérard, 'Different Uses of Cloth Samples in the Manufactures of Elbeuf, Sedan and Verviers in the Eighteenth Century', unpublished paper, delivered at 'Textile Sample Books Reassessed: Commerce, Communication and Culture', conference organised by the University of Southampton at Winchester, June 2000.

Kılıç, Nalan, '1650 Yılında Bursa (B 87 Nolu Mahkeme Siciline Göre)' (unpublished Master's thesis: Uludağ University, 2005).

Miller, Lesley Ellis, 'Designers in the Lyons Silk Industry, 1712–87' (unpublished Ph.D. thesis: Brighton Polytechnic, 1983).

Sheng, Angela, 'Textile Use, Technology, and Change in Rural Textile Production in Song China 960–1279' (unpublished Ph.D. thesis: University of Pennsylvania, 1990).

——, 'Circulating the Roundel: Knowledge Mobilization in Textile Design and Technology between China and the Mediterranean Shores, 500–1500', presented at the peer-reviewed panel on China and Cross-Cultural Exchange, 500–1500, chaired by Susan Shih-Shan Huang and Diane Wolfthall, Rice University, at the annual meeting of the College Art Association, Chicago, 15 February 2014.

——, 'Materiality and Knowledge Transmission: Weaving Velvet in the Global Early Modern Cultures', presented to the Spring Colloquium, 'Material Splendor and Global Early Modern Art', Department of Art History, University of Southern California, Los Angeles, 24 April 2015.

Wiederkehr, Anne-Marie, 'Le dessinateur pour les étoffes d'or, d'argent et de soie' (unpublished thesis: Université de Lyon II, 1981).

Contributors

Suraiya Faroqhi
Professor of Ottoman Studies (retired)
LMU Munich
Professor Emeritus
Bilgi University, Istanbul
Professor
Ibn Haldun University, Istanbul

Kayoko Fujita
Professor
Ritsumeikan University, Kyoto

José Luis Gasch-Tomás
Marie Curie Fellow
Spanish National Research Council (CSIC)
Madrid, Spain

Karolina Hutková
LSE Fellow in Economic History
London School of Economics and Political Science, London

Ben Marsh
Lecturer
School of History
University of Kent
Canterbury, UK

Rudolph Matthee
John and Dorothy Munroe Distinguished Professor of History
University of Delaware
Newark, USA

Lesley Miller
Senior Curator (Textiles), Department of Furniture, Textiles and Fashion
Victoria and Albert Museum, London, UK

David Mitchell
Visiting Research Fellow
Centre for Metropolitan History, Institute of Historical Research
University of London

Luca Molà
Professor of Early Modern Europe: History of the Renaissance and the
Mediterranean in a World Perspective
Department of History and Civilisation
European University Institute, Florence, Italy

Lisa Monnas
Fellow of the Society of Antiquaries
Independent Textile Historian
London, UK

Amanda Phillips
Assistant Professor of Islamic and Ottoman Art and Material Culture
McIntire Department of Art
University of Virgina, Charlottesville, USA

Giorgio Riello
Professor of Global History and Culture
Department of History
University of Warwick, Warwick, UK

Dagmar Schäfer
Director at Max Planck Institute for the History of Science, Berlin
Professor h.c. of the History of Technology
Technical University, Berlin, Germany

Angela Sheng
Associate Professor, Art History
School of the Arts (SOTA)
McMaster University, Hamilton, Canada

Index

An asterisk (*) indicates terms that appear in the glossary

A

Accessories 6, 30, 32, 202, 218, 259
Administrative Office of Maritime Tributary
 Trade in Fuzhou 57, 59, 73
Aesthetics 3–4, 6–7, 9, 32, 106, 110–11,
 115–17, 119, 122, 337
Agents 82, 92, 179, 183, 225, 232, 245–6,
 248, 291
Agrarian economies 2, 297, 325
Ainu 297, 302, 318
*Akmişe 108–9
*Alaca 119, 140, 142
*Alamodes 193, 207
Aleppo 78, 80–2, 99, 104, 107, 118, 145–6,
 190, 214
*Alto e basso 153, 157, 171
America 1–2, 4, 14–17, 104, 214, 251–8,
 260, 263, 265–83, 288, 294, 296, 324–7,
 329–30, 336
American
 colonies 15–16, 267, 271–3, 282–3
 Revolution 266–7, 278–9
 sericulture 15–16, 254, 266–71, 276,
 282, 294
Amsterdam 14, 79, 81–2, 86, 91–2, 97–8,
 248, 333
Anatolia 12, 76, 80, 83, 96, 111, 118–20,
 141–2, 191, 202, 335
Ancient Japan 297, 299, 319
Ancient Roman period 10
Annual quota 36–8, 40, 44, 61–2, 96, 99
Antiquity 1–2, 8, 75, 325–6
Antwerp 79, 181, 183–4
Apparel 44, 155–6, 188, 269
Apprentices 144, 190, 195, 206, 217

Apprenticeship 236–7, 240, 242
Arab traders 59
Arabia 105
Arable land 56–7
Armenian merchants 78–9, 83, 100, 135
Artefacts 6, 14, 17, 23, 29, 45, 52, 122,
 127–8
Artisanal labour 61–2
Artisans 33, 49, 55, 61–3, 105–6, 108, 113,
 122, 129, 132, 136, 138, 143–4, 150, 184,
 212, 232, 254–5, 279, 297, 313, 319
Atlantic commercial failures 258, 266, 327
*Atlas 104, 111, 113, 115–17, 120, 123
Avarice 265–6, 268, 280

B

*Baldacchino 153, 168
*Baldekyn/baudekyn 175–7
Bales 81–4, 90, 95–7, 99, 187, 191, 202, 214
Bandar 'Abbas 92, 95, 97–8
Bankers 168, 233
Barriers 188, 231
Batavia 91–2, 95, 99
*Baudekyn. See Baldekyn
Bauleah 287–9
Bed hangings 209
Bedding 13, 209
Beijing 9, 21, 30–2, 54, 60–2, 73, 319
Bengal 11, 14–17, 75–8, 87, 92–4, 96–9,
 101, 188, 276, 281–94
Bengali silk 94, 96, 101, 312, 315–16
Bilecik 103, 115–16, 119, 130
Black velvet 66–7, 158, 168, 172–3,
 179–80, 184, 260
Blossoms 117–18, 122, 259

Board of
 Finances 60
 Trade 267, 271, 276
 Works 60
Bologna 150, 166–7, 191, 332–3, 335, 344
Bolognese *filatoio* 332, 333, 336
Book of Rates 152, 163, 180
Bouclé 259–60
Bounties 271, 334
'Brand' 244
Brazil 214, 216, 219
Bribes 91
British
 imperial sericulture 276
 legislation 283
 market 281, 285, 289
 silk industry 281–2, 284–5
 state political economy 17
 weaving techniques 291
Broadcloths 117, 202–3, 208
Brocaded
 cloth of gold 150, 165
 patterns 26, 30, 63, 160, 230
 satins 74
 silks 57, 155, 168–9
 velvets 12, 103, 112, 114, 118, 121, 156,
 172–3, 176–7
*Brocades 13, 42, 54, 66, 100, 132, 139,
 150, 163, 187, 207, 216, 225, 297, 299,
 313–14, 318
Brocading 30, 103–4, 111, 116, 122, 153,
 160
Brocatelle 160, 163, 185
Bureau of Miscellaneous Manufacture 62
Bureau for Raw Silk Tabby 36
Bursa 15, 76, 103–11, 113, 115–17, 119–23,
 128–30, 135, 138–41, 145–6, 335
*Bürümcük 128, 138
Byzantine empire 4, 9–10, 328

C
Cadiz 211, 214–15, 274
Caftans 132–3, 135, 137, 139–44
Cairo 12, 104, 109, 113, 118, 127, 142–3,
 146–7
Calenderer 207, 220–1
Canterbury 14, 187, 205, 222
Cape of Good Hope 76, 81

Capital 13, 21, 30–1, 34, 36–7, 42, 54,
 61–2, 89, 119, 122, 141, 175, 185, 252,
 255, 297, 299, 317
 cultural 233, 240
 financial 211, 233, 236, 242, 275, 287,
 324, 331
 human 333
 intellectual 267
 social 16, 56
Capital Defence Unit 61
Carpets 55, 109–10, 113, 142, 144, 185
Caspian region 76, 78, 88, 91, 98, 100, 108,
 151–2
Castile 251–2, 254, 260–1, 263
Castilian fabrics 260–1
Castilian fashions 258–9
Catholic Church 133
*Çatma 12, 103–6, 111–23
Cauls 152, 162–3, 193
Central Asia 3, 27, 78, 325–6, 328
Central Europe 12, 127, 329, 336
Ceremonial clothes 84, 137, 144, 324
Chain of production 12, 14, 346
Chalice veil 164–5
Chambre de Commerce 227
Charles II 188, 200, 202–3, 269
*Chaúl 258, 260–1
Chenghua era 44
China
 dynastic age 2, 21–2, 25, 32, 43, 47, 84
 empires 3–4, 18, 60, 72, 297, 318, 320,
 334
 mainland 85–6, 94
 as a regional supplier 11, 76
China-centred economy 311–12
Chinese
 civil war 13, 86, 100, 187, 298, 301
 damask 15, 30, 40–1, 58, 258, 260–1, 299
 diagrams 268
 drawlooms 27–8, 40, 312
 ships 57, 303–8, 312, 316–17
Chios 118, 122, 127, 141–2, 146–7, 151
*Chirimen 299, 314
Christian merchants 107, 145
Church as silk consumer 12, 75, 128–30,
 135, 163, 164–5, 169
Ciclatouns 176
Çintamani motif 130

Climate 4, 16, 39, 54, 82, 253–4, 268–70, 287–8, 325–6, 330
Climate change 29
Cloaks 15, 170, 173, 261
Cloth of estate 153, 158, 179
*Cloth of gold 104, 130, 135, 150, 153, 158, 160, 165, 169–70, 173, 175–82, 185
Cloth of gold of tissue 153, 158, 160, 166, 177, 181–2
Cloth of silver 153, 160, 163, 181, 183
clothworkers 220–2, 339
Cloud motif, pattern 24, 42, 63, 66–7
Cochineal 153, 156, 198, 214, 258
*Cocoons 151, 271, 273–4, 277, 280, 292
 processing 255, 258, 275, 286, 291, 293, 328, 330
 quality 289–90, 292, 294
 storage 290–1
Collected Statutes of the Ming 31, 37
Colonial
 America 251, 269, 273
 authorities 266–8
 boycotts 278
 economy 257
 government 258
 initiatives 282
 labour 280
 policies 17
 sericulturists 274
Commerce, Atlantic 258, 266, 327
Commercolly 287, 289
Commissionaires 233, 249
Commissions (orders) 39–40, 110, 117, 128, 165, 179, 183, 244, 247, 268, 273
Commoners 18, 32, 42, 71, 301, 320–1
Compound silks 109, 122–3
Compound weaves 31, 53–4, 63, 103, 123
Conscripted labour 60, 62
Conspicuous consumption 214, 218
Constantinople 106, 110–16, 118–20, 123, 328
Consumers 3, 8, 10, 12–14, 18, 75, 82, 93, 104, 109, 116, 119, 123, 128, 138, 145, 147, 165, 185, 202, 217, 227, 232–3, 247, 249, 280, 298–9, 312, 326–7, 335, 341
 ancient Greek and Roman 326
 culture 317
 demand 232, 323, 336

society 317, 320
 taste 15, 17, 334
Consumption 1–4, 8–9, 12–13, 47, 67, 106, 115, 122, 127, 140, 146–7, 149–85, 266, 268, 297, 299–300, 318, 320, 324–5, 328, 334, 341
 changes in 104, 123, 189
 conspicuous 215, 218
 of luxury goods 73, 103–4, 116, 118, 122
 patterns 6, 17, 115, 325
Copes 130, 165–7, 173, 179
Copies 70, 136, 272, 287
Copper 298, 311, 315–16
Copying 232
Cordoba 253, 260
Coromandel 82, 97, 337, 339
Correspondence 104, 113, 169, 183, 244–5, 248–9, 272, 278
Corvée labour 11, 30, 45, 47, 62
Cosimo de' Medici 173, 179
Cotton 39
 cultivation 6, 43, 56, 60, 71, 84, 104, 108, 113, 119–20, 122, 138, 140–1, 143, 171, 217–18, 244, 251, 266, 283, 312, 319, 323–31, 333–41
 fibre 18, 26, 30, 331
Counterfeits 178
Court of Orphans 14, 188, 197, 209, 220
Cracow 136, 142
Craftsmen 22, 30, 54, 61–2, 137, 144, 169, 219, 257–8, 299, 312–13, 317, 321, 333, 336
Creoles 257–8, 262
Crimson 66, 113, 116, 153–4, 156–8, 165, 167, 170, 172–5, 178–9, 182, 191, 203, 258
Crippins 162–3
'Crisis' of the seventeenth century 261, 335
Cross-cultural trade 74
Cultural
 capital 233, 240
 difference 248
 diversity 320
 impact 147
 likings and local fashions 261, 263
 network 249
 politics 301
 values 321

Cushions 13, 103, 111, 113, 115–19, 121, 123, 128, 135, 139, 165
Customers. *See* Consumers
Customs 84, 107, 334
*Cut tuft 52, 54–5
Cycle of
 consumption 122
 fashion 232, 340
 production 122
Cyprus 108–9, 175

D

Daimyos 11, 17, 64, 69, 302, 316
Damascus 12, 104, 106–7, 109, 120, 127, 137–41, 146–7
*Damasks 13, 15, 30, 151, 160, 185, 187–8, 192, 207, 216, 253, 258, 261
Damga 138, 142
De-sinicisation 296
Deshima 86–7, 295
Design 3, 6–8, 10, 14–15, 22–3, 25, 27, 29–33, 45, 54, 57, 64, 69–70, 111, 113, 129–30, 132, 135–6, 140, 142, 144–5, 163, 166–7, 173, 183, 237, 238, 240, 242, 266, 271–2, 296, 299, 314, 321, 337–8, 340–1
 floral 57, 118, 130
Designers 14–15, 113, 115, 118, 142, 228, 231–3, 236–7, 240, 242–3, 245, 248–50
Designing 232, 249
Diplomacy 116, 169, 301–2, 309, 311, 318, 320
 and gifts and exchanges 9, 13, 80, 145, 169–70, 269, 337
Diversification, diversifying 4, 6, 8, 13, 87, 94, 115
Diversity 13, 22, 320
Domestic
 economy 267, 294
 industry 79, 162, 273, 316
 markets 14, 17, 52, 67–73, 78, 127, 232, 253, 300, 314–18
 production 17, 151, 282, 297–8, 314, 316–17
Donsu 299, 313
Double-crossing machines 286–8
Dragon robes 8, 24–6, 28, 31, 38, 41–2, 46, 67–8, 71–3, 259

Drawings 170, 234, 236–7, 243
Drawloom 27–8, 40, 115, 193, 312, 336
Dress 170, 173, 258, 261–3, 327
 codes 23–4, 45–6, 258, 319–20
Dutch
 calendar 207
 looms 195, 212, 218
 merchants 90
 mills 192–3
 ships 94, 98
 trade missions 97–8
 traders 17, 302–4, 309, 311, 315
 velvet 216
Dutch East India Company (VOC) 11, 75–101, 296, 337
Dye industries 15, 252, 256–8, 263
Dyeing 6, 9, 34–5, 37, 39, 65, 143, 207, 213, 215, 219, 257, 297–8, 301, 314, 319, 334, 338
Dyeing techniques 17
Dyers 190–1, 206–7, 212, 214, 221
Dyers' Company 190
Dyes 24, 36, 56, 140, 156, 167, 169, 320, 338

E

East Asia 1, 12, 75, 81, 84, 92, 95, 100–1, 251, 258–9, 299, 311–12, 318, 321, 324, 327–8, 332
East Indies 268, 275
Eastern Mediterranean 78, 80, 104–5, 107–10, 118, 122, 127
Ecclesiastical 129–30, 135, 160, 164, 175, 185
Economic
 crises 105
 development 3
 environment 13, 253, 320
 forces 11, 84, 318
 growth 189, 254, 270, 317
 historian 2, 105–6, 323
 history 1–2, 105–6, 232
 power 119, 312, 320–1
 role of silk manufacture 150
 sectors 257, 261
 system 311
 trends 123

Economy 1–2, 3, 15, 17, 29, 59, 103–5,
 107, 122, 127, 218, 249, 253, 255, 267,
 278, 294, 296–7, 311, 325, 331–2, 324–5
Edirne 12, 109, 111, 116
Edward IV 162, 178–9
Edward VI 166
Egypt 108, 127, 142–4, 147
Eleonora di Toledo 173–5, 179
Embargo 108, 303, 315
Embroidered textiles. *See* Textiles,
 embroidered
Embroiderers 135, 143, 165, 176–7, 191
Embroidery 14, 30, 55, 67, 69–70, 129–30,
 152, 162, 167, 173, 187–8, 295, 301,
 314, 319, 337
Emperor Hongwu 22, 59–60
Employers 130
Employment 190, 218, 232–3, 240, 242,
 247, 249, 258, 270–1, 286, 289, 293, 297,
 333, 335
 children 293, 334
 men 293
 women 217, 293, 332, 334
English calendar 207–9, 218
English East India Company (EIC) 9, 11,
 16, 76, 188, 276, 281–94
English mills 192–3
English Turkey Company 99
Enlightenment associations 267, 271
Entrepreneurs 17, 169, 231, 267
Estate inventories 105, 111, 113, 116–17,
 119–20, 137
Eunuchs 21–2, 42–5
Eurasia 2, 7, 16, 100, 324–6, 333, 335, 340
European
 aristocracy and wealthy elites 13, 149,
 176, 178, 297
 demand 79
 market 75, 78, 84, 86, 96–7, 100, 287,
 295
 merchants 79, 302
 politicians 282
 producers 3, 13
 reeling technologies 281–94
 silk industry 79, 329
 specialists 288
 traders 299, 319, 321
 Western 6, 97, 99, 109–10, 133, 325

Evelyn, John 200, 204, 207, 210
Excavated textiles. *See* Textiles, excavated
Exchange of
 patterns 30
 silk imports for exports 15, 82, 84, 91,
 94, 100, 109, 213, 252
 staff 30
 techniques 17, 30
 templates 30
'Exchangeman' 195
'Exchangewomen' 217
Exotic 211, 217, 263, 266, 327, 337
Expansion in European silk 12, 157, 184,
 219
Expensive textiles. *See* Textiles, expensive
Expertise 6, 10, 17, 31, 33, 36–9, 41, 232,
 267, 280–1
Experts 16, 106, 146, 271, 275, 281
Exports 82, 86–7, 94–6, 97–100, 123,
 129–36, 219, 294, 315–16

F

Fabric samples 74, 96, 183, 226–8, 233,
 246–9, 275, 278–9, 295
Fabrics, mixed 14, 120, 140, 142, 168, 187,
 192, 206, 209, 212, 215–16, 218, 254,
 284, 334
Far East 7, 130
Fashion 3, 6, 8, 12, 26–7, 29, 77, 104, 108,
 117, 122, 133, 137, 139, 179, 211, 226,
 228, 231, 243, 246, 249–50, 252, 263,
 277, 295–321
 cycle of 132, 340
 design 232–3
 in dress 258, 260, 263
 global 259–61
 press 245
 silks 236–43, 249
 trade 237
Fashionable 31, 63, 135, 160, 179, 204,
 211–12, 217–19, 227, 231, 242, 248, 337
Fashions 24, 122, 137, 144, 232, 248,
 257–8, 263
Fees 95, 242
Female
 artisans 138
 workers 40, 58, 267
Field of Cloth of Gold 165, 181

Figured
 ribbons 198
 silks 115–16, 120–1, 123, 150, 152, 207, 231, 336
 velvet 12, 103, 153, 160, 168
Filatoio 332, 336
 Bolognese 332, 333, 336
*Filatures 271, 273, 275–8, 287–94
Finery 165, 265–6, 268, 277, 280
'First among equals' 170
Fixed prices 84, 95, 101, 116, 311
Flanders 79, 248
Flexible production 231, 336, 338, 340–1
Floral designs 57, 118, 130, 144, 337
Florence 7, 10, 104, 108–10, 149–51, 165, 168, 170–2, 175, 181, 185, 328
Florentine silk. *See* Silk, Florentine
Flower motifs 42, 120–2, 130, 136, 172, 206, 209, 214, 225–6, 258–9
'Fluid silk'. *See* Silk, 'fluid'
Foreign
 merchants 86, 152, 176, 183
 silks 144–5, 169, 227
 specialists 288–91
 trade 59, 295–321
Foreigners 17, 52, 57, 70, 73, 101, 296, 299, 302
Formosa 85, 94, 101
Fort Zeelandia 85, 87, 94
Framework knitters 196–7, 210–11, 214
Framework Knitters' Company 211
Frankish
 merchants 105, 107–9
 silks 111, 113, 116, 119, 123
Freelancers 233, 240, 242, 247
French
 designers 15
 fashion 133
 merchants 96, 105, 226
 Revolution 248
 sericulture 79
 silks 163, 183, 216, 225, 227–8
Fujian 49, 52–3, 56–9, 61–2, 69, 316
Fundamentals of Agriculture and Sericulture (Nongsang jiyao) 39
Fur 72, 104, 120, 135, 168, 170–1, 178, 188
Fuzhou 57–60, 62–3, 73, 316

G
Galloons 192–3, 216
Garments 58, 67, 70–1, 73, 106, 111, 113, 120, 123, 135, 139, 168, 172–3, 175–6, 178, 181–2, 253, 260–1, 263, 277, 299, 301–2, 327
Gartering 195, 198–9
Garters 193, 211, 218, 269, 278
Gasa 258, 260
Genoa 104, 108–9, 150, 184–5, 254, 261, 333
Genoese velvet 184, 215
Georgia 99, 265–6, 271, 273–4, 276, 282, 288
Germany 4, 79, 247, 339
Gifts to the tsars 12, 129
Global diffusion 328–30
Globalisation 7, 321
Gloves 164–5, 200, 211, 216–18, 247
Gobelins 237, 240, 242
Gold
 brocade 26, 54, 156, 208, 215, 225, 299, 313
 lace 162, 194, 204, 209, 215–17
 thread 24, 30, 63, 104, 120, 150, 165, 167, 181, 203–4
Goldsmiths' Company 203
Granada 15, 151–2, 253, 260–1
*Grosgran/grosgram/grogram/grosgrain 205–7, 212, 225
Guidebooks 313
Guilds 167, 332
Gujarat 82, 119

H
Half-silks 170, 181, 185
Hall for Ritual Silks 26, 37, 60
Han dynasty 8–9
Hand-looms 195, 313
Hand-weavers 198
handkerchief 16, 269–70
Hanefis 139–40
Hangzhou 14, 31, 49–50, 53, 62, 74
Headdresses 70–1, 152
Heavy silks 109, 129
Heeren XVII 89, 91–2, 98
Hemp 18, 30, 60, 71, 269, 318, 323, 338
Henry VII 153, 158, 165, 180
Henry VIII 162, 165–6, 179–80, 181–3

Hirado 84, 89, 303, 308, 310, 312
Historians 2, 10, 21, 24–5, 34, 45–6,
	105–6, 127–8, 146–7, 251, 263, 324
Holland 11, 80, 82, 84, 90, 92–3, 97, 195,
	295
Home decoration 139, 141
Homespun 268, 277–80
Honour 168, 182–3, 265–80
Household
	goods 103, 106
	production 40, 59, 61, 267, 278, 291,
		293, 331
Hundred Crafts Academy 57
Hundred officials 30
Huzhou 60–1

I

Iberian Peninsula 69, 212, 216, 253–4
Imperial
	bureaucracy 37, 60–2, 74
	control 45
	court 38, 41, 297
	relations 278
	ritual 9, 21
	style 113, 115
	use 9, 30, 43, 67, 69
Import
	bans 110
	substitution 104, 296, 303, 315–18, 321,
		334
Imports 11, 16, 70, 78–9, 81, 84, 86, 89,
	91, 93–4, 97–8, 111, 123, 135–6, 149,
	162, 181, 184, 187–9, 203, 228, 252,
	255, 261, 267, 278, 281, 298–300,
	310–12, 334–5
India 2, 10, 17, 88, 93–4, 101, 104–5, 108,
	140–1, 145–6, 283, 297–301, 325–6,
	328, 331, 335, 337–40
Indian
	fabrics 119–22
	silk 96, 98
	textiles 84, 312, 337
Indigo 56, 138, 258
Industrial Revolution 324
Industrialisation 3, 6, 18, 324
Innovation 3–4, 9–10, 12, 14, 49–74, 146,
	157, 188, 210, 218, 268, 281, 285–6, 314,
	321, 331, 341

Inspectors 233, 289–90
Interaction 122, 317, 329
Intra-Asian trade 100, 311
Inventories
	post-mortem 146–7, 252
	probate 12, 184, 197, 252, 256, 324
Iran 6, 10–11, 75–84, 86, 89–101, 104–5,
	107–8, 133, 138, 140, 144–6
Iranian silk 11, 76, 78, 80–3, 89, 91–101,
	108, 145–6
Isfahan 83, 89, 90–1, 98–9, 144
Islamic law 137–8. *See also* Sharia court
Isolationist policy 70
Istanbul 12, 104, 129–32, 135–8, 140–1,
	145
Italian 6, 13, 16, 51, 79, 81, 104, 106,
	109–10, 113, 127, 141, 145, 149, 166,
	181, 184–5, 192–3, 254, 259, 271, 276,
	279, 285, 293, 326, 333, 335–6
	merchants 15, 78, 105, 176, 178, 184
	silk 93, 107, 111, 150–60, 191, 212,
		260–2, 289
	technologies 17, 333
	velvet 67, 111, 144
	weavers 51
Italy 2, 4, 7, 11, 13, 16, 66, 69, 78–80, 97,
	105, 109–10, 122, 138, 157–85, 187, 192,
	252–3, 260, 263, 268–9, 271, 273–6,
	281, 288, 291, 325, 329, 332–3, 335–6
Itowappu 311–12, 315

J

Jamaica 211, 214
James I 182, 189, 282, 334
James Wiss 286, 288–90, 294
Japan 2–4, 6, 11, 17, 64–6, 69–70, 73–4,
	84, 86–9, 92–5, 98, 100–1, 295–321
Japanese
	designs and motifs 321
	empire 3–4, 86, 296
	silk 70, 295, 316
	silver 84, 87, 298, 311
	traders 298, 303, 311–12
Jewish merchants 107, 145
Jiangnan 29, 33, 37, 47, 62
Jin-polychromes 30, 38, 40–3
Joseon Korea 310, 318–20
Judges 137, 147, 254

K

Karmasūt 120–3
Kasimbazar 287–9
Kemḫā 103, 106, 111, 113, 115, 117–19, 123
Kimonos 300, 314–15, 321, 337
Kinran 299, 313
Kisve 143
Knights 168–9, 171
Know-how 8, 13–14
Knowledge 8, 12, 14–18, 31, 51, 61, 96, 237, 243, 248–9, 266, 283, 286, 288, 294, 333, 337
 economy 280
 exchange 15, 275–7
 transfer 281
 transmission 62–3, 146, 310
Korea 4, 53, 65–6, 302, 310, 317–20, 328
Kosode 300–1
Kuṭnī/kutnu 119–20, 138, 140
Kyoto 297–9, 301, 311–13, 316–17, 321

L

Labour 3, 6, 10–11, 17, 29–31, 37–47, 59, 61–2, 71, 73, 170–1, 189, 240, 254, 263, 266, 271–2, 280, 327, 335
 corvée 11, 30–1, 45, 47, 62
 efficiency 271
 gendered division of 40
 organisation 4, 281, 291–4
Lace 162–3, 184, 187, 189, 192–3, 195, 202–5, 209–10, 212, 215–19, 270
 men 216–17, 221–2
 weavers 196, 221–2
Ledgers 105, 109, 111, 165
Legee silk 191, 212
Legislation 105, 164, 166, 169, 188–9, 219, 232, 271, 283
Levant 76, 78, 96, 188, 202
 Companies 13, 76, 80–1, 98–9, 181, 187, 212
 merchants 14, 187–8, 190, 193, 206, 218, 222
Linen 18, 153, 166, 172, 176, 179–81, 190, 205, 217, 301, 323–5, 327, 331, 339
Ling silk 40–1, 59
Lisbon 80, 214, 217

Literature 16, 41–2, 106, 228, 266, 273, 280
Local
 bureaus 31, 33, 36–7, 39, 60, 62
 conditions 1, 18, 34, 39, 46
 environments 18, 321
 expertise 38
 gazetteers 36, 40–1, 43, 51, 63, 72
 politics 11
 production 41, 59, 128, 144, 280, 285, 293
 sources 37, 40, 42, 44
 specialities 30, 41, 73–4
 styles 17, 136
 techniques 6
Localisation 4, 49–74, 103–23, 280
Localities 21–47
Lombe, Sir Thomas 192–3, 273, 333
London 13–16, 83, 149, 152, 165, 175–6, 178, 183–4, 187–219, 225–8, 272, 275–6, 281, 284, 288–91, 332, 334, 337–8
Long-distance 2, 11–12, 80, 105, 246, 326, 331
Looms 6, 8, 14, 27, 31, 34, 36, 40, 41, 51, 59, 63, 69, 115, 129, 150, 157, 190, 193, 194–5, 198, 206, 212, 218, 231, 236–7, 255, 280, 298–9, 313, 331–2, 336–8
Loops 49, 51–2, 133, 153, 160, 163, 166, 173
Lucca 58, 109, 150, 152, 157, 160, 173, 182
Luo-gauze 30–1, 40, 57, 63
Lustrings 193, 206
Lyons 207, 225–50

M

Macao (Macau) 66–7, 299
Machinery 278, 286, 288, 294, 331–3
Mamluk 107–8
Manchu Qing 9, 72, 94
Manila 86, 299
Manila Galleon 251–63
Mantle 64–5, 69, 73, 170–1, 181
Manufacturers 12–14, 63, 140, 142, 145, 212, 225–6, 228, 232–3, 236–7, 240, 242–3, 245–7, 249–50
Manufacturing partnership 193, 212, 214, 233, 236, 240, 242, 247

Maritime
 prohibition policy 64, 319
 trade 10, 59, 63, 70, 73, 99, 299
 traders 87, 89, 298, 302–3, 311
Mass production 299, 314
Matsumae 297, 302, 317–18
Mawangdui 10, 49, 51–2, 74
Mecca 119–20, 143
Medici 10, 109, 165, 172–4, 179
Medieval period 4, 10, 13, 51, 75, 79, 108,
 187, 253, 298, 321, 323, 325–6, 332, 338
Mediterranean aesthetic 111, 122
Meiji Japan 3, 17, 296
Mercers 159, 162, 176–7, 179, 206, 215,
 217, 220–2, 227–8, 242–3
Merchants
 Armenian 78–9, 83, 100, 135
 Christian 107, 145
 Dutch 90
 European 79, 302
 Frankish 105, 107–9
 French 96, 105, 226
 Italian 15, 78, 105, 176, 178, 184
 Jewish 107, 145
 Levantine 14, 187–8, 190, 193, 206,
 218–19, 222
 Muslim 119
 Ottoman 104, 109, 132, 135
 Persian 109
 private 80, 86, 89, 91
 state 132
Mesopotamia 80, 118
Metal 16, 51, 84, 121–2, 132, 153, 203–4,
 233, 237, 311, 314–15
Mexico 15, 214, 216, 219, 252, 255, 257
Mexico City 211, 256, 258, 263
Middle East 12, 14, 75, 88, 104, 109, 187,
 326, 328
Migration 11, 13, 39
Milan 150, 157, 160, 163, 168, 171, 261,
 333
Ming 2, 10–11, 21, 21–31
 dynasty 22–3, 30, 32, 42–3, 45, 47, 55,
 59–63, 67, 69, 94, 298–9
Ministry of
 Rites 31, 33, 60
 Works 30
Mise-en-carte 237–8, 240–1

Mixteca 251–2, 254–5, 263
Modes of production 3, 15
Modifications 209–10, 288
Mohair 104
Moldavia 136–7, 146
Monasteries 128–9, 166
Money 75, 83, 96, 141, 143, 242, 292, 314
Mongol 27
Mongolian 11, 22, 25
Monopoly 81–3, 311, 313
Moon Harbour 59, 64, 73
Moral 3, 7, 71–2, 218, 249, 267
Morality 58, 189
Moscow 128–30, 132, 136
Moths 290, 292
Motifs 15, 49, 67, 69, 111, 113, 115–18,
 122, 130, 160, 253, 258, 314, 319–21,
 337
Mourning 169, 202, 244, 260
Mulberry trees 4, 9, 44, 56–7, 60, 150, 153,
 189, 254, 265, 268–9, 272–3, 275, 280,
 282–3, 292–3, 299, 328, 330
Murcia 253–4
Muslim 73, 107, 129–30, 132, 140, 253–4,
 329
 elite 128
 merchants 119
 weavers 11, 136

N

Nagasaki 66, 70, 84, 86, 93–4, 295, 297,
 302–4, 308–9, 311–12, 315–17, 319
Nanjing 21, 24, 31, 34, 36–8, 49–50, 60–2,
 69, 74
Naples 261, 269
Narrow wares 14, 152, 162–3, 187, 193,
 215
 weavers of 193, 203, 205, 212, 215
Nasīj 54–5, 63
Native Americans 254–5, 257
Near East 2, 7
Nederlandsche Handel-Maatschappij
 (Netherlands Trading Society) 295
Networks 6, 9, 11, 13, 18, 21, 30, 34, 41,
 59, 91, 100, 104, 119, 231, 243, 248–9,
 267, 311, 320
New England 266
New Exchange 217

New Spain 15, 17, 214, 251–63
New Sweden 268
New World 12, 156, 266, 269, 272, 331
Niche 120, 142, 324
Nishijin 299, 312, 315–17
Nobles 167–9, 300, 319–21
North America 2, 15–17
Nouveau riche 72, 300
Novi 287–8
Numerical data, lack of 14–17, 104, 146–7, 271, 282–3, 288, 294, 324

O

Oaxaca 251, 255, 257–8
Organzine 191–3, 212, 276
Ormesino 152, 160, 170, 173
Orphrey 165
Orthodox 128–30, 132–3, 135, 136
Osaka 301, 309, 311
Ōsode 300–1
Ottoman 12–13, 76, 78–9, 82–3, 97, 103–23, 127–47, 219
 empire 2–3, 9–10, 12, 18, 78, 80–1, 96, 105, 108, 119, 127, 136, 141, 185
 merchants 104, 109, 132, 135
 silk 12–13, 103–23, 127–47, 142, 144–7, 191
 velvet 111–12, 114, 118, 121, 135
 weavers 104, 110, 122, 136

P

Paduasoy 193, 270
Paonazzo 153, 170, 173
'Paris fashions made in Lyons' 232
Patriotism 279–80
Patronage 43, 129, 166, 182, 246, 271
Patrons 135–6, 142, 245
Patterning and Embroidery Bureau 58
Patterns 3, 4, 6, 13–14, 17, 24–6, 29–30, 33, 39, 41–3, 46, 51–2, 57, 63, 67, 73–4, 98, 115–16, 130, 140, 142, 153, 160, 179, 194, 198–9, 207, 210, 216, 218, 226–8, 230–1, 237, 246, 268, 293, 301, 325, 327, 333, 335–6, 340
 books 15, 225, 229–30
 tower 28, 40
Payment 21, 41, 47, 60, 62, 82, 87, 92, 136, 179, 212, 242, 248, 252, 256, 279, 297

Pennsylvania 265–80
Pepper 64, 70, 81, 84, 109–10, 319
Pepys, Samuel 209, 211, 217
Persia 4, 6, 11, 17, 105, 110, 191, 203, 218–19, 297, 304–8, 312
Persian 9, 16
 Gulf 76, 81, 83, 89
 merchants 109
 silk 107, 122, 191, 193, 213
Philadelphia 16, 271–6, 279–80
Philippines 251–2, 256, 258
Picote 259–60
Pile 52, 55, 66, 111, 113, 122, 151–3, 166
 loops 49, 51
 -on-pile 168, 170, 172–3, 177–9
Plantations 44, 266, 331, 335–6
Poland 110, 128–9, 133–6, 146, 245, 248
Polish 12, 127–8, 135–6, 142
 nobility 129, 133
 traders 135
Political power, decentralisation of 320
Pope 10, 58, 66, 149, 164–5
Portugal 80, 262, 333
Portuguese 64–6, 73–4, 81, 83, 86, 297–8, 300, 302–3, 305–8, 310–12
 traders 17, 64, 67, 69–70, 73, 304, 310–11
Pouchon, Joseph 284–5
Powerbrokers 232
Prices 7, 12, 15, 78, 81, 84, 87, 89, 91–2, 94–101, 103, 105, 111, 113, 115–17, 123, 139, 146, 151–3, 158–59, 177, 183, 191, 198, 206, 210, 219, 245, 255, 257, 276, 311, 315–16, 323, 327, 336
 fixed 84, 95, 101, 116, 311
Princely gowns, robes 10, 23, 27, 37
Print culture 271
Printing 337–41
Private 37, 41, 135, 164, 227, 237, 267, 279, 299, 301, 312, 318
 buyers 96
 merchants 80, 86, 89, 91
 sector 10–11, 62–3, 69, 73
 weavers 39–40, 45
Prizes 274, 277
Processing 2, 6–7, 9, 18, 189–93, 255, 257, 277, 282–5, 288, 291, 321, 327, 330–3
Product differentiation 249, 340

Production 1–6, 8–18, 21, 23–4, 30–2, 34,
 36–41, 43, 45–7, 50, 52, 56–7, 60, 62,
 69, 75–6, 91, 96, 98–9, 103–5, 108, 110,
 115, 121–3, 128–9, 140–1, 147, 150–2,
 162, 192, 195, 203–7, 210–13, 218, 231,
 243, 248, 252–5, 258, 261, 263, 266–8,
 271, 275–80, 282–5, 287–91, 293–4,
 296–9, 312–21, 324–5, 327–33, 335–6,
 340–1
 centralisation of 62, 294
 cycle of 122
 flexible 231, 336, 338, 340–1
 quotas 36–8, 40, 44, 61–2, 96, 99
Products 228, 232, 270
Profit, profitable 6–7, 16, 64, 67, 81–2,
 84, 87, 89–94, 97–8, 110, 255, 293–4,
 298–9, 311, 315
Puebla (de los Ángeles) 251, 255, 257–8,
 263
Pure silk 104, 139–40, 175, 254
Purple 25, 153, 156, 158, 179, 182, 211

 Q
Qing dynasty 3, 21, 72, 101, 259
Quakers 267, 269, 271–5, 277–80
Quality
 control 60, 138, 336
 high 6–8, 13, 40–1, 44–5, 66, 73, 100–1,
 108, 120, 136, 141, 145, 149–50, 184,
 283, 287, 291, 295, 298–9, 302, 309,
 312, 315, 317
 inferior 81
Quanzhou 49–50, 57–60, 63–4, 69–74
Quilts 113, 116–17
Quinam 304–8, 312

 R
*Raw silk 4, 6–7, 11, 16–17, 36, 38, 44–5,
 57, 60, 70, 75–101, 138, 141, 146, 151–2,
 162, 187–93, 218, 233, 256–7, 263,
 267–8, 270–3, 276, 278, 281–5, 289–91,
 294–6, 298–302, 309–11, 315–16, 321,
 328, 335–6
 domesticated 75, 316
Ready-made 176, 202
Reeled silk 8, 45, 105, 107–10, 122, 275,
 277, 284, 287, 290–2, 294

Reeling
 machine 281, 285–8, 294, 296, 331
 new methods 288, 291–4
 Piedmontese 16, 273, 276, 281, 285–9,
 291–2, 294
Regulations 31, 54, 60, 107, 109, 123, 179,
 253, 319
Renaissance 13, 108, 117–18, 123, 127,
 153, 164, 325
Resources 83, 96, 255, 266, 315
'Reverse engineering' 327
Ribbon
 frame 195
 weavers 189, 195–6, 203, 216, 220–1
 weaving 195
Ribbons 2, 162, 175, 187, 191, 193, 195,
 198–200, 202–3, 212, 215–19, 247,
 259–62, 284
 figured 198
Ritual 4, 9, 21–2, 30–2, 60, 325
*Rizo. See Bouclé
Royal
 court 100, 135, 139
 Exchange 195, 215, 217
 family 175, 249
 household 178
Royalty 133
Ruling classes, elite 45–6, 70, 248, 298,
 301, 319
Russia 9, 80, 96–7, 105, 128–32, 245, 248
Russian 79, 106, 130, 132, 136
Ryukyu 64, 302, 309, 316–17

 S
Safavid 11, 76, 78–80, 82–4, 89, 91, 93,
 95–101, 108, 111, 142, 144
Sakai 299, 311
Sakoku 70
Sales 98–9, 104, 164, 176, 215, 227–8,
 232–3, 243–4
Salesmen 228, 233, 243–4, 247–9
Sample books 14–15, 228–30, 247
Samples 74, 92, 96, 183, 226–8, 233,
 246–9, 275, 278, 289–91, 295
Samurai 69, 299
*Sarcenets 203, 215, 218, 225
Sashes 133, 136, 142

*Satin 7, 24–5, 31, 40, 58, 61, 63, 70, 73–4, 104, 111, 141, 151–3, 156, 158–60, 163, 167–70, 172–3, 175–6, 178, 181–3, 185, 188, 198, 204, 206, 215, 218, 225, 258–60, 313, 336, 338
Satsuma 297, 302, 309, 316
Seasonal 153, 226, 232, 237, 247
Seclusion policy 301–3
Second-hand 168, 171
Selling 103, 128, 141–2, 146, 164, 195, 226, 243–9
*Serāser 104, 113, 115–17
Sericulture 1–2, 4–7, 9–10, 12, 14–18, 34, 37–40, 42–3, 47, 56, 59–60, 62, 75, 78–9, 81, 127, 150, 251–2, 254–5, 257, 263, 266–71, 273, 276, 281–3, 291–4, 296, 317, 320–1, 327–32, 334
 French 79
'Set-term service' 61–3
Seville 15, 214, 260–1
Shandong 23, 37–42, 53
Sharia court 103, 116. *See also* Islamic law
Shirvan 78, 99, 191
Sichuan 8, 33, 37, 41, 42–5, 70
Silk (raw silk and spun yarn)
 Asian 11, 75–101, 326
 'broken' 113
 brokers, retailers 8, 14, 212, 215, 233, 252
 bundled 256
 'call' 152
 Company 277, 279
 Florentine 111, 145, 150–1, 153, 173, 215
 'fluid' 44
 heavy 109, 129
 inferior 90, 293
 lampas 54, 58, 103–4, 153, 155, 160, 175–6, 184, 336
 spun 191, 206, 256, 258, 268, 277–80, 293, 331, 336
 tabby 36, 40–1, 44–5, 49, 63, 71, 74, 152, 191, 200, 206, 209, 215, 336
 white 40, 82, 170, 191, 214, 270, 303, 311, 316
 See also Bengali silk; Indian, silk; Iranian silk; Italian, silk; Japanese, silk; Ottoman silk; Persian silk; Pure

silk; Raw silk; Reeled silk; Spanish silk; Twisted, silk; Uses of silk; Vietnamese silk
Silk as a
 colonial objective 268–9
 commodity 2, 16, 18, 21, 78–9, 82, 84, 266, 276, 312
 Ling 40–1, 59
 luxury 2, 7–10, 18, 21, 54, 57, 66, 73, 75, 79, 103–4, 106, 108–11, 113, 115–17, 120, 123, 130, 133, 136, 144, 146, 149, 167, 171, 175, 184, 189, 218, 267–8, 278, 324
 payment 21, 41, 47, 60, 62, 82, 87, 92, 136, 179, 212, 242, 248, 252, 256, 279, 297
 'public-spirited' design 272
'Silk makes the Difference' 189
Silk road 100
Silk throwing. *See* Throwing; Thrown silk
Silkmen 191, 195
Silks (cloth and silk goods)
 broad 187, 191, 215, 218
 weavers of 191, 197, 206, 213, 221–2
 weaving of 205–10, 213
 Florentine 115–16, 120–1, 123, 130, 152, 215, 231, 336
 French 163, 183, 215, 225, 227–8
 goods
 cost of 7–8, 42, 113, 143, 156, 168, 180, 182, 220, 225, 270, 277, 290, 324
 duties on 45, 164, 184
 half-silks 171, 181, 185
 plain 14, 41, 60, 63, 65, 71, 104, 152, 160, 176, 185, 187, 191, 206, 246, 336
 See also Stockings, silk
Silkwomen 152, 162
Silkworms 1, 14, 17, 44, 56, 98, 254, 256, 266, 268, 270–4, 280–3, 292–3, 296, 326, 328–30
Silver 15, 47, 62, 84–9, 91, 94, 103, 111, 113, 115, 143, 153, 160, 163, 165–6, 168, 173, 181–3, 188, 192–3, 195, 198, 200, 202–6, 215–17, 225, 247, 252, 255, 257, 298–9, 301, 303, 311–12, 314–15
*Sīreng 103, 115, 117–18, 120, 123
Slaves 55, 335, 340

Smyrna 96, 190–1
Society for Promoting Useful Knowledge
 272
Song dynasty 39, 53, 56
South Asia 2, 88, 103, 119–23, 129, 302,
 312, 314–15, 319, 321, 325, 327–8
Southampton 175, 181, 184
Spanish 15, 79, 86, 181, 212, 215, 249,
 251–2, 254–61, 263, 274, 299
 America 330
 empire 251
 silk 151–2, 253
 velvet 69–70
Specialisation 150, 191, 195, 231, 237, 325,
 327, 331, 336
Specialised 30, 63, 137, 150, 209, 247, 331
Specialists 4, 14, 144, 150, 190, 207, 209,
 212, 217, 268, 274, 276, 284, 286,
 288–92, 294
Spices 65, 70, 76, 81, 84, 90, 100, 107, 110,
 319
Spindles 192, 314, 331, 333
Standards 3, 6, 24, 32, 116, 289
State, states 6–7, 9–11, 13, 16–17, 21, 57,
 60, 64, 70–4, 77–8, 96, 99–100, 104,
 106, 108–9, 123, 149, 167, 171, 173,
 179, 204, 251, 253, 267, 280, 318–21,
 334, 336
 control 37, 188, 301, 311, 323
 merchants 132
State-owned 9, 21–47, 59, 62–3
Statistical data, lack of 218, 310, 318
Stockings 15, 187, 190–1, 192, 209–14,
 216–19, 247, 261, 269
 silk 138
 trimmer 220–1
Stoles 164–5, 170
Sub-contractors 191, 209, 211, 213–14, 216
Sultans 106–8, 110–11, 116, 119, 122,
 128–9, 132, 135–7, 141, 143–4, 146, 285
Sumptuary laws, legislation 6, 12, 163,
 165–7, 178–9, 184, 188, 219, 278, 314,
 320, 323
Supervision 31, 291, 294
Suzhou 31, 49–50, 54–5, 61–3, 66, 69,
 71–2, 74, 313, 328
Syria 76, 80, 105, 108, 118, 140–1, 191

T

Table-top looms 193–4
Taffeta 104, 151–2, 167–8, 173, 176,
 179–81, 185, 188, 191, 198, 205, 218,
 251, 258–61
Tafta 104, 111, 113, 115, 119–20, 138
Tailored 27, 69, 109
Tailoring 27
Tailors 70, 189, 210–11, 252, 256, 258,
 260, 294
Taiwan 11, 85–7, 311–12, 316
Tang dynasty 25, 27, 56, 297
Tapestries 184, 250
'Tartar' cloths 326
Tartaryn 152, 175
Taste, tastes 7, 15, 17, 108–9, 110–15, 122,
 136, 140, 160, 167, 179, 185, 217, 232,
 237, 243–4, 246, 248–9, 252, 259–60,
 263, 334
Taxes 41, 84, 95–6
Technical 3, 6, 8, 28, 32, 52, 61, 67, 73,
 111, 132, 237, 249, 253, 276, 285, 296,
 299, 337
 change 1, 23, 46
Techniques 6–8, 17, 30, 33, 52, 55, 69, 122,
 247, 253, 266, 281, 285, 294, 298–9, 301,
 314, 319, 321, 328
Technological 6, 23, 228, 272, 296, 334–6,
 340
 change, diffusion 1, 10
 choices 9, 23, 29, 34, 47
 innovation 4, 52, 210, 281, 314, 321,
 331, 341
 know-how 13
 transfer 16, 333
Textile sizes 38, 67, 116, 123, 143, 246, 336
'Textile spheres' 323–8
Textiles
 embroidered 39, 58, 67–70, 113, 133,
 139–40, 142, 156, 164–5, 181–3, 200,
 203–4, 209, 258–9, 295
 excavated 8, 22–5, 27, 29, 42, 46, 54
 expensive 13, 42, 57, 71, 82, 99, 113,
 115–16, 132, 138–9, 151–3, 166, 168,
 170, 178–9, 181–2, 185, 187, 191,
 198, 202, 206–7, 211, 213–16, 248,
 256, 323, 334–5, 337, 340

heavy fabrics 73, 82, 111, 160, 163, 170, 185

light fabrics 6, 30–1, 58, 104, 110, 123, 138, 152, 160, 163, 176, 185, 244, 284, 337

mixed fabrics 14, 120, 140, 142, 168, 187, 192, 206, 209, 212, 215–16, 218, 254, 284, 334

Venetian fabrics 111

Thrace 111, 119

Thread, threads 1, 4–10, 17–18, 24, 30, 36, 42, 44, 63, 67, 90, 98, 103–4, 107–11, 116–17, 120–1, 123, 139, 143–4, 150, 152–3, 155, 160, 163–4, 166, 168, 181, 191–2, 195, 203–4, 214, 217, 237, 253, 256–8, 263, 275, 280–1, 284–7, 293, 295, 299, 311–12, 314–18, 331, 336

gilt 103, 144, 155, 314

Throwing 16, 192–3, 213, 219, 273, 284, 331–3, 336, 340

*Thrown silk 8, 13, 151, 187, 191–2, 206, 211, 213–14

Throwsters 191–3

Tokugawa 3, 17, 69–70, 84, 295–6, 298, 300–14, 317–21

Tombs 8–9, 22–7, 29, 42–4, 46, 49, 54, 57, 66–7, 137

Tonkin 17, 87, 89, 94, 98, 101, 304–8, 311–12

Tools 8, 15, 17, 331

Topkapı Palace 106

Topkapı Palace Museum 106, 121, 141–2, 144

*Torcitoio. See Filatoio

Trade
 cross-cultural 74
 routes 2, 11, 77, 79, 83

Traders 14, 17, 41, 59, 64, 67, 69–70, 109–10, 119, 127, 132, 135, 145, 299, 302–4, 309–12, 315, 319, 321

Trades 1–6, 8–15, 18, 21, 26, 37, 40, 45, 52, 56–7, 59, 63–7, 70, 73–4, 76, 78–82, 84, 86, 89, 94–5, 97–101, 104–6, 107–9, 119–20, 135–8, 141, 146, 149, 165, 167, 187–222, 226–8, 232–3, 237, 243–7, 249, 252–3, 255–8, 261, 267–8, 271, 276, 281–2, 284, 288, 290, 293, 295–321, 326

Transfer 4, 11, 16–17, 219, 254, 281–94, 296, 299, 313, 320–1, 328–9, 333

Transmission 16, 51–2, 61, 253, 281, 294

Travelling salesmen 244, 247

Trends 13, 63, 99, 118, 123, 172, 298–300, 303, 314

Trendsetters 244

Tributary 31, 57, 59–60, 302, 311, 319, 321

Tribute Bureau 57

Tsars 12, 128–30, 132, 136

Tsushima 297, 302–10, 311, 316–17, 319

Turkey 170, 181, 185, 190–2, 219

Turkish 80–1, 104–5, 139–40, 163

Twisted
 silk 193, 256
 thread 192
 yarns 256, 314

Twisting machines 314

U

United States 280, 296

US–Japan Treaty of Amity 296, 302

Uses of silk 8, 18, 30, 103, 117, 324

V

Valencia 253–4, 275

Value 2, 86, 98, 109, 115, 120–1, 127–8, 137, 146–7, 164, 173, 182, 195, 198, 200, 209, 211, 213, 215–16, 253, 257, 260, 269, 275, 278, 282, 295, 297, 318, 324, 338

Values 3, 7, 23, 29, 33, 103, 120, 152–3, 321

Vanity 188, 267

Variety 113, 116, 123, 144, 164, 175, 188, 198, 213, 231, 249, 283, 313, 319, 328, 336, 340

*Velvet 10, 12–13, 49–74, 103, 111–12, 114, 118, 121–2, 132, 135, 139, 144, 150–3, 156–8, 160, 164, 166, 168–73, 175–84, 185, 187–8, 202, 205, 207, 209, 216, 225, 258, 260, 313, 336–7

 Alto e basso. See Alto e basso
 çatma. See Çatma
 Genoese 183–4, 215
 'swan-down' 51, 63, 66, 72

Venetians 81, 111, 116, 138, 145, 150, 152, 165, 169–71, 176

Venice 13–14, 78, 80, 104–6, 108–10, 150,
 164–5, 170–2, 177, 183, 185, 194, 332
Verenigde Oostindische Compagnie (Dutch
 East India Company, VOC) 11, 76, 296
Vermis Sericus 328–30
Vesta 169, 173
Vietnam 4, 11, 75, 87, 89, 94, 100, 297, 311
Vietnamese silk 84–9, 100
Visual cultures 4, 63
Vizier 96, 119, 129
Voided velvet 12, 53, 103, 112, 114, 118,
 121, 151, 153, 156, 172–3, 178

W

Wall hangings 135, 142, 175
Wang Xijue 66–7, 71
War of Independence, American 273, 276,
 279
Warps 151, 191–2, 195, 212
Warps and wefts 14, 119, 336
Warring States period 298, 312
Wealthy 8, 12, 14, 56, 111, 113, 116, 137,
 139, 142, 145, 147, 176, 184, 188, 260,
 262, 273, 301
Weavers 191, 195, 203, 205, 212
Weavers' Company 219, 226–8
Weaving and Dyeing Bureaus 30–1, 35–7,
 39–40, 43–44, 60–2
*Winding 8, 192, 213, 271, 276
Wire 16, 51, 66, 111, 190, 203
Wire thread 153, 160, 163
Woduan 70–2
Woollen 215, 327
 cloth 82, 100, 150, 339
 garments 172–3, 217
 industry 325, 335

Woollens 13, 18, 82, 109, 113, 123, 216,
 323–5, 327–8
Workers 115, 130, 142, 144, 168, 181, 193,
 195, 254, 267, 283, 333, 335
Workforce 39, 288
Workshops 7, 9, 11, 17, 29–30, 33–4, 37,
 39, 41, 43, 57, 61, 257, 287

Y

Yangzi Valley, Lower 49, 56–7, 60, 62–3,
 69, 74
Yanzhou 38–41
Yastaqiyya 139
Yuan 11, 22, 26–7, 29–37, 39, 41, 43, 45–7,
 54–5, 57–9, 63, 74, 298
Yunzhi 63
Yūzen-zome 314

Z

Zhang Shicheng's tomb 54
Zhang-velvet 10
Zhangzhou 10, 49–52, 56–7, 59–64, 69–7
Zheng 87, 316
Zhengde period 44
Zhenjiang 34, 36, 60
Zhisun 25, 27, 54
Zhu Chun 23, 42, 45–6
Zhu-satin 40
Zhu Tan 23–7, 39–42, 46
Zhu Wan 64
Zhu Yuanzhang 24, 26–7, 31, 33, 37–8, 40,
 42–3, 45–6
Zhuanghua jin 63
Zhuozhou District 30

PASOLD STUDIES IN TEXTILE HISTORY

The following titles from the Pasold Studies in Textile History series are available from Boydell & Brewer:

Geoffrey Owen
The Rise and Fall of Great Companies: Courtaulds and the Reshaping of the Man-Made Fibres Industry

Giorgio Riello and Prasannan Parthasarathi (eds)
The Spinning World: A Global History of Cotton Textiles, 1200–1850

Giorgio Riello
A Foot in the Past: Consumers, Producers and Footwear in the Long Eighteenth Century

Douglas A. Farnie and David J. Jeremy (eds)
The Fibre that Changed the World: The Cotton Industry in International Perspective, 1600–1990s

Katrina Honeyman
Well Suited: A History of the Leeds Clothing Industry, 1850–1990

Printed and bound by CPI Group (UK) Ltd, Croydon, CR0 4YY

23/04/2025

14661045-0001